THE UNDERCUT READER

the undercut reader
critical writings on artists' film and video

edited by nina danino and michael mazière

WALLFLOWER PRESS LONDON & NEW YORK

First published in Great Britain in 2003 by
Wallflower Press
5 Pond Street, London NW3 2PN
www.wallflowerpress.co.uk

A catalogue for this book is available from the British Library.

ISBN 1-903364-47-7

Book design by Rob Bowden Design
Typesetting by Loaf Design

Printed in Great Britain by Biddles Limited, Guildford and King's Lynn

contents

acknowledgements

The editors wish to thank all the individuals who as *Undercut* Collective members, artists, writers and funders contributed to the journal over the years to make such a unique project possible.

The *Undercut* Collective (1981–1986) issues 1–16: Nina Danino, Graham Foskett, Nicky Hamlyn, Stuart Marshall, Michael Mazière, George Menzies, Peter Milner, Lucy Moy-Thomas, Tim Norris, Michael O'Pray, Lucy Panteli, Jinny Rawling, AL Rees, Guy Sherwin, Claudio Solano, Susan Stein, Gillian Swanson, Penny Webb, John Woodman.

Editors 1986–1990: issue 17 – Nina Danino assisted by Michael Mazière and Lucy Panteli; issues 18 and 19 – Nina Danino and Michael Mazière.

Special thanks to: AHRB Centre for British Film and Television Studies, British Artists' Film and Video Study Collection, British Film Institute Stills Library, The Canadian Film Council, Claire Barwell, David Curtis, Elena Danino, Peter Gidal, Malcolm Le Grice, Jean Matthee, Colleen Sullivan, Anna Thew, Gary Thomas, and all the artists who provided original visual material for this collection.

This book is dedicated to Isabelle & Thalia

introduction
nina danino, michael mazière

Artists' film and video has become one of the most popular and compelling practices in the visual arts, yet very little historical contextualisation has taken place. Throughout the 1990s and until recently, film and video work has been celebrated with little historical or critical reference to the wealth of work which had gone before it. We have compiled this collection with this context in mind.

The Undercut Reader is an anthology of writing and visual works from *Undercut*, the only UK journal dedicated to artists' film and video between 1980 and 1990. The journal represented a major attempt by a group of artists and intellectuals, at a crucial period of transition, to critically explore the aesthetics and politics of film and video practices within the context of visual arts and independent cinema.

Undercut was published by an editorial collective of young and established filmmakers, artists, critics and writers in film and video, and was founded at the London Film-makers' Co-operative in 1981. The journal had a readership of artists, filmmakers, academics and enthusiasts in the UK, Europe, Australia, Canada and the US. It represented an important voice and a unique platform for the debates and practices of experimental film and video art. Many contemporary artists, filmmakers and critics contributed writing and visuals to its pages.

The journal created a critical space for the discussion of avant-garde and experimental time-based work (film, video, photography, performance, expanded and installation work). Its aim was to stimulate debate and to break down denominations of artist and critic. It differed from other academic film/cinema journals in its interdisciplinary, artist-led approach combined with rigorous critical writing. *Undercut* reflected on how the debates around medium-specific practices were challenged, influenced and changed by a broader experimental spectrum of practices and poetics such as: narrative and representation, feminist perspectives, questions of identity, cultural and issue-based work, gay politics, the new imagination and aesthetics of hybridity.

The material in this Reader is drawn from a total of 19 issues published. This includes theoretical pieces, critical appraisals of new films and videos by artists, interviews with filmmakers and artists, polemics and critical perspectives, artists' films and video and photo-pieces especially made by artists for the magazine.

This collection aims to provide invaluable documentation, critical perspectives and historical traces to artists' film and video practices. Furthermore, we hope that it will inform current debates and practices through its wealth of reference and critical material. Our selection of material has focused on British work. This has meant that much European work is not represented here nor is work which focused more exclusively on the wider debates of the Independent and Community arts sectors. We felt that in the case of the latter, these have been published in alternative sources.

We have attempted to represent the range of issues and concerns that dominated the journal. Many artists and critics gave generously to *Undercut* and in order to represent the full range of contributions and to give the reader the opportunity to follow up material not included, we have included a full list of back issues that are available, and we aim that all the material will eventuallly become available on the internet.

We have attempted to convey the lively, controversial and committed tone of the magazine and to give a clear idea of the aspects of film and video it promoted. We have therefore aimed to represent the diversity of the forms of contribution, artists' photo-pieces and statements, critics' perspectives, manifestos, interviews and interventions as well as positions taken.

The material has been divided into thematic sections. A unique aspect of the Reader is the reproduction of the journal's distinctive trademark photo-pieces. Also included are five new essays to reflect on and draw out the critical debates and to provide a bridge between historical and contemporary practices in film and the visual arts.

chapter 1 revisitations

art, film, video: separation or synthesis?
barry schwabsky

What is the relationship between art and film today? The range of possible answers can be glimpsed from the following series of recent examples:

A well-established painter, Julian Schnabel, leverages his standing as a blue-chip artist represented by a gallery whose owner is also a Hollywood producer to become a director within the commercial movie system. His gallery artwork and his work as a filmmaker remain two distinct, parallel ventures – though some artworld denizens who consider his paintings overrated cannot resist the opportunity for a backhanded compliment: 'He's finally found his true medium!'

An up-and-coming sculptor/performance artist, Matthew Barney, begins making a sequence of eccentric narrative films that pursue and expand on the thematic content of his previous, more gallery-bound work – and through these films he builds on the early acclaim for his gallery-based work to become a hugely successful artist. Although some of the films enjoy theatrical release and none are typically shown in galleries, they become Barney's primary work as an artist; the sculptures and photographs he exhibits in galleries are now essentially souvenirs of his films.

A somewhat younger artist than Barney, Tacita Dean, makes her name largely by means of film works – clearly influenced by structuralist cinema of an earlier generation, though with evident differences partly to be accounted for by the fact that these works are designed to be shown in galleries; in them, the film apparatus itself tends to become part of the quasi-sculptural matter of what can then be seen not so much as film, but as film installation.

Fiona Banner, another English artist of Dean's generation, has never (if I am not mistaken) made a film or video, but many of her works have been 'remakes' or 'translations' of popular films into neo-conceptual text-based artworks: *The Desert* (1995), for example, being a moment-by-moment description of *Lawrence of Arabia* (1962) presented as a kind of mural. The sheer quantity of verbiage makes linear reading unlikely, if not impossible. Whatever narrative drive the film had is broken up into a landscape of fragments whose order of reception will be different for every viewer – a kind of anti-movie.

A filmmaker who has become well known on the international alternative circuit, Isaac Julien, shifts the focus of his practice from theatrical presentation to gallery/museum installation, and becomes sufficiently well-accepted in this new venue that he becomes the bookmakers' favourite to win the Turner Prize (though in the end he does not prevail).

Given all these occurrences and many more, this is probably as good a time as there has ever been to re-examine the (missed) connection between the worlds of art and avant-garde film in the post-War era. In the first half of the last century, it was normal for avant-garde artists (especially but not exclusively those associated with Surrealism) to experiment with film, as witnessed by works like *Anemic Cinema* (Duchamp), *Rose Hobart* (Cornell), and most obviously *Andalusian Dog* (not just Buñuel, remember: Buñuel and Dalì), all of which are part of the history of cinema as well as that of art. In the early to mid-1960s, Andy Warhol's work crossed the two worlds, as did Michael Snow's a bit later; but they stand out as exceptions. In view of Allen Kaprow's prescient statement of 1958, 'The young artist of today need no longer say "I am a painter" or "a dancer". He is simply an "artist"'[1] – soon to become a watchword of generations of Fluxus, Conceptual, installation and other 'trans-media' artists – the claim embodied in the name 'artist' may simply have become too all-encompassing, too self-aggrandising to allow for common cause with those whose mission was to reinvent film (or dance, or music, or literature, or any of the other arts whose roots were not in the 'plastic arts' of drawing, painting and sculpture) as an artistic vehicle.

In the early to mid-1970s performance artists and process-oriented sculptors like Dan Graham, Joan Jonas or Richard Serra often essayed film works, but soon either dropped their involvement in the moving image altogether or shifted their interest to video – which for many, at the time, was attractive precisely to the extent that they could use it as an otherwise

inartistic 'non-medium'. Of course, this phase in which video's 'styling' of its contents was nearly invisible was very brief indeed, and soon enough one could work within the art system as a video artist in the sense of working with a specific medium just as any painter or sculptor does – but except for Snow there were no prominent artists working with film as a primary medium within the art world after Warhol's abandonment of it in 1966. From the time the video camera came into broad use up until the mid-1990s, moving pictures in a gallery context could be assumed to be video. Art and film, one might say, had agreed to disagree.

But now that art has again begun moving toward the incorporation of film, the situation has had to be re-examined, and this rethinking of the historical relation between art and film has been taking place not only through the work of a great number of individual artists, but also on an institutional level, through a number of large-scale exhibitions that have attempted to come to grips with the problem – among them *L'Effet Cinéma* (Musée d'Art Contemporain de Montréal, 1995), *Hall of Mirrors: Art & Film Since 1945* (Museum of Contemporary Art, Los Angeles, 1996), *Spellbound: Film and Art* (Hayward Gallery, London, 1996), and *Cinéma Cinéma: Contemporary Art and the Cinematic Experience* (Stedelijk Van Abbemuseum, Eindhoven, 1999). But what has been peculiar about this recuperation of art's relation to film is that, in terms of the 'film' or 'cinema' part of the equation, it has consistently sidelined the kinds of film that would on the face of it appear most relevant to late-modern and contemporary artistic practice – that is, the various forms of avant-garde, experimental, poetic, materialist and structuralist cinema that have eschewed the conventions of the narrative feature. Instead, the focus has been precisely on narrative features, primarily of the Hollywood variety, secondarily those that arose in the wake of the *Nouvelle Vague* – the cinema of Godard, Antonioni, Fassbinder and so on. The artist Pierre Bismuth, in an extremely lucid text published in the catalogue for *Cinéma Cinéma*, expresses this quite clearly: 'There is at present a whole generation of artists who are attracted by the film industry. This affinity does not necessarily have to do with the medium or even the form of film; rather, it is a question of value and social function. … However, art does have its affinities with a part of the history of cinema, as represented by the research of Etienne Jules Marey or the Lumière Brothers. The reference is to work by those for whom the cinema was a means of enquiry, a technique for examining reality and not just representing it. … The films that per-

petuate this tradition today are no doubt even more isolated than the most isolated artworks.'[2]

Perhaps the fact that Hollywood makes the movies that most people see, including artists and curators who are thereby affected by it, is explanation enough for the art world's focus on commercial cinema. But keep in mind the double sense of the title of the Haywards show – not only that of a film by Alfred Hitchcock, which is to say Hollywood cinema at its artistic pinnacle, but also a description of the fascination exerted on the rarefied domain of the fine arts by this popular spectacle that did in fact manage to produce remarkable art. The art/cinema pairing therefore turns out to be a variant on the 'High/Low' theme that has been so important to contemporary art at least since the beginnings of Pop Art more than forty years ago. In other words, artists may be interested in cinema precisely to the extent that they experience it as not structurally connected or homologous to art. This is what allows it to function as 'material' to be worked on. Regarding many of the artworks that seem to approach cinema (including some of his own works), Bismuth continues: 'Just as a sound piece does not necessarily refer to music, most of these works do not refer to cinema. Exploring an interest in phenomena such as duration and the unfolding of a process, in the question of what it is that characterizes or defines an event, and in the passage from the activity of watching to that of showing, automatically takes these works into a sphere that is shared by the cinema. But on a deeper level, they do not particularly seek to achieve this proximity.'[3] It can also be added that artworks that cite film – paintings, text works, photographs, and above all video installations – remain far more numerous than those that actually use it as a medium. In many situations film and video are treated as essentially interchangeable, so that works made as films are exhibited as video or DVD for the sake of convenience, despite the differences in visual texture among the media.

What Bismuth says is true enough, but perhaps an involuntary connection is more telling than a willed one. What is there about the art of our time that insists on this approximation to the condition to cinema, to paraphrase Walter Pater? In order to answer the question, one would have to examine works in which this connection was very deeply secreted in their form, perhaps nearly unnoticeably so – but one must begin, which is all I can do here, by casting an eye on a few of those cases where the connections are more emphatic and therefore uncomplicated. The fact that in certain works an artist like Bismuth

avails himself of pop cinema does not mean that he allies himself with its pretense to merely 'represent' but rather that he founds his 'examination' on a previously existing representation. Nonetheless such works can be accused of being parasitic. As Bismuth's colleague Pierre Huyghe remarks of one his own works: 'The actress who plays the part of Grace Kelly in the remake of *Rear Window* isn't interested in the character Grace Kelly plays, but in the way that Grace Kelly plays that character.'[4] The work is still founded on the sense that there was an original and originary relationship between an actor and a character, even if this possibility has now had to be sacrificed for some other end. Huyghe continues, 'it's very naive to think that because you're remaking something you're not doing things differently' – as though the only way to prove the impossibility of repetition were precisely by means of enacting it. But it could very well be that artists like Huyghe or Douglas Gordon really are in fact only ever repeating Hitchcock through their 'remakes' of *Rear Window* or *Psycho*, or even that Bismuth was merely repeating Blake Edwards (to take a somewhat less obviously exalted case) in his work based on *The Party*. Their deconstruction of the film narrative, to all appearances constituting a critique, may actually be a way of reveling in what one might call (paraphrasing Adorno) the 'fetish-character of looking' – since what we really want from the movies are simply the 'good bits', and we put up with the story insofar as it makes them possible. For that reason, Hitchcock or Edwards may proleptically reveal more about Huyghe's, Gordon's or Bismuth's work than they retrospectively reveal about his. Because this is a problem so deeply and unsettlingly bound up with the nature of temporality, I feel justified in repeating – yes, repeating – the temporizing cliché: Perhaps only time will tell. More to the point may be the admission of Mark Lewis: 'I accept absolutely the banality and inevitability of cinema's reliance on certain traditional forms.'[5] It may be precisely the unrequited need for such forms that certain artists seek to fulfil through their use of cinema, even though they tend to do so under the deceptive guise of 'critique' or 'examination'.

With regard to the experimental film world, its disconnection from the art world, during the period covered by this anthology, seems even more complete than the art world's disconnection from film during the same period. Reading back through the 19 issues of *Undercut*, it is striking – given the breadth of the magazine's practical and theoretical interests, how little reflection there is either on the broad relations between film and either the idea of (fine) art or

its institutions or on the specific differences between the typical situations of public display in the two fields – gallery presentation and theatrical presentation. Of course, this mirrors the reciprocal disinterest of the artworld in experimental film, an interest that is equally surprising in both cases, given previous moments of rapprochement between them.[6] Where the relations between film and fine art are touched upon in *Undercut*, it is usually by way of reflection on the relations between film and video. (Only fairly late in the magazine's career, in 1986, is there explicit acknowledgement of the fact that 'much new work does not locate itself exclusively in the use of one medium or production method but rather takes from different formats and practices'.)[7]

The relations between film and video, as they appear in *Undercut*, may best be summed up by the inscription on the blackboard seen in the still from Godard's *Slow Motion*, seen on page 31 of the magazine's second issue and reproduced in this collection on page 202: 'Cain et / Abel / / Cinéma et / Vidéo.' Of course there were essays on video work alongside the far more numerous ones on film throughout the history of the magazine, but surprisingly little discussion of the relation between the two practices. Perhaps most poignant is Peter Milner's reflection that 'video leaving film as something of a backwater has preserved for the avant-garde film a degree of autonomy', and the somewhat nostalgic recollection of 'the American underground where perhaps there is greater institutional support for the indefinite equation between "art" and "film".'[8] Deke Dusinberre, reviewing Hal Foster's landmark anthology of postmodern thought, *The Anti-Aesthetic* (1983), remarks that 'just how marginal avant-garde film is in relation to the other fine arts and the criticism which accompanies them' can be seen in the book's total neglect of film; video gets slightly better treatment, presumably because it 'has access to a more conventional but extremely important artistic network: that of the art market'.[9]

Interestingly enough, the most thoroughgoing reflections published in *Undercut* on the specific topic of video's relation to art raised some thought-provoking questions about the possibly contingent nature of that relation. Mick Hartney noted that: 'Critical and curatorial treatment of video within the visual arts establishment all too often operate to perpetuate the impression that the values and potential of the medium are limited to those of traditional visual art practice. While the production and presentation of video art has benefited from this effect, the gal-

lery – as a physically, if not politically, neutral space – is more hospitable to new or hybrid art-forms … it would be patently wrong to assume that the line of descent which is discernible from painting and sculpture through to video art represents an exclusive or even dominant source of inherited concerns.'[10]

But if it was correct, in 1983, to question the seemingly self-evident relation between 'video' and 'art', from today's perspective it can be seen that the rise of installation art in the 1990s raised problems for which projected video has presented itself as the perfect answer. Installation's use of the entirety of a room as its support brought back problems that had been dormant in art for more than two centuries. 'Taken to its logical extreme', wrote E. H. Gombrich, 'the principle [that frescoed wall should be treated as a fictitious window] must in fact deny not only the wall but the room itself, which is what Giulio Romano did in Mantua, in a sensational showpiece which is not, perhaps, the height of stupidity, but the height of folly, when regarded as a room – precisely because it is the ultimate in dramatic evocation, the equivalent of a 3D horror film.'[11] Today, the best way to transform a space totally, to impose an artistic fiction on it, is to darken it so that its literal character becomes invisible and then to completely surround the viewers with images projected on all surrounding walls. In other words, it may be that art, or one important strand within it, is working its way toward a new form of spectacle, a new form of presentation that marries the spectatorial mobility allowed by the traditional gallery with the overwhelming displacement of reality possible in the cinema theatre. So far we have essentially seen various forms of compromise between these two still-distinct situations, but it is not hard to imagine that a true synthesis is just around the corner.

1 Allan Kaprow, 'The Legacy of Jackson Pollock', *Art News* LVII 6 (October 1958), p. 57.
2 Pierre Bismuth, 'The Rules of the Game', *Cinéma Cinéma: Contemporary Art and the Cinematic Experience* (Eindhoven: Stedelijk Van Abbemuseum/Rotterdam: NAi, 1999), p. 55.
3 Ibid., p. 56.
4 'Freed Time Scenarios: An Interview with Pierre Huyghe by Françoise Chaloin', *Cinéma Cinéma*, p. 88.
5 'A Sense of Disbelief: An Interview with Mark Lewis by Charles Esche', *Cinéma Cinéma*, p. 102.
6 In the case of the United States, this has recently been highlighted by the exhibition *Into the Light: The Projected Image in American Art 1964–1977*, curated by Chrissie Iles for the Whitney Museum of American Art, 18 October 2001 – 27 January 2002, and which included work by a wide range of figures including some, such as Paul Sharits and Michael Snow, who are these days better known to the film world than the art world.
7 Untitled editorial note, *Undercut* 16 (Spring/Summer 1986), p. 1.
8 Peter Milner, 'The London Film-Makers' Co-op: The Politics of License?', *Undercut* 10/11 (Winter 1983/84), pp. 2–3.
9 Deke Dusinberre, 'Ceci n'est pas une Theorie (or, How I became a Post-critic)', *Undercut* 13 (Winter 1984/85), p. 47.
10 Mick Hartney, 'Landscape/Video/Art: Some tentative rules and exceptions', *Undercut* 7/8 (Spring 1983), p. 88.
11 E. H. Gombrich, *The Uses of Images: Studies in the Social Function of Art and Visual Communication* (London: Phaidon Press, 1999), pp. 39–40.

the solitude of a system
michael mazière

I want to show you different emotions.

– Dirk Lawaert[1]

that incidentally is what I love
in general about the cinema
a saturation of magnificent signs
bathed in the light
of their absence of explanation

– Jean-Luc Godard [2]

Working through the *Undercut* archive has reminded me of the magazine's wealth and diversity, and also of how the publication illuminated a unique chapter in the history of film and video practice. Editing this anthology has revealed not just the change in the context and practice of artists' film and video, but even more, the motivation and political positioning of its participants. In many ways *Undercut* represented a thread between anti-establishment/'underground' practices of the 1960s and 1970s and the contemporary issues facing visual artists working in the moving image today. If the 1960s can be see as producing artist-led collectives and the 1970s a period of institutionalisation, then the 1980s provided a transition period of shifting cultural contexts and artistic hybridity.

In this piece, I wish to explore the trajectories of UK traditional experimental film and video art practices (as defined by *Undercut*) and their subsequent intersection with the new film and video practices within visual art. The search for a 'space' for the work, both psychologically and physically, seems as potent today as it did then. Artists' film and video has traversed collective practices, alternative television and white-

walled gallery, perhaps sitting comfortably only on the edges of defined systems, close to a world before language. Materials and process – central to the debates within many *Undercut* issues – are also still key to creativity. Digital technology has closed a few doors, but opened many windows – giving film and video artists access to individual systems of production and (potentially) distribution.

poetic empiricism

'We are in search of the artistic practice which situates itself between art as poetic (the effacement of knowledge) and art as knowledge (the effacement of the poetic). It is this productive tension which we hope to address.'[3]

As *Undercut*'s mission statement testifies, its dedication to experimental film and video is framed by a belief in the poetic and a respect for the empirical. This search involved an engagement in discourses including independent film, documentary, animation, video and performance art. *Undercut* was a potent and consistent platform throughout a time of extreme political change, shifting aesthetic and slippery borders. Numerous strategies and dialogues were developed throughout this decade of shifting pluralism in the arts. For evidence of this, one need only look at the cinema programmes of the London Film-makers' Co-operative (LFMC), the London Film Festival Avant-Garde screenings, the Film and Video Umbrella packages and to further writings in *Independent Media* and *Performance Magazine*.

Framed by the closure of the structuralist period and the beginning of the Young British Artist (YBA), *Undercut* traced these varied routes, and gave voice to a radical, confident if sometimes exiled community, addressing questions rarely approached today. The mainly artists-run magazine operated on a voluntary basis, founded on collective aesthetic and philosophical principles, giving wide space to writers and artists from Stuart Hood to Peter Gidal, Sally Potter to Mona Hatoum, Christine Delphy to Isaac Julien and Ian Christie to Cerith Wyn Evans.

Now that distinct 'experimental film' and 'video art' practices seem dissolved, fragmented or integrated into the visual arts, are the questions *Undercut* once raised relevant to practitioners today or limited to academic discourse? For example, with fewer and fewer theatrical venues in Britain today, are we witnessing a film and video scene where experimental film is fast becoming a traditional practice of rarefied artefacts? Is video art now only to be found, repackaged and commercialised almost solely in the gallery?

black box and white cube

'The retreat of these artists from the classical cinema environment is taking place at a time when art cinemas are dwindling, meaning there are fewer and fewer venues able to present the artists' work on screen.'[4]

The visual arts sector today has an appetite for film and video. This could seem like a godsend, but closer examination brings up many contradictions. Although experimental film and video art have often operated in multiple contexts, the benefit of full integration into the visual arts sector could be dangerously at the expense of film and the cinema. Gallery owners with little knowledge of experimental film and video art pre-1990 run the commercial gallery world.[5] Galleries had been uninterested in work that is a non-collectable non-commodity. Conversely, the art world was perceived as corrupt by a radical generation. Today some artists work in both formats – for the black box and the white cube. Once acquired, gallery support can liberate the film and video artist – they can concentrate on their practice while leaving the gallery machine to look after them.

Film and video artist Matthias Müller, having recently worked in the gallery sector remarks 'After twenty years of "experimental film", I know for certain that I can't make a living based on sales volume… Therefore, there's no alternative to a serious gallery that sells limited editions – and at a price corresponding to that for comparable works in other artistic disciplines.'[6] The artist Bjørn Melhus presses the point further: 'Up until now, it was these artists especially who were dependent upon grants, sponsorship, teaching assignments or even completely unrelated activities to make ends meet. In many cases, this kind of self-exploitation sooner or later led to stagnation or to giving up on artistic work altogether.'[7]

In the last decade, the film and video arena has thrived in the visual arts. But the recognition of pioneer experimental filmmakers and video artists (many of whom are represented in *Undercut*) has come as an afterthought – albeit a welcome one. While young artists such as Sam Taylor Wood and Eija-Liisa Ahtila have had solo shows at the Hayward and Tate Modern respectively, only recently has Irit Batsry won the coveted Whitney Biennial prize of $100,000 for her video piece *These are Not My Images*[8] and filmmaker Isaac Julien been shortlisted for the Turner prize.[9] Furthermore, the recent success of the *Shoot Shoot Shoot* event at the Tate Modern also surprised the establishment. It was not thought that such 'obscure' work might pull capacity crowds.[10] Yet this late recognition of artists' film and video by the visual art

establishment did not come about easily. Nor has it yet resulted in significant museum purchases or exhibitions of key works from the 1970s and 1980s.[11]

a third space?
'I would say this film's fullness is best understood in a cinema with excellent acoustics, even carpeted walls, in a space which is black, like the old Co-op, like Kubelka's first avant-garde cinema. A space which accentuates absolute concentration in every detail of the relationship between sound, image, silence and auditorium.'[12]

In the mid- to late 1980s, it became clear that film and video artists needed promotion and visibility if they were to sustain their practice. The search for extra funds and sustainable spaces, and the desire to enter a wider arena, made television increasingly attractive. Unfortunately the advent of Channel 4's Independent Film and Video Department in 1981[13] had not catered to this work, mainly funding 'franchised workshops' working under ACTT agreements and producing content-led 'political work'. The whole process and language of television production was an anathema particularly to experimental filmmakers close to their *materials*.

Nevertheless, a number of Arts Council, Channel 4 and BFI schemes were put in place to boost the small but essential funds from the Arts Council Film and Video Sub-committee, specifically to fund artists' television. From the mid-1980s to the mid-1990s this strategy did provide extra funds and new audiences to experimental film and video artists, but the demise of Channel 4's remit towards independent practice ended the promise of TV as a cultural venue. John Wyver's now well-known declarations in his article 'The Necessity of Doing Away With Video-Art'[14] had celebrated these new possibilities. But while it rightly pointed to the hermetic tendencies of video art, it has now become a testament to an unfortunate utopian view of broadcasting in the UK. To be fair, Wyver's argument for a pluralist practice was not totally misjudged. Artists' film and video did need to branch out, but the arena he chose proved to be disappointing. Most people today, including artists, do not expect television in the UK to deliver art, they expect it to deliver programmes *about* art.[15]

In the 1990s, with the rise of YBAs and exhibitions such as *Spellbound: Film and Art* at the Hayward Gallery, and *Pandaemonium* at the ICA,[16] the links between visual art and artists' film and video entered a new era. While broadcast opportunities faded and the UK's 'independent' cinema became ungraspable, film and video artists were searching for new oppor-tunities. The original artist-led organisations – the LFMC, London Electronic Arts (LEA), Hull Time-Based Arts (HTBA) and others offered consistent but limited forms of support.

With lottery funds suddenly available, The Lux Centre (combining the LFMC and LEA) was created as the first new centre with a cinema, gallery, film and video production combined with a distribution service. During its five years of operation, The Lux often acted as a bridge between the traditions of experimental cinema and video art, and the new work of visual artists in film and the moving image. In effect, this was a materialisation of what the *Pandaemonium* festival strived to do. The Lux sometimes walked a delicate cultural tightrope by mediating between the process-based, artisanal practice of experimental film and video (as articulated in *Undercut*) and the conceptual and ironic work of YBAs.[17] Even so, with so many gallery artists working with film and video today, there is still little relationship between visual arts and the traditional culture of artists' film and video.

In terms of funding and support, the restructuring of the BFI, the Arts Council and the closure of The Lux Centre[18] has also increased the space between film and the visual arts. But as Barry Schwabsky posits in his essay in this publication (above), the possibility of a synergy between the separate contexts of cinema and the gallery may yet be developed.

a subjective imaginary
'The view being suggested … is a Kleinian one and it might be objected that to understand avant-garde film by the application of the concepts of part- and whole-objects e.g. the breast, penis, nipple, vagina, faeces, is to reduce an art practice much concerned with conceptual matters to one dictated wholly by unconscious primitive phantasies. In reply, it must be stated that what is at stake here is the aesthetic level of film – the Kleinian approach is only a means of dealing with experiences that do not seem to be captured by signification, literal or symbolic, but are more identifiable with Barthes's "third meaning".'[19]

It is not simply the quest for a physical locale that has challenged contemporary film and video artists alike – it is also the place of meaning for this practice. The experimental moving image is elusive and often pre-language, resting outside of signification. It may be that in a similar way a physical space and cultural context is as hard to sustain as any *imaginary* artistic space outside of dominant cultural language. Modernist experimental practice often deals with an unconstituted subject.[20] The project and trajectory

of *Undercut*'s texts also point to that subject *in crisis*, struggling to understand the world through visual fragments and shifting parameters.

The artist views the world through a camera, alienated from the scene, seeing with a third eye – the process is solitary and the view fragmented. The image can be in and out of focus, before or after signification, it is a process of construction and unravelling combined. The artist peers towards the light. If he/she forgets, the image becomes disembodied, the process of perception reverses. Who is generating meaning? The chair becomes texture, light, colour – the car becomes movement, blur and noise. Keep looking through the camera, for a long time, the world falls apart … beautifully and darkly. Then take the footage and manipulate it – through print and processing, optical printing, digital layering, multiple screens … and make something. The fragments organised into a multitude of pieces, like a child's vision, without narrative or perspective to order or structure. But as Baudrillard suggests: 'Avoid irony at all costs, that final paradoxical wink … art which laughs at itself and its own disappearance under that most artificial of forms: Irony.'[21]

In *Undercut*, writers from Peter Gidal to Jean Matthee use a variety of languages to address or touch on subjectivity: the discourse of Lacanian Psychoanalysis, Marxist politics, history or gender to elucidate the work and the artist. The fact that *Undercut* was written in confident yet tentative forms is a testament to the difficulty of getting closer to that unconscious and subjective process. Anton Ehrenzweig[22] calls this creative process 'Unconscious Scanning' and sees it mostly present in modernist art. While *Undercut* covers a period in which post-modernism was on the rise it remains deeply rooted in a modernist tradition. As Michael O'Pray writes, 'The knot of the problem was an attempt to articulate a theory of film *as art* which was not reductive to either some vague notion of context (ideological), or subject-spectator position or semiotic-intertextuality.'

Led by artists and rooted in practice, *Undercut* nevertheless remained near Jansenist in its approach to filmmaking and the creative process. But it also considered subjectivity a central part of the debate and many structural films have a highly subjective sub text: 'I want you to know that I don't want to show my feelings: that is the message I address to the other.'[23]

digitally yours

'*Here the experimental arts are in a good position, since the critique of drama, visuality, identification and non-linear thoughts have been its hallmarks across its wayward and contradictory history. … The same combination of art and technology which made up the first decades of artists' films are at work today. … It might even be said that the role of the media artist in this environment is, at last, to be avant-garde.*'[24]

As AL Rees posits above, the development of digital media can be used to the advantage of an avant-garde approach. The advent of DV technology offers new tools for film and video makers. These tools are making possible the production of high-quality moving-image work cheaply and truly independently. With new lightweight cameras, DV technology brings a new lightness of touch to many aspects of film and video, from production through to distribution. A technology in itself will not provide a new language but many of the filmmakers active or covered in *Undercut* (myself included) have now moved onto using digital systems. John Smith, master of filmic light, and dedicated to 16mm for decades, is now shooting and editing on DV.

A key factor in the philosophy of the LFMC, the control over the means of production, is comparable – colour, intensity, editing and the pleasure of discovering new *materials*, specific to DV. Linearity can be explored vertically with much ease, as the plasticity of digital editing encourages. Its effect on the exhibition space and reading of the moving image are in their experimental infancy. It will not replace film for the artist, but does provide a new kind of writing process. But where it differs enormously from the philosophy of *Undercut*'s filmmakers is that it does not require collective engagement. In fact, it is an isolating process of production, akin to writing, a kind of *cine-écriture*.

Perhaps this is where the road between then and now diverges most dramatically. It feels like technology is making artists (and the world at large) ever more autonomous. While this counters experimental filmmakers' historical collective practice perhaps this independence takes artists' film and video one step closer to finding a place … or space … or a system of solitude.

1 The full quote reads: 'Dirk Lawaert who teaches film at the University of Leuven introduces the subject of experimental film to his students with the phrase "I want to show you different emotions"'. Peter Milner, 'The London Film-makers' Co-op – The Politics of License', *Undercut*, no. 10/11.

2 Jean-Luc Godard, *Histoire du Cinema*, Chapter 4b: 'signs amongst us', p. 92. ECM New Series.

3 *Undercut* Mission statement, March 1981.

4 Rheinhard Wolf, 'Film between Black Box and White Cube – Part 1', Oberhausen Film Festival on-line magazine: http://www.shortfilm.de/ikf/pages/magazin/index.php

5 This also applies to a new generation of Supercurators who still have never seen an experimental film or a piece of video art prior to 1995, aside from the work of famous visual artists.

6 Matthias Müller, 'Film between Black Box and White Cube – Part 2', Oberhausen Film Festival on-line magazine: http://www.shortfilm.de/ikf/pages/magazin/index.php

7 Bjørn Melhus quoted in 'Film between Black Box and White Cube – Part 2', Oberhausen Film Festival on-line magazine: http://www.shortfilm.de/ikf/pages/magazin/index.php

8 In many ways this marks the final integration of video art if not experimental film traditions into the visual arts. Its importance should not be underplayed for it signals not only the acceptance of a personal, poetic and highly experimental practice as valuable in the visual arts but also its expression in the moving image.

9 The fact that a renowned filmmaker who has worked across many film disciplines, shorts, documentary and feature-length fiction is now to be found successful in the gallery world also seems to close the loop between film, video and the visual arts. It is a testament not just to his talent and timely shift into visual arts but also to the incredible pull the gallery environment has had on film and video makers over the last ten years.

10 The *Shoot Shoot Shoot* event curated by Mark Webber comprised a season of structural films from 1966 to 1976 and a seminar in May 2002 at the Tate Modern. The programme covered an identical period and similar artists to the 'Perspective on English Avant-Garde Film' touring exhibition curated by David Curtis and Deke Dusinberre in 1978.

11 Although the writer and curator David Curtis is now planning a comprehensive retrospective at Tate Britain of 36 hours of UK experimental film and video for May 2003.

12 Anna Thew, *Space for Thought*, Tryptich Catalogue on Michael Mazière published by South West Media Arts.

13 Peter Gidal: 'In case anyone hadn't noticed, by the way, empiricism's been back for a while, the result of which is in England we have little problems like BFI-*Screen* types saying things like "there is no film outside its context"'. 'The Current British Avant-Garde Film: Some Problems in Contexts', *Undercut*, no. 2.

14 This article originally presented at the Video Positive Festival in 1991 was also published in the London Video Access catalogue of 1991 and in *Diverse Practices: A Critical Reader in Video Art*, Julia Knight (ed.), University of Luton Press, 1996.

15 This was not inevitable and is not the case across Europe. Although diminished, Arte, RTE and others still broadcast and commission some artists' film and video.

16 *Pandaemonium*'s moto was 'Where Art and Film Collide'. The work was shown in two distinct sections – single screen in the cinema and commissioned exhibitions in the gallery. Traditionalist film and video artists showed work in the cinema and younger artists were working with installation. The aim was to bring these two worlds together but the event revealed a gulf between the two.

17 The Lux did strive to bridge the gaps between visual arts and experimental film traditions commissioning and exhibiting film and video work by artists from varied practices such as John Maybury, Dryden Goodwin, Jane and Louise Wilson, and Gillian Wearing amongst others.

18 Recently reopened as an archive and distribution service.

19 Michael O'Pray, *Undercut*, no. 3/4.

20 Jean Baudrillard, *Liberation*, 20 May 1996 (my translation).

21 See Nina Danino's essay 'The Intense Subject', following.

22 Anton Ehrenzweig, 'The Hidden Order in Art', 1967.

23 Roland Barthes, *A Lover's Discourse – Fragments*, trans. Richard Howard. New York: Hill and Wang.

24 AL Rees, *A History of Experimental Film and Video: From Canonical Avant-Garde to Contemporary British Practice*. London: BFI, 1999.

the intense subject
nina danino

I have just returned from *Documenta 11* where at least half of the work was projected in a multitude of settings; installations, sculptural environments and mini-cinemas. Many works were large-scale, followed linear/narrative structures and involved sheer length (Ulrike Ottinger's six hours, Kutlug Ataman's 'many hours', Cragie Horsefield's ten hours, as well as many feature-length pieces). These durations put the absorption of the total work beyond the capacity of the viewer, who is entranced and overwhelmed by scale, sound, light and time in a form of spectacle. The freedom from conventional cinematic codes was vital and energetic and yet the work, in its unwillingness to declare limits, also absolves the spectator from the need to 'stay', beyond the hypnosis sometimes induced by duration and particularly by the stasis of some of the images. There seemed to be a privileging of the spectator's pleasure, the context of exhibition, the power of spectacle, aesthetics and the demand for predominantly conceptual ways

through which to engage with intentionality and authorship. I could not find the bridge between the artists' films at *Documenta* and the body of work represented here in this Reader, which seems to stem from an altogether different place as art.

To attempt to locate some differences, I would propose an intense subject: the expression of a difficult subjectivity produced or constructed by film as object and as experience. This work seems to be created out of a certain state of marginalisation and solitude as 'production process' away from both the gallery and big cinema. Its imaginary and drive is obsessional and often circulates around loss and gaps of expression or emotional 'fullness' yet can also be silent, quiet or restrained. Whatever tone it takes, at its centre is the 'self' and a certain introspection which is involved with trying to find a way to 'speak' this self. It is a small but powerful and unique group of work which emerges in the 1980s which makes a radical break with film as a form of scien-

tific investigation or epistemolgical knowledge as developed in the traditional avant-garde. It makes its break from structural film which precedes it and develops a language which attempts to interprenetrate forms of knowledge with 'lived' experience. These practices privilege an entirely new raft of visuality(ies) which would be able to cope with subjected expression; abstract notions of desire, libidinal movement, content, the search of identity, sexuality. As a filmmaker showing and making at the LFMC, this new climate seemed to offer both engagement with the personal awareness of avant-garde film as material and form (henceforth called experimental film) but away from formal structuralism from which, as a woman, I felt estranged. It would be a long, drawn out process, before these new forms felt entirely 'at home' at the LFMC given its historic association with (modernist) formal/structural aesthetics and beliefs.

I believe that the key factor which generated these new images and voices was the new demands on representation and on the medium of film (and video) from a gendered perspective. Because of its marginalised status, avant-garde film offered women access to production and a validation of 'personal' filmmaking.[1] A space for the exploration and representation of experiences not previously spoken in art, such as the objectification of the image of woman through the (camera) gaze (*Reassemblage*, *Thriller*, *Light Reading*). Terms such as 'limits', 'difficulty' and 'struggle', which demarcate relationships of intense individual engagement (often referring to 'heroic' feats of endurance, duration or formal optical virtuosity), in particular, the term 'troubling' (not normally associated with critiques of materialist work), with its connotations of psychic investment, begin to take on different forms of expression. They begin to underpin the terms of new work not strictly concerned with the control of perceptual phenomena and ideological mastery of the apparatus (also machinery in its more prosaic meaning of a technical base) but in relation to three previously suppressed dimensions which begin to map out a new psychic landscape: (experimental) narrative, the subjective and 'the feminine'. I would say that it is the (re)engagement with these three dimensions which characterises this gallery of images and voices. They produce an eclectic mix of new film languages, some of which went cold some bore more fruit.

The emergence of new forms from the existing avant-garde was not without overlap or common boundaries. Joanna Kiernan discusses how women

artists working in the tradition of the avant-garde, tried to apply procedure to issue-based work or personal drama.[2] Whilst keeping many optical techniques (e.g. superimposition, repetition, reframing), the mastery of surface and display of technical manipulation is exchanged, in some work, for a stumbling awkwardness, a deliberate lack of polish. Conceptual framework (methodology, theorisation) is interpenetrated by the experiential. Systemic procedural methods, described by terms such as 'pure' and 'rigorous' as a mark of critical esteem, are used to different ends by women working in experimental film – for expanding or multiplying levels of meaning rather than draining them (Jean Matthee, Lucy Panteli). Quiet, as well as virtuoso, performances inscribe the filmmaker but also create intense subjects of film/writing.

However, there are limits to the extent to which the language of structuralism, with its emphasis on procedure and engagement with the means of production, its objectivising rhetoric of representation, was capable of inscribing gender or any subjectivising stance. As Michael Mazière points out, 'the subjective is at odds with objectifying mechanical devices'.[3] Although Michael O'Pray makes a case for the potential for forms of identification to take place through abstraction and materialist strategies, through unconscious phantasy, there is clearly a problem in the use of abstraction in order to establish 'difference' since this would require clarifying forms of identification and subject position which is anathema to a structuralist position.[4] Christine Delphy, shown several examples (*Motion Picture*, *Retour d'un repère composé*) of such attempts 'to deconstruct or decompose or analyse ways in which women are objectified by the camera',[5] replies that abstraction is useless in this regard and that it is only through the use of existing recognisable norms and forms that these norms can be critiqued and changed. The problem for her also lies in the fact that 'you can't go directly beyond men's language and then stay at that "beyond" stage creating a women's language. You've got to use the words we have and progress in those words, moving them slowly out of their meanings'.[6] This problem is discussed in 'Cultural Identities: Questions of Language', in relation to languages of mastery (be they languages of dominance supported by hegemonic ideology(ies) or elitist languages which do not recognise 'difference') which is that speaking in these languages necessarily suppresses 'difference' and thereby the subject and that in doing so, alter-

native forms of signification (of 'lived' experience as well as knowledge) cannot emerge.[7] Barbara Meter points out that women in the avant-garde 'are making just as finely structured films'.[8] But the adoption of a language which denies the specificity of the subject (other than constructed as a neutral spectatorial one) must happen at precisely that price. This predicament either causes a critical rupture or else leads to forms of hysteria. So two potential subjects collide here, one trying to find a way to speak and one, as Constance Penley proposes, constructed through the armoury of technology, a subject 'affirmed in his own reality … a conscious subject, unified and affirmed as the place of the synthesis of all perceptions'.[9] It was the gendered subject which set itself at odds with this other subject. The two seemed irreconcilable. It is not surprising that in this bind of visual representation, there is an intense need for new forms to be produced which will give expression to internal life and validate personal knowledge. As Joanna Kiernan can see, the only way past masculine structures is by 'listening to the self'.[10]

If total abstraction denied or restricted the possibility of 'listening to the self' there is a great deal of discussion and anxiety about how far to go in the process of decomposition, reconstruction or totalisation without replicating its 'fixing' tendencies. As Jacqueline Rose points out, 'the question … is "deconstruction or not" or "how far" or "how successful"'.[11] But the project of reconstruction is already underway. Paul Wallace agrees that 'an aesthetic ideology which excluded the dialectic between signifier and signified made it impossible to deal, in the work, with such issues as the representation of women' and as some filmmakers 'are beginning to recognise, radical practice needs to be able to totalise; in other words deconstruction is only half of an adequate approach: we also need to be able to reconstruct'.[12]

There is a re-engagement with meaning, representation, thresholds of identification and, therefore, forms of narrative (avoiding the formalist formulas applied by Independent film). The imperative to 'speak' is performed at the point of the interpenetration of levels in 'the struggle to create synthesis out of conflicting forces',[13] e.g. aesthetic, intellectual, intuitive, social, formal concerns (in Fine Art practices of sculpture and painting) and subjective experience, i.e. 'their experience of their own situation as women'.[14]

If there is a relationship between experimental film and the kind of gallery art in moving image seen at *Documenta* it can be linked to these approaches which were at the forefront of interdisciplinarity and

the subjective in Fine Art rather than in the theoretical debates around film as a specific medium in film departments, notably at the Royal College of Art, where in a sense, the debate had already been lost or moved on, by women's use of the personal in video and performance, site specificity, the expansion of the moving image in installation and multiple projection. Environmental Media at the RCA was at the forefront of interdisciplinarity in video, performance, installation and film, which broke down the barriers between the traditional Fine Art practices and co-joined formal concerns, medium-specificity in relationship with the subjective. Paul Wallace (on a viewing work from the Department) argues, from Sartre, that in order for a dialectic relationship to be possible it must occur within the realm of the subject (not in a transcendental realm). The very notion of dialectical reason is premised on the subject's relationship to the world and each other. Dialectical reason is itself the interpenetration of supposedly binary forces, objectivity and subjectivity, as part of a process. The strength of a work of art is its ability to cope with, and reflect, this tension. In this, knowledge and experience are also factors in this tension. At a certain point the dialectical relationship may be overcome by unproblematised signification and content. Wallace's concept of 'abstract subjectivism' describes regressive forms of intense subjectivity galvanised around excess of visual sensation and surface and atmosphere 'which suppress any sense of struggle or contradiction in the construction of our appearance'.[15]

Forms of narrative, exiled by structuralism, are reapproached as a form of expression of the 'self'. David Finch argues compellingly for the link between an emerging experimental film and poetic forms of narrative through (the aural tradition of) lyrical epic poetry and splits off drama with its enactment or presentation of acts in the present as the distant (Aristotelian) relative of Hollywood 'narrative' film with its fixed points of reference in subject construction. He also argues that it is drama which constructs the unengaged spectator by means of 'conventions of enigma, suspense and withholding the ending'[16] – all these conventions are rejected or reworked in experimental narrative forms in film.

Narration, with its links to the voice, has a disembodied dimension (which enables the construction of mobile subjectivities) rather than fixed points of view. Crucially, 'the term "narrative" is applicable to much experimental cinema, in that it works with the temporal gap between the time of projection

and of the image's referent – with absence'[17] rather than with the present tense of drama. It is these displacements of temporality (memory: Nina Danino, David Finch), sometimes aurality (story telling: Tina Keane, Annabel Nicolson) and the foregrounding of absence (as meaning rather than as 'empty signifier') that makes the experience of the work as 'full' or even moving in its relationship to absence and time. Many of the works seem to be constructed out of the difficulty of saying or of finding the right language to say. Not surprisingly, the acoustic, whether inscribed as silence or through the voice, begins to be heard.

Both for Christine Delphy, who believes that it is not possible to speak in anything other than the given male language, and Joanna Kiernan, for whom 'it is hard to imagine what a fully feminine speech might be',[18] the need is to find a way to inscribe this unspoken dimension into film texts. Paradoxically, one of the ways in which this begins to be attempted is through the very act of vocality. The voice – itself a dimension of corporeality banned from the realm of optical mastery of structural film – begins to circulate (*Shadow of a Journey*, *First Memory*, *Light Reading*, *India Song*, *Stabat Mater*, *Sunless*). The voice becomes the messenger which leads us out of the impasse of a restricted visual – or more accurately – optical economy.

This acoustic dimension is a complex field which does not just replicate 'the trap of false identification',[19] i.e. that of a simple 'fixing' of subject construction or spectator identification. There are many different voices heard here. Some in their 'single organising omniscience',[20] some protesting that they do not want to sound like women's films 'which sound sort of intoned … trying to make points in words',[21] in a dialogical and interrogative mode, in juxtapositions of sound and image or voice tracks which elide subject/object or subject/other positions, slipping between pronouns and the subject of speech – as 'the mobility and multiplicity of meaning which avoids fixing'[22] (Patrick Keiller, Ann Rees-Mogg, Jayne Parker, John Smith, Lis Rhodes, Nina Danino). In a pragmatic way, voice-off techniques also construct spaces beyond the frame and out of reach of vision. As Alison Butler points out, the voice creates these temporal/spatial gaps (which David Finch identifies in the lyrical structure and which Duras' *India Song* is produced from) that are also equivalent of the presence/absence paradox of the cinematic signifier. But this vocality is 'the speaking subject not as illusionist entity but as construction

through film discourse'[23] rather than (only) as spoken content.

Alison Butler identifies two linked characteristics in experimental film by women, the trope of self-inscription and film as self-realisation. Looking through and remembering many of the films reviewed or written about here, the question of (self-) authoring seems to be a motivational force in the work as well as a 'logic' in it. Stemming, according to Alison Butler (quoting Judith Mayne), from women's 'difficulty of saying "I"'.[24] Many of these works (also by men – since we are now talking about tropes which on one level are a form, although on another) are realisations of the subject's psychic (gendered) investment. However, these tropes or strategies have a direct link to women's doubly difficult relationship with self-representation as both the subject (as artist) and object (as woman) of vision. Jean Matthee identifies this predicament from a Lacanian approach: 'To be ~~The~~ Woman as 'artist' is to be in many places, both specific places and no place, at once. It is the impossible solicitation, to be both subject and object and neither subject nor object at once'.[25] Paul Wallace traces these tropes in the work of Sandra Lahire, which combines the dialectic forces 'between the subjected nature of the anorexic ego and the desire to reflexively transform the image'.[26]

The purpose of the act of self-inscription is not 'the construction of a coherent subject position for the author'.[27] This subject is never transcribable into a diegetic 'dramatic character' but retains a self-reflexive dimension which is constructed in the viewing as much as through the authoring act. The personal pronoun, whether enunciated or spoken, is very strong in the work. The expression of subjectivity takes a variety of tones from quiet, detached observation (Guy Sherwin, Nick Collins) through to highly charged vocabularies of image and work which are surprisingly expressionistic and sometimes performative, always combined (in a critical engagement) with formal and aesthetic considerations as factors which attempt to 'reflexively transform the image'. It is surprising how often the psycho-dramatic drives of the work centre around personal and intimate subject matter; often the domestic setting, family or interrogations of it, (mother/daughter, mother/son, family or domestic/inner circles, relationships, as autobiographical material across a wide range of attempts and approaches (Ann Rees-Mogg, Nina Danino, Michael Mazière, Nicky Hamlyn, Will Milne, Guy Sherwin, David Finch, Annabel Nicolson, Cerith Wyn Evans,

Anna Thew). Sometimes these attempts represent or access through representation, archaic and memorial sensation and desires linked to the fact of being a (desiring/suffering) person in the world. However expressed, this articulation is often distanciated or abstracted through fragmentation and veiled through analogy or metaphor but a subject of desire and a desiring subject, far away from the technologically-conscious, optically-centred, self-mastered, subject of structuralism, is both producer and produced, by this art.

A new artistic endeavour surfaces from the crossings of multiplicity of voices, subjectivities and formal approaches which manifest themselves in a more openly subjective, yet formally informed work. The films as texts are a form of speech act, 'but a speech act without a speaker'[28] and are indebted to the articulation of a sensitivity 'from the feminine side' (not gendered necessarily but articulated as a field or pressure on the dominant – here, the accepted avant-garde practice). This way of thinking about the 'feminine'; as a transgressive field on the dominant language is indebted to French feminist thinking in psychoanalysis. The 'feminine' for Kristeva is a privileged site for the production of art. It is everything that does not have a place in signification and in each production escapes being named but is the very thing that is being reassigned a place in the object film, as a site or text, mobilised and inscribed by the pulsion of (in Kristeva's term; the semiotic) drives and desires and in filmic terms, rhetorics of representation which perform varying degrees of (psychodramatic) totalisation. This can be produced by different kinds of art and it is not reducible to genre nor a style nor particular privileged content. But whilst gender may not necessarily give automatic access to it nor gender specific content, it is true, in the ways that I have tried to describe, that the condition of woman through its exclusion from language must draw closer to it (see Jean Matthee's Lacanian exposition of this place).[29] Rhetorically speaking, in terms of the experiments of the films here, it is manifested as/through a range of strategies; improvisational methodologies, metaphor, acoustic relationship to the visual, performativity, association, fluidity of subject position, the polysemic, elision, allusivity, slippage of meaning, fragmentation/totalisation, introversion, partial framing, materiality, medium specificity, hybridity, cross fertilisation of media/footage, interpenetration of social and personal, of knowledge/experience, intersubjectivity, techniques of structuralism, the style of poetry, temporal/spatial displacements. These forms may begin to answer Joanna Kiernan's question as to 'what a feminine speech might be'.

These signifiers and rhetorics all cross in a new aesthetic very different from the formalism and visual patterning of structuralism. However, like all codes and forms of art, the transformational potential of experimental strategies which bore such powerful fruit becomes exhausted, codified and in need of rethinking. The context of exhibition has shifted, as have production bases, linearity has shifted into simultaneity. The work represented here is unique and continues through the different artists/filmmakers to respond to shifting contemporary challenges but in its documentation here, represents a connected yet heterogeneous artistic community of intensity, of corresponding voices and subjectivities, in discussion, and visual debate trying to find a new place from which to make meaningful practice.

1　Alison Butler, *Women's Cinema: The Contested Screen*. London: Wallflower Press, 2002.
2　Joanna Kiernan, 'Reading *Light Reading*', *Undercut*, no. 10/11.
3　Michael Maziere, 'John Smith's Films: Reading the Visible', *Undercut*, no. 10/11.
4　Michael O'Pray, 'Modernism, Phantasy and Avant-garde Film', *Undercut*, no. 3/4.
5　Christine Delphy, 'On Representation and Sexual Division', *Undercut*, no. 14/15.
6　Christine Delphy op. cit.
7　'Cultural Identities: Questions of Language', *Undercut*, no. 17.
8　Barbara Meter, 'From Across the Channel and 15 Years', *Undercut*, no. 19.
9　Constance Penley, *The Future of an Illusion*. London: Routledge, 1989.
10　Joanna Kiernan op. cit.
11　'Cultural Identities: Sexual Identities', *Undercut*, no. 17.
12　Paul Wallace, 'Media Production in Higher Education: the problem of theory and practice', *Undercut*, no. 16.
13　Ibid.
14　Ibid.
15　Ibid.
16　David Finch, 'A Third Something: montage, film and poetry', *Undercut*, no. 18.
17　Ibid.
18　Joanna Kiernan op. cit.
19　Paul Wallace op. cit.
20　Alison Butler op. cit.
21　Janey Walkin, 'Interview with Anne Rees-Mogg', *Undercut*, no. 14/15.
22　Joanna Kiernan op. cit.
23　Ibid.
24　Alison Butler op. cit.
25　Jean Matthee, 'On Wounds, Artificial Flowers, Orifices and the Infinite: A Response to the films of Nina Danino', *Undercut*, no. 19.
26　Paul Wallace, op. cit.
27　Alison Butler op. cit.
28　Ibid.
29　Jean Matthee op. cit.

undercut and theory
michael o'pray

Undercut's life was virtually co-extensive with the 1980s. Its first issue appeared in 1981 and its last in 1990. To immediately declare an interest, I was an active member of the Collective between 1981 and 1984. I joined with issue 3/4 and left emotionally exhausted with issue 12. It does not seem long when I look at the dates in that sentence. It seemed much longer at the time. The collective produced four issues a year for some time (at times producing a double-issue to ease the workload), before finances and resources slowed it down to a more erratic timetable, ending with issue 19. The magazine witnessed a period of enormous change – the establishment of what was to be a longstanding right-wing Conservative government (from 1979 to 1997), the introduction of new technologies, especially the domestic VCR and the computer, and the rise of new film forms and practices like the New Romantics, Black cinema and the experimental narrative, all in the early 1980s.[1]

Asked to write about the magazine and its relationship to theory, I was at first perplexed as I never think of it as having too much to do with 'theory', even though I wrote what could be called a 'theoretical' article for it, as did others. It seemed that theory existed in the journal in various guises – in straightforward theoretical essays, in artists' statements, in film and book reviews, in interviews and in the photographic art works it published. It was never dedicated to theory. But after the theoretical explosion of the 1970s, theory was in the air and inescapable even if by the early 1980s film theory was in crisis and giving way to film history (for example, the rise of British film history in the 1980s) and to more diverse approaches.

It is an obvious point, but one that needs to be made, and that is that *Undercut* was the London Filmmakers' Co-op's magazine, established some years after the Co-op's 'heroic' period – 1971 to 1976 – during which it was based at Prince of Wales Crescent as a production as well as a screening and distribution centre. *Undercut* set up a collective comprising Co-op workers and invited members. Surprisingly, the Co-op's relationship to its magazine was very hands-off. This distance was important strategically as Malcolm Le Grice was aware when he observed in 1986 that 'there remains a subtle distinction between the editorial policy of *Undercut* and any representation of a collective attitude of the Co-op'.[2]

In fact, relations with the Co-op were distant and sometimes fractious in my experience, criticised for its over-theoretical approach to film. *Undercut*'s film-making members often worked around and in some cases *in* the Co-op,[3] while others showed there. In the case of the critic-historian Collective members, their allegiances were to the Co-op and to experimental, avant-garde or artist's film (the differing nomenclatures litter the writings).

Screen was the most influential film journal of the 1970s. It had set out to establish a grand theory of film representation rooted in Althusserian Marxism and Lacanian psychoanalysis, which depicted mainstream cinema as a realism of reactionary ideological import. It had a dual purpose – first, to rescue certain mainstream directors like Ford and Hitchcock as 'unconscious' subversives, providing symptomatic readings of their films, and second, to forge an avant-gardism located in the early formalism of Novy Lef and the ideas of Brecht. Laura Mulvey's seminal essay 'Visual Pleasure and Narrative Cinema', published in *Screen* in 1975, was essentially a call for a new avant-garde cinema, one which identified with a political modernism found in the 1970s work of Godard and Straub/Huillet.

This notion of a political avant-garde was influential at the Co-op. Important for *Undercut* was the fact of the emergence of the Independent Film Association in the mid-1970s, which brought together the formal film avant-garde of the Co-op and the political independent cinema.[4] It is useful to remember that IFA statements about independent film involvement with broadcast television in 1974 were signed by avant-garde filmmakers.[5] Nevertheless *Undercut* also reflected an unease with this political stance especially as it seemed to be too defined by a relationship to the mainstream. In many ways *Undercut* was an attempt to forge a sense of the idea of 'personal as political', especially in its support of women filmmakers, who viewed themselves as in a separate tradition outside the mainstream.

Undercut appeared after the film avant-garde's most serious incursion into *Screen*[6] which had seemed to consolidate (if at the very margins) the British avant-garde's union of purpose with *Screen*'s project. But by 1980 this project had more or less collapsed and the debate was marooned in a theoretical context still committed to notions of narrative. In fact, *Screen* theory was hopelessly crude when faced with

the avant-garde's predilection for complex disjointed forms and structures in which 'narrative' played no part. *Undercut* was an attempt to wrestle avant-garde matters from *Screen* and explore them in a more sympathetic and wide-ranging way.

By the early 1980s there was a distrust of theory in the Co-op among filmmakers themselves, as Tim Norris was quick to inform Noel Burch and Stuart Hood in his interview with them in the first issue. The activist-filmmakers associated with the Co-op were largely from the art schools, where they had encountered film, but fortunately not too cohesively. For example, the Royal College of Art's Environmental Media unit was a hotbed of experimental film and video teaching. Interestingly, at the Film School the intellectual and cinematic diet was fairly broad with Stuart Hood, Peter Gidal, Steve Dwoskin and Ray Durgnat on the teaching staff. It produced many diverse Co-op-based filmmakers.[7]

In many ways, *Undercut* was extremely conscious of this interwining of what Peter Wollen had named the two avant-gardes – that is the formalist and political modernist traditions.[8] The magazine's response was an aesthetic and theoretical eclecticism, governed almost unspokenly by a commitment to the practices (and ideals at times) of the London Filmmakers' Co-op, that at the time was distancing itself from the Le Grice/Gidal theoreticism. In fact the subtitle 'the magazine from the London Filmmakers' Co-op' is on the cover of every issue except the last two, numbers 18 and 19. In other words, in retrospect, the eclecticism was a position against the *Screen*-theory orthodoxy which had become insufferably claustrophobic for many at the time. Early issues of the magazine are littered with an awareness of the narrowness and paucity of the kind of theory and of the filmmaking sanctioned by *Screen*-theory, sub-Brechtian/Straub-Huillet, text-obsessed costume dramas that seemed to be undermining more formal fine-art-based Co-op aesthetics.[9] Typically, at the same time and reflecting its lack of dogmatism, it published writings by *Screen* theorists and *Undercut* supporters like Paul Willemen and Rod Stoneman.

One tendency of the magazine was to set itself apart from the dominant narrative-based film theory. But interestingly, Le Grice's writings had been exploring 'narrative'-based concepts since the late 1970s as had his ambitious concept-film trilogy with their dual titles of subject-matter and theoretical concept e.g. *Blackbird Descending – Tense Alignment* (1977), *Emily – Third Party Speculation* (1979) and *Finnegan's Chin – Temporal Economy* (1981). In fact, content and

forms of experimental narrative were emerging in, for example, the work of Patrick Keiller, David Finch, Jayne Parker and Nina Danino, who often owed more to the poetic-narrative tradition of such avant-garde filmmakers as Maya Deren, Humphrey Jennings and Kenneth Anger than to the formalist-structural one.

Equally, there was much nervousness on the collective about the notion of the 'auteur'. It was usually set in terms of a Co-op policy of extreme democratisation so that no filmmaker was given public status above another, despite the private acknowledgement of the relative worths of particular artists. Hence names were not allowed on the front cover for some years. Part of this was also theoretical, namely the idea that film was a signifying system and not a subjectivised expression of an artist. But art-school training, with its emphasis on the individual and artistic expression and creativity, was never conducive to anti-authorshipness and many articles were on individual filmmakers.

What is fascinating is how liberal *Undercut*'s editorial decisions were in relation to theory. The first issue included an array of positions – Paul Willemen, Stuart Hood, Philip Corrigan, Gillian Swanson, Sylvia Harvey, Simon Blanchard – all of whom were much more concerned with the idea of an 'independent' political (of sorts) cinema, than an experimental/avant-garde Co-op-based one. The common ground was in their shared marginality to cinema, their Left politics and their commitment to forms of collective practice. They did not share a particular film theory or for that matter a view of film's function.

The first two issues of *Undercut* carried the following statement on its inside cover, stating its desire:

To work with the space that exists between art discourse as art and art discourse as politics. This space opens the necessity to retrieve, or replace, the term 'avant-garde'.

What is true is that *Undercut* rarely dealt with 'art discourse', but mainly with *film* discourse. The 'new art history' had not really taken off in 1981.[10] Equally, in the 1980s, the art world had not succumbed to film and video (that was to happen in the mid-1990s), and most film practice was largely theatrically-based single-screen.[11] But the statement is an interesting one. It allows, for example, for the 'replacement' of the term 'avant-garde'. *Undercut*'s theoretical eclecticism was in part a response to the possibility of avant-gardism being redundant. One option (although never sustained) was an accent on form (a kind of formalism I subscribed to at the the time … and have

since) and process from the artist's point of view. The knot of the problem was an attempt to articulate a theory of film as art which was not reductive to either some vague notion of context (ideological), or subject-spectator position or semiotic-intertextuality.

A constant theme was that of defining, in theoretical terms, a film avant-garde.[12] It would seem as if film theories relating to spectatorship, authorship, film meaning etc (even sheer indifference to such matters) could be tolerated in a way that the problems of the avant-garde's *identity* in the 1980s could not.

The notion of 'avant-garde' is a fragile and vulnerable one. There was an attempt at Kleinian psychoanalytical rendering which has the effect of broadening the aesthetic grounds of avant-garde film into ones shared by other visual arts.[13] Retrospectively, it can be seen to be delineating an 'art discourse' while distancing it from French discourse theory, thus countering Metzian and Lacanian models. In some ways this was an assertion of *Undercut*'s position as independent of dominant film theory as represented by *Screen* at the time.[14] On the other hand, the relationship of politics and theory to avant-garde film was also explored, but with the same frustration as to the 'dangers hidden in the conceptualization of a possible avant-garde as the negative reflection of a dominant cinema'.[15]

A historicist, modernist-driven idea of film avant-gardism was criticised by Alain Sudre, who demands a truly experimental research attitude in which film would engage with science and philosophy, moving the avant-garde film away from a form of dogmatic essentialism.[16] A few years later Michael Mazière reiterates his commitment to film-as-signifying-process and takes a swipe at my 'catholic' British avant-garde 'round-up' article. At the same time, he argues that we need to get beyond certain conceptual frameworks in order to forge a film language. This tension between a singular mode of filmmaking and a more pluralist open-door one runs throughout the magazine, and it implies that the avant-garde can be understood as either a particular aesthetic practice, or as occupying a certain position vis-à-vis the mainstream, where different aesthetic strategies may exist.

Interestingly, reading through the issues, theoretical writing tends to bunch up in the early issues and dies away somewhat in the later ones.[17] One imagines that there was a post-1970s pressure to be 'serious' and theory always meant that. But as the decade went on, film theory became increasingly irrelevant. It was replaced more and more by post-modernist ideas and a semiotic-based *art* theory.

The major exception is the important issue (number 17, 1988) on 'Cultural Identities' which reflected a fascinating and genuinely urgent debate around the new wave of black filmmakers associated with the avant-garde tradition. It was also eager to disassociate itself from many of its ideas and strategies – both filmic and political. But it is a debate emanating from outside and not within the Co-op movement.[18] Another original contribution was the special Landscape issue of 1983 which also acted as a catologue for landscape film and video shows at the Co-op, Air Gallery and B2 Gallery. P. Adams Sitney argued that with that issue '"landscape" had, at least at that moment, become a term in the epistemology of cinema'.[19]

Of course, many of the film reviews and artists' writing involved theory but often in a more critical mode, Patrick Keiller's being examplary of such a mode of work, in which he was clearing a cultural space for his work, a contemporary surrealist position, but without finding it encumbent upon himself to *theoriticise*. Of this matter *Undercut* was quite conscious, encouraging different kinds of theories, critiques and ideas especially where they were grounded in a practice. It also supported different kinds of writing. It was these sympathies that deliberately set it apart from the claustrophobic theoretical musings of *Screen* which, at the time, still cast an enormous shadow over film discourse, even in *Undercut*. My own memory is of a collective very aware of producing a magazine which aimed to be very different to most of the other film journals. Sometimes the result was rather scrappy, and the pressures of four issues a year (there was never a lot of good material around) added to this. Creative tension between ideas could at times collapse, giving way to incoherence. But *Undercut* was different in the space it gave to creative work, especially artists' writings[20] and photography[21] and associated forms like collage (Peter Kennard) and of course Biff, which some of us (myself included) were guilty of getting rid of in a fit of po-faced purism. It was always fun to have an image we could 'bleed off' – the printing jargon itself was exciting – getting rid of text and obliterating the page with sheer visuals albeit always black-and-white.

The single major influence, and a constant thread throughout, was Peter Gidal – not only as an artist and theorist but as 'voice' or model. Gidal's charisma lay to some degree in his uncompromising views which had been consolidated by his refusal to show images of women in work and then of people in general. It was an edict perhaps taken up more by male filmmakers than women.[22] For example, Gidal's tough review of Le Grice's *Finnegan's Chin*, marked a discur-

sive watershed of sorts between structural film and a filmmaking moving towards a possible avant-garde-art-cinema.[23]

But what is striking about the early issues is the range of cinema engaged with – the art cinema of Godard, Rocha, Greenaway and Marguerite Duras jostled with the avant-garde work of Tina Keane, Patrick Keiller and Peter Gidal. This was a reflection of the Co-op's own shifting interests. For example, the New Romantics and gay-inspired filmmakers took their influences from a wider range of films – Hollywood bio-pics, Godard, Kenneth Anger, Werner Schroeter, Derek Jarman. Tarkovsky's films were fashionable with younger film students who wanted minimalist forms to have some spiritual content (which they found in Tarkovsky's *Stalker*).

Issue number 17, put together by Nina Danino, published the papers and debates of a conference on the subject of black cinema in Britain, at which independent filmmakers discussed their relationship to aesthetics and avant-garde film practice.[24] Fascinatingly, Gidal, who participated in the conference, occupies the horizon of the debate, his work representing the 'formalist' excesses of avant-gardism against a more politically-oriented film practice, which also wished to place itself outside what it saw as the avant-garde ghetto. The dispute was essentially an old one between formalism and subject-matter. Another way of formulating this difference was to locate it in a perceived (but misleading) dichotomy between a Vertovian politics of perception and Eisenstein's call for action. The two avant-gardes lived together fairly peaceably in the pages of *Undercut*.

With the rise of the funded workshop sector and the arrival of Channel 4, the desire to reach a wider audience and the political and aesthetic strategies that necessitated ran throughout the 1980s. Later in the 1980s, the Arts Council of Great Britain also set up funding dedicated to black film and video-making. Most of this support had inbuilt and idealistic expectations as to the size and constitution of the audience for the films they funded. Of course, broadcast television solved this without too much effort by simply programming such material late at night.[25] Theatrical release was much more difficult. Paying audiences had to be attracted outside London's fairly large inbuilt audience of fellow-filmmakers and media activists.[26]

Undercut was at heart committed to sustaining film practices outside the institutions, especially television. While space was given to articles on television and workshop-based practices, its editorials were

sceptical of the demands placed on artist filmmakers by television commissions. In many ways *Undercut*'s instincts were right. When the film and video explosion occurred in the mid-1990s, it was in the galleries and venues like the Lux and not in television. A fairly substantial audience seemed to appreciate the differences between seeing a film/video projection in a real space and seeing it on a television in their front room. Issues of scale, environment and social space have been crucial to the installation work of the past few years. In fact much of the work is such as to make television exhibition nigh impossible. Artists made work for social spaces – galleries and cinemas especially.

It needs to be stressed how few film installations were made and exhibited in the 1980s – the galleries preferred video to film and film projection was seen as an expensive anachronism. But *Undercut* had made the connections between film and photographic art work with its publication of art-work by Mark Lewis, Richard Long, Jo Spence, Hannah Collins, Peter Kennard, John Hilliard, Mitra Tabrizian, Susan Trangmar and Karen Knorr (the last three, very much the Polytechnic of Central London-Victor-Burgin-school of photo work).[27]

In many ways, and over a decade later, *Undercut* remains ahead of the contemporary art scene's new-found love for the moving image. With a few exceptions, critical writing on contemporary film/video artists is lodged in postmodern cultural theory with its built-in anti-aestheticism. Present-day critics, curators and artists are fairly uninformed on experimental film history. Not knowing their history they are condemned to repeat it. Hence the contemporary art establishment's indifference to the films of the past three decades or more whilst deplorable is, sadly, totally in character.

Undercut's importance in the realm of theory was one of attitude. It understood that practice could not be 'blackmailed' by theory (in Barthes' phrase) but had a more complex and diffuse relationship to conceptual explanations. It stood against the more rigid orthodoxies of journals then and, sadly, even now. *Undercut* also resisted academicism (by and large), which is a common affliction of the contemporary museum-led scene. On the contrary, it published the exploratory, often raw-edged, writings of filmmakers themselves, grappling with ideas rooted in practice. *Undercut*'s overriding commitment to practice and to the presence of practitioners on the collective (pure critics or theorists like myself were always in the minority) made it more responsive to the often awk-

ward and wayward voices of filmmakers themselves. As such it was a journal in the rich tradition of twentieth-century art journals run by artists themselves.

1 See my essay 'The British Avant-garde and Art Cinema from the 1970s to the 1990s', in Andrew Higson (ed.) *Dissolving Views: Key Writings on British Cinema*. London: Cassell, 1996. On the 1980s see AL Rees *A History of Experimental Film and Video*. London: BFI, 1999.

2 Malcolm Le Grice, 'A Reflection on the History of the London Filmmakers' Co-op', in Margaret Dickinson (ed.) *Rogue Reels: Oppositonal Film in Britain, 1945–1990*. London: BFI, 1999, p. 107.

3 Initially Nicky Hamlyn and Peter Milner were key links to the Co-op itself.

4 On the IFA see Dickinson, 1999, op. cit.

5 For example, Peter Gidal and Malcolm Le Grice along with Steve Dwoskin, Simon Hartog, Laura Mulvey and others. See Dickinson, 1999, op. cit. p. 125.

6 Articles on the film avant-garde, by Gidal, Le Grice, Deke Dusinberre, AL Rees, Stephen Heath, Pam Cook, Ben Brewster and others, had appeared in *Screen* in the late 1970s.

7 As divergent as John Smith, Will Milne, Patrick Keiller, Nina Danino and Cerith Wyn Evans. RCA film students were not necessarily Gidalians or even formalists. It was in the early 1980s that a strong group of Gidalians emerged which included Michael Mazière, Rob Gawthrop and Lucy Panteli.

8 Peter Wollen, 'The Two Avant-gardes', in Michael O'Pray (ed.) *The British Avant-Garde Film 1926–1995*. University of Luton Press/Arts Council of England, 1996.

9 See for example Nicky Hamlyn's critique of the film *Freud's Dora* in *Undercut*, no. 3/4.

10 For example, AL Rees and Frances Borzello's edited book *The New Art History*, the first of its kind, was not published until 1986. *Screen* under Mark Nash's editorship in the early 1980s had begun to engage with art history – with essays by T. J. Clark, Peter Wollen and Griselda Pollock – against some opposition.

11 In fact, it was an awful decade for film installation or what was known as expanded cinema. For instance, Chris Welsby had enormous difficulties throughout the 1980s finding a gallery that would show *Rainfall*. The same was not quite the same for video

12 Gidal in *Undercut*, no. 2; Norris, O'Pray, Rodowick in 3/4; Sudre in 5; Mazière in 12; and Auguiste, Attilla, Gidal, Julien, Merck and others in 17.

13 See Norris and O'Pray in *Undercut*, no. 3/4.

14 Although Mark Nash's editorship had drawn the journal into art theory debates using Peter Wollen, T. J. Clarke and Griselda Pollock.

15 See R. N. Rodowick in *Undercut*, no. 3/4, p. 62.

16 See Alain Sudre in *Undercut*, no. 5.

17 Willemen, Gidal, Le Grice, Rodowick, Sudre, Mazière, Swanson, myself and others contributed essays grappling with theoretical ideas around the avant-garde and other film concepts.

18 Although it is worth noting that Issac Julian and the Black Audio Collective both exhibited their first significant works at the Co-op 'Territories' and 'Signs of Empire' in 1984.

19 P. Adams Sitney, 'Landscape in the Cinema'.

20 See especially Milne, Keiller, Hamlyn, Mazière *et al.*

21 For example the work of Richard Long, Susan Trangmar, Mark Lewis.

22 Jayne Parker persistently flouted it by re-establishing the 'nude'.

23 As found in Germany in the films of Klaus Wyborny, Elfie Mikesch and Heinz Emingholz.

24 *Undercut*, no. 17. 'Cultural Identities' are the edited papers and debates from the event organised in March 1986 at the Commonwealth Institute by Lucy Panteli assisted by John Akomfrah and Michael Mazière. *Undercut* contributors and a collective member spoke at this event. Work from the Co-op was screened alongside more overtly political documentary films.

25 The *Eleventh Hour* slot on Channel 4 was the most important outlet.

26 See Rod Stoneman, 'Incursions and Inclusions: The Avant-Garde on Channel 4 1983–93', in Michael O'Pray (ed) *The British Avant-Garde Film 1926–1995*. University of Luton Press/Arts Council of England, 1996.

27 Incidentally, many of the original editorial collective had completed the unique PCL postgraduate course in film – AL Rees, Lucy Moy-Thomas, Gillian Swanson and myself.

materials, materials, materials: questions of technology and history
julia knight

introduction

Revisiting the writings in *Undercut* fifteen to twenty years after they were written I am struck afresh by the sheer variety and breadth of the coverage. On the one hand, the subject matter ranges from the animation work of Norman McLaren, through Micheal Snow's *Wavelength* (1967) to Peter Greenaway's *The Draughtsman's Contract* (1982), from the work of Stan Brakhage, through British landscape films to filmmaking conditions in Soviet Russia. While on the other, complex theorisations and critiques of the avant-garde sit alongside very personal, spontaneous reflections on moving-image practices. What emerges from this diversity of content, compounded by references to the likes of Dziga Vertov, Laszló Moholy-Nagy, Man Ray, Len Lye and Humphrey Jennings, is a sense of the history of experimental film. Although the coverage in *Undercut* may not be comprehensive, those contributing to the journal were clearly able to draw on a long tradition of engagement with and writing about the art of making films.

As a product of the 1980s the writings in *Undercut* have of course themselves now become part of that history. And one recurring concern that emerges when looking back at that history is the technological base of moving-image media: 'the machines and the

materials', together with the technological processes or procedures, which are used to construct and present moving-image 'content'. This concern throws up a range of issues, but rather than attempt a comprehensive overview, I have focused on those which – for me, as more of an observer of the history than a participant in it – stand out, namely: the attention given to the 'materials' of filmmaking, especially in the work of the British structural-materialist filmmakers and filmmakers inspired or influenced by them; the question of video and its marginalisation as an art form; and issues around controlling technology. What follows therefore is obviously a selective discussion, but one that tries to explore the importance of these particular issues.[1]

attention to materials: film

When you read *Undercut*, time and again reference is made to how moving-image technology shapes 'content'. Patrick Keiller, for instance, observes: 'Wide angle lenses take in more of immediate surroundings, but also exaggerate distance and so severely undermine the perspective so important to 2D impressions of 3D. Wide screen formats work best with landscapes, motorways and other horizon-type spaces, but in narrower, more vertical surroundings, perhaps with standing people, they become unwieldy.'[2]

Writing in 1983, Mick Hartney explained: 'The video camera does not respond well to bright sunlight, to extremes of heat and cold, to moisture, movement or shock. It works best … in the cossetted environment of the studio, where temperature, lighting, voltage levels … can all be carefully controlled.'[3] This, he suggests, accounts for the paucity of video art work dealing with landscape – in contrast to the landscape 'genre' that exists on celluloid.

However, the most frequently addressed and referenced example of 'attention to materials' is the filmmaking practice that writers variously term structural, structuralist or structural-materialist. As those familiar with the history of experimental film know, this work informed the ethos of the London Film-makers' Co-operative (LFMC) in its early years. A number of articles refer to the history of the British structuralist movement, usually identifying it as a descendant of, although distinct from, US structural film. They note how its anti-illusionist concerns resulted in an engagement with the physicality, the materials and apparatus of filmmaking at all levels. Not only did filmmakers foreground the material of film, such as grain, splices, dyes, colour, film stock and so on, they experimented with the technologies of processing, printing, editing

and projection. As Peter Gidal expresses it: 'In fact, the real content is the form, form become content. Form is meant as formal operation, not as composition.'[4] And as Mike Dunford among others observes, this aligns it with the modernist aesthetic in other art forms and its interrogation of the medium. It was an approach to filmmaking that built on the same 'intense self-reflexivity and concern with the medium of expression as its own source of content'.[5]

But as AL Rees reminds us in an essay written for the *Shoot Shoot Shoot* event held at the Tate Modern which looked back at 'The First Decade of the London Film-makers' Co-operative & British Avant-Garde Film 1966–76': 'The aim was not just formal.'[6] While the filmmakers' concern with materials has at times seemed fetishistic, it was intended to make viewers aware of and reflect on the material processes of the signifying apparatus. It was also intrinsically linked with the integrated practice of the LFMC owning the means of production, distribution and exhibition. Indeed, speaking at the Tate Modern event both Rees and Gidal were at pains to point out that the structuralist film work and its attention to materials took place within a political context. Rees contextualised it within the libertarian optimism of the era, and the co-operative and anti-Vietnam war movements of the time,[7] while Gidal spoke passionately about the political nature of the everyday co-operative working methods of the Co-op filmmakers.

That the structuralist position is referenced so often in *Undercut* is hardly surprising. Since the journal was produced out of the LFMC, it is in a sense part of its own history. Hence it is obviously an important part of the Co-op's identity. But it is also taken as an important reference point – a starting point even – and subsequent developments are repeatedly mapped out in relation to it. Hence over the years of *Undercut*'s publication, a neat linear history of British avant-garde film emerges:

- The British structuralist movement grew out of the 1960s US structural film, but developed a distinctive identity to counter US hegemony.[8]
- Peter Gidal coins the term structural-materialism for the direction taken by British filmmakers during the late 1960s and early 1970s.
- The strict 'formalism' of structuralist filmmaking is not totally abandoned but a 'representational' element is reintegrated, as exemplified by the 'landscape films' of the 1970s. In contrast to Gidal's assertion that 'the real content is the form', according to Deke Dusinberre, 'not only does shape determine

content, but content determines shape'.[9]
- The early 1980s sees a return to narrative, representation and visual pleasure as a reaction to the strict formalism of earlier practices.

As this schematic history demonstrates – and writers frequently assert[10] – its starting point is regarded as a vital context for understanding developments in the 1980s. Other writers also reinforce this by explicitly acknowledging an indebtedness on the part of later moving-image practices to the work of the structural-materialists. Asked to write something in 1990 about British experimental film, from her vantage point in Holland, Barbara Meter commented: 'Looking again at the British avant-garde after 15 years is as if I have plunged into an orgy of romantic images, graining colours, decadent and dark moods and personal evocations. What a reaction against the asceticism of the formal and structural film which reigned at the time I was around. A predictable reaction of course – and one which is *highly indebted to just that formal movement*. I think that *all of British experimental film pays a tribute to the structural movement* (even when being vehemently the opposite, like the work of Cerith Wyn Evans, Derek Jarman, Anna Thew etc). Whatever it did, this formal "regime" certainly made an extremely clear point of film as an autonomous art, as an answer to film as a derived medium' (my emphasis).[11]

As if to reaffirm this influential role of structural-materialist film, all the screenings of the work at the *Shoot Shoot Shoot* event sold out – and most of these were held in a 300-seat auditorium – some 30 years or more after they were made. And both Peter Gidal and Malcolm Le Grice, its chief exponents, have certainly been in positions of influence as teachers of film at art colleges, counting William Raban, Annabel Nicholson, Michael Mazière and Lucy Panteli among their students.

attention to materials: video

All this suggests that the structural-materialists occupy a very privileged position in the history of British avant-garde moving-image work. While this may be deservedly so, it also marginalises a number of other areas. In the context of *Undercut*'s preoccupation with 'the materials and the machines' video art is the obvious example, especially as artists' engagement with video started to happen at around the same time. Because video, like film, is a moving-image technology, those working with or writing about it found it necessary to assert video's distinctive identity to prevent it from being viewed as a poor relation to film.[12]

They did this by comparing the production systems of the two media to assert how video differed from film. And although *Undercut*'s primary concern was understandly the medium of film, this debate crept into its pages. Writing in 1985, for instance, Nik Houghton contrasts the ease and speed with which video effects can be achieved, 'at the press of a button', to the 'slower, more labour-intensive processes of film', and lists the following distinctive, technology-based characteristics of video:

- Synchronous – image and sound are automatically recorded in sync
- Instant – tape can be instantly replayed and requires no intervening system
- Electric – image is electrically generated, abstract in that it does not exist until mediated by technology
- Defined – by the box or screen through which it is played
- Edit-Easy – 'flash-frame' edits, repeated edits and jumpcuts can be quite easily achieved
- Intertextual – with the correct equipment broadcast television, and mainstream films distributed on VHS, can be simply pirated
- Effects-based – image mixing, colourising, freeze-frames, distortion and 'picture framing' can, with the necessary technology, be quickly and easily obtained.[13]

At the same time, video art suffered from its technological base. Whereas the structural-materialist film-makers wanted to expose the seemingly 'invisible' materials and production processes of film construction, the technological base of video seemed all too apparent. As David Hall asserted: 'Video Art. Together the words perhaps seem at odds, even incompatible. Video is a very new and strictly technical term, invented simply to identify the electronic signal which carries television picture information.'[14] As a result, in this country there was a resistance within the art establishment to accept video as an autonomous art form, which engendered a widespread critical neglect, and artists – most notably Hall – found themselves constantly arguing for its legitimacy. This resistance was, of course, compounded by the cheapness and ease – unlike film – with which videotape could be copied, which sat uneasily with the idea of the unique art object. Gerry Schum, for instance, tried with little success to market limited editions of artists' videotapes from his Videogalerie in Düsseldorf in the early 1970s.[15]

controlling technology?

Yet the technology of video had a particular appeal for many women artists. It was cheap and easy to operate, enabled them to work alone and allowed them total control over their work. Such control was extremely attractive for the kind of work they were engaged in, which often addressed issues relating to the body.[16] But, as is evident in some of the *Undercut* articles, this issue of control in relation to production technology is nothing new. Vanda Carter ponders the question of why women in particular chose to use rostrum camera and frame by frame filmmaking techniques. Time and again she finds that they stress the importance of being in control of their work – 'I could be very much in control of the result I wanted to see',[17] 'I like to control everything within my frame' – and concludes that the animation technology gives the women the 'freedom to create images without compromise or intervention'.[18]

According to many, the advent of digital technology has afforded moving-image artists an even greater degree of control. In the early days of video, for instance, Steve Littman has recalled that 'editing equipment worked mostly by hope and prayer alone: it was down to you and your ability to hit or miss the desired edit point … the technology tended to be used for long takes of particular set ups'.[19] Computerised equipment transformed the possibilities by enabling very precise and fast control of the editing process and gave rise to the first edit-based video form. As digital technology continued to develop, the array of special effects achievable multiplied dramatically and created the illusion, according to Steve Hawley, that 'the video artist has at last the capability of fully controlling the instant medium'.[20]

But the reality is that the nature of the technology often limits both access to it and what you can do with it. Littman came up with the idea for a National Videowall Project as early as 1986, but was only able to realise it three years later as part of the first major *Video Positive* festival. It utilised 34 monitors and was only possible through the sponsorship of the videowall system manufacturer, Samcom. Littman has explained, however, how access to the technology can in fact limit rather than enable artistic control: 'Given the amount of equipment involved, [it] took a full week to install … and cabling was everywhere. … [This] combined with the power requirements, meant that, once installed, the system could not easily be moved, reconfigured or reinstalled. Thus, although all of us [the participating artists] would have liked to devise our own configuration of moni-

tors, instead we had to devise a common platform'.[21]

Some *Undercut* contributors also argue that the technology spins out of control. Houghton argues that as art colleges kitted out with new computerised video equipment in the mid-1980s, 'techno' concerns supplanted fine art ones. Access to the latest equipment was prioritised over ideas and resulted in an indiscriminate use of the ever-growing range of digital effects. For Houghton 'spectacle becomes everything'[22] or, as Hawley expresses it, the effects overload leads to 'an obliteration of meaning'.[23] And this has remained a concern in most areas of moving image work. In a documentary about the *Alien* films, broadcast last year, for instance, Ridley Scott reflected that: 'Technologically I can do anything now, today, and that's the danger, you know. The tools … the means to the end become the end rather than purely a tool.'

changing attitudes and technological convergence

Nevertheless, it is evident from the pages of *Undercut* that by the end of the decade concerns were starting to shift. In particular, the structural-materialist past and the distinctions between film and video that had been insisted upon so vehemently in earlier years no longer seemed so central. Moira Sweeney's review of the first ICA Biennial in 1990 is a good example. She asserts – in contrast to Barbara Meter's view – that there is 'no one reference … to contextualise the vital undercurrents in contemporary British film and video' and goes on to comment: 'If the selection is characterised by anything it is the cross-fertilisation and mergence of previously porlarised forces. Material differences in film and video are no longer issues, rather it is a question of which medium is most suited to conveying a particular message.'[24]

Indeed, while I have suggested that the structural-materialists occupy a very privileged position in the history of British avant-garde moving-image work, the continual referencing in *Undercut* of their role within that history also suggests that by the 1980s knowledge of it could not be assumed, that it was not always known to younger filmmakers. In discussion at *Shoot Shoot Shoot*, AL Rees commented that the event could not have happened ten years ago, as there simply was not the interest in this earlier work. He reminisced anecdotally that the only way to get students to look at this work in the early 1990s was to say it would help them make better pop promos and adverts. Speaking at the same event, Chris Welsby stated that he had come across at least three

examples recently of curators and critics claiming particular techniques or strategies as 'firsts' for film which had already happened in the 1960 and 1970s and professed himself shocked at the appalling ignorance of film history in people 'who should know better'.

As art colleges and media departments move over to fully digital production and screening platforms, this is in a sense hardly surprising. The creative and technological landscape is entirely different for young artists today. As AL Rees has pointed out,[25] for instance, the filmmakers working in the 1960s and 1970s could experiment with and reconfigure the technology at every possible level, whereas it is hard for those working in a digital environment to break into its actual 'architecture'. For all the technical sophistication of the latest digital equipment, celluloid technology offered artists far more tactile control of their 'materials and machines'. Yet, despite these differences, the issues and concerns that were raised in the pages of *Undercut* in relation to the technologies of film and video are recurring in discussions of digital and new media art. Just as in the past there were debates about the specificity of the film and video mediums, for instance, there have been extensive debates about the unique characteristics and aesthetics of digital media. Similarly, echoing the structuralists' engagement with 'the materials and the machines', a prevalent strand within online and new media art is concerned with deconstructing and rewriting software code. Hence, the history of British experimental moving-image work – and the publication of this anthology – can (and in many ways should) provide an important context and reference point for contemporary critical art practice.

1 As Michael Mazière pointed out, in commenting on a draft of this essay, with regard to my emphasis on structural film: 'The materials, technologies and issues discussed in *Undercut* were mainly post-structural, which were much wider and included pleasure, identity, sexuality etc.' and that pure debates around structural film 'kind of disappeared (at least in the form described) from the pages of *Undercut* half-way through its publication run' (email correspondence with the author, 17 June 2002).

2 Patrick Keiller, 'The Poetic Experience of Townscape and Landscape, and Some Ways of Depicting It', *Undercut*, no. 3/4 (March 1982), p. 47.

3 Mick Hartney, 'Landscape/Video/Art: Some tentative rules and exceptions', *Undercut*, no. 7/8 (Spring 1983), p. 91.

4 Quoted in Michael Mazière, 'Content in Context', *Undercut*, no. 7/8 (Spring 1983), p. 116.

5 Mike Dunford, 'Video-Art: the Dark Ages', *Undercut*, no. 16 (Spring/Summer 1986), p. 6. An excellent account of this area of filmmaking can be found in AL Rees' book, *A History of*

6 AL Rees, 'Locating the LFMC: The First Decade in Context', *Shoot Shoot Shoot* broadsheet (The Lux, 2002), p. 8. The *Shoot Shoot Shoot* event comprised a season of films which ran from 3–28 May 2002 and a seminar on 4 May 2002 with invited speakers (David Curtis, AHRB Centre for British Film and Television Studies; AL Rees, Senior Research Fellow, Royal College of Art; Ian Christie, Professor of Film and Media History, Birkbeck; and filmmakers Lis Rhodes, Peter Gidal, Chris Welsby and Anthony McCall).

7 This is detailed in Stephen Dwoskin's book *Film Is: The International Free Cinema* (Peter Owen, 1975).

8 Critic Deke Dusinberre recounts: 'Was it Jonas Mekas or P. Adams Sitney … who said something to the effect of, "London? There aren't any avant-garde filmmakers. Go to Germany instead".' Deke Dusinberre, 'Deke Dusinberre on British Avant-garde Landscape Films', *Undercut*, no. 7/8 (Spring 1983), p. 49. At the same time, however, Michael Mazière informs me that it is rumoured Hollis Frampton told P. Adams Sitney: 'I have found your structural filmmakers – they are all in Britain!' (from email correspondence with the author, 17 June 2002).

9 Ibid, p. 50.

10 See, for instance, Dunford, p. 7.

11 Barbara Meter, 'From Across the Channel and 15 Years', *Undercut*, no. 19 (Autumn 1990), pp. 28–9.

12 Many of these debates and arguments are detailed in my edited anthology *Diverse Practices: A Critical Reader on British Video Art* (University of Luton Press/Arts Council of England, 1996).

13 Nik Houghton, 'Joining the Dub Club: Funkers, Scritch and Big Noise', *Undercut*, no. 16 (Spring/Summer 1986), p. 12. Mick Hartney also discusses the differences at some length in 'Landscape/Video/Art: Some Tentative Rules and Exception', *Undercut*, no. 7/8 (Spring 1983), pp. 90–1.

14 David Hall, 'Foreward', *Artists Video – An Alternative Use of the Medium* (Biddick Farm Arts Centre, 1977), unpaginated. Quoted in *Diverse Practices*, p. 221.

15 Such endeavours were not helped by the fact that early videotape was not a particularly durable medium. As Sean Cubitt has pointed out, 'much early videotape has already degenerated beyond any viable viewing quality'. Cubitt, *Timeshift – On Video Culture* (Routledge, 1991), p. 86.

16 As Cate Elwes has explained: 'Video recording equipment has always been relatively simple to operate and it is possible to work alone without the intrusive presence of the crews demanded by 16mm film-making. It was also easy and relatively cheap to record long monologues on tape in contrast to the three-minute limitation of super 8 film. Artists had total control over what they chose to preserve or erase.' See Elwes, 'The Pursuit of the Personal in British Video Art', in *Diverse Practices*, p. 266.

17 Martine Thoquenne and Caroline Leaf respectively, quoted in Vanda Carter, 'Not only Animation', *Undercut*, no. 13 (Winter 1984/05), p. 15.

18 Ibid, p. 15.

19 Steve Littman, 'The Videowall System: An Underexplored Medium', in *Diverse Practices*, p. 176.

20 Steve Hawley, 'Spin, Tumble, Freeze: technology and Video-Art', *Undercut*, 16 (Spring/Summer 1986), p. 10.

21 Stephen Littman, 'The Videowall System: An Underexplored Medium', in *Diverse Practices*, p. 183.

22 Houghton, p. 183.

23 Hawley, p. 10.

24 Moira Sweeney, 'Sign of the Times – A Review of the First ICA Biennial 1990', *Undercut*, no. 10, p. 36.

25 Also voiced during discussion at the *Shoot Shooot Shoot* seminar.

chapter 2 avant-garde theory

problematising the spectator placement in film
malcolm le grice

The following essay has been slightly modified from the original. This was initially an attempt to shorten the text – not very successful – and an inevitable desire to clarify one or two aspects that were less well explained. I have tried not to add new ideas even where I would approach the issue differently now – however, any scholar concerned with strict historical accuracy should return to the original publication as I have not indicated where I have made changes in the text.

The original was published at a time when Christian Metz was by far the most challenging and influential theorist working from the perspective of dominant cinema. I found his work stimulating but was frustrated by his lack of reference to experimental film which I believed addressed similar concepts but through a problematic practice. I was even more frustrated by the way his followers at Screen seemed positively to oppose linking this theoretical base to any work that may have given it a hard time and used it to give further critical credibility to what I thought of as reactionary cinema.

The essay also related directly to a period in my own work initiated by After Lumière – l'arroseur arrosé (1974) and included After Manet – le déjèuner sur l'herbe (1975), Blackbird Descending – tense alignment (1977), and particularly, Emily – third party speculation (1979). Each of these films explored, in one way or another, how the camera 'stood in' for the spectator, how it 'represented' the filmmaker's authority, the complexities of shifting 'identification' in the cinema experience and the way the film's viewers needed to construct the coherence for themselves from intentional and problematic discontinuites or disruptions.

Since I began making films in 1965, much of my theoretical concern has been with the role and condition of the spectator. The shift towards a similar concern in Christian Metz's writing represented by the article 'The Imaginary Signifier'[1] enables (and demands) a relationship between his work and my own practice in a way that seeks to transform rather than exploit or simply analyse the conditions of the spectator.

One object of Metz's article is to define that which is special to the cinematic signifier. More precisely he terms this a signifier effect (already introducing the spectator subject by implication), which he defines as 'a specific coefficient of signification (and not a signified) linked to the intrinsic workings of the cinema'.

In discussing signification in general, Metz aligns himself to the awareness that signification is not 'just a consequence of social development' but becomes 'a party to the constitution of sociality itself'. Metz quotes Lacan – 'the order of the symbol can no longer be conceived as constituted by man, but rather as constituting him'. But Metz sees, by what he nicely calls 'the partial "uncoupling" of the laws of signification from short term historical developments', the capacity of the semiotic to function as a radical, definitional, sociality. Implicitly this recognises that the conditions of signification are not immutable, however deeply determined.

To define the intrinsic condition of the cinematic signifier Metz is forced to go via the only cinematic practice he knows, the dominant industrial fiction film. For him, the fiction film is 'film in which the cinematic signifier does not work on its own account but is employed entirely to remove the traces of its own steps, to open immediately on to the transparency of a signified'. However, this transparency applies to every film which Metz might envisage including his non-fictional genres like documentary, as they also come from a context with an investment in maintaining the transparency of the signifier. This in part leads Metz to the notion: 'Every film is a fiction film'.

Without positing the whole avant-garde cinema, or even Structural/Materialist film as some *absolute* alternative to the cinematic form which provides Metz's historical reference points, it is nonetheless a polarity within which instances can be quoted providing some embodiment of what is the implicit obverse of Metz's definition, namely film in which the signifier *does* work on its own account.

When Metz says 'attempts to "defictionalise" the spectacle, notably since Brecht, have gone further in the theatre than in the cinema', he helps to obscure substantial cinematic developments which have aimed themselves directly at this problem. I see the predominance of the fictional in cinema as a historical problem related to the economic/social function cinema has been called upon to perform and the deep effects this has had in the development of cinematic conventions. Metz on the other hand, unaware of films which have attempted to 'work on the signifier' and 'defictionalise the spectacle' sees it as a product of intrinsic conditions of the cinematic signifier itself which is from the outset 'fictive and "absent"'. In spite of his own concept of the partial uncoupling of the laws of signification, which he would evidently consider to be at play in Brechtian theatre, his argument on the cinematic signifier sails very close to naturalizing it as an immutable essence of the cinematic.

In support of his argument of the intrinsic fictiveness of cinema the concept of a special condition, or degree of 'absence' for the cinematic signifier is fundamental. He supports this contention of absence in various ways from a demonstration that a can of film does not contain those 'vast landscapes' which are the subject of its images to detailed comparison with theatre where the actors (here seen as synonymous with the signifiers) are really there in the real time and space of the theatre. He points out emphatically that everything in film is recorded and that what is recorded is by definition absent. In both the comparison with theatre and in the issue of recording, Metz's arguments for a special absence of the cinematic is faulty. If in the theatre, the actors (or props) are considered either as the signifiers themselves, or their real presence somehow resists the transparency of the theatrical signifier, this is no more than an argument of an awareness of the material reality of the signifying substance. It is parallel to those movements in painting which drew attention to the material of the painting rather than simply using that material to construct a pictorial illusion. There are more than enough films from the avant-garde cinema which draw attention to, or work with, the cinematic materials like colour, light, screen, acetate, shadow, auditorium etc. to make it quite clear that an awareness of the signifying substance is as possible in cinema as in any other medium. Beyond the material substance of the cinematic image itself, as a photographic record, even if that which has been the subject of its recording is 'absent', its recorded trace, like a footstep in concrete, is present. Locked in this terminology, the cinematic image is a 'real image', though strictly within the specific parameters that the mechanism and medium is capable of recording. The confusion occurs when the specific limits of the recorded image are read beyond those limits not as a 'real image', but as an 'image of the real'.

photo quiz maureen paley

Is the record turning at 45 RPMs or 33 RPMs?

Indeed, consideration of the cinematic signifier (its intrinsics) might best be focused on the *problematics* of the relationships between – the substance of the record, the material processes of recording and that continuum out of which it is a recording. The image is a *production* and *inscribes its production* however much these inscriptions may be effaced or attention drawn away from them.

The cinematic signifier for Metz can be seen as no more than the theatrical signifier at an extreme end of theatrical naturalism, where the actor, props, vast landscapes or what you will, are also made transparent. They are understood as absent in cinema because parameters of presence are assumed beyond the specifics of the cinematic image. This condition is only possible whilst film's specificity is made transparent in order to preserve the naturalistic theatrical signifier. However much Metz may argue the extension of perceptual registers in cinema, a factor which clearly assists transparency, these registers (better expressed as the parameters of range and resolution of the recording) remain specifiable.

My refutation suggests that, if the fictiveness, or imaginariness of the signifier may be counteracted in theatre by asserting the physical presence of the actors, then such a condition is equally open to cinema through asserting *its* material condition. However, this tempting elevation of the cinematic signifier to the status of its own reality, its presence,

is also problematic, rebounding on the assumption that the signifier is present in theatre. In a film which, for example, draws attention to the screen surface, the projector beam, the intermittent mechanism or whatever material aspect might be chosen, is it correct to assume that the signifier is present? At the moment that the signifier functions as a signifier, whatever the medium, it becomes transparent. Attention to the signifier in its material sense (as the signifying substance) does not escape the process of standing for that which it is not. It is incapable of standing for itself in any more than a representation of some *aspect* of its properties. Films which may be described as working on the signifier counteract transparency more by making aspects of the signifying *process* evident (tracing the path of shifts and transformations between signifying substance and signification), than by asserting the unproblematic presence of the signifier. I can see no distinction in kind to be made on this level between film and any other signifying practice. The signifier is neither unproblematically present as substance, nor absent as signification. Its absence, inevitable in certain moments of the signifying process, is not to be demonstrated on the basis of some special intrinsic condition of the cinematic medium.

Up to this point in Metz's argument he has looked for the special conditions of cinematic signification mainly within the medium and apparatus. More fundamentally interesting is a shift which concerns itself

TEST YOUR LISTENING COMPREHENSION

Study this picture for 3 minutes and ask yourself the following questions:

with the conditions of response in the spectator/subject. In order to approach this problem, Metz refers to that general science of the subject, psychoanalysis and, in particular, the work done on the specular regime by Jacques Lacan.

My own resistance to the dominant cinema has frequently been expressed in terms of demanding or encouraging a more conscious or self-aware spectator. I have argued against the manipulated passivity of the audience to both film and television and have sought filmic devices to establish what I have called a speculative/reflexive mode in the spectator. The rhetoric of this enterprise has been interpreted as a denial of psychology and the unconscious. On one hand, my broad rejection of symbolist expressionism is not as a rejection of the unconscious, but a rejection of the unconscious manipulation or exploitation of the unconscious *so that it remains unconscious*. On the other hand, the concept of a *self-conscious* spectator has been an attempt to break the subjugation of the spectator's ego by the film and filmmaker (but more importantly – subjugation by the multinational cinematic corporations through the *agency* of the films and filmmakers). Neither positions deny the psychological or the fact of the unconscious. To date any application of psychoanalysis in cinema has been at the level of symbolic interpretation – a psychoanalysis of the filmmaker via the film text, or a form of socio-psychoanalysis. Little work has been done on the more fundamental psychological mechanisms at work in the cinematic experience – a possibility Metz opens up.

As a painter influenced by abstract expressionism, my early reading of Freud remains an underlying frame of reference. From my later reading of Lacan, I have some reservations about the use of psychoanalytic language outside the practice of psychoanalysis itself. I am not in analysis and my main concern is with filmmaking not criticism or interpretation, so if psychoanalytic concepts are to be productive for me I must relate them to my experience in the cinematic.

What Metz draws on from Lacan concerns the relationship between the formation of the ego and the image – the way in which fundamental unconscious formations are embodied in the imaginary function. His main reference is to Lacan's description of the mirror phase, the formation of the ego through the perception of the body image, and consequent imaginary coherence. In addition, Metz incorporates the way in which the mirror image in the presence of others (primarily assumed to be the mother) gives to the child its sense of being an other in the presence of others like itself. This likeness is used to understand the capacity to *identify with the other* through the *image of the other*, a fundamental mechanism in socialisation.

Metz encounters an immediate difficulty in relating the cinematic to the mirror phase, noting that the spectator's body is not reflected in the film

To what record are we listening in this picture?

image. He overcomes this by suggesting that cinematic perception is only possible subsequent to the spectator's ego formation in the mirror phase, maintaining the analogy of cinema with the mirror by a special emplacement, whereby the mirror suddenly became clear glass.

In his pursuit of a mirror analogy, Metz misses what might be a productive avenue, film's capacity to reflect time as a parallel for the way a mirror reflects space. Though not a crucial point, I may also note that in the home movie the subject's image is 'reflected'.

Taking account of the spectator's bodily absence from the screen, Metz turns to identification with the represented characters, but because he is drawn towards his more challenging formulation of the spectator's placement (my term) in the scene, he moves quickly over character identification as secondary to a primary identification based on self-identification in the mirror phase. This is unfortunate – it remains debatable that all the mechanisms of identification with others are secondary and subsequent to the identification of ego with the self body-image. Many aspects of the mechanisms of identification, either with others or objects in the child's stages of extreme dependency, also have a very primary psychological form both before and after the mirror phase. Furthermore, in the cinema which Metz uses as his basis of reference, because of the transparency of the signifier, identification with

character is paramount. His argument that there is no loss of identification during long periods in which no image of a character appears on the screen fails to take account of the fact that identification with others on the screen, as in its social formation, is not simply an identification with the likeness of their bodies to our own, but an intricate concern with the consequences of their actions.

Long periods (in fact always short except in the avant-garde cinema) of what Metz calls 'inhuman' sequences are always contained within structures of narrative consequence. An identificatory response to them will already have been conditioned by their narrative context. To understand the psychological mechanisms at work in the film spectator we need to look more broadly at the mechanisms of identification at work in social relationships in general. This is particularly important in a critique of cinema where the signifier is (intentionally?) transparent, opening directly, as it were, onto the scene of the imaginary action. Mechanisms of identification preceding and superseding the mirror phase are deeply intricated with what Metz tries to differentiate as the spectator's identification with self. At the same time, even in those avant-garde films which eliminate the portrayed character or may even eliminate all photo-recording, the issue of identification in the consequences of the film's transformation is still implicit in the spectator's attention. Whatever distinctions may be drawn between the spectator's self-identifica-

Would you adjust the volume in this picture?

tion and identification with the characters, actions and objects of the screen image, it is only in some instances of experimental cinema where these issues are raised *as problematic* by the *film texts themselves* (not just superimposed by a critical theory onto films which do not even consider this an issue).

In attempting to define the spectator's identification with self as more primary than identification with the screen's characters, Metz turns the lack of image of the spectator on the screen to profit, reasoning that the spectator's ego must therefore identify itself elsewhere.

In one paragraph in which he talks of the 'subject's knowledge', he outlines a number of factors necessary to be known by the spectator in order for film to be possible. After a (metaphorical?) first-person description of a knowledge of being within a cinematic space knowingly perceiving and knowing therefore that 'I am the place where this really perceived imaginary accedes to the symbolic', he goes on to what is for him a key concept: 'In other words, the spectator identifies with himself, with himself as a pure act of perception … as a kind of transcendental subject'. He sees this inevitable self-identification of the spectator as a necessary consequence of the very possibility of the cinematic perception. Fundamental here is Metz's concept of the spectator as 'the constitutive instance … of the cinema signifier (it is I who make the film)'.

In spite of recognising that this transcendental subject places the spectator into the illusion of deity, in spite of recognising that the state of 'all perceiving … all powerful' is an extreme reaction of the ego to the *frustration* of its power, with all his consequent attention to the 'perversion' of voyeurism in cinema, Metz does not attempt to dislodge this condition of the spectator from an intrinsic essence of cinema. Of course it is in the spectator that the film experience is constituted, but, and it is crucial, to what extent does the spectator make that constitution, and to what extent is that constitution made in the spectator as the final point of a corporate production? Unconscious complicity in the constitutive process has a different status to knowledge of that process. It is distinct from a condition where choices are being *made by the spectator*, a necessary condition before the imaginary can approach the symbolic.

Metz follows his general concept of the spectator's identification with self by some consideration of identification with the camera. My interest in this issue comes from a general concern with the role and place of the spectator in my own film work and, since 1974, into a specific consideration of the spectator's relationship with the camera and the act of cinematic recording.

Metz's transition from the spectator's transcendent self-identification to identification with the camera follows the argument concerning the placement of the spectator/subject in quattrocento perspective and its continuation in the development

What is the sound of this dog's master's voice?

of the optical apparatus. The spectator, it is argued, by occupying the 'empty implacement', inscribed by the viewpoint of the camera, is put in the relationship to the scene previously occupied by the camera in the act of recording the image. Through the psychological arguments which express the equation between seeing and causing as a reaction of the ego to its inability to possess or control the object of its gaze, Metz interprets this 'empty implacement' as implicitly that of an all-seeing, all-powerful 'God himself'. I accept the broad psychological argument concerning the formations in the specular regime, but there is a significant sense in which the camera, as a definable mechanism, is capable of clarifying the limits which the apparatus imposes on the image and its ideological or psychological placement of the spectator.

The image can become *specifiable* in its relationship *as a production* through awareness of the camera and its properties as a mechanism thus counteracting the omniscience of the point of view. This may take place by making evident within the film work the specific limits of access to the scene available through the camera. In this way, the viewpoint becomes relatable to a *causal agency*, readable in a materialist sense rather than as a generalised 'ideal' access (in effect unread through the transparency of its inscription). This point of access need no longer be interpreted as an immutable natural condition, before which the subject is powerless leading in turn to the illusion of absolute ('God himself') power as a reaction to support the ego. It might be argued that the camera as a mechanism, like quatrocento perspective, is more intrinsically inclined towards the materialist specificity of access to (and construction of) the image, than the transcendental omniscience which Metz sees as intrinsic. Whichever way this is read, the camera and its functioning in a film constructs the image *within a system of production* (a motivated causality) and this is inscribed in the resultant image. It is a historical problem if this inscription is suppressed and if film practice fosters a misreading of the historical for a natural or theistic causality however much this is supported by the psychological compliance of the spectator. Where Metz talks of identification *with* the camera, I feel a better expression would be identification *through* the camera as the specificity of the camera is not raised to the symbolic in the process understood by Metz.

Except in a small line of development from the early films of Warhol (which includes work by Michael Snow, Peter Gidal and myself), there are few instances where the camera identification becomes problematic within the film itself. In these cases, certain constraints in camera movement and edited construction *demand* consideration of camera implacement (both in a spatial and temporal sense) as part of the film experience. In this work, whilst there is still identification *through* the camera with the components of scene or action, there is also an inevitable shift towards an identification *of* the camera as a spatio-temporal implacement.

We must distinguish an identification with the camera as *camera – as mechanism*, from the components of the scene (recorded through it) and its (invisible) subsumption as an agent of the narrative. Crucial here is a distinction between *identification of*, *identification with* and *identification through*. If *identification with* involves a transfer of the subject's ego to the condition of another (an other), with all its vicariousness, but social necessity, in the same process, *identification of* involves a differentiation of the subject ego from that object. Though *identification with* and *of* are interdependent in the process of relationship between the ego and other objects, identification of requires a degree of resistance and psychological separation from the 'object' (other). In the process of *identification with* a character, it is necessary to make some *identification of* that character. In social interaction, identification with another is never without the conflict that comes from recognising the difference of the other (and the other's desire) from the self. In the same way, if there is to be any meaning to the concept of identification with the camera, there must be some element of identification of the camera (a similar condition of inevitable conflict). Identification with the camera, far from being a common condition within the cinematic experience, is a difficult condition to initiate and maintain, as this involves a conceptualisation of an implacement not represented directly in the scene but inscribed through its effects. In general (in dominant cinema codes), this identification is most frequently approached via the personification of the camera in the character point-of-view shot, or its extreme extension as the point-of-view of the first person filmmaker. In both these cases, identification with the camera, as such, is lost as the identification becomes relocated in the personification becoming again an identification with a character. In a sense, the more the identificatory process bypasses the conflict implicit between identification *with* and *of* and transfers itself to another object, the

more we should consider this as an identification *through*.

Identification *through* the camera is thus 'directly' with the components of the scene and action as if unmediated. In the dominant cinema, it is mainly because of the continual *dislocation* of the viewpoint that the spectator has no alternative but to identify through the camera with the source of the narrative continuity. Some continuity in the camera implacement (most frequently but not exclusively achieved through the device of the static camera and long take), begins to differentiate the *viewpoint* from the *scene* and, crucially, also begins to develop some distinction between the (cinematic) mechanism and the ordering authority. Without some specificity of viewpoint, as a consequence of the spectator's incapacity to locate the ordering authority, the ego is forced to adopt an idealist physical and psychological location. The spectator's illusory identification with this unspecifiable ideal location masks that it is in fact an identification with the power of the institutional authority behind the narrative order.

Metz refers us to Baudry's observations in 'The Ideological Effects of the Basic Cinematographic Apparatus', that the spectator is in a submotor and superperceptive state. For me, an examination of the relationship between the motor and sensory regimes in the cinematic experience is crucial. Using the term sensory rather than specular allows us to include the auditory aspect extending the concept of identification with the camera to identification with the microphone. Fundamental dissociations between the sensory and motor regimes are at work in cinema (Baudry's 'submotor'). The spectator is at rest in a seat and, not only is the more obvious motor activity, that of walking about in the space, eliminated (it is largely only effective in the initial and subsequent instances of walking to and from the cinema), but in the cinematic experience, the spectator is crucially unable to enter into the action and cannot influence its outcome by intervention. The latent desire to do so is maintained through identification with those portrayed characters who seem able to do so by their actions. By identification with the characters, the spectator seems to act towards the determination of consequence.

In the fundamental development of the relationship between the subject and the world the subject becomes implicated in the sensory through the consequences of general motor engagement. Thus, whatever the fundamental psychological basis of motivation, its transformation towards relative voli-

tion is moulded by the developing capacities of the motor regime. Motricity and motive become deeply correlated.

The effect of this implicatedness in the world is inscribed in the sensory construction of the subject (and, one must assume, the ego), within which the effects of the mirror phase are a stage. In the cinematic, the question of the spectator's implication or disimplication becomes fundamental. It is evident that the spectator's sense of implication in the narrative action itself is unavoidably vicarious, and illusory, but what of the more detailed issues of the specular and auditory response?

In the same way in which motor engagement in the film's action is impossible, the less evident motor actions normally deeply intricated with the specular and auditory are also highly reduced. In the specular, the neck muscles are not called upon to swivel the head as the screen is contained within the visual field of a static head, the eye has little lateral or vertical movement to make as the pertinent aspect of the image is normally held near the centre of the screen. As the image is flat, there is not even a necessity to refocus for various distances. Similarly, no motor demands are made in locating the auditory source.

For the moment I shall leave aside the auditory issue (dissociation of the spectator's voice) and concentrate on the active component of the specular – *the look* (for which *the listen* might be an auditory equivalent). The look is the operation of the motor regime in the specular. In the same way in which motor and motive become generally interrelated, in the specular they are intricated through the expenditure of energy in the determination of the perception. It is evident that the greater the perceptual shift desired by the subject, the greater the motor investment required to bring it about. Perceptual changes in the world are deeply related to the economics of this expenditure of motor energy. In the conventions developed by the cinema the disimplication of the spectator under the illusion of implication extends to *the look* through the dissociation of the specular and motor regimes.

The consequences of this are particularly demonstrable in the conventions of camera movement and action montage. Whatever the basis of specular desire, the initial engagement of the spectator in cinema rests on there being some correspondence between the object of that desire in the spectator and the agency (filmmaker, corporation) that creates the film image. This engagement is main-

tained in particular by the conventions of camera movement and montage following the spectator's desire to maintain contact with the development of the action. The camera follows movement or the cut opens on to the pertinent continuation of the action. Though this may include sophisticated suspensions in the action, they only do so within the context of ultimate co-ordination. What is important here is the *detailed psychological effect* of the continued provision of the desired object in the scene. The spectator *seems* to bring about the perceptual change as an act of volition when that desire is satisfied by its provision in the film. As a camera follows action, or an edit maintains continuity, there is sufficient correspondence with the desire of the spectator that the experience seems (unconsciously) to be one of choice exercised in the look. But, in the same way in which the spectator is unable to enter the action in the crude sense of intervening in its consequence, the spectator initiates no perceptual changes of the cinematic scene. The apparent implication of the spectator, by the apparent responsiveness of the camera movements, and scene changes to the spectator's volition produces a fundamental illusion of choice and control where none exists. If, in cinema, the sensory/motor dissociations are basic, is the dissociation of the sensory/motor from implicated volition inevitable, and in what sense can the spectator *appropriate* the cinematic experience (come to 'own' it – raise it from the imaginary to the symbolic)?

Many of the devices which Structural/Materialist work has adopted might be interpreted in terms of making the fundamental dissociations evident or problematic, in this sense clarifying the relationship which exists between the film, the filmmaker and the spectator. To this end, the devices and strategies have served, as it were, to *expel* the spectator from the text (also attempting in some respects to expel the filmmaker), rather than create an unconditional engagement. Easy and immediate correspondences between the film's structure and the expected desire of the spectator have been resisted simultaneously with an attempt to permit, encourage or initiate the spectator's own *symbolic activity* as the basis for appropriation of the film experience.

Theorising from my current film work I want to focus on choice, motive and the spectator's symbolic as they relate to the motor aspect of the sensory/motor relationship. In the auditory regime, the symbolic activity of the subject emerges from the *aural*

production, the act of speaking, the motor activity of the voice. It is clear that in cinema the spectator's voice is subsumed by the film text in the same way the spectator's 'intervention' and perceptual action are. In the specular, the *directedness* of the look, might be considered as an equivalent to the symbolic activity in the production voice in the auditory. Directedness, the motivated look, is here seen as an equivalent to the production of the voice – the motivated symbolic in language. Thus the development of the symbolic in the specular may be directly related to the subject's implicatedness in the act of choice and selection in the look. Given the supression of motricity in both the look and the voice in the cinema experience, if this concept of symbolic production by the spectator is to be developed it must be understood as an interior act.

Whilst the concept of the spectator's interior voice may be readily grasped, the concept of the operation of *the look* in an interior sense is more problematic. However, to support both cases, the spectator must produce an (interior) auditory and specular construction for the film which is not directly that of the film experience. To initiate this, spectators must first be expelled from the film text in order to create a 'space' in which to produce their own conceptual construct as an *act of the symbolic*. In other words, the spectator must *become* the *constitutive instance* of the film by constructing a symbolic relationship the film text. In this formulation, such a conceptual (symbolic) construct is not synonymous with the spectator's ego in any whole sense. I suspect that the expulsion of the spectator from the text counteracts the tendency of the ego to identify itself satisfactorily within the form of the body image via any identification it might make in the screen image. Indeed, a cinema signifier locked into the form of ego construction of the mirror phase, as it is in the dominant, unproblematic narrative cinema form, may be seen to short circuit the ego concept into a body image and help to maintain a fixation at that stage – thus inhibiting the development of the symbolic. Therefore we must ask if the regressive pleasure of cinema is utilised politically by the cinema institution in order to maintain a pre-symbolic disimplication of the spectator.

These notions are presented more in the spirit of a search for the productive problematics than a rhetorical conclusion.

1 Christian Metz, 'The Imaginary Signifier', *Screen*, vol. 16, no. 2.
2 Jacqueline Rose, *The Imaginary, the Insufficient Signifier*, BFI

modernism, phantasy and avant-garde film
michael o'pray

Lacanian film theory, as it has been developed and applied in this country over the past decade, has failed singularly to address itself to anti-narrative and anti-illusionist forms of film. Whilst not under-estimating the work of Gidal, Le Grice, Heath, Penley and others[1] who have attempted to force some connections between avant-garde film practice and recent film theory, it remains a fact that progressive film culture in Britain is dominated by the study of dominant mainstream cinema, television and media culture. Ironically, coincident with the emergence of this film culture was the development of an English avant-garde film practice dedicated to a structural/minimalist strategy which eschewed 'content', nar-rative and illusionist techniques. Stressing film as process, 'the politics of perception', and the material-ity of the camera, the gate, the printer, the projector, the celluloid, the screen, this avant-garde movement has been fundamentally at odds with any concep-tion of film which views mainstream narrative film as a possible progressive determinant and element of the social formation.

If Lacanian theory, where it has been appropriated by film theorists, stumbles before avant-garde film, it is when the latter accentuates the formal, visual and materialist features of film, and this failure should not be seen to be one attributable to psychoanalysis *per se*. In this article I shall attempt to relate a film aesthetic to a more Kleinian position in psychoanaly-sis.[2] By suggesting a closer link to exist between the formal, visual and materialist strategies of structural/minimalist film and unconscious phantasy, I hope to establish, if tentatively, a means of resolving the avant-garde's head-on confrontation with a particu-lar use of psychoanalysis which identifies diegetic personages with positions in the Oedipal trajectory and thus renders film essentially narrational in terms of the unconscious scenarios of the 'family romance' and such. Shape, sound, image, rhythm, colour, light, movement – formal concepts – will instead be the implicit subject matter here. My argument will be at a general level and in many ways will be under-developed and schematic as it also tries to assert a relationship between the discourse of modernism, aesthetics and avant-garde film.

the 'gaze' of modernism
Since subject matter in painting came under threat in the Romantic movement of the nineteenth century, both the formal aspects of art and the art-ist as the 'spiritual' source of representation have come to dominate the practice and ideology of the modernist movement (understood in conventional terms) and its avant-garde.[3] Modernism was largely determined by its severance of the longstanding relationship between form and subject matter, thus, in effect, disconnecting aesthetic values from cul-tural ones. With modernism, art as the 'servant' and product of culture was opposed in the nineteenth century and afterwards by a view that denied the stability and resourcefulness of broader cultural values and instead relocated such qualities both in the artist's subjectivity and personal values and in the formal features of art. The cultural ramifications of art through the production of symbolic repre-sentations of a conventional kind in the choice and treatment of subject matter, were renounced. Art was no longer, as Stokes puts it, an invitation to the spectator to share an 'established ritual' but rather, and increasingly so as modernism progressed, to 'contemplate a personal process'.[4]

A digression at this point may be instructive, or, at least, suggestive. Foucault's reflections on the institutions, practices and discourses of punishment in France from the Middle Ages to the nineteenth century, describe the body as the object of meticu-lous torture and ritualised execution before the great 'progressive' transformation of the nineteenth century.[5] In earlier times a social and discursive com-plexity rendered the body symbolic of certain 'reali-ties' – political, judicial and epistemological. Torture and execution, in 'exquisite' technology, esteemed the body in various ways: as the repository of truth (confessions of guilt achieved by torture, by that very fact, were 'truths'); as the body politic (all crime was essentially regicide in that the criminal embod-ied, so to speak, all civil aggression and unrest in the face of the absolute and God-ordained authority of the monarch); and as the body of spectacle in public execution (the 'dramatic' representation of the literal tearing apart of the body where the ambivalence of the spectators' identification with both criminal aggression, and the monarch's need to avenge it, was projected).

In contrast, in the nineteenth century, the criminal's soul became the object of punishment

by imprisonment, accompanied by rigid discipline and underpinned by an ideology of 'humanism' and 'reform'. At first sight, a paradoxical change seems to have taken place in this transformation. The body, under capitalist and bourgeois rule, became object in a different sense – the object of a 'gaze' (represented in the panopticon)[6] by which the body ceased to be the 'natural' representation of converging social, cultural and religious discourses and practices. On the contrary, the Law (i.e. the legal system as opposed to the absolute monarch) articulated through legal abstraction a rationalistic conception of the soul. Although tantamount to a denial and repression of the body as representation, such a system in its incarceration of the criminal indifferently imposed a form of brutality upon it. In France, modernism was constituted in the same break of bourgeois rule with the *ancien regime* and absolute monarchism – a break marked by the French Revolution. In England, the discontinuities took a different form. Painters such as Reynolds, Gainsborough, Wilson and Stubbs represented civil qualities in the second half of the eighteenth century (notably, characterised as the 'Age of Confidence')[7] associated with manners, gentility and harmony. Elements of such an art were its representation of a 'natural' claim by a powerful landed aristocracy to power and authority; a subtle ideology of the ripeness of economic development (the great benefits of the Agrarian Revolution) where the rustic genre in painting, for example, incorporated the 'natural' symbols of the culture (gentry, labourers and animals pose in a tamed landscape e.g. Stubbs' *Reapers* (1785); Gainsborough's *Sir Benjamin Truman* (c.1774); Moiland's *The Tea Garden* (1790)) as if it were the very source and sustenance of art. In such work there exists very little disruption between representation, subject matter and form – all is of a piece. The referent has found its 'natural' mode of representation in its historical context. With modernism, art was eventually to represent independently of a facile reliance on equally facile conventional associations. When artists came to lack confidence in their culture's dominant ideology and in its ability and authority to sustain art, then art itself was to conceive of itself as producing culture, and not vice versa.

As in Foucault's understanding of the political anatomy involved in forms of punishment, modernist art also renounced its former relationship to an object 'naturally' imbued in cultural and ideological values. To appropriate Foucault somewhat, art established its own 'gaze', one which came to conceive its object as bereft of an established symbolic and

ideological value and instead was valued for its 'is-ness' (for Stokes) or, what Gidal calls, its 'there-ness'. Art became, in other words, its own object. The substitution of the art object itself for the traditional subject matter not only freed art from dominant cultural associations but also, in a paradoxical way, paralleled in the Foucault example above, raised the object, in the name of an indifference to reality and subjectivist demands, to a dominance thinly veiled by the so-called lack of referentiality implied in its practice and ideology. As Constance Penley has pointed out the referentiality of avant-garde film, say, to itself qua object and process does not negate the problem of reference, realism and representation but only adopts a different, and in the end perhaps more mesmerising, object.[8] Of course, the reflexivity of modernist practice does not mean that cultural, symbolic and ideological elements disappear – quite the opposite, they exist in a marginal and hermetic form that relates to dominant culture in an obtuse and complex fashion.

avant-garde film and representation
With respect to avant-garde film, it shares with other art forms a more intricate relationship with conventional representations than has been implied in the above discussion where the attempt has been to articulate very general trends and characteristics. Degrees of autonomy exist. For example, the notion of the two avant-gardes set out by Peter Wollen[9] grapples with this problem by seeking to isolate the characteristics and histories of avant-garde cinema. In many ways, the distinction I have been making above between modernist and non-modernist art finds its echo in the 'two avant-gardes' debate. Godard, for example, is committed to a modernism that has not shed its attachment to cultural symbols of dominant ideology, but rather achieves its effects by a strategy of representing such symbols as potent modes of reaction, dominance and exclusion. On the other hand, the filmmakers of the English co-operative movement, for example, have understood their radical position to be one more readily identified with the formal and material aspects of film, thus eschewing, by and large, the subject matter characteristic of Godardian film. In short, for the structural/minimalist filmmakers – occupying the material wing of the material/signification opposition – 'the image taken does not have already an associative analogue, is not a given symbol or metaphor or allegory'.[10]

Accordingly, material/structural/minimalist film has been characterised at times as constructing an 'empty

signifier' which if true reveals a crucial problem for recent film theory, namely, that of the easy separation of its psychoanalytical component from its semiotic one. That is to say, while it is perhaps true that linguistic constructions (taken in their broadest sense as being concerned with meanings) can be empty of meaning (nonsense sentences), it is not similarly true for psychoanalysis that representation (the operation of the Imaginary in Lacanian parlance) can be suspended or even displaced altogether.

If a visual representation is taken linguistically as a set of meanings, then it follows that such representations will not make sense sometimes, as in the case of the 'empty signifier' for example. Concerning psychoanalysis, the notion of representation is understood in terms of phantasy and thus there is no sense to be attached to the idea of an incoherent or meaningless representation in the context of that discourse. Where representation in film is conceived as a complex phantasy then there cannot exist a film which does not represent. The 'empty signifier', in other words, is not possible. This distinction between linguistic and phantasy representation marks a difference between the semiotic and the psychoanalytic, rendering inappropriate the reduction of the latter to the former. Language is governed by different elements and rules of formation from the unconscious.

The tension between semiotics and psychoanalysis in relation to film theory is the topic of Christian Metz's 'Metaphor/Metonymy, or the Imaginary Referent'[11] where he seeks to separate the two disciplines as distinct theoretical integrities through a discussion of the couples: condensation/displacement (the mechanisms of the unconscious) and syntagmatic/paradigmatic (the mechanisms of semantics). Central to this problem is the importance of the non-linguistic character of the unconscious. The semiotic approach to film, with its emphasis on signification at the level of consciousness, is in many ways grossly naive, for how else could a structural/materialist film's lack of subject matter (its abstractness or sheer materiality) be considered an 'empty signifier'?

This tendency marks an indifference to the fact that psychoanalytical representation and meaning can be produced not only by diegetic personages and objects and their relationship to a filmic scenario (as in the orthodox portrayal of dreams) but also by more formal elements e.g. colour, mass, shape, light, movement. In a film like Mike Leggett's *Shepherd's Bush*, the representations are in one sense non-representational – there is no conventional 'content' – but they are associative in terms of phantasies of a most general nature.

The identifications, projections, introjections and splittings set up in phantasy in relation to the viewing (and production) of a structural/minimalist film are not those achieved in mainstream cinema. They take a more general form, and if we need to be reminded of the force of such generalised phantasies then we have only to acknowledge the fears, anxieties and even horror caused by indiscernible shapes in the darkness, the furtive movement behind the door, the hanging mass of mountain above a lake – the vague moments of the nightmare. In such cases it is not that a particular dream personage or narrative determines the feelings in the subject, rather it is the less determinate and often unimportant elements such as a noise, a colour, a movement, which more often than not signal a further and unconscious phantasy – a more infantile and primitive one.

Similarly, there is a need to reject the analysis of film in which diegetic characters and narrative structure are 'read off' in terms of beliefs and desires and Oedipal characters. Films are not dreams. Even if they were, as we have seen, such an approach is inadequate. Phantasies attach to the formal too and to this extent the distinction between form and content is removed. The critical emphasis entailed by this view would stress the rhythmic incantatory use of flickering light enveloping the spectator; the aggressive fragmentation of film in montage and frame composition; the reparative function of voice-over, and so forth.[12] Through such introjection and projective identification by the spectator and filmmaker(s) alike, the film asserts phantasies of a primitive kind, constituting film as more than just a conceptual exercise in the case of structural/minimalist production but also as a visual representation of aesthetic resonance.

The view being suggested here is a Kleinian one and it might be objected that to understand avantgarde film by the application of the concepts of part- and whole-objects e.g. the breast, penis, nipple, vagina, faeces, is to reduce an art practice much concerned with conceptual matters to one dictated wholly by unconscious primitive phantasies. In reply, it must be stated that what is at stake here is the aesthetic level of film – the Kleinian approach is only a means of dealing with experiences that do not seem to be captured by signification, literal or symbolic, but are more identifiable with Barthes' 'third

meaning'. In particular, the writings of avant-garde filmmakers such as Michael Snow continually refer to an experience of film in the vocabulary of aesthetics – 'beautiful',[13] 'sensual'.[14]

That there is an aesthetic level in art seems difficult to deny if difficult to articulate. Avant-garde film practice thrives on the tension created by the aesthetic effects of a visual form embedded more often than not in theoretical strategems. Like filmmakers, critics acknowledge the aesthetic experience and are often unable similarly to rise above conventional modes of its expression. Deke Dusinberre, for example, discussing Guy Sherwin's *Short Film Series*,[15] tries to establish a domain for the film where such matters as 'visual sensuality' and 'visual richness' are in excess of purely 'theoretical considerations' and lead him to view *Short Film Series* as being of the 'most importance'. The fact that critics, like filmmakers, use such concepts as if they were transparent, signals the problem of achieving a theory of aesthetics for the avant-garde (and perhaps art in general).

The two parts of this article – the first on modernism and the second on a psychoanalytical account of aesthetics in relation to film – have not been successfully brought together. This is due partly to the tentative nature of the piece and also to the problem of understanding both the history of an art form's practice and discourse and its aesthetic effectivity. Stated more plainly, the relationship between understanding the place of Michael Snow's *Wavelength*, say, in the history of avant-garde film-making and modernism in general and our response to the film as 'beautiful' or 'visually satisfying' or whatever, is complex and still obscure. The above piece I hope will provoke some thoughts on this issue.

Finally, avant-garde film and modernism in general are active at a more precarious (hence more threatening for producer and spectator) level where representations are tenuous, obscure and always on the verge of being uncontrollable. The struggle to construct art with such resources – rejecting the facile representation or readily available technique – and to serve both the social and the aesthetic (however obliquely) in a progressive way ensures a unique project in the domain of the aesthetic and in the final moment – the political.

1　Peter Gidal, 'Theory and Definition of Structural/ Materialist Film', in *Structural Film Anthology*. London: BFI, 1976, and 'The Anti-Narrative (1978)', *Screen*, vol. 20, no. 2; Stephen Heath, 'Repetition Time: Notes around "Structural/Materialist Films"', *Wide Angle* vol. 2, no. 3; Malcolm Le Grice, 'Towards Temporal Economy', *Screen*, vol. 20, no. 3/4, and 'Problematizing the Spectator Placement in Film', *Undercut* 1; Constance Penley, 'The Avant-Garde and Its Imaginary', *Camera Obscura*, no. 2; Peter Wollen, '"Ontology" and "Materialism" in Film', *Screen*, vol. 17, no. 1; AL Rees, 'Conditions of Illusionism', *Screen*, vol. 18, no. 3.

2　Metz in 'The Imaginary Signifier', *Screen*, vol. 16, no. 2 uses the Kleinian notion of the 'good object' – a formulation which had no influence on British film theorists.

3　This alignment of modernism with the avant-garde is contentious and avoids many issues for the sake of the argument.

4　Adrian Stokes, *The Critical Writings of Adrian Stokes, Vol III*. London: Thames and Hudson, 1978, p. 180.

5　Michel Foucault, *Discipline and Punish: The Birth of the Prison*. Peregrine, 1979.

6　Designed by Bentham, the Panopticon achieved the maximum visibility of those incarcerated through a central tower within a circular organisation of cells whose windows faced on to the tower. See Foucault op cit. p. 200–28 for a fuller description.

7　In *The Tate Gallery: An Illustrated Companion to the National Collections of British and Modern Foreign Art*, London, 1979.

8　Constance Penley, 'The Avant-Garde and Its Imaginary', *Camera Obscura*, no. 2.

9　Peter Wollen, 'The Two Avant-Gardes', *Studio International*, 1975.

10　Peter Gidal, 'Theory and Definition of Structural/Materialist Film', in Peter Gidal (ed.) *Structural Film Anthology*. London: BFI, 1976, p. 6–7.

11　In *Camera Obscura*, no. 7, 1981.

12　See Michael O'Pray, 'On Adrian Stokes and Film Aesthetics', *Screen*, vol. 21, no. 4 for an outline of this Kleinian approach.

13　'Letter from Michael Snow to Peter Gidal on the film *Back and Forth*', in Peter Gidal (ed.) op cit p. 51.

14　Jonas Mekas, 'On Malcolm Le Grice', ibid p. 35.

15　Deke Dusinberre, 'See Real Images!', *Afterimage* 8/9, 1980–81.

politics, theory and the avant-garde
david rodowick

In the last ten years or so, a great deal of theoretical activity has been generated around questions involving the relationship between film and ideology, especially in a select group of European and American film journals. Although the debate crosses a number of different disciplines and perspectives, there seem to be two central questions at stake: to what extent and in what ways has commercial (that is, narrative/representational) film practice participated in the perpetuation and support of the dominant ideology in a given culture; and, conversely, to what extent and in what ways can an alternative textual practice intervene against the perpetuation and support of the dominant ideology in a given culture?

Not since the 1920s, in Weimar Germany and Soviet Russia, has there been a time in which the inter-relationship between theoretical work, political activity, and avant-garde artistic practices been so thoroughly argued. Commenting on the 1976 Edinburgh Film Festival, one of the first such events to specifically address the possible intersections between contemporary textual theory and avant-garde film practice, Donald MacPherson writes that: 'It has become increasingly evident that filmmakers do not just produce cultural objects, and that the processes of distribution, exhibition and critical discourse constitute part of the film text. In the same way, a 'political film' does not by itself guarantee a political reading; it is always a question of the juxtaposition of accompanying discourses … neither filmmakers nor film theorists can expect to continue in complete isolation.'[1]

Out of this debate has grown a diverse group of films which I would like to call the 'political avant-garde'. The problem which I would like to address concerns the definition and theory of this avant-garde as a historically comprehensible movement. The diversity of films and filmmakers alone radically complicates this task, as Peter Wollen noted even in 1975 in his essay, 'The Two Avant-Gardes'.[2] Here Wollen outlines the points of convergence and divergence between two avant-garde traditions, both of which are committed to formal experimentation as a means toward promoting and/or analysing political change. The first tradition, characterised by the apparatus of 35mm commercial filmmaking, would include the films of Godard, Straub and Huillet, Jansco, and now directors like Marguerite Duras and Chantal Akerman would undoubtedly be added. The second tradition may be characterised by the English Co-op movement, the 'structural/materialist' film as defined by Peter Gidal, and to a certain extent by the North American structural film. In the same article, Wollen also intuits a 'third avant-garde', something of a synthesis of the two as represented in films like Jackie Raynal's Deux Fois. It is this third movement, dominated by films exploring feminist issues largely in expanded, experimental narrative formats, which has exhibited the most growth since the initial publication of Wollen's essay. It would now include not only Raynal's films, but also the work of Yvonne Rainer, Sally Potter, the Dora group, Wollen's own work with Laura Mulvey, and many others.

Ignoring for the moment the differences in approach, formal strategies, and political points of view among these three general groups, it is my contention that what unites them is a certain relationship to contemporary textual theory in which their own textual strategies are formulated and their political effectiveness adduced. The aim of these strategies is to activate a certain space of reading in which the relationship of spectator to text may be altered. In an interview in 1974, Wollen clarifies this position by distinguishing between three modes of political filmmaking – the agitational, the propagandist, and the theoretical – all of which have different purposes for different audiences: 'Agitation is for a specific conjuncture and for a specific limited audience. Propaganda is aimed at a mass and presents a general kind of political line and broad ideas, and the theoretical film is again for a limited audience and a specific conjuncture rather than an immediately political one.'[3]

Wollen continues by differentiating the theoretical film by the kind of reading it presupposes. It is to be approached with the same set of expectations that one would have before, say, a philosophical or analytical essay. Certain difficulties are to be expected and further research or theoretical work on the issues addressed is presupposed.

Therefore, given that the films of Gidal, Rainer, or post-1968 Godard constitute a field which is more comprehensible in its discontinuities than its regularities, especially where the material conditions of production and distribution, aesthetic aims, and political objectives are concerned, it is still possible to constitute quite a large number of films as the complex unity which I would like to call the political avant-garde. Thus, it is their incompatibilities, the contradictions they throw up one against the other, which renders comprehensible the aesthetic ideology which unifies them. In this manner, most of the films present themselves as having an especially close relationship to theoretical work, both in terms of the conceptualisation and execution of their aesthetic project; they understand their political project as a specific kind of work on signification and/or work on the material apparatus of signification in the cinema; and all understand themselves to be constituted in contradistinction to dominant cinematic practices.

It would seem, then, that what Wollen calls the 'theoretical' level of political filmmaking is the special concern of the political avant-garde. With this in mind, I would like to outline a few ideas which may clarify the special relationship of the political avant-garde to theoretical work.

The first of these concerns is the conceptual field

which seems to unify the political avant-garde. This is defined as the particular discursive formation in which the various elements and practices necessary for conceptualising this movement are given their structure and theoretical coherence. It is only necessary to look through recent issues of journals such as *Cahiers du cinéma*, *Cinethique*, *Screen*, *Afterimage*, *Camera Obscura et al.* in order to understand the frequency with which a given set of concepts, assumptions, and problems crucial to the formulation of the political avant-garde have been articulated.

Sylvia Harvey's excellent *May 1968 and Film Culture*[4] gives the most concise account of these elements, but in short, we can look to the *Tel Quel* group for a theory of the modernist text, to post-structural semiotics for a theory of language and representation, to Lacanian psychoanalysis for a theory of the subject, and to Althusserian Marxism for political theory. More recently, feminist theory has played a significant role in altering the shape of this conceptual set. I should also emphasise how Soviet revolutionary film culture and the writings of Bertolt Brecht have structured this conceptual field by setting historical precedents for the issues involved. Both are important for their initial formulation of problems concerning the relationships between political and aesthetic practice, their critiques of illusionism in representation, and their emphasis on formal innovation.

Finally, it should be emphasised that the conceptual field only conditions the possibility of certain kinds of formal strategies and theoretical assumptions. Each film negotiates its own relationship to the shifting status of theoretical concepts within the field and articulates its own aesthetic solutions to the problems which it confronts there. The unity which defines it is a horizon line which houses an archive of material discourses and assumptions beyond which the theoretical film has not yet begun to think itself, lacking for the moment the apparatus in which to state its next move.

A second characteristic of the political avant-garde is a phenomenon of *intertextual referencing*, by which I mean to indicate a set of formal strategies whose purpose is to complicate and break down conventions of reading which cause us to differentiate between the project of a 'theory' film and that of theoretical work properly speaking. These strategies often take the form of citations of all types (visual, written, oral, etc.) or dense montages of diverse textual material. They are all aimed, moreover, at challenging the attitudes with which we confront films in order to shift our mode of consumption from one of pure entertainment, or of the meditative consumption of the art gallery, to one which is more analytical. This is to be accomplished first of all by emphasising the complex materiality of cinematic signification: its intermixing of diverse specific and non-specific cinematic codes. In a second move, the text's situation in a complex field of discourse, its *inter*-textuality in Kristeva's sense of the term, is underscored. The illusion of the physical unity and integrity of the text is broken down in order to demonstrate that beyond its autonomous borders, it is structured in a system of reference with other discursive forms. This restores to the film a sense of its status as *écriture*, that is, as a kind of writing. However, even if a film insists on its material integrity, as would Gidal's structural/materialist practice, the strategy of citation (or better yet with respect to Gidal, the bracketting off of the film within a theoretical field of one's own devising) can be understood as the valorisation of a set of assumptions in which the film is to be automatically read and interpreted, judged and defended. Intertextual referencing thus serves a sort of bibliographical or footnoting function which establishes a context for reading the film.

The formal strategies I have just described lead us to a third characteristic of the political avant-garde: its reconsideration of the place of the subject-spectator. Writing on Peter Gidal's work in *Afterimage*, Anne Cottringer notes that 'perhaps the most radical aspiration of the avant-garde is the possibility that it offers of a different articulation of the subject, plucking she/he from their traditional unproblematic role.'[6] I have already explained how the 'theoretical' film attempts to shift the positions, and the points of view, from which it is read. However, the political avant-garde, in its more radical moments, seems to claim something more than a change of the spectator's reading attitudes. In this manner, Wollen will speak of Kristeva's work as the development of 'a semiotic based on the material character of the signifier and the practice of writing as a subversion of conventional codes, especially those of representation, and a "de-structuration" of the conscious subject in favour of a subject fissured and split by arti-culation with the order of the unconscious and his or her own body.' Wollen is also correct, I think, in pointing out the rather arcane nature of such a hypothesis. Nevertheless, the idea remains popular within the writings on the political avant-garde that work on conventional (that is, bourgeois) codes of representation can initiate a transformation of the category of the subject. The possibility of this transformation is the most radical

claim advanced by the political avant-garde in the arena of political praxis, and the manner and degree in which this transformation is thought to be possible is one of the most interesting ways of differentiating among the various avant-gardes. Thus, on one end of the spectrum, we have Wollen's rather modest claims concerning the theoretical level of filmmaking as requiring a thinking or learning subject rather than a purely spectating one, and on the other, Gidal's claims that the materialist film transforms the spectator's cognitive relation with the image by enforcing his or her ceaseless reflection on the material processes of the signifying apparatus.[7]

My last hypothesis demonstrates how the political avant-garde has come to define itself as the 'anti-narrative'. It may serve to summarise the tentative observations which have preceded it in that it tries to pinpoint the functional relationship which has united the development of the political avant-garde with the history of contemporary film theory. The paradox of this relationship is that, in actuality, attempts to define a specific theory of the avant-garde film as a feasible challenge to dominant ideologies and representations have been sporadic, incomplete and inconsistent at best. What we do have in terms of theory is a kind of patchwork quilt held in place as a negative unity with respect to a given norm: the classic, realist, narrative text.

Perhaps I am exploiting the obvious, but I feel it is necessary to explore the dangers hidden in a conceptualisation of a possible avant-garde as the negative reflection of a dominant cinema. This returns us once again to the problem of the conceptual field which has been dominated historically by theories of narrative in the recent discussions which have tried to incorporate theories of ideology within theories of cinematic signification. Intentionally or not, the consistency of this work has tended to obfuscate the fact that our present understanding of the narrative text is not a substantive norm but a theoretical construct. Work on film theory has thus generated a series of assumptions about formal mechanisms thought to function ideologically in the narrative text – mechanisms of identification, voyeurism, scopic pleasure, realism, etc – and in dialectical response, a haphazard, unofficial aesthetic is formulated in which the avant-garde is defined as the interrogation or deconstruction of these mechanisms. In this manner, we have been given conceptualisations of the avant-garde such as the 'anti-narrative' of Peter Gidal[8] or Wollen's analysis of the work of the Dziga Vertov Group as a 'counter cinema' negat-

ing narrative transitivity with intransitivity, identification with estrangement, pleasure with unpleasure, and so on.[9] With this in mind, it is also necessary to understand that narrative theory has not only radically conditioned our most consistent theories of the avant-garde (such as they are) thus motivating and authorising a certain kind of film practice, it has also generated an implicit set of assumptions concerning how these films should be read and evaluated. Therefore, the success or failure of this particular avant-garde or that rests on the theoretical model with which it has been antithetically defined; and indeed, the range of formal experimentation which characterises the political avant-garde may even be examined and understood as the desire to test this model while attempting to counteract the political effects it is thought to produce.

In summary, what I have been searching for is not only a way of historically defining some recent trends of the avant-garde; I have also been trying to account for the relative poverty of theories concerning the avant-garde. It is easy to understand that in many ways narrative theory has functioned almost as a kind of 'conceptual' ideology which has conditioned, limited, and even restricted our understanding of what the avant-garde could be, both aesthetically and politically. This is not to propose the radical utopia of an avant-garde which transcends or resists theoretical work, and in fact, I feel a great deal has been accomplished on both the practical and theoretical fronts in the past few years. I have only tried to sketch out a few ideas which may clarify our understanding of the 'political avant-garde', and which may hopefully help us to advance conceptually in areas where we have previously stopped short.

1 'Edinburgh Film Festival 1976', Screen, vol. 17, no. 4 (Winter 1976/ 77), p. 111.

2 Edinburgh Magazine no. 1 (1976), pp. 77–86. First published in Studio International (November/December 1975).

3 'Penthesilea, Queen of the Amazons. Laura Mulvey and Peter Wollen Interviewed by Claire Johnston and Paul Willemen', Screen, vol. 15, no. 3 (Autumn 1974), p. 131.

4 London: British Film Institute, 1978.

5 No. 6 (1976), p. 94.

6 '"Ontology" and "Materialism" in Film', Screen, vol. 17, no. 1 (Spring 1976), p. 13.

7 Compare, for example, Wollen's interview with Johnston and Willemen and his article '"Ontology" and "Materialism" in Film' (op. cit.) with Gidal's 'Theory and Definition of the Structural/ Materialist Film', in Structural Film Anthology (London: BR, 1976). See also AL Rees' 'Conditions of Illusionism', Screen, vol. 20, no. 2 (Summer 1979), pp. 73–93.

9 'Counter Cinema: Vent d'est', Afterimage, no. 4, pp. 6–18.

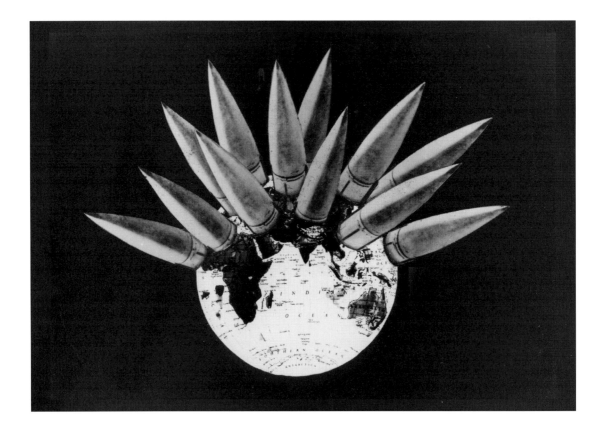

The threat of nuclear war is growing every day. It is vital that communicators in all media find ways to present the argument against nuclear weapons. In this country, Parliament has attempted to keep rational debate to a minimum and the media have, to a large extent, concurred. The debate has been largely instigated by the hundreds of small anti-nuclear groups that have sprung up all over the country and by the Campaign for Nuclear Disarmament and its European counterparts. It is within this debate that I have been producing photomontages. The photomontages have been constructed to be used in a variety of contexts and to be available as a resource, an imagebank, for the anti-nuclear movement.

The nuclear industry has not revealed its destructive potential to the documentary camera since we saw photographs of the victims of the bombing of Hiroshima and Nagasaki. The photographs we see today in the press illustrating an article about Britain's 'defence' system are now likely to be of Trident missiles looking like innocuous space rockets or Cruise missiles looking like friendly little aircraft. These would probably be placed next to a picture of the Defence Minister whose bland face would not reveal that another part of the social services was being destroyed in this country to pay for a weapons system which was aimed at destroying the people of another country. I am constructing montages in an attempt to turn these disparate elements into a visual language of communication.

– Peter Kennard

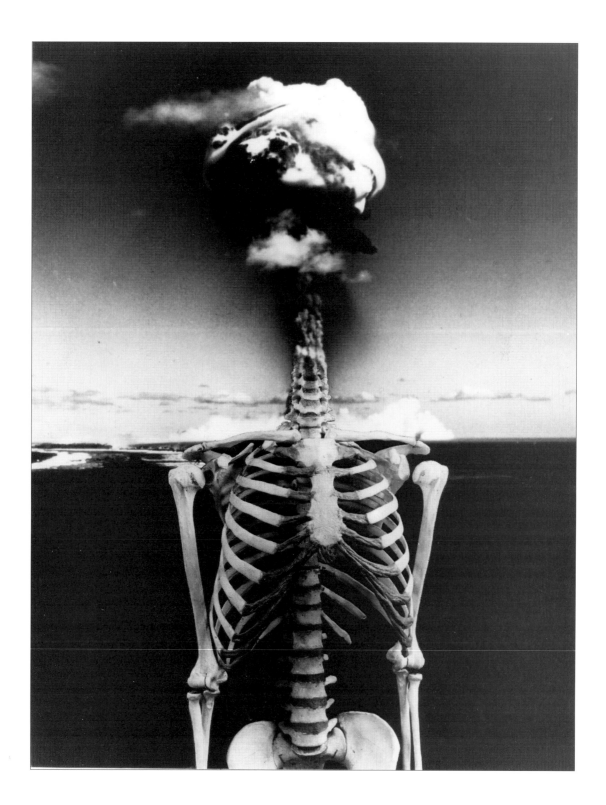

the london film-makers' co-op: the politics of license?
peter milner

The following attempt to discuss the cultural politics and history of the London Film-makers' Co-op originated partly out of the need to convince hard-pressed funding bodies to continue their funding. It is equally for internal use also, the need being in an organisation even as pluralistic as the LFMC for a policy agreement upon which to construct the future. Indeed absence of an explicit policy statement has perhaps more serious consequences for those who are naturally left to form private interpretations of *raisons d'etre*. Last year this culminated in notorious antagonisms, ballot-rigging and other unconstitutional practices on the part of a group who saw such expedients as essential for the acquisition of a 'politics' – conflating, of course, the words 'politics' and 'policy'. Arbitrarily importing a very particular politics into an organisation, as if it were a vogue commodity purchased for the sake of political credibility, falsifies the 'politics' thereby obtained. Even at the level of the microcosm which the LFMC is, historical development is a reality which cannot be ignored.

At best the words which follow can only be tentative. It is also perhaps something of an anathema to enclose what for Nietzsche was a 'rotting corpse' within the genteel clichés and liberal optimism with which one approaches English funding bodies.

Although it is true to say that the London Film-Makers' Co-op has come to mean different things to different people, according to the nature and the level of their engagement with it, its objectives and direction are determined by a pivotal notion of 'experimental cinema', which, in spite of the divergence of practices encompassed, holds a surprisingly broad consensus. This, it should be stressed, is rather removed from the narrow, hermetic and one-dimensional practice that is often attributed to it. For one thing the word 'practice' involves more than just the practice of filmmaking and covers equally that of cinema and distribution which are housed under the same roof. This can incorporate the programming of work, such as mainstream film or TV, which though not avowedly experimental in itself, provides an appropriate context for work which is, or permits 'experimental readings' of mainstream material.

This definition is by no means too diffuse, and for the reasons which follow is, in relation to the current state of independent film and video, almost unique and potentially polemical. What confusion does exist over the term 'experimental' may be attributable to its vulgar scientific connotations. Certainly within the last few decades the idea of 'art as research' has gained some prominence (the name of the Arts Lab, which preceded the Co-op, might be cited as evidence). This is perhaps less to do with scientific procedure, though, than the notion of 'progress' enshrined within modernism (and taken in a somewhat ironic and sceptical light by the Frankfurt School, for whom any such notion is tied inextricably to the technological 'progress' which informs it). Moreover the general tendency of post-war Marxism, *pace* Althusser and Macherey, has been to identify Art as a specific form of knowledge and so philosophically to consolidate this idea for those working in Art.

Within semi-commercial video, on the other hand, heavy emphasis on purely technical experimentation (chroma-key, quantel, digital, 'effects' etc) is coupled to a rationality that is both critical and scientific. But commercial in the last instance: innovation is thus subordinate to the commercial imperative as a mere proving ground and experimentation in the cultural sense is almost impossible to conceive of. It is not surprising then, that in the independent sector with its increasing assimilation of film and video, the avant-garde has tended in recent years to be dropped from the agenda in favour of political expedients. On the other hand it is perhaps the fact that the circumvention by video – leaving film as something of a backwater – has preserved for the avant-garde in film a decree of autonomy from marketing strategies.

Yet despite the utilitarian and scientific connotations of the word, 'experimental' is a description applied throughout Art to works which are either complete in themselves, idealist or Romantic (Schoenberg's music for example). In film the confusion is compounded, because for reasons which are economic and historical, film, or more properly 'cinema', has always had a quasi-autonomy. Thus one speaks of the 'film industry' as something apart from high culture. At the margins, however, it is pulled in opposing directions by discourses of knowledge (the documentary film) and by discourses of aesthetics (the 'art-house' film). The phrase 'experimental film' may well represent a negotiated armistice between

mutually antagonistic factions, but certainly within the history of the London Film-makers' Co-op at one moment, it assumed a literal interpretation: experimentation within the projection situation to uncover the essence of cinema. Thus cinema itself fell within the gaze of objective knowledge claimed by the documentarists, and yet this was within the scope of practices which were decisively aesthetic – expanded cinema. If this was quickly surpassed then it was probably on account of a failure to appreciate that any such essence of cinema is institutional rather than material. The persistence of the search led ultimately to the arena of psychological speculation, and losing all cinematic specificity in the process gave way to a conjuncture of psychoanalysis and sexual politics in the media.

Since this period, experimental film at the Co-op has incorporated into its definition much of the poetic and exotic elements of the American underground where, perhaps, there is greater institutional support for the indefinite equation between 'art' and 'film'.

Dirk Lawaert, who teaches film at the University of Leuven, introduces the subject of experimental film to his students with the phrase 'I want to show you different emotions'. In some ways this perhaps summarises the objectives of the avant-garde. Experimental film has the licence to – and very often does – transgress technical, formal, ethical laws and to violate taboos. It has the capacity to be 'emancipatory' not merely in the sense of the phrase 'sexual emancipation' used either in the context of the culture of the 1960s or more recently of feminism and gay politics, but also potentially in a sense which is much wider then the political didacticism that is becoming a norm in the independent sector. For such a film culture to exist it goes without saying that it has to operate outside of the technological orthodoxy of mainstream cinema and television. Also it has to, so to speak, obtain absolution from the constricting conditions of profitability that apply in those cases. For the same reason experimental film has of necessity to remain somewhat indifferent to the appeals for populism that emanate from elements of the cultural left even though many of its advocates share similar objectives in the purely political sphere. The size of audiences is a factor subordinate to the exploration of aesthetic or ideological 'effect'; yielding to the former through compromises in the name of communicability would diminish the possibilities for the latter. (This does not, however, preclude initiatives to make avant-garde film more accessible.) It is seen as perhaps

inevitable that this work will always remain a little obscure, its contribution to culture being less a matter of statistics and mass persuasion than 'ideological' work at an almost 'abstract' level within a more or less autonomous sphere. In this respect the 'experimental' is often perceived by critics and theorists as political for the very reason that only through such a practice are conventional ideological 'values' thrown into confusion. The theory is that through such (reflexive) practices the social discourse will be forced to reveal itself for what it is. This may seem like a thin and rather improbable justification. But it should be added that the political and cultural importance of the experimental sphere arises from the very fact that such work is under no obligation to make such proclamations or to attempt to justify itself in these terms. The very nature of the practices are such that the notions of artistic consciousness and of poetic imagination retain a critical power in themselves and are beyond the scope of the polemic against 'auteur theory' in the art-house cinema of the 1960s.

To a certain extent the meaning of the existence of the London Film-makers' Co-op is that experimental film practice cannot exist without radically altered conditions of exhibition, distribution and production. There are two things to say about the production methods of experimental film which distinguish it from the dominant sector. First they are traditionally, though not necessarily and now less frequently, spontaneous or improvised. That is to say there is the minimum of planning, techniques are improvised sometimes out of choice rather than necessity, so that the filmmaker has a number of degrees of freedom. Secondly the filmmaker has control over most of the processes and within the Co-op has the option of handling the work entirely alone if s/he chooses. Outside the LFMC this practice is described (usually contemptuously with stress on the final two syllables!) as 'artisanal' with the meaning of the 'artist' working directly through all the stages of the material process of the work. This has a negative and a positive aspect. At one level it is a vestige of the practice of art schools and of the belief that the filmmaker must intercede at all stages in order that the principle of 'the artist' remains immanent. The other aspect is that the considerable amount of equipment and resources acquired offer a unique autonomy which also constitutes a form of technological emancipation. Conventionally, a particular process or machine is merely a link in a chain whose function is both to perform and to

conceal the effect of its function in the final result; the desired effect is determined at a very early stage, the rest follows mechanically. When it is no longer required that the machinery is 'transparent' in this way then its functioning (and malfunctioning) becomes a fruitful resource of possiblities. The film-maker no longer is the apodeictic source of ideas which are mechanically translated into film, but rather these arise out of an intuitive interaction between the machine process and the artistic mentality.

Within the London Film-makers' Co-op it is possible to delineate two parallel traditions of experimental filmmaking. The first is the spontaneous improvised low-budget tradition already outlined. The second is one that has evolved gradually with the technical development of the workshop to a level compatible with professional 16mm film production. Here work is produced within the working methods of professional film production, but other aspects of the work are genuinely experimental. The working methods evolved using professional equipment may be quite unlike the orthodox ones. The themes or ideas of the work may be outrageous, poetic or arcane; the notion of politics which the film works with may be tentative; the way that the film addresses the audience and the notion of the audience it is addressing (which may deliberately differ from that which it is actually addresses) may also be experimental. The circumstances of production are a further possibility of experimentation, particularly if this involves minority or marginalised groups (this is not so much to resurrect Peter Wollen's thesis of the 'Two Avant-Gardes' but to point to a practical distinction within the Co-op which cuts across both categories).

Regrettably, the kind of experimental film practice supported by the LFMC is seen at present as being at the periphery of the concerns of most funding bodies for film. The first thing that should be said is that this is a contradiction. In the early 1970s the aims of the LFMC and of the emerging independent film movement were practically identical and this lead to the birth of the Independent Film-makers' Association (at a festival of avant-garde film in Bristol). What distinguished this movement from an expedient assembly of entrepreneurs (or for that matter from the 'Free Cinema' of a preceding generation) was a commitment to both a particular politics and aesthetics. The belief, however naive, was that there was a revolutionary film language to accompany revolutionary politics. With the professionalisation of many of the workshops concerned, many groups began to concentrate on more didactic

or campaigning work leading to fragmentation of the original consensus, though in many of the films concerned one can see 'touches' which appear as token gestures to placate the demand for 'formal innovation'. Yet in spite of the divergence of the positions there was a prevailing respect among groups for each others' work. Since then, however, the notion of what independent film practice is has become very standardised and bears more of a resemblance to a consensus on socialist/feminist filmmaking. To an extent, the uncritical enthusiasm with which agreements with the Association of Cinematograph Theatre and Allied Technicians were accepted may be to blame. Many other factors have entered into the situation, such as aggressive competition for Channel 4 funding. One by one the bodies which traditionally funded independent and experimental film accordingly adopted ACTT codes of practice as a condition of their funding. Fewer projects have been funded, but with vastly increased budgets. The London Film-makers' Co-op might be said to have remained true to the original faith, but the consequence is that the kind of film practice that it supports has been marginalised and even stigmatized as 'reactionary'.[1] This is not to suggest that it has not moved with the times, for the kind of filmmaking it supports has changed considerably since 1966. The 'independent sector' on the other hand has in many ways compromised its own autonomy and has lost much of the original specificity that defined it. Because of the carve-up of funds that has largely excluded experimental practices there is a possibility that the most valuable form of independent film could disappear.

1 The group of women who withdrew from the LFMC in frustration (following a failed attempt to install 'radical' candidates) used the following argument:
• The Co-op is governed by a notion of avant-garde film.
• So far it has failed to define itself in respect of this practice so we are in the dark as to what this policy or practice may be.
• Since this group has decided to withdraw in disgust, apparently taking with it the concerns of black filmmakers, they can only presume that 'avant-garde film' is reactionary.
 As a syllogism this does not work. But what is more false about it is the expectation that the avant-garde should (re)define itself in the political arena (and that to do so would be in keeping with the times). Had they really grasped the meaning of the world 'politics' in the totality they would have realised that it is 'political' in itself to preserve autonomous art, particularly at a time when institutions, such as the Royal College of Art, no longer respect autonomy. Indignation at the non-alignment of aesthetic practices is futile and contradictory. It also belies a failure to perceive that the 'political content' of any particular culture lies more with the way that it is read and appropriated and with the critical practices which are attendant upon it.

towards a specific practice
michael mazière

Any reviewing of avant-garde film practice is embedded in a search for an appropriate language with which to articulate the many positions and concerns at work.

At a time when a reassessment (in experimental filmmaking) is in progress, categories are being questioned in order to explore the theoretical points which informed them. When political strategies fail to address and attack an increasingly right-wing government it might be argued that artistic shock tactics are effective, although in the long term those tremors are easily co-opted and reduced to the individual excentricism they often span from. Furthermore, the moves towards 'new forms of pleasure' linked by a return to representation and narrative through as yet undefined 'postmodernist' practices have defused many of the political assumptions of the avant-garde. Those who never really considered the political validity of the structural/materialist project in its mostly anti-narrative and anti-imaginary applications can now leave the 'political' work to the revived sector of British social realism and stylistics located in the 'independent cinema' and Channel 4. Entrepreneurial interventionism has become the strategy of such work which produces decorative formalism nostalgic for its origins in social realism. The place for experimental film is then uncertain, as any clarity in intention, form and process is masked by, on the one hand, dogmatic theories which see modernism and self-reflexiveness as a negation of textual organisation and so ultimately producing meaninglessness or on the other by an open pluralism which sees film in terms of transgression and style.

The desire for a heuristic base for experimental film practice to consolidate the ongoing epistemological engagement with film as film stemmed from a reaction to the unspecified use of literature and fiction as the determining cultural referents of film. As narrative film is constructed as cinema it places itself in the field of an industry. The resultant hegemony monopolises not only the means of production/distribution/exhibition but also its scope as a separate autonomous practice such as painting, sculpture, music, poetry.[1] It is in the tense relationship with modernism – specifically through abstract painting – that

experimental film has gained autonomy as art.[2] By reading experimental film in relation to cubism, surrealism or process-oriented action-painting film gained a status at the cost of a certain specificity of its medium. The multitude of elements and signs which constitute a filmwork cannot be reduced to a surface, a one-dimensional formalism, but have to be seen in relation to a multiple, fragmented framework. Unfortunately experimental film often remains largely dependent on more established fine art practices, unsure of its context and affected by the same anxieties concerning the future of the formalist project as voiced in other arts.

One attempt to consolidate this move towards an autonomy from both cinema (whether commercial or art-house) and fine art was the structural/materialist project. It articulated and posed a set of problematics in order to contextualise avant-garde filmmaking in relation to specific political practices; the need was felt to pose a different theoretical basis to a particular film practice. The special emphasis on process, procedures and materials at work in film was intrinsic not only to an understanding of film as film but also of the subject's construction in that equation.

With the concerns for the viewer mainly derived from Lacanian and Althusserian definitions of the subject and ideology, a wave of theoretical meanderings (mostly from *Screen* in the 1970s) gave an emphasis on the viewer's construction of the film. This left the filmmaker *carte blanche* to forgo visual concerns and delve into deconstructing, subverting and manipulating narrative codes. The contribution of psychoanalysis and semiology are questionable in so far as experimental film (practice) was attempting to define itself outside, (although in relation to) the dominant structures of identification and narrativisation.[3]

With the recent surfacing of concerns around desire and new forms of pleasure,[4] imported yet again from French theoretical concerns (although by now well represented in Britain), politics have focused on the decentralization of the phallic order of pleasure. Undoubtedly any work which engages in problems of sexuality must deal with representation as an order if it is not to present a vacuous 'liberation'. At this point avant-garde film

is placed in the ambiguous position of having an ill-defined and fluctuating relationship with language, art and politics.

The crisis of modernism, faced with its own blank canvas and the tendentious involvement with desire and the imaginary, has led to a regressive mode present in much of contemporary art practice. Experimental/avant-garde film has not been without this return to overdetermining imagery and icons, as regressive symbols follow each other endlessly. In a recent article, 'Life in the Trenches', Michael O'Pray gave an overview of contemporary experimental film.[5] The article on the one hand pronounces 'the collapse of the structural movement' and on the other sees the 'New Romantics' as 'the first cohesive and genuine movement in British avant-garde since the structural one'. Relegating the issues brought up by the structural/materialist position to a 'historical moment' is, in effect, inhibiting many connections, cross references and possible interactions.

How the avant-garde has been constituted to include, at the same instant, vast contradictions in political intent yet ironically similarities in aesthetics and techniques is a point worth following up. Not to see films in terms of 'movements' can lead to a more pertinent appraisal of the various directions now being taken up. The techniques used in much of what is termed 'New Romantic', such as refilming, repetition, variable speeds and superimposition are not only products of that 'movement' but are also reminiscent of the extensive use of manipulatory devices used in co-op filmmaking in the 1960s and 1970s. The use of twin screen, triple screen and complex installation also emphasises those links. The determining connection here, if only by default, is the continual refusal of any form of realism, although as a lot of this work reveals, shock and excess does not achieve cultural or political significance *per se*. Techniques and procedures have to be used in the context of formal processes with distanciation as a necessary factor or the results can be pure effect and similar to its indiscriminate use in pop videos.

In this context what is needed to establish a valuable position for experimental film practice is a recognition of its specificity, not only in relation to its aesthetic exploratory task or its political aspiration but also to its reflexive analytical and philosophical dimension. Alain Alcide Sudre argues for an experimental practice devoid of the connotations carried by the term avant-garde (such as the transgression of political and moral interdictions) and presents the search for a theoretical framework as such: 'In film as for any other artistic or scientific practice there is no fundamental level of description from which we could describe or analyse it as a whole. Theoretically we have to refer to a pluralistic conceptual framework, and the function of an epistemological reflection is to differentiate these approaches, to define their area of validity, while envisaging the multiple connections between different levels of analysis.'[6] Areas of practice and enquiry are variable so that connections can be made at different levels, although the continual re-evaluation of form and the concern for process and procedure are a constant interest. What needs to be broken down are the constricting dualities which limit the reading and interpreting of experimental film. For example formalist/non-formalist, materialist/illusionist dichotomies do not necessarily move towards deciphering the conditions of filmic elements in a given film. Distinctions have to be made within the problematic diegesis produced consistently in experimental film, through material transformation but also mimesis, 'traces' and operations on content. Theoretically the quest is still for a language which can describe, define, propose and question the issues at work without being purely derivative of other practices, a space where new terms are engendered through, by and with a film practice confident of its specific independence.

1 This linking with fine art is extensively present in Paul Sharit's article 'Words per Page' which traces a historical and contemporary relationship between film, painting, dance and music.

2 The recent package of films 'Cubism and the Cinema' selected by AL Rees and David Curtis, is a good example of that move.

3 An interesting and more topical direction was followed by Michael O'Pray in finding links between psychoanalysis and avant-garde film, mainly in their relation to Klein's notion of part-object and primitive unconscious phantasy. These are to be found in 'Modernism, phantasy and the avant-garde film', *Undercut*, no. 3/4, and 'Movies, Mania and Masculinity', *Screen*, vol. 23, no. 5.

4 In that context *Fragment of a Lover's Discourse* by Roland Barthes was an original text but also *Le Nourveau Desordre Amoureux* by P. Bruckner and A. Fin Kergraut. More recently Julia Kristeva's *Histoires D'Amour* and Godard's *Passion*.

5 'Live in the Trenches', Michael O'Pray, *Undercut*, no. 10/11.

6 'Getting Away From Avant-Garde Film', *Undercut*, no. 5.

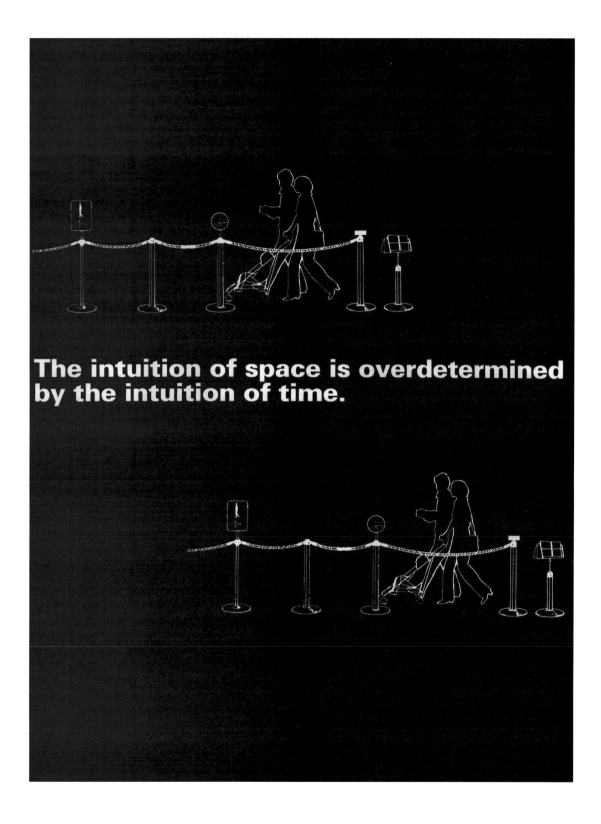

The intuition of space is overdetermined by the intuition of time.

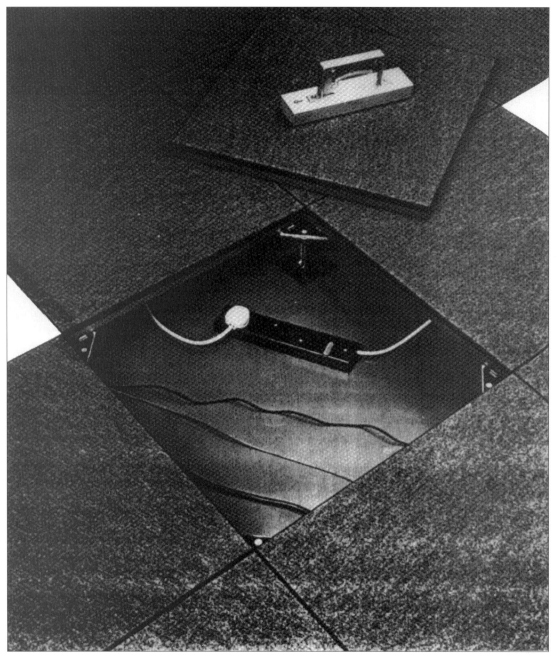

untitled

cerith wyn evans

on representation and sexual division: an interview with christine delphy
lisa cartwright

introduction

Christine Delphy is a French sociologist and radical feminist theorist. In her 1969 essay 'The Main Enemy'[1] (and in her later articles 'For a Materialist Feminism'[2] and 'A Materialist Feminism is Possible'[3]), Delphy puts forth materialism as the methodology feminists must use and develop autonomously from Marxist materialism in order to effect a total break from the dichotomous gender categories which comprise 'humankind'. Central to Delphy's theory is the point that one must be either a man or a woman in order to *be*; humankind is fundamentally, irreducibly dual. According to Delphy, this simple fact is maintained, extended and perpetuated in order to maintain, extend and perpetuate the dominance of men as a social force within that dichotomy. Feminist revolution would be the elimination of gender categories as a meaningful/useful construction. This would completely overturn 'being' itself, since one's sex is central to one's being.

This interest in eradicating sexual division rather than in making conditions between the existing sex categories more equitable, is what distinguishes Delphy's *radical* feminism from cultural and various other feminisms.[4] Though Delphy's use of materialism owes much to Marxist materialism, her work differs from that of socialist or *marxist* feminists in that she sees the primary struggle as being that struggle against patriarchy and not the (related but distinct) struggle against capitalism.[5]

Delphy perceives gender as a system of signs (linguistic and visual) which create meaning while categorising according to a system of differences. She emphasises that images of sexual difference are constructed *prior to* the process of filming and that they are brought into play when constructing or when 'reading' film images.

Crucial to her argument are the notions of *dichotomy* and *continuum*. Dichotomy refers to the categories of sexual division which operate according to a system of opposites (he/she, man/woman) and are therefore *absolute*; one necessarily occupies one or the other and so one's identity is positioned within the social order.

The visual *signs* of gender, however, work on a continuum and are therefore negotiable on an individual level. These terms (physique, length of hair, dress, etc) describe in a relative way; one may fit in or deviate from a 'standard' or 'norm' dictated by one's gender category. Each of these terms are contributing to one's positioning according to one or other gender category through the way they are made sense of through language.

If film works to give objects meaning, how is sexual division established through the construction of meaning in film? How can our understanding of these processes lead into the construction of different film practices that visually activate against the reproduction and enforcement of sexual division?

1 Most recent printing in the anthology *Close to Home: A Materialist Analysis of Women's Oppression*, Hutchinson, London, 1984.
2 Reprinted in English in *Feminist Issues*, Winter 1981 (a quarterly feminist journal).
3 *Feminist Review*, London (a quarterly feminist journal).
4 For definition/background on radical feminism, see 'RFOC Reasserts its Reasons', *off our backs*, Aug/Sept 1984. (Washington DC-based monthly feminist newspaper).
5 For an excellent critique of socialist/marxist feminism, see 'A Materialist Feminism Possible' (see footnote 3, below).

Lisa Cartwright: Radical feminist analyses of representation seem to have come to a stopping point. It seems that the more we talk about images the more we realise that you cannot undermine the power of images with words. How can we make images which work against sexual division and the oppression of women without falling into the trap of repeating the sexism we are trying to undermine?

Christine Delphy: When people, when women, want to undermine a representation we must first repeat that representation. The question is, what gets more weight in the end – the repetition, the representation or the act of undermining? You want to go beyond the category or perception but at the same time you have to use these categories; they are the only ones that exist. Any view of the world necessarily goes through language and is therefore a representation.

Take Kate Millet's analysis of sexual oppression.[1] It is not about so-called 'real' sexual oppression but about how it is described or prescribed in literature. She has to explain it and describe it, thereby repeating the sexist plots and characters. Say we want to look at 'what actually happens' rather than cultural reproductions through representations. That same problem of categories crops up. For example, *housework*: I keep saying 'housework is *not* housework' but

in order to say this I have to use the term housework – and not only once, I have to use it twice. We must use these same categories because *they are the only ones we have*, they are the concepts at our disposal in the culture and people must be able to understand to what empirical reality concepts apply.

These concepts only serve a purpose in our analysis because of our need to criticise them, but politically and ideologically they are wrong. A critique may create new concepts, possibly, the second time around but in order for the critique to be effective you must specify exactly what the critique applies to. There is always this important double and contradictory movement back and forth. Things are not as they appear.

LC: In terms of images, when one makes a film about women one usually makes images of women. So that every representation immediately establishes a sexual identity. The most basic and neutral act of producing an image is asserting sexual identity, thereby reproducing what a 'woman' is and what a 'man' is.

CD: This problem is not even specific to feminism, though it is a contradiction, for instance, when we use the word 'women' and we do not agree with the category 'women'. In the first editorial statement in *Questions feministes*,[2] excerpts from which are printed in *New French Feminisms*,[3] we say that we are aiming for a world without sexual division.

LC: Yes but a Marxist approach takes sexual division as a given and proceeds from there.

CD: But you'll find that Marx was using words that were loaded, that were against this analysis. It took him pages and pages to say that capital was not what it looked like, that work was not what it looked like and he still had to use language – words are the only descriptive tools we have. *But these descriptive tools are not descriptive tools*. They are not neutral. They incorporate implicitly a view of the world which is always in contradiction, because you are criticising the very words you are using.

LC: When you deal with language and set up a critique of language through language that is one thing. It is not the same thing to take *images* and describe or criticize them in *words*. How we represent ourselves through images is different from how we represent ourselves through talk.

CD: Yes, with language you use ready-made categories. You cannot call a woman anything but a woman. It is true that it is different with images but at the same time there are things in common. For example, if you want to show a non-stereotypi-cal image of 'woman' you must show a person and show that that person is normally labelled 'woman'. Language predetermines what is in people's minds. Even non-linguistic perceptions are informed by language, by categories. Languages are not just words, they are categories of perception.

Let us say you wanted to make a critique and you show a human being who is perceptibly neither male nor female. Then '*it*' would be a nonperson. There is no in between, no third category; there is no gender category of simply 'human being'. You cannot show a person without showing *his* or *her* race or class. It would seem very abstract, though people *would* understand that you want to convey some commonality of conditions that is underlying or beyond the actual concrete situation but you could not do that with gender. That is the problem, there is no identity without gender, there are no persons who are not *men* or *women* and it is impossible to get rid of that! It is so basic that, without that, you cannot even name yourself, nor, therefore, see yourself, nor, therefore, be anything – be *anyone*!

So, in reality, the concept of 'humankind' is *not* a cognitive tool. You do not perceive a human being, you perceive a *gendered* human being. And that shows exactly the limitations of our knowledge, and of our critique of knowledge.

LC: If we are beginning to come to terms with this through words how do we begin to come to terms with it in images?

CD: I am not even sure it can be undermined with words at this point! This may be why one of the main critiques[4] of radical feminism is that we 'want to become men'. If one wants to stop being a woman one does not necessarily want to become a man! *But* is it conceivable to be *neither*? There is no way of perceiving a human being who is neither male nor female.

That is not to say that only men have human being status. It is true that they have fuller human being status and we are not at that level. Women *are* perceived as human beings, though as a *lower order* of human beings. What is important is not so much comparing status as understanding that this concept of humankind is *not* working at a cognitive level.

LC: How can film be used to show how the concept of humankind does not even exist without the idea of sexual division?

CD: This would mean doing with images the same sort of intellectual questioning we are trying to do with words. I am not sure this is possible with images.

LC: But is it a valid project?

CD: There would be two problems: one, the problem of what we can do with words; two, would the process and the possibilities and the difficulties be the same with images as with words.

Words are very discrete – in the sense that they are not on a continuum. As soon as you say 'he' or 'she' you have established entities. It is dichotomous; either/or – that is what I mean by discrete. There is a contradiction in that, in language, that dichotomy has got to be there, while with perception the visual signs are gradual and many; there is a continuum. I am not just talking about cultural productions but about how people represent themselves in everyday life. In perception there is a continuum of masculine and feminine and therefore there is a possibility for ambiguity which does not exist in cognition.

LC: Do you really think there is possibility in ambiguity?

CD: In real life, yes. What is interesting is to what extent it poses problems. I remember being in Greece with a friend and seeing this person. *It* was so ambiguous it took us days to figure *it* out. It was a real problem – we could not talk about *it*!

LC: But you are talking about a purely visual experience.

CD: I am talking about reality as representation. The way things look. This chair has all the characteristics of a representation. In its very form it gives off signs, before it is filmed, as it is apprehended by my eye.

LC: Does visual phenomena have meaning in and of itself? Are you saying that that that person in Greece, say, *it* is physical being has no meaning if you can't figure *it* and it remains a visual phenomena?

CD: *It* has to be attributed to gender before it can have meaning, before *it* can be incorporated in discourse. Otherwise we could not talk about *it*. Everything has got to be nameable, describable. If something has no meaning it does not exist … it is eliminated from the picture, it is not perceived, period.

LC: It is a funny contradiction that this meaninglessness ends up by being the only area where the possibility of no sexual division can be possible. It seems like we can only look to the possibility of not that – but we cannot even think it!

CD: You cannot name an unsexed person so you cannot think of that person, you cannot think about *it*; or you *could* think about *it* as a problem, the problem being to *name* it. At the same time there is still the contradiction within the fact that the signs of gender are on a continuum whereas the categories he/she are dichotomous. For instance, when you are talking

about a man you simply say 'he' and that is absolutely undisruptive; you do not say to what extent he is or is not fully a man. Maybe he is a very effeminate man, but once you determine that a person is a man he is a man. That category is instrumental not in describing gender division itself but in understanding the world: you can say, 'He opened the door'. It is in order to say that a person opened the door that you have to be able to say 'he' or 'she'. So these categories seem to serve a purpose other than establishing sexual division. The contradiction is with the signs. They allow you to think about this person in this world, yet are not themselves dichotomous.

LC: So through language we *make* them dichotomous? As soon as you name you assign a position in a social order.

CD: Yes, but you cannot call that into question. Everything must have a position. You can question the given position but you cannot question the fact that it *has* a position. We *cannot* question the process of naming. Naming and cognition are synonymous. If we could not name we could not know, we could not *see*.

LC: So when one is seeing one is also constantly naming.

CD: Necessarily. If you cannot name you cannot see.

LC: Experimental film is about trying to understand the relationship between an object (in this case an image) and its name; how we come to know what we see. This is the only way I can see how we can begin to think about how sexual division exists in images.

CD: I just do not see how you translate this problem visually. When you say experimental film is about questioning the definition of words, questioning the division of reality into discrete entities, what are you questioning about *images*? Images are *not* concepts, so how does one go about questioning them?

LC: In *For a Materialist Feminism* you say that 'it is not only the interpretation of the object which is of concern but also the look which perceived the object and the object that it constituted right down to the most apparently "neutral" and "technical" concepts'.[5] In that sense experimental materialist film is not dealing with just the basic material of film itself but with the real relationships between that material, that image, the film as object, the object imaged on film, the look which perceives the image/object/*film* – right down to the most 'neutral' and 'technical' concepts at every level of film. Feminist experimental film is about understanding how what

this involves is establishing sexual division as the very basis for knowledge, for meaning.

CD: I see limitations in this. We do not know how to get around this basic fact of our perception being dichotomous. Gender division is so basic to cognition that we cannot see how to get around it. Certain signs, like a businessman's suit or a woman's high heels, are overriding but a person *can* overcome signs and make their outcome not immediately apparent.

LC: What are the implications of that? Any one could put across a theory of androgyny or ambiguous identity as something new but when it comes right down to it you have to understand that ambiguity or androgyny in terms of precise meanings. If I were to make myself into a person of confused signs so that it would be impossible to tell whether I am a man or a woman, there is still the fundamental fact of my being a woman. Ambiguity or plurality does not get away from gender. That is that bedrock you talk about.

CD: Right. You see, what people do in effect is *not* to question gender division, but to try to find more signs and be more analytical about it so that they can eventually classify that person. They will work until they can classify – and so do I. I have got to be able to speak of people, to say that he or she went to the beach. Otherwise I cannot even speak. At the same time that I question gender division I have to be able to classify the person, locate the person within the dichotomous category of humankind.

Ambiguity is interesting in an experimental psychology set up. This is the only way to see how the classifying process works. It can make people realize how they come to classify; that perceptions cannot be *given* in the world, that they must be worked at.

LC: So it makes you aware of how you hunt for meanings whether they seem to be there or not?

CD: Exactly. It *could* make you more aware of the discrepancy between the ideology of gender division. Yet you have to hunt for clues and in the end it is really not an either/or process at all but a process wherein the categories are not mutually exclusive, precisely because of the contradictory signs. You cannot completely dismiss signs of the other gender because right to the end you could *not* determine which gender the person is. You become aware that the outcome is a social construction, an addition of signs recognized as meaning. Therefore, there is no point at which you can take into account other signs, because they do not have any social meaning, do not exist. You become aware or *could* become aware

of what signs are relevant for classifying someone into gender categories and subsequently what signs are not relevant. And signs are made relevant or they are eliminated. Either you do not see them (in which case they do not exist) or they are incorporated. For example, short hair used to signify a man and long hair, a woman. That is no longer true. Signs are incorporated into the gender system or they lose their meanings.

The following discussion took place after screening the following films: Motion Picture (Lucy Panteli, UK, 1979); Retour d'un repère composé (Rose Lowder, France, 1982); Light Reading (Lis Rhodes, UK, 1979); Bred and Born (Joanna Davis and Mary Pat Leece, UK, 1983).

CD: According to your explanation of *Motion Picture*, Lucy Panteli was trying to deconstruct or decompose or analyse the ways in which women are objectified by the camera. She tried to get a picture of the so-called reality of the way women are filmed as part of the construction of reality. I understand the intention, but it does not come across. You do see that the filmmaker has analysed, decomposed, one frame at a time … but with no context, with no signs to tell you what this means, you are left with a notion of some possible meanings. We focus on the gesture, the woman, the lampshade.

LC: So you are saying that without the theoretical context you cannot understand what this film is for?

CD: Yes. But even with a theoretical context it does not immediately convey this meaning and this meaning only. The achievement of a work of art is to convey an unambiguous meaning (and hopefully the meaning that the artist intended!).

LC: So you view the work of art in general as something which should convey unambiguous meaning?

CD: In my view, a work of art is a success when the author has managed to convey her world view. By unambiguous I mean that she has managed to convey a very definite world view. I think this is particularly true of movies, though it is less true of novels. When a movie is all things to all people it is a failure. When people say 'you can imagine this and I can imagine that … that is what is great about this movie', I say 'So what's the point of making the film?' That is what reality is all about. You can interpret it one way and I can interpret it another. It is like a projecting test in psychology … you see an elephant, I see my mother and father copulating. What is the point? What I want is for the author to really override

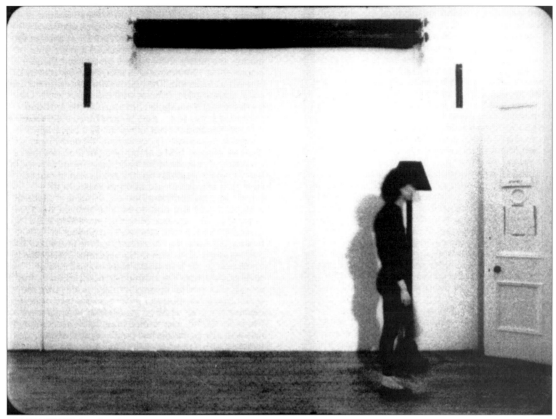

MOTION PICTURE Lucy Panteli

my world view with hers. If her production is for me to project my world view onto, I do not need her production to project my world view!

LC: I agree with you completely. So *Motion Picture* was not extreme or specific enough to put across its problem – it could have been other things too?

CD: Yes, and the same applies, generally, to the three experimental films. The intention is interesting, the results may be interesting, but it is a haphazard sort of thing. *Retour d'un repère composé* was aesthetically pleasing and left something to the imagination but her intentions, of showing that what we are seeing is not reality as it is but a series of abstracted objects, did not come across. If you had not told me what she intended I could have seen many other intentions and again, I could have projected my own ambiguous interpretations – it is such a fascinating light show.

LC: Do you think the fascination was too great to allow the distance that would be necessary to understand the film in terms of…

CD: No, not that the fascination was too great. It

could have been fascinating and still have worked according to the author's intentions.

LC: *Motion Picture* did limit its project. It certainly was not dealing with anything other than women's image on film. It certainly was not about 'women's role as mother' or 'women in the work world' viewed transparently through film! In that sense it was not ambitious! It did limit its project, working and re-working one aspect of film.

CD: The fact that it is about how women are filmed does not come through. It is too ambitious because it focuses on that without relating it to the traditional image. For a film to be didactic – which is what we want in order for it to convey its meaning – it should start from a traditional meaning, going back to it and slowly building.

LC: What would you call a traditional meaning?

CD: Well, what the film wants to say is that this is the way women are traditionally viewed … through the camera lens. But it *does not* start by saying that. It starts by filming a woman differently.

Retour d'un repère composé does not do it either. In

RETOUR D'UN REPÈRE COMPOSÉ Rose Lowder

order to show how a representation is constructed you must first show the representation as it is usually given – that is, as a mere reflection of reality. Then show, by moving one thing at a time (like focus, light, then distance), that it is constructed to look like reality. This has been done in, say, German expressionist films. They were filmed from unusual angles so that reality would look different but it was not carried this far and it was not designed for theoretical purposes. It was designed to give the viewer a sense of strangeness, of worry. The films play on an emotional level but that could be done at a cognitive level.

LC: There are crucial differences between playing on vision at an emotional level and working on what the connection is between the image and the emotion. One difference is in the relationship between stylisation and effect. Abstract expressionism assumes there is going to be a particular feeling produced by a particular image

CD: Absolutely. These techniques are precisely the techniques we want to question … precisely the techniques of social construction of the object.

Abstract expressionist films use that social construction for something else.

LC: They rely on a preconception of what emotional effect an image produces, whereas experimental films question that very connection, that very preconception.

CD: But that does not matter. Let us say we have a frame from some expressionist film. Taken out of its narrative context, what we see is that, say, a building is filmed from an angle so unusual that we cannot recognize it. In the course of the narrative movie this is of course designed to give the viewer a sense of insecurity and unreality. But we do not have to take it to that stage, we can stay at the stage of cognition. Before it produces an emotional effect, it produces an effect on cognition.

LC: Isn't it always difficult where you have a theory, especially if it is radically opposed to the situation that exists and to the technical materials of production?

CD: I am not so sure. In theoretical work people keep repeating what they intend to do. For example, they keep repeating that they want to bridge the gap between traditional class analysis and sex/class analysis. And they just do not do it. They cannot do it. And you have *got* to do it. Somehow you have got to do it. Writing theory is, in a sense, a creation – you create a theoretical world. You make it come true for the reader. If you have a strong vision you must put it into words, even if that vision is abstract. Somehow that connection *has* to be made. Theories about women have to be understandable *by* women. I know women who are working on linguistics studies which no one understands because they are so technical. At the stage they are at now, the work certainly would not seem relevant to a women's group, or any given woman. Yet what they are doing is basic, it is very important. What they are doing is relevant to how sexual dichotomy informs our world view. They are trying to go down to the basis of language construction, to how we use language. At this stage not only can it not be communicated to most of us; its importance cannot be totally grasped *yet somehow that knowledge has got to be communicated*. And it takes time to formulate the links between these less obviously feminist projects and the more clearly feminist projects. It is important to establish these links and establish them *explicitly*. This is part of the work — to be able not just to feel why the work is important but to explain clearly why it is important, how it relates.

LC: And in trying to explain clearly you come to

the same problem with men's language.

CD: It's like in *Motion Picture*. At one point the motion of the woman walking across the room is held up and reversed over and over, so that she moves back and forth. You cannot go directly beyond men's language and then stay at that 'beyond' stage creating a women's language. You have got to use the words we have and progress in those words, moving them slowly out of their meanings. This traditional meaning is always there, any world view has to be created from a world view that exists.

A critique of images in film is one problem of a material process, but you have more basic images. They are not archetypes and they are not produced by 'creative artists' but they are produced by people themselves. They are the images we deal with in the 'real' world. Before an object is reproduced on film it is already a representation, an image. These are the kinds of images we have to start analysing. And images on film cannot be analysed in the same way. To the viewer, and, quite often, to the subject (him or herself), a human being is a representation. Thirty years ago, before the second wave of the women's movement Goffman, in his book *Stigma*,[6] was talking about conveying the meaning of an identity which is not whole. He cut across traditional social categories and set apart the disabled, women, non-whites…

LC: You mean he was analysing the way people view minorities?

CD: Precisely not! He was *starting with* minority groups. He was starting with image and how image conveys the meaning of, let's say, a less-than-full identity.

LC: So he understood that a full human being is a man?

CD: Exactly. He said it outright before anyone else did. The only completely acceptable person in the USA is a white middle-aged tall American man. Going back to the movement, I think we need to be more reflexive about it – we should try and see what it can teach us. We need to analyse it.

LC: Do you see a relationship between this need for analysis within the movement and the project of experimental film, which, instead of prescribing or showing a reality – the facts of women's position – it deals with how our position comes to be prescribed, reinforced, through film in the first place?

CD: I am not sure films have to be experimental to do this.

LC: But the project which can be carried out with narrative or documentary films is different. For instance, in *Bred and Born* the problem they deal with is really clear – they even state it in the film. They are looking at women's position within patriarchy through the family. That is *one* project. But it *does not even begin to approach* the questions raised by experimental films — particularly the problem of how, right from the start, in the very act of pointing the camera, of creating an image of woman, of anyone, film is working for establishing gender division. The real project of that film was something else and it was very clear, and it did what it wanted to do in terms of its sociological project.

CD: Right, but at this stage I am not sure that experimental films are stating these questions, are carrying this out. Nor am I sure that this project must be non-narrative. I just do not know how you could work on that question with film.

LC: But I don't see how narrative films *could* deal with that problem. As soon as you have an assumed connection between images and what those images mean, you make an immediate connection between the image and a *literary* meaning, so that you are beyond the point where you have to stop in order to question how that connection is made (immediately) in the first place. This is the point from which experimental films have to work.

CD: My main interest is to start where images are created, to start in everyday life – before they are reproduced in art. To show that an image is an image, that an image of a leaf is an image and a leaf is something else. The danger is that one could think that only the light and camera are making that leaf into an image and before that, the leaf was just so much matter. It is not. A leaf is already an image. But the leaf does not exist independently of the way we view it.

LC: It has no meaning.

CD: But before it is filmed, as soon as it is perceived, it has meaning.

LC: But how do we *know* that? We talk about it, we think it in words, in image. So we come back to a medium.

CD: With experimental psychology we could see the fact that a sign has different meanings in different contexts and for different people and we would not have to pretend that there are an unlimited number of meanings; there are *not*.

LC: How do we get to the main point that as soon as there is meaning there is the establishment of gender division?

CD: The development of comprehending a phenomenon is never done through one medium. It is an understanding first, then it is expressed in differ-

ent forms. For example, gender is necessarily a system of signs because it has got to be apprehended in the social world, in what is called reality – not in what we see on the screen. Gender dichotomy informs everything in life. This dichotomous view is even more explicit in some cultures, like traditional Chinese culture. The *yin* and *yang* were sexualised as a system. Some structuralists like Levi-Strauss say that the mind works through such dichotomous categories, wherein everything is opposed to everything else. But you do not simply oppose, say, strawberries to cherries. Each one is that thing and it is a whole network of things that oppose it. The most common system of things that are in opposition to one another *and* are related to things with which they have affinities, is the gender system. In the women's movement there are conflicts about gender as a system of signs. Radical feminists criticise cultural feminists because cultural feminists associate women with characteristics that are traditional stereotypes. Of course they are not resexualizing the world – it is already sexualized; they are trying to give it another meaning. What we can learn from this is that nothing is not in this gender dichotomy. By doing this, cultural feminists are just following a tradition of giving everything a sexual meaning. We should be seeing one step beyond – or one step *before* this; but look how threatening it is, even to feminists, to think of things being neutral, to think of things not having any sexual significance.

LC: Earlier you were talking about how we have managed to do away with the content, but we are left with the bedrock, the form, of sexual division – something which we cannot get beyond or before. Don't we have to look at how the 'content' permeates the 'form' so that even that dichotomy does not hold up?

CD: You can separate the two. Take, for example, cultural feminists: they are associating femaleness with traditional values, but they are also associating femaleness with values which are not traditional – like vegetarianism, which is not in the Western tradition and is not particularly female. What can we learn from this? That women want to get together and live as women and not as slave-women. *And, still, to do this they must create a whole new lifestyle wherein everything has meaning and is related to their being female or feminine* (the two being associated very often). And they cannot, or, at least, it is very difficult for them to, leave whole areas which can be neutral or meaningless. They cannot leave ways

of doing things which are indifferent (in the sense that we can eat meat or we cannot eat meat and be feminists either way). What we learn from this is not so much about content precisely, but about the very fact of division – that *that* is central. This is a formal basis in the anthropological sense … that is, what lies within the concept of 'women' and the concept of 'men' varies according to the culture, but you always have that division. It is what you put inside the category that changes.

LC: So this form is 'in' not just the perceptions of individual women; it is in their creations. It is in their films … in the camera itself, in the object before its ever having been filmed, it's in the act of pointing the camera, it's in the film itself, it's in the filmed object … it exists at every level, this form. Understanding how this works at every level, no matter how primary or basic or technical, is what feminist experimental film is about. It is not so much that I want to talk about *film*; it is that I want to make clear that this *dealing with the form* in film or in any other field, is necessarily radical feminist work. We could be talking about any field…

CD: Right! And we would still be saying that it is informed by this basic world view.

LC: In her essay 'Reflections on Experimental Film',[7] Rose Lowder has written about activism, not in the sense of going out and marching in the street but in the sense of doing radical work within one's own field. What she thinks needs to be done most urgently right now, in film, is to deal with the very 'basic' and 'neutral' technical and not technical concepts within the field – within *any* field. Until we deal with this we cannot go *on* using film *for* anything.

CD: Yes, but, at the same time, the filmmaker cannot take the object filmed as being unproblematic. The very fact that a filmmaker or some other person can view that object means it is already a construction.

LC: But the camera is capable of making the object appear differently or of making it seem not to mean what it might otherwise mean, or to render it meaningless by removing or adding elements from the image which take away or give meaning. Like light … I could film this cup so that it appears (or does not appear) as a meaningless streak of light – 'abstractly' – or I could expose it 'properly' so that it reads as 'cup'. So there is a way we can use film to show how film works at every level to give objects meaning, i.e. to establish sexual division.

CD: Yes, more generally how meaning comes to be attached to objects which do not possess it in

LIGHT READING Lis Rhodes

and of themselves. Certainly the camera can do *that* … the still camera can also do that and it has been done. That is one of the great things about photography – it shows us how in the real world we always think we see (or can know) objects. Cognitive psychology also does this. It points up something we forget – that there are things we do see which we at the same time do not see. We chase it from our minds. As a technical object, the camera can fix these moments of incomprehension. This has been done in experimental photography as a sort of game, but it is not enough. The implications of the theory for society have not been drawn out. We have to examine how meaning is produced, how sexual division is established through meaning.

1 Kate Millet, *Sexual Politics*. Doubleday: New York, 1969.
2 'Variations sur des themes communs', Editorial Collective, *Questions Feministes*, no. 1, June 1977. (Note: For background on QF, see 'What is Feminism?', Christine Delphy interviewed by Laura Cottingham, *off our backs*, March 1984.)
3 QF Editorial Collective, 'Variations on Common Themes', trans. Elaine Marks, reprinted in Elaine Marks and Isobelle de Courtivron (eds) *New French Feminisms*. New York: University of Massachusetts Press, Schocken Books, 1981, pp. 212–30.
4 Psychoanalyse et Politique, an off-shoot of the MLF (French women's movement – Mouvement Liberation Feministe which, led by Antoinette Fouque, worked against radical feminism and the women's movement generally to reclaim the 'real' woman beneath men's construction of 'woman'). (Note: For background on Psychoanalyse et Politique, see 'french feminists' interview' by Brooke, *off our backs*, January 1980, 1.
5 'For a Materialist Feminism', Christine Delphy, *Signs*, Winter 1981, p. 70.
6 Irving Goffman, *Stigma*. New York: Prentice Hall, 1963.
7 Rose Lowder, 'Reflections on Work in Experimental Film', *Feminism/Film*, no. 1, Spring 1984, pp. 30–4.

media production in higher education: the problem of theory and practice
paul wallace

This article aims to explore two areas that are relatively new to media education: the later philosophy of Jean-Paul Sartre and the field of media production in higher education. These two areas are linked through the notion of dialectic. Sartre's later work is based on the idea of dialectical relations and seeks to provide a theoretical framework for a historical anthropology that would be equipped to deal with both the structural and historical aspects of particular cultural fields.

In *The Critique of Dialectical Reason* Sartre argues that whereas analytical reason is composed of single externally related units, the logic of dialectical reason consists of a double internal movement. The fact that this is difficult to grasp is, he argues, due to the dominance of analytical reason in our culture. We tend to think in terms of 'either-or'. This produces a state of mind in which things must be either single or double. Sartre's point is that in a dialectical relation things are both single and double,

i.e. there is a single process in which two points are internally related to each other. For example, in the relationship between objectivity and subjectivity both 'moments' or stages are part of a single indissoluble process but at the same time they are not immediately identical. Analytical reason can only think this relation in terms of two externally related points; this is why attempts to construct a dialectical point of view from within analytical reason have tried to reject the duality of subject and object. It is only because we think of singleness and doubleness as mutually exclusive that we are unable to conceive a relation in which they were conjoined. As a result, we tend to reject dialectical thinking, at least in academic circles, as a form of confusion.

Analytical reason tends to produce a model in which a 'theory' and 'practice' are seen as two externally related entities but from a dialectical point of view we then need to go on to see the internal connections between these moments. In general our

thinking in the fields of cultural and media studies has become dominated either by the view that everything is different and that there are no common underlying structures, e.g. Foucault, or by the view that a single level in society is reflected in all the other levels, as in Lukacs. Sartre's approach argues for real differences which are at the same time linked by common structures. From a Sartrian viewpoint, theory and practice are linked by the ideology or philosophy which underlines them. They have their own relatively separate forms but are connected by a common logic.

Theoretical work operates on the level of knowledge and is in contradiction, at least to some extent, with practices which take place on the level of practical aesthetic experience. I take the view that the project mounted in recent years to explain the whole of culture from the point of view of the sociology of knowledge is deeply flawed in its basic assumption that literature and art can be viewed solely in terms of knowledge. It is here that a dialectical view such as that put forward by Sartre is of value since it takes us beyond the point where we are faced with the either-or question of whether art and literature are knowledge or 'lived experience'. It also provides us with a way of surmounting the problem of whether, if art operates at a level beyond rational logic, the apparatus of dialectical logic can be of any use in coming to terms with it. Sartre shares with Hegel the view that 'rational logic', as it is usually perceived, is synonymous with analytical reason; and that what we call the irrational is in fact dialectical reason. So from a Sartrian point of view there is a logic of knowledge and lived experience and this logic is dialectical.

This argument is particularly relevant to the split that exists in the field of media education between Fine Art-based practices, e.g. sculpture, painting and studio-based work, and those determined by the sociologically-based analytical theories of cultural/media studies, e.g. history of art and complementary studies. The tendency is for arguments to polarise around, on the one hand, the drive to annexe Fine Art practice to an analytical-sociological theory and on the other, to resist this pressure by stressing the synthesising and intuitive nature of creative practice. Sartre's theory shows us how, in theory and practice we can be aware of the interpenetration of knowledge and experience; of how, in literature and art both the sayable and the unsayable can be fused in a single work.

The opposition Sartre sees between analytical and dialectical reason is also of use in our view of the two main hegemonic forces in society: capitalism and patriarchy. As Simone de Beauvoir has said, a key question for those who support socialism and feminism is whether there are any common links between these two systems.[1] In other words, although they are clearly different do they also share something in common that tends to make them mutually supportive and so form a double-block to feminist-socialist practices? I would argue that patriarchy and capitalism both operate in terms of a single rather than a double or dialectical logic. In the commodity system, single externally related units are placed above the dialectical structures of human praxis; and in patriarchy, a single sex, the male, is made the only criterion of value. So both the patriarch and the bourgeois subject (and they are often combined in the same person) impose a single identity logic on those subjected to their rule. This argument is an important one in relation to the theoretical and practical work of staff and students in art institutions. If true, it explains why single identity logic has such a powerful hold over the work produced. It also helps us to see why it is pointless to condemn in any simple way work which reproduces this logic. As Sartre points out we are all in the hegemonic field and so, in a certain sense, we cannot help but reproduce its determinations. To suppose otherwise would be to assume that we can completely remove ourselves, at will, from dominant social conditions and view them from a completely free position. Such a position is idealist since it negates the dialectic between consciousness and social being. In fact, it is the hegemonic field itself which produces this idealist distortion in our thinking. The either-or logic of analytical reason leads to a position in which we think that dominant ideology is over there and we are over here. Dialectical reason teaches us that although we may want to struggle against our conditioning there is a very real sense in which hegemonic modes reach into our attempts to change and structure our movements against dominant forces. For example, as Sartre points out in *L'Idiot de la famille*, although Flaubert was constantly railing against the bourgeoisie he did so in a way that reproduced the logic of his class. The fault lies in thinking that at the required moment we can simply break the chains of our conditioning and adopt a position which is free from the dominant ideology. Sartre argues that struggle against dominant modes is itself socially conditioned; that it is the contradictions within the social conditions of a class or group

that produces the possibility of social change: for example, the contradictory position of the intellectual vis-à-vis the universal mode of knowledge s/he practices and the pressure from the dominant class to use that knowledge in the service of a minority.[2]

As a researcher, I have adopted an approach which I call critical empathy.[3] This is an attempt to combine both a sense of the pressures that people are working under and an attempt to critically reflect on the work that I have seen. I have tried to cover both those institutions which produce avant-garde/independent work and those that relate more closely to the dominant media institutions. I have chosen to look at three of the former in this article but it would be undialectical of me not to point out that although this dichotomy between avant-garde and conventional does help us to explain some of the major differences between the two areas, there is also a sense in which it obscures the fact that struggle against dominant modes of theory and practice are also going on, albeit in a limited way, within institutions that are closely attached to the dominant media. I would point to some of the work being done by women at the National Film and Television School. Similarly, some of the work produced in the avant-garde area is deeply imbued with the ideology of dominant social forces. The institutions that I write about here were chosen because of their influence on the field of avant-garde/independent work.

st martins' film and video unit

The research I have done has concentrated on the period in which Malcolm Le Grice was in charge of the department. My experience at St Martins forcibly brought home a major point about doing any kind of anthropological research in art colleges: namely that given the largely informal nature of staff-student contact a great deal of the 'teaching' that goes on is at the level of inter-subjective relations. Of course projects are set, lectures are given etc, but for most of the time the pedagogic practices of tutors operate at the level of what might be called the individual-collective. I conjoin these terms because what seems to be crucial to an understanding of art college courses is the way in which individual personalities take on a collective significance.[4] In art colleges the subjective level takes on an extra significance since it is very often because a tutor has some degree of charisma or personal magnetism that they become institutional figures in this field.

In the course of the interview with Malcolm Le Grice he mentioned Sartre and a preference for

German philosophy but also expressed an 'intrinsic sympathy with the Empiricists'. Again, when discussing the notion of objectivity he was careful to point out that although he 'didn't understand the concept of objectivity' he was against the idea that everything is completely personal. There is a curious contradiction here between the aversion to objectivity and the stress on materiality in the kind of work Le Grice has been associated with. Surely the material is also objective and if so how can one express a lack of understanding of the latter? I think this contradiction stems from a certain subjective idealism in the work of Le Grice and other filmmakers in this field. We tend to forget that Kant's philosophy has had a profound influence on the development of thought about art and knowledge. Hegel produced a profound critique of Kant's philosophical position, his main point being that although Kant recognized the difference between perception and thought, he failed to see the dialectical connection between objectivity and subjectivity.[5] The result was a theory in which a contradiction existed between a use of empirical evidence in practice but a denial of its validity in theory. I would argue that the illusionary nature of the image content stems from a Kantian problematic. One of the results of this position is a theory of the image which fails to recognize its dialectical nature. By this I mean that images and the imagination possess a double rather than a single structure. As Sartre has pointed out in *The Psychology of Imagination*[6] the image is both a presence and an absence. To take the view that images are somehow unmaterial is to suppress the peculiar materiality of images.

Many of the students at St Martins were working against any simple theory of the image as illusion. Perhaps this testifies to the degree of openness encouraged in the department and the fact that in recent years Le Grice and others have felt a certain inadequacy in former theories of materiality and illusion.

Alongside the Fine Art tradition, which has been mainly male dominated, there is the emergent presence of feminist work. Unlike some of the other colleges that I visited, St Martins has a number of female tutors. In talking to Tina Keane and Anna Thew it became apparent that like other feminists they stressed the dialectic between the individual and the collective; and that through their work and their teaching, students were made aware of this relation. It was this sense of the interpenetration of levels that emerged very forcefully in the interview

with Tina Keane. Men tend to keep their 'private' lives very separate from their 'work'. Tina Keane immediately broke this convention by talking about the impact that the birth of her daughter Emily had on her life. She said 'I really feel that if I could mix the intellectual and the intuitive and do something very simple – then I really feel I would have achieved something'.

Similarly, in talking to Anna Thew, I got the sense that both her theoretical concerns and practical work are shaped by the notion of interpenetration; and of the struggle to create a synthesis out of conflicting forces. For example, the conflict which many of the women I talked to seemed to feel between the formal concerns of the painting and sculpture they had been surrounded by at art college and their experience of their own situation as women. The point most often being made was that an aesthetic ideology which excluded the dialectic between signifier and signified made it impossible to deal, in the work, with such issues as the representation of women. Anna Thew's 'personal' history contained elements which typified the situation of many other women in this area; namely the decision to move into film, video and performance. An example of the way that this enabled her to combine aspects that would usually be categorised as separate, is her first performance piece called *Leonardo's Notebooks* in which her own concerns with the limitations of language became mediated through an imaginary conflict within Leonardo's own linguistic and visual codes.

Looking at the work produced at St Martins over the last three or four years it is clear that a particular oppositional genre of film and video exists in which, although a great deal of 'difference' exists in the juxtaposition of images, the logic which structures this flow is single rather than double. We tend to forget that although, as in Cubism, a work may contain a multiplicity of views or fragments, if each of these pieces is structured internally according to a single logic we have only moved from a simple empiricism to a form of hyper-empiricism. This is not to say that each work cannot be extremely interesting visually. My point is that, as a general mode, it remains dominated by the hegemonic structure underlying capitalism and patriarchy. This kind of work at St Martins is then, in structural terms, very similar to the more 'objective' work one finds in colleges and film schools concentrating on documentary or realist fiction.

Of all the films I have seen, Sandra Lahire's *Arrows*[7] still seems one of the most powerful and imagina-tive. What I liked most about the film was its sense of struggle. Lahire's film also contains beautiful images; for example the metaphorical sequence based on the notion of anorexia that moves from flamingos at one end to nuclear rockets at the other; but there is also a profound dialectic between the subjected nature of the anorexic ego and the desire to reflex-ively transform the image that has been produced by this process.

Both in her films and in her writings[8] Lahire shows us that opposition, in her case, from a lesbian stand-point, requires a re-thinking of the adequacy of 'dif-ference' as a key category; and that the total rejec-tion of such notions as Truth and Wholeness in the 1970s, now act as a block on oppositional practices which wish to go beyond a repetition of the domi-nant logic in 'different' forms. This necessary shift in our consciousness comes, in part, from the very forces which oppress radical practice. When liberal toleration ruled, 'differences' allowed us to remain within the dominant structures yet also allowed us to express alternative views. Now conservative authoritarianism holds sway and it is only through oppositional practices that we can confront the oppression exercised by this system.

Isaac Julien's *Territories* (produced collectively by SANKOFA)[9] places us at the centre of the con-flict between black and white society, particularly through its depiction of the antagonistic relations between a white police force and black youth. Instead of keeping public and private experiences apart, the film seeks to show, through superimposi-tions, voiceover and contrasting sounds, the impact of social pressures on inter-subjective experience; and the attempts to contest these determinations through opposing practices, particularly in the sphere of black homosexuality.

Henrietta Payne's *Piccadilly Line* is concerned with the movement back and forth between the thoughts of a drug addict on his addiction and film of a young man confronting his parents with what he sees as the deprivation that their drug-taking has inflicted upon him. Here the dialectical struggle is entirely within the relationship between the two genera-tions, as the parents try to argue that their alterna-tive lifestyle has provided the son with a different set of values, while he argues that their preoccupation with themselves has robbed him of a loving fam-ily. The main point is that if you remain within an aesthetic which sees the recorded content of a film or video as simply an illusion you will be unable to form a dialectical view of this process. A comprehen-

sive theoretical viewpoint needs to accept and take account of the ways in which what used to be called the pro-filmic event can be just as creative as what goes on behind the camera and in the process used to produce the image.

north east london polytechnic

In theoretical terms one of the main inputs into the course came from the structural-materialist tendency with an emphasis on the 'material base' of film.

So far we have discussed dialectic in terms of interpenetrations between images of social and inter-subjective experience. This does not represent the only type of dialectical relationship to be considered and the position taken here is not restricted to a single form of work. The point is that dialectical relations consist of a movement between relatively separate moments in a whole process rather than a fixed opposition between single identities. As Sartre says, 'If the work has this dual intention, it matters little what formal structure it assumes. … The relationship between the singular and the universal can equally be captured in a hundred other ways. … None of these forms has any precedence over the others – to claim the contrary is to lapse into formalism (the universalisation of a form that can only exist as one expression of a singular universal).'[10]

The films by Peter Collis were very much in the structuralist-materialist mode consisting of multiple manipulations of found material and extra-filmic objects through a wide variety of technical processes, ranging from animation to experiments in optical printing. One of the most striking features is the intensity of some of the black and white contrast. The films were *Filmage* and *35—16—9.5—8.8mm*. The video by Louise Sheppeard, called *Interference*, contained almost no experimentation at the level of the video signifier but instead developed an experimental situation at the level of the recorded image. The video starts with a shot of a room; a TV set is in the background, armchair in foreground. A figure comes in (male), turns TV on, sits in chair. The video's production had come out of the experience of watching TV and finding it very hard to turn off. 'The video's about someone not being able to escape the seemingly passive television. In the piece this is brought out where he actually becomes physically trapped in it at the end.' Both pieces, I think, have a dialectical structure. In Sheppeard's video this occurs through the dramatisation of the experience of being objectified by television, the figure in the screen representing the internalisation of the viewer in an external object. Instead of the viewer and TV being kept at the level of analytical separation the sense of an internal dialectic is recognized, operating mainly here at the level of the TV process. In Peter Collis' case the extent to which the subject is constituted by the pre-filmed image is deliberately worked against in order to externalise the desire of the filmmaker for a range of visual pleasures.

the department of environmental media at the royal college of art

This is one of the departments that has been closed down by the new Rector at the RCA as part of a utilitarian attempt to suppress all work which does not immediately relate to the market place.

Clearly, most of the work produced there contains some kind of critique of dominant practices[11] and one of the interesting things about the department is the number of women who taught or were students there. We live in a culture where subjective values of a certain kind have for a long time been institutionalised in places like art colleges. In part we should be grateful, I suppose, that spaces exist for the expression of subjective interests, but any fully informed socialist or feminist perspective is bound to recognise that bourgeois and patriarchal ideology have played a considerable part in the formation of these institutional enclaves. Insofar as the Environmental Media Department was a part of one of the main centres in which these ideologies of art flourish, it would be surprising if no hegemonic determination was in evidence there. My own impression was that a certain amount of abstract subjectivism did in fact exist in the Department but that, at the same time a conscious and determined attempt was being made by certain tutors and students to question this hegemony.

It is important at this point to emphasize the difficulties involved in formulating any adequate dialectical account of the relationship of artists and intellectuals to the class struggle and to the women's movement. Sartre has stressed that one of the traps in this area is the attempt, by socialist writers and intellectuals, to identify too closely with the working class.[12] I think this applies even if one has come from a working-class background since in order to become an intellectual one must have moved into the middle class. Sartre's solution is to draw a parallel between the attempts of the petit-bourgeois intellectual to break with the particularist tendency in his/her own ideology and the efforts made by the working class to emancipate itself. In

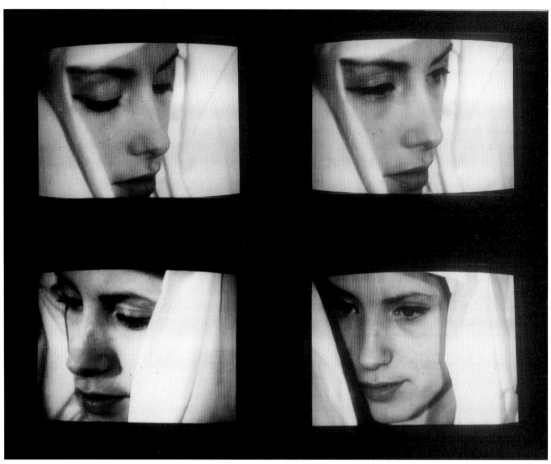

PORTRAYAL Sera Furneaux

the area of feminism an extremely complex situation exists where women who are separated from working-class women at one level are also linked to them through the struggle against patriarchy.

The position I take is that there is a certain form of subjectivity which embodies the single logic of commodity values and patriarchy and that this logic could be found in some of the work produced in the Environmental Media Department.

This is particularly the case with students working in the New Romantic mode, producing work which is mainly concerned with an abstract conception of beauty where the underlying intention is to suppress any sense of struggle or contradiction in the construction of our appearance. This is similar to other work in this area produced by students at the RCA Film and Television School, where a return to quasi-religious imagery masquerades as a progressive move away from structuralist-materialism.

There are more intermediate stages between a rigidly abstract and single mode and a more dialectical and concrete practice. Some of the work in the Environmental Media Department goes to the opposite extreme but I felt that Sera Furneaux's video work moved beyond a too rigid sense of abstraction.[13] There is a subtle dialectic in the temporal process of looking at a person's face in which the Other's presence is gradually assimilated. It is the depiction of this that makes portraits by Bellini or figures painted by Piero della Francesca far more complex and concrete than any photograph. The video image is photographic but in its temporal duration is able to give us the opportunity to perform this dialectic of looking. Sera Furneaux's video pieces *Portrait* and *Portrayal* present us with such an experience. Over and above this, Furneaux also performs a series of transformations that dialecticize the process of looking. *Portrayal* starts with a close-up of a woman's face

– there is a sense of stillness; the eyes look down, the eyelashes move slightly. What I like about the piece is the way that subtle movements in the sitter's on-going consciousness are recorded and at points highlighted by in-camera mechanisms.

Of all the work I saw in the Department the most outstanding, in dialectical terms, was Mike Stubbs' *Contortions*.[14] It lies somewhere between (and beyond) much of the work produced at the RCA Film and TV School and in the Department of Environmental Media. It incorporates both the element of narrative found in most of the work of the former and the self-reflexive stance found in the latter. These are joined in a consciousness which is capable of critical irony. What is most important, I think, is that the film addresses itself directly to the contradiction between identification and distance that besets the intellectual's relationship to the working class.

One of the main pleasures of the film is the way that it incorporates a critical view of both working-class experience and forms of educated consciousness. For example, in one scene a middle-class intellectual (what Sartre would call a false intellectual) harangues a working-class character in a way which reminds one of idealist Marxists complaining about the working-class's lack of analytical rigour. This complex sense of a double distance from both middle-class education and working-class experience

is conveyed by Mike Stubbs' own comments about one of his tutors at the RCA. He says: 'When I spoke to Peter Gidal about *Camera-Sick* [a video piece by Stubbs] his attitude was that it was enough of a problem to want to make this work, and that – from his Marxist point of view – I shouldn't use people. He said, "I don't use people because I know that I can't make a film without exploiting someone." That really screwed me up for about three weeks – then I realised that I do want to include people – it's what interests me – people – so I decided to make it and risk exploiting people – rather than turning your back on it but being ideologically sound.'

Here is an example of the theory-practice problem, or of a conflict between two forms of theory and practice. Stubbs is, I think, more dialectical in the Sartrian sense since his approach contains an internal dialectic between experience and thought.

Since Colin McCabe's *Classic Realist Text* article, dominant opinion in media studies has tended to reject any voice or narrative presence which appears above the level of the narrative segments. As a strategy aimed at combating the overview of bourgeois humanism, this had some merit but it also blocks any comprehension of the movement of thought in a dialectical critique. What was opposed, in essence, was totalization. As filmmakers like Sandra Lahire are beginning to recognize, radical practice needs to be able to totalize; in other words deconstruction is

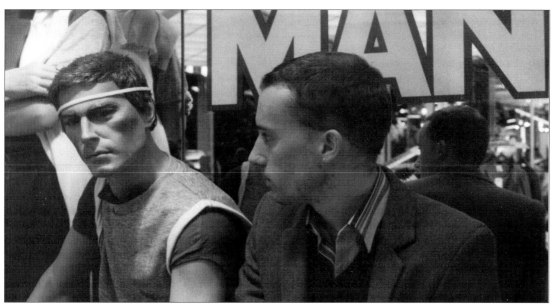

CONTORTIONS Mike Stubbs

only half of an adequate approach: we also need to be able to reconstruct.

Althusserian Marxism has taught us that there is no such thing as a popular culture of the working class. I prefer Gramsci and Sartre's belief that an objective popular spirit does exist and that it comes from the material situation of the working class, despite the fact that it is often overlaid with mystificatory ideology. Stubbs' film keys into that objective spirit; during a period when most radical practice in film and video ignores the experience of the unemployed it manages to explore this area without falling into the trap of false identification.

1 *Simone de Beauvoir Today: Conversations 1972–1982* with Alice Schwarzer. London: Chatto and Windus, The Hogarth Press, 1984.
2 See Jean Paul Sartre's essay 'A Plea for Intellectuals', in *Between Existentialism and Marxism*. New York: William Morrow, 1976.
3 This notion is based on Sartre's approach in his work on Flaubert.
4 See *The Family Idiot Volume I*, trans. Carol Cosman. Chicago and London: University of Chicago Press, 1981.
4 For a full account of Sartre's theory of the institution see *Critique of Dialectical Reason*, trans. Alan Sheridan-Smith. London: New Left Books, 1976.
5 See Hegel's *Logic*, trans. William Wallace, Oxford: Oxford University Press, 1975.
6 Jean-Paul Sartre, *The Psychology of Imagination*. London: Methuen, 1972.
7 *Arrows – a personal experience of Anorexia*, a film by Sandra Lahire, distributed by Cinenova, 113 Roman Road, London E2 0QN.
8 *AND Journal of Art and Art Education*, no. 3/4, 1984.
9 SANKOFA Film and Video.
10 Sartre, *A Plea for Intellectuals*, op cit.
11 See Peter Kardia's 'Making Room for Environmental Media', *AND*, no. 2, 1984.
12 Sartre, *A Plea for Intellectuals*, op cit.
13 Sara Furneaux showed work in the 1984 Department of Environmental Media Show.
14 Mike Stubbs' film *Contortions* was shown in the 1983 Department of Environmental Media Show.

a third something: montage, film and poetry
david finch

1. the image

I am after feeling which film can express without depending on reaction to something pictured.
 – Stan Brakhage, 1955

What does it mean to say that a film or a videotape is 'poetic'? Does a 'poetic' film have qualities specific to film, or is it a film with literary decoration added? I think that a film can be poetic in a real, non-literary, sense and that this is one of the strongest and best powers of film. In his book *The Film Sense*, Eisenstein addresses the relation of film to poetry directly. He is defending the montage principle against the aesthetics prevailing in the Soviet Union in the early 1940s. He argues that montage is a principle founded on the way the human mind works, and that it is fundamental to all the arts: 'a principle which, if fully understood, passes far beyond the limits of splicing bits of film together'. The chapter 'Word and Image' discusses film and poetry in terms of a common montage principle.

Eisenstein characterises the montage image as a mental event, not a static picture or an object – 'the desired image is not fixed or ready-made, but arises, is born'. This image is produced by the receiver in response to concrete representations – pictures, sounds, words – selected and combined by the artist. These representations are partial and incomplete aspects of the idea imaged: the impression of wholeness in the image produced comes from the fact of the viewer having produced it him/herself, as an *idea*: 'the strength of the montage method resides in this, that it includes in the creative process the emotions and mind of the spectator'.

Eisenstein's distinction between representation and image, and his insistence that only this or that precise combination of representations will give rise to the 'most complete image *of the theme itself*', implies that the image is not a translation or illustration of anything, but the action of the film itself, that the film takes place in the mind of the viewer.

The film montage image in this sense is not essentially different from the poetic image: both are mental images, despite the difference between picture and word. The operation of montage is partly metaphoric: film montage and language metaphor use some of the same mental processes.

metaphor: comparison
Metaphor is the describing of one thing in terms of another. In both language and film, the result of this combination can be a description by comparison, translatable into a comparison – e.g. 'this person's cheeks are like apples in that they are round and red, so I will use the metaphor "apple-cheeked".

film metaphors as comparisons: juxtapositions of
- apples/smiling faces (Dovzhenko)
- body/spoken descriptions of landscape (Menken/Maas)
- cornfields/sea
- ice breaking up/workers marching (Pudovkin)
- workers killed/cattle killed (Eisenstein)

comparable language metaphors:
- 'apple-cheeked'
- 'Oh my America, my newfound land' (Donne)
- 'sea of corn'
- 'political thaw'
- 'butchering of the workers'

But beyond these comparisons, metaphor in both film and language can produce a third thing from the combination of two elements, an image not producible in any other way.

Unfortunately, Eisenstein is very much concerned, in *The Film Sense*, that the viewer's experience should correspond to the author's intention, and he elaborates a defensive model of (respectable and acceptable) montage as a technique for the efficient transmission of a theme. This model weakens the full force of his concept of montage as the production of a mental event in the viewer, of the image as arising from the viewer's imagination.

He sets aside early on in *The Film Sense* those aspects of montage less under an 'author's' conscious control: 'The "leftists" of montage saw it from the opposite extreme. While playing with pieces of film, they discovered a certain property in the toy which kept them astonished for a number of years.' This property is the fact that any two film shots spliced together and projected will produce meanings, a third something, with or without an intention on the part of the editor. But some poetry and some films of the 'avant-garde', 'experimental' traditions work in ways that make use of the relative autonomy of the viewer implied by Eisenstein's idea of the montage image as a mental event.

metaphor: a third something

The metaphoric combination can produce something beyond a description by comparison: a 'third something' which cannot be named or pictured; an image which can only be produced by one particular combination of representations.

For instance, the work of the nineteenth-century American poet Emily Dickinson (1870):

Great Streets of silence led away
To Neighbourhoods of Pause –
Here was no Notice – no Dissent
No Universe – no Laws –

By Clocks, 'twas Morning, and for Night
The Bells at Distance called –
But Epoch had no basis here
For Period exhaled.

Dickinson's metaphors in this poem are not reducible to simile, saying something is like something else. 'Great streets of silence' refers only to what it produces in the reader or hearer; it is not reducible to 'great silent streets' or to 'silence like a great street'.

She achieves an 'explosive' effect – something big coming suddenly from something small – by 'including in the creative process the emotions and mind of the spectator'; this is the 'dynamism' Eisenstein is talking about, and this may be why her poems sometimes produce an effect of a voice speaking in the reader's head.

Where she is describing something recognisable, she is producing it as a poetic event rather than describing it as an object:

The Clouds their Backs together laid
The North began to push
The Forests galloped till they fell
The Lightning played like mice

The Thunder crumbled like a stuff
How good to be in Tombs
Where Nature's Temper cannot reach
Nor missile ever comes

'The lightning played like mice' combines the movement of lightning with the movements of mice – even their quietness, since lightning happens in the moment of silence before the thunder – to make 'a third something', a perception which is also a conception.[2]

Examples of film montage producing a third meaning, an image which cannot be pictured:

Fire of Waters (Stan Brakhage, 1965): image: darkness, and flash frames of suburban American houses at night, seen against the sky.
sound: a long silence, followed by a sound like the sawing in half of a screaming sheet of metal.

Machine of Eden (Stan Brakhage, 1970)
close-ups of a loom/long shots of a landscape.
Anticipation of the Night (Stan Brakhage, 1957)
a long film, including camera moving over
children asleep/polar bears and flamingos at dusk.

The working methods which produced these film
examples are not those discussed by Eisenstein in
The Film Sense: they dispense with the written sce-
nario and its implications of film as being a transla-
tion or illustration of something else. In doing so they
free the filmmaker to find the precise combination
of representations which produces 'the image of the
theme itself'. The theme does not pre-exist the film.

Anglo-Saxon riddle-poems give rise to provisional,
'experimental' images which are autonomously pro-
duced by the listener or reader to a greater extent
than those of 'higher' poetic forms: the reader is
trying to guess the subject of the poem, and while
the process of guessing is still going on, metaphors
unroll in directions relatively uncontrolled by an
author's intention. The poems are anonymous and
common property; they are a game, the end of which
is to arrive at a shared reality after passing through
a frightening/funny process of having to reconstruct
the common thing – the answer to the riddle.

*My neck is white, my head yellow, also my sides; I am
swift in my going, I bear a weapon for battle; on my
back stand hairs just as on my cheeks; above my eyes
tower two ears; I walk on my toes in the green grass…*
 – (excerpt) trans. R. K. Gordon

The riddle itself could be compared to those photo-
puzzles in which an unusual view of a familiar object
is captioned 'what's this a picture of?', but the mental
images produced in the process of solving the riddle-
poem are comparable to the provisional, 'experimen-
tal' mental images, without resolution, or resolving
into and out of objects of little 'significance', produced
in the watching of some English experimental films, in
which perception is thrown back on its 'conceptional'
aspect: the fact that the most ordinary thing seen is a
mental construction. Nicky Hamlyn's film *Guesswork*
(1979), for instance, presents two-dimensional colour
compositions which do not quite escape the recogni-
tion by the viewer that they are the surfaces of inte-
rior walls, doors, etc.[3]

In some traditions of experimental film, as in
some poetry, the image is produced through the
partial autonomy of the viewer/reader's imagination
– dynamically – to an extent which Eisenstein, for

historical reasons, could not advocate to the readers
of *The Film Sense*.

*…could not the same thing be accomplished more pro-
ductively by not following the plot so slavishly, but by
materialising the idea, the impression … through a free
accumulation of associative matter? … The plot is no
more than a device without which one isn't yet capable
of telling something to the spectator! … Someone
should try, at least! Since this thought occurred to me, I
have not had time to make this experiment.*
 – Eisenstein, *Film Form*, 1949

2. film tense
film and painting
In the same chapter of *The Film Sense*, Eisenstein
quotes Leonardo's description of an unrealised
painting of the Deluge, and discusses it as a 'shoot-
ing script'. The imaginary painting is standing in
for Eisenstein's 'image of the theme itself', and
Eisenstein takes Leonardo's sequential 'treatment' as
a validation of his minimum, defensive, conception
of montage, which could be summarised as saying
that montage is the right details in the right order.

Eisenstein points out that Leonardo's description
'forcibly recalls to us that the distribution of details
in a picture on a single plane also presumes move-
ment – a compositionally directed movement of the
eyes from one phenomenon to another'. He goes on
to claim that 'here we see a brilliant example of how,
in the apparently static simultaneous "co-existence"
of details in an immobile picture, there has yet been
applied exactly the same montage selection, there
is exactly the same ordered succession in the juxta-
position of details, as in those arts that include the
time factor'.

Although it is true that the composition of a
picture influences the movement of the eye over
its surface, Eisenstein is overstating his case in his
desire to show the universality of montage in the
great art of history: his example is not a painting
but a description of a painting. Music, film and writ-
ing have the capacity to exert a strict control over
the sequence of the work, which painting does not.
Added to this, Eisenstein's conception of montage as
the production of a mental event amounts to more
than the 'ordered succession in the juxtaposition of
details'. And the relation of detail to whole picture
in a painting does not correspond to the relation of
'representation' to 'image' in his conception. One of
the resources of montage in painting is this relation,
the combination of detail and whole contributing to

'a third something': an 'image'.[4]

The main point I take from this is that for Eisenstein, montage is more than film editing and is not confined to film, but is bound up with sequence. He admits that Leonardo's description 'is executed in accordance with features that are characteristic rather of the "temporal" than of the "spatial" arts'. Film shares with writing, with language, a sequential nature, a basis in time, which painting and sculpture, two other models for film-as-art, do not.

Types of poetry and types of film

Aristotle, in his *Poetics*, treats poetry as the art of telling a story for the sake of it (as opposed to for the sake of information). He does not define poetry as an elusive effect, but describes it as a practice of narration, 'forms of imitation or representation'. He begins by indicating a broad field of 'live' performance in which 'the imitation is produced by means of rhythm, language, and music, these being used either separately or in combination'. Epic and tragic poetry belong to this field of 'imitation or representation', along with sung lyric and religious poetry, instrumental music, and dance. He adds that 'the form of art that uses language alone … has up to the present been without a name'.

Aristotle then compares two types of poetry, epic and tragic, and argues the superiority of tragic (dramatic) poetry over epic poetry. Although he sides with Hollywood, it is useful to apply Aristotle's division of poetry into two main types – epic and dramatic – to types of film: the dramatic structures of the commercial feature film, and the epic and also lyric structures of some kinds of 'experimental' and 'avant-garde' film.

The invention of drama is the replacement of narration, the method of epic poetry, by presentation. The epic poet-performer who tells-narrates the story as something remembered, past, sometimes impersonating first one character and then another, but remaining a narrator, is replaced by actors who present the story by enacting it. The emphasis is moved from word to action, from narration to presentation, from a past tense of narration to a present tense of drama. In epic poetry, the story – of Odysseus' travels or the siege of Troy – is already the common property of the audience and is recalled by the collectivity of poet and hearers as shared history. Drama takes the story away from the audience by the conventions of enigma, suspense and the withholding of the ending.

This invention did not happen all at once:

Aristotle writes, 'Aeschylus was the first to increase the number of actors from one to two, cut down the role of the chorus and give the first place to the dialogue. Sophocles introduced three actors and painted scenery.'

The invention of drama lies not in impersonation, for this was part of the performance of epic poetry, nor in bodily performance as in dance, nor in 'painted scenery': but in the imitation of action by action, the imposition of the dramatic present tense.

So, tragedy diverged originally from epic poetry, the other principle story-telling form, in its relation to time, through the replacement of narration by presentation: 'tragedy tries as far as possible to keep within a single revolution of the sun … whereas the epic observes no limit in its time of action'. Similarly, in the commercial dramatic cinema, time of presentation and time of action are made to appear to coincide as far as possible; changes of scene – 'meanwhile' – from one place to another are liberally exploited (Griffith's parallel montage), but changes of time – 'that night' – (which belong to narrative rather than to drama) are generally to be passed over unobtrusively.

Aristotle's division of the field of poetry into the dramatic on the one hand and the epic and lyric on the other turns on this recognition of the replacement of narration by presentation. The division is continued in film: it is the question of the dramatic present tense which most strongly divides commercial dramatic cinemas from traditions of experimental and avant-garde film. The dramatic present tense, more than photography, is the basis of 'illusion' in film; 'experimental' film can be characterised as exploring the temporal possibilities of film, which commercial dramatic cinema seeks to bind to a 'gripping' present tense.

dramatic film

The famous opening shot of Orson Welles' film *Touch of Evil* begins with a close up of a time-bomb being set; music urgently imitates the ticking of a clock as the camera cranes up over the main street of a small town at night.

The setting of a clock which is also a fuse – the indication of a limited length of time before an explosion, supported by the rhythm of the music, posing the question 'how long?' – is paralleled by the use of a single take – 'how long is this piece of film?' – and the movement of the main characters away from the bomb – 'how far will they get? will they cross the border?' – amounts to an ostentatious

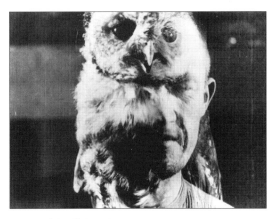

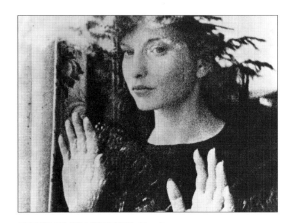

STACHKA (STRIKE) Sergei Eisenstein MESHES OF THE AFTERNOON Maya Deren

fusing of the time of the film strip – projection time – and the time of the story, in a dramatic present tense.

The dramatic present tense in film is created by a particular use of its temporal nature, which necessarily provides a present, in the sense that film unrolls in time. Film editing in the 'played film' works hard to conceal the lapse of time between the making of separate shots, but this is in the service of the principal concealment: that of the lapse of time between filming and viewing. Film 'illusion' depends not so much on the supposed veracity of photography, as on the (illusionistic) suppression of the nature of photography as a partial record, linked to a past (not present) event.

Although the film 'illusion' hangs on the creation of a dramatic present tense in which the time of presentation and the time of what is presented are held together, the time of the feature-film story is invariably longer than that of the telling and its time is thus 'concentrated'. This contributes to the strong identifications and concentrated 'experience' of the heroic which sells the played commercial film. In industrial society, in which the majority live by selling their labour time, in which people are short of time, the commercial cinema offers a kind of injection of time. An experimental cinema which offers a musical, rhythmical and reflective relation to the time of its projection is not offering the illusion of gaining time. The dramatic present tense is the basis of this illusion (which is, literally, a waste of time).

Commercial cinema is not 'narrative' cinema but dramatic cinema, and the tense of its storytelling is taken over from theatre, the invention of actors replacing a narrator, to present the action. In fact, the term 'narrative' is applicable to much experimental cinema, in that it works with the temporal

gap between the time of projection and that of the image's referent – with absence.

epic and lyric film

At a symposium on 'Poetry and the Film' held at Cinema 16 in New York in 1953, Maya Deren cut through a lot of confusion by defining poetry in opposition to drama, reproducing Aristotle's division of tragic and epic. She expressed the distinction in terms of time, opposing the 'horizontal' development of sequential dramatic action to the 'vertical', poetic investigation of a single moment in its relations to things not necessarily contained in the action of the story.

Deren illustrated her distinction between horizontal and vertical by the example of Shakespeare's 'mixed' form of theatre: 'In Shakespeare, you have the drama moving forward on a 'horizontal' plane of development, of one circumstance – one action – leading to another, and this delineates the character. Every once in a while, however, he arrives at a point of action where he wants to illuminate the meaning to this moment of drama, and, at that moment, he builds a pyramid or investigates it "vertically".'

At the same time as illustrating her horizontal/ vertical distinction, Deren's example makes it clear that the dramatic form has never been pure action or pure dramatic present, but requires elements of other poetic forms – epic, lyric and song.

Deren is indicating that a fundamental relation between poetry and film lies in the fact of sequence, 'time-basedness', and what is done with it. The commercial cinema has stuck with the dramatic present tense, while other traditions of cinema, including some documentary and some experimental cinemas, like Deren's, have explored the relation of the

present of film projection to tenses other than the dramatic present, and to uses of time comparable to those of poetry, song and music – song being the form in which poetry and music belonged together, with dance, before their 'Aristotelean' separation.

montage: image and time

A link between these two main ideas – montage image and complexity of tense – lies in Bertolt Brecht's and Walter Benjamin's notion of montage as 'interruption' of the flow of presentation, the breaking of apparent unity between the time of story and that of its presentation.

Brecht described his theatrical practice as 'epic theatre' and 'non-Aristotelean theatre', in direct opposition to the Aristotelean idea of tragic drama, and in opposition to Aristotle's preference for the dramatic over the epic form of poetry.

Brecht gives the new technical possibilities of the stage as reasons for the return of techniques of narration to theatrical performance and points out that these technical possibilities are the product of an industrial age which requires new techniques of understanding; the conditions of action have become too complex and powerful to be excluded from the representation of the action.

Prominent among these stage techniques of narration is the projection of film and still images in a montage relation to the played scene: 'the background took up a position in relation to the proceedings on the stage, calling up on big screens the memory of other simultaneous events in other places, overlaying or counterposing to the action quotations by means of word projections'.

Brecht's montage approach implied also a different relation to time. In replacing suspense over the outcome with attention to the proceedings, the epic theatre separates the time of the story from the time

of its telling; the story is not presented but narrated. Brecht's technique of the interruption of dramatic action in order to allow the audience to think about the history of the situation confronting them, uses as interruptions performances of lyric poems and songs, in which the moment is considered 'vertically' – in its relations to the audience's experience.

Eisenstein, in *Film Form*, recognises the breaking of the temporal unity of film and action as a resource of montage: 'conflict between an event and its duration' through slow motion and stop motion. But Dziga Vertov went further in his concern with the relations between montage and film time; his writings repeatedly refer to the film camera's ability to stretch or compress an event in relation to the time of projection. As in his slogan:

> DOWN WITH
> 16 frames a
> second!

Time is integral to Vertov's concept of montage; the 'cine-thing' is 'built upon intervals', the Kino-Eye is 'a microscope and telescope of time'. His appeal for a cinema of actuality includes time as an essential aspect of his conception of the documentary subject: 'out – into the open field, into space with four dimensions (three plus time), into the search for our own material, our own measure and rhythm'.

history

Vertov's understanding of film in terms of time extends to his attitude to the photographic aspect of film, which is often seen as the basis of its illusory nature, but which offers the possibility of variable relations between the present of projection and the past of which the photographic image is a partial record. These are the relations necessarily excluded by the dramatic present tense, but which are far from excluded from documentary film; shots of barrage balloons in black and white crop up in television documentaries like captions: 'London 1941'. The relations here are not so much excluded as frozen and heavily restricted.

The photographic aspect of film can open a gap between the present of projection and the 'story'. Vertov recognised this as a relatively unexplored resource of film meaning, and recognised photography as the basis of a radical anti-illusionist potential in film, in opposition to the commercial played film.

GUESSWORK Nicky Hamlyn

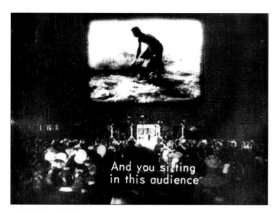

SHESTAYA CHAST MIZA (ONE SIXTH OF THE EARTH) Dziga Vertov

This potential lies in the nature of photography as a record of absence, placed by the filmmaker in a worked relation to the projection present of film. Vertov wanted to use this to produce history, using the film to call up a shared historical awareness in his audience – as in this montage sequence, apparently realised by Vertov in the KinoPravda newsreel no.13: 'the coffins of national heroes are lowered into their tombs (taken in Astrakhan in 1918), the tombs are filled in (Kronstadt, 1921), a gun salute (Petrograd, 1920), eternal remembrance, hats are removed (Moscow, 1922)'.

I have suggested parallel relations between the commercial played film and drama, in the use of the dramatic present tense, and between traditions of experimental and avant-garde film and the epic and lyric forms of poetry.[5] Two active elements common to both experimental film and poetry are a commitment to montage – making a mental image of something that cannot be named or pictured directly, and a use of tenses other than the dramatic present, in relation to the 'musical' present of the work, the present produced by its performance in time.

Film shares with epic poetry a further potential: the capacity for a collective address to an audience on the subject of its own history and experience. Vertov's films, in particular *Man with a Movie Camera* and *One Sixth of the Earth* include the audience as subject-matter of the film and provoke a shared thinking about a common history and present. This vital potential, now largely lost to printed poetry, is still open to film.

To articulate the past historically does not mean to recognize it 'the way it really was' … It means to seize hold of a memory as it flashes up at a moment of danger.

– Walter Benjamin

1 Dickinson's effectiveness as a religious poet is directly related to her ability to produce montage images in Eisenstein's sense; the invisible cannot be pictured, but needs to be imaged:

> 'Tis whiter than an Indian Pipe –
> 'Tis dimmer than a Lace –
> No stature has it, like a Fog
> When you approach the place –
> Not any voice imply it here
> Or intimate it there

2 'Klee's usage, in these cases, of the virtually unloaded or empty signifier … is possibly the dominant factor in the adequate presentation of materialist art practice in works such as Alter Klang, Doppelzeit, etc. Signifiers approaching emptiness means merely (!) that the image taken does not have a ready associative analogue, is not a given symbol or metaphor or allegory: that which is signified by the signifier, that which is conjured up by the image given, is something formed by past connections but at a very low key, not a determining or over-determining presence, merely a not highly charged moment of meaning.' – Peter Gidal, *Theory and Definition of Structural/Materialist Film*, 1978 (my italics). It seems to me that highly charged moments of meaning, strong images in Eisenstein's sense, do often come from the combination of 'low key' representations – it is precisely not given, 'loaded' symbols alone which produce the poetic image.

3 Also, for instance, Peter Gidal's 'Denials' (1985), which is blue-grey in colour, silent, with some 'flash-frames', with what looks like a small area of the exterior stone surface of a building, filmed hand-held in overcast light, moving in and out of focus and therefore in and out of grain. For me the film succeeded, now and again, in effecting a kind of weightless state of metaphor – a mental process of combining the sparse representations into very provisional images, with very little 'resolution', a kind of mental imaging of the film itself – whatever that may be. Although it probably was not the filmmaker's intention, the film gave me an emotional feeling of death and blindness. Michael Snow is quoted by Gidal as saying, about *Room Film* (1973), 'I felt as if it were made by my father, as if it were made by a blind man. I felt that searching tentative quality, that quality of trying to see.'

4 The whole painting is not equivalent to the film montage image, as Eisenstein is suggesting here, but is one aspect of the work, one 'representation' which the viewer combines with other parts of the painting, to produce a mental image; this is most obvious where collage is used, as in Max Ernst's painting with a real button, or Picasso's with a piece of sandpaper.

5 There is also a relation between experimental film and music, which I am not considering in any detail here, beyond claiming that the forms of poetry and music are historically and fundamentally linked in song. The conception of poetry I am using necessarily refers to its origins (before printing) as something performed, sung, although the survival of poetry as song is more an idea than a reality in the 'West'. Even a poet such as the Chilean Pablo Neruda, who, at one time, made a strong commitment to poetry for public performance (Canto General) is known to me only through books. My experience of poetry is almost entirely book-based, with the exception of anonymous traditional ballads, which can still be heard sung, but the idea of the poem as song survives, and seems more and more important to me.

chapter 3 close-up on artists

'messages': a film by guy sherwin
gillian swanson

In the notes on his *Short Film Series* for the Arts Council of Great Britain *Film as Film* catalogue (1979), Guy Sherwin states:

Individual films within the series attempt to articulate contradictions of both space and time within one composite image.

These contradictions are those between image-illusion (what is referred to outside of the image itself; the pro-filmic content) and the material processes of the image construction (its materiality as an image).

In his film, *Messages*, Sherwin brings these contradictions into a relation of conflict, asking us to question not only the image itself, but the transformation of content through the image. His use of experimentation investigates formal aspects in relation to content through a project relating to representation and perception. This induces a questioning of the seemingly natural correspondence of signifier to signified as the base on which conventional ('realist') representational practices are founded. Focusing attention on the mechanisms through which film signifies and is perceived, Sherwin uses content to address the properties of film material and process – a content which is problematised by the instability of sign systems.

Michael Mazière, in his article on Landscape Film[1] argues that an experimental use of content can defy the two 'opposing' categories; the anti-illusionist project of opposing traditional forms (frequently argued in terms of evacuating or minimalising content in the image) or the modernist interest in creating new forms of representation that fragment perceptual codes. He proposes that a questioning of content *through* addressing formal mechanisms may bring these two concerns together.

Constantly in transformation, content cannot be 'fixed' – it is neither a 'given' referenced by the signifier nor purely a product or signifying practice but instead a production of these two set in tension.

At one level, Sherwin signals the transformation by emphasizing the way the medium exerts a control over perception by the constructing and ordering of images. This transformation creates new visual impressions in a way which makes objects 'strange' and draws attention to production of the image. Distortion of perspective in an overhead shot of a hand dropping sticks makes them appear to fall very slowly and reach the ground later than we expect, while the opening images consist of a hand turning the blank pages of a book, on which we can see the shadows of the grasses which surround it (though we only see part of them). Moving into different shapes and forms, the shadows are no more than fragile traces and impressions, transformed by their 'projection' onto a surrogate 'screen'.

We are presented with a blank white screen. Gradually, a part of the image seems to darken, stands out, assumes a distinct form, appears as a word. We realize that lack of focus was what presented the image as empty, and that there is (was) a text in front of the camera. As the first word goes out of focus again, is removed from view, a new word appears below the first and the process continues as the whole text is revealed to us word by word:

> *names*
> *are*
> *what*
> *you*
> *see*
> *when*
> *you*
> *look*
> *at*
> *things*

Elsewhere this process is repeated through the manipulation of the aperture. The idea is simple, as it refers so directly to the processes of rendering visible perception and producing language. Yet it is

this directness of address which enables us to participate in unravelling their seeming equivalence and which forms the basic intention of the film.

For *Messages* does not stop at 'presenting' images and their production – it also adheres to the oppositional project of addressing the nature of signification and the arbitrariness of the signifier. This attention to the arbitrary nature of images functioning conventionally as signs is also explored through relating images together through visual – graphic – correspondence rather than meaning; patterns of line and angle link images of trees, sticks, railings, shadows from a moving roundabout etc. Shots are not related by codes of representation that rely on meaning but use abstract associations, to problematise the reading of content. One of the unifying themes is a concern with the relation of image and language as specific signifying systems; the process of 'naming' visual phenomena or of rendering visible ideas of abstractions expressed through language. Sherwin uses quotes from Jean Piaget's *A Child's Conception of the World* (1929) and from his daughter Maya between the ages of two to four years (words produced as images, for this is presently a silent film), to examine the way the child's visual perception is brought into question by its entry into language. In this way the attempt to 'know' the world through these can be related to the language and image system in film.

The properties of sign production involve three systems of reference; *indexical*, the causal 'trace' which refers to the material and the processes of its production, *iconic*, which relies on physical resemblance and *conventional*, which is an arbitrarily agreed relation between sign and meaning and performs a symbolic function. The image potentially contains all three of these elements. Language, however, has a different referential system, constructing meaning through a system of differences which takes on significance only through the symbolic level.

These ideas can be related to Sherwin's attempt to question the way signification conventionally works to 'fix' meaning through systems of reference. The different referential systems of language and images produce a (productive) mismatch in what is expressed, exposing a gap which opens up the apparent coherence of the production of meaning.

The process of 'naming' is the child's attempt to construct the world through words as an attempt to gain control by positioning itself through language. This is shown in the use of one of the first images in the film, which attempts to render visible a non-visual phenomenon, the wind. The epistemological contradiction of being able to name something one cannot see is expressed through the text following an image of a tree, its branches moving in the wind:

why can't you see the wind?

The contradiction is also represented through the use of focus, though form is not used to 'express' the wind metaphorically. We can 'see' the wind through the movement of the branches but as the tree gradually goes out of focus it becomes unidentifiable except by our knowledge of its presence as the original image. As it slowly changes to a grainy blur of darkness on the light screen, the visual trace of the wind is simultaneously erased as the branches merge together, their movements no longer being perceivable. Meaning is not located within the image and so cannot be directly related to content – it is put into a relation of conflict with content through the production of the image.

The interest in 'naming' as a process is tied to that of rendering visible by constructing images which incorporate language in a visual patterning. A pebble is slowly rotated in front of the camera to reveal one by one a series of words written into it in chalk. The visual concentration on shape is described and presented through movement within the frame and the graphic arrangement of letters, as opposed to the text's use of metaphor:

pebbles are round because the water makes them swell up.

These different forms of 'access' to the object or idea represented direct our attention towards the specific nature of the activities of perception and making sense through language. This point is made even more strongly by the occasional appearance within an Arabic text of iconic characters – figures of birds which stand out as recognizable through a different system of references.

Messages uses the temporal relation between image and text (in a way which could only be done by using the concentration and duration of *reading* a text represented visually) to draw out this separation between the perception of an object and its naming. The production of meaning is shown as a continual process where the succes-

MESSAGES Guy Sherwin

sive movement of images is part of the transformation of content. A fixed camera allows us to see stones on a river bed. The water runs across them, continually performing a change upon the objects represented through the play of light on the surface of the water. A hand reaches into the water to take a stone out and it becomes different again in size, shape, texture and detail. Impressions are continually effaced by subsequent ones, no one image being the 'correct' or stable rendering of the object.

This represents a *pleasure* in change and in the incessant movement of visual forms and the newness of perception which links Sherwin's work to the exploratory work of the early avant-garde in the affirmation of the constant renewal through the power of the image.

There are moments, however, when the film appears to use images to *reproduce* (reflect) the experience of seeing objects which exist outside film and the impulse to produce meaning comes from that 'other' existence (and thus that 'other' consciousness, the child's), seen as being formed elsewhere. This is most evident in the later part of the film, when the child's utterances do not address questions relating to representation ('Are there women robbers?' and 'Are there toys in prisons for children?'), the images having an ambiguous relation to the text. In this case, it is a pan along a wall with broken glass cemented into the top. Whereas I have tried to show that it is the film's project to address the instance of meaning-production, at points such as these it appears that contradictions in verbal and visual constructions are effaced by simple thematic illustration. (Similarly, the accompanying of a text which questions time, 'Are there times when there aren't any hours?', by an image of a clock with no hands points to a direct use of illustration.)

These examples show the difficulty of the project around content. Sherwin does not resolve contradictions between image and language in signification, but they are addressed in a direct and sustained way. In his attempt to relate the processes of filmic representation to a child's perception of the world, the specific nature of the differentiation of language and image systems is revealed through the translation of the complex, multi-levelled process of the child's accession to a position in meaning.

1 Michael Mazière, 'Content in Context', *Undercut*, no. 7/8, p. 119.

interview with anne rees-mogg
janey walkin

My reasons for asking Anne Rees-Mogg to talk to me originated from a general interest in the practices of women filmmakers of her generation and in particular from my interest in her own specific concerns and experiments with film. We watched *Grandfather's Footsteps* in her home and talked about her work and my interest in using documentary forms.

Janey Walkin: To start off by asking you something pretty obvious. How and why did you become interested in film as a medium?
 Anne Rees-Mogg: I think I became interested

in film almost after I'd started making film. I'd been doing some paintings about colour and soap bubbles. This was in 1965/66. There wasn't very much independent film in England at the time and the first international exhibition of underground film hadn't happened. I borrowed a 16mm camera for the summer and I made a very pretty little film, pictures of soap bubbles and interference patterns, oil on water; things that I'd always been interested in all my life. At the same time, the summer of '66, I took home-movie shots of my two nephews (one of whom is Grandfather, in *Grandfather's Footsteps*),

and I realised the soap bubbles film didn't really satisfy me; it was too much like painting. The other film which was a home-movie and therefore hardly to be regarded as a film at all, contained what I needed, which was expressing things about people and ideas. I saw that much more as being the direction that I was going to go in. I also had a lot of interest in futurism at that time and in Muybridge and the early beginnings of cinema, like slipping lantern slides. I was disappointed with the first two films in that film isn't about movement in the way that a Muybridge horse is about movement; film is about the illusion of movement. It's about time and it's about trying to remember what happened last. I've become increasingly aware of trying to work on people's memory of what they've seen. I did about 5, 6 years later make a little film with this guy Renny Croft turning a cartwheel, which is my only film which is just about film structure. You have to turn a cartwheel at a certain speed otherwise you don't get over. So I did that from fast to slow motion and then blew up one shot and turned it into postcard-size photographs and re-shuffled them and animated them. That was a kind of homage to what I had thought were my beginnings, but in fact the much more personal autobiographical/biographical aspect became much more important.

JW: How do you go about using autobiographical or personal subject matter structuring it? I'm thinking of *Grandfather's Footsteps*.

AR: *Grandfather's Footsteps* is a growth from four or five films. The first of the longer, sort of half-hour ones is called *Real Time*, and I'll go back to that one because it is the most autobiographical one too. That was in 1974. In 1966 I was trying to invent my own. I got very occupied with the idea of real time, but it's also about my life-time. I was aware of formalist ideas that were going around like, say, Malcolm Le Grice's films like *Berlin Horse*, but I did know that I wanted to do something quite different. I was trying not to be within the conventions of an English avant-garde. I felt much more related to American films like Jonas Mekas, and diary films. I'd invented this shot in the film before, that I made in 1970 with my nephew Anthony – animating all the photographs I could find of him. So I re-did that, in a section about my mother in a film called *Real Time*, which was very much about my life; and then I animated all the photographs of family and relations. And there's one section called 'Family Likeness', where everyone starts from being one and they end up being as old as my mother, who was the oldest.

Then there are four real-time, 2 minutes 40 seconds shots going down the motorway towards the west. The shot where the lorry comes is a real-time shot, and it's meant to be a real-time shot.

JW: The reason for having a real-time shot like that would be what? Say, in relation to something like Chantal Akerman's *Jeanne Dielman*?

AR: I think the reason would be rather obscure for anybody else. In that (real-time) shot in *Grandfather's Footsteps* I was trying to make a contrast. None of the other shots have any specific length. So there isn't a preconceived, drawn structure onto the film.

JW: What is the response that you get to something that is autobiographical? Is it a concern of yours?

AR: Yes it is a concern. A concern I use back in the soundtrack, where [in *Grandfather's Footsteps*] I am almost answering the audience from my knowledge of previous audiences. Yes, and I've had criticism both from audiences and from Chris Auty, about being a blinkered, cultured member of the Ruling Class, which unfortunately I didn't know – I mean, all those years and I hadn't realised I was a ruler! When I was working on *Real Time* I felt that what I really wanted was not to make a film at all, but have a print-out of my thoughts. But I think if I was very fanciful, I would probably make rather different films. As it is, I can make films out of my experience and my relationship to what I speculate about other people's experience, like my Great Grandfather's. It is a detective story.

JW: It is in a sense a diary and typical, in a way of female concerns in filmmaking.

AR: They [audiences] don't seem to mind about that really, but they keep up on the idea of class, that is in England. I've been in America and never get questioned there about class, but I do get questioned about other things. For example, in *Real Time* in each of the motorway sections I got the people to drive at 60 mph so it was a minute – you know – a minute was a mile. And for me that was important and that each of the four sections has got a very different soundtrack. There's a heavy one in the middle in the winter about an experience that I had, nearly dying and how this was in fact rather an interesting experience and not unpleasant. And I found two men, one in York and one in New York (by chance), reacted quite strongly against the sense of death being part of the speculation.

JW: That's maybe understandable given that audiences won't necessarily see films as part of a genre

that yours might fit into or a category; they seem to be trying to make people look at experiences and histories in a different way.

AR: Oh, yes. I still very much want that. I'm just less didactic about it than I would have been in 1974, and I became more and more aware of film being memory. And that's partly why I called the film before this one *Living Memory*. Trying to make people think 'Oh, how does that connect?' In all my films there's a slightly rag-bag quality of this happening after that. They're a bit like threading beads. I made a film while I was in hospital, which was a very simple slide-tape about having cancer and having radiotherapy and I think I did it partly for therapy for me if you like. Because I could take slides and do some tape recording, and it was like a way of thinking that I could get out of there some time. But I made the effort with that, to take it with all the paraphernalia back to the hospital and show it to the doctors and nurses. I think there's quite a lot in *Grandfather's Footsteps* which is almost discussing with the audience the way one has to produce oneself and the way one has to produce one's films.

JW: I was wondering what other artists you felt some sort of empathy with?

AR: I was going to talk about how I arrived at the soundtrack for *Grandfather's Footsteps* and that rather relates. I write from one notebook to another. I don't script something totally beforehand. I kept writing things that I wanted to say and it was no good. They sounded like the soundtracks of a lot of women's films and I didn't want them to sound like that. So I decided the only way that I could get across the things that I actually wanted to say, quite overtly, was having written them down and having tried to say them to myself, and none of it satisfying me was, to just talk to somebody who was sympathetic, and who was helping me, and all of that talk was just done [recorded] in one afternoon.

JW: Is that because you wanted it to be more honest, or just less literary in style?

AR: It wasn't more honest, it was just that the other stylistically didn't work for me and also because I had felt that, usually women's films, they tend to, oh, Laura Mulvey, Carola Klein, Sally Potter even, it's a bit sort of intoned. They're trying to make points, in words.

JW: Having that kind of discussion soundtrack, rather than something that is as you say, intoned, or didactic – there is room for manoeuvre perhaps?

AR: It was something that I had to work towards, because I was rejecting ways of trying to convey

REAL TIME Anne Rees-Mogg

what was essentially information, and because they sounded wrong. I felt that it's a trap and it's become a convention.

JW: Can you say a bit more about what you think has become conventionalised in the way soundtrack and images are constructed in recent women's films?

AR: The very fact that I decided that I wouldn't do the soundtrack in a way that I felt didn't work in these women's films, was because I looked at the films and decided that. Films that I very much admire and feel a certain closeness to – Hollis Frampton's film *Nostalgia* is a super-lovely film which is trying to convey ideas about time and about images. It's a more sophisticated film. Chantal Akerman's film she made in New York, *News From Home*, and on the poster I did for *Grandfather's Footsteps* there's this little three-liner by John Jost, and somebody said, 'Oh well yes, your films are actually quite like his'. I think I feel a little bit more at ease with American films on the whole.

JW: Is that because of film or art traditions?

AR: There's an acceptance of the home-movie, the diary, personal experience, as being perfectly valid. Some of John Jost's films – *Angel City* – I really like. I'm still very involved in my interest with my films being films that are about film.

JW: A BBC documentary on your grandfather would obviously give a different impression.

AR: I suppose the film that I would make, would try to show how one is looking for the pieces to fit together. That was what *Grandfather's Footsteps* was always intended to be about. I started off with his glass negatives and knowing who he was and knowing the countryside very closely, but his writings which I really like, his little inventions, I didn't find until the second summer that I was working on it.

JW: I wanted to ask you about your education in the Land Army ?

AR: Oh, yes! Well I did get to some extent educated. I had no formal education. I was a sickly child, so my parents didn't send me to school. And sometimes I had governesses, but mostly I just read and drew, because I love drawing. That was my language, I suppose. Which is a bit lonely. Then the war came and by that time I was 16 to 17 and I was still at home so I worked on the farm. And of course I got really strong. I'd always been a bit weedy before then and I became strong.

JW: And you weren't presumably on your own?

AR: Oh, I was on my own. I was working on my father's farm. I had to join the Land Army because I couldn't get any clothes otherwise and you couldn't get any wellie boots. But again, you have sort of status, prancing around in uniformed green jersey, corduroy breeches and a kind of British warm over-coat. And I learned a lot of things which, of course, do come through in film. This concern with feeling a relationship to agriculture is probably from there. Then I went to art school after that and I remember the man saying: 'Oh she hasn't got any academic qualification so she'll never be able to teach!' And I did commercial art and I loved it. Then I taught in Art Schools which I've been doing ever since. But now I'm lucky, as most of my teaching is film teaching, which is what the students want and what I want to do. I think that actually it is an important part of my own production. The people who have worked with me have really made a terrific contribution, like Tony Potts and of course Anthony. When he was a kid he had to stand for hours in a corn field when I was painting. I think he was relieved when I took to making films!

JW: Yes, it must be quite difficult to expect even your relations not to play up to the camera.

AR: I don't creep up on them! I think that is why I still try to show that these were the people that helped me make the film. And I want that to come through – my gratitude to them. I'm quite interested now in the idea of acting in films but still haven't used actors and scripts.

JW: It's interesting the way you might approach actors and scripts.

AR: In *Real Time* I used my mother who isn't alive any more, and Anthony.

JW: Going back to what you said about women's films, Laura Mulvey and so on, I wonder what you feel about the debate on what constitutes women's filmmaking or the language, of feminist cinema?

AR: I feel that a lot of the women – English women – are probably too didactic, the irony, or humour is rather lacking, and I don't reject it, but I don't want to be identified as part of a feminist film aesthetic. I find I am critical of the sort of ponderousness, which is also matched by other English films made by men; usually they're using actors very much of the 'Can I pass you the Coca-Cola glass' type which is okay if you speed it up and then it turns into something a bit Straub! But obviously I'm reacting against things that I perhaps respect but feel irritated by; certain aspects of the academicism, or the way they have become a kind of language of how you use language particularly, how you use actual words.

JW: A language of how you use language?

AR: Yes. Oh, I think that with film which doesn't have a conventional narrative people are speculating why this is happening, where was that bit shown last? – you've got to give them things like commercial breaks. And to some extent the real-time lorry sequence in *Grandfather's Footsteps* is quite funny and it's different in pace and it's a little bit of a rest.

JW: And that was a formal decision?

AR: Formal, or considered. All my work is like building a jig-saw puzzle with bits…

JW: That you want to have…

AR: That I want to have, but which haven't necessarily been cut for that picture, so I have to create the formal structure as I go along and I can't preconceive it except *Muybridge Film*, which was 5 minutes and was completely preconceived. But then I remember Dave Curtis saying 'Look, this is not really a structural film, this is a celebration of Renny Croft!' because there's a bit where he's in very slow motion turning a cartwheel and instead of cutting it at the end, I let him look round and think what's he supposed to do and glide slowly out of the picture and it's a dead giveaway on the kind of filmmaker that I actually am.

JW: There is more space to move around, and having ideas or images or bits of writing that you want to assemble, you have to find the framework to assemble them in.

AR: And when you're editing and even when you're pondering (because writing my two note-books back and forth is a part of editing, I think), you're seeing if you can discover a way. There was this heavy chap in Hull and he said that in *Living Memory*, the two young guys fooling around in a corn field (which happened to be their dad's corn field) shouldn't fool around in corn fields: He said, 'What's more they're treading on FOOD!' So I mean everybody has to be responsible for their own semi-ology. I want my films to allow the people who are looking at them to relate to them and un-relate and relate back again. And to have their own specula-tions which may or may not run parallel with those that I am trying to impose upon them. That's what I want the most and sometimes it happens.

Anne Rees-Mogg died 17 December 1984.

the poetic experience of townscape and landscape, and some ways of depicting it
patrick keiller

introduction

The desire to transform the world is not uncommon, and there are a number of ways of fulfilling it. One of these is by means of the adoption of a certain subjectivity, aggressive or passive, deliberately sought or simply the result of a mood, which alters experience of the world, and so transforms it.

There is nothing particularly new or unusual about this. The subjectivity involved is that of the wandering daydreamer – Edgar Allan Poe's in *The Man of the Crowd*; Baudelaire's flâneurs and dandies; Apollinaire's *Baron d'Ormesan*, the inventor of amphionism; Louis Aragon and his contemporaries in *Le Paysan de Paris*. The thrill they all seek is the frisson Aragon termed 'a feeling for nature', their realm is the street and the common object of their speculation the phenomenon of place.

I began to pursue the 'feeling for nature' several years ago. My starting point was that of an architect, and my motivation the desire to find, already existing, the buildings that I wanted to build but for a number of reasons was unable to. The more I looked the more I found, and the more I found the more I looked, but gradually my interest shifted from the instant transformation of a building (object), to the discovery of a deeper sensation of place (space) akin to the *stimmung* that Nietzsche discovered during his last euphoria in Turin, and that so affected de Chirico.

The present day flâneur carries a camera and travels not so much on foot as in a car or on a train. There are several reasons for this, mostly connected with the decline of public life and urbanism (another kind of flâneur lives on in fiction – the private investigator – but his secrets are well hidden behind the street fronts), but also because there is something about a photograph or a shot in a film that exactly corresponds to the frisson that Aragon identified. As early as 1918, in his first published writing, he wrote:

Likewise on the screen objects that were a few moments ago sticks of furniture or books of cloakroom tickets are transformed to the point where they take on menacing or enigmatic meanings.[1]

I became a sort of architectural photographer and filmmaker, trying to produce photographs and film footage that interpreted the objects of my desire as I saw them.

It occurred to me that a common aspect of these interpretations was a kind of analogy that saw the places I 'discovered' and photographed in terms of other places that I knew, or knew of, and it also occurred to me that much of this experience of other places was gained from looking at photographs and films. The image of a place on the screen is transformed in exactly the same way as the objects to which Aragon refers, both by the photography itself, by the images that precede and follow it, and by the narrative.

To a certain extent, I began to look at places as potential photographs, or better still, film images, and even the still photographs took on the character of film stills. This visual material deliberately depicts places that are nearly or altogether devoid of human presence and activity, but which because of this absence, are suggestive of what could happen, or what might have happened. They are places in which events might take place, and the events are seen rather as possible contemporary myths. But the myths have a history – maybe they are history

Demolition of coal hopper at nine elms, london, 1979

– and this history can be constructed as a narrative – a reconstruction of a past daydream or the construction of a new one – which links still images or provides a setting for the film, in the same way as the locations provide a setting for the action in other films. The aim is to depict the place as some sort of historical palimpsest, and/or the corollary of this, an exposition of a state of mind.

Such is a summary of the development of this activity up to now. What follows is an attempt to map out the tradition which has supported this development. There are different aspects to this: the literature of the wandering daydreamer, whom I perhaps inaccurately term the flâneur; the visual arts tradition of the reinterpretation of everyday objects and landscapes, which might be termed surrealist realism, though it probably has more to do with photography as a way of seeing than any particular mode of thought; and a way of depicting places in literature and film where they are inextricably bound up with the state of mind of the characters who inhabit or observe them.

the flâneur

The flâneur as a literary motif appears in two modes, or rather can be seen as signifying two types of experience. The first of these is that of a wanderer, perhaps a dandy, who takes the city as his salon, strolling from café to bar in search of amusement and perhaps romance. His chance encounters are largely with people, and his haunts chosen for the company they provide, rather than any melancholy architectural quality, and the oneiric quality of his experience is largely the result of his surrender to the randomness of urban life.

The other type of flâneur drifts through the city as if it were the substance of a dream, marvelling at the transformations that this brings about. He may meet others, he may fall passionately in love, but this is not his motive, it merely enhances his experience by enabling it to be shared.

There is also the lonely life of the street photographer, who acts the flâneur in the hope of recording little glimpses of the marvellous with his camera. His is a difficult task, for poetic insights so rarely survive their capture on the emulsion. But I digress…

Edgar Allan Poe wrote, in 1840, a short story: *The Man of the Crowd*. The narrator, a convalescent, sits in a coffee house in London observing the thronging pedestrians passing the window. With that new vision often granted to those recently recovered from illness, he is enjoying finding distinct types among the passers-by, when an old man who fits none of these captivates his curiosity. He leaves the coffee house and follows the man as he wanders through the streets with no aim other than to be constantly in a crowd. The afternoon turns to evening, and the evening to night. Still the old man walks on and still the narrator follows fascinated, trying to discover what the old man is about. On the evening of the following day he gives up his pursuit, knowing that it will never end: "'This old man,' I said at length, 'is the type and the genius of deep crime. He refuses to be alone. He is the man of the crowd.'"

While Poe's attitude to the old man is far from any sympathetic identification, here I believe for the first time we see some recurring themes in 'urban dream' writing: the narrator's convalescent state, a heightened state of awareness:

One of those happy moods which are so precisely the converse of ennui – moods of the keenest appetancy, when the film from the mental vision departs…

And his resultant rather alienated observation through the window of what came to be called 'modern life'; his subsequent pursuit of an enigma; the description of the streets through which they pass, the low-life – they enter a gin-palace at dawn – and above all the emerging sensitivity to the erotic implications of crowds.

Poe's reputation in Europe was considerably enhanced by Baudelaire, who praised and translated his works. He quotes *The Man of the Crowd* in *The Painter of Modern Life*. Baudelaire's writing is full of awareness of 'the poetry of modern life', the life of the streets and boulevards and other public places, but specific references to townscape are rare. His encounters are with people, or spirits,

but not places. In the letter to Arsène Houssaye, which serves as the preface to *Paris Spleen*, he writes of his desire to create the poetic prose of which the book is composed: 'It was, above all, out of my exploration of huge cities, out of the medley of their innumerable interrelations, that this haunting ideal was born.'

Apollinaire produced the most demonstrative of flâneur writings. In *The Wandering Jew* the story is not unlike *The Man of the Crowd*, but here the enigma guides the narrator through Prague until it transpires that he is several centuries old.

The most prophetic of Apollinaire's stories here is 'The False Amphion', one of the *Stories and Adventures of the Baron d'Ormesan*. The Baron is an old acquaintance of the narrator, who thinks he is a tourist guide, but the Baron, on the contrary, has invented a new art form, amphionism:

'The instrument of this art, and its subject matter, is a town of which one explores a part in such a way as to excite in the soul of the amphion, or neophyte, sentiments that inspire in them a sense of the sublime and the beautiful, in the same way as music, poetry and so on…'

'But,' I said laughingly, 'I practice amphionism every day. All I have to do is go for a walk…'

'Monsieur Jourdain,' cried Baron d'Ormesan, 'what you say is perfectly true! You practice amphionism without knowing it.'

Now this is all very ironic, but the irony is directed not at the idea of poetic wandering, but at the Baron's insistence that the art consists of composing the journeys, rather than on the one hand building the buildings, or on the other concretising the poetic experience of wandering among them – in other words, that the art depended on the sensibility of the artist, not what he did with it. The Baron's adventures are full of similar misunderstandings, such as the filmmakers who, for the sake of realism in their film, pay a man to actually murder a couple.

The point about subjective transformations of townscape is that they do depend on a certain state of mind, which can be adopted deliberately (this is why I write of 'aggressive' subjectivity), but not by an audience, (and probably best not at all, for it is best to take one's reveries as they come).

tourism

This was certainly the case on 14 April, 1921, the date of the first surrealist event. Organised by André Breton, it was to consist solely of direct experience of the city. The Surrealists had already explored brothels and the 'cretinous suburbs' as well as the flea market, but they had not yet demonstrated their discoveries to the public.

The new itinerary would 'put in unison the unconscious of the city with the unconscious of men' and was to take in St. Julien-le-Pauvre, the Parc des Buttes-Chaumont, the Gare St Lazare and the Canal de l'Ourcq. The first expedition, advertised throughout Paris, to St. Julien-le-Pauvre, was a complete failure. It rained and no tourists turned up, and the rest of the tours were cancelled.

It was more than thirty years before anyone tried anything like this again. Once more in Paris, in the early 1950s, the Lettrist group developed the techniques of 'drifting' and 'pyschogeography'. Drifting was a free-association in space. Drifters would follow the streets, go down alleys, through doors, over walls, up trees – anywhere that they found desirable. Later 'mass drifts' involved teams linked by walkie-talkie radio. Psychogeography was the correlation of the material obtained by drifting. It was used, amongst other things, to make up 'emotional maps' of parts of the city.

In 1958, the Lettrists evolved into the Situationist International, and in 1968 their polemic was influential in 'les évènements'. Drifting was still a preoccupation. In *Ten Days that shook the University*, an account of the election and subsequent propagandist exploits of a situationist-inspired group who gained a short-lived control of the students' union of Strasbourg University, there is a strip cartoon of two cowboys riding through a landscape:

'What's your scene man?' asks one.
'Reification,' the other replies.
'Gee – I guess that means lots of hard work with piles of books on tables?'
'Nope. I drift. I just drift.'

Or so, at any rate, went the English translation. Drifting, it seems, has reconstituted itself as a myth.

le paysan de paris

Louis Aragon began writing *Le Paysan de Paris* in 1924, three years after the ill-fated touristic event. It is constructed about descriptions of two places: the Passage de l'Opera, in whose bars he and his contemporaries drank and talked, and the Parc des Buttes-Chaumont, which they held in high esteem as an oneiric location, and which was to have been the subject of one of the touristic ventures. Between

the two descriptions, he outlines the genesis of 'a feeling for nature':

I felt the great power that certain places, certain sights exercised over me, without discovering the principle of this enchantment. Some everyday objects unquestionably contained for me a part of that mystery, plunged me into that mystery. … The way I saw it, an object became transfigured: it took on neither the allegorical aspect nor the character of the symbol, it did not so much manifest an idea as constitute that very idea. Thus it extended deeply into the world's mass. … I acquired the habit of constantly referring the whole matter to the judgement of a kind of frisson which guaranteed the soundness of this tricky operation.

Now I have already compared this frisson to that preceding the click of a camera, but Aragon's account of his discovery outlines a way of looking at things that runs through the whole history of twentieth-century art, and twentieth-century attitudes to pre-twentieth-century art. On the next page he looks at petrol pumps:

The nameless sculptors who erected these metallic phantoms were incapable of conforming to a living tradition like that which traced the cruciform shapes of churches. These modern idols share a parentage that makes them doubly redoubtable…

Petrol pumps identical to these turn up in the paintings of Edward Hopper – *Gas* (1940) and *Four-lane Road* (1958) – and in the photographs of Robert Frank – *The Americans* (1958). Similar perceptions of everyday objects occur in painting, sculpture, photography and film in areas as diverse as metaphysical painting, film noir or 'conceptual' art, never mind pop-art. The transformation may be seen both as a realisation of the ontologically miraculous, and as a hysterical alienation from banality. What is remarkable about Aragon's transformation is not just that he managed to perform it without benefit of nostalgia, which so automatically provides a poetic cloak for any object (those petrol pumps, or their heads, also turn up highly priced in antique shops), but that he managed to direct it at whole districts of the city. André Breton said of him, years after their break:

I still recall the extraordinary role that Aragon played in our daily strolls through Paris. The localities that we passed through in his company, even the most colourless ones, were positively transformed by a spellbinding romantic inventiveness…[2]

Breton, for whom the street was 'the fountain of all true experience' wrote another classic text of Surrealist Paris, the story of his relationship with the enigmatic, innocent, experienced Nadja. An account of surrealist love (shared revelation rather than physical passion), their affair takes place in the streets, in cafés, on trains. Some of these locations are illustrated by a number of remarkably prosaic photographs. The eroticism portrayed is as much that of their relationship with their surroundings as with each other. Georges Bataille writes:

Erotic activity, by dissolving the separate beings that participate in it, reveals their fundamental continuity, like the waves of a stormy sea.[3]

Love is the conquest of the discontinuity of individuals. Hence the erotic dimension to 'losing oneself in the crowd' or indeed of losing oneself in the city, habitually so alienating, reconstituted instead as a dream. It is in such an appropriation, such a repossession of townscape – or landscape – that the possibility of an erotic relationship between people and public space is to be found.[4]

There are other Surrealist townscape texts: Robert Desnos' *La Liberté ou l'Amour* and those of Walter Benjamin, notably *Marseilles*, in which he converts the then new cathedral into a railway station, and *Hashish in Marseilles* which enjoys the transformations enabled by the drug.[5]

Benjamin recounts the remark made of Eugene Atget that he photographed the deserted Paris streets 'like scenes of crime': 'The scene of a crime, too, is deserted; it is photographed for the purpose of establishing evidence. With Atget, photographs become standard evidence for historical occurrences, and acquire a hidden political significance.'[6]

It was Georges Bataille who pointed out that 'architecture covers the scene of the crime with monuments' (this is perfectly true, just think of Trafalgar Square). Atget's depiction of public places in and around Paris captured, in the most modest way (this is surely his strength), the sense that 'anything could happen', that the Surrealists were later to write about, as well as being evidence of all the terrible things that already had happened. They reveal an ambiguity, a potential for transformations both subjective and

actual, in ordinary locations. The crime that Bataille and Benjamin allude to is an ambiguous affair, but its major resonance is that of the rarity, in everyday experience, and in actuality, of such transformations. They come about only, if ever, in reveries, revolutions or the more poignant moments of war.

Atget's photographs were of the streets: Surrealist photographers went to more exotic locations. Eli Lotar's photographs of the abattoirs at La Villette illustrate Bataille's entry 'abattoir' in the *Dictionnaire Critique*. Bataille concerns himself with outlining the significance of abattoirs, that they are the modern counterpart of sacrificial temples in which animals were killed for both religious and alimentary purposes, the cursed status of abattoirs in modern times resulting from the denial of their religious function. Lotar's photographs demonstrate this world within the one we think we know, as they demonstrate the camera's ability to unmask it. It is almost as if the machine was built for this purpose, as we now know only too well, for indiscriminate transformations of the ordinary into the miraculous now form one of the mainstays of advertising.

anguish

At the same time, the discovery of the ability to perceive the marvellous leads to the discovery that things have a habit of not staying that way:

Although I can always see how beautiful anything could be if only I could change it, in practically every case there is nothing I can really do. Everything is changed into something else in my imagination, then the dead weight of things changes back into what it was in the first place. A bridge between imagination and reality must be built.[7]

In Poe's writing, taken as a whole, two things seem to stand out as most remarkable: his descriptions of extraordinary states of consciousness, and of rooms, buildings and landscapes. Many of his works consist of little else: *The Philosophy of Furniture*, a treatise on decor; *The Domain of Arnheim* and its 'pendant' *Landor's Cottage*, which describe respectively the creation of a superlative landscape garden by an individual of exemplary endowments, and an idyllic cottage inhabited by an idyllic couple in an idyllic setting. There is no other purpose to these works than these descriptions. In *The Pit and the Pendulum*, the greater part of the writing is description of the narrator's delirium as he hovers on the edge of consciousness, and most of the rest details his

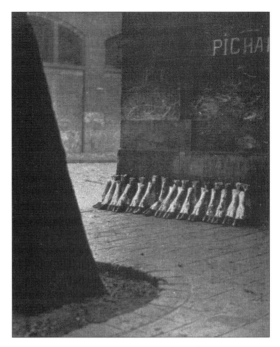

ABATTOIRS OF LA VILLETTE Eli Lotar, As Published In Bataille's *Documents* No. 6, 1929

gradual awareness of the awful particularities of the dungeon into which he has been cast. In *The Fall of the House of Usher*, the place and the state of mind of its residents are even more inextricably bound up, though not this time in the first person, for the narrator is a guest:

I know not how it was – but, with the first glimpse of the building, a sense of insufferable gloom pervaded my spirit. I say insufferable; for the feeling was unrelieved by any of that half-pleasurable, because poetic, sentiment with which the mind usually receives even the sternest natural images of the desolate or terrible.

With this observation, Poe distances the narrator from the reader, who cannot help imagine some 'poetic' gloom precisely because it will only exist in his imagination. Poe is pinpointing a rather photographic dilemma, for photographs of unpoetic gloom, provided they are good photographs, generally make it look rather poetic whether this is the intention or not, as in war reportage etc. The narrator goes on:

I looked upon the scene before me … with an utter depression of the soul which I can compare to no earth-

ly sensation more properly than to the after-dream of the reveller upon opium – the bitter lapse into everyday life – the hideous dropping of the veil.

Here he compares a particular state of mind with that following the loss of another, again a kind of paradox. But this is typical, for Poe is at his best when describing not just the heightened states of mind of his characters, but the anguish which their (and presumably his) sensibilities bring about in their everyday lives. Thus, of Roderick Usher:

He suffered much from a morbid acuteness of the senses; the most insipid food was alone endurable; he could wear only garments of certain texture; the odours of all flowers were oppressive; his eyes were tortured by even a faint light; and there were but peculiar sounds, and these from stringed instruments, that did not inspire him with horror.

Throughout Poe's work, there is an implication that those who have access to heightened states of awareness are bound to suffer. Delirium is the result of illness or injury (*The Pit and the Pendulum*, *The Oval Portrait*), persons of extreme sensibility suffer (*Usher*), are haunted by irrational fears (*The Premature Burial*), or turn to drink and murder (*The Black Cat*), and those who cultivate the senses in the face of suffering and adversity invite destruction nonetheless (*The Masque of the Red Death*). He seems especially familiar, like the narrator in *Usher*, with the depression encountered when any heightened state departs.

This is a recurring theme in Baudelaire. In *The Double Room*, one of the prose poems which make up *Paris Spleen*, the room is an idyllic space, the light, the furnishings and the company are sublime, but then little memories of current circumstances alter this perception:

And that perfume out of another world which in my state of exquisite sensibility was so intoxicating? Alas, another odour has taken its place, of stale tobacco mixed with nauseating mustiness. The rancid smell of desolation.

There is clearly a political dimension to this:

Each subjectivity is different from every other one, but all obey the same common will to self-realisation. The problem is one of setting their variety in a common direction, of creating a united front of subjectivity. Any attempt to build a new life is subject to two conditions: firstly, that

the realisation of each individual subjectivity will either take place in a collective form or it will not take place at all; and secondly, that 'To tell the truth, the only reason anyone fights is for what they love. Fighting for everyone else is only the consequence.' (Saint Just)

Transformations of everyday space are subjective, but they are not delusions, simply glimpses of what could happen, and indeed does happen at moments of intense collectivity, during demonstrations, revolutions and wars. It is this realisation, together with that of the individual's predicament, 'his desperate desire to flee from the prison of his subjectivity, his furious longing to find some escape from the ugliness of modem life',[8] that set up a dialectic that can inform an outlook on the townscape and landscape that constitute our surroundings, which are, as Bataille points out, the physiognomy of our society.[9]

It is the desire for collectivity that brings me to film, both in this essay and in practice, for while the experience of making a film may not be particularly collective, nor even the experience of seeing a film, the experience of having seen a film nearly always is. How then do films depict experience of space and especially of space transformed? I am attempting here to differentiate between depicting space, and depicting experience of space. This is in a way an unnecessary distinction: nearly all films depict space and in doing so establish, if only inadvertently, a presentation of how the space is experienced, an atmosphere. This comes about as the result of narrative, editing, camera movement and so on and results in the same kind of transformation that Louis Aragon describes in the passage I quoted in my introduction. Narrative, for instance, sets the scene, and it is with words that metaphors are most easily made. This is why the tradition I have outlined so far is essentially a literary one. It is also why there are more architectural critics than there are architectural photographers. It might be possible to list a number of filmmakers with an 'interest' in spatial experience, but I do not aim to be that pedantic. Suffice it to say that some films have more of a sense of the experience of space than others, and all that remains is to say how this might be.

I return here to the theme of townscape and landscape – external, public space. I do not ignore the importance of, say, *The Incredible Shrinking Man* or *The Attack of the Fifty Foot Woman*, but these and many other films that deal a lot with space are outside the scope of this essay. The spaces I

am referring to are the spaces of human habitat – buildings, townscapes and landscapes, and I refer to them as more or less discrete volumes: the space enclosed by the walls, floor and ceiling of a room, by the sides of a street or a valley, or a flat, featureless landscape and a few telegraph poles. We experience these spaces as enclosures or surroundings within which we stand, sit and move about, in contradistinction to objects, which we stand or sit on, and move around, in both senses of the phrase. The hollowness of space is what characterises the experience of it, and is what must be depicted in order to depict this experience. This requirement creates a number of difficulties both for film and still photography.

These start with the familiar one which is exemplified by, say, the lamppost growing out of someone's head in the holiday snapshot, but the problems of depicting three-dimensional space in two dimensions clearly do not end there. In architectural photography detail is important, as details help define scale and so, through perspective, depth. This is why professional architectural photographers use large-format cameras and fine-grain film. Cinematography is restricted to relatively small formats, but the large screen size and the absence of an enlarging printing process compensate for this. Film definition is in any case much better than television, and it is because of this, and the small screen size, that television movies seem to fail to depict space effectively, all the more so if they are made on video. We notice this when they appear on the big screen. In *The Long Good Friday* – conceived as a television movie – the locations are used not as spaces, but as signs, in a rather crude semiotic sense. We see A Dock, A Pub, A Church, The River, these all used as objects, not spaces, to denote rather than create the atmospherics of the story. On the small screen this might be an appropriate ambition, but the cinema offers other possibilities.

The size of the cinema screen permits depictions of space that approximate to life size, and so a sort of realism in this direction starts to become feasible. There is an incongruity between the situation of a walking pedestrian in a street and a seated spectator in front of a screen, but a convention as familiar as this can be transcended in the imagination. The essential problem is one of viewpoint: the eye takes in a much wider field of vision than the camera, as the business of seeing is infinitely more sophisticated than the business of taking pictures. In any case, the perception of space is not merely a visual affair. The wide view of 'eyes + brain' is augmented by memory, hearing and balance so that we have an awareness even of the space we do not see. In the cinema this awareness is replaced by another one constructed from story, memory of what we have just seen and sound-effects, incidental music and so on, but the problem of view remains. Wide-angle lenses take in more of immediate surroundings, but also exaggerate distance and so severely undermine the perspective so important to two-dimensional impressions of three-dimensional space. Wide-screen formats work best with landscapes, motorways and other horizon-type spaces, but in narrower, more vertical surroundings, perhaps with standing people, they become unwieldy.

It appears that to depict space in a film, you have to film a space that fits. This is yet another reason why nearly everyone makes films in studios and on sets. It is also why film is not very useful as a documentary record of spatial experience. Kevin Lynch's research work at MIT on imageability and memorability in the view from the urban motorway is described in his book *The View from the Road*. His team tried out subjective (moving picture) camera as a recording technique, but discarded it in favour of simple sketches and text, as the camera's combination of restricted viewpoint and lack of selectivity denied the advantages of its realism. At the same time, real architecture often does not make good film sets. In Joseph Losey's *The Servant*, for instance, the locations are carefully chosen and photographed – the pans across the trees and house fronts in Royal Avenue, and the transformation of the Queen's Elm that is effected by the omission of the smell of cigarette ends and sausages. In Losey's later *Don Giovanni*, the surroundings are Palladian throughout, and the film has a sort of sub-plot consisting of a fight between Palladio, whose spaces are on the whole rather tall, and the camera's horizontal format. The camera wins, and Palladio is at best sold short, and at worst a nuisance, except in the few wonderful scenes where the perspective suits the camera, notably those that use the *trompe-l'oeil* 'streets' in the Teatro Olimpico.

It seems, then, that making moving pictures of spaces and places involves the same sort of considerations as any other picture making – perspective, framing, proportion, left and right, and so on – even when the camera is moving, and especially when it is not. The virtues of this approach can be seen in those of Vermeer's paintings where there always seems to be more shown of the corner

of the room than there actually is. In other words, the picture of the very corner of the room is so good that we can infer the rest of the room from it.

This might be one way of putting experience of space into films. The first way that occurred to me, however, was the device known as 'subjective camera'. The paradoxical, special-effect status of this view depends on the camera's impersonation of a character in the film, and is entirely appropriate to the special-effect, heightened-awareness mood in which a new inspection of everyday surroundings might best be carried out. It is confined to fiction – there is nothing paradoxical about a hand-held walking-camera view on the news – and can be avoided by the over-the-shoulder view that Hollywood invented for this purpose. You see what the character sees, and the back of the character, and nobody gets mixed up. Similarly, when on the road, if a mere rolling perspective disconcerts, we can include, in order of cumulative appearance: the end of the bonnet; the windscreen with or without wipers; the steering wheel; the driver's hands on it; the dashboard and finally a rear view of the driver in the seat, though by this time there is not much left of the view down the road.

Paradox aside, these two types join with others in a wider classification which could be called 'moving linear camera at eye level', and is often used in combination with long, narrow perspectives. These are, for instance, the corridors of the hotel at Marienbad, the streets of Hiroshima and Nevers, the cellars and halls of the Bibliothèque Nationale, and other spaces in Resnais' films. There is no paradox here, no ambulatory camera movements, and the characters are in view, but the sense of space is still rather subjective.

Vehicles bridge the gap between subjectivity and the camera's view. A camera moving on a vehicle sees space in much the same way as a camera moving on a dolly in a studio, so the incongruity of the walking camera does not arise, even where there is no evidence of the vehicle's existence, as in the long drive at the beginning of Renoir's *Le Crime de Monsieur Lange*. Drives like this often occur at the beginning of films, as if to transport the audience into the film, and especially where much of the later action is in flashback, and the idea of time travel needs to be firmly established. This is also the case in Edgar G. Ulmer's *Detour* where the road view under the titles is, appropriately enough, looking backwards, again without any obligatory evidence of car and with plenty of camera shake. Both

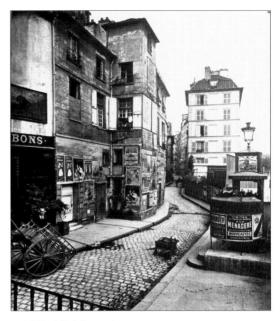

RUE DES URSINS Eugene Atget

Renoir's and Fritz Lang's versions of Zola's novel *La Bête Humaine* (*La Bête Humaine* and *Human Desire*) begin with symphonic railway engine's point-of-view sequences. Abel Gance, I am told, worked with Renoir on this part of his version. Both are intercut with wheels turning, engine driver looking out of the cab etc but the perspectives 'down the line and round the bend' do not include evidence of the engine and so show what might be seen if it were sentient, which in the narrative, it practically is. A connection between sensuality, eroticism and railways is firmly established at the beginning of the film, and by the time the narrative starts we are already used to the idea.

The ambiguity of the vehicular view can produce quite complex meanings from simple technique. My own attempts to film moving through space were inspired by a scene in Hans Jürgen Syberberg's *Ludwig, Requiem for a Virgin King*. The camera, mounted on a slow moving vehicle, looks ahead down a mountain forest track. We infer from the context that this is a sleigh ride, and we hear the aria *Come down to us O Night of Love*. There is no attempt at realism: the horses pulling the sleigh are definitely not there, and the tyre tracks from the previous take are clearly visible in the snow. The movement between the trees, which develops its resonances as music and camera proceed, suspends the irony we might feel, but it does not deny it.

It is possible to imagine oneself sitting in a room, for example, in two ways. The first is to picture what one would actually see – hands, knees, shoes, the floor, the walls, the window, the view out of it and so on – a subjective view that corresponds to the camera views at eye level that I have mentioned up to now. The second view sees oneself in the chair in the room, perhaps from outside the room or from above (though probably not from across the room, as one should generally not look oneself in the face). This is the view of oneself from outside, and is a reflective one, found not in the here-and-now, but in memories and dreams. Without going any further into the philosophical implications of this, I should like to compare two imaginations with two types of architectural drawing. The first of these shows, for example, what a person standing in a town square would see – an eye-level perspective – and the second shows the person in the square – an axonometric or an aerial perspective, perhaps presented as the view from a first-floor window. Strangely enough this second drawing tells us more about the experience of the square than the 'subjective' perspective, because we explore it, armed with our own eye-level memories of similar spaces.

In the cinema, the limitations of the eye-level camera view can be transcended in precisely the same way. In *Psycho*, we are given both views in the same take. At a particularly suspenseful moment in the house, the camera climbs the stairs in a rather subjective manner, then makes a rising pirouette to the ceiling of the landing, metamorphosing into something between a bird and a balloon. In Jean Epstein's *La Chute de la Maison Usher*, which includes some early walking camera, the recurring view is from high level in the huge room in the Usher house, with Usher himself painting or whatever in the opposite corner. The empty room is full of weather, denoted by the billowing curtains. There is a resemblance between this scene and that of the Blackpool ballroom in Humphrey Jennings' *Listen to Britain*, the weather replaced here by the swirling pattern of dancers on the floor.

Two films about memory – Chris Marker's *La Jetée* and Resnais' *Toute la Memoire du Monde* (his documentary about the Bibliothèque Nationale) – install the memory and dream quality of the view from above in the memory spaces of the museum of natural history in *La Jetée* and the library. At a higher viewpoint, in Eisenstein's *October*, the camera observes revolutionaries in the streets from behind a czarist machine-gun position on top of a high building, but our sympathies do not change sides. We continue to identify with the people in the street. This is not only because the context is so strong — it illustrates that it may be much better to convey experience of space from a point of view quite other than that of the characters whose experience is depicted. This is a political matter too, for here we come back to collectivity, and the transformation of the streets. Surely the stupidest way to film such events would be from an individualistic viewpoint (though this is how they do it on the news).

Higher still, we come to another view, not yet of the earth from space, but of Phoenix, in the long aerial beginning of *Psycho*. The higher we ascend above the city streets the more we can see, but the less we know about events beneath. It is left to us only to speculate with some statistical certainty that somewhere in our field of vision every secret crime and passion is taking place. Sure enough, when the camera swoops in through the open hotel room window, we find the lovers dressing. The implications of the aerial view are delivered.

In the end, it seems that it is the things that we do not see that are most important to the depiction of spatial experience in films. The threat, the bad smell, the mood: the picture itself is important not so much for what it shows of what is there, but for on the one hand what it does not show of what is there (the corpse in the wardrobe), and on the other, for what it does show of what is not there (the enigmatic qualities of the furniture and the cloakroom tickets). The space has to be properly depicted, but this is only groundwork, on which the transformations that the cinema can effect are built.

1 'On Decor' in *Le Film* September 1918', reprinted in Paul Hammond (ed.) *The Shadow and its Shadow*, London: BFI, 1978.
2 From *Entretiens*, Gallimard, 1952.
3 *Eroticisme*, Editions de Minuit, 1957.
4 Bernard Tschumi writes on this, and Bataille, in 'Architecture and its Double', in *Architectural Design*, April 1978.
5 Both works reprinted in *One Way Street*. New Left Books, 1980.
6 'The Work of Art in the Age of Mechanical Reproduction', reprinted in *Illuminations*, 1970, and in 'A Small History of Photography', reprinted in *One Way Street*.
7 'Self-realisation, Communication and Participation' (Chapter 23 of *The Revolution of Everyday Life*), Raoul Vaneigem, 1967, as translated and reprinted in *Leaving the Twentieth Century*, Christopher Gray (ed.), Free Fall Publications, 1974.
8 *Paris Spleen* is Baudelaire's last manifestation of these, writes Lewis Piaget Shanks in his biography, quoted in the New Directions Paperback Edition of the former.
9 In his entry architecture in the *Dictionnaire Critique* in *Documents* no. 2, 1929.

'shadow of a journey'
tom giles, peter wollen

Shadow of a Journey begins, visually, with a movement of watery images flickering across the screen; and meanwhile, on the soundtrack, a woman sings a Gaelic song. Shadows on the sunlit water are identifiable as those of a ship's railings, a life-jacket and one or two passengers. Evidently the film was shot from the ferry whose passage is causing the water to churn across the picture. The film locks into the viewer's continuum and the lilting song is complementary. The apparent situation is the familiar one of a journey during which the passing scene is registered but only partially engages the thoughts.

During a break in the soundtrack the mechanics of the film can be more clearly appreciated: it is made up of a series of repeating sequences which are processed in such a way that the discreet frames are almost distinguishable; the separation of light and dark is exaggerated; and visually the result is a series

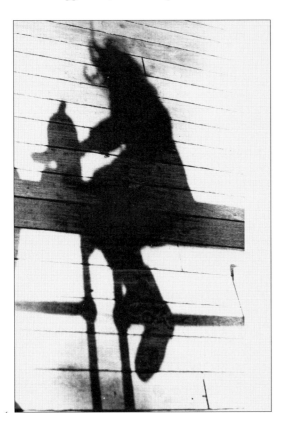

SHADOW OF A JOURNEY Tina Keane

of images which remind me of some abstract paintings. This is interesting but the effect on the eyes hovers on the border of discomfort. When the soundtrack resumes, there is a dislocating shock; for what is now narrated is the traditional account, verbally transmitted by the female generations, of an episode which took place on the Isle of Harris some 130 years ago when a rapacious laird, with the assistance of the British Army, evicted 30 families from their crofts. The slight visual disturbance caused by the film now relates to the much greater one caused by the pathos of a story which is one tiny specific instance of the sum of misery caused by exploitation and greed.

The dislocation of one's perception from the real-time continua set up by the film into the past of the historic episode is achieved by skilful timing and juxtaposition so that a single image (the water) is seen to belong to both film and story. It is that of the channel being crossed in the ferry; it is also the Atlantic which the evicted crofters had to cross in mid-winter to exile in Nova Scotia. Furthermore, as the narrator describes the flames of the burning crofts fired by the Red Coats, the colours of the film change from greens to purples and pinks, transforming the images so that now there is a resemblance to flames. The visual imagery therefore has a dual existence both as a record of a recent real-time experience to which we can relate directly and as a part of the story: it becomes, as it were, a bridge by which the viewers can cross, from their own personal reality, to that of others many years ago and thereby imaginatively share in the horror of the experience.

The strategy of juxtaposition of two separate elements, one a specific focus, the other a continuum, is a familar feature of Tina Keane's work. In *Shadow Woman* a recitation of the events of life for the immanent female was juxtaposed with a small girl who played through the sequences of hop-scotch as we watched. This game is as old as recorded history so 'as many generations of girls have played this game as women have passed through the shadowy life of the recital'. Gradually the real child lost her identity and was transformed from an individual at the beginning of her life-adventure to an anonymous unit of repetitive history. In *Playpen*, a pre-recorded video of women aged from 6 months to 80 years was juxtaposed with Tina Keane herself sitting in the playpen with a camera placed so

as to pick up this scene for relay on a second monitor. By manipulating a mirror she was able to interfere with the camera's age of vision and feed into the monitor the reflections she picked up with the mirror. The reflections were of course of ourselves and we became both observer and observed. (I was reminded of the last scene of Virginia Woolf's *Between the Acts*, where mirrors were used to make the audience see themselves as part of the pageant of history. In fact, there seems to be much in common between these two women artists: Woolf also typically sets minute fragments of real lives against a continuum: e.g. *The Waves*, *To the Lighthouse*, etc.)

The full significance of Tina Keane's work does not lie in any of the separate elements but in the resonance of the juxtapositions she contrives. And I use the word 'contrive' deliberately, for there is nothing random about the formal devices she deploys to effect her fusions. But these are not immediately obvious. They are there, but fastidiously understated. The burden is on us to pick up the clues and mentally and imaginatively effect the significant combinations. It is what happens within our minds which is important. Her work is a sum of magnitude which greatly exceeds the unassuming parts she puts together.

after seeing 'shadow of a journey'
peter wollen

1. What are films but shadows? Shadow-shows. 'The proper name of my exhibition is Lez Hombres or the Shades; that's the proper name for it, for Baron Rothschild told me when I performed before him.' 'We calls it the Chinese show.' The showman Mayhew talked to in 1853 wanted to put on a shadow-play with human figures instead of cut-outs, but the theatre cost too much to rent – a disappointment, it would have been 'one of the most beautifullest scenes in the world'. According to tradition, the shadow-show was invented in the reign of the Emperor Wu Ti, more than two millennia ago. For so long the sight of moving shadows has been one of the most beautifullest.

2. What are films but journeys? There is a strange effect of movement in *Shadows of a Journey*. The moving ship (its shadow) is stationary on the screen, but the sea across which it travels is moving. The sea is a screen which rocks and laps and the shadows thrown on it seem to float on an imaginary surface.

3. In 1969 P. Adams Sitney wrote a notorious article in which he defined 'Structural Film': 'Four characteristics of the structural film are a fixed camera position (fixed frame from the viewer's perspective), the flicker effect, loop printing (the immediate repetition of shots, exactly and without variation), and rephotography off a screen'. *Shadows of a Journey* is fixed-frame, looped and re-photographed. It is tinted, it has a grainy texture, it changes time, it is reflexive, showing us the shadow of the camera which is shooting the film. Yet when I saw it, I did not think of 'structural film' at all. In fact, it seems forced to mention it now, though it fits Sitney's criteria better than many films he and

others have deemed 'structural'.

4. The story of the Clearances and the sound of the song in Gaelic give the film a particular meaning. It is a link in a chain ('As I have heard from my mother as she has heard it from her mother') of women's unwritten memories taking us back into the historic past, itself a precarious journey. The '45 is at the far edge of memory, as the island of Harris is on the far edge of the continent, the last inhabited place. Even there the homes of the people were burned and they were driven out. We journey to hear of another journey, across the sea to Cap Breton, exile and yet further hardships.

5. 'The horrible old days. … It is, I think, better forgotten if one could do it'. But she cannot: the story is 'indelible in my memory', anguish medicine does not know.

6. I said to Tina that it sounded as if the story was being read, and she replied that it is told in Gaelic: its speaker had to write it down to tell it in English. The story was heard and spoken in its own language, Gaelic, and to record it in English meant to deviate through writing and reading. Soon afterwards I met a friend whose family came from Cap Breton. His grandfather had fled there from the Black Hundreds. 'He spoke three languages: Russian, Yiddish and Gaelic. He thought Gaelic was English because he knew they spoke English in Canada'.

7. 'The one good thing about Cap Breton was that you didn't notice the Depression'. Art is one way of noticing hardships and beauty is one resource for combatting them, even the beauty of shadows, mere moving shadows.

on wounds, artificial flowers, orifices and the infinite: a response to the films of nina danino

jean matthee

To experience Nina Danino's film, *Stabat Mater*, and then to write about it is to attempt to grasp a complex network of associations and changing relations, tracing lines that are neither logical nor chronological. Connections arise and pass away, through associations of ideas that approximate the play of metaphor and metonymy, images and experience, turn and return, intersect and transect, oscillating to and fro in an endless series of detours and displacements.

Nina Danino's films, *First Memory* (1981), *Close to Home* (1985) and *Stabat Mater* (1990), are matrices of codes, rhetorics, signs, styles and strategies developed to cope with, explore and enact the dimensions of an invisible crisis of meaning, identity, difference (moral, religious, political, aesthetic) and the paradoxical absurdity of trying to draw near to an illusive M/Other,[1] who leaves traces, inflicts wounds, unsettles and displaces subjectivity and language while remaining uncaptured by them. Language fails, always fails, must inevitably fail. The pain of the failure remains as a pressure within these texts. Her films are not a self-sufficient or self-satisfied expression of this crisis, a mere formalism of the signifier, but find repercussion in psychical pain felt as an experience in/of these texts. Pain, loss and fundamental incompleteness mobilise these films that oscillate in irreducible ambiguity, provisional solutions of flight from loss and immersion in loss, while longing to suture up the gaps, wants, lacks, holes, wounds through the phantasised memory of plenitude, of union, of completion, of presence, of immediacy and of satisfaction even, of the self being one with the mother.

What the experience of these films uncovers is the radical absence behind this phantasy precipitating the excruciating possibility of an impossible encounter with a non-representable M/Other. 'The Woman'[2] who comes toward the light does not enter signification but is signalled as a pressure, through; the disruptive rhythmic syntax, the destablised framing, the play of difference that reveals difference, abject reversals, the momentary loss of meaning and desire, oscillating ambiguity, the voluptuous signifier/grain of the voice swaying the text toward an excess that breaks phallic closure. Like all dreams, phantasies and the body in representation dispersed by desire, Nina Danino's films have the inscription and performance of Patriarchal Law on them. The films enact this violation, that of being incurably wounded by language and vice versa, the wounding of language and subjectivity by M/Otherness.

Nina Danino's films, as do other films by Sandra Lahire, Jean Matthee, Jayne Parker and Moira Sweeney enact and explore the dimensions of a predicament of *The Woman* lived as femininity, that is a masquerade. At the same time trying to refuse this reduction to a mask, attempting to disrupt the seductive agreement of woman with/as the image. This work forms part of a larger body of work that is obsessed with the feminine as the lost cause. This enactment and attempt to recover the loss has produced various strategies. Here in the context of a response to *Stabat Mater*, Julia Kristeva's concept of the semiotic chora appears to have been enabling, as a way of emphasising the reality of the drives (semiotic) in the Imaginary. The more or less repressed semiotic pulsion that puts pressure on, or within, the homogeneous monological closure of the symbolic order – positing an excessive or transgressive Other. This is a way of opening the image and the body of the text to the lost cause who is feminine and 'is not yet'.

The films of the artists mentioned bear the traces implicitly and explicitly of the impossible paradox of *The Woman* as 'artist' enacted textually. To be *The Woman* as 'artist' is to be in many places, both specific places and no place, at once. It is the impossible solicitation, to be both subject and object and neither subject nor object at once. In other words, the woman artist is compelled to take up the position from which she can gain the 'correct distance' for the dialectic/logic of desire through which she can read, produce and manipulate representations, be a simulacrum of; the subject of language, the place of the phallic interpretor, the place of 'the one who is supposed to know'. While at the same time as a 'woman' in the field of signification she must produce herself as an object of desire and be the signifier which guarantees the operation of the phallus. In the field of signification for the woman to hold on to her desire necessary for the representation of desire/art she would be considered to be transgressive, to be a thief of masculinity, punishable with excommunica-

STABAT MATER Nina Danino

tion from femininity: 'If the masquerade goes, taking femininity with it, what is left?', 'When women give up the masquerade what do they find in bed?', 'This difficulty is the price they pay when they leave the masquerade'.[3]

So, in the field of signification she is compelled as a woman, to be the object and as image-maker, the subject. ~~The~~ Woman as 'artist' furthers this undecidability and oscillating ambiguity even more. For ~~The~~ Woman is in her alterity neither subject nor object but a radical difference that cannot be described and whose otherness undoes identity and the fiction of the 'one who is supposed to know'. ~~The~~ Woman reverberates and troubles against the concept of the masquerade and 'what it can do for women', whether the concept is understood as alienation, or fulfilled femininity or as a hyperbolised strategy for the attainment of feminine desire as represented. In other words the point I am trying to make is that to be a woman artist is to live out an impossible predicament of suffering, anxiety and sacrifice, no matter which way one looks at it.

I recognise in Nina Danino's films the traces of this impossible dilemma of undecidability and oscillation of ambiguity, as though the only space from which the films could be made is at an impossible threshold of demarcation where the prohibition and the ideal are expected to come together in her and in her films as kinds of fetishes to protect the phantasy of owning the phallus from the fear of castration. Nina Danino's films struggle for more, more, more, from language and from subjectivity through a developing toleration of textual ambiguity, that is perhaps the alterity of the M/Other.

To unveil this radically different M/Other would be to unveil perhaps the site of castration, lack and the loss of meaning? This would involve a transgression beyond the demarcation and limit of the logical binary differences that secure identity within the dialectic of expenditure caught in the concept of the Master/Slave. This transgression would undo the economy of accumulation, mastery, utility and the enslavement by mediation. It would be an expenditure without return. This encounter with the M/Other would be an encounter with meaninglessness which is not possible for identity or representation. Hence Blanchot's claim that a certain kind of art is an absolute like madness and death. As Derrida suggests, through the adventure of a poetic movement one can approach a relationship of meaning to this unmeaning. To make a film is in a certain sense a compromised and restricted enterprise. A film is always in a certain sense a fetish, something standing in for something else, the bringing of endless possibility to a controlled and reduced possibility. Condemned to a certain compromise Nina Danino approaches alterity through the pull and play of contradictions across certain limits in the sketch of a poetic movement.

Nina Danino's films are mobilised by loss and defend against loss, the Law demands that they protect against castration, while they simultaneously try to sway toward jouissance. To experience jouissance is to suffer loss, the loss of desire and the impossibility of satisfaction. Like all texts these films have elements of complicity, but it is in the nature of poetry/experimental film, to do many things at once. Her films, like dreams, have the capacity to misbehave and they do. They are like duplicitous, anarchic cries against the socialising, symbolic, syntactical order.

The films' logic of desire propels an interpretation of gender signifiers and their relationship to the fear and site of castration without being reduced to this. Through the ambiguity of the metaphors and the purposeful state of ambivalence and irreducibility of gender, one finds in her most recent film *Stabat Mater* a locus of play and a dynamic of reversals in which opposites are opposed, the movement and play that relates these opposites to one another, reverses them and makes one side cross over into the other: dead/living, inanimate/organic, closed/ open, dissimulated/unveiled, robed/unrobed, phallic/invaginate, spectacle/chaismic, outside/inside, contained/uncontained, ideal/base, restricted/general, the particular/the Infinite, masculine/feminine…

These reversals at the threshold of an archaic boundary produce an experience of abjection and

STABAT MATER Nina Danino

STABAT MATER Nina Danino

in this irreducible ambiguity can be found what remains of the sacred. As Julia Kristeva points out, the death of God is an aesthetic event, the site of the sacred has moved from religion to art. What remains of the sacred can be found in art's remains. The space of art as the possibility of an enactment of sacred rites that activate a searing encounter with the Real.[4] For Julia Kristeva, this encounter can produce the w/rite/ing[5] of the Real. The transgression of the archaic boundary that demarcates the proper and improper body, the clean/pure/ideal and the defiled/contaminated/erotic body rends the separation of logical differences on which identity depends and vice versa. For Lacan the Real is the woman as Other. In the Western tradition the voice of the Other is always the voice of the woman. Nina Danino's film is this movement from the known to this unknown Other. *Stabat Mater* (There Stands the Mother) trembles under the pressure of these kinds of tensions.

The back and forth oscillations of images and associations across a certain demarcation, a veiling and unveiling, dressing and undressing, robing and unrobing, of 'the mother's garden', in the imagination, echoing the framing and re-framing by a hand-held camera, with shots cut as an unpunctuated torrent building and constructing the spectator's experience as chaismic. The corporealised vision of the spectator, seeing from where the camera is, in a shifting unsteady swoon, in some kind of effusion: devotional, poetic, erotic, melancholic, sacrificial?

a lush garden … a stone virgin … the mother's garden … stone grave … a flower … the virgin bride … an artificial flower … mother's voice … a deserted street … the veiled virgin … a blue sky … the virgin's lament … the voluptuous voice … the madonna … the sorrowful mother … torrent of words … apotheosis of virginity …

the rhetoric of a realist image … a syntax of jouissance … the hollow of a blue bay … Infinity… the rose … the madonna's flower … the lover's flower … the flower's blossom … the flower of the cross … a dead God … a stone phallus … nothing sadder than a dead god … a spiritual veiling of castration … all stinking tatters … melancholy … blue spacing … the mother's body flowers … the stony tower … a pagan lament … palms … the opening and closing of eye irises of sphincters and camera apertures … the flower of the madonna's body … the unveiling of the veiled one … the flowers of the body of the mother … the resuscitation of a stony ideal … something base … the Infinite

These reversals and play of difference across archaic boundaries of pure/impure, the crossover of the ideal with the erotic puts death into the deathless mirror. As an imaginative and psychological operation, a third dimension of meaning is produced by the reversals, but not presented positively in the film as a positive thing but not as a no thing either but as a vertigenous slippage of meaning.

I found myself imagining the possibility of unveiling the Virgin Madonna and almost thinking the unthinkable, imagining the unimaginable, that of a voluptuous encounter with her blossoming body flowers. The orifices of the body boundary, being the weakest point in the demarcation of inside and outside, the necessary separation for identity. This imagined possibility of an imagined encounter of a daughter with her M/Other. This unveiling; imagined, spiritual, psychological, physical, was akin to a movement that might lead to a tearing of the boundaries of the cultural 'I', a voluptuous encounter with the possibility of an impossible uncovering of the wound that could be the site of castration, without being reduced to it?

The film and my experience of it was achieved through a certain fullness that resembles a hollow lack in which tolls the woman's cry – Encore, Encore, Encore! ~~The~~ *Woman* who comes, comes towards signification but delays, delays infinitely. The name of such a feminine God is a nameless name, the name of the mother that can neither be mastered, possessed, stripped bare, nor laid bare, that one writes by not writing. A wound that always lies open between the shots and the words and sounds of the film it both supports and undercuts.[6]

~~The~~ *Woman* can neither speak properly nor be spoken but can be heard in her cry. ~~The~~ *Woman*'s cry. This cry is inseparable from a repetition beyond the pleasure principle, the repetition of unpleasure. This transgressive cry that goes beyond the limit breaks up and rends. It can never be incorporated or domesticated. The apprehension of it is this certain throbbing oscillation that cannot be comprehended by reason.

Nina Danino attempts a risking, a putting at stake, a trying for something beyond the concept of immediacy or presence, or the dutiful enslavement by mediation. The film attempts to burst out, to break out, to liberate all that is enslaved, but to represent it is to lose it, so it must paradoxically remain in excess of a text that is condemned to compromise.

Stabat Mater's soundtrack is more a lament that is perhaps more a cry (le cri that disrupts écriture/ le cri of l'é-cri-ture), (an abject cry for what is lost),[7] (the cry of more, more, more that is the jouissance of the woman as Other).[8]

Stabat Mater's image track is more the burst of a shattered mirror, which is perhaps more the ego giving up its image, which is perhaps more the impossible look of oneself in the Other. That is, the Other within and the Other from without.

Stabat Mater is a film that is more of a poem, that is more of an anarchic cry – its aberancy is a feminine operation.

On thinking how to 'end' with an openness that questions the certainty of a conclusion I thought of this:

… then the opportunity will come and the dead poet who was Shakespeare's sister will put on the body which she has so often laid down. Drawing her life from the lives of the unknown who were her forerunners, as her brother did before her, she will be born. As for her coming without that preparation, without the effort on our part, without that determination that

when she is born again she shall find it possible to live and write her poetry, that we cannot expect, for that would be impossible. But I maintain that she would come if we worked for her, and that so to work, even in poverty and obscurity, is worthwhile.[9]

Woman (truth) does not allow herself to be possessed.

The truth about woman does not allow itself to be possessed.

That which truthfully does not allow itself to be possessed is feminine.

One must not hasten to translate this as femininity, as the femininity of woman, the feminine sexuality, or other essentialising fetishes: this is precisely what is assumed when one remains at the vacuous level of dogmatic philosphers, impotent artists, or inexperienced seducers.[10]

… the author is only a link among many different readings[11]

1 For Julia Kristeva, the woman who is the other woman, the woman who is Other, is an Other that is perhaps 'the nonlogical difference of matter', matter that is mater, who is mother. For her the mother that matters is the M/Other. This mother is the 'dirty' mother. (Julia Kristeva, *Powers of Horror: An Essay on Abjection*, New York: Colombia University Press, 1982.)

2 Lacan writes 'The Woman' as ~~The~~ Woman. The woman is for him a no thing that must forever be blurred. 'There is no such thing as *The* woman since her essence … she is not at all … This *the* is a signifier characterised by being the only signifier which cannot signify anything, but which merely constitutes the status of *the* woman as being not at all which forbids our speaking of *The* woman. There is woman only as excluded by the nature of things which is the nature of words.' Since she is always excluded by the nature of words, The woman is the no thing that must forever be barred in/from language. (Jacques Lacan, *Feminine Sexuality: Jacques Lacan and the ecole freudienne*, Juliet Mitchell and Jacqueline Rose (eds), New York: Norton, 1982.)

3 Borrowed from Stephen Heath's paper 'Joan Riviere and the Masquerade', *Formations of Fantasy*, Methuen.

4 For Lacan the notion of the Real is that which resists symbolisation and has a paradoxical character.

5 For Julia Kristeva the artist after the event of the death of God in the absence of religious rites takes on the impossible task of writing the unnameable and unveiling the abject. Kristeva cit. op.

6 Here I am indebted to Mark C. Taylor's use of Jacques Lacan's most important seminar *Encore: Le Seminaire XX 1972–73*, Paris: Edition du Seuil, 1975. (Mark C. Taylor, *Altarity*. University of Chicago, 1987.)

7 Julia Kristeva.

8 Jacques Lacan op. cit.

9 Virginia Woolf, *A Room of One's Own*, 1929.

10 Jacques Derrida, 'The Question of Style', *The New Nietzsche*, (MIT Press), 1985.

11 Georges Bataille.

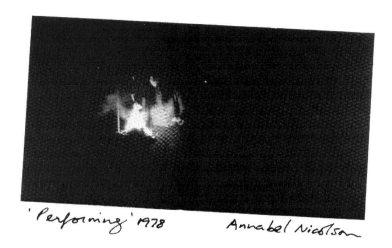

'Performing' 1978 Annabel Nicolson

'there's a flower called the night blooming sirius it's a semi-
tropical flower and it's kin to the lotus and it only blooms one
night of the year I remember my mother telling me how her
grandmother used to invite friends to come round on the night of
the opening they would sit together and drink home made wine and
they would watch the night blooming sirius open they had to sit as
close as possible to the bud because this flower only opens in the
dark and once it does open it gives off the most beautiful fragrance
I remember when I was a child and I first saw this happen I went out
to the backyard and I stooped down as close as I could to the night
blooming sirius and I was there for a couple of hours just watching
and I had the feeling that if I looked away even for just a second
I might miss the opening'

"I remember other figures around me...I remember my grandmother
and I remember my great grandmother who were really very important
figures around me...especially my great grandmother had something
very powerful for me...she used to tellme a lot of stories you know
a lot of very old stories these kind of stories between magic and
superstition that people living in the mountains..quite isolated
they keep these kind of stories..these kind of fables my great grand
mother used to tell me...I was fascinated by this kind of relationship
between me and my great grandmother do you remember any of the
stories no I don"t remember stories I just remember the
feeling when she was telling me these kind of things'

Yes. I suppose for a long time I forgot that feeling and when
I could again feel this very strong relationship with the nature
around me it was very important, because it's not only nature, it's
a way a child looks at nature, which is really something with magic.
I think if you have an experience like that when you're a child it
signs you. It's something that stays in you for a long time, but you
can't be a child anymore because you have to face society with all
sorts of roles and for women there is so much pain in doing that.
Of course you have to, not you have to - you forget. It's a part of
you which stays inside. It needs something to get out again, some-
thing that can touch your body, so your body can change again
and you can feel the same kind of magic feeling with nature and
you can look at nature in the same way. It's not at all nostalgic,
it's just recovering something that's yours. It's very important
because we take a lot of our creativity from that point. There are
conflicts also becuase it is not something so easy to recognize.
Going back is not easy because you have to face something, so there
there are a lot of conflicts in doing that. I think it's very important
to remember the first feelings we had about the world, this very
strong relationship, we have to recover something, we have to talk
about it, we have to try to remember. Also try to remember what
happened to make us forget, to make us enter roles that restricted
us, took away space from us.

landscape in 'i dish'
jayne parker

Landscape in 'I DISH': I didn't really think about it, other than that she should be by the sea digging, with her back to the water. Wind, sea, sand, light, all clean and cleansing. I chose a sea-scape with a lot of sand. A vast space. Noone there.

Through the camera: I didn't have to go back very far for her to look quite small. I watched her from a distance, respecting her, her space, her privacy. In a space like this the camera, light meter, tripod, are very small. They are minimalised. It isn't she who is being made small, it is the camera.

I didn't observe her in close-up. The close-up shots are from her point of view.

She is on the edge of the frame. She is on the edge of the landscape digging out of frame. She is not contained. She is reaching for something outside. The landscape continues in the dark. At first she can't see what she is digging for, but she knows where to look, where to start digging. She feels the ground with her hands. She is working the landscape. She isn't simply part of nature. Compared with her energy, the landscape is still. She has more energy than the wind. In the stillness she is purposeful, content, at ease. This is the open landscape.

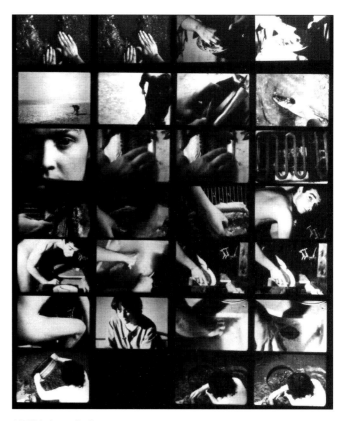

I DISH Jayne Parker

She is never vulnerable in open land-scape, not even when she is naked in the pond – which is a metaphor for the inner/third landscape which is inside her. You have to be naked to clean inside. He only cleans skin in the room. She cleans inside where things collect and grow.

Life is warped hope dug in
Women are holes
Things grow and fall away
from the inside.

She is only vulnerable in the room/closed landscape/his landscape. There is a lack of land-scape for her in the room. She is contained, restrict-ed, fettered. Everything is tight. His landscape/room is a closed space which he possesses. He occupies it completely. Her movements are confined to the edges of his space.

She has an outer landscape and an inner landscape. Only the inner landscape possesses her. This inner landscape is littered with hooks by which she is caught. The inner/third landscape is itself a hook. You cannot detach yourself from your sexuality.

OPEN LANDSCAPE: SEASCAPE
Digging for fish
MOVES TO INNER/THIRD
LANDSCAPE: POND
Sifting for hooks

VIA

THE ROOM/CLOSED LANDSCAPE
She cooks
eats
waits

'13 most beautiful women' and 'kitchen'
peter gidal

The question of a filmtime which *contradicts* in its machinations that of dominant cinema, both fiction and documentary. The unstopped duration, the concrete material passage of time 'upon something', foregrounds the lack of edit.

But this is not therefore 'more real', it is the particular, concrete, i.e. the remnant, that which is cut from the rest. It doesn't stand for the rest, is thus not a symbol or metaphor. And it doesn't allow you to be in a position of knowing the rest from it (logical deduction, rationalist truth, etc). It presents itself, its apparatus, as one *extreme* function (therefore as arbitrary), choice, a selection, a part, a difference. A relation, thus, between the time of the film's passage through the projector and the time of the film's passage through the camera, *and* the time of 'the' film's reception (thus) by the viewer. Thus a concept which proposes the existence of 'shot' in cinema as dialecticisable.

It (unending duration) positions the viewer in a place of seeing, i.e. perception, without conflating that into knowing (as it is one extreme function, *not* the whole), without mixing the two up. The separation of the two underlies avant-garde film practice from Warhol on.

So, each moment, each filmmoment, is a specificity, inseparable from the mechanism (of its repreduction) and from one's relation and thought (and unthought expectations) to it. The filmapparatus, in other words, can't be meta-physically subtracted from the film, from the effects produced, which are given, here, as specific transformations of and in film and filmmeaning. This opposes conventional film fiction or documentary which always necessarily disallows a production of effects presented. In such film we are in an imaginary space, and imaginary time, a seamlessness, a whole, in a position of our seeing equalling our knowing, 'science' and 'fantasm' becoming one, etc.

Of course always each effect is a specific effect of film in film. But Warhol's work here is a begin to such problematic being *engaged* (I am overreacting further into the problematic than any one Warhol film singularly does).

I am talking of the film as a work with its problematics, in the context of what (other films) we are about to see, as often advances help elucidate the prior, which may have had certain aspects sub-merged in certain other, at the specific historical time more dominant readings (such as with the Warhol films, the specific profilmic event; though in form that problem is constant. The different pro-filmic contents take on differing orders of importance in different historical moments).

Thus, for example, the subject matter of Warhol now seen with a difference, or even a distance, compared to the early 1960s, which does not deny what the film's mechanisms were instituting materially. It isn't as if each moment in history has an interruption, or a production, has a different set of contexts and meanings with the film becoming yet again mere pretext for the most suitable. A film, a production, has concrete effects. Opposition too aware of context can become formal play – opposition unaware easily irrelevant (i.e. retrogressive). Leave to later questions of what their final determinations are, and by what they are finally determined.

Problematics in the early Warhol *13 MBW*: duration, frame, character, viewpoint, illusionist/imaginary space (depth), sound. The silence, durable, brings itself forth versus the possibilities of (imagined) offscreen sound. This 'imagining' is not some poetic act on viewer's part, but rather, the imagining constructed by cinema in the sound-cinema epoch. Any vacuum established, any 'timelessness' that is produced as a thought or feeling from this film is thus in opposition to something else, something not there, sound. Thus a constant defence against a difference, and a constant problematisation: why this not that (these questions do not come up when the dominant given conventions are fully utilised, there are then no absences, always nothing as part of something, always something as part of something. Always a fullness perceived in that other system (consciously or unconsciously in the way one is positioned, finally, in knowingness). The vacuum established in that noiseless period of duration is full as the noise in so many other Warhol films (*Kitchen*), machines rattling, banging, moving, cups being moved, people, appliances, etc. In *13 MBW* silence makes discrete from whatever else there 'is'. Again and again it brings one back to the film, its concrete abstractions: concrete, as in a specific series of effects, images, relations … abstract, as in meanings, philosophical materiali-

sations, inseparable from the material unreeling. Limit is the film's 100 ft. 'end' (or 1200 ft. 'end') not onotological and necessary but a convenience given as such (enough is enough, philosophically and materially).

The image in *13 MBW* is a head staring back … the question of the given line from your eye through the cameraperson's, the cameralense, through to the subject to be identified into, who, looking back, becomes the object of your viewing, but this as in all cinema, only here foreground, made (un)clear … specifically resituating the viewer *from* that line. The shift for the viewer, for his/her identifications, takes place: am I, viewer, as behind and through the camera-eye therefore filmmaker, identified (by the apparatus or by my self) with (in this case) him, or with some person in the unseen space. The subject of the film looks into that space; our identification mechanism would allow that. In fact where is the justification given to make that clean decision of identification into the one or other, or are we not constantly undermined in our knowing where that identity is, placing us in unknowingness. Inability to grasp the truth of a representation, and the problem of sexuality in the making of that 'truth': wherein is sexuality the emanation of a biological given: in *13 MBW* is any facial enactment feminine and if so, how is that act ingratiated, the character producing it constituted by it? Is it not, conversely, visage as visage, the voyeuristic camera stare which premises a (repressed or not) stare back. This latter would be an obsessive engagement with staring and staring back predicated on the materialism and the specified historical moment given: 2 stares.

The above points to a realism, but one not of reproducing a series of meanings, or even questioning them, but of *enacting* a *procedure* inseparable from the mode and process of film and cinema. The determining factor historical not eternal is the process of attempted reproduction, i.e. the cinematic apparatus. Also, in *Kitchen*, sexed positioning always is an enactment taking account of the camera to whom it is addressed and to film which in its unceasingness makes demands, aggresses by its refusal to abstain. Sexual role-playing within the script in *Kitchen* is imbricated with this apparatus cinema which is one point in the circle as opposed to a viewing-plane here looking at a viewed plane of theatre there. Little is left when the process is ended. It might do to remember that in most

13 MOST BEAUTIFUL WOMEN Andy Warhol

cinema much is left, most of the meaning is left, retained, extracted, the process long having been concluded, and it might do to remember that surplus meaning, that value retained, is precisely surplus value in meaning, expropriated, resultant from extreme division of labour. So there is a political question in the aesthetic which too must be answered: in whose interest is this exploitation of surplus for consumption (as opposed to institutionalisation of production) . Production is a discourse not a religious 'moment'.

I won't discuss here the more overt parodying of sexual role, and the equation of impotence with male sexuality, and obsessive repetition in compulsive act and speech act with the active female sexuality, both as parodies of existing conventionalised forms, without an interior logic sustaining the characterisation, no *a priori* whatever. Sure there are economic, sexual, ideological determinations but they're not to be historicised away from *this process*. Sexuality and sexed positioning as convoluted, (and hysterical, hysterically funny) disallows the holding onto type, biological or otherwise, Lacan's constant rememoration becoming thereby a memoryless carrying-on never though in an anarchic forgetting of the closures awaiting each position and the concommitant oppression; thus the next move is motored. The real, as residue, nothing else left, no choice, this material all: such politics. (Note: not anti-psycho-analytic or antianalytic, just anti-evolutionising to *another* process.) Are we not constantly undermined in our knowing where identity is, placing us in unknowingness. Inability to grasp the truth of a representation, not able, disabled, from our being placed in the position of an in an imaginary fictive

or documentary 'real'. Now this could be political if such placing of the viewer is political. If it is not it is not.

A psychologistic interpretation can never be totally voided from any production, and with the Warhols the nihilistic formulation is evident in the movement towards stasis, the constant running out and down, towards entropy, unpleasure principle and deathdrive. Possibly this persistence of movement upon that which moves less produces such a nihilistic stance. But the machine (camera, projector) as unstoppable, durable, and unendurable. *And* 'the cinema' as machine.

In *13 MBW* any deepspace centre point out from the film (frame) is problematised that is to say it doesn't situate you comfortable within a convention of normalcy in relation to image, narration, etc … you find yourself placed easily with difficulty, somehow recouped by the representation yet viewing it without an end (no narrative which can be followed and no implied narrative which can be phantasmed ahead and then retrospectively justified, made straight and even, technologically) and without end, the moment to moment movement of it always in reference to the moment to moment movement of you, viewer as separated, precisely not co-opted; viewer and viewing as not excised or repressed.

The problem is that from this one could conclude: unrepression. As if there were this blanket or veil which once lifted could betray the (ever-present) truth, whilst the point is precisely not that but the present in a non-metaphysical (i.e. noneternalised, semiotic, impossible) sense: each concrete labour has effects and produces effects and the viewer's incorporation (as a term of relation for that process) is a specific effect which in *Kitchen* and *13 MBW* is problematised by not being given as natural and prior to and free from that which constitutes it. Material relations form the 'I'. As such, then, there is no present, as the signifier signifies each moment something not-here.

If the observer is part of the system observed (inasmuch as such words then can have a meaning) no forms can precede the perceptual activity, yet of course they do (the acetate with its recording of light, producing images) often in early Warhols a stasis through lighting which allows space only to be constituted in and through action, not separate as a 'real representation'. At the same time since ideology resides in all representation, and the viewer is embedded in the ideological, the

primary materialist function can hardly be ascribed to the (conscious or ucs.) viewing subject. Here the difficult problem of ideology (in certain interest we are positioned in certain ways) versus the phenomenological comes forth. The short way out of this must be to see the ideological as constantly placing the 'I', a cipher, contradictorily, and oppositionally though not only when a politics of opposition is *chosen* (the contradictory objective placing through ideology may always include oppositionality but the latter for various historical reasons of each individual in relation to what ideology in fact is, is usually repressed not to say supressed). Ontology and epistemology are not divorced but seem so, – the phenomenal must be seen as the non-existent but phenomenal. Self as cipher as effect of apparatus' ineffable stare (duration): and as cause which in turn effect of another, political, apparatus. So in fact all film practice a negation practice, not a constituting different practice which can then be fetishised difference, fetishising difference, as substitute for stylistic.

no intention

The actor's role 'vis à vis' or rather *in* the film image ('acting') and the question of any represented self as opposed to a character taken up and dropped and not even that by some 'one' but by a 'one' inseparable from those characterisations which destroy not only narrative but character. Thus the unfixed locus of the actor's presenting of self, the support structure for the 'aura' 'of' 'the image' is in Warhol's early films fragile and constantly resituated, a series of poses, all of which are given as a series of poses, none of which are given as poses which could be dislocated from a real underneath. Thus an antipsychological notion of character.

Note on *Kitchen*: Characters in and outside the film are constantly almost 'caught', held in by the reflection of the mirror played with by Edie, which (through prior knowledge) we realise is capable of freezing an image or framing one which may not be the 'right' one for the scene; a tension is set up precisely because of the mirror's capacity as active term, rather than mere reflector of that which is given as correct or purposeful. Edie's playing with the mirror reflects from within the space though alluding to a without which could not be the space of the audience but is (impossibly) 'there'. The viewer's identification into that space becomes problematised as Edie's view wavers from the inte-

rior space to the cameralense and viewer to those behind. This is all play, a chattering down to silence, remembering of lines then resuscitated by copies of the script … impossible to nail down the 'real' dialogues, monologues, etc. Same goes for the sudden changes of mood, in high camp. The film thus also as learning instrument, didactic, a procedure presented, a dialectic of/in film as to its possibilities: redundant in the natural's constant capitulation to labour.

Roles and masks are never metaphysically united in a body: spirit or essence are not found to reside anywhere at all. The residue of all this is politics and ideology, material history. It is as if such work were the process of a culture which no longer necessarily reproduces the bourgeois, thus the work is in advance of the present. Such work is also to remain unseen, denied, elided, unprocessed, etc., as the contradictions increase and their 'author's' position increasingly has a different objective (meaning). Andy Warhol is not the work, is of no interest to the work, though producer. Conflict even there, as in the contradition in the films between the material support of film as physically foregrounded and presented (duration, grain, light/dark, focus, frame, cameramovement, stillness. etc.) and the fixing or impossibility thereof of whatever representation it is that is 'filmed'.

john smith's film: reading the visible
michael mazière

The choice is mine: to subject its spectacle to the civilized code of perfect illusions, or to confront in it the awakening of intractable reality.

– Roland Barthes[1]

John Smith's work has constantly shifted between two concerns; on the one hand his films stem from an imagist tradition and focus on purely visual phenomena, and on the other they delve into the ambiguities of the English language by placing verbal usage, its imaginary connotations, in surprising and always humourous situations. Although not necessarily mutually exclusive these two directions are rarely given equal balance in individual films (as the hegemony of one concern places the other in the background).

In *Leading Light* the camera follows the window-shaped pool of light around the room from various camera positions over the course of the day. The determining nature of the light is countered through manipulation of the aperture, shutter release and lens. Apart from the rigour of the initial set up (i.e. one room, one day, one camera position) all other decisions seem to have been taken on a purely intuitive basis. Working through variables in controlled but nonetheless unpredictable ways the film presents a breadth of vision which in expounding filmic construction automatically questions representation. John Smith states: 'The film is not intended as an academic exercise – I wanted to make a film of light cast by the sun largely because I found it beautiful. At the same time I did not want to make an illusionistic film about the sun moving around a room, but instead to employ these events within an essentially filmic construction.'[2]

Leading Light presents with rigour and beauty an existant multiplicity in the perception of space not only through the exterior changes but through the perceptual apprehension of these changes. Description and interpretation are here not separated or differentiated, but present as in experience; the viewer is engaged in receptive and active processes in the gap between looking and reading, intention and production.

Associations plays with meaning, not in its construction but rather in the absurdity of meaning as given, of packaged knowledge. Using the text from 'Word association and linguistic theory' by Herbert H. Clarke and images from colour supplements, the film creates, through associations, a rebus where words are replaced by pictures in a seamless continuum of puns. On projection this extremely dense object comes very close to being an exercise in attention where the subjective condition of the viewer seriously affects the reading of the film. The ubiquitous connections, often humourous, displace meaning in very much the same way as nineteenth-century English nonsense poetry, forsaking understanding for the benefit of a more ephemeral psychological gymnastics where ambiguity becomes the determining factor. In front of such a barrage of information the viewer is left dazed; contrary to the more attenuated procedure of *Leading Light*.

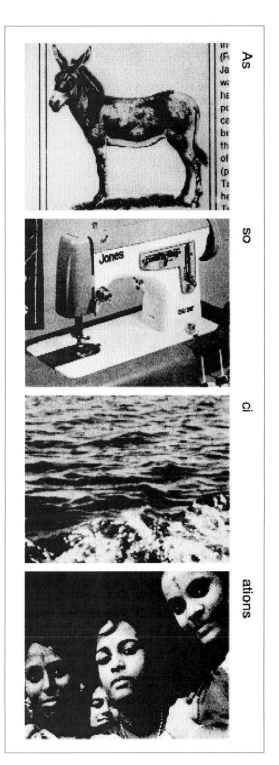

ASSOCIATIONS John Smith

In *Girl Chewing Gum* an authoritative voiceover preempts the events occurring in the image, seeming to order not only the people, cars and moving objects within the screen but also the actual camera movements operated on the street in view. By treating the documentary aspect of the film as truth many of the illusionistic codes and devices come into play bringing screen space, voiceover, representation and content in an improbably exposition of veracity. In referring to the use of voiceover in documentary, the film draws attention to the control and directional function of that practice: imposing, judging, creating an imaginary scene from a visual trace. This 'Big Brother' is not only looking at you but ordering you about as the viewer's identification shifts from the people in the street to the camera eye overlooking the scene. 'This is the phantasy of the all-perceiving subject (subject and centre of the look) which is thus seen to be inscribed within the very apparatus of cinema itself. This same phantasy can be recognised in an idealist ontology of film which sees the development of cinema as increasingly realistic appropriation of the world.'[3] The resultant voyeurism takes on an uncanny aspect as the blandness of the scene (shot in black and white on a grey day in Hackney) contrasts with the near 'magical' control identified with the voice. The dénouement overturns this identification as the text strays into imaginary description of visual detail not available, to eventually forego the film's images altogether; by this time the effect is complete and the viewer has no trouble in visualising such improbable phrases as '… a helicopter in his pocket …'. The film, while attesting the disturbing nature of a documentary use of images, relies more on the power of language and its appropriation of images to determine power and meaning. The most surprising effect is the ease with which representation and description turn into phantasm through the determining power of language.

Summer Diary is one of John Smith's most personal films which by its complexity has not made it the most popular. '*Summer Diary* starts by alternating between shots of a tree and unsensitized film – over the dark sections a voice describes the weather. Discrepancies soon occur between the description and the represented scene. As the film progresses, the relationship of image and sound is clarified, but at the same time the verbal descriptions start to involve imagery

LEADING LIGHT John Smith

and consequently become more ambiguous.'[4]

Summer Diary attempts to fuse the concerns present in both *Leading Light* and *Girl Chewing Gum*, that is to work equally with the visual and verbal so that a dialectic is possible and productive for both areas. The film's concern lies in memory and the awkward distance between reminiscence and fact, personal accounts and objective phenomena. The alternating structure leaves respective absence in the sound and the image which, as the film progresses, is filled up by re-enactment on the image track and spoken diary text on the soundtrack. The initial confusion is clarified as the black and silence become the locus for memory where visual and verbal descriptions are given space to reflect the constant relation between past and present, imagination and perception, projection and introspection. Lacan's remarks on the 'Imaginary function' are relevant here: 'C'est parcequ'elle pare à ce moment de manqué qu'une image vient à la position de supporter tout le prix du désir: projection, fonction de l'imaginaire. A l'oppose vient s'installer au coeur de l'être, pour en

désigner le trou, un index: introjection, relation au symbolique.'[5] The function of memory presented through reminiscence and re-enactment presents the subjective at odds with objectifying mechanical devices (such as camera, thermometer, calendar…) but engaged in the construction of a personal and historical position.

Hackney Marshes sets out to construct a space by recording events and objects from one camera position throughout the length of a day. The film was edited in camera, the selection of shots and the pace was largely improvised during the course of filming. The film takes on a 'motif' in the painterly sense of Cezanne: a detached observer translating a scene onto a surface. With selective method and some abstraction technique, the view is constructed piece by piece with a visual dexterity and sense of rhythm which gives the film a polished and controlled aspect. The concern here is not to reveal the space but rather to produce the perceptual processes present in the visual and mental construction of a space. To the forefront is the phenomenological process of experience which constructs the visual world through abstraction, repetition, movement, selection, which in no way mimics human visual response (e.g. eye movements.) but translates them into a filmic construction. The rectangular 11 by 14 frame here gains all its value as an area of repairage where the overall filmic space is filtered through, shot by shot, thus matching space to a variety of visual scales. The film comes close to being totally abstract although because of the production set up the notion of document is still present. In fact it might be considered, like many other of the films discussed, that the effectiveness of the work is that it operates between two opposites; here record and abstraction, reflection and construction. Subsequently a remake of *Hackney Marshes* was made for Thames Television, and although context and intentions do not fall into this article some interesting differences were brought out from its viewing. The later version dealt with high-rise housing and combined the visual effects of the former with some extremely clever montage of interviews of the people living in and around the estates. What is most striking is how the montage of interviews provided the most subversive elements in reflecting the contradictions voiced by the interviewees and

how the visual constructs seemed decorative and often gratuitous. The documentary format, its level of address, overdetermined the reading of the film; the unrelated use of different techniques left only the most dominant forms prevail, in this case, the sociological interview.

Celestial Navigation could be seen to work in the tradition of British landscape film in that it incorporates a 'natural' element (the earth's rotation) into the structure of the film. Filmed in the course of one day on a beach the film uses pan and tilt movements to follow the shadow of a spade and retain its vertical position in the elements which can be intellectually measured as variances and towards a deciphering of the construction of the film; but these are not keys to the viewing of the work and the films are in no way puzzles to be reconstructed in the mind after viewing. Many peripheral elements come into the film adding humour to an otherwise near-scientific exercise. The tide comes in, a sand castle is built and washed away, a cyclist crosses the scene, which all work to incorporate human presence without denying the original strategy. The changes of colour, light and sound signify also different sets of variances and give the film an aesthetic pleasure in conjunction with the reading of the system.

John Smith's films work to throw into play the multi-layered premise of cinematic activity, itself crossed by many signifying substances which gathered onto the screen operate and are read in varying ways. Systems and strategies are mostly suggested so that 'The film presents material which is open to interpretation – I don't believe that any film does, or should have, an ultimately correct reading'.[6] This is not to be interpreted as a free for all, that the subject constructs the film in isolation according to his wishes, desires etc, but that working with a specific set of units, variables, motifs, images and words one can produce films which engage the viewer in an active, critical and pleasurable activity. It is in the construction of the films that a reading space is left, by denying a hegemonous structure, an orientated multiplic-ity is produced. The films are for the most part manipulative and do not repudiate illusionism in all its facets, on the contrary it might be argued that the work is set against dominant mechanisms but always at a necessary distance in order to retain an exploratory aim.

It is this heuristic nature of experimental film practice which gives it a specificity,[7] and in so

CELESTIAL NAVIGATION John Smith

doing different projects and formal strategies gain a continuity not, at first, visible. It is such a stance which permits a range of concerns, from purely perceptual to ideological and historical, enabling the work to transcend the limits of specific discourse in art and produce an attainable, complex and enjoyable text. The emphasis of the work is placed on reading, outlining different trajectories, possibilities. Anton Ehrenzweig's concept of 'unconscious scanning',[8] which favours syncretic processes to rationalisation, articulates well the intuitive and unconscious processes involved in the production and reading of art. That movement between the unconscious scanning of open structures and attempted moments of rationalisation is the one performed by these and many other experimental films; attempting to forego a conflict of alienated dissociation, to bridge the spaces between ambiguity and rationality, intuition and comprehension, dissemination and focalisation.

1 Roland Barthes, *Camera Lucida*.
2 See 'A Perspective on Avant-Garde Film', A CGB Catalogue, p. 81.
3 Jacqueline Rose, 'The Talking Cure', in Colin McCabe (ed.) *The Imaginary*, p. 157.
4 John Smith, 'Films 1975–82', p. 7.
5 'It is by averting that moment of lack that an image comes to the position to support the whole price of desire: projection, imaginary function. Opposed to this at the heart of being comes to install itself, to point out the hole an index: intro-spection, relation to the symbolic.' (My translation) Jacques Lacan. Remarques sur le rapport de Daniel Lagache, *Ecrits*, p. 655.
6 "A Perspective on Avant-Garde Film", p 82.
7 See Nicky Hamlyn, 'Seeing is Believing', *Afterimage*, no. 11.
8 Anton Ehrenzweig, 'The Hidden Order In Art', Chapter 3. 'Unconscious scanning'.

a few days in geneva
mari mahr

Mari Mahr's sequential images are influenced by her interest in cinema and her familiarity with filmmaking procedures. But her photography does not record places, events. Her montages are re-creations of emotional responses, of memories. She works against the excess of realism inherent in photography by contriving unsettling foreground and background relationships. Combined in her working practice are a personal precision and a delight in the unexpected visual richness of material imperfections. Mari Mahr's close involvement with her work is perhaps partly demonstrated in the fact that she works at home, but more significantly in the value that she places on self-imposed restrictions. The moral commitment she feels towards her work is resistant to fashion and therefore will enable her to continue to develop her own style.

– Penny Webb

'mother desire'
michael mazière

Mother Desire is a photographic and video project dealing with masculinity and identity specifically through the real and imaginary male relations to the mother. It is a combination of subjective and collective recollections drawn from personal history, contemporary voices and imagery – drawing from memory, photography and literature. It is of crucial relevance through its unveiling of hidden aspects of gender and its questioning of the limits of masculinity.

This piece is based on a single image taken by my father of my mother, myself and my brother and sister a few hours after my birth. Each section has been blown up with inscribed text to create an interplay between the photographer, the subjects and the process of photography. The nostalgia triggered by the image is subverted through fragmentation, while the collusion of the subject with the photographer is brought to light through the word interplay. My desire for the image is locked in the specific momentary nature of photography.

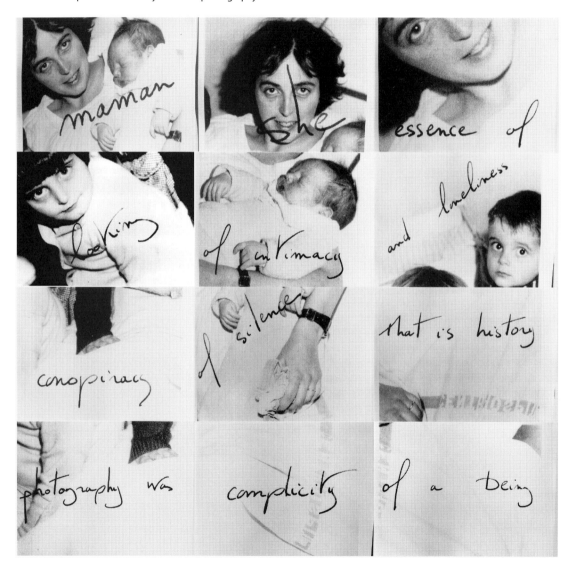

'on the mountain' and 'land makar': landscape and townscape in margaret tait's work

tamara krikorian

On the Mountain (1974) and *Land Makar* (1981) are supreme examples of Margaret Tait's intimate style of filmmaking and demonstrate a rare quality of observing change at close quarters both in town and country. The filmmaker's own description of the 'corto mettragio', the type of short film which was shown in Italy before the main feature in the 1950s, serves as a clue to the style of her films. These film essays apparently appeared as poetic evocations of a subject rather than descriptive documentary. Often the film consisted of a shot to shot continuity based on pictorial allusion. This device of pictorial allusion is one which Tait frequently uses in her work. The narrative emerges through the linking of images in one's memory, often through repetition or duplication, the camera hovering and returning to the same subject.

In 1952, when Margaret Tait returned to Scotland from Rome where she had been studying at the Centro Sperimentale Cinematographia, the opportunities for filmmaking were extremely limited. There was, of course, the possibility of working under the auspices of the Films of Scotland Committee but this prescribed a certain attitude to film, very much dominated by John Grierson's view of what filmmaking should be. Insofar as she defines her own attitude to filmmaking, Tait considers that the educative or journalistic use of film has the same relation to the filmmaking that she is interested in, as text books or newspapers to literature.

A better analogy can be made if one relates Tait's practise to that of a painter, gathering and sifting material. She rarely works to a precise script, but makes lists of material to collect. She will gather this, shooting fragments over a period of time, maybe even years, as in the case of *Land Makar*, where the film is descriptive of the change in seasons. The pace of production is set by Tait's need to work on her own, using her camera – or rather the film celluloid, as a diary. She denies that she has affinities with film diarists like Jonas Mekas or Ian Breakwell but her work is entirely personal and even idiosyncratic and her method of recording the minutiae of places and objects around her reveals an intimate approach to documentation very much related to keeping a diary. Any suggestion that she is recording for posterity is quickly refuted with the reminder that film is ephemeral both in its material and form. One recognises this as typical of a certain modesty that the filmmaker is noted for. However, *On the Mountain* made in 1974, goes a long way to disproving her argument.

Made in Edinburgh's Rose Street, *On the Mountain* incorporates the whole of a previous film (*Rose Street*, 1956), including the leader and titles. The original was shot in black and white, and the negative was lost, and for this reason Tait had the idea of preserving the film by framing it complete in colour, in a contrasted look at the same street in 1974. The title refers to the words of a childrens' song, a recurring theme in the film: 'On the Mountain stands a lady, who she is I do not know'. We are never told who she is. Could it be some reference to the castle on the rock? The location, Rose Street, notorious for its pubs, including favourites like the Abbotsford and the Kenilworth, which features in the film, is where Margaret Tait after returning from Italy had a small office with her company logo, Ancona Films, on the door. Consequently her knowledge of the street and her observations of change in both films is extremely precise.

Tait's pacing, which may have been developed in response to her years in India in the Royal Medical Corps during the war, is quietly meditative. The camera searches endlessly without intruding, establishing a personal style, which must be seen as separate to conventional documentary or *cinéma vérité*. She talks about 'stalking the image' and 'breathing' with the camera, as if she was pacing a deer forest or searching for a golden eagle. The intention is calculated and the response intuitive. The original of *Rose Street* is reminiscent of post-war Italian neo-realist films; a group of women and children sit on a doorstep; teddy boys talk to a shopkeeper, a shoemaker and jeweller are seen at work; women try on hats in an expensive boutique. A window cleaner goes about his business, (the window cleaner appears in *On the Mountain*); an accordion player strikes up a tune; a child begins to dance, children on bicycles tear around a corner into Rose Street Lane. They play hopscotch, bells ring, a man sings 'Come back to

LAND MAKER Margaret Tait

ROSE STREET Margaret Tait

Sorrento' but more important still, the street is alive. People live there in the centre. Life is lived out at street level.

On the Mountain records and preserves the change. The camera broods and recognises the dustcart. Changed is too gentle a word, the street has been ripped apart by the developers. An ugly modern precinct has emerged with shabby boutiques and plastic food. The back lane where the children played hopscotch reveals a gap site, a decaying Princess Street, with thumping machines and concrete. Through the gap, the rock and the castle stand firm in the face of progress. Where have all the people gone who lived in these tenements above the shops in Rose Street, in 1956? To some derelict housing estate on the windy outskirts of the city no doubt. These are not questions posed by the filmmaker, but conjectures which emerge from watching the film. A space is left for the viewer to draw his or her own conclusions.

Mary Graham, the protagonist of *Land Makar*, and a close neighbour of Margaret Tait's in Orkney, is a crofter working her own land. 'Land makar' means poet of the land. Makar was the old word for poet, deriving from the sixteenth century in Scotland at the time of William Dunbar. Mary Graham ploughs on an ancient tractor, hand scyths with the help of her family and friends. The hand-held camera follows her, through the seasons, to watch her feeding her hens and re-making a haystack destroyed in a gale. We observe through Tait's eyes the tending of the land and the loving care with which the crofter watches over the swan's nest and works her garden. The poet is close to the land. Here the style of farming has barely changed, apart from a change of crops. Corn is grown now. People no longer stone-ground their own wheat. Mary Graham does not see

anything poetic about her work. Margaret Tait, in conversation in the film with Mary Graham, says, 'I see you as creating the beauty of the land', and Mary Graham replies, 'Some beauty!' A realistic if not sardonic response to Tait's idealism.

There are no trees on Orkney. The wind shapes the landscape as much as the crofter. The ambition of Mary Graham is in tune with nature, unlike her city counterparts or more greedy colleagues elsewhere, she is at the mercy of the elements and she says, 'we had a poor winter and a poor summer!' A copy of the *Orcadian* on 23 September 1978 has the headlines – 100 mph gales. These gales blew down Mary Graham's haystack.

The sound of the crofter's voice in the film gives it its authenticity. There is no attempt to circumvent the difficulty of understanding the language by adding voiceover or substitutes. As a non-Orcadian one must grapple with Mary Graham's language recognising some words and missing others. Mediation and interpretation would simply destroy the authenticity of the subject. The words and their meaning would become distorted and their relation to the image subordinate. The subject would become devalued. The sound both in this film and in *On the Mountain* and indeed in all Tait's films has a distinctive quality. She uses it as collage, juxtaposing and producing the unexpected, drifting through the familiar and unfamiliar. The use of sounds in *Land Makar* are naturalistic though rarely recorded in sync.

The subject matter of *On the Mountain* and *Land Makar* is very different, but in recording on the one hand, the destruction and change within a city, and on the other, the making and changing of a landscape, Tait has brought to our attention her very distinctive style. There are other films like

Aerial, Colour Poems and Where I am is here, which reveal more of a poetic structure and film portraits like the Portrait of Ga and Portrait of MacDiarmid which also merit this attention. However, the memories provoked by On the Mountain and the sensitive observation of Land Makar are overwhelming evidence of a poet filmmaker at work.

on 'stonebridge park': a film by patrick keiller
nina danino

There are two parts with an interval which separates them. The first is a walking camera shot along the Flyover at the North Circular Road. The second is a walking camera shot up the steps and along the bridge which gives on to a view of Wembley Stadium. Except for the last section of Part II when this view is accompanied by the music of Beethoven's 3rd Symphony, the only sound is a narration read by a man's Voice.

This is what I have been thinking, for the most commonplace event to become an adventure, you must, and this is all that is necessary, start re-counting it.
– Antoine Roquentin (Nausea)

It is not so much the desire to change the world which prompts the telling, but the inevitable re-creation of a transformed world which comes into existence at the moment of re-counting. There is no mystery behind the shop fronts, no magic contained in objects, no enigmatic meanings in looming city structures. The generality of the objects and structures which surround us, the commonplaceness of the events over which our lives agreeably or disagreeably stumble, are imbued with the particularity of our individual perception only at that point when that perception is externalised. How else could we have suspected that the view from the bridge at which the film ends could be a sight of such ominous import if it had not been for the disembodied voice of our narrator? It is not so much that these inherent qualities in Wembley Stadium are revealed via a perceptive or insistent scrutiny, but that given the shade of his thoughts that is the way that he sees it.

Our man, it seems, has no urgent desire to change the world but is quite simply struggling to understand it and thereby keep a slipping foothold in it. The urban landscape which is his scenario is transformed into a world of menacing potential, containing in it all manner of unidentified threats.

Who could tell what was forming in the heads of the drivers of these tin hulks?

The disembodied voice which begs this question corresponds exactly with the headless walking camera shot which takes us on our journey across the Flyover, as it leans now over the bridge to get a view of the cars which drive under it.

This is Part I and although we have been travelling across this complicated structure only a short while we seem in the process to have lost our general sense of direction, almost in keeping with our narrator's labyrinthine train of thought.

The fabric of his moral reasoning is being corroded, he has been uprooted from those values and beliefs that offer him meaning and stability and the landscape 'suffused with guilt' responds to the shade of his mind. The film-noirish quality of his mental entanglement with the world is enhanced by the black and white images, the allusion to the world of petty crime to which he once belonged and for which he paid his price (a short spell in Wormwood Scrubs), and by which, once again, in his mental anguish he foresees himself being swallowed up.

Unlike film noir the scenario is not the darkly lit corridor of a hotel or the shadowy mystery of the back alley, but the cold, bright day in an open landscape, announcing, however, the same kind of pending threat and underlining the vulnerability of our narrator. The irony of his convoluted ruminations is not lost when we understand the petty nature of his crime. It is the same irony which posits him as the ordinary man of the crowd: 'I saw a carefree future slipping away – a comfortable flat, a nostalgic car, perhaps one day a devoted lover' and sets him wandering in solitary thought across the bridge.

The walking camera shot across the two bridges of Parts I and II presents a contradictory interpretation. Its unedited, forward-looking continuity, the human origins of its rhythmic movement, the shoulder position at which the shot is held, corresponds to the narrator's 'point of view', paradoxically reminding

STONEBRIDGE PARK Patrick Keiller

us at the same time of the camera's existence. Our relationship to the protagonist is dual, for we achieve an interested involvement and self-identification with his predicament but are constantly aware of the position in which we are placed as the voyeurs of his public/private reverie. The bridges along which, with our headless wanderer, we have been travelling, are the metaphorical connections between the present and the past, it is through the process of journeying across them that we imperceptibly enter into the film-dream and into the memory of past. Each presents the possibility of a time-lapse, a journey between bridge and bridge, and a subsequent re-positioning of the narrator/protagonist to the story which he tells and the time-level in which it occurs, because of this displacement our own position too is shifted.

After a brief interval we have been transported to the second bridge upon which our wanderer indulges in further mental excursions into the general: 'every man lives in his own prison to a lesser or greater extent, whether he knows it or not', and by working out 'the greater scheme of things' is desperately formulating his own little plan of action. It is not the trivia of the domestic, the enclosure of the interior but the monumental proportions of the aggressive urban landscape which is his setting, it is from the Napoleons of this world from

which he draws justification for his own 'little escapade' and yet it is to an altogether less 'heroic' but unequivocally male world to which he belongs, a world of garages and pubs, of solitary walks on ugly wasteland, a world trapped and boundaried by the structure which men have built and from which he is trying to extricate himself. The irony, which is nevertheless not without a measure of sympathy for the plight of its protagonist, is central to the narrative drive of the film.

Stonebridge Park hinges on the re-construction of the commonplace into the realm of adventure, the aggrandisement of the trivial, the transformation of the banal into enigma. The story is a monumental rendering of what is sadly the enactment of a petty crime and the mental anguish that it brings to its perpetrator, enacted and remembered in the vicinity of the North Circular Road. The film calls into question the relationship between the 'telling' and the 'seeing', the narrator in his role as raconteur and protagonist and the relationship of the author (narration)/filmmaker (camera) to the raconteur. It is the re-arranging of 'who says what, when?' in the two parts which points out the artifice integral to a filmic construction and which, as Antoine Roquentin, who is the hero of another story, points out, occurs at the point of re-counting.

william raban's landscape films: the formalist imagination
michael o'pray

One of William Raban's last pieces of work in painting, before he turned to filmmaking, was a canvas which he had wrapped around a tree trunk and left for several months to the ravages of the weather. At intervals, the canvas was treated with a thin wash of paint. It was then retrieved, discoloured and marked by the rain, sun, wind and tree resins.[1] This project, in its concern for the arbitrary effects of natural elements on basic art materials – canvas and paint – was to be extended and developed, only through the apparatus of filmmaking – the camera, film stock and soundtrack. Numerous ideas are at work in Raban's tree canvas, all recognisable within the broad strategies of modernist art. Some of these ideas translate with relative ease into the medium of film, others quite forcibly clash insofar as film is a different medium characterised essentially by its mechanical means of representation of reality, a conception extensively called into question and pushed to its limits by the English structural film movement of which Raban was a leading member.

Raban's reputation in this country and abroad rests, in the main, on his work in what is called landscape film[2] – a genre closely associated with the English avant-garde film movement of the late 1960s and 1970s. If procedural and structural strategies were paramount for these filmmakers, it was the landscape film which asserted a problematic terrain of aesthetic pleasure, in its most acute form, such that a certain ambiguity towards landscape films' imagery became a feature of the critical discourse of the time. Other filmmakers who worked in landscape were notably Chris Welsby (the most systematic, consistent and successful of them all), David Pearce, Jane Clarke, Mike Duckworth, Renny Croft, and later John Woodman, Martin Sercombe and Alan Renton. Raban with Welsby is seen to be the originator and finest exponent of the genre, but he has always retained a broadness of interest outside the concerns of landscape as in *Soft Edge* (1973), *Body Print* (1973), *Diagonal* (1973), *Time Stepping* (1974), *At One* (1974), *Surface Tension* (1974–6), *After Eight* (1976), *Autumn Scenes* (1978) and *Black and Silver* (1981 with Marilyn Raban). However, in what follows I will try and show how that connection is there to be made between the landscape films and others.

Deke Dusinberre, in his programme for the important Tate Gallery screenings, included the major landscape pieces by Raban – *View Film* (1970), *River Yar* (1971–2 with Chris Welsby), *Colours of this Time* (1972), *Broadwalk* (1972) and *Angles of Incidence* (1973). Not included, and made since that show in 1975, are *Breath* (1974), *Moonshine* (1975), *Wave Formations* (1976), *Canal Incident* (1977) and *Thames Barrier* (1978).

Like many English experimental filmmakers, Raban is from an art-school background (he studied at St Martin's School of Art), and he has named as some early influences, such artists as – Jasper Johns, Mark Rothko, Larry Poons, Morris Louis, Jackson Pollock, Class Oldenburg and Mark Boyle.[3] A common feature in some of these artists (for instance, Rothko, Pollock and Louis) is an emphasis on surface where a shallow spatial mode is explored, something which Raban was to stress in his own films, particularly *View Film* with its frontality in representing a tidal ebb against a bleak

TREEPRINT William Raban

BROADWALK William Raban

marshland where, at times, the rain falls on the camera lens gradually obliterating the view. The effect is, at once, to reduce the perspective of the representation to a flat surface, at which point the image is almost abstract – an effect brought about by the weather as causal agency in the film process. Similarly, in *Sunset Strips*, the static shot of a budding ash tree at sunset has an all-over rough-grained blue colour tone which effectively drains the image as naturalist representation, and instead emphasizes the formal aspects of colour and shape. The slightly shifting camera perspective and use of stretch printing, in the same film, fragments the image in duration. Thus, the working through of conceptions of surface depth by the effects of weather conditions on the lens plus a dominating colour tone in *View Film* and *Sunset Strips* respectively, relates to aesthetic traits in the American abstract-expressionist movement as it merged into what came to be known as Minimalism. Raban's work has been steadfastly representational, so too much should not be made of this connection with broader fine art movements. In fact, the tension and resonance in Raban's films depend upon the subtle shifting between representation (characteristically, a landscape) and abstraction, mainly achieved by exaggerating a formal aspect of the image stream e.g. framing, colour, time-lapse and frontality.

This characteristic has meant that Raban's films often express an aggressive conflict between a conventional beauty, often of composition, as in *Colours of this Time*, in the landscape image, and its mediation through formal properties of the film process. This quality cannot be stressed too much in the context of his work for it is the very thing which makes them, aesthetically speaking, very satisfying. Landscape, on such an account, is never the contingent imagery of a formal exercise, rather the landscape imagery absorbs the filmic work through which it is constructed as and in the film, ensuring that formal experiment is invested with emotional and aesthetic affect. This sensual dialectic is a central feature of Raban's films that distances it from much landscape film that is often insipid or academically formalist.

Another important aspect of the films is their use of soundtrack – a factor very little discussed. In *View Film*, for example, the presence of the voices of the filmmaker and friends as they weather the filming conditions serves two main functions. First, it is a part of Raban's project to represent the film as process and production, and so it is important that the spectator is aware continually of how the film is made – over a lengthy period of time and in one session of shooting (the time-lapse of the tidal water also encourages this knowledge) with all the mundanities that go with that – subvert-

ing the image of filmmaker as mysterious creator. Second, it adds to the rough edge quality of the film, serving the purpose of aggressively undermining a potentially 'beautiful' image. *Broadwalk* is an excellent example of sound used in this way. This film is a telephoto view looking northwards up the Broadwalk in Regent's Park. The lens distances the camera from the film subject and a 24-hour period is condensed by single framing with a 30-second recording at 24 fps at the beginning and end of the film. The film was also stretched. The soundtrack is the effect of superimposed loops of echoing footsteps and is powerful, acting as a rhythmic counterpoint almost to the visual track. A reviewer at the time described it as 'evoking its own atmosphere of hysteria, and Armegeddon'.[4] The description is apt in its recognition of the underlying tension and violence of the film, making it one of Raban's strongest pieces.

Broadwalk's soundtrack was to be forerunner to a series of equally powerful ones – in *Surface Tension* and *Black and Silver*, notably. In *Breath*, a film structured by breathing, whistles and the eventual convergence of three people with cameras on a point near Hay Tor, Raban's use of sound with its connection to the human – breathing – puts the film into relationship with *Soft Edge* and *Body Print*, where in the former, in particular, the body determines to some extent the structure of the film and, of course, its representational characteristics. In *Soft Edge*, an excellent and rarely seen film these days, a spring driven camera with a close focus lens traces very slowly around the shape of a woman lying naked on a blanket. A microphone taped to the camera records the whirr of the camera whilst the film is running. At the end of each 30-second take, the microphone continues running recording the rewinding of the camera and conversation between Raban and the woman. Besides the notion of real time being expressed through sound, the film also has associations with *View Film*'s conversations, stressing the ordinary day-to-day discourse in which the film was made, its contingent features – structured by the weather in one case and a body in the other, and by the filmmaker's decision as to the procedure to use and so forth. Interestingly, an extended notion of landscape would incorporate a film such as *Soft Edge* in its implied metaphor of body and land and the general aim of structuring film by natural phenomena. Equally, the aggressive mode of the visual imagery is worked against the soundtrack which is warm, humorous and in the

end, intimate, undercutting the formal drive and aspirations of the visual track. *Soft Edge* is also the film closest to the expressionist painting school, even if the tone is ironical, and has been described as 'an academic life drawing which uses the camera as a pencil', but it has the feel of a 'drip painting', the hand-held camera being used almost intuitively so that the production process is implicated in the representation (sound and image) itself. Very few of Raban's films were to be so loose and spontaneous in feel with the exception perhaps of the early section of *Autumn Scenes* and perhaps *Time Stepping*.

Colours of this Time records all the imperceptible shifts of colour temperature in summer daylight, from dawn until sunset. The idea for the film came from Raban noticing in previous time-lapse work that colour film tended to record the actual colour of the light source rather than local colour when long time-exposures were made. Thus, the film is centrally experimental although the frame composition is a concession to a more traditional aesthetics. The film is a true representative of the structural English school of filmmaking in its experimental innovation relating to colour temperature, although for this viewer it seems to lack the visual strength of *View Film*, for example. *Angles of Incidence* is a film which is rated as a classic of the landscape genre although in many ways it seems that landscape is rather marginal to it, both as representation (the film is of a window frame, through which a landscape is perceived) and as formal concern, in so far as the film is crucially about framing controlled by camera movement which as Dusinberre points out[5] distinguishes the film from the static-shot format of *River Var*, *View Film* and *Colours of this Time*. The anti-Romanticist trait in the structural landscape filmmakers is at its most extreme here, reducing the 'landscape' to a continually shifting subject matter within a window frame, itself within the film frame, and it is between the latter two devices that the film operates involving a highly complex interweaving between frame, light, colour, perspective. A brilliant film in conception and execution, and as a two-screen piece using synch projectors it is transformed into a visually witty one too, establishing an overall rhythm between the two screens.

River Yar is probably the most important and finest landscape film of the English school. Made with Chris Welsby, and one of the first films to be made by both filmmakers, its use of two-screen projection, time-lapse and real time, arbitrary sound

recording and the landscape itself, all converge on a wholeness of effect in which formal procedures and visual beauty are inextricably bound. Even though rarely shown, it has acquired a status which on recent viewings seems quite justified. It has all the rawness and emotional investment of *Broadwalk* and *View Film*, together with an innovatory quality which must have daunted any landscape filmmaker who had to follow it. Organised around the autumnal and vernal equinoxes, its scale makes it the English equivalent of Michael Snow's *La Region Centrale*, representing a more empirical and experimental stance against the metaphysical force of Snow's work and, interestingly, evoking a melancholic and sombre mood that connects it with the English landscape painting tradition.

As Dusinberre says, River Yar 'contains all the seeds of their subsequent development', particularly in the case of Welsby, whose work since has been totally dedicated to landscape in some form or another. Raban, as we have seen, was to take on different questions and subject matter at times. For instance, in the late 1970s, he made *Wave Formations*, an abstract film using three screens and sound. Three colour fields pulse in and out – blue, red and green – the image track being printed on the soundtrack so that a hissing sound (as of waves as it happens) is heard as the colours fade in and out. The final sections of the film involves the two extreme screen images overlapping the central image so that it is the size of two-screens with blue at the extreme right-hand edge (usually), and green at the left-hand edge and the centre section divided into the three colours mixed. Eventually the three colour fields converge onto one screen producing white. Characteristically, Raban's 'wave formations' are waves on the actual visual and soundtrack of the celluloid, structuring a film which is landscape in a more symbolic sense, but also reminding us that landscape qua colour has certain properties which mediated through the filmic apparatus – film stock, projector, etc, produces its own results. So landscape has the broader meaning pertaining to 'natural' phenomena such as colour, which Raban's film reminds us, is always constructed in reality through perception, and by means of the objects having the colour and light sources used. The film relates to the equally abstract and inventive *Diagonal* and *Surface Tension*, the latter being a two-projector single-screen piece of two films of the same image (a rectangle)

one positive, the other negative, projected onto the same screen, slippage of synchronisation and 'off registration' prevent the two images from cancelling each other out as they should in theory. David Curtis[6] has compared the film with the films of Richter and Ruttmann, the loud harsh soundtrack is also reminiscent of work produced by Kren (*Baume im Herbst* for example). Another film which should be mentioned although it has no connection with landscape is *2' 45"* which, although I have not seen, is elegant in conception as a document almost of a film projection event where the audience, screen, film and filmmaker become subject of each film ad infinitum. *Take Measure* is in the same vein, a projection event with the film snaking through the audience from screen to projector and so on.

Other works which can only be mentioned here, but deserve separate discussion in the future are the installation pieces such as *Pink Trousers*, *Moonshine* and *Illusionists* (with Marilyn Halford). *Moonshine,* as a two-screen film (originally made in 1975), is ephemeral and bordering on the abstract with an evocative use of colour and framing, and celebrates the coincidence of the time of sunset with the rise of the full moon. Shot from the roof of a Thameside warehouse it became a series culminating in the installation for 12 or 6 screens with tape sound, and first performed at the Arnolfini Gallery in April 1976. For this viewer the two-screen version associates in mood and tone – impressionist colour, coolly regarding and always maintaining the integrity of the subject matter and filmic materials – with *Sunset Strips*.

Black and Silver,[7] the experimental narrative film made by William and Marilyn Raban with BFI finances and released in 1981, has a long beachscape section which treats the natural setting in a more symbolic mode associated with the themes of the narrative – the tale of the princess depicted in Velasquez's *Las Meninas*. However hand-held camera, long sweeping pans that blur the image and repetitions reveal old interests and questions, found in the early formal landscape films. This more Romantic rendering of the landscape is complicated by the fact that Marilyn Raban was co-filmmaker, so that authorial readings are difficult to make. Nevertheless, although not an entirely successful film as narrative it does show that whatever the subject matter the filmmaker, like the spectator, projects phantasies onto the materials being worked over.

In the landscape films William Raban has pro-

duced work where formal aspects evoke phantasies on the spectator's part of landscape as good object but embedded with its own destructive forces to which the films are reparative responses. Hence, the use of time-lapse, repetition, in-camera editing, excess of colour and so on are often governed by the 'structure' of the landscape and 'natural' phenomena – seasonal cycles, daily light cycles, tides. Importantly, Raban's work is never simply the observation of these phenomena, but the working over of that subject matter by means of the filmic apparatus itself. If landscape and nature are capable in a scientific sense of exotic forms through the capacities of the camera, film stock etc, thus undermining the Romantic attitude, the artistic work in the production process, gathers up that fragmentation – the result of 'science' – to some sort of wholeness again. Necessary for this transformation is aggression, power, control in the service of reparative aims. Where there is simply power, as Stokes remarks, all that gets reconstructed is 'the insensitive, the manic, and often, strangely, the academic'.[8] The need to deny any form of symbolism – conventional or otherwise – in modern art, entails the rejection of subject matter as such, except when inseparable almost from formal content, so to speak. No wonder that the object of much recent art is art itself, as if this general conception of art was all that could be invested with worth. Anti-art,

in this sense (and landscape film as discussed in this piece is not anti-art), relies completely on art in general as a notion by which anti-art's activities are permissible and intelligible at all – a paradox. [9]

In summary, Raban's landscape films are some of the high points of the English film avant-garde in its formalist period of the late 1960s and 1970s. Genuine experimental innovation was matched in his work with an imagination which did not concede to the insipid and the picturesque, instead producing a robust, yet elegant art – visually and technically exciting – all qualities associated with the finest moments of the English film movement.

1 See Annabel Nicolson's description in 'Artist as Filmmaker', in *A Perspective on Avant-Garde Film*, Arts Council Catalogue, 1978, p. 30, also published originally in a longer version, *Art and Artists*, December 1972.
2 See Deke Dusinberre's 'St George in the Forest: The English Avant-Garde', *Afterimage*, 6; Birgit Hein, 'The Structural Film', in *Film as Film*, Hayward Gallery, 1979 Catalogue.
3 In conversation with William Raban, 1983.
4 In programme notes for *Festival of British Films*, part of Camden Festival 1973.
5 Deke Dusinberre's programme notes for *Avant-Garde British Landscape Films*, Tate Gallery, 1975.
6 David Curtis in *Studio International*, March/April 1976.
7 See Michael O'Pray, 'William and Marilyn Raban's *Black and Silver*', *Undercut*, no. 5.
8 Adrian Stokes, *The Invitation in Art*. Tavistock, 1965.
9 Adrian Stokes, 'Form in Art: A Psycho-Analytic Interpretation', in *A Game That Must Be Lost*, Carcanet Press, 1973.

reading 'light reading'
joanna kierman

Light Reading is a new departure for Lis Rhodes. As a personal drama, both metaphoric and psychological, it is radically removed from the visually abstract, systemic, and coolly intellectual films previously associated with the filmmaker.

The previous films were made by applying manufactured graphic marks such as 'Letratone' directly on to the film strip. The graphic textures simultaneously covered the image and the sound area of the film, producing by the same means visual and aural rhymes and tones. The film strips would then be optically printed with manipulations of focal length, camera movement, repetition, and duration. While this work is clearly based in the processes of the film medium, it displays abstract experimental qualities usually associated with music rather than the visual arts. Through the use of a logical system, the

films present an enclosed language which provides its own conditions and limitations for production and reading. The work assumes an objective status, standing apart from either a social or an individual context.

Over the last few years some artists and critics have recognised that such 'pure' works can become appropriated by the very same ideological discourses and institutions which they oppose. However, *Light Reading* is not a change brought about by the general 'formalist dilemma' (to which it would be a late response). It results from the recognition that our patriarchal society elides the sexual identity of feminine utterances, projecting instead a masculine construct of femininity as the *difference from*; or incorporating feminine speech in the terms and definitions of masculine constructs as *indifference*. It is

hard to imagine what a fully feminine speech might be, since all language has evolved under masculine domination. *Light Reading* attempts to shake free of the objects and categories of language, especially those of sight. In seeking a language which speaks her as a female subject, Lis Rhodes turns over and folds back language, piecing together an immanent story of her struggle in a double movement of negation and construction.

Although in *Light Reading* Lis Rhodes uses forms and principles from her previous work, their meaning and function, are radically altered by their new disposition. The speaking voice of the filmmaker is central, the images always caught in relationship with the voice, its expression, the words which it speaks. What is spoken takes the form of an internal dialogue – questioning, describing, reiterating. Verbal language is used symbolically, but also playfully, even comically, so that meaning slips in between words/phrases – 'could she not mind for herself? could she not change her mind?' – taking advantage of language's capacity for conceptualisation, yet evading its tendency for fixing meaning in identity. The filmmaker's use of her own voice asserts unambiguously the subjectivity, and the personalness, of what is uttered. That the text in the main uses the third person 'she' indicates (among other things) that the speaking subject is a construction within the film's discourse, a place which could be taken by other (female) subjects; both filmmaker and spectator become 'she' from each other's point of view. But in using the filmic forms that she has developed over the years, Lis Rhodes speaks for herself, or perhaps more to the point, *through* herself. The images become touchstones for a past 'not past', which must be re-read, made to give up other meanings.

The film begins in darkness, with only the woman's voice heard speaking with a restrained urgency of darkness, light, sound and presence:

she will not be places in darkness, she will be present in darkness, only to be apparent, to appear without image, to be heard, unseen, she lightens her own reading, she reads by light of herself.

A metaphor is set of darkness and physicality; voice is presence, closer to the body; light is knowledge, the public display of truth. These metaphors already exist in our culture, in the history of Judaism and Christianity, and in the history of Western metaphysics. They suggest that the film may become

an archeology, reaching back to before history. The images, when they appear, also connote such a meaning. Black and white, they suggest the early silent cinema; a certain out-of-focus negative image of a head looks almost foetal; the abstracting quality of black and white film stock is intensified by the two-dimensional images. While the metaphors of light and voice are strongly evoked, the essentialism caught within them, the implied quest for origins, is equally revoked by the real process of the film text which allows meaning to slip and slide, to return and return again to new beginnings.

The first image is strands of black film typewriter ribbons, the letters stamped out and showing white. There is a similar image, in negative, which shows the relief edge of stencil numbers. Both images are made by shining a light directly onto the object and through the breaks in its surface, exposing the film. The images are transparent and shadowy, dark and luminous, echoing the image of light emerging from darkness in the reading. But the numbers and letters, although the symbols of two languages, are unordered and unable to signify within their systems. Black and white still photographs, sometimes shown in negative, intercept the numbers and letters that move rapidly up the screen as though on an unwinding scroll. A transparent ruler, placed across the photographs on the animation rostrum, indicates the accurate measurement involved in filmmaking; a pair of scissors indicate the cutting of the shot, and the carving of the image from the world. Juxtaposed with a verbal text which is sharply phrased, and camera movement which is mechanical and swift, these objects also imply a critique of their own properties. The measurement of the ruler could suggest the constraint of logic, its overdetermination, and the cutting scissors a vicious weapon signalling the oppression of patriarchy. What is acknowledged here is the presence of contradiction within the filmmaker as female subject, the uncertainty about what is the imposition of the outside world. The verbal text plots the polarities of logic and feeling through a constant back and forth movement between brusque directions for filming and printing – 'total length four hundred and forty feet. Print next twenty feet head to tail' – and lyrical, evocative passages – 'the tree is olive with new leaves, the white stairs let in light'.

While looking for a story, the text tells of finding the beginning and end collapsed into one another, and a past which threatens to submerge the present. Sequence does violence to thought but, 'in a

LIGHT READING Lis Rhodes

moment the story was apparent'. A particular narrative segment is repeated twice: 'she said I was to wake her in an hour and a half if it didn't rain. It's still raining, what should I do? Should I wake her or should I let her sleep longer.' This segment stands out from the text because it implies a temporal and spatial location, which makes it open like a vignette from the symbolic abstraction of the verbal text. An image of an unmade bed, which is repeated many times throughout the film, also has the quality of a narrative fragment, part of a much larger scene. The image is a black and white photograph which has a torn edge and is very grainy, as though blown-up. Across the sheets on the bed there is a deep shadow which is hard to identify, even when the photograph is zoomed into close-up. It might be a sleeping body, a vast blood stain, or just a shadow. Both fragments concern doubt: in the verbal fragment an action is suspended in irresolution in a context suggestive of depression; in the picture there is doubt as to whether a violent action has already occurred. The two fragments are also connected metonymically by 'sleep' and 'bed'. Another statement, 'I dreamt last night that I was dead', could also apply to the photograph, extending the metonymic chain to bed/sleep/dream/death. But as this linear chain of associations is constructed it also begins to function as an encompassing metaphor for an unconscious or murdered psychical self, capturing 'story' in an image.

Most of the text uses the third person 'she' but the first person 'I' intervenes when the story fragments quoted above emerge from the surrounding more abstract discourse. The use of 'she' is a key textual strategy since it gives the sexual identity of the subject, it disunifies the subject creating conflict and different subject positions, it extends subjectivity to other 'shes', and most importantly it provides

a fictional self distanced from the authorial self. When 'I' intervenes with the story, the authorial self purports to break through the text in direct address. But then of course 'author' becomes a fiction in the text, rather than the implied author lying behind the text. Such an anterior author is constructed by any text; what happens here is that the place of author is represented by both the textual figures 'I' and 'she' which become aligned and proximate as divisions of the self. The spectator/reader having already accepted the 'she' as a surrogate 'I', is forced at the interjection of a textual 'I' to acknowledge the division of the subject in speaking. Drawing attention to the division of subjectivity gives depth to the metaphor of the self who, unable to speak herself, is asleep, or dead, or dreaming.

The suggestiveness of the spoken text, the fragmentary, constrained vision of the images, encourage an interpretative response from the spectator. While a familiarity with feminist discourses might well inform an interpretation of *Light Reading*, in lacking that knowledge little would be lost except the 'feminist' label and the pointer it gives to 'further reading'. The film forces the spectator to read for herself, to take the responsibility and the authority for a reading. The construction of an interpretative spectator coincides with the filmmaker's conviction that her own knowledge is valid in itself; that it does not require the endorsement of an outside authority, that listening to the self is the only way past masculine structures. Yet meaning in *Light Reading* is not completely open, unconstrained; the spectator is quite forcefully chanelled towards realising certain ideas, encountering specific difficulties. Using metaphor and literal images the film text makes explicit references, but it does so without naming, using signs symbolically, not indexically. And alongside the symbolic, representational plane is placed a for-

mal, material plane which carries a different kind of meaning. A surface with the translucency of a black chiffon veil, for example, or the imagined thud of the metal letters against the delicate typewriter ribbon, produce feelings which are experienced in their immediacy, without the circumlocution of thought. An idea can be made at once explicit and elusive. For example; the metaphor of light operates crudely on one level because it is a metaphysical cliché, but it becomes multiple by appearing in different verbal contexts, gathering meaning to itself, and restoring the manifest light of the screen to signification. Thus the spectator is drawn in by accessible, known imagery, but finds that imagery transformed, made difficult and uncertain.

The textual process interweaves several themes and narratives. The central narrative is the tortuous coming-into-being of the film itself, which could also be understood as a coming into consciousness. The film begins 'surrounded by sounds no longer heard, images lost from sight', and then verbally interweaves the development and frustration of sound and image. The visual images seem to work like a fulcrum in this process. Few in number, and apparently denotative, they intensify the words and in return become filled with meaning. One is also aware of the meaning shifting while the image is the same. For example, there is a black and white photograph of a man's legs in stride which relates to a wide-image of the sound of footsteps. Initially there is the sound of footsteps 'moving backwards and forwards'; then, 'sound of running footsteps'. These phrases are preceded by directions for filming and printing – 'stretch print the next frame six times'. For images, to begin with 'blank frames', precede sound; and sound precedes thought. 'The sound of the shot is louder'.

Sound and image become mixed, their sensual information entwined. The shot could also be from a gun, and one thinks in this connection of the violent-looking bed where a crime might have been committed, holding its mystery.

As the sound develops, so does the image. There is a photograph of some spectacles in negative. The shot resembles an X-ray and suggests close inspection. But this image is difficult; seeeing contains a contradiction – as it reveals it also obscures. Throughout there has been a critique of logic, rationality, measurement – 'how can you feel so reasonably?' – which is presented as aligned with the objectification of sight. The reader speaks of looking closer, but the frame fixes her, leaving her without an image that she recognises. 'Frame' is the word reiterated continually in the reading. The film text flees the conspiracy of the frame to capture its meaning, thus the strangely unrevealing quality of the images. They behave like verbal language with an arbitrary relation to their referent, rather than being tied by resemblance. The resemblance of the image to the world too easily and innocently repeats its ideology.

There is one shot of Lis Rhodes, as she is seen over the shoulder, reflected in the round mirror of a powder compact. The voice may speak and hear itself, but the image of the self must always be in reflection, from the mirror/camera, or from the other who looks. 'I am both subject and object', she says. It is here that the discourse of the film can be understood as specifically feminist. Women must see themselves as they are seen by men; they have never been in a position to produce an image of themselves.

There is an anger which sweeps out in the vanguard of *Light Reading*, threatening to run off with it, or burn it up. It is an anger that makes *Light Reading* political, because it militates against the existing order, and seeks to address other women. Poised precariously, absolutely vulnerable, *Light Reading* manages not to be consumed by anger, but produced by it. This is managed I think, by the juxtaposition of two extremes of expression. On the one hand the film is forceful and declarative, using an expressionistic style of rapid mechanical camera movements and high contrast black and white imagery, to communicate to the spectator notions of psychological violence and angst. The connotations of the expressionist style are as accessible as the thematic metaphors of light/darkness, and voice/silence discussed earlier. On the other hand, the film uses these known images and strong connotations in a process which makes their meaning multiple and even elusive. For although *Light Reading* is polemical and aggressive enough to make a political intervention, it is a poetic film, not an essay. As poetry, it presents a political position throughout its structure, not solely in its rhetoric. Part of that position is the slippage of the film's meaning and the personalness of its meaning – personal to the author as an individual, and to the unique understanding and interpretation of each individual in the audience. Balanced between politics and poetry, *Light Reading* bothers the spectator with unanswered questions and unresolved meaning. It is this 'bother' that pursues the spectator long after the film is over.

descent of the seductress
jean matthee

One map out of at least fifteen sets made for the purpose of orientation during manual optical improvisations.

Filmstrips (overleaf) taken from a body of work fabricated from purloined footage (always less than 24 frames) lifted from mainstream 1950s melodrama

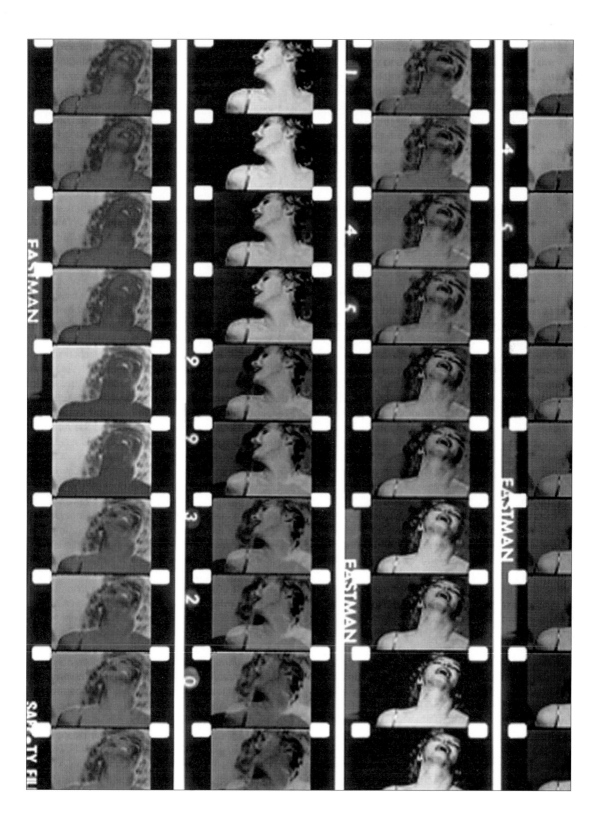

'almost out' by jayne parker
nina danino

ALMOST OUT Jayne Parker

Almost Out is a confrontation/statement with fragments of dialogue.

I film my mother in a studio. She is naked. She can see her image in a monitor. I am afraid of filming my mother. I am afraid I will make her angry. I want to see my mother as she really is but I do not know how to look at her. When I try to imagine filming her I only see words. My mother allows me to film her because I am her daughter. She does this for me. She wants to ask me if I think she has been a good mother.

I controlled my mother when I was inside her, growing. She expelled me. I want to control her now. She does not allow me to possess her. Her body was mine when I needed it. Now it is hers again. She has claimed it back. I want her to desire me. She says she does not. My mother is a symbol for power, authority, control. I want to please my mother. I think I want to please all women. I want power. To be seen, to be desired and to remain untouchable is to have power. The cameraman films me. I am naked. When I see my image on the screen I do not associate my image with myself. I do not feel like that image. I see myself talking, taking on a pose, displaying an attitude. I become a spectator of my image. The image is fixed, I change.

I feel that my mother is inside me. She is very heavy. I want to push her out, gently, because I care for her and do not want to hurt her.

questions by nina danino

Editing: The Daughter speaks her parts like in a play. She uses a script to which she glances when she forgets the exact lines. This is like in-camera editing, her participation, being filmed over 'real', unbroken time. What is the meaning behind the decision to reveal the scripted nature of her lines in this way, and conceal the structuring (editing) of the Mother's responses?

Lighting: Both protagonists were naked. The Mother was framed in mid-shots and close-ups. Her face and shoulders, her lower body, her upper torso, sometimes filmed from a low camera angle looking up. Her body was fragmented and filmed in a harsh studio light. For me, this was in striking contrast to the Daughter's participation, filmed from a downward camera angle, in a red/soft light.

Sound: The Daughter's voice tones were hushed, soft, the lines of the script were poetic, having a somnolent, hypnotic effect. But in its repetition, the questioning directed at the Mother was both exhausting and demanding.

Camera: In relation to the nudity and in particular to the intimacy of the dialogue between Mother and Daughter, I could not reconcile the intervention of the camera as gendered, as male.

Acting: The end titles credit three people as the performers in much the same way that a television play would. The Daughter by so and so … the Mother, and the Cameraman. This seemed to be

ALMOST OUT Jayne Parker

a work, not so much about narrative or character intervention, but more about enactment and performance, similar in the manner of representation to, say, a Beckett play. Can you comment on the use of acting within the piece, for example? (I am thinking also of the first question on scripting and editing.) What I kept asking was 'Is the Mother's part documentary (acting or being herself) or 'enactment'? What was your position as a performer within the piece, as real Daughter, rehearsed part, as all these and arbiter, video-maker?

Audience: Somehow, because my position vis-à-vis these five formal aspects was unsure, I felt that I was being called to witness the enactment of something, but from the outside. This enactment itself remained sealed within its own internal structure, the relationships about which it sought to speak protected from the exterior.

response by jayne parker

When I film my mother I am questioning her. All questioning can be aggressive. When the cameraman films me I am making a statement.

My mother uses her nakedness as a reward – she considers it enough to show me her body. She is not a victim. She gives nothing away.

The audience has its own points of reference. I cannot answer for them. I do not try to manipulate the audience. It is taboo to show one's mother naked unless she is conventionally attractive.

'metastasis' by the aleinikov brothers, moscow: a review
peter gidal

In Riga, Latvia USSR I saw this extraordinary filmic (more gloaming than gloom) film. The following is the least I could do:

Neg…car…
…gas masks glowing…
operatic (screaming/screeching sound)…
missiles
submarine, tank, lights … (kitschmusic)
black and white interior shots … not neg anymore…
filmmaker's back … slow turn of head…
sits high on a chair ('like' Eisenstein?)
montage on steps of Odessa…
Chile … montage (organ blasts)
death…
PEKOAMA … opticals neg/pos/glazed pulsating
infrared (in black & white)
Duchamp
crowds swarming (Swan lake sound) Grovenor
Square police violence
death and art and rock and roll (russian)
3 words repeated over and over and over in loop
edits
slap on the kitch sounds, folksy russia laid over shot of
unhurried time, a donkey standing, still neither sentimental not
nonsentimental … a 'naturalistic' shot, amongst

everything else.
the donkey's legs quiver. bike rider. doom music.
dancing.
solarized glowering … the image on point of disintegration again and
again…
and again as before…
tanks, needlework, … sound: YADMUSHTO
PANASHDA … over and over …
the killing of a sheep…
gasmasks, people walking, pos, neg, walking, gasmasks…
aerobics, greenham common,
russian comedy routines…
the soundtracks' repeats repeat…
the image gloaming,
(the end is in the beginning.
Or not.)
Black leader, white frames, clear, black, grey, white, then silences.
black, grey
white.
End.

a nice plant for the middle of the table. Id get that cheaper in wait wheres this. I saw them not long ago. I love flowers.

Id love to have the whole place swimming in roses God of heaven

the mother's garden
nina danino

Virgin and Child with Angels in the Rosegarden (opposite). Xerox of painting and line of text.

One of five panels (13 x 10¾ ins) comprised of image and text photocopied from various sources; painting, writing, photographs. They accompanied five large-scale drawings made in 1989 on the theme of the maternal from images of mothers, grand-mothers and myself . I made this group of drawings as an act of 'getting close to' the subjects of my representation through the hand-made artefact, the labour intensive production of the image and the intimacy evoked by the act of looking – I see them as devotional.

We live in a civilisation where the consecrated (religious or secular) representation of femininity is absorbed by motherhood. If, however, we look at itmore closely, this motherhood is the fantasy that is nurtured by the adult man or woman of a lost symbolic construct in which femininity is focused on Maternality.

It is only normal for a maternal representation to set itself up at the place of this subdued anguish called love.

sources
Image: *Virgin and Child with Angels in the Rosegarden*, Stephan Lochner (Wallraf-Richardtz Museum, Cologne); *Line*: James Joyce, *Ulysses* ('The Bodley Head'); *Quotes*: Julia Kristeva, 'Stabat Mater', *Tales of Love* (Columbia University Press).

interview with chris welsby
michael o'pray, william raban

Michael O'Pray: You were a painter before you made films. What kind of paintings were you doing?

Chris Welsby: Prior to coming to art school in London, I was doing a lot of landscape painting. Afterwards I became much more interested in sys-tematic and abstract painting. I did a lot of straight-edge colour work of one sort or another – systemic pieces, I suppose, though I did not quite realise it. I was quite influenced by the systems group at Chelsea Art School, people like Malcolm Hughes, Peter Lowe and Jean Spencer. It seemed to relate very much to the kind of interest I had in music, so most of the paintings were actually sequential in some sort of way. Then I worked in photography, dealing with what Professor Coldstream called 'the despicable dimension' – time. It seemed a logical progression to move on to doing sequential photo-graphs like the *River Yar* series, and then, later, tape-slide pieces which led to film.

MO: How did you start in film – through art col-lege, the Co-op?

CW: Anne Rees-Mogg and Brian Young were at Chelsea, and they were keen on people making films. I worked with other people on films and I knew William also, and we started making films together – time-lapse ones at first, which is only one step, as far as I am concerned, from doing sequential photo-graphs in that one is always dealing with the frame as a unit, in very much the same way as in music you can deal with a note or a series of notes. Time-lapse was very much about the ability to construct a film frame by frame, and not at all about effect, although it obvi-ously has quite a dramatic one.

MO: You both made films together and yet only *River Yar* seems to have survived.

William Raban: The first film we made was a standard 8 film of the river Test – a time-lapse from dawn to dusk. It is the same view as *View Film* which I made afterwards in Autumn 1970.

MO: Was your interest in photography one reason why so many of those early films are static shot, where you seem to work within the frame?

CW: I suppose it was my old friend Monet telling me a few things. The idea of a single viewpoint just seemed simpler at the time. Later it became more complex. Even in time-lapse films like *Seven Days* I was dealing with pans though, but the earlier ones, as you say, dealt with a fixed viewpoint.

WR: You mentioned the painting influences as being initially of the 'Chelsea constructivists' – sys-tems paintings – but, on the other hand, you spoke also of the influence of music, for example, John Cage, and Monet – what about the whole concept of naturalism? A lot of the procedures you use in

SEVEN DAYS Chris Welsby

your films developed from your paintings and photographic pieces and are concerned with chance occurrences in the subject, so that the procedures you adopt are deliberately analytical, like the intervals are constant in the recording process of a time-lapse film. Your intervention at one level can be seen as quite minimal, as if you are always letting the subject represent itself.

CW: That brings me to a definition of landscape. It seems to me that landscape is furthest away from the influences of mind on nature, and I mean nature in its scientific sense. It can include everything from a chair, or a field, or an ocean. All along, I have tried to deal with something which is between what in nature bears the signs of mind upon it, what is structured, measured, systematic and predictable, and on the other hand, what in nature that is quite the opposite. So you have two poles, going from high technology, through architecture, through gardens, to landscape, although all of these things have the influence upon them of mind to a lesser or larger degree. To get away as far as you can from the mind's influence, you have to go to the middle of the Pacific! Most of the films are positioned between these two extremes – that which is more structured and less chance-like and that which is less structured and more chance-like. Since I use a camera which is quite mechanical – it is not exactly high tech of course, especially not these days – it could stand as a metaphor for technology. One reason for using landscape as subject matter is that it is at the other end of the sliding scale. In the later work, at least, I tend not to deal with the park or garden, but maybe just the sky or the sea.

MO: Is there any sense for you in the thought of nature being a threatening force which needs to be somehow controlled? Underneath, the schematic and rationalist account you have just provided there

is the idea that runs through all art, of the need to control, in some way, both the subject matter and the materials by which it is constructed.

CW: Yes, although the idea of control is a partial and not a total thing. An image which really interests me is that of Brecht and Weil's *Mahagony* where there is a city, and, at the same time, a map on the wall of a cyclone coming closer and closer. Thus, on the one hand, there are all sorts of machinations and politics (with a small 'p') going on, and on the other, there is a force which is much greater. If you have ever been stuck out at sea or on a mountain in a blizzard, you will have realised there is a force which is very much greater than you or your control.

MO: Are you aware of this idea when making your films?

CW: Yes. The structure of *Seven Days* is a balance between a mechanistic structure – the sun rises and sets, the time-lapse interval – and the vagaries of the Welsh weather – when it was sunny and when it was not – which you could not predict. The film attempts a symbiotic relationship between camera/structure, filmmaker and the landscape. As the structure begins to disintegrate or become obscured by the storm, the balance is destroyed and the result is ultimately death-like.

WR: It is interesting that you chose *Seven Days* because the panning movement you mentioned earlier is totally controlled by a machine that is pre-set, the camera being mounted upon an astronomical telescope mount. The turning of the camera on the mount is entirely manual and not by machine, it is your judgement whether the sun is in or out as to whether the camera points down at the land or up at the sky. Your presence and activity as filmmaker. and your being part of that landscape experience is undeniable. Looking back at an earlier film we made together, *River Yar*, there was no real reason why we had to be there when we made the film. If we made it now the machinery is there both for controlling the exposure of light on the film and for a completely automatic time-lapse. Do you think your presence when making a film is crucial to the film?

CW: In *Seven Days*, yes. I could have had a light-sensitive switch which would have told the camera when to trip, and would have turned it round if the sun came out or went in and would have given a threshold. But that would have involved much more machinery. We had to be quite careful really, for example in setting up the camera, not to destroy whatever it was we were filming.

MO: You would not be interested in making a

totally automated film?

CW: I think *Streamline* comes close to it because the camera just goes along ten yards of wire at a regular speed and as close as I could get it to a straight line, given the technical problems. That is what I wanted from it. Obviously, other films are less technically automated and involve my activity and presence much more. Films like the recent *Estuary* could have been totally automated, but it is important that it was not.

WR: I bet it would have been a very different film if it had been!

CW: Yes, it would be.

WR: I remember visiting you on the boat Christmas 1981. Your experience of being out there on the boat in the freezing cold, getting wet and rowing ashore in gales seems absolutely crucial to the audience's understanding of the film. One knows with *Estuary* that you followed a set procedure, the point of view of the camera being determined by the swing of the boat on the tide on its mooring chain, and the sampling of the sound and picture being every 15 minutes, however some incredible things happen – so-called chance occurrences – like the geese flying through the frame and the sounds on the soundtrack. It must be an incredible temptation to cheat your own system, to switch on the recorder or camera fractionally earlier or later to catch significant events.

CW: Yes, but to use the analogy of music again, just as to follow a score mechanistically, and to play the note exactly as it is written would make a very dead piece of music, so although I decide to take a four second burst of film every fifteen seconds, I may vary very slightly one way or another. Of course, if I vary too much then it simply becomes a different piece of music. It is important that I have a structure which is slightly flexible within given limits. If I cheated and went beyond those limits it is no longer that film, but another one.

WR: Another important point about *Estuary* is the deliberate use of underexposure which adds to the drama of the experience of watching the film, especially in the storm sequence. An automatic light metering system, if you would have done it without being there, would never have got that quality of light in the film.

CW: Yes, that is the main area of flexibility in *Estuary*. Every exposure was taken with a Weston light meter. I decided whether it was important to emphasise the sea or the sky or a cloud detail, or whether I wanted a balance between them, or to bring out a particular colour or tone. It is very much composed in terms of the exposure.

MO: Landscape film can fulfil two requirements – a formalist one and an aesthetic one gained from the image itself. For example, *Streamline* is a beautiful film and not just formally, but in that it is of a stream, of stones beneath moving water.

CW: But it is the way it is filmed that is significant, isn't it? I hope it is anyway. Just the idea of a straight line traversed at a regular speed could not be less dramatic. I feel that whatever 'dramatic' content there is in the film comes from the stream, where it gets louder and softer, where there is a still patch, and where the sensation of a straight line gets destroyed because the motion of the water is too strong. For me, the straight line in *Streamline* is a metaphor for technology.

MO: But the ideas the filmmaker has in making the film are often very different to the viewer's in seeing it.

CW: The film is very much based on experience. If you ever walk up a steam like that you walk a high bit of ground and suddenly it is quiet and you can talk and hear. Then you reach a steep bit and it becomes very noisy and you have to yell and shout. *Streamline* is, to some extent, based on the experience of walking up the stream.

WR: There is an extent to which your experience as a filmmaker is not transformed, because ultimately the viewer's experience of *Streamline* is no less random or chaotic than your experience in making the film. You do not orchestrate the way in which you use the camera relating to particular preferences and choices in camera movement or framing, and allow these decisions to be made for you by things going on in the landscape or by procedures you set yourself. The represented image of the landscape does not actually transform into something else other than a picture of the landscape. You preserve the chaos and randomness of nature and do not try to harness it into a procedural whole.

CW: But it is transformed and harnessed by the fact of the straight line as a metaphor for technology. The images in *Streamline* were very highly selected. There was about two miles of stream. I spent a lot of time wandering up and down trying to decide which particular composition I wanted, not unlike composing a photograph. The picture is ten yards long and I saw it at the time as a ten yards long photograph. It became quite confusing deciding which part of the river was right or wrong. I left markers and then decided. In a way it is like some of my static-shot films. *Streamline* has a fairly conventional composition with a sort of climax towards the end just as in Romantic music. In

many earlier films with static frame shots I have used quite conventional Golden-Section-like compositions, and by doing this one can cancel out that side of the decision as to what the composition is going to be like. I was thinking in *Streamline* of the film stock, which is 300 feet long, if rolled out, giving one a straight line of film showing water and rocks. There is also a similarity between the celluloid of the film and the water's surface when the film goes in and out of focus because the camera was quite near the surface of the water.

WR: Was the speed of the camera's tracking movement determined by the film's speed of 24 fps?

CW: Yes, and the speed of the water. If I had tracked the film very fast the straight line would have been too heavily inscribed. I tried to time it so that sometimes the less predictable flow of the water would take over from the more predictable direction of the camera. At times, you know you are following a straight line, then suddenly the water swirls and you drift off. Primitive music and the Western tradition right up to Schoenberg use a similar structure – a straight line. In recent times, twelve bar blues and the music of Steve Reich for example are also concerned with a linear axis.

WR: You deliberately turn film conventions on their side, quite literally in a number of films where you both film and project in portrait format. By such a simple device as turning the frame on its side, it seems quite clear that you are working outside the area of cinema and relating more to fine art.

MO: To extend that point, in the last few years in *Shoreline I* and *II* and the *Estuary* installation work, and the new work – a film projected onto a mirror in the gallery ceiling, producing a cone of light on a screen hung parallel to the floor at about knee height – you seem to be directing your work towards gallery space. The light-cone work – which has not been seen yet – seems very sculptural a presence qua object within the gallery and not simply a film. How much did you ever see your work as relating to mainstream cinema in the way that Gidal insists that his does, for instance?

CW: Practically not at all. I have enough difficulty with the weather – the tide, rain … [laughter]. The best films, from my point of view, I have made have been by myself with perhaps one other person. The idea of dealing with specific weather conditions, and also with actors and film crews would seem chaos to me.

MO: But if those problems could be ironed would you be in the least attracted to making, for example,

an 'experimental narrative' film?

CW: Not at the moment, but it is an interesting proposition.

MO: It seems an important question, for me, whether avant-garde film today aligns itself with the fine art domain or mainstream cinema, in whatever form. William's *Black and Silver* and Malcolm Le Grice's later work seem to pose that problem. In the three gallery pieces – *Shoreline I* and *II* and *Estuary* – how conscious were you, if at all, of moving towards a more fine art/gallery terrain with these works?

CW: The three pieces you mentioned are concerned with relating gallery space to an outdoor space, particularly in *Shoreline I*. They are quite different films. *Shoreline I*, when seen in a gallery, has its own perspective which is carried along by the idea of the horizon going right through the piece. But when you look at it from one end of the room to the other, it has a perspective which has to do with the gallery, and absolutely nothing to do with the perspective of the shoreline and horizon. It is a totally artificial seascape. You go into the gallery and you are confronted by something which is 30 to 40 feet long and 6 feet high, and you think 'Ah, the sea'. But actually, it isn't. Gradually you see that they are just repeats of the same film loop and that the perspective is totally impossible. They could not possibly be different loops of film otherwise the cameras would have had to be each about twenty miles apart, and there are not that many beaches that are that long and that straight. Or, the camera would have had to have been turned around 200 for each shot, in which case the horizon would have been curved as in Jan Dibbett's *Dutch Mountain*. The other thing which is quite important is the sculptural aspect of the work. The projectors are on six identical plinths, the loops of film are visible, strung up to the ceiling, all of which confronts the very bland image of the beach. Like two opposing armies, they confront each other – the means of representation and the actual representation itself. It is that element I am trying to emphasize in the new piece.

WR: Isn't there a contradiction? The six projectors in line are not the same as the single camera which took the shot, so you never actually reveal the trick. In fact, it is implied that the cameras must have been twenty miles apart because of the parallelism between the six projectors and six screens.

CW: With a little thought though one would realise that it was impossible. Finally, one ends up looking at the projectors, the loops and also the image. Somewhere in between is the meaning of the film.

STREAMLINE Chris Welsby

MO: The recent film, however, involves the projector being concealed so that it is as if the cone of light is coming out of the gallery ceiling.

CW: Yes. The film has been shot but is not finished yet. It does rely heavily on what I call the sculptural aspects of the work. There is a cone of light with a screen three feet above the ground.

MO: It seems to be at quite a remove from all the other films.

CW. Only because it is freed form the idea of a very definite duration – a very definite narrative, as in *Seven Days* and *Streamline*. I don't think one could see a narrative in *Shoreline I* or *II*.

WR: *Streamline* is narrative surely in so far as it is a representation of an unfolding of events.

CW: Yes, it has a beginning and an end – a very definite one.

MO: In your writing about technology, nature and film, there is a sense in which you seem to see your filmmaking as almost a moral activity and stance in terms of trying to defeat the aggressive and destructive aspects of technology.

CW: It is certainly not a nineteenth-century Rousseauesque stance by any means.

MO: I didn't mean moral in a derogatory sense, which was a reaction against the technology of the time and its destruction of the landscape and environment. My sense is not that, as I use technology – a camera which is used as a representative of technology as a whole. The way it relates to landscape is very important for me. The idea of the structure and the context of the film simply grow up side by side and are worked out together in some sort of way. I do not impose my ideas on the landscape.

WR: In many ways that is close to Ruskin's idea of being true to nature and you said earlier that you choose procedures which are sympathetic to a particular location. Is there any similarity there?

CW: No, I don't think the work is true to nature. I think it is an absolute distortion of nature.

WR: So are Monet's paintings.

CW: Yes. I wouldn't say that I was anyway involved in a sort of compromise between art and life.

MO: Do you see the films as a way of educating people into having a certain attitude towards their environment and to technology even?

CW: It is to do with a reassessment – what is this thing we call landscape? What is this thing we call nature? I see landscape as part of what we call nature, which is everything that cannot be included in the definition of mind. And nature would include, on this definition, all of technology too. If one uses landscape imagery as I do, it is simply using one end of the spectrum of what one calls nature. One could say that anything which is not landscape is mind, that is, ideas and concepts.

MO: So nature is matter.

CW: Landscape is a subdivision of nature as a whole. The degree to which we call it landscape is the degree to which mind has had an effect on it, the degree to which it is structured and modified by ideas and concepts.

MO: An unrepentant dualist!

CW: No. I have obviously confused the issue by speaking of 'opposites': mind and nature, technology and landscape. But it is the structural relationship between these categories which matter. All the films are concerned with integration. The relationship between mind and nature is in a constant state of redefinition. Technology and landscape are both part of nature. To divide the intellect from the emotions and set one against the other is asking for trouble. To set technology against nature is also foolhardy. Mind is not nature, but the relationship of one to the other is not an opposition between two poles. It is the constant modification of one system by another. To see mind as being separate from the body is the ultimate folly.

MO: Your work is quite unique in many ways, particularly in its almost hard, purist concerns with landscape and film form from which you have never wavered. Has this been difficult?

CW: I don't know about filmmakers but I know that people in the arts are always going to be concerned with landscape. While it exists, and I feel it will for a while, it seems an enormous subject to deal with. I do meet people I knew from the past who ask if I'm still 'into' landscape, but it's, to me, a totally bizarre question.

WR: Whilst many of your procedures that are concerned with representing a landscape do seem to pick up methods of operations found in the landscape, for instance, the *Wind Vane* films which use the wind's power to make random movements of the camera, you have never made a landscape film which has not been concerned with making a landscape image. You have never taken an elements of nature to make a film, such as an abstract film. Is this deliberate?

CW: There are two answers to this. Firstly, I don't like to re-edit films after shooting, in the printing or on the bench. It becomes like nineteenth-century studio painting, and consequently loses the power and immediacy of the landscape. Secondly, I think my films move in and out of being abstract images e.g. the long blank sky section of *Seven Days* and sections of *Windmill*, when the whole picture surface is broken up into non-representational areas of light and tone.

WR: Are there films that you look back on as more or less correct in their procedures? In other words, are there certain procedures you would not use again and others you might wish to develop now?

CW: I don't think I shall use time-lapse again. I find the 'real-time' sampling of Estuary, Sea/Shore and Cloud Fragments are less distracting as a means of composition and compression of time. Being based in London can be a problem: structures and ideas exported to a landscape don't work. It's important that my perception of landscape and the building of a film structure work in parallel. It is therefore impossible for me to predict in any detail which filmic structures I will adopt or invent in future. It is important at present to get closer to the source material. *Estuary* was a step in this direction and the new installation piece will take this move a stage further.

documentation in sand

<div align="right">

nick collins

</div>

At 2pm on a Sunday a figure, sliding on it's stomach, descends a steep incline, and leaving a pink train in the otherwise yellow sand, moves towards a small lake, outside the picture's edge. At 8.30 on Monday morning, if it has not rained, among the tracks of vehicles, unlike the marks of any machine, the depressions of knees and elbows. For a short time, the figure gives scale to the space, but afterwards, and in the photographs, ignoring the green fields and trees which fringe the place, the abundance of visual fact contains no information and without the evidence of movement, the myriad prints of wheels oscillate in nearness and distance.

sadness 'n' beauty
will milne

When did art leave the beauty business, beauty leave the art trade? A word that sounds like bathing queens or prize roses, verging on the kitch and fifties. But willy-nilly there's things that lassoo you, cut to the quick, too often for no reason at all that you can think of, and sometimes there's nothing that quite maps that territory like the word 'beauty', bleeding overtones of tragic, fleeting fragility and incipient absence. We know all the bull about art as pursuit of some neat truth: kill some dragons/save a theoretical princess. But after its all been and gone there's the factor that puts bums in seats, turns heads or makes money move, and it's not all neatly thought out. Not only is it irrational, but it's downright perverse, a moth to flame situation, the lure of the lurid, the pull of the drop. Nothing sells like bad news. Sadism? Misery abroad makes horn the sweeter? Masochism? Only desolation can unzip the blank pursuit of logical alleys? Is it endemic to the worship of the graven image? Those who stupidly seek satisfaction from objects will suffer the inevitable impossibility of its consummation? Or is it that satisfaction cannot be given – that depicted desolation is a negative from which to print something more positive, suitable material for transmutation, transubstantiation or translation? It could be an inevitable part of the process of any progress – the tragedy of time that kills as it delivers and sometimes it hardly seems worth the effort. Either in the child development paradigm or in more everyday situations, the new and the old, fear and hope clutch and twine around each other. If stasis wins it's the nine-tenths law of possession, if movement does, it's a crime, something's lost, so there's this constant fight, and therefore any good object is soon surrounded by shadows and wraiths, infested by them and invested in them. Nevertheless, that's the truth, and that's what we're after, after all, isn't it – the whole truth and even a little bit more, just a bit more in case there's a leak in the truth bucket. This so-called truth means that that's realistic, that sadness is a valid position, no more of this 'smile, brother, smile' crap, come on with the rain. No point in doing happy works, there's no action there. Ditto abstracts. Absence makes the heart grow. Where it grows to is anybody's guess – if it grows it may well leave their art, or it learns to surround and escape its own hollows, framing them, shelving them, putting them in mothballs or on television. But it's better to be seduced and abandoned than to be forever fixed in one state of mind, a single hang of heart. Not a whole lot better, just a bit.

chapter 4 cultural identities

introduction
nina danino

The *Cultural Identities* event was held at the Commonwealth Institute, London, in March 1986. It was the first time black and white filmmakers, critics and theorists from different cultural backgrounds came together in a series of film screenings and discussions which examined how individual and national identities are ideologically defined by, perpetuated through, and constituted within film and the institution of cinema. This chapter presents the four discussions held at this event.

The introductions by Behroze Gandhy, Kobena Mercer and Reece Auguiste were commissioned for the publication of the debates in *Undercut* 17 with the aim of contextualising for the reader the central questions and key issues. In these discussions, questions of cultural identity, i.e. gender, ethnicity, sexuality, nationality, are raised in relation to representation and the film image, in particular how the films screened at the event, construct, question or challenge these identities. Therefore, the point of departure and agenda for these discussions is set by the films.

'Culture and Representation' raises questions around how racial or cultural difference is represented in film. Referring to the parameters set by ethnography as a predominantly Western film practice which often uncritically advocates notions of 'objectivity', the central issues at stake are: What criteria determines objectivity? What is the status of the colonial/Western gaze? What powers are invested in this 'objective' look? This is raised by three films, which in very different ways, address cultural difference from the subjective perspective which defines or perceives it: *Reassemblage* by the Vietnamese filmmaker Trinh T. Minh-ha, is a visual study of women in Senegal, *Sunless* by Chris Marker is a travelogue/film essay of the impressions of the modern landscape and culture of Japan on the Western traveller/cameraman and *Moi, a noir* by Jean Rouch chronicles the life of a young black docker in Abidjan in the Ivory Coast, using a commentary by the protagonist recorded live as he watches himself in a cut version of the film.

This question of 'objectivity' and representation is followed through in 'Questions of Language'. *Riots and Rumours of Riots* by Imruh Bakari is a documentary about contemporary black youth, Caribbean immigrants' experiences in Britain and events leading up to the riots of 1958. *News and Comment* by Frank Abbott is a critique of news and current affairs presentation in television and the media. Both films critically evaluate received 'norms' of objectivity, by drawing attention to the assumptions and constructions behind reportage and documentary. These films also raise the notion of a language of dominance which serves an established order, whether it is the language of patriarchy under question in *Serious Undertakings*, *Signs of Empire* or *Unsere Afrikareise*, which use very different strategies to uncover the assumptions and power behind the images and language of colonialism.

The films discussed in 'Sexual Identities: Questions of Difference' raise a number of issues ranging from the place of representation in feminist film practice, particularly in experimental film as raised by Lis Rhodes' *Light Reading*; the representation of sexuality in Jean Genet's allegorical tale of homosexual love, *Un chant d'amour*, the representation of race in Isaac Julien's *Territories*, and questions of racism in Julie Dash's film *Illusions*, which uses the conventions of narrative cinema in order to critique how white Hollywood denies 'difference' and excludes black intervention. As with *An Epic Poem* by Lezli-An-Barrett, a feminist re-working of the myths of love and *Watercolour* by Joanna Millett, which comprises a series of filmic experiments with the material of film (as film), these films refuse the conventional methodology of narrative cinema and attempt to re-work and construct new cultural meanings presenting the 'personal' or a subjective perspective, as an integral part of the work. Race, gender and sexuality are seen as facets of cultural identity, of equal importance to, for example, class. Importantly, this debate outlines, once again, some of the problems for oppositional film practices which, while not wanting to refuse rep-

resentation altogether, have to resolve questions of how to represent sexuality, race and gender without duplicating and perpetuating racist, sexist or heterosexist positions. The two films which set the agenda for 'Aesthetics and Politics', are *Close Up* by Peter Gidal, which combines abstract visuals with a soundtrack comprising interview material with Nicaraguan revolutionaries, and *Hanoi, Tuesday 13th*, by Santiago Alvarez, a filmed montage, which includes re-worked newsreel of the Vietnam war. Both films deny the visual strategies of narrative cinema which treat film as 'transparent' and open up the debate around questions of representation or non-representation, narrative or anti-narrative strategies in film as constituting political positions in themselves and the politics and

place of desire and pleasure in oppositional film practice. What is called for finally, is the critical space to enable the development of a new aesthetic, a new set of criteria defined and articulated by the needs and demands of black independent film practice in Britain.

These discussions ought to be read in the light of a first meeting between filmmakers, critics and theorists from different cultural backgrounds, where vocabulary is being formulated and the agenda to some extent is being contested and negotiated. At the time and in this re-publication, the exhilarating clash and exchange of ideas and positions still represent a range of questions which continue to inform and be relevant to representation in contempary moving image.

culture and representation
jean rouch, john akomfrah, clare joseph

Jean Rouch: The hero of *Moi, un noir* is Oumarou Ganda, whose name in the film is Edward G. Robinson. He was a very simple worker on the harbour of Abidjan, in the Ivory Coast when I met him. I was doing a survey on the migrant people from the north of West Africa who were going to the south, to the Ivory Coast and Ghana to try and find a job. I met him working as a docker in the harbour. He was very poor, a veteran of the Indo-China war and he was a kind of romantic rebel who was against everything. At the same time he was full of art and we made *Moi, un noir* because of his own strange story. He was, in fact, in love with a girl who was a prostitute on the harbour and he had a group of friends, one of whom was a boxing champion – they were a kind of family who tried to reconstruct their own village life in a big town. One of his friends, Toure Mohammed, who played the part of the American FBI agent in the film, was a little drunk one day and he asked a taxi driver to drive him down a one-way street and he said to a policeman who stopped him, 'You cannot stop me because I'm an American federal agent.' A fight started and unfortunately he hurt the policeman and was sent to jail for three months. Fiction was in fact becoming reality. The film, which had started as a kind of chronicle of a group of young African lads and girls in a town in the Ivory Coast, became a kind of comedy and then it became a tragedy because Toure Mohammed had to spend three months in jail.

Moi, un noir won an award in Paris in 1958, but the

premiere of the film in Abidjan was censored by the government of the Ivory Coast. The authorities said that the film was violently against the French, against the white people, that it was a dangerous film. In the film there was a fight between Ganda and an Italian sailor. They said that it was impossible to depict a white man fighting a black man.

It was the beginning of a community and Ganda decided to become a filmmaker. Some years later we opened a workshop and a cinema in Niamey, a town in Niger, and I asked him to come there to be trained as a filmmaker. His first film, *Cabascabo*, was about his life in the French Army in Indo-China. It won an award at the Cannes Film Festival and Ganda became a kind of Ousmane Sembene. Their careers were very similar, because Ousmane Sembene also was an ex-soldier in the French Army. Oumarou Ganda became one of

MOI, UN NOIR Jean Rouch

the best filmmakers in French-speaking West Africa. He won a lot of awards in the festival of Carthage, in the festival of Ouagadougou and others. He died four years ago and his burial ceremony was attended by all the professors at the University, all the ministers, and the President of the Republic of Niger. We were very moved because it was the first time that these people were paying tribute to a creator who never went to school, who was a simple worker on the harbour.

My point is that a filmmaker using a camera as a tool can, at the same time, give birth to other filmmakers. Dziga Vertov, who was making films in the Soviet Union in the 1920s, said, 'What's important is not to make a film, but to make a film which gives birth to other films.' That's the reason why I like very much *Moi, un noir*; because in this film you have the metamorphosis of an actor who is not an actor, who was a human being who discovered the power of filmmaking and became himself a filmmaker, and I think it was a good introduction to filmmaking; I worked as an anthropologist and the problem of cultural identities is of course, very close to anthropology. The work of Oumarou Ganda was also on the same subjects but in a very different way because he was inside the culture and he tried to make films which could explain to another public his own culture, his own beliefs, his own way of life, his own joys and all the sorrow that was his life.

John Akomfrah: The issues which Jean Rouch has been grappling with for the past 35 years or so in cinema are ones which throw up a number of problems for us. The Guyanese novelist, Wilson Harris, in his essay 'The Interior of the Novel: Amerindian/European/African Relations',[1] talks about 'the curious footnotes of history and history books which sometimes speak volumes of the interior of a landscape, the landscapes in which men lose themselves to find themselves'. For me, what makes this essay interesting, is the way in which Harris sees the footnotes of history as encounters. In this case an encounter in the most racialised of interiors; the Caribbean.

The encounter he talks about takes place in the 1830s between the English Governor of the islands of Demerara and Essequebo and an Amerindian chieftain called Mahanava who had gone to claim compensation for services rendered to the English occupying army. The Governor was impressed by Mahanava's claim that he had a large fighting army in the jungle but because he felt that the information might be exaggerated he decided to check for himself. His subsequent secret investigation led to

what I would call one of those 'moments of race', in which culture and representation become the same. A moment in which the body, in this instance a racial body, is simultaneously displaced and inscribed in culture in order that the business of constructing a new representation might begin. It is a moment that the Indian feminist Gayatri Spivak has called 'the moment of worlding'.[2]

The Governor of Demerara was mortified to learn that there was in fact, no army. The forces Mahanava had spoken of did not exist; he had lied. And it wasn't clear – this is the interesting point – how long this lie had been lived by both coloniser and colonised. It had governed relations between coloniser and colonised in the policing of the colony. The Amerindians were reduced, in that instance, to what Wilson Harris calls a 'nightmare relic'.[3] The process of unmasking the fiction of the Amerindian presence – unmasking and revealing this absence necessarily pushed it to the margins, to the footnotes, the 'other'. In this process which is simultaneously a process of revealing and of 'worlding', race isn't just an object, a facade; it becomes the very site of representation. And precisely because it is the site of representation it is the way through which the cultured body comes into focus. I think this is the point that we can easily forget in an age of ethnicity when some of us seem to be the prisoners of our culture, torn between cultures and so on.

Mick Eaton, in *Anthropology, Reality, Cinema: The Films of Jean Rouch*[4] mentions what he calls the 'institutional discourses of ethnology'. To understand ethnography he prioritises the semiotic sphere. Dealing with cultural representation is something we can't really do without talking about ethnography. In ethnographic film, instances of repetition, instances of difference, are almost implicitly anchored to questions of race. Instances of repetition appear in *National Geographic*-type films, for example, shamanistic cults, rituals and the endless array of disappearing worlds. These are not necessarily the material of Jean Rouch's ethnography but they are the stock-in-trade of some kinds of ethnographic film. There are also scenes of contrived subjectivity. There are the humanist attempts that underlie most of ethnography, masking cultures in favour of a global 'human family', so that instead of having distinct, autonomous, separate cultures, a human family is prioritised. Doing this merely reveals the 'nightmare relic'. What is ethnography without the idea of the native? Can ethnography exist without a process of ordering?

I believe that there is a double process of displacement and recuperation, which is best exemplified by

the story of an African filmmaker who went to see the film *Les Maîtres fous* by Jean Rouch in Paris. In this film the Hauka sect in Ghana perform rituals which involve personifying their colonial masters and, in the process, a dog is killed and its blood is drunk. After the film, the African filmmaker was greeted outside with: 'Oh look, one of those dog-eaters.' Perhaps the fate of ethnography is to be forever circumscribed by the drama of attraction and repulsion, to live and re-live a moment, the significance of which it attempts to fix as the final encounter, the encounter which will ultimately annihilate racial difference. If this is the case, we shouldn't be ashamed to admit it. I'm inclined to think that this is the case. When we turn to the footnotes in the history books of cinema, to the references on ethnography, we may well find that Wilson Harris was right.

Clare Joseph: *Reassemblage* by Trinh T. Minh-ha looks at how film is fictitious in itself and how it builds up a cinematic language that is also fictitious. The form that this takes is always based on the position of gender, race and class. Cinematic language has always been informed by these categories and for this language to be successful it has to be 'transparent', the audience must never truly acknowledge themselves and the way that their position is constructed around race, class and gender. *Reassemblage* points out a way of deconstructing and displacing this transparency in the very way the film is made.

The filmmaker says, 'I'm losing the need to express myself, the need to reform, to re-construct what I actually am'. She acknowledges the similarity between herself and the women she is filming. So she has lost the need to look for an 'other', an original, to locate what 'other' is. Once she realises this, she works at isolating the symbols that are usually used to indicate the self-destructiveness of black societies, whether they're in Asia, Africa or the Caribbean. She reworks these symbols in such a way that the audience, who depend for their knowledge on ethnographic and anthropological filmmaking, can either question what they're seeing and what is absent from the film or they can re-invest, re-instill their notion of 'self' into what they are seeing, whether the person is black or white. Through this, she acknowledges that the construction of identity within dominant cinema is built up through a re-investigation, a reworking of identity based on nationality and that nationality is always defined by the hierarchies of gender, race or class. She acknowledges that knowledge and looking are undivided, that they are the same thing within cinema and that nationalism itself is a state of

mind which is always reworked within cinema and is located around 'difference'. What black filmmaking can do and what Trinh T. Minh-ha's film does is to look at the contradictions in making a film which is based on an identity which is nationalist. She goes beyond that and says, 'I don't have to look for myself, what I'm filming *is* myself'. She uses repeated close-ups and pans to focus on detail, disrupting audience identification and building up information and knowledge about the people being filmed, but she acknowledges that, in film, the strategy of disrupting audience identification can be re-appropriated by dominant cinema. Consequently, throughout the whole film she asks herself and the audience, 'Why am I making this film?' She dislocates the camera from herself, from the audience by asking, 'Who is that subjective "I"?' But within this a contradiction can arise, identification can be formed by constructing an 'other' and she realises that her own identity has been constructed and is being re-worked by going to this country[5] to look at these people. The film is about focusing on these contradictions within itself and within cinema. The contradictions are based on dichotomies of nationhood and 'otherness' and can be understood only through investigating the medium which is used and reworking its elements, the dialogue, music, sync, sound etc.

JA: Do you see *Chronicle of a Summer* as a turning point in your filmmaking approach, as distinct from previous films which were non-sync?

JR: *Chronicle of a Summer* was made in 1960. In making this film I discovered two things. The first was technical; we had new camera equipment with sync sound, which was very light. This meant that you could film in places which might have been impossible before. *Chronicle of a Summer* was shot by two people. It was the time of *la nouvelle vague*,[6] it was possible to have an opportunity of making films. The second point was that it was a way of discovering my own tribe and what could be my own identity. That was very difficult for me because I discovered that I was a foreigner in my own tribe and that I was closer to my African friends than to the people in Paris and of course, this discovery was the beginning of something important for me. A very simple example is the attitude we have in Europe to death, and the attitude of my African friends to death, which is so different. Two weeks ago, in Paris, I was at the funeral of one of our professors who had died. It was so dull, it was like throwing a dead man into the garbage, and it was so different from what I had tried to understand in Africa that, at the time, I felt a stranger in my own country.

I was preparing an anthropological study about

the beliefs of the Songhay people, north of the Niger river, and I went to Accra because at this time, there was a new religion taking root. The religion of the Hauka had started in 1925, when an ex-veteran of the First World War came back to his own country on the border of Nigeria. There are in this country very important trance rituals in which people dance and are possessed by the spirits of nature: the sand god, the water god, and so on. This man came with new gods, these gods came from the Red Sea and their names were: the Governor, the Captain, the Lorry Driver, the Engineer, the Doctor and so on. They were the gods of the new civilisation, they were the gods of strength. These new gods 'spoke in tongues',[7] with an accent – an English accent or a French accent. In *Les Maîtres fous*, the Hauka play the roles of our civilisation, the Governor, the Doctor and so on and they kill a dog and drink its blood. It was one of the first times that we had used portable sync-sound recording.

I screened *Les Maîtres fous* at the Musee de l'Homme in Paris, improvising a narration from the projection booth. My professor and friend said to me, 'This film is a scandal, you have to destroy it'. I decided to wait. I tried to understand why they were asking me to destroy the film. I could understand the young African people asking me to destroy it, because in the film they saw some African boys perform a sacrifice and eat a dog, their faces covered with blood, but why had a French professor asked me to destroy it? Suddenly, I discovered the reason: it was because in the film these people who were dancing, playing the roles of our European civilisation, were making anthropology in reverse and it was unbearable to see. The blood on the faces of these people was more shocking, because it was the Governor who was covered in blood. The French title *Les Maîtres fous*, 'The Mad Masters', is a pun, meaning at the same time that these people were masters of their own craziness, but also that the Masters, i.e. the white men, were crazy.

At the time, the film was absolutely censored everywhere, now it is distributed everywhere and some of the more radical of my African friends consider that this film is, maybe, the best image of what was colonialism in West Africa. I have thought about why *Les Maîtres fous* had such an impact. What is the meaning of a concept in a culture without *écriture*, without writing? In the trance dance, very simple people were playing the roles of their masters, they were expressing a concept, and this concept was shared by all those who took part in the film and assisted this ritual. That was an idea which was transmitted to the film's audience. The film is very rude and brutal. From

my point of view, the image of my own society after *Chronicle of a Summer*, was more like the people in *Les Maîtres fous*, who were eating dogs, dancing, foaming at the mouth and so on, than the 'normal' people that I filmed in Paris.

The world has to be a world of difference and these differences are absolutely normal. We see in our own culture the very important role that immigrants are playing. I'm not just referring to the workers, the people who clean the streets and so on, but the people who are doing other things as well. For example, during the last film festival in Paris, there were two films made by Algerians working in France, which raised issues around these subjects. We are now at the beginning of a new epoch in which we have to share our differences, and that's the only future for the world. In our civilisation, because of Christianity, we have lost a very important technique, which is the technique of trance, which gives the opportunity for a person to play a role, to express their *fantasme*. I think that for Western people, maybe the most dramatic thing is that we have lost our identity.

Questions/responses from audience (Aud): My culture is European, and I don't feel that I've lost my identity at all. I think that we're all constantly challenged by new identities, in this country especially. I'm also quite bemused by your term 'simple people', with reference to the people who took part in *Les Maîtres fous*, I don't feel that term is right at all.

CJ: I think that the strategy of filmmaking re-instills emotions of identity, the European identity and self, mainly through the objectification and the repressive way in which black societies are depicted. The indigenous and latent meanings in these images are repressed and negated in order to bring out meanings which confirm the identity and knowledge that mainstream audiences have of those cultures. Dichotomies between the natural and intellectual are set up. If you compare an anthropological film on Africa and Chris Marker's film *Sunless*, you'll see that a dichotomy was being set up between Africa and Asia, in that, the popular knowledge is that Asian people are more intelligent, more intellectual etc. than African people. So that, in *Sunless*, the so-called rituals of the Asian people of that culture; the Japanese, were gone into in great detail and reasons were given for those rituals. Whereas in anthropological films about Africa, the rituals are not so much given meaning, but are expressed in such a way that they are reconstructed to seem as if they are inherently natural; as if there is no logic behind them, apart from one which is connected with the natural. This totally

negates the systems which exist within those African societies and maintains the idea that European societies are more civilised, that there is more logic, more reason, more intellect in European civilisation and therefore in the European mind.

The back-up comes from outside the cinema. These films just reinforce those things that you supposedly already know, knowledge that you already have, in order to perpetuate what you believe in for longer and longer.

Aud: By making films you give people identity, they gain their sense of dignity by seeing themselves. What exactly is your reason for studying and observing?

JR: I started to make anthropological films in order to understand others. In August 1942, when I was an engineer working on the building of roads in Nigeria, there were ten workers killed by thunder. People who are killed by thunder are deemed impure, and I attended for the first time, a ritual. I did not understand how, in this ritual, people could change their own personality and I saw that the only way to try and understand it was to make a film. So I started to use a camera as a tool to record this kind of manifestation. Now, after more than forty years making films on the same subject, I still do not understand. Other people will have to study it again and again to understand. Now we think, for example, that in anthropology a unit of time is not ten years or twenty years but that generations are needed in order to understand how this very complicated system of thought can be touched. Maybe what I leave behind are films that some other person can use.

Aud: A problem is that filmmakers train in film then go to other cultures which they do not understand. They ask people who are performing a ritual what the ritual is for and why they do it and these people reply, 'We don't know'. Western scientists are so objective, they want an answer to everything. If people say they don't know, they don't know.

JR: I think that the best thing is for the people themselves to make a film about these kinds of things. That brings up the problem of equipment, but now you have more and more opportunities, even in Africa.

Aud: You said that funerals in Africa are joyous. They might externalise funerals with joyousness but it doesn't mean that they're joyous occasions. A funeral is only joyous when somebody old dies, when somebody young dies, it's not a joyous occasion, it's more like a Western funeral service, it's very sad, very cold. So that, when you're looking at something, you may think you're looking objectively but you're not, because you haven't understood it to begin with. And when somebody says, 'I don't know', it doesn't necessarily mean they don't know, it might mean they can't explain, that it can't be explained to an outsider.

Aud: What worries me is that we have a vision of the future in which somehow, anthropology supplies all the answers without responding to questions about power relationships between the researcher and research, between black people and white people. For example, have you come to terms with the history of Algeria as a Frenchman or as an anthropologist?

JA: My own understanding of Jean Rouch's work is that it has been dealing precisely with this problem. There is no way in which anybody can say that there is another ethnographer who has dealt with the question of difference more rigorously than Jean Rouch. In all of your films that encounter between filmmaker and tribe or society, is taken on board and worked with. Almost all of the material I've read about your films, always points to the way in which you see that encounter as a problematic one which has to be resolved. So in that respect, I think you can begin to give answers to questions like that, even if it's just in terms of giving your own experiences on some of the work that you've done with certain tribes, or around certain films. They might not be enough but at least they are answers based on your work.

JR: Yes, but like you, I'm a witness to what is going on, to things which are changing and to things which are happening. Anthropologists are not making the future, I cannot give the answers.

1 Wilson Harris, 'The Interior of the Novel: Amerindian/European/ African Relations', first published in K. L. Goodwin (ed.) *National Identity*. London/Melbourne: 1970, and also included in *Explorations: A Selection of Talks and Articles from 1968–1981* by Wilson Harris, Dangaroo Press: 1981.

2 Gayatri Chakravorty Spivak, 'Three Women's Texts and a Critique of Imperialism', in Henry Louis Jr. (ed.), *Race, Writing and Difference*. University of Chicago Press: 1986.

3 'Mahanava had lied. A nightmare relic was all the king now possessed. His tribe or tribes in fact had melted into the ground over the centuries – split up and decimated within an ordeal of change which had breached their innermost resources' Wilson Harris, op cit.

4 *Anthropology Reality Cinema: The Films of Jean Rouch*, Mick Eaton (ed.), BFI: 1979.

5 *Reassemblage* by Trinh T. Minh-ha is a visual study of women in Senegal.

6 *La nouvelle vague*: The origins of the 'New Wave' can be traced back to an article entitled 'A Certain Tendancy of French Cinema' by Francois Truffaut in 1954, which condemned the existing values of French cinema.

7 Glossolalia or 'gift of tongues': the power of speaking in various languages, especially as miraculously conferred on early Christians, or of abnormal utterances under religious emotion.

questions of language
behroze gandhy, gillian swanson, carole enahoro, lina gopaul, frank abbott

introduction by behroze gandhy

In many ways the debate around film language brings up many of the old arguments which were rehearsed in the late 1960s, when oppositional film practices prioritised and addressed issues of class, or in the late 1970s, when the language of psychoanalysis was used to explore issues of gender. The significant question now, in the 1980s, is in what way is the debate extended and informed when issues of race are incorporated on an equal par with those of gender and class, and how can an oppositional film language address the issue of 'difference', be it in relation to race, gender, sexuality or class.

This debate on 'Questions of Language', starts off by raising the notion of a film language which acknowledges subjectivity and problematises the notion of 'objective reality' in film. Gillian Swanson calls for a film langauge which forces the spectator to acknowledge his/her own subjective point of view and the conflicting positions each individual occupies in relation to categories like race, class and gender, thus shattering the myth of a unified cultural/national identity. In relation to this argument, *Reassemblage* by Trinh T. Minh-ha was seen by the audience as coming closest to resolving the issue of acknowledging the filmmaker's position and subjectivity in relation to the subject she is filming – an examination of Senegalese culture – whilst acknowledging her own Vietnamese identity. This strategy is seen as an alternative, a step forward from the problems raised by the work of Jean Rouch and questions of objectivity/subjectivity in ethnographic film.

News and Comment examines how the use of language, specifically in the media and broadcasting, reinforces positions of dominance and constructs notions of 'objectivity'. *News and Comment* and *Signs of Empire*, in very different ways, address the notion of a language of dominance, and pull the debate towards the question of whether appropriating the language of dominant culture is a viable strategy for a radical film practice. Is 'difficult' or so-called 'elitist' film language the best tool of an oppositional film practice which must address social, political, economic issues as they affect an audience who might not be able to decode this language? How 'experimental' can a film be, before it becomes inaccessible, except to a minority audience? The other part of this question relates to the way forward for a black filmmaking practice. Is breaking the pass laws the only policy of cultural apartheid? Should black practitioners follow a policy of separate development?

Carole Enahoro questions the validity of an oppositional film practice which uses a language constructed from a culture of dominance. From her point of view, language is a tool of power which comes from the educational system: using dominant language, in documentary or experimentalism, is not necessarily to give in uncritically to that language, but could be a way of analysing and changing how it is used. This question is brought up also in relation to race and representation in *Signs of Empire*, which uses stereotypes in order to analyse and de-construct them, but was more specifically discussed in relation to *Unsere Afrikareise*. Peter Kubelka's film attempts to re-appropriate the imagery of stereotypes of the subordinate African culture which he is filming by re-working this imagery using notions of irony, but this lays itself open to one problem which is that, 'If you made a film which is full of irony, it may be interpreted in an opposite way to what the filmmaker intended' – a view expressed by a member of the audience. The debate around Kubelka's film focuses on several sequences in the film which stuck more in the minds of the audience than others. One of these sequences is of an African man carrying meat home, the shot focuses on a close-up of his penis. The debate around this and other instances in the film is polarised on the one hand by the view that this image is purely voyeuristic and provides yet another opportunity for the fetishisation of natives and on the other, that the use of this image is a strategy which is successful in some ways by drawing attention to the process by which an exotic culture is eroticised. But, as one woman from the audience points out, 'If it asks you to focus on it, don't you really run the danger of representing the same things again?'

This question is brought up again in 'Sexual Identities': does how one sees and understands the world depend on the associations and assumptions that exist within one? Does the way we view an image depend on the education we already have? Are we fixed by our cultural identities, or can film language subvert those preconceptions, be a part of a process where we come to understand how we see things round us a bit better?

Gillian Swanson: I will make some connections

between the idea of cultural identity and of language, by thinking about how film language constructs relations, positions, for us to occupy.

When film speaks, it speaks from a certain position and it has certain kinds of address, it assumes a position for those to whom it speaks. Whilst on one hand there are formal positions, there are also cultural ones, which rely on certain kinds of social and cultural knowledge in order that we should be able to make meaning out of what is said and what is seen. As a form of speech, where does the film speak from and who to? What is it saying and how? Those relationships are important in producing meaning and they constitute a process of speaking or representing. The kind of authoritative address that is constructed by most documentary is one which does not make clear those relations and the kind of positions that we are assumed to occupy, it operates according to a kind of implied norm. A position is offered to the spectator which we have to take up, to the extent to which we engage or participate in the film at all, even if it conflicts with our own sense of self. So our cultural positions become defined by our difference from, or deviation from, that norm which is established by the film.

It is important to examine how the place of personal identity or individual identity is composed from the range of positions which we, as individuals with our own histories, occupy inside a number of categories, like race, class, gender, sexuality and so on. Our position in relation to each one differs, so our identity as individuals is a precarious balance of those different positions. We are made up of sometimes conflicting categories, so our position in relation to gender, for instance, may be in conflict with our position in relation to class or race. By taking apart those categories we can start to look at their constructed nature. This can offer us a way of examining how our notions of, say, femininity and masculinity, are built and how our judgments about the appropriateness of behaviour or 'image' are related to these cultural expectations.

The political significance of the link between film language and the notion of identities reveals the tensions that exist in our experience of personal identity which cannot be as a whole, as unified, as the myth that we are offered. Just as some people or groups are marginalised by our culture, some aspects of our identities are marginalised as well, so that we all occupy a kind of problematised position in relation to the categories of experience and identity. To participate at all in culture we have to respond to the positions that are legitimised for us. We have to find ways of being

included, but we are also juggling all those different parts of ourselves which are suppressed or rendered absent by our culture and which are not given a place in representation. While no two people actually have the same history, there are some aspects of ourselves which are in conflict with dominant culture and which show up as a kind of fracture in its apparent coherence. One can conceive of a film language in which these different positions and points of similarity, the allegiances that we form around those points of fracture, are acknowledged. Re-working film language can be a way of looking at the way we are offered certain perspectives or positions. But the meanings that are produced also depend on the positions we bring to bear on the film from our own social experience and so this formal re-working must address this process. This would be a film language that questions the very process of positioning.

Reassemblage by Trinh T. Minh-ha does this by speaking from a subjective point of view. This acknowledges the filmmaker's position which is outside of the culture of the Senegalese women she is filming, while also exploiting the points of similarity in terms of gender. It asks the spectator to acknowledge his or her own positioning as a constant process that is taking place in relation to every image, at every moment.

This notion of subjectivity linked with the idea of address could inform filmmaking in a number of ways; firstly in its acknowledgement of its own position, i.e. where it is speaking from. Secondly, in the way that it makes clear a specific address, in other words, what knowledge and experience it calls upon and how it acknowledges that in the terms of its construction. Thirdly, in its acknowledgement of a diversity of positions occupied by the audience, or a diversity of positions occupied within one spectator, for example, in relation to gender in film. An oppositional filmmaking practice should take responsibility for the many potential ways in which film could be interpreted. Having taken things apart, the process becomes one of building up, so that the positions that we are offered and the elements of cultural identity can be reconstructed in new ways; in ways which acknowledge that our personal identities are historically formed. We can become active in re-composing categories so that we can start to think through different ones, no longer constrained to think of ourselves only in terms of the norms of gender and race and class as constructed by dominant culture. This can be a way of actually empowering the audience to construct a new type of understanding of cultural and

SIGNS OF EMPIRE Black Audio Film Collective SIGNS OF EMPIRE Black Audio Film Collective

personal identity through representation.

Carole Enahoro: National identity is embodied in a stereotype perpetuated mainly by the media with the purpose of preserving the status quo. If one regards oneself as sharing many of the characteristics of this given stereotype, then one creates for oneself the sense of belonging to a national constituency and to the dominant culture. The stereotype is not inclusive of the marginal. How does a film practice oppose this view?

Film can investigate or question given material, for example, documentary footage, newsreel and so on, thereby exposing positions of power. It can question the audience's perceptions of those positions by introducing oppositional or contrasting positions, thereby forcing the audience to re-assess it's position vis-à-vis issues of gender, culture, race, sexuality and so on. Film practice can re-organise positions of power by the investigation of those positions, an example of this is *News and Comment* by Frank Abbott, which questions media stereotypes by deconstructing the material, enabling the audience to question their passive role. This is an effective and powerful approach, but whom is this film addressing? The film is critical of the process of selection of language and the dissemination of information so as not to adopt the dogmatic posture of most 'objective' documentaries, but this is insufficient if one is not well acquainted with the language which the film uses. There is no such thing as total objectivity since all words and images carry a personal and political statement.

The use of deconstruction in the Australian film *Serious Undertakings* poses the same problem. Even ignoring the fact that Aboriginal rights were just not mentioned at all, whom is this film addressing? If it is trying to deconstruct, why is its structure intellectual-

ist? The manner in which it questions existing stereotypes indulges in the very practice it is criticising.

In *Signs of Empire* there is a similar problem. The language it uses needs decoding, de-intellectualising, to make it accessible to the general public, where it might be more useful to society, rather than to an elite of avant-garde filmmakers.

National identity is also explored in Peter Kubelka's film *Unsere Afrikareise*. Kubelka's aim to criticise the Austrian industrialists and their trip to Africa, conflicts with the depiction of Africans as part of a natural landscape, as objects of erotic interest and as primitive peoples and with his comparison of our way of life, our movements, our existence, to that of animals. Kubelka's intention seems to be to criticise his own race but as much as he tries to criticise the bourgeoisie, he reaffirms his membership of it by his depiction of Africans. It is this, and the aesthetically pleasing nature of the film, that is most disturbing to me.

Riots and Rumours of Riots is successful in decoding the language of power. It presents a historical perspective by blatantly and openly constructing history through a series of subjective realities, thereby addressing itself to an audience of both dominant and marginalised cultures. However, simply hearing accounts of past history does not give to those of the marginalised culture the power to be able to overcome the constant reinforcement of the history of dominant culture. The audience is forced to question its perspective in relation to historical accounts; the personal experience becomes political.

Cinema which addresses itself to the dominant culture either by the use of language in the film, or by the way the film is structured, renders the marginalised culture powerless by rendering it passive.

Lina Gopaul: Britain, one of the major colonial powers, was a leading force in what has been

NEWS AND COMMENT Frank Abbott

NEWS AND COMMENT Frank Abbott

described as 'worlding', by the Indian feminist Gayatri Spivak, that is, the mapping out of supposed uninscribed territories in order to understand their people. These newly organised territories had to be made comprehensible. One of the forms this understanding took was through the denial of cultural heritage. This was a step towards exploitation for the denial of people's cultural values and systems is one means by which we are told, 'you cannot represent yourself, therefore you must be represented'. Given this historical process, we can then ask, how did this notion of 'worlding' construct a British cultural identity? In terms of race, class and gender, what are the ideological processes which produce and reproduce the signified images, culture, power and control?

Racism is a structural feature of our society, it is not beliefs or ideas floating in the air, but beliefs and ideas that are structured and sustained by the practices of the society in which we live. In terms of race, Britain has a long history forged directly out of slavery, economic exploitation and imperialist expansion. This history has structured contemporary British life and can be seen in the stereotyped perceptions that white British people have of black people. These perceptions are fixed around definitions of subordination and domination. These stereotypes are polarised around ideas of superior and inferior beings, inferior cultures. These are some of the images used in *Signs of Empire*, images that you can actually find in various historical texts, geography books etc. In such images, subordinate ethnic groups and classes, appear not as products of particular historical relations, such as the slave trade, European colonisation, the development of 'underdeveloped' societies, but rather, as a category of naturally inferior beings. When we use race categories based on colour, we invoke centuries of meaning, meaning loaded with notions of purity, sexuality and Christian virtue. Importantly, there is an inter-relationship between the imagery invoked by race and values and the beliefs which underlie

nationalism and nationhood. An important reason for analysing stereotypes is that they are a complex conjunction of realities and representations.

There are a variety of ways in which colour and race can become stereotypes inscribed as 'reality' or can be negotiated with representation. Identities are central to political power and success, in relation to this, Black Audio Film Collective has attempted an investigation into the colonial narrative, its imagery and its fantasies. We have interrupted its tales of objectivity, of the 'other' and in doing so, we have tried to point to the process by which we politically chose identities as part of the struggle against this colonial baggage, against this fixing, locating and dislocating.

Frank Abbott: In terms of production, *News and Comment* enables certain discussions to take place. The film, the text, the images, the experience of people watching, create a context in which certain issues could be raised, talked about and discussed. The film's position is from the point of view of someone sitting on the sofa, looking at the telly, and it was directed at other people sitting on the sofa, looking at the telly. It was an attempt to take what was going on in the late 1970s around the area of debate about the media and media studies and to incorporate the process of watching a film, within the process of analysing and questioning what was being watched, so the question of language is quite strongly foregrounded. How to speak correctly, comes up as a question at the very beginning of the film, where the child learns language and learns to use the machinery of language i.e. the camera and the tape recorder. There is a simplistic approach at that point to the relationship between language and reality. This relationship breaks down as the child asks the narrator what 'either' means – a word which is quite difficult to explain. Then the address of the film is to problematise the relationship between a child's simple eyes looking at the world and the media looking at the world. There needs to be some agreement around the notion of objectivity

or it becomes impossible to do anything. *News and Comment* was an attempt to find a new objectivity; to actually knock open the questions. A lot of debate and discussion around the media has gone on since then which has opened up those questions which the film was trying to deal with at that time. *News and Comment* was trying to stimulate, rather than to answer, these questions.

Questions/responses from audience (Aud): *Signs of Empire* could have shown not just past representations of colonialism but also Indian and African Art. Is it adequate solely to have a representation in film and in the archive footage? Why didn't you have the people themselves reciting their struggles and their views?

LG: Britain is an inherently racist society, it is not enough to show 'ethnic art' which has been neglected. The starting point for Black Audio Film Collective was to intervene in this supposed 'objective' history of ourselves and to show our own particular stories, by doing so, we are trying to show how fictional this history was, except in its representation of power. I do not believe that art made in Africa or in India actually addresses questions around power, around control, around colonialism. You cannot get away from this colonial past, it is there wherever you look. You need to begin to investigate it but that does not mean that you neglect looking at black art.

CE: I would say that language in this culture is taught by white people and because of that black people are forced to adopt that language in order to assert what they know is true, and because of that it seems to be subverted.

Aud: *Signs of Empire* looks at power relations, it takes pictures of icons and books etc. and uses the very language that informs British cultural identity, that is the purpose of using that language.

CE: Then who is *Signs of Empire* addressing? Is it addressing itself to dominant culture, to the people who know that language, or to the marginalised culture, the people who are not well acquainted with that language, but who know another language?

Aud: Are you saying that people who are from marginalised cultures cannot speak the language of the dominant culture that they are in, that they are not that well-educated?

CE: Certain tools are used to protect dominant positions and language is one of them. The educational system is at the service of the dominant culture.

Aud: Rather than talking about a simple language or a difficult language, as if there was such a thing as a difficult language, I am thinking in terms of

languages constructed in dominance and I have to say that the kind of language that is used in *Signs of Empire* is constructed in dominance, and because of that, it made me not want to engage with it. I had to find a different way of getting into it and that is a problem.

LG: As black practitioners there must be room for all sorts of developments. You call it a dominant culture, I will call it a cultural and national identity. We took most of the text for *Signs of Empire* from the writings and speeches of eighteenth-century administrators and all sorts of people who were in India, Africa and various other parts of the colonies at the time. We wanted to use that language and to show that it was powerful, but that at the same time, there was resistance, something which very few people pick up. One of the most powerful things about *Signs of Empire* is that it points to strategic dates which have been forgotten and it reminds us that regardless of the power of this dominant language, in the colonies there was extreme resistance. That is very important to be aware of. There are very few black groups around, I believe there must be space for all kinds of developments. This does not necessarily happen to white practitioners, the space does not close in.

Aud: I do not agree at all, I think women have been closed in for years and they are a different marginal group as well. Here also, there is the problem of internalising and taking on another language. I don't think you can use the fact that you are isolated as a way of explaining your work. Who were you talking to? The black community or who else in British society?

Aud: I don't see why black people are made to feel they have to be responsible for educating all black people. What is being said, it seems to me, is that black people have a ghetto where they live, where they speak, which determines the kind of work they should make and if you break out of that area, you are being drawn into the system where you are using so-called dominant language. What is not, to my mind, being acknowledged, is that dominant language is all language, is spoken language, it is all kinds of language, whatever language people speak, whether they are so-called 'suppressed' or 'de-processed', that language is part of dominant language. So you cannot say that by doing this kind of work you are speaking to an elite, because who is this elite? What language are they speaking, is it so fixed? Are black people speaking a suppressed language, a marginal language, is it different and totally divided from, the so-called 'dominant language'? All language interrelates.

NEWS AND COMMENT Frank Abbott

CE: I would say that language is power and when you create a certain language that is used in debates of national or cultural importance for example, it is used as a tool of power and that tool of power comes from the educational system. When you use a language which a lot of people do not understand, you yourself, form part of that system.

Aud: You are still not leaving room for negotiations; I don't know how many black filmmakers there are in the UK, or in Europe. *Riots and Rumours of Riots* is one form of film-making, just like *Signs of Empire* is another and there is space for negotiation between the types of languages they both use. So when you say that *Signs of Empire* is elitist because it uses specific types of languages, it is because you think black people cannot understand it.

CE: There is a certain language which is used by people in dominant positions, with certain educational and class backgrounds, which must be decoded by those in marginal positions. I am not talking just about blacks, but all marginalised groups, or about simple language. I am talking about another completely different form of language that has inherent power. All language has power.

Aud: I get the impression that there is an extremely simple notion being used of dominance and subordination in relation to language, taking as an example, the way that language embodies power through the educational system. But the language of psychoanalysis is one of the many languages which has systematically been eliminated from any form of formal education precisely, I would suggest, because of its explanatory powers. Secondly, the notion of the kind of language you are talking about, which embodies power, is actually the kind of language that is spoken, for example, by television anchormen, by newspaper journalists, people who write leaders in papers. The language of the popular tabloid press. The *News of the World*, *that* is the main, dominant, intellectual language that we have to live with.

This notion of 'everyday understandable' language, embodies power by censoring any form of precision language but power struggles within language have to be acknowledged as well. Carole Enahoro's argument holds true perhaps in a slightly different way than intended. There is a way of using technical language which is extremely mystificatory but that is a different kind of strategy. We can tell the difference between language of mystification, technical jargon for instance, and a language which tries to find an appropriate and precise way of communicating.

The language of *Signs of Empire* is quite different from similar experimental types of language, the kinds of constructions which, for example, white film-makers have been practising in the past. It does not do it in the same way. It re-introduces a notion of history to notions of experience, cultural history, cultural heritage etc., which similar experiments in the white sector have not taken on board.

Aud: It seems to me that *Serious Undertakings* has a lot in common with other films in wanting to say something about finding that your history, or what you understand of your history, or how your history has been represented to you, determines what you say. The filmmaker is a woman, she is articulated in a different way by the male intellectuals talking about their histories and the history of Australia which determines who they are. We have got to go back and change the significance of that history.

Aud: The view has been expressed that *Unsere Afrikareise* makes the Austrians appear somehow more advanced, looking with some contempt at the Africans. I perceived that film entirely in the opposite way. I perceived the Austrians as extraordinarily brutal and un-civil. They seemed to be people who go around shooting animals which are much more beautiful than themselves and observing lovely girls who are to be seen working extremely hard, while they lounge around in some vehicles or drinking, eating and joking. So I thought that the point of the

UNSERE AFRIKAREISE Peter Kubelka

UNSERE AFRIKAREISE Peter Kubelka

film was to show how embarrassing the Austrians appeared in another setting but that, presumably, is irony. So that if you make a film which is full of irony, it may be interpreted in an opposite way to what the filmmaker intended. The more sophisticated the film is – and when I say sophisticated, I am not using any improper word, I mean a film made as a result of having seen many other films – the more open it is to very many interpretations, which make it probably more interesting.

CE: What I find most disturbing about the film is the fact that it seems to be a critical look at the behaviour of the Austrians, or, by extension, of any European in Africa. When you see it at first you think, yes, it is very critical of them but you do not realise what is going on behind, i.e. the actual depiction of the Africans. That is what I find very disturbing, not the initial impact but what was behind the initial impact.

FA: *Unsere Afrikareise* is trying to deal with notions of the exotic. Usually a film crew goes out, finds the exotic in some other country and comes back and says, 'Look at this strangeness, this exoticism, this difference'. In a sense, there is a way in which the film tries to present the visitors to Africa as being the strange and the exotic ones, but there is a whole history for us, of seeing Africa and Africans as exotic *per se*, through the history of how we have always perceived it and the film does not deconstruct that, it feeds off that. This gives the film a dynamic which makes it a very good film in trying to deal with that, but obviously I think it is dealing in a very difficult area.

CE: *Unsere Afrikareise* is so disturbing because Kubelka does not acknowledge his own position. It is as if he is outside of both cultures or has distanced himself from what he is saying and what he is representing. Every film must face up to the range of meanings that can be created. In *Reassemblage,* for example, there is a definite acknowledgement of

that potential 'otherness'.

FA: To a certain extent there is an imperialist mysticism about Africa, so Kubelka tries to stay on the outside of his European culture but he is still taking that mystical view by not entering into the politics of the situation of the African people in the film.

Aud: In *Unsere Afrikareise*, there is a sequence of an African man going home, carrying meat. The Austrian couple are also shown going back across the wheat fields to their house. In the first image the camera is focused on the lower part of the man's body and his penis is in the way of the meat. It wasn't even focused on the meat, I think it was focused on the penis. That, to me, was voyeurism. The second image of the couple is a long shot which enables one to be distanced and objective. There is a difference in values in these two images.

Aud: *Unsere Afrikareise* makes a very crude attempt at something but the overall aim of the film was to try and make white viewers think about the way they have looked over and over again at black bodies, on all sorts of films on television, from the age of ten. The constant use of shots of the lower half of the bodies of black people right through the film, maybe was supposed to be drawing your attention to the way that those figures have been eroticised, sexualised.

Aud: If it asks you to focus on it, don't you really run the danger of representing the same thing again? *Reassemblage* draws your attention as a white viewer to images, it made me think how cinema is about surfaces and how racism is very much about surfaces, and those two ideas come together in a number of these films. So that film can be part of a process where I come to understand how I see things round me a bit better.

Aud: I just wonder whether that will always depend on the associations and assumptions that you already have. Seeing an image or interpreting an image according to the education you already have.

sexual identities: questions of difference
kobena mercer, jacqueline rose, gayatri spivak, angela mcrobbie

introduction by kobena mercer

The debate presented here must be one of the most intense, frustrating, exciting and open-ended dialogues in film criticism that I can remember. It was an important event, bringing to light the sheer scale of the complexity that characterises cultural politics today. As such, the debate dramatises a convergence of ethnic and feminist political perspectives around the question of 'cultural identity' in film and cinema. With questions of sexuality in the foreground, the common concern with 'difference' in the debate also underlines the transformative impact which sexual politics and psychoanalytic theory have had on the way we talk about films. The outcome of this convergence has produced a discourse on cinema made all the more compelling by the uncertainty or impossibility of any consensus.

There seem to me to be three key issues involved: reassessing the meaning of cinematic 'independence', re-thinking the relations between film practice and theory, and re-appraising the problematic issue of the politics of pleasure with regards to film and cinema as institutions of popular culture.

The need to recognise inflections among different traditions of 'independent' filmmaking is a current that runs across all four of these 'Cultural Identities' debates. It may be agreed that the term usefully distinguishes film practices that are critical or 'oppositional' in relation to the politics, ideology and aesthetics of the dominant commercial film culture. But it cannot be taken for granted that this same term adequately articulates the strategic choices and conditions that inflect different meanings of cinematic 'independence' between films made in Europe and America and those made in the Third World.

In the case of the former, the centralisation of the film industry as an apparatus of capitalist entertainment in the 1920s and 1930s created spaces on the margins for alternative practices which became institutionally accommodated as 'art-cinema', with its own 'avant-garde' and its own canon of 'auteurs'. In the latter, however, independent film in Latin America, India and Africa developed at a later historical point (during the 1960s and 1970s) and the orientation of counter-hegemonic film culture in these contexts has aligned itself with notions of 'agitation' or 'education' rather that 'art'. The salience of the documentary genre in this tradition empha-

sises this inflection. My remarks on 'combined and uneven development' in the debate allude to the need to make these distinctions, particularly as the new black independent productions in Britain draw critically from both traditions.

These inflections also underpin the discussion of didacticism, an issue brought into focus by the way some of the films shown, seemed to aspire to a transparent relation of theory and practice. Gayatri Spivak diagnoses this as a 'globalising desire to save the world' with an aesthetically, politically and theoretically 'correct' film practice, and Angela McRobbie emphasises how much the 'precious' desire for 'purity' evoked by some of the films sidesteps the political problem of popular pleasures. What emerges is a feeling that the Leninist desire for 'correctness' now seems somehow archaic, or at least outmoded as a political ideal. The debate around didacticism presents an opportunity to re-evaluate the inheritance of the theoretical frameworks that characterised the 'ascetic aesthetic' of independent practices in the 1970s (in England, at least).

Informed by the Brechtian critique of realism and the Althusserian analysis of ideology, film criticism and theory formed in the moment of the new left after 1968 encouraged avant-garde practices that sought to disturb or dislocate the viewer, inscribing an 'alienation-effect' or modernist 'shock' to effect a critical, reflexive attitude towards the cinematic apparatus, where it was argued that the very technology of the camera (based on Renaissance linear perspective) was 'contaminated' with the ideological effects of bourgeois hegemony, 'structural-materialist' filmmakers, for example, outlawed the representational image.[1] It was as if the films wanted to 'teach' their audience a thing or two about cinema and in this way to decontaminate hegemonised subjects out of their ideological illusions, as in Plato's cave. As an aesthetic strategy this appropriated Althusser's epistemological opposition of science and ideology, seeking 'scientific' guarantees at the level of theory for practices that ruled pleasure out of the question.

Today that positivist relation of theory and practice has collapsed: it no longer has the same kind of political credibility it once claimed. The 1980s have seen a reaction against asceticism, demonstrated in the opulent excess of 'New Romantics' and more

generally by the return to narrative. Jacqueline Rose's defence of the texts whose didactic qualities elicited impatience amongst the audience accurately observes that, 'These films have not won out institutionally'. But this could also be interpreted as a criticism of a strategy which is now exhausted, ghettoised in art schools and academia and unable or unwilling to engage with the contaminating and contaminated question of pleasure.

The pleasure principle of popular cinema was identified as a key political problem by Laura Mulvey's epochal analysis of narrative structures of spectatorship which showed how deeply the traditional psychic, sexual and political economy of the Hollywood movie reproduced and conserved the hegemony of patriarchal ideology, centrally and crucially dependent on the endless erotic objectification and exploitation of women's image.[2] This framework underpins the intense discussion of two salient moments from *Territories* and *Un chant d'amour*. The ensuing exchange emphasises the value of psychoanalytic concepts in film analysis, but the critical voices emanating from black, gay and lesbian perspectives also focused on the limitations of an aesthetic of 'passionate detachment' prescribed as the antidote to the sordid filigree of voyeurism, fetishism and scopophilia inscribed in the dominant construction of white male heterosexual identity.

The black man in Genet's film, like the representation of the 'native' in ethnographic documentary, is fixed like a stereotype in the fetishistic axis of the look. In both instances, the black subject is subjected to a 'pornographic' exercise of colonial power, endlessly returning it to the position as the 'other' whose 'difference' is subordinated to the construction of a European identity. But this is a profoundly ambivalent process; as Gayatri Spivak says, 'the movie moved me', raising the question: can we still say that Genet made an exquisite and beautiful film if it is so imprisoned by a desire which reproduces colonial fantasy?

As with the image of the white old lady in *Territories*, it is impossible to contain or articulate the admixture of emotions aroused by talking in theoretical stereotypes that label this as 'sexist', that as 'racist'. As Rose argues, the question raised by the hierarchical ordering of sexual, ethnic, national differences in the construction of identity is whether or not we want 'identity' as a political category in the first place. Neither feminism, ethnic politics nor independent filmmaking can embrace a simple logic of 'opposition' – radical feminism or anti-racism often

LIGHT READING Lis Rhodes

collude with the categorical essentialism they seek to overturn – but a deconstructive affirmation of 'difference' is equally problematic as it often implies a politics of indifference where 'anything goes' (as in the neo-conservative response to postmodernism).

But this is not an either/or issue. Rose cites Black Audio Film Collective's *Signs of Empire* as a text that refuses identification for the spectator, in this way attempting to 'undo' the barrage of colonial discourse through an aesthetic of 'terror', likened by Rose to the logic of psychoanalytic enquiry, but equally identifiable within the ascetic emphasis on displeasure. This is not the only strategy because texts such as *Illusions*, adopting certain narrative conventions fully aware of the risk of ideological contamination, offer access to positions of pleasure and identification which, for black spectators have not always been available in mainstream movies. As Spivak points out elsewhere,[3] sometimes a little bit of essentialism is a strategically necessary choice. For me, the representation of the two black men

in *Territories* offers an image of identity denied and excluded in a political sense by the image in Genet's film. It seems to me that it is not a question of the marginal particularism of homosexuality transcended by 'the human' (a globalising view that could be recruited to powerfully homophobic ends), but of how the same or similar elements are always open to antagonistic discursive articulations.

Indeed, what seems to be absent from the debate is a sense of cultural politics as a practice of articulation[4] in a historical situation which demands that we think a multiplicity of differences at one and the same time. An impossible demand perhaps, but the doubts expressed as to the adequacy of psychoanalysis in dealing with the specificity of ethnicity revolved around the concern that it subordinates all other differences to 'sexual difference', which thus becomes a hypostasized absolute as the critical difference, not just one among many.[5]

If anything, these are two of the key issues at stake in the way the debate returns to the notion of a diaspora in trying to designate the effects produced by black British independent films. Spivak's term, 'hybridisation', is one worth extending as it connects the post-colonial problematic of 'identity' (not more complex than either the chromatic metaphors of black and white or the neo-colonial emblem of nationality can allow) with the post-modernist problematic of 'difference', where binary contrasts collapse into the flux of a heterogenous intertextuality.

Spivak's comments in an Australian radio interview, however, are more confusing: 'I'll tell you a story. I was at the Commonwealth Institute in London to discuss some films made by black independent filmmakers and one of the points I made to them was (in fact I am a bit of broken record on this issue), you are diasporic blacks in Britain, and you are connecting to the local lines of resistance in Britain, and you are therefore able to produce a certain idiom of resistance; but do not forget the Third World at large, where you won't be able to dissolve everything into Black against White, as there is also Black against Black, Brown against Brown, and so on.'[6]

I don't remember it in quite the same way. Unlike earlier generations of black filmmakers rooted in a 'monologic' single-issue discourse on ethnic politics, I feel the younger workshops fully accept and engage in the hybridised space of being black and British, which in a society that predominantly regards these two terms as mutually exclusive,[7] entails a logic of resistance that must be 'dialogic'. These issues were followed up at the conference on Third Cinema in the 1986 Edinburgh Film Festival, another event in which consensus seemed to be out of the question.[8] One thing at least is clear: that we have to deal with the paradox in which traditional sources of cultural identity and authority are becoming decentred (post-modernism), while questions of 'race' become increasingly central to culture and politics in the way the society represents its experience of crisis (post-colonialism).

This paradox was also a precondition for the debate which took place at the Commonwealth Institute, an unlikely venue, which opened its doors in a wave of 'benevolence', as did other institutions. Many of these spaces are no longer available, many have closed down or are now squeezing out the possibility of 'independence' and freezing out opposition in the cold winds of the marketplace. Important as it was, it is an open question as to whether the conversation which took place can continue in the face of a conservatism that would have us believe that our cultural identity has overcome those contradictions and that 'it's great to be great again'.

1 See Jean-Louis Baudry, 'Ideological Effects of the Basic Cinematographic Apparatus', *Film Quarterly*, winter 1974 and 'The Apparatus', *Camera Obscura*, no. I, 1976. On independent cinema in Britain see Peter Gidal (ed.) *Structural/Materialist Film*, British Film Institute. 1975.

2 L.aura Mulvey, 'Visual Pleasure and Narrative Cinema', *Screen*, vol. 16, no. 3, 1975. See also, for her reflections on the impact of that article, 'Changes: Thoughts on Myth, Narrative and Historical Experience', *History Workshop Journal*, no. 25, 1987.

3 See interview with Angela McRobbie, 'Strategies of Vigilance', *Block*, no. 10, 1985, and Gayatri Spivak, *In Other Worlds*, Methuen, 1987.

4 In the sense that Mouffe and Laclau 'call articulation any practice establishing a relation among elements such that their identity is modified as a result of the articulatory practice', *Hegemony and Socialist Strategy*, Verso, 1985, p. 105.

5 A concern expressed by Mandy Merck, 'Difference and its Discontents', *Screen*, vol. 28, no. 10, 1987.

6 From 'Questions of Multiculturalism', an interview with Sneja Gnew, Hecate Spring 1987 (Sydney), p. 141.

7 On this issue, see Paul Gilroy, *There Ain't No Black in the Union Jack*, Hutchinson, 1987, especially Chapter 2 on 'Race, Nation and Ethnic Absolutism'.

8 See my report, 'Third Cinema at Edinburgh', *Screen*, vol. 27, no. 4, and for an alternative (outrageously ethnocentric) view see David Will's report in *Framework*, 1, pp. 32–3.

Kobena Mercer: I would like to address two points: film theory and independent practice on the one hand and issues concerning race, sexuality and representation on the other.

There is a sharp contrast between the way in which independent filmmaking practices make use of film theory. In Lezli-An-Barrett's film *An Epic Poem*,

an account of woman's place in official history is presented in terms of late 1970s film theory, the issues being transposed very literally onto film. The main protagonist, for example, is a researcher. There is a precious feel about the theory which is translated onto film to try to make a 'correct' film. *Light Reading* by Lis Rhodes and *Watercolour* by Joanna Millet both seem to be very constrained by the theoretical concerns of the European avant-garde. There is an emphasis on self-reflexivity and they seem locked into their own images of themselves. The use of different film stock, filters, colours and so on in *Watercolour* may tell us something about the materiality of film and how the actual picture is constructed but, as with *Light Reading*, it does not give much away. In contrast, *Territories* by Isaac Julien, or *Illusions* by Julie Dash, have something which the ear and the eye can feed on; there is a kind of nourishment for the imagination, as both engage in cinematic storytelling, *Illusions* is informed by black American independent filmmaking debates but it also tries to engage with mainstream narrative conventions. The black woman's voice in *Illusions* is the signified for the image on the screen, which is that of the white female star as the key signifier of desire in mainstream cinema. The other illusion is the position of a black woman who, like Sara Jane in Douglas Sirk's *Imitation of Life*, passes for white. The film explores the personal and political situation she is placed in within the film industry, in terms of race and gender. In this sense, *Illusions* tries to engage in a broader debate around the presence or absence of black people in mainstream American film culture.

Territories is informed by theoretical debates and by a tradition of independent filmmaking in this country, for example, in its use of experimental devices in the editing and its layering of sound. But more importantly, it engages with a whole number of issues relating to black culture and the political meanings in events such as carnival, in a way which has been conspicuously absent from white independent filmmaking. Music is used in *Territories* to create a simulacrum of carnival, with its constantly interrupted music, recreating the effect of walking through different sounds systems, like the dub records being played, hollowing out the space. This creates a critical distance, enabling a pleasurable reflection on the political issues being addressed.

Jean Genet's film *Un chant d'amour* belongs to a different historical period, but there is an overlap between *Territories* and *Un chant d'amour* in terms of sexuality and the attempt to represent images of

homosexual desire. *Territories* seeks to address images of desire into which black people could imagine themselves. These are issues which have not been on the agenda of black independent filmmaking, which, because of its marginality, has been preoccupied, up to now, with questions of truth and the documentary tradition, in order to counter and find an alternative voice to the representation of black people in mainstream media. *Territories* is courageous in trying to bring up the question of sexuality and pleasure in terms of the cultural politics of black people's lives in this country. It is addressing a question which is raised by the event of carnival itself, that is, the plurality of sexual identities, of opportunities and possibilities of sexual expression, a form of expression which may be denied in ordinary life. So in different ways, *Territories*, *Illusions* and *Un chant d'amour* engage in established conventions of storytelling and narration to bring out certain questions of fantasy, sexual identity, sexual difference and sexual preferences, and that is their main difference from *Light Reading* and *Watercolour*; which are more locked into a space defined by avant-garde filmic concerns and the debates within white feminism.

Jacqueline Rose: One of the things that I am going to try to suggest is that the opposition between avant-garde and political concerns is not viable or tenable, or should not be. I say this in relation to the work which I have done, which has been largely in the area of psychoanalysis and feminism, and specifically questions of fantasy, subjectivity and sexual difference, and in relation to some of the problems of that work which could be seen to have links to problems of political analysis in film.

One question which has come up in these discussions is whether psychoanalysis is an oppressive or dominant discourse; is it an excluded language; is it universal or specific? These are common criticisms that are made up of psychoanalytic language, but it is relevant to this discussion in that, as I see it, psychoanalysis, rather than being a metalanguage which can simply be applied to film, is itself caught in certain problems which have been very sharply focused by the films discussed in these debates. In 'Questions of Language', Lina Gopaul of Black Audio Film Collective, indicated that their tape-slide work, *Signs of Empire*, focuses on 'the processes whereby we choose identities against the colonial barrage, against this fixing, locating and dislocating.' The idea is that the colonial barrage of images does all that at once or does both those things, locating and dislocating at the same time. Psychoanalysis works

at exactly the same level, of that notion of fixing of identity, which is also a dislocation of identity. It assumes that there is a necessity of identity for all subjects, but that identity is always unstable. It assumes that identity will always be sexual, but that is always something of a lie because it is constantly undoing itself. There is resonance between the idea of a colonial barrage which fixes you and undoes you at the same time, and the way psychoanalysis talks about how we define ourselves sexually.

This leads to the problem of how to work politically, or indeed, whether we need the categories of identity and difference in order to do so. John Akomfrah's point in 'Culture and Representation', that the new racism, for him, was not the racism of an absolute difference, but 'the new ideology of the family of man' which annihilates all difference. Jean Rouch, speaking in 'Culture and Representation', also focused on the problem. On the one hand, he said that what we need is the category of 'trans', by which he does not mean trances, but t-r-a-n-s, meaning 'to cut across'. He said that we have lost the ability of 'trans; the ability to put oneself in others' place through fantasy'. To me, this meant that what we need strategically, is a blurring of identities and differences, where we cut across different positions and identify across boundaries, which is very like the psychoanalytic account of sexual difference. However, he also stated that in relation to our loss of identity, we need a definition of the 'ancestor', meaning, as I understand it, a continuity of identity and lineage in which we can recognise ourselves. In this sense he was contradicting the category of identity or loss of identity which he had been advocating through the notion of 'trans'.

This problem of identity or difference becomes more complicated when the issue includes the question of images and representation of women. It is in this context that the critique of identity as a mystificatory device becomes critique of representation and specifically of filmic representation, in the way that it endlessly returns to fetishise and degrade the body, which is almost always, by implication, the body of the woman. This clash around the question of whether we want identity or not becomes even stronger when there is also a counter-strategy in film theory against any recognisable representation, but one which also demands the re-assertion of the excluded female voice and image. What do you do when the critique of the apparatus suggests the use of images of the body of woman, the most corrupt form of colonisation, and yet you still want to use

images? It is no coincidence that many of the films contextualising this debate have focused around this question of the image of the woman.

In *An Epic Poem*, the image of the Rokeby Venus[1] is the focus for a political strategy and the quote from the newspaper reads: 'When a suffragette had slashed the picture, this picture is neither idealistic nor passionate, but absolutely natural and absolutely pure.' But what does that mean? What naturalisation of the body of the woman is being criticised here? Sequences from *Sunless*, by Chris Marker, show a Japanese sex show on television, where a light system actually focuses on the genitals of the woman and blots them out and a woman's voiceover says: 'You point to the absolute by hiding it. Of course it's what religion has always done'; what fetishisation of the body of the woman is being reproduced here?

Unsere Afrikareise by Peter Kubelka, raises a related set of questions about the position of the film to the native 'other'. Was it criticising the obsessive, aesthetic and eroticised return to the black image of the 'other' adequately? For example, the image of a black native woman who turns her neck is intercut with an image of giraffes. The repeated juxtaposition, the constant cutting between the image of the woman and the image of the animal and the subsequent mutilation of the animal, is a real danger point in the film because it can be read as saying, this is the mutilation that colonialism inflicts to the image of the woman, but it also fetishises the woman as a native, as exotic, as naturally something of which we are deprived.

Reassemblage, by Trinh T. Minh-ha, highlights some of the same problems and makes them part of its own explicit commentary. The filmmaker, a woman, focuses on the question of what it means in terms of her own voyeurism, to be looking at and filming the images of beautiful black women in Senegal. She seems to be saying: 'This is pornography but I'm doing it, I know that I'm doing it, therefore it isn't.' The voiceover says: 'An American man went to see an ethnographic film and he turned to his wife afterwards and said, I've just seen a piece of pornography'. *Reassemblage* allows for that reading of the film, then tries to undo it, but the images are possibly too strong for that undoing, and therefore it falls into the voyeurism of the cinematic look, the look which is itself, ultimately, a sadistic look, whose viciousness is seen so clearly in Jean Genet's film *Un chant d'amour*, In relation to this problem, *Light Reading*, by Lis Rhodes, pushes to the furthest extreme a filmmaking strategy which refuses any

representation of the woman. It uses a strategy which refuses the cohering of the image and the focusing on the woman's body which happens simultaneously. *Light Reading* is not just preoccupied with avant-garde film strategy but with a political issue. The problem is the image of the cinema as the image of the woman in particular. The undoing of cinema and the undoing of the image of the woman come together at the same time. The problem there is that *Reassemblage* presents images of a particular sexualised nature, and its notion of what an identity of women could be was too close to the classic representation of women.

This leaves one with the question of what could be a positive identification. Of what one does when that critique is taken as far as it can go, as in Peter Gidal's film *Close Up*, which presents us with an absolute refusal of any imagery juxtaposed with a voice-over by Nicaraguan revolutionaries. It seems to be a political question of whether or not we want identity as a category and it raises the issue of a confrontation between an anti-racist and feminist representational politics, for although there are crucial links between feminism, avant-garde film practice and racial politics, in no sense would I want to suggest that there is an identification between the three. The relationship and differences, however, could be crudely summarised in this way: Feminism cannot extol difference, it cannot celebrate difference, or promote it in some simple sense, because it is always already constructed as sexual difference. On the other hand, feminism cannot abandon difference, because it is through the concept of difference that it recognises itself as such. It is only from that place that it can make a statement.

Avant-garde film cannot accept identity because identity is the chief site of the ideological machine, but it cannot abandon identity because it is the place through which political identification and solidarities have to be constructed and necessarily take place.

Racial politics cannot extol difference because difference is the site of the supreme ideological mystification, but it cannot abandon difference because it is through the articulation of that difference that the equally oppressive ideology of a great 'family of man' can be challenged.

Gayatri Spivak: I am very struck by the didactic quality of the British films – they had what I would call a 'literary' quality, in a rather conservative sense of literature. Specifically the films by women – *Light Reading*, *An Epic Poem* and *Watercolour* – which were about appropriating the proposition. Although

TERRITORIES Isaac Julian

critiques of logic, critiques of the construction of history were made, there was always an ambiguous status stored. Desire in *Light Reading*, for example, was disclosed by the images of the mirror. The repetition of shots seemed to be a mark of the women's films. The desire through this repetition to appropriate the construction of a proposition, despite their rejection of the tyranny of logic and the narrativisation of history. The word 'conception', in 'My conception of love', at the end of *An Epic Poem*, is repeated over and over in a very allusive style, so that, as we look, we think of all other kinds of filmic texts. In *Light Reading*, the sentence 'She raised her hand', is repeated; you see the hand, you hear the repeated words and see the mirrors. This repetition creates the desire to appropriate the proposition which we ought to think about in terms of First World feminism. *Territories* contained what in the US context one calls a 'globalising' desire, which comes from the hybridisation of post-colonial peoples on First World soil, the dynamism of their resistance emergent in phenomena like Indie-pop in Britain. The extraordinary aura of that resistance, which in some ways is made possible by varieties of socialised capital, the desire to have that as a model, leads to the insistence on the diaspora over and over again. The use of the documentary footage in *Territories* as a text to work from, reflects the site of that desire. The reverse side of the insistence on the diaspora is to talk about culturalism and ethnic identity. It is my contention that the insistence on the diaspora, in some senses, trivialises the desire to reside in the First World, by which, of course, I am not uncontaminated. The other side of it is not the great narrative of nationalism and national identity. For me, as an outsider, the British films have this desire to 'save the world', the diaspora as the model for all kinds of laundry lists,

resistances and so on.

Un chant d'amour and Julie Dash's film *Illusions* are very different. Genet's film belongs to another era, the 1950s, and *Illusions* alludes to the early 1940s. Because of this, both do indeed occupy a different kind of space. In *Un chant d'amour*, what was really absent was a desire to occupy the space of the teacher, the didactic desire which is there in *Illusions*, the politically 'correct' film. Genet had no looking-glasses and the figure of the prison warden in his film becomes very ambivalent, as the warden himself also becomes the spectator in the erotic sequences where he spies on the inmates through the peepholes of their cells. But there is some textual sympathy, a narrative sympathy for the prison warden as well, which we do not know what to do with. Using the body as an allegory in the positioning of the policeman and the other characters, Genet begins to talk about the nature of love, not as solitary confinement, because it is impossible, not quite auto-eroticism, because it is impossible, not quite a clean arena for the spectator, because in that space the outlines are shifting, but in fantasies of coupling. The fantasies of coupling begin to become so well choreographed that at the end of the film you actually see the body plunging outside the space of the framed prison cell and the eye spying on it through the keyhole. It seems that male homosexuality becomes the name of the human. I am very moved by texts where so-called marginal groups, instead of claiming centrality, redefine the big word human in terms of the marginal. This is what happens in Genet's exquisite film because the desire for transparent didacticism is not there. It uses an old-fashioned allegorical technique and it comes off because of the humility of the text.

Illusions, in some ways, is about Ella Fitzgerald. It is Fitzgerald's voice which you hear over the powerful war shots at the beginning of the film. That voice, in the context of US black women, is one that is impossible not to recognise. Because of this full allusivity, the filmmaker, Julie Dash, takes the risk of both sympathising and mocking the two black women who are the central characters, because they are identified with the American Dream. The War, which is a big, unmissable symbol, and Ella Fitzgerald, the Voice, are strong allusive presences, but neither of the black women have access to the Voice that we recognise. The text of *Illusions* is not a universal text; you have to perhaps be within the US context to see what is going on. It mocks globalism, even though the central figure is black. It is not really about choosing to be black but a comment on the Constitution of US blacks and whites, and from that point of view, I must say that although I generally speak critically of US critiques of globalism, I was moved by that movie.

Angela McRobbie: Emerging from these debates is a sense of 'crowdedness', a sense that perhaps there is no longer the space, the precious space, for example, for feminist avant-garde filmmaking, which can no longer exist unchallenged. It can no longer have the kind of purity that it might have had even five or ten years ago. The fact that in this debate we are trying to put critiques of imperialism alongside questions of racism, as well as thinking about a feminist strategy, is in many ways too much at once.

The distinction or division between the films which contextualise this debate seems to lie between those films which still reside within the legacy of Brecht and the Brechtian link with the avant-garde, and the idea of breaking the flow, challenging identification and combining that with feminist theory which is not going to offer either simplistically positive, or criticise simplistically negative, images of women, or which brings these two sides together in an over-didactic way. We seem to be moving between a more aggressive and more 'correct' political film strategy on the one hand, from films which are applied theory, which represent a kind of *Screen*isation of cinematic practice, and on the other hand, films which in many ways allow a space for popular culture. To challenge white culture is also to implicitly be within a space of popular culture, Kobena Mercer has very usefully raised this in his work on Michael Jackson.[2] That position of resistance within pop culture, for example, raises the questions: 'Can popular culture also be avant-garde?'

Questions/responses from audience (Aud): If Jacqueline Rose is in the minority in her appreciation of *Light Reading* as a politically and ideologically correct film, doesn't this imply a bankrupt heritage of film theory?

JR: You are making a point about pleasure and filmmaking. If you see the perfection of the image as also a return to the required perfection of the body of a woman and Hollywood as the apparatus that does that, which is the central theme of *Illusions*, then the moment you put an image of the woman on the screen, you have a problem. Given that avant-garde filmmaking is oppositional to Hollywood and to the encoding of sexual difference, *Light Reading* could be seen as taking to its logical conclusion what a strategy around that problem might be. That

is not the same as saying that the film is politically correct. *Light Reading* is also contradictory because it does deconstruct any possible recognition of the image of the woman in the film, but there is a gendered subject 'she' referred to, and that 'she' puts her hand up at the end of the film and in the name of that 'she', she says 'stop', and starts of read and begins to re-read.

Aud: But is it enjoyable?

JR: In relation to pleasure, one of the questions we have to ask is whether that notion of 'enjoyableness' is what we are asking from political filmmaking. Maybe a critique of a certain form of pleasure has been necessary to a political strategy, maybe now we are re-thinking that question. I enjoyed it by the way.

Aud: Can you elaborate on the problem of pleasure and of moving the audience?

AM: That is a really crucial question. There is a very good feminist case to be made in favour of not easily moving your audience, and audiences have always been over-easily moved, whether by popular box-office directors such as Stephen Spielberg or others. One of the arguments has always been to refuse that notion of being moved, whether it's in a Brechtian sense or whether it's in a contemporary sense. There is a tradition of critical writing and filmmaking which challenges meaning and takes up the idea of a woman's time and space, or challenges notions of continuity in cinema, which is very valuable, but at the same time leaves one cold. In relation to that, making a film about women without using the image of her body, is really a critical attempt and should not be devalued, but at the same time one wants to move on from there; but where does one move on to? A filmmaker who, in my opinion, does all those things and at the same time keeps the pleasure of the audience, is Chantal Ackerman.

GS: Towards the end of *Territories*, there is an image of an old woman who is walking on the street with riots happening in the background. Then her image is freeze framed, she is fixed, blurred by video interference lines across the screen, then the image is reversed, as if the woman is walking backwards. In *Un chant d'amour* the masturbation sequence of the black man is quite different from the other men's.

I would like very much to have a reaction to these two moments of representation of individual figures for whom we have certain historical baggage.

Aud: One is extraordinarily sexist and the other is extraordinarily racist.

KM: The issue about the old white woman and the implied violence being done by that band of video

'fuzz' comes up quite a lot. It is white viewers who make the comment and I think it perhaps suggests an implicit identification in terms of national identity. Seeing it in the context of these debates, there is another dimension to the issues which *Territories* is addressing, which is the mediation of the popular press. Young black males are represented as dangerous, as a threat to British society and its national identity. This is an essential aspect of the way the new racism articulated by Enoch Powell in the 1960s works, i.e. that white people are in the minority and that they are being persecuted or threatened by 'alien cultures', that they are being 'swamped'. I think that the issue which that image of the old woman brings up is not ageism or sexism but the importance of gender in terms of the construction of national identity. That is one point that I think is being hinted at in *Territories* by that shot.

GS: Could it be reverse discrimination? It is quite possible to say, 'It's not my problem to worry about the victimisation of men.' And men will reply, 'Look, we've been victims too.' But the rich and the poor are not equally free to sleep under the bridges of Paris.

In Genet's film, what's going on is much more insidious because it is not critical, it is hyperbolic admiration. The choreography and beauty of the body was a bad aspect of the film, but I think it had to be there. That extraordinary objectification of the black male body within the pre-liberation of the gay community is not something one can ignore. The final shot, when the black prisoner actually stops moving, we do not see him jerking off anymore. He lies down and there is this quiver in his butt, which is almost like a death shot, it is beautiful, it is the only shot in the film which is outside of the fantasy of coupling, which almost participates in the textuality of fantasy, where the body is not part of the real. The role of the black man in Genet's film is much more insidious than the white woman in *Territories*; it is not a moment of openly acknowledged political criticism but a dubious kind of objectified admiration. Masturbation is choreographed as dance.

Aud: We are being asked to identify homosexual desire across race difference. I don't think we could call that sexist or racist.

Aud: What distinguishes the image of the black man in *Un chant d'amour* is that it is an image of self-sufficiency. Here is one person who, in fact, does not need another, but the film depicted sexuality narcissistically. *Light Reading*, which is against the use of images of women, does not take on board images of gender. We have got to take that on board

as well, we cannot just make films like *Light Reading*, deprived of people.

GS: What Genet is doing is feminising the body of the gay male in the dance sequences of the film. It is a reference to the question of how one should describe the gay body politic. Should it be by referring to femininity, or the lesbian body politic or by referring to masculinity? For example, the film uses mimicry, sexual pleasure and eroticism, which is a much more complex question than various versions of solidarity against heterosexist opposition. It is a different kind of participation to the mainstream tradition of the abject disposition of women's bodies and the power-grabbing disposition of male bodies.

AM: One sees also in popular culture, in contemporary photography and pop music, a kind of imposition of self-sufficiency on the black male and female body. Two examples that come to mind are obviously Grace Jones in the way in which she is manipulated and her image is created by an overtly racist white man,[3] and also in Robert Mapplethorpe's photographs.[4] In all these contemporary discourses one sees precisely the same kind of notion of narcissism and self-sufficiency, androgyny and masculinity.

Aud: Does *Un chant d'amour* fetishises desire?

GS: The word 'human' cannot be without the deployment of power. There can be no allegory of the human condition without a display of, and participation in, the play of power. In *Un chant d'amour* all of these definitions: solitary confinement, auto-eroticism, specular gaze, fantasy etc. begin to shift, and the deployment of the space of power becomes uncertain. The black man does not participate in this extremely important power scenario at all. He is not just Narcissus, because Narcissus was also looking at himself. The black man is being watched by the prison warden and us.

JR: It is actually at the point of looking at the body that sexual difference inscribes itself across that moment of looking. It is that moment that sets up difference with all the effects that follow from that, in terms of a binary polarity, which then, through other concepts, like the unconscious, never completely happen. It is that moment of looking, which is central in setting up the body of the woman. Some things then follow from that, like fetishism or narcissism, structures which are not only of relevance to the question of colonialism and racial difference. For example, to quote from the voiceover in *Signs of Empire*: 'It is on the degree of curliness and the twist of the hair that the most fundamental differences of the human race are based'. That is a

question of fetishism, to take one tiny little bit of the body and to create through that the whole 'otherness' of the 'other'.

It seems to me that the question as discussed in this debate is 'deconstruction or not' or 'how far' or 'how successful'. There is a consensus that says that you just cannot take the body of the woman off the screen because that's like a deconstructive project gone too far. But what does 'too far' mean? Should there be a strategy which uses images which are 'corrupt', but which tries to undo them? Or should there be a strategy which counters that with a positive assertion uncontaminated by that history? So from where should those other images be produced? It is from that point that one might say that images are so contaminated that they cannot be used. This raises the feminist point about the representation of bodies of women in cinema. I am not advocating a filmmaking practice that never uses them, but there is a real risk in using them and I think this risk is exemplified by *Un chant d'amour* as well.

We also need to think about our relationship historically and institutionally to avant-garde film. The debate about avant-garde filmmaking, in some sense, has been repeatedly lost. The analogy which comes to mind are the long queues outside the British Museum to see the abstract art from the New York Museum of Modem Art. People who would never dream of going to see non-representational films but who stand in front of abstract paintings and appreciate them because they have broken through into a general cultural consciousness. Yet these same people will sit and giggle at the film *Watercolour*. These films have not won out institutionally. *Illusions* is not just a piece of archaism in the sense that it refers to the 1940s; it is referring to an encoding of cinema which is going on and making multi-million-dollar films now, still.

AM: How can one make a film which is pleasurable, which does not cut people off with cold, avant-garde theory? Maybe the problem is that pleasure is not a monolithic category, it cuts across not only race and gender and historical specificity, but also identity. Pleasure has got to be situational, specific and precise, and therefore the problem is that one cannot be prescriptive about making films or making music or writing a text which can guarantee this 'fix' with the audience in a good, political, progressive way, precisely because pleasure is the point at which one's psycho-biography comes into play.

GS: The question of the representation of a system of values or the question of where pleasure resides,

is quite different from what people get pleasure from. One of the most difficult things about identification is that politics produces and constructs other people's and one's own, genuine feelings of identification. One should clear a representative space for one's self which is not one's identification patterns or one's autobiographical, confessional, gestures. One decides to make all of these predicaments politically representative and scrupulously historical in some way and that can be useful. I would say that outside of the emphasis in these debates on resistance in the First World by black groups, the key question is not one of nationalism or ethnicity, but that of how identity is constructed.

KM: Is there any common ground between white independent filmmakers, avant-garde theory and black filmmakers? I think there are political, economical and institutional differences which make for an uneven development. I do not think that you can make equations between the terms of white independent film practice and what black filmmakers are trying to do, which is to establish black independent film culture in this country, without addressing those uneven developments. In particular, I mean the way black people have been more or less excluded from the resources that you need to make films, which white, middle-class filmmakers can take for granted.

To return to the question of fetishism. In terms of the centrality and the importance of the image of woman in cinema, in order to realise its exchange and semiotic value in patriarchal culture brings up a question that has not been raised in debates on film theory; and which is one that white feminists have not taken on board, namely the absence of black women from mainstream cinema. For example, in *Gone with the Wind* it is the relationship between the black 'mammy' and the white heroine that is the basis on which that kind of fetishism depends. This applies in popular culture more generally, where the fetishistic position of woman depends on her whiteness.

Psychoanalytic theory in film criticism has ignored the questions raised by race and representation in cinema, which is why the image of the black man in Genet's film amounted to a form of fetishism. The black man is only there in that very short part at the end of the film. He is nowhere else. I have certain reservations about the ethnocentric limitations of psychoanalysis and feel that there are other ways of understanding these processes which are not inscribed in institutional or legitimated bodies of knowledge. That image of the black man in Genet's film turned on the whole white European curiosity about black sexuality, black male sexuality, in particular. Eddie Murphy, in his video *Delirious*, actually talks about this fear and fantasy of the black phallus: he says that the white man came to Africa, invented this myth that the black man had a big penis and then turned around and said 'I don't believe it'. So even in a popular discourse like comedy you have all the ideas of fetishism, disavowal, splitting and so on, which are not inscribed in any legitimated institutionalised theory. Also, psychoanalytic theory has really tended to focus on visual communication, the look, etc. and paid very little attention to the ear, to aural/oral culture and for example, how subjective identity, sexual difference and sexual choices are articulated by black men and women in forms such as music, for instance.

JR: Psychoanalysis has been an excluded and subordinated discourse in many institutional practices. There seems to be a similar set of problems in the two forms of film language, the two forms of cinematic discourse, around whether identity was possible, desirable or always, in some ways, a trap. So as not just to refer back to, or to be drawing on, what is still, despite the exclusions and especially in this context, the authority of the white, middle-class woman who speaks from the place of psychoanalysis, I want to refer to *Signs of Empire*, which does use psychoanalytic terminology and is often criticised for similar reasons that Kobena Mercer has made here.

Clare Joseph of Black Audio Film Collective said something which has really struck me. She said that *Riots and Rumours of Riots*, which was a film about an alternative identity and the need to construct that history, made *Signs of Empire* possible. So she seemed to be saying that there isn't an antagonism between the two forms of filmmaking practice but that on the contrary, one makes the other possible. I think perhaps that might be a more constructive way of thinking about these relationships.

1 *The Toilet of Venus* by Diego Velazquez. painted between 1649–50, was retitled *The Rokeby Venus* after Rokeby Hall in Yorkshire, where it was housed from 1813 to 1905. Many questions have been raised by art historians. Why is Venus seen from behind? Why does the mirror reflect only the face of the model? Venus is looking not at herself but at the spectator – only she meets 'his' gaze via the mirror.
2 Kobena Mercer, 'Monsters and Metaphors: Notes on Michael Jackson's Thriller', *Screen*, Jan–Feb 1988.
3 Grace Jones' image manager was Jean Paul Goude, who was responsible for marketing her public image.
4 Robert Mapplethorpe has produced two books and photographs of black men: *Black Males*, 1983, and *The Black Book*, 1987, for a critical analysis of this work see Kobena Mercer's essay 'Imagining the Black Man's Sex', in *Photography/Politics Two*, Comedia, 1987.

aesthetics and politics: working on two fronts?
reece auguiste, martina attille, peter gidal, isaac julien, mandy merck

introduction by reece auguiste

An interrogation of cultural identities through the parameters of politics and aesthetics presents a set of theoretical difficulties. Problems to do with how questions of politics and aesthetic sensibilities relate to audio visual culture. Politics and aesthetics have been the subject of much debate in the writings of theoreticians as diverse as Benjamin and Lukacs; Tarkovsky and Glauber Rocha. Artists who are passionate about the development of audio visual culture must take into account the histories of left radicalism and artistic production but also, more importantly, the contributions that can be made towards these debates by these writers and theoreticians.

There are other problems inherent in the ideologies of interpretation; paradoxes of *langue* and *parole*, of being caught between the metaphoric in speech and the symbolic in political thought. The texts presented by Martina Attille, Peter Gidal, Isaac Julien and Reece Auguiste constitute modalities of difference(s) and a plurality of strategic interests. These political positions in film culture are themselves articulations of different moments in the history of independent film culture. Moments that attempt to address critically issues of sexuality, gender, race, power and the broader issues of representation and cinema.

In this debate we are presented with Peter Gidal's materialist film practice and non-representational cinema, with Isaac Julien's critique of European master discourse and Western Europe's avant-garde cinema. Martina Attille considers the construction of multiple identities in cinema and the position of black film practitioners in the institutional matrix of the cultural industries. Reece Auguiste speaks on black independent film poetics and the possibilities of developing an aesthetic of terror based on the convergence of cinema and New World poetics.

Of equal importance is the subsequent debate, which centres largely on questions of desire and pleasure in cinema and which gives rise to some questions on the supposed oppositional/confrontational politics between Black Audio Film Collective and Sankofa. It could be said that in this debate there seems to be a refusal to recognise parallel developments in black independent film culture and the possibility of black filmmakers having a space to develop and experiment in film art, of finding the appropriate methodological tools for visual production.

Essentially, we are struggling to construct and articulate a politics that can begin to address, in cinema, the complexities of post-colonial existence in the already troubled terrain of post-modernism. At the time of the debate I remember thinking, 'When did I last note white workshop groups being pitched in opposition to each other?'

Peter Gidal's concerns with epistemological issues of the split between knowledge, production and optical projection was another point of issue in this debate. His non-representational and anti-narrative stance denies the possibility of truth and pleasure in cinema. It is a position that belongs to various debates as encountered in the pages of *Screen* and previous issues of *Undercut*. 'If I hear the word desire one more time, I am going to throw up', was Gidal's response to the introduction of desire on the agenda. I am still forced to maintain that desire and pleasure are imperative criteria in the development of independent film culture.

Finally, two points: cinema is a relatively new artistic movement in comparison to painting and sculpture, so the possibilities for innovation and experimentation are immense and allow for a plurality of forms and expressions. Secondly, the presence of black filmmakers in Britain is also relatively new. With new arrivants we must have new departures. You must now draw your own conclusions from this debate around politics and aesthetics.

It is amusing to note that these discussions were hosted by the Commonwealth Institute, where in its exhibition space, colonial and post-colonial fantasies around national identities are frozen and fixed for public consumption. Nicos Mendoza[1] would also have been bemused by this paradox.

1 In the oral traditions of the diaspora, it is said that Nicos Mendoza was a Brazilian artist and bohemian who, on hearing from travellers that the Lumière brothers were in India with an instrument that could record movement, left his canvas and paint box for India. In some sections of the New World he is now a deity: The god of light.

Martina Attille: Industrial countries in the First World are undergoing a political crisis, which is both economic and cultural. People on the left and the right are trying to find some direction, trying to identify some of the problems. There is also a plurality of identities, articulated by specific interests coming from dif-

ferent social groupings. It is no longer adequate just to group people in terms such as black women or the working class, because within those categories there are constituencies that are making claims and giving voice to their own particular interests and needs. There is also a realisation that identities are not actually fixed, that they can be constituted towards forming and consolidating political allegiances and it becomes increasingly difficult to talk about a monolithic Left. It is probably more accurate to talk about the constituencies within the Left. Politics and aesthetics; it is difficult to divide them, especially when aesthetics can be aligned with politics. One instance when aesthetics becomes very self-conscious is in the work of film production; when you talk about the audience that you want to address and when you want to make the best use of cultural forms available to you. Aesthetics in a film collective like Sankofa inevitably means talking about desires, what sort of films you want to produce, what sort of images you want to see. Not talking so much about positive images, or a purity of representation, but about a diversity which allows us far more space than is allowed by present images of black people. Our work in Sankofa is to broaden the vocabulary of production on our own terms, contributing to a cinema that affirms our existence and our politics and also to have a certain amount of autonomy in that practice. This does not necessarily mean looking for some authenticity but that we should recognise the economic and cultural processes of change and inevitable repositioning of interests, not only in production, but also in film forms, in theory and the economics of production. It means being aware of the 'interests' of funding institutions, like Channel 4 and the BFI, and also the need to make international links with other filmmakers in the black diaspora. We are very aware that there are forces which want to define what black film practitioners should be engaged in. People find it very difficult when we do draw on wide sources in our productions. They think maybe we should be concentrating on ethnic problems or positive images. We as a group recognise that working in this culture we do have access to a wide range of languages. A film like *Territories* has been regarded by the BFI and others to be very much like Jean-Luc Godard's work, when in fact it draws on far wider sources, going beyond Eurocentric theory. In Sankofa we recognise that in a time of economic and political reaction, each intervention in film theory and in film practice tends to pull people into line, rather than to encourage a pluralism of approaches to production or even to theory. Intervention makes it possible to clear

the way to finding out where political allegiances can be made. Allegiances are probably far more important than specific identities.

If anything, our practice is about encouraging dialogue rather than indoctrination.

Reece Auguiste: on black cinema, poetics and new world aesthetics. The histories of black independent film practice in Britain has hemmed black filmmakers into a set of social relations which demand that the inventories of cinema be addressed anew. An analytical reading of this cultural field reveals two distinct, yet interrelated historical antecedents which inform our filmic practices: the early period of British black independent film production from Lionel Ngakane's allegorical *Jemima and Johnny* (1974), to the 1970s, with the films of Henry Martin, Horace Ove, Imruh Bakari (Caesar) and Menelik Shabazz, and the political and aesthetic interventions of Third Cinema, as a counter-movement in film, which is critical of its own position, as it is of European cinema.

Our point of departure is that each generation re-writes its own history. Black independent film practice is at a critical conjuncture where it must make a radical departure from other film practices. Our presence in independent cinema, as it is currently structured and mediated by the institutional and the political is, I believe, engaged in a struggle for its epistemological terrain through modes of visual articulation and narrative concerns which do not desire to emulate or mimic other cinemas. It is a cinema critical of its own discourse as it is of other cinemas.

There are two distinct traditions from which black independent filmmakers can extrapolate materials towards the development of their own film aesthetic; one is the literary traditions of the diaspora, rich and diverse in myth, parables and orature and its diverse practices in the diaspora, the second is Teshome Gabriel's theoretical work on Third Cinema: *Third Cinema in the Third World: The Aesthetics of Liberation*. It is these interrelated fields that are capable of producing the desired inflections, new forms and new narrative structures in cinema. Black British independent filmmakers are the product of the New World, also of Africa and India, and whether born in the Third World or in the spectacle of declining British inner cities, they have a generic connection with the perils, pleasures, passions and contradictions, the cultural landscapes of the New World.

A combination of the system of racial representations and the inventories of cinema have structured our engagements with the histories and practices of cinema, with narrative forms and structures, and with

political/economic questions upon which independence is based.

I shall make reference to Brazilian cinema – Cinema Novo – a cinema of extreme solitude, reflection and revelation. Historical, geographical and economic differences aside, I am compelled to reiterate Glauber Rocha's insights on oppositional film practice: 'When filmmakers organise themselves to start from zero, to create a cinema with new types of plot lines, of performance of rhythm, and with a different poetry, they throw themselves into the dangerous revolutionary adventure of learning while you produce, of placing side by side theory and practice, of reformulating every theory through every practice, of conducting themselves according to the apt dictum coined by Nelson Pereira dos Santos from some Portuguese poet: "I don't know where I'm going, but I'm not going over there"'. I am not arguing for an uncritical reproduction of the filmic practices of Third Cinema; I make reference to Glauber Rocha so as to demonstrate an affinity with the desire to rupture and embark on new beginnings. Black filmmakers are constituted by diverse histories of exclusion and emigration; by cultural experiences emanating from the historical conditions of the New World, Asia and Africa. The cultural terrain upon which we work is invested and structured by pluralism, which indicates the immense problems involved in attempting to affirm a unitary definition of cultural identity and social experience(s) through the apparatus of cinema. Cultural diversity disavows the singular and monolithic in cultural production. It is precisely this diversity of experiences that must inform aesthetic production and the problematisation of representation.

It is revealing that Walcott once remarked that: 'The truly tough aesthetics of the New World neither explains nor forgives history'. Given that in this forum we are talking around the binary of politics and aesthetics in cultural production, it is appropriate that I enunciate the invaluable contribution that New World literary discourses and aesthetics can make in the development of black cinema in Britain. It is here that memory must assume the position of privileged informer. The extrapolation of memory from literary forms and contexts crystallises the intersection between literary concerns and cinema. New World poets such as Pablo Neruda of Chile and the Martiniquan, Aimé Césaire, for example, have made memory the substance of their work. The desire to grapple with the tropes of memory, with the intersection of myth and history must not be understood as being exclusive to literary productions although these constitute a body of archival material which can inform our film practice.

Walcott reminds us 'that myth never emanated from the savage but has always been the nostalgia of the Old World – its longing for innocence'. Our vision is not naive, unlike the great monumental poetry of the Old World; we do not pretend such innocence. Memory as it is conceptualised by New World poets is salted with the bitter memory of migration and fragmentation. It is this acidic taste of memory that has to be brought to the service of the struggle of black independent film practitioners.

New departures in film culture also necessitate a struggle for radical forms, reference points, for a filmic vitality in narrativity and audio-visual style. Film practitioners cannot continue to re-articulate the discourses which structure positive/negative representations of race. Filmmakers who want to develop a cinema of relevance must jettison the discursive concerns of multi-culturalism and the positive/negative image to the cultural wasteland. Our presence in the 1980s demands an interrogation of the rhetoric of race in relation to cinema. It also necessitates a re-politicisation of the technological apparatus of cinema. Politicisation can occur in the production process itself. A testing of possibilities and limitations. Thus the successes of the black independent sector rests on an astute reading of the political economy of independence, institutional practices and a radical reconvergence of cultural identities and filmic representation/production. If Walcott's notion of an aesthetics which 'neither explains nor forgives history' is to supersede the dominant discourses of the European avant-garde and other cinema traditions, then filmmakers have to interrogate and evaluate the genealogy of those traditions. Again, it is a question of testing limitations. Engagement with cinema thus assumes a set of multiple practices, which is why I believe that the title of the forum is both inadequate and deceptive. The struggle for new life and vibrancy in cinema must occur on multiple fronts.

The Ethiopian film-maker, Haile Gerima, has signified the importance of literary subjects in the formation of oppositional cinema: 'Because of the rich history of black literature and our renewed oral tradition, the independent cinematographer must, out of necessity, incorporate and fully use this astounding body of resource material'. Gerima's insights put into sharp focus the organic connections between New World poetics and the possibility of forging new aesthetic presences in black cinema.

It is possible, I believe, to develop an aesthetic of

terror in cinema akin to Walcott's 'tough new aesthetic', which is ultimately transgressive, capable of producing mutations and incisions, which can ensure that the Western gaze can never regain its privileged position as the ultimate arbiter of symbolic meaning and representation. A black independent cinema which attempts to register an aesthetic of terror is concerned with possibilities, critical of its genealogy and trajectory. When we allow memory to assume the seat of privileged informer, of having a transgressive function, then the process of re-naming begins. As Walcott says: 'We were blest with a virginal, unpainted world, with Adam's task of giving things their names.' The act of naming things anew is a fundamental prerequisite of a cinema with new voices and visions.

Finally, I shall address the issue of audience accessibility and questions of language. My reference point is Black Audio Film Collective's slide/tape production *Expeditions: Signs of Empire* and *Images of Nationality*. The collective has often been asked the question, 'Who is your audience?' The question is always premised by the understanding that the language in which we have chosen to articulate colonial exigencies is thought of as rather abstract, difficult and ultimately inaccessible. I must deploy a Shakespearean subject so as to affirm the importance of the use of this language. The subject? Caliban.[1] A subject whose historical existence is characterised by a psychic split: the language of Caliban's unconscious is as much to do with exclusion and accommodation, as with fear. The paradox is that Caliban's presence reveals to us the psychic turmoil of his master Prospero. Through Caliban's action, Prospero's soul is revealed. Listen to Walcott on this dilemma: 'Your view of Caliban is of the enraged pupil. You cannot separate the rage of Caliban from the beauty of his speech, when the speeches of Caliban are equal in their elemental power to those of this tutor, the language of the torturer has been mastered by the victim.' Now the terrain upon which we work is such that the critical deployment of that language is towards the production of new meanings. This is viewed as collaboration with dominant language, but for us it is victory.

Peter Gidal: in representation or out? some condensed notes on aesthetics and politics. To endlessly denounce questions of form as irrelevant at best and elitist at worst, is to play straight into the hands of dominant representation, i.e. dominant forms. By 1986 this ought no longer to have to be stated. It certainly ought not to be arguable, as the alternatives are to pander to various realisms, or to pander to carefully watered-down formal changes which are already co-

opted, and do not inculcate resistance to anything. Academicism thrives precisely on such co-options, which is why, in the end, literary analysis takes over, as it did in the appalling libertarian voice of reaction of Gayatri Spivak in the debate on 'Sexual Identities'. Spivak's thrice-repeated denials – and I quote: 'I don't dislike these British films' – is a slick marginalisation of British work, the better to dispense with its force. 'Didactic' is her condescending code word for this work. Spivak's denials also betrayed a notion of pleasure which denied the political question of the ideology of pleasure. This digestible post-modernism is in power in academia, especially in the United States, France and here.

Clare Joseph's carefully precise elucidation in 'Culture and Representation' leaves me with one problem, namely, the notion of 'political identification'. I fear that the concept is not the same as solidarity, because identification destroys the objects one is ostensibly identifying with. To identify the other is not the same as 'identification with'. 'Identification with' structurally excludes a political solidarity because it substitutes the self and the ego for, and in the place of, any other political identification. I think that this is important to realise, so that we do not end up with another realism as a decoy for the realism we are supposedly doing battle with, although we need realism of another kind.

What worries me is the illusion that one individual's identifications could equal solidarity, and by individual I am referring to the viewer. That is why taking a position is a political act, but it is not based on nature, ethnicity or biology. Otherwise, being black would be the problem, or being a woman would be *the problem*, rather than oppression being *the problem*. All positions are arbitrary; this does not mean that they are irrelevant, but simply that they have nothing to do with a natural order or essence.

First of all I try to make films, secondly, I try to make films where each image, each object, is never given the hold of any recognition. To not reproduce the given as given, to see each image, each object, each imaginary space-time narrative as imaginary projection, so that nothing takes on the status of truth. The lack of recognition, and I am not saying that it always does, can force the construction of all representational motives as constructions, as artifice, as unnatural, as ideology, so that representation is always impossible.

There is always a split between knowledge and perception, between what we *know* and what we see. In other words, what we think we know must not be thought to be the same as what we think we *see*. That

HANOI, TUESDAY 13TH Santiago Alvarez

split produces a process of film which simultaneously produces a spectator and a spectating that constantly problematises representation. I see no other way to practice film – there must be other ways, but, judging from the response in 'Sexual Identities' to Lis Rhodes' film *Light Reading*, perhaps understandably, some ways of filmmaking find less solidarity than others. The radicality of Lis Rhodes' film is not easy. This is the difficulty we have as filmmakers and theoreticians. Voyeuristic pleasure is a structure of power in certain sex interests, or, as Christine Delphy would say, sex-class interests. One can hardly expect an easy relinquishing of such power, and spectators collude, to say the least. The endless reproduction of dominant forms of 'unproblematic' voyeurism is what dominant representation is all about, that is its narrative. All I can add is that irony does not change a damn thing and if I hear the word desire one more time I'm going to throw up.

Materialist film, a materialist avant-garde, has to get rid of difference, not fetishise it, but that can only be said to an audience that accepts avant-garde and experimental filmmaking as a valid process. And obliterating difference must be simultaneous to understanding its historical construction and existence. The material of film, for example acetate, and the material of ideology, produce representations which are part of the contradictions within the varying historical materialities of the act of viewing. If you reject experimental film it is of no issue to argue pro or con this concept or that. But I assume that there is some sympathy with avant-garde film here.

The concept of difference assumes a dominant male norm against which the 'other' is 'other', so it must, by definition, be obliterated for a radical process to find its expression; but without such a polemical, political position, the illusion of the 'possible' becomes, unfortunately, broader rather than reduced.

Isaac Julien: on black british independent cinema, the avant-garde and post-modernism.

A few black filmmakers were in the front line of the formation of a black British cinema. Among these were Menelick Shabazz and Horace Ove. These black filmmakers attempted to document the struggles of black, Third World people on British soil who formed or still form, the underclass of British society. These films were anchored in a reality documentary mode, dealing specifically with race as a problematic. In oppositional filmmaking circles, this should not be seen as 'ethnic' or 'other' or anti-racist work, but has to be recognised in the light of the creation of a British identity which is a plurality of multiple identities.[2] It is the white British who have to learn that being British is not what it was. Now it is more complex, involving new elements, consequently there must be a fresh way of seeing cinema and a new way of seeing *per se*.

Experimental film as a left-wing political film practice seems to contain a number of discourses collapsing into each other; the interrelation of race and gender and the primary positioning of 'difference'. On the left of avant-gardism is pleasure, which the avant-garde self denies, clinging to the purism of its constructed ethics, measuring itself against a refusal to indulge in narrative or emotions and indeed, in some cases, refusing representation itself, because all these systems of signs are fixed, entrenched in the 'sin or evil' of represention.[3] The high moral tone of this discourse is based on a kind of masochistic self-censorship which relies on the indulgences of a colonial history and a post-colonial history of cinema of white representations based on our black absence. The problematic that surfaces when black filmmakers experiment with the idea of black film text and the subjective camera, is that subjectivity implies contradiction. But this is not, in itself, fixed. Black political filmmaking works to unfix the 'other' fragmented self in order to construct a new filmic language, to reconstruct black representations in British cinema, be that in narrative, abstract film, documentary or film essay.

The dominant master discourse demands: 'Let me know your culture, tell me your story', even though we are trying to tell the stories to ourselves first. Critics are only here in typical, First World, master discourse fashion to analyse and criticise, to slot black film into identifiable, legitimised categories. So our work gets compared to, say, Godard's work. An attempt has been made in this debate to keep discussion within a dominant discourse, within its own paradigms. We are aware of this and also critical. To do this is an attempt at containment, a marginalisation

of our work in relation both to films made by Third World filmmakers and Third World to First World black filmmakers born on British soil. It also has to be noted why we are here, the struggles of black communities which have taken to the street to express their frustration, are continued and mirrored in other spaces, i.e. cinema.[4]

A simplistic and unproblematic polarity has been forged here between black film practices and the practices of avant-gardism. Structuralism in film has replaced old orthodoxies with new ones. To challenge the Eurocentric master discourse is not only to be seen in binary terms of opposition but also as an intervention which revitalises different film practices with black British identities and black film culture, shifting the definitions of cultural identity itself. More importantly, it reveals the pleasures of our existence, as does black music. Territories and ideas have to be explored politically through construction and reconstruction, then thrown away, if we are to change and master narratives and conventions, and to invest in cinema a wholeness. So that when one enters in on a black subject, it is not seen as 'ethnic', 'other' or 'different', but whole, thus changing the terms of definition for blackness and what it means to us. This does not imply that we enter into romantic ideas of black nationalism. I accept that there exist multiple identities which constitute national identity, which should challenge with passion and beauty the previously static order. Black cinema is part of post-modernism, it needs a space to grow rather than spaces that attempt to fix it.

Mandy Merck: This is an interesting counter-position which not only describes pleasure but unpleasure as an ideology, an ideology comparable to a concept of sin or evil, as Isaac Julien said.

Peter Gidal: Did Reece Auguiste say that 'memory must not have the function of truth'? If memory mustn't have the function of truth, which I totally agree with, I cannot see why anyone would bother allowing representation at all, since we know that truth is an ideology. But does that link up with the point that 'avant-gardism' or experimental film (because 'avant-gardism' is just a derogatory term meaning nothing) lacks pleasure? I do not understand how Isaac Julien could possibly say that, and I am shifting it by saying that what he seems to be saying is not so much an attack on my kind of work, or a certain kind of avant-garde experimental film, but directly in opposition to what Reece Auguiste was arguing. That is more important in my view, because the Co-op filmmakers[5] have been hearing this for 25 years, that

their work lacks pleasure. Some film work has theory, some hasn't theory, some just lacks pleasure because time, duration, is difficult to watch. Standing in front of an abstract Paul Klee or Jackson Pollock painting takes three seconds (although it shouldn't), and you can wander off and say it's radical, or it's reflections of nature, or it doesn't matter because it's a three-second experience. Whereas a film has duration, takes time and the displeasure is built into the structure. Experimental filmmakers have been dealing with that for a long time. This question is not just one of the apparatuses within experimental non-narrative film, but involves a political position.

RA: What I said was that memory must assume a position of privileged informer, meaning that the oral and literary tradition of black culture has to inform a black independent film practice. Memory is convoluted, it is contradictory, it comes in different shapes.

MM: You mention the need for a certain kind of displeasure and the need not to have to posit the question 'who is your audience?' or not to kowtow to them. Do you see that as necessarily different from Isaac Julien's position on pleasure?

RA: I believe that black culture is very passionate and our histories are themselves passionate movements and I cannot conceive of a political cinema, a cinema of commitment, where passion is excluded. Passion has to inform and structure the film text, that is why I have tried to make the connection between terror and pleasure. Referring to Black Audio Film Collective's *Signs of Empire*, at screenings, some people have either walked out, or, those who have managed to sit through it felt that they had been intimidated by the sound or the sheer impact of the images. To them, that was unsettling. From our position, we believe that that in itself is pleasurable. It is traumatic, it is terrifying, but yet, paradoxically, it produces immense pleasure.

IJ: It seems to me that a number of different styles of filmmaking have manifested themselves around the London Film-makers' Co-op, so that you have the embodiment of 'women filmmakers' and the embodiment of 'gay filmmakers', each having their own discourse and making reference to and re-framing themselves in relation to different ideas of what is an avant-garde filmmaking practice. But debates around pleasure are being recognised and discussed, even within experimental avant-garde filmmaking.

Questions/responses from audience (Aud): I would like to ask some questions about the films but, I am really not used to these abstract words, and all I can go on is the images that I have seen and talk

CLOSE UP Peter Gidal

CLOSE UP Peter Gidal

about these. For example, when I think about the image in *Moi, un noir* by Jean Rouch, of the black woman stripping for whatever reason, I am disgusted by it. It is a white man – the film director – she is stripping for. In my opinion she would not have done that for a black filmmaker. The film director, Jean Rouch, took advantage of the political situation which allowed him to be a spectator for the woman stripping, and in which black people, too often, have had to prostitute themselves to get a result.

PG: That exactly gives the reasoning behind my own filmmaking, which is that even if you fall asleep or walk out or get bored stiff, you do not get traditional pleasure, passion or terror. The point being that you won't get what disturbed you so much in Jean Rouch's film, which is the primary voyeuristic pleasure of all cinema, independent or otherwise. And the reason why my work, whether good, bad or indifferent, disturbs people on one level, apart from qualitative questions, is precisely the absence of those kinds of pleasure that you are objecting to in Jean Rouch's film *Moi, un noir*, which is a black woman taking her clothes off for black men, or white men, or the spectator, or the spectator by proxy, which is what happens in almost every film you have ever seen. So, as far as I am concerned, theoretically, again rightly or wrongly, there is no option if you take the position you do, to make films more or less like I do.

Aud: Referring to Peter Gidal's earlier comment that 'all positions are arbitrary', I don't think we can validate arbitrariness as the given order. It is not entirely arbitrary that there are discriminatory laws in this country. We need to think through questions of positioning beyond its arbitrary nature. To use that as a basis for saying that we cannot have representation, is a very massive jump of category.

IJ: One of the demands we have insisted on in Sankofa, is to allow for a plurality of film practices

to exist side by side. Peter Gidal talks as if there is a law of filmmaking with the master discourse always entrenched as the norm for most discussions. He sees differences in the papers given by myself and Reece Auguiste, but I do not see that as a threat to co-existences. Even in terms of the film practice that Peter Gidal is speaking about, there has to be an attempt to experiment in film. Also, when he talks about pleasure, his film practice is described in terms of countering Hollywood cinema; a cinema of white faces appearing cinematically to your pleasure but to our unpleasure, that is a major difference.

PG: Obviously, the arbitrary does not mean that things are not determined, racism, sexism, have determinations and certain class/sex interests. People and class groups do things for reasons, gain and loss, but the point is that the arbitrary simply means that it does not have to be that way; it could be another way, and power could be in other hands and could be exercised differently. It seems that the one thing that still seems to elicit the most difficulty, in terms of representation, is a non-narrative experimental film practice. In independent film practice there are largish groups that accept narrative, largish groups that accept homosexual voyeurism, largish groups that accept anti-neo-colonialist film practice. The one thing that people seem to have greatest difficulty with and I do not understand quite why, is a film practice that refuses to give recognition to the image, to the space, the time and the language, for that half hour that they are watching the film. In the end, it's the kind of work that doesn't have narrative recognition, that doesn't give a representational whole and that doesn't allow voyeuristic pleasure of any sort, that everyone seems to agree finally is the one thing that is not to be done, and my constant question is, 'why is that?'

MA: In response to Peter Gidal, there is a problem

in the way that experimental film is taken up as if there is one sort of experimentalism, which excludes films like *Territories* or *Passion of Remembrance*, because it is not your particular strain of experimentation. Perhaps the difficulty in reading your film is not so much a difficulty or a problem of non-representation, it is a problem of inadequacy because it doesn't say or respond to some of the things that are happening, and from my experience of black independent film production and the debate around it, there is a real need to reconstruct. Our lives have been fragmented and our relationship to mainstream cinema is not one where we can afford to get bored of hearing the word 'desire', because none of our desires have come even near to being fulfilled. We are involved in talking about what we can and want to see, what images we want to construct which benefit our politics and determines to some extent our future. So I don't think you should focus the debates around your particular film practice, because yours is one amongst quite a few practices and in a way it limits the debates on what black independent production is all about, which is about plurality. Not all black filmmakers want to make the same type of films.

Aud: I think it is wrong to describe all kinds of representational images as voyeuristic. There is voyeurism in the traditional sense, in the scene in *Moi, un noir* where the woman exposes herself for the sexual pleasure of someone who has them at their mercy, but I think it is wrong to apply the term voyeurism to simple representation. For example, *Hanoi, Tuesday 13th*, by Santiago Alvarez, is representational and I think it would be a mis-application to describe as voyeuristic, looking at the peasants in Hanoi, caught in the scenes of war. They were treated with a great deal of respect and sympathy, we could identify with their fate, so it is wrong to denigrate all representation as voyeurism to begin with.

What I feel is lacking in Peter Gidal's work is a consciousness which is meaning-bestowing. We try to bestow meaning on the world and Peter Gidal's film *Close Up* just closes me out, I cannot bestow any meaning at all. For me, the denial of expectation in *Close Up* amounts to frustration, it leaves me unable to make any sense of it and I do not see that it has any political function because to me, it's meaningless.

PG: This is not meant glibly but what you have said is exactly what I want to be produced in the viewer. In as far as anyone who makes any work can have any control, that kind of response is exactly what such films in general, ought to be producing, i.e. not to have the illusion of meaning from

what you see, not to have the illusion of pleasure by seeing Vietnamese bombed to smithereens by American bombers, or the illusion of displeasure or the pleasure in that displeasure, or the building up of a cathartic relationship which by the end, frees one from any political responsibilities, from any political acts, because after all, catharsis has operated through identification with the Vietnamese. I agree that there are problems with that, there are also problems with being Vietnamese and being bombed to smithereens by America, but that is a different set of problems. I don't want those problems solved in the viewing because they cannot be solved in the viewing. So, in a very strictly materialist sense, the films are meaningless, they do not allow the consumption of a meaning which would then reside within one, ending all the processes of meaning, of engagement, of thought, of memory. That is why, just to answer the first point, I think that all cinematic activity where there is recognition, is voyeuristic and produces a political impotence under the guise of identifications. I don't want to do that, I may be wrong, I may be right, the films may be good or bad, but that is what I think the films should not do. If people walk out, if they fall asleep, that's a problem.

MM: Only one political filmmaking strategy is being interrogated over and over again. Neither Reece Auguiste or Isaac Julien make films like Peter Gidal. Reece Auguiste however, on the face of it, argues rather like Peter Gidal, about aesthetic strategy and both Reece Auguiste and Isaac Julien attempt to resolve and recognise their differences with a discourse around passion, which is interesting because of their use of the text 'Narrative Cinema and Visual Pleasure'[6] which calls for a radical pleasure but also calls for a sense of passionate detachment.

Aud: I think there has been a polarisation, an attempt to play off Sankofa against Black Audio Film Collective. The point is, that new filmmaking culture in Britain is distinguished from previous generations of black filmmaking in this country, from the work of Horace Ove for example, by the engagement with the theory and practice of the European avant-garde. There are different strands in European modernism which question the classical regime of representation. There is something in front of you which is a picture or a novel, and there is something outside which it refers to. One is formalism and another is collage. Formalism calls into question representation by addressing the materials to hand, be they emotions, language, or the cinematic apparatus itself. That has led to

a kind of dead end which is characterised by a moralist condemnation of mainstream cinema and the pleasures if offers. That is very different from the collage stream in modernism, from people like Rodchenko to Andy Warhol for example, where representation has been questioned by engaging with the artifacts and objects of popular culture. That's the difference between one section of the avant-garde which has turned its back on popular culture and another which engages with it, calls it into question, but in a more heterogeneous way. For example, the relationships between film and music in Velvet Underground in the 1960s, or of Roxy Music from this country in the early 1970s, where high culture and modernist theory formed popular cultural practices. There was an engagement between the two and I think that is what Sankofa and Black Audio Film Collective are involved in. They're engaged with the dominant forms of representation and in a way they're also drawing on bits and pieces from the European avant-garde, the modernist tradition, so as to call into question the way in which black people are being represented in mainstream culture. I think that is the main difference, I do not think it's a binary position, let alone a kind of black/white opposition.

1 For a re-reading of Shakespeare's *The Tempest*, in which Caliban and Prospero appear as metonyms of New and Old Worlds respectively, see for example, George Lamming, *Water with Berries*, Longman, 1971. See also George Lamming, *The Pleasures of Exile*, Michael Joseph, 1960.
2 As outlined in Hanif Kureshi's essay, 'The Rainbow Sign', in *The Rainbow Sign and My Beautiful Laundrette*, Faber and Faber, 1986.
3 See Paul Willemen, 'An Avant-Garde for the Eighties', *Framework*, 24, Spring 1984. 'This "avant-garde" would, in fact, correspond to modernism. The other one is described as reacting against purism; rejects ontological presuppositions or investigations and is concerned with semiotic expansion (use of mixed media; montage of different codes, signs and semiotic registers; heterogeneity of signifiers and signifieds is activated, etc.). This would correspond to the avant-garde approach. The tendency towards semiotic reductionism clearly corresponds to the "conservative" impulse, explicitly articulated by Greenberg towards maintaining the autonomy and institutionalisation of "high art"'. p. 60.
4 Robert Crusz, 'Black Cinema, Film Theory and Dependent Knowledge', *Screen*, vol. 26, no. 3/4, 1985.
5 London Film-Makers' Co-op. Set up in 1966, it comprised a workshop, a distribution library and a cinema. The workshop was set up with the intention of enabling film-makers to have complete control over their film through all the processes of 16mm film production.
6 Laura Mulvey, 'Visual Pleasure and Narrative Cinema', *Screen*, vol. 16, no. 3, 1975.

UN CHANT D'AMOUR

Jean Genet/France/1950/25 mins

The only film made by Jean Genet, playwright and novelist renowned for his homosexuality, his prison sentences, and general contempt for the French bourgeoisie. *Un chant d'amour* is a poetic story of love between men set in a prison wing housing convicted murderers in solitary confinement. It is a visually striking film and, in line with much of Genet's work, its controversial portrayal of homosexual desire caused it to be suppressed and banned for 24 years.

CLOSE UP

Peter Gidal/UK/1983/70 mins

Close Up is a provocative and potentially dangerous pulling together of two opposing aspects of film form – namely a documentarist soundtrack comprising interview material with Nicaraguan revolutionaries on the subject of art, propaganda and imperialism, and an image track of much beauty veering towards the abstract as the camera moves ceaselessly ever the objects in a room or those represented in blown-up photographs. (Michael O'Pray, Monthly Film Bulletin)

AN EPIC POEM

Lezli-An-Barrett/UK/1982/30 mins

Using poetry, archive, allusions and re-enactment. *An Epic Poem* explores the contradictions inherent in man's conception of love through the myths and representations which support it. 'I was searching to understand the contradictions women confront within our experiences of love. That love controlled by the proto-types set up through "histories" polices our emotions, directing our social, economic and sexual status' (Lezli-An-Barrett).

Central to the film is the Rokeby Venus slashed by militant suffragette Mary Richardson. It becomes an entry to the 'historic' past, but also to myth and the unconscious, its imagery developed and shifted in tableaux-like series of encounters between Aphrodite and Ares.

HANOI, TUESDAY 13th

Santiago Alvarez/Cuba/1967/38 mins

Although the opening and closing sections of this Cuban film are extremely savage compilations of American and Vietnamese newsreel material, it is principally a beautifully filmed montage of people and places caught up between war and peace: the rice fields where only the animals have to be rounded up, the air raids, the dead, the wounded, the dazed. There is no commentary, only a mixture of Afro-Cuban and Asian themes echoing the tragic changes in mood.

ILLUSIONS

Julia Dash/US/1982/34 mins

Illusions – set in the fictitious 'National Studios' in Hollywood in 1942 – takes a critical look at the question of appearance as it is manifested through war propaganda produced in Hollywood, and its deceptive use of cinematic techniques like sound dubbing. *Illusions* specifically addresses the issue of politics and race through the eyes of a black woman. Mignon Dupree is black, but she is taken for white by her co-workers because her skin is fair. She is determined to succeed as a film producer, even at the risk of losing everything if her racial identity Is discovered. Mignon becomes vulnerable when her work brings her into contact with a black singer whose voice is being dubbed for a white actress. These conflicting realities jeopardise her disguise, making her aware of the harsh realities of racial interactions. This experience forces her to redefine her own existence in direct contrast to the Hollywood images of the screen. She learns to reject the Hollywood model but also creates her own.

LIGHT READING

Lis Rhodes/UK/1978/20 mins

A photograph of a crumpled and seemingly bloodstained bed provides the film's central image into which the camera vertiginously and repeatedly zooms. Fragments of words, letters and text are perplexingly intercut into this image providing a strange lexicon of signs and language. (Michael O'Pray, *The Elusive Sign*)

MOI, UN NOIR
Jean Rouch/France/1957/80 mins
The film is an account of a week in the life of Oumarou Ganda and his friends, who are from Niger, and are working as casual labourers in the harbour at Abidjan. In the film, Ganda adopts the pseudonym of the film star Edward G. Robinson. The visuals, which were shot mute, are punctuated by a commentary provided by Robinson during the first edited version of the rushes. Robinson, seeing himself projected on the screen for the first time, talks about his aspirations, his uncertainties and his day-to-day realities. The film points to a multiplicity of readings: as a social document exposing the conflicts between a traditional way of life and the Western values encroaching upon it, as the dialectics of life and dream; and as a document that attempts to expose the anxieties and *joi de vivre* of the new African generation. (Arthur Howes, *Undercut*, no. 9)

NEWS AND COMMENT
Frank Abbott/UK/1978/35 mins
A political film about television and the way we watch it. It attempts to open up a series of questions around the form of TV news and current affairs presentations, without adopting the form of the material it is analysing. *News and Comment* keeps asking the question, 'How to speak correctly?' Speaking correctly is seen as a major cultural indicator of class and social identity in this country. It specifically asks what it is to speak correctly on television and searches for answers by pausing, repeating and analysing the sounds and images which flow into our living room through the TV set.

REASSEMBLAGE
Trinh T. Minh-ha/US/1983/40 mins
Through a complicity of interaction between the film and the spectator, the filmmaker challenges traditional ethnographic documentary style in her visual study of women in Senegal, making women the focus, not the object, of her study.

Reassemblage is not so much about the reality that she encounters but about her perception of that reality. Through its approach to documentation, it constitutes a reflection on the cinematographic language commonly used in ethno-documentary films to portray foreign cultures. Tinh T. Minh-ha wants viewers to realise how much we impose on what we see. Part essay, part poem and visually exquisite, *Reassemblage* is also a work of film criticism – one that plays with the qualities of film itself. In its form and content it critiques both Western science and documentary traditions.

RIOTS AND RUMOURS OF RIOTS
Imruh Bakari (Caesar)/UK/1981/33 mins
Riots and Rumours of Riots is a documentary history of immigration from the Caribbean to Britain, from the period of World War Two up to the 1958 Notting Hill riots, viewed from the perspective of the 1980s. It uses diverse material in the form of still photographs, posters, handbills, newspaper clippings and newsreel footage to enhance the observations made by the pioneers of West Indian immigration to Britain. It foregrounds the important part played by the older generation of blacks in British history, particularly their role as servicemen in the War. It contributes to a better awareness of the social milieu which gave rise to early forms of radical black politics in this country.

SERIOUS UNDERTAKINGS
Helen Grace, Erika Addle/Aust./1903/28 mins
Serious Undertakings could be described as a film about sexual difference and national Identity, maternity and terror, the place of women in Australian landscape myths that we use to create our history. But it would be more accurate to say that the film invites us to imagine connections between these problems, to question the way that Australian intellectuals – writers, artists, critics – have defined them as problems, and to enjoy a sparkling demonstration of how cinema itself produces connections and definitions that we often take for reality. (Meaghan Morris, *Financial Review*)

SIGNS OF EMPIRE
Black Audio Film Collective/UK/1983/25 mins
A slide-tape text on nation, race and the colonial encounter. An audio-visual engagement with mythologies around which presence(s) is/are secured: the conglomerate of signs which structure the narratives on national Identity. An investigation of a monumental symbolic order – the geo-political indiscretions which organise contemporary subjectives. A poem on remembrance. (Black Audio Film Collective)

SUNLESS
Chris Marker/France/1982/100 mins
Sunless is a fictional diary constructed from documentary footage from around the world. Images predominantly from Japan intermingle with glimpses of Iceland, Africa and the US, and are accompanied by readings from a series of letters from a traveling cameraman sent to a friend. The narration complements, clarifies and intensifies the images on the screen from the multifaceted and contradictory nature of modern Japan, to a penetrating essay on the locations for *Vertigo*, to the shots of bomber planes and Polaris missiles, or the image of the three children on a road in Iceland. In *Sunless*, the threatened destruction is universal, the obliteration of a planet that will wipe out time and memory as well.

TERRITORIES
Isaac Julien/UK/1984/25 mins
Territories makes moves towards a general semiological reading of black culture, asking not what does 'blackness' mean for white society, but what does 'blackness' mean for black society.

The carnival – specifically the Notting Hill carnival – is one cultural manifestation considered in the tape. How would one conduct a 'history/herstory' of that event; would one begin with the troubles of 1978, the race riots of 1958, or go back to the Caribbean, to Trinidad, or indeed beyond, to Africa?

The street, another territory, governed by race, class and sex, mediated by the glance, the site of a complex play of power relations, images of decaying urban Britain collide in this video with images of the inexhaustible inventiveness of black street culture. (Pat Sweeney, *Independent Video*)

UNSERE AFRIKAREISE
Peter Kubelka/Austria/I966/13 mins
Kubelka was commissioned to document the 'trip to Africa' undertaken by a group of bourgeois Austrian tourists. What he produced has been described by Jonas Mekas as 'the richest, most articulate and most compressed film I have ever seen'.

In this film Kubelka paid close attention to the slightest variations in rhythm within long shots, and he accented them by sound and editing. An example of this would be the African women presumably pounding grain with a giant pestle. With each of her blows there is a synchronous groan. Sometimes he will let her establish a rhythm by making two or three blows without interruption; then he will cut at the very frame in which the pestle hits the block to the static head of a carcass, so that the groan seems to come from the skeleton as if it had been hit on the head by the pestle. (P. Adams Sitney, *Visionary Film*)

Hailed as a classic by the avant-garde, it nevertheless contains many problems by its use of extremely powerful images.

WATERCOLOUR
Joanna Millett/UK/I982/9 mins
A kitchen sink forms the image upon which a series of filmic experiments are conducted. Liquid, colour, surface, sound. Through varying the aperture, separating the colours and superimposing them, a continuously fluctuating process is set up in which the various separations occasionally mix at random to appear 'realistic'. References are made to the old stereotypes but images such as these are transformed (cinematically) so that the association between 'woman' and 'sink' is problematised.

chapter 5 experimental animation

frameless film
nicky hamlyn

Eighty years after photography was invented, Man Ray, the American artist, reinvented it. Although his cameraless photographs, called Rayograms, functioned primarily within the context of the Surrealist movement, they also represent a return to basic principles, to a rediscovery and reappropriation of the medium in question that has obvious parallels with English Structural filmmaking of the 1970s.

In one sense Rayograms are more directly and properly photographs than are those produced through the mediating system of lenses required to make a perspective image; a cunning, not to say labour-saving method, that removes at a stroke the elusive and recondite skills supposedly needed to create a 'Great Photograph': a sense of the moment, of composition and chiaroscuro etc. The Rayogram and its cinematic equivalent the cameraless film (of which Man Ray was also a progenitor) reassert Photography's innate banality and in so doing provide a necessary antidote to the pompous claims to humanity of the Great Photograph.

The cameraless project is at once more modest and more profound, and the rediscovery and reinvention of Cinema is probably nowhere taken up more literally than it is in this work: the painstaking academic/archaeological project of analysis and reconstruction exemplified in the work of Noel Burch, is here sidestepped in favour of a direct and vivacious engagement with the filmic materials themselves. There is a familiar vocabulary of marks and images that characterise the cameraless film: scratched, drawn and painted shapes made directly on the filmstrip; hand tinting, shading and overdrawing on found footage as well as the use of Letratone, xerox imagery and the celebrated wings and petals of Stan Brakhage's film *Mothlight*. There are, however, two distinct subgroups to be identified in this area: those filmmakers such as Tim Cawkwell working on a frame by frame (in-frame) kind of animation, which functions within the established technical parameters of 'animation' that all Cinema does, on the one hand, while on the other a form of cameraless filmmaking where the

image is not contained by the frame but spreads across several frames. As a concomitant of this, the idea of cameralessness is frequently extended to include the projector, whose shutter mechanism is,

MOTHLIGHT Stan Brakhage TEN DRAWINGS Steve Farrer

after all, identical in function to that of the camera.

In this second group, which may be more accurately described as 'Frameless', the role of the projector is not simply to present a series of still frames in rapid succession, but to literally move the film in order to activate it, and in this respect the precise mechanical peculiarities of projection, namely framing and speed, are to some extent unimportant. If a conventional animated film is shown at slow speed, certain marks become visible which are imperceptible at 24fps. However, what we do see is, effectively, a diminished, slowed-down version of the intended film, but if a frameless film is shown in this way we experience a different, though equally valid event, for there is no ideal envisaged projection speed for which the latter is designed as there is for the conventional animation film. The apotheosis of this attitude is the case of Paul Sharits, some of whose work is designed to be shown on a modified projector from which the shutter has been removed.

Many of the English artists who have made frameless films began by presenting film performances in which the projector was the main protagonist. Lis Rhodes, Steve Farrer, Ian Kerr and Rob Gawthrop all showed pieces at the Festival of Expanded Cinema at the ICA in 1976. Rhodes and Kerr worked jointly on an installation consisting of two one-hundred-foot loops of black and clear spacing which, when shown side by side on the gallery wall, gradually deteriorated through the process of projection and contact with the ground and air. Rob Gawthrop showed found footage on a projector which he manipulated during the screening by removing and hand-holding the lens, opening and closing the gate and slipping the film on and off the claw. Of this group, all bar Gawthrop went on to produce frameless films which, as will be seen, developed out of these process-orientated events.

There are numerous historical examples of what might conceivably be classed as cameraless, if not frameless, films. Hans Richter, Tony Conrad, Paul Sharits and Peter Kubelka have all produced a variety of minimalist Cinemas from which the image has been expunged and in which the remaining concerns are light and darkness, duration and rhythm as perceived phenomenon. All these films, however, are conceived in terms of single frames, and because these single frames are invariably imageless, the question of cameralessness ceases to be an issue. How the frame contents were originated is here irrelevant.

In the films of Len Lye, Stan Brakhage, the aforementioned ICA grouping and, more recently, Nick

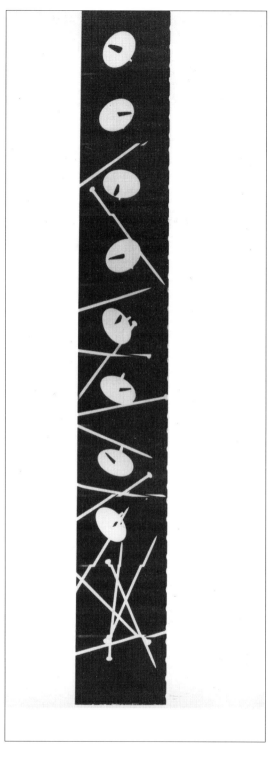

THE RETURN TO REASON Man Ray

POST OFFICE RETOWERED Ian Kerr

LIGHT MUSIC Lis Rhodes

Gordon-Smith, an entirely different conception is operating in which the film is considered as a continuous strip. Artwork is prepared in lengths by a variety of means and spills across not only the frame lines but also the soundtrack area to produce synaesthetic optical sound. Because the resulting (projected) film cannot be so easily predicted the relationship between the artwork and the projection event is frequently a fortuitous and experimental one. This feature of the work distinguishes it both from the abstract film mentioned above and from frame by frame animation. Frame by frame, and especially cel-type, animation already exists as a dormant film; like a stationary train its eventual movements are predictable as, clearly, they need to be. While individual drawings for conventional animation are, in a sense, stills from a film, frameless artwork exists partially as artwork in its own right; indeed in the work I will consider here there can be no such thing as a still frame, except as arbitrarily imposed by the framing act of the projector.[1]

Perhaps the quintessential frameless film remains Stan Brakhage's *Mothlight* (16mm, colour, silent, 4 minutes, USA, 1963). Certainly it exemplifies all the familiar aspects of the genre and even now retains considerable novelty value for the filmmaker's methods of growing mould and sticking moths' wings and dead leaves onto clear film. Brakhage's most recent film to appear in London, *Hellspitflexion* (16mm, colour, silent, 1 minute, USA, 1983) is a rhythmically complex and visually elusive work which mixes (apparently) hand-painted and camera-originated material. The body of the film consists of streams of colour which, although seemingly frameless, actually retain a considerable amount of static form. These

sequences are in turn interspersed with lengths of blue spacing and ambiguous shots of what look like eclipsed light sources. Like much of Brakhage's work, *Hellspitflexion* operates on the dividing line between abstraction and representation, a strategy Brakhage uses to pull representational imagery away from a naturalistic order into a firmly poetic one. What is interesting about his approach in this particular film, though, is that instead of merely attempting to tread that dividing line, he hops continually from one side of it to the other in order to establish and counterpose two subtly different strands of meaning: abstracted representations on the one hand and anthropomorphic abstractions on the other. It is this dialectic, expressed through the concrete rhythm of the film, that drives the work along and creates internal drama.

That (more or less) abstract film of this kind can continue to occupy a filmmaker over such a large number of years is indicative of the inherent richness and potential of an area that is frequently dismissed as redundant or meaningless.

Of the English filmmakers, Lis Rhodes has probably produced more frameless work than anyone else. Although she has introduced elements of biography and representation into her more recent and much more well-known films – *Light Reading* (16mm, B&W, sound, 20 minutes, UK, 1979) and *Pictures on Pink Paper* (16mm, colour, sound, 35 minutes, UK, 1983) – these employ many of the formal devices that were developed in two earlier works – *Light Music* (16mm, B&W, sound, 15 minutes, UK, 1975–77) and *Dresden Dynamo* (16mm, colour, sound, 5 minutes, UK, 1972). *Dresden Dynamo* is the earliest-listed of Rhodes' films and originally came about through an interest in

optical sound. She discovered that a certain grade of Letratone transfer made the note of middle C when applied to the soundtrack area of 16mm film and projected at 24fps. Out of this initial interest in sound Rhodes developed a series of abstract films that explore the relationship between what an image looks like and what, literally, it sounds like.

The imagery was created by applying Letraset and Letratone to clear film. From these originals, negative and positive copies were made which were finally printed through colour filters to create various permutations of two-colour and black-and-colour footage. The use of a regular-patterned image source like Letratone ensures a consistency of registration from frame to frame that is barely possible with hand-drawing which, by contrast, looks jerky and unstable. Compared to hand-drawn work, *Dresden Dynamo* has almost the quality of computer animation, except that there is a depth and texture present that is usually lacking in the latter. The variations in the picture are created by overlaying two or more sheets of Letratone and shifting them in relation to each other to make Moire patterns. As previously mentioned, the sound is generated by the image spreading over the optical soundtrack area and it is left like this in 'level sync', which means that the sound actually comes 26½ frames after the picture when it is projected in the normal way. The strength of *Dresden Dynamo* lies in the fact that it is at once both aggressive and exciting but also measured and lyrical. Although the film is generated from what is, after all, a very mundane source material, the filmmaker succeeds in transforming that material into a work that is never banal or predictable.

Steve Farrer's film *Ten Drawings* (16mm, B&W, sound, 20 minutes, UK, 1976) can be seen as developing out of previous experiments with photographic drawing. At the ICA in 1976, his performance piece took place in red light, forming a darkroom in which he stapled sheets of photographic paper to a large board by means of a staple gun with a small torch attached to it. The sheets were then developed and fixed with spray-on chemicals and finally the lights came on. The image on the paper, like the mark of Zorro, recorded the pattern of movement of the staple gun as it travelled from one corner to another of each sheet in turn.

From here it is a small step to *Ten Drawings* the film, which consists of 'a selection of ten short films. For each film, 50 strips (45cm) of clear film stock were laid side by side to make a rectangle 45cm by 80cm (50 x 16mm). A geometric shape was drawn or sprayed

onto each rectangle … then the strips of acetate were joined together, starting from the top left hand corner (beginning) and joining the bottom of the first to the top of the following and so on until the bottom right hand corner (end) to produce the film. The soundtrack is created by the image carried over into the optical soundtrack area. … The surface marks can manifest themselves in three ways:

a) a drawing (drawing of a film)
b) a film (film of a drawing)
c) a soundtrack (sound of a drawing)'[2]

(*Ten Drawings* also exists as a Rayogram, which Farrer made by slipping sheets of photographic paper under the film strips and exposing them to light before they were joined up to make the film).

As Deke Dusinberre remarks in his article on the film: 'A straightforward description and analysis of Steve Farrer's *Ten Drawings* would make it appear a relentlessly formalist film … but there are other points of interest which contradict the integrity of a formalist analysis. Most immediate is the spontaneity, the ludic (game-playing) quality of the film. … The act of marking/making is inscribed directly onto the celluloid in a bold and direct manner; this enhances the participatory aspect of the film, which entails the recognition and eventual prediction of the pattern of the marks. The success of this tactic lies in the fact that the completion and fulfilment of an anticipated pattern offers as much pleasure as does the occasional surprise.'[3]

In contrast to *Dresden Dynamo*, *Ten Drawings* is a quiet, almost reticent film; even where the drawings are relatively complex, for instance in number five, the image is dark and flowing, the sound desultory and abrupt. Although Farrer's recent return to filmmaking is marked by new concerns of an autobiographical/sexual nature, his work (in multi-screen Super 8 and Tape/Slide) conveys, like that of Rhodes, a continuing interest in process and performance.

The films of Ian Kerr, who studied with Steve Farrer and Lis Rhodes at the North East London Polytechnic, and participated with the latter on a series of performance pieces in the mid-1970s, are distinctly different from those of his contemporaries. Kerr creates strong iconic statements, invariably from found images which are often banal. In *Persisting* (16mm, colour, sound, UK, 1978) an image of the Yangtse bridge is re-filmed with a soundtrack of popular Chinese music and the legend 'persisting in our struggle', while in *Post Office Tower Retowered* (16mm, colour, sound, 7 minutes, UK, 1977–78) the source is a postcard of the eponymous landmark which was cut into verti-

cal, 16mm-wide strips, which were perforated with a splicer and printed onto colour stock. The film exists in a number of versions, with and without sound. In a second form, a variety of different views of the Tower were treated in the way described above, while in a third, two 35mm colour slides of the Tower by day and night were cut into 16mm widths and manipulated by hand at the contact-printing stage (echoing Rob Gawthorp's projection performances). The resulting black and white negative was then reprinted onto positive film with a three-second optical-sound loop.

Because of its particular use of photographic imagery, *Post Office Tower Retowered* raises some interesting paradoxes on the representation of movement and the relationship between movements and objects. In an ordinary tilt shot down a tall building the resulting film would appear, when projected, to recreate the image that was visible through the viewfinder of the camera (which is not at all the same as 'panning' down the building with the naked eye). The filmstrip itself, however, would consist of a series of blurred, overlapping views of that building which would not appear to bear any relation to the projected experience and, depending on the speed of the camera movement, might well be virtually indecipherable. In *Post Office Tower Retowered* the converse is the case. The filmstrip constitutes a kind of paradigmatic tilt shot; every frame is sharp, and the contiguity of any one section of the Tower to its neighbour is exactly reproduced on the film-strip, consisting as it does of an unbroken photograph of the entire building. When projected, however, this sense of contiguity is largely absent and we experience instead a fragmented and fleeting impression of the building.

Of course it may be argued that the particular experience of disjointedness here is merely a product of projection speed, which could be offset by slowing the projector down. Such objections, though, are hypothetical and in any case do not affect the film's problematic which is the discrepancy, and even irreconcilability, between film as static strip and film as projected experience.

Another filmmaker working within the frameless genre is Nick Gordon-Smith, who has employed a complex variety of working methods and source materials in his film *Bird Xerox* (16mm, B&W, sound, 7 minutes, UK, 1983). Small book and magazine illustrations were reduced on a Xerox copier and cut into 16mm wide strips. These strips were treated with turpentine and the softened ink transferred directly onto clear film. The resulting master was then contact printed. Besides the illustrations, the filmmaker also

used a mixture of re-filmed Muybridge photographs of birds in flight, children's transfer sheets and found footage. These were also copied and transferred by the same process before being intercut with the other material. With the magazine pictures a degree of intermittent registration is achieved through the insertion of a bird's head every quarter of a second or so, between the single images that spread over the intervening four or five frames. Thus the bird's head is seen as a regular rhythmical pulse that stands out from the more abstract, flowing body of the film. These sections are in turn contrasted with the Muybridge fragments so that a dynamic relationship is established between in-frame animation (Muybridge, found footage) and frameless movement (the Xeroxed illustrations).

In his current film, *Animals in Heaven*, Nick Gordon-Smith is attempting to gain greater control over pace and registration by pre-registering the images on paper strips which are then reduced in the Xerox copier. The results are transferred, using the turps method, before being re-filmed on an optical printer, the use of which permits finer control of the speed of movement from frame to frame, as well as of the pace and rhythm of the work as a whole. The numerous processes employed here generate a rich variety of textures that are central to the character and the efficacy of the films. Indeed the imagery is often so degenerated by successive reproduction that it becomes virtually abstract, so that the recognition of objects and the criteria by which we distinguish them from purely abstract shapes becomes a central issue in the viewing experience.

There are various observations that can be made regarding the kind of frameless filmmaking that I have considered in this article. Perhaps most significant is the fact that there has been a continuous strand of activity stretching from Man Ray in the 1920s to Nick Gordon-Smith in the 1980s. In that time a number of different preoccupations have come and gone within the avant-garde, but there continues to be a fascination with a form of experimentation that exploits directly the facts of the projection experience. Nor are these experiments of a crudely reductive, tautological nature (films 'about' projectors, sprocket-holes or whatever). In its simplest expression the decision to work outside the recognised technical, aesthetic and economic constraints of Cinema reflects a basic dissatisfaction with the status quo, while in a more developed form one can identify in frameless and cameraless film the elaboration of an aesthetics that frees the filmmaker from the inflexible reproductive

logic of camera/printer/projector. By abandoning the camera it becomes possible to extricate representational imagery (birds, buildings etc) from the banality of normal photo-reproduction so that such imagery can be used for different ends. Furthermore, the moralistic arguments of representation versus abstraction can not only be avoided but superseded, since so much cameraless film softens and calls into question this polarisation.

Whether this work ever develops into a sustained and full-scale genre remains to be seen, but if it does not it will not be because there is an insufficiently large aesthetic territory to be explored. Rather, it will be because of the extremely marginal position to which the work (along with other forms of

avant-garde film) has been effectively confined by the various cultural institutions with a controlling interest in Independent Cinema. This alone is enough to ensure a lack of interest in the work because the consequence of such marginalisation is obscurity, and ultimately, invisibility.

1 At the same time as filmmakers were presenting film performances at the ICA in 1976, a group of Parisian artists, notably Ahmet Kut, took the notion of the film-strip as artwork to its logical conclusion by making unprojectable celluloid sculptures. For a detailed discussion of the differences between live action film frames and animation art-work, see 'Le Defilement: A View in Close-up', by Thierry Kuntzel in *Camera Obscura*, no. 2, 1977.
2 Quoted in 'See Real Images' by Deke Dusinberre, in *Afterimage*, no. 8/9, Spring 1981, p. 99.
3 Deke Dusinberre, *ibid*.

not only animation
vanda carter

The reasons why people adopt particular filmmaking techniques are often overlooked in critical appraisal of work. The relationship between filmmaker and equipment, and with film itself, is one of the foundations on which individual style is developed. It is frequently assumed that purely aesthetic decisions govern filming and editing choices at every stage, whereas all filmmaking practice is pre-formed by the amount of money available, what equipment one has access to and by the practical situation and social context in which one works. 'Aesthetic' decisions are made within these boundaries, struggling constantly to push resources to the very limits, but never escaping these basic constraints.

Pondering the question of why people, and particularly why women, may choose to use rostrum camera and frame-by-frame filmmaking techniques, I am reminded of something Lotte Reiniger, the German silhouette animator, says in Felicity Field's film *The Dancing Silhouettes*. Lotte Reiniger gives her reasons why, in 1917, she began to work with cut-out silhouettes: 'I wanted to make film. You cannot be an eighteen-year-old girl and want to be a film director. But with the little figures, I could do it.'[1]

She has a point. Nearly seventy years later, the situation for women who want to work with moving images is not very much different, is it? While researching this piece, I have watched hours of film which uses, in one way or another, frame by frame filmmaking techniques. It was all made by women working more or less outside the commercial sector.

The range of techniques used in the films is huge; scratching on film, drawing on film, cel animation, cut-out, model, line-drawn and collage animation, frame by frame optical printing, screen printing onto film, under the camera assemblage … to name a few. Something which strikes me is that very few of the filmmakers stick to one style or technique. Visually, the range of styles is so diverse that it seems misleading and redundant to apply a catch-all word like 'animation' to filmmakers working in the independent/experimental sector. The word has come to mean certain types of styles popularised by the well-known commercial studios (the Walt Disney 'style', the computer graphics animation 'style' etc). The only thing most independent work has in common with this is that it is also shot frame by frame. Maybe we should abandon the word. The working methods of experimental you-know-what are so diverse that the word tells you as little about the look or intentions of a film as the phrase 'live action' does about all the rest.

And yet there *is* a difference between live-action filmmaking and rostrum-based filmmaking which it seems worth identifying. I am not sure that you can ever separate technique (working methods and situation) from intention. Going back to equipment and its influence on style, the experiences of working with drawn images and a rostrum camera is totally different from going out to shoot a live-action film. Martine Thoquenne, who uses both in her work, talked to me about this difference: 'When I first started to make films I was working with Super 8. There was no ques-

tion of working with a crew. I had my scrapbooks and objects, using the rostrum camera was right for me then – there was no-one to order around, I could achieve inexpensive effects and I could be very much in control of the result I wanted to see.'

Caroline Leaf, the Canadian filmmaker, also uses techniques of working with carefully controlled spontaneity under the rostrum camera. She too stresses the autonomy of rostrum work: 'I like to control everything within my frame. I like the quiet of animation. … The finished film shows my hesitations and miscalculations and flickers with fingerprints and quick strokes.'[2]

In addition to the minimal production problems of rostrum working, it is also cheap (providing you can get access to a rostrum), and it is possible to work alone. You do not need a car, or lots of money, or a gang of friends and lots of confidence to do it. For women, who rarely find ourselves in this position, this is obviously an important consideration. Martine said: 'I think women do animation so that they don't have to be bossed around. You don't have to compromise yourself. You don't have to feel secure about giving orders. Your intensity does not get broken down.'

For those women who are confronting themes of emotion, unconscious feeling or sexuality in their work, drawing on their own contradictions and feelings, seeking an adequate filmic language for self-expression, the need to be organised, controlled and diplomatic in a live-action shooting situation may work directly against this need for precise, uncompromising, emotional honesty. Some people just prefer to work at their own pace, or with privacy, to use a rostrum table-top as a fine artist uses a canvas with the added dimension of movement. Lotte Reiniger acknowledges this similarity to fine art method: 'The benefit is that you can work all by yourself. You don't have to divide the work between so and so many artists. You can really work like an artist paints pictures.'[3]

What all these women have stressed, speaking about their working methods, is the importance of having freedom to create images without compromise or intervention. For women, the outside world is always, to some extent, a foreign country. The streets are dangerous, the architecture is male, the culture, styles and symbolism of things have generally been made by men. It is a foreign world reflecting a foreign consciousness. We live in it and (try to) work in it, but our relationship to this world is inevitably different. Vera Neubauer told me that she sees herself as working against male tradition rather than outside it. The images in her two films *Animation for Live Action* and

FASTER PRINCESS Martine Thoquenne

The Decision are drawn from the daily lives of women, men and children, intertwined with the stories we tell each other and ourselves about our lives. The viewpoint is that of a woman reinterpreting and recreating this daily 'reality' into stories of her own. Scratch animation on a kissing couple from an old Hollywood movie transforms the hero into a crocodile. A mother tells her child a story in *The Decision* about a princess who could not choose between six princes. The princess realises that really they allow her no choice at all. And the child says: 'Mum, what happened to the princess?' The mother says: 'Never mind. Go and play. I've work to do.' A happy ending would be dishonest.

The entire recorded history of creative representation has been used against women, to objectify us, classify us and impose male emotional responses on images of our selves. Not least in the ninety-year-old tradition of film in which every new 'movement' has found new ways of objectifying women and telling us preposterous stories about how we should and should not behave. As a direct result of this, I think, most women do have a keen distrust of all techniques of filmmaking, all ways of viewing and interpreting the seen image. We know from experience that there is more to seeing than meets the eye. The eye is selective. All filming, processing, printing and editing techniques are selective. It is perhaps not surprising, therefore, that many women filmmakers these days use a wide variety of techniques in their work, deliberately not remaining faithful to one style or system. Martine Thoquenne confirms this: 'I am doing animation mixed with live action because I like to work with contradictions. I like to make comparisons. I don't necessarily believe in using only one technique. Animation is, in a way, the most magical thing you

can do, but it is not less "real" than live-action foot-age.'

In her own film *Faster Princess*, a mixture of live action, cut-out and pop-up book animation, the mixture of visual styles is vital to undermine the dividing line between fantasy and reality. A girl gets dressed up for a ball, but the dress has a front and no back, her life and her romantic fantasies come into conflict and she herself moves in and out of a children's fairy-tale book. Martine describes the process of making film, pointing out that the relationship between the filmmaker and her film is not one way: 'Of course, I really would not say that women use the rostrum because they can't cope with direction and all it involves. But sometimes it can be a good way for a woman to start to work with film. You do not have to compromise yourself and your ideas.'

The use of mixed techniques is, in itself, a characteristic of the style of both Vera Neubauer and Martine Thoquenne. As soon as a filmic 'reality' is suggested, it is undermined by a change of style without a change of subject. And the undermining and juxtaposing goes on, pointing out, among other things, the naive-ty (and boringness) of searching for one narrative, one coherent interpretation among all the alternative realities. To take an example from Vera Neubauer's film *The Decision*, a cute, line-drawn baby's bottom, wriggles in the frame. Animated babies are so sweet. Then, unexpectedly, it dumps a pile of animated shit. Yuk. But a little later, all the strength of this unusual

animated image is diluted by the juxtaposition of a real live, live-action shit-encrusted baby's bum, making the drawn one seem too sanitary to be true. But then, babies' bottoms are sweet. It just depends how you look at them…

Animation methods have always lent themselves to the creation of alternative realities, to postulating bizarre worlds full of rich contradictions. The laws of cause and effect, gravity, size, behaviour, need not apply. Many women in the past, known as experimental filmmakers rather than for animation, have used sequences of animation in their work, precisely – it seems to me – to broaden out the range of possible meanings or interpretations of their work: Storm de Hirsch, Chick Strand, Marie Menken, Margaret Tait, to name-drop a few. Maybe sometimes the outside world is inadequate to provide us with images. Until women have more influence on how it looks and functions this may be so. Maybe, when the outside world gets too boring or too expensive, more women should try running for the nearest rostrum camera. With rostrum filmmaking you can remake the world, or, for a while, abandon it altogether.

With thanks to Vera Neubauer and Martine Thoquenne for sharing their thoughts with me.

1 Lotte Reiniger, speaking in *The Dancing Silhouettes* by Felicity Field.
2 From *Experimental Animation* by D. R. Russett and C. Starr. New York: Van Nostrand, 1976.
3 Lotte Reiniger, op. cit.

interview with vera neubauer
claire barwell

The Decision. The decision? Is the problem to be deci-sive or to have to choose? Vera Neubauer has created her own highly idiosyncratic style of filmmaking in which such ambiguities are constantly held in play. A style which bursts upon the screen in a riot of images and a dazzling array of techniques. Nothing is sacred: everything is potential material. From psychoanalysis, aesthetics and obstetrics to housework, children's games, munitions factories and pinball machines, images which hold the screen for an instant are woven into a rich critique of production-line society.

Born in Czechoslovakia, Vera Neubauer has lived in England since 1968. From making animated shorts for children's television both in Germany and Britain, she now teaches part-time and has produced two of her own films for the BFI Production Board. *Animation*

For Live Action, completed in 1978, is many-layered like a paper fortune-teller. Contained within the inverted commas of a sinister male voice claiming to be the author(ity) of a film about his ex-wife, she, as filmmaker, shows her own duality as subject, creator and object of her creation. The animated heroine per-secutes the animator who in turn contemplates the destruction of her creation. Not afraid to confront the painful, the film embraces both the everyday of work and housework and the hopes and fears of 'where-does-it-all-begin' and 'what-if'. Themes of filmmaking as process and 'women's lot' run through both her films and in *The Decision* (1981), told as a comforting fairytale heard on the radio, fantasy and reality are fused into a complex whole. 'Any princess', wooed by many suitors, says 'Yes' to all of them, but rows of nap-

pies on the line, a drunken husband walking through his wife and the mesmerising spinning of the washing machine interrupt the fantasies of dancing and lovemaking, etched on a black screen in vivid primary colours.

An infectious delight in moving images is shown in the use of found-footage from old movies (a 1930s Hollywood lover, male, turns into a green dragon breathing fire), old zoetropes beating a rhythm in light, and giant shadows of film racing through an editing machine.

The narrative is sometimes drowned in the abundance of powerful images, boldly cut together with breathtaking speed, but both films win through with a sharp, wry humour and a highly original use of the medium.

Claire Barwell: Both of your films show a fascination with the mechanics of filmmaking. What was it that first made you want to make films?

Vera Neubauer: I used to make collages and it always seemed a waste to decide on one position which had to be glued down when there were hundreds of different possibilities. It was a natural progression to moving images, besides, I always like to work in sequences.

CB: When did you make your first film?

VN: Oh a long time ago, at art school. 8mm – it was quite fun. It was very fast so that most of the things were lost. All the work that went into it just vanished. I had to put the tripod on a table and have the camera almost on the ceiling. I had to climb on the table, press the button, climb down, move it again … I was trying to get anybody, you know, any friend who was available to 'click' when I wanted! After the weekend I was aching all over!

CB: But you had made a film!

VN: I'd made something, yes. Some of it wasn't there unfortunately. There were some great things in it – clocks and smoking cigarettes but when you looked you couldn't see them!

CB: What part of filmmaking do you enjoy most now?

VN: I love all the processes – I like to be involved in all of them. In making up the story, designing, drawing. I quite like animating under the rostrum camera, but on the last film I had that done outside which was actually very nice. You can afford to look at it, to say you like it or you don't – you haven't been stuck with it all those days in that dark room, you have a distance from it. When you do it yourself you have to learn to like it – you progress from the tears to learning to live

with it.

CB: So it's much easier to be a director, to have that distance from the physical process?

VN: Well, let's say it's inevitable. A one-person production limits what you can do, though it does make you invent simpler ways of working.

CB: When you embark on a film project do you start from a narrative idea, an argument you want to develop, a strong image or…?

VN: It's like asking which language you think in – according to the circumstance. I work with bits and pieces, sometimes it's a piece of paper, and the tool you work with suggests something, other times you think of the best visual way to express a certain idea. It's like trying to invent a fresh way of seeing and communicating – a new language. Animation for me is a different way of thinking. There are so many possibilities: the real, the impossible, the exaggerated, the absence of things – and all of that you bring into the cinema with you. The way you put it together – that's what it is.

CB: Your films defy conventional labels – does that worry you? Or are there film practices with which you identify?

VN: I like the first animators of the time when people were still amazed by what film can do. When they still used cinema for what it was – magic, a miracle, when film could do all the things that live theatre or literature could not, before they started to pretend that film was life, before animation became just a style.

CB: Which are the animators then that you most admire?

VN: Emil Cohl, Max Fleischer – but Robert Breer I like very much. He does these fantastic films – they're so fast. If you put them on a Steenbeck and run them in slow motion you can see the divorce he went through, his whole life story, condensed in a couple of frames.

CB: You don't use one style of animation, or one technique, but a mixture – how did that come about?

VN: I like to help myself to anything that comes along, that is cheap and quick! Animation is such a lengthy process that you have to find a way of working whereby the film is still relevant to you by the time you finish it. There are things that are so much quicker and clearer said with drawing, and other things that drawing can never express, or that would be too tedious to draw – so why not use live action?

CB: So definitions and distinctions in filmmaking annoy you?

VN: Yes. Film is a piece of celluloid put through a

FRAMES Vera Neubauer

projector. How one arrives at the imagery is irrelevant (I'm not talking here about politics in flimmaking!). Whether the film went through a camera or not is not important, or whether you scratch it or stick butter-flies on it. What matters are the relationships between different images and sounds and the meanings they produce. I like a mixture, the border in between – like the border between countries – the ambiguity in film of not knowing where you are, whether you are asleep or awake, whether you are imagining or wit-nessing the event.

CB: Thinking of the borders between countries – do you feel involved in the current debate about British cinema?

VN: In the current economic and cultural crisis I understand the concern of my English friends to create a British cinema with its specific cultural back-ground that is identifiable as such rather than being influenced by, let's say, Hollywood. Yet nationalism as such worries me very much. I sense the danger of walking the tightrope between talking about national identify and becoming chauvinistic. In fact, I like to make visual films that do not rely on the spoken word so they can be understood anywhere.

CB: In *Animation For Live Action* you appear as the central figure – is it an autobiographical film?

VN: Most people who create, whether they write or act or paint or whatever, exploit their personal experiences. I don't know whether I am the central character. I have used my figure – it was there when I needed it and it was more economical. It was a mix-ture of fiction and autobiography.

CB: Do you want to say which parts were autobio-graphical?

VN: I don't know. I mean, if you see what happens next door it's still your experience if you've witnessed it.

CB: Children and the world of children play an important part in your films. Has having children affected your work?

VN: Having children and working at the same time needs more self-imposed discipline. One has to learn to use every minute of one's time. On the other hand it possibly made me more determined. You may be judged by your own children one day and it may just be the most important judgment. It makes me think that somehow you do it for them as well.

CB: Many of the same preoccupations appear in both your films. Are these themes that you feel will always be with you?

VN: Yes. Some of them fascinate me, like the aspect of filmmaking whereby one can manipulate the mate-rial at every stage of the production. I like to incor-

porate that into my narrative for two reasons. Firstly, filmmaking is my job, I have been trained to express myself. It is a job that I do next to coping with children, housework and the rest of it, just like all working mothers. I would like the film to be understood as a generalisation of a woman coping with her life and the everyday, dealing with her situation and understanding it through her work.

CB: Is this the character from *Animation For Live Action*?

VN: It is both films in a way. Though I have cut a hell of a lot of that out of *The Decision*. The witch was supposed to be the filmmaker. There is a shot of film passing through hands when she makes her magic. And as the witch is flying you see things boiling and film being handled. I've cut a lot of it out, but it was there – I had her making the movie.

CB: And your second reason for the theme of filmmaking?

VN: I like, as I said before, to juxtapose the reality and the fantasy. There's a distancing of this reality so as to achieve an awareness in the audience of the manipulatory process happening on the screen. This relates to how ideas of ourselves are formed artificially, but for the most part we are unaware of it. It is an interesting and difficult subject that I find important to come back to.

CB: And why do images of children recur so frequently in your films?

VN: I use images of children for different reasons. I have children, they are there when I work, they interfere and influence. They are also a constant reminder of one's own childhood and the circle of life. Just as the witch in *The Decision* represents the future of every princess, a child is the past of every old person. I also like the juxtaposition of the beautiful advert baby with the one who also shits and pukes and cries.

CB: In *The Decision* there is a scene where the baby's shit knocks over the mother – was this a cry for help from a beleaguered Mum?

VN: That particular one is a metaphor. The shit is a metaphor for the children not needing their parents in the end. The parents' dependence on their children being much greater than the children's on them. The parents give themselves completely to their children and the children grow up and push their parents away. I don't think anybody understood that. People take it more literally.

CB: *The Decision* is presented as a fairy story – was there one in particular that inspired you?

VN: No, I used a prototype, a story with a little twist. My princess, instead of saying 'No' to all her suitors, says 'Yes' and loves them all.

CB: Why the fairytale format?

VN: Fairytales have been passed on from generation to generation, made simple for children to understand, yet their symbolism is complex. They are forming the child into the role it is expected to fulfil as an adult. This is why I use the fairytale to represent history, upbringing and expectation.

CB: Do you have an audience in mind when you make your films?

VN: While I'm making a film I try not to think of an audience. If I did I would be inhibited.

CB: And once they're made?

VN: I would like them to be seen by women and by men. Maybe more by men, they would act as 'eyewashes' for them. Women may find them more familiar but I hope there would still be enough there to make them think and ask questions. I would like my audience to be much wider than it is but there is a problem with distribution in this country at the moment and this in turn makes the financing of animated and short films almost nonexistent. It is a vicious circle. My films have not really been shown very much except in art houses where you get a middle-class audience that congratulates you and says thank you very much for the experience.

CB: Looking back, which part of your film(s) do you still like the best?

VN: I like the beginning of *The Decision*. The little piece every projectionist cuts off or projects against the curtain, the piece everybody turns up too late to see. It's the title that says 'That is where everything begins' followed by a close shot of the backside of a newborn female baby. When I got the rushes back and projected them in the viewing theatre I could hear the reactions of the male projectionists. They were disgusted and angry – so I knew it was good! These men must see hard-core porn films by the dozen yet they could not take the mess of a newborn baby – something a mother has to deal with twenty times a day!

CB: Do you see yourself as a feminist filmmaker? Is feminism relevant to your work?

VN: How can feminism not be relevant to any work today, or life for that matter? Even those who work completely against it are still influenced by it.

CB: So what projects have you got up your sleeve now?

VN: The less money there is to go round the more projects I collect in my drawer and the more irrelevant it becomes to talk about them. I would like to make a live-action movie.

locating mclaren
david curtis

Perhaps surprisingly Norman McLaren has suc-
ceeded, as few other filmmakers have, in polaris-
ing his critics; some envelope him in a blanket of
unqualified approval, others totally dismiss him.
Most authors of histories of animation see McLaren
as the supreme exponent of the 'experimental' car-
toon – a figure perhaps not to be emulated but to
be admired from a distance; an artistic 'genius' privi-
leged to inhabit a world removed from commercial
pressure. Authors discussing the avant-garde film
– the area in which such artists usually reside – rarely
give McLaren a mention. His work is too orthodox,
too compromised, or evades too many questions.
But these reactions are themselves an evasion of
the difficult problem of locating McLaren's position.
Is he an avant-garde animator like Len Lye, Harry
Smith or Robert Breer, or does he belong more prop-
erly in the commercial artistic camp with Walerian
Borowczyk, Jiri Trnka or perhaps his 'pupil' George
Dunning, or is he some form of exceptional cross-
breed like Alexandre Alexeieff, Yogi Kuri or Peter and
Joan Foldes? This article does not claim to answer
any of these questions, but by discussing McLaren's
films with these questions in mind, it may at least
establish some links and cross-references of use to
others researching this field.

The biographical details sketched out in the
accompanying interview reveal surprisingly little
about McLaren's own view of his work, his aesthetic
preoccupations or his achievements as an anima-
tor. He talks several times about his sympathy for
the art of choreography and his frustrated ambi-
tion to be a dancer. He says of his American work,
'My ambition in 1940 was to make abstract films
to interpret the spirit of music. Many of my films
were born of an enthusiasm for some scrap of
melody.' Put these together and one can deduce
that he recognises that the impulse behind his
dancing shapes on screen is anthropomorphic
rather than abstract or concrete. Discussing his
student work he is consistently reticent about his
own first drawn-on-film experiments constantly
deferring to Len Lye's priority in that area (a priority
his filmography would seem quite clearly to deny).
He talks about a limited interest in Surrealism and
the important influence of specific films like Oskar
Fischinger's *Study No. 7 (Brahms' Hungarian Dance)*
and Alexeieff's *Night on a Bare Mountain* – both sig-

STUDY NO. 6 Oscar Fishinger

nificantly synaesthetic works with distinctly balletic
features. These, plus Emile Cohl, Charlie Chaplin,
early Walt Disney, and unspecified 'abstract works'
he saw at the Guggenheim in 1939/40 (probably
by Fischinger since Fischinger was patronised by
Baroness Rebay of the Guggenheim, at that time),
are the only influences or heroes McLaren admits
to during the interview; no other abstract filmmak-
er living or dead is even mentioned. One develops
the image of a man who isolates himself from those
who one might have expected to be his closest
colleagues (Harry Smith, Robert Breer, the Whitney
brothers etc).

His relationship with Len Lye is a case in point.
For two men who independently invented the
idea of animating directly on the film's surface
to encounter each other so early in their careers
must surely have been exhilarating, or traumatic
(or perhaps both). Yet beyond deference McLaren
offers us nothing. Nowhere (that I am aware of)
has he ever attempted to analyse the similarities
or differences between their positions. (When

RAINBOW DANCE Len Lye

discussing *Fiddle-de-dee* in the interview he acknowledges it as being 'much influenced by Lye' – but leaves it at that.) Nor has he ever related his own position to that of Fischinger or Alexeieff; he seems determinedly aloof even from his acknowledged heroes.

And perhaps this illuminates the problem critics have with McLaren; his island is so secure that one is wary of making speculations on his behalf. Eulogies and evasions provide an easier answer.

Paradoxically, McLaren's first live-action shorts at the Glasgow School of Art show him being extremely eclectic. The montage of ideas and techniques in *7 – 5* (1933) and *Camera Makes Whoopee* (1935–36) is extremely inventive and influenced in no small measure by the Russian films he saw at the Film Society (as McLaren is the first to admit). *Hell Unlimited* (1935) boldly equates the interwar call to re-arm with capitalist interests in Europe (naming companies without equivocation); but retrospect forces one to ascribe this stand to student radicalism – what survives in the later work being a preoccupation with technique and its innovation and the kind of non-political pacifism which motivated films like *Neighbours* (1952).

But if McLaren withdrew from the idea of being a radical in the commercial film world (where Dziga Vertov or later Jean-Luc Godard might have been his models), he remained radical at least in his determination not to become a conventional animator. Not once, even when he had little control over his subject matter, did he make a conventionally cel-animated film. Even his works for John Grierson in London like *Book Bargain* (1937) and *The Obedient Flame* (1939) manage to circumvent the obvious to that extent. His standard response to such commis-

sions is identical with that of Alexeieff, who spent a lifetime dealing with equally daunting material: 'invent something ingenious'. This was an axiom adhered to by many European animators of the interwar period, uniting McLaren and Alexeieff with Lye, George Pal, Fischinger and even Hans Richter. Consequently a film like *Mony a Pickle* (1938 – for the GPO) is seen as a challenge to turn what could have been a static film about thrift in household furnishing into a tour-de-force of cavorting animated photos.

It is much to Grierson's credit that McLaren and Lye were encouraged to be inventive in this way, though it is worth remembering that private industry in the late 1930s was more prepared to patronise 'experimental' work than it is now. But unlike Lye, who could make a film like *Colour Box* (1935) – perhaps the most radical avant-garde film of the 1930s – for the GPO, McLaren kept most of his more far-reaching experiments to himself – the unrealised sound-drawings of 1937, the real-time *Colour Cocktail* (1935) and his first completely abstract paint-on-film experiments of 1933. But many of these ideas he would return to and develop in later years at the National Film Board in Canada.

Of McLaren's released films, only *Love on the Wing* (1938 – for the GPO), his first essay in 'direct' (on the film's surface) figurative drawing, really breaks new ground. The concept implicit in this particular procedure, which he developed in *V for Victory* (1941), *Hen Hop* (1942), *Dollar Dance* (1943) etc, stands as McLaren's most distinctive contribution to the art of animation. Though it shares a great deal with Lye's contemporary development of the 'direct' method, the two concepts are poles apart in purpose and implication and one cannot help wondering if there was not a degree of conscious decision behind their divergence – to circumvent the awkwardness of direct competition.

Lye's painting and stencilling of the film's surface is entirely abstract (apart from the GPO's slogans – which would be equated with the stencilled lettering in Cubist Braque or Picasso), all the elements confirming the flatness of the 'picture plane'. McLaren's drawings imply 'real' space (though like most figurative animation they also tend to operate parallel to the picture plane for ease of animation), scale, proportion and even the specifics of movement are there to be read as relating to the 'real' world. What the artists share is a fascination with the irregular vibration of lines and surfaces 'directly' drawn and painted frame by frame; an exaggera-

tion of the 'boiling' (as it is known in the trade) implicit in all frame-by-frame work, but strenuously suppressed by commercial animators from Winsor McCay onwards. Lye and McLaren recognised 'boiling' as unique and essential to animation, and their enthusiasm has been shared by many artist filmmakers since (notably by Breer and Smith), and more recently by independent commercial animators like Dunning, Dick Williams and Bob Godfrey. The boiling line and the connected idea of the line continuously involved in changes of shape link directly with one of the animators he mentions, the pioneer Emile Cohl. The 'surreal' (McLaren's label) metamorphosis of one subject into another in *Love on the Wing* recalls the 'fantasmagoria' of Cohl's film of that title (and of *Drama among the Puppets*), and it embodies a concept close to the root definition of animation. It is an idea that is recognisably a motivating force in early Disney and Fleischer brothers, and in the work of avant-garde animators like Smith and Breer (and even, stretching a point, in the computer animation of John Whitney and Peter Foldes).

McLaren states that it was necessity that caused his return to the idea of directly-drawn sound with the films *Dots and Loops* of 1939–40. After six months in New York he no longer could afford access to sound transfer equipment, so he drew his own soundtracks. Though one cannot claim hand-drawn sound as a McLaren invention (he himself probably saw Hans Pfenniger's and Laszlo Moholy-Nagy's experiments at the Film Society, and may have heard of Fischinger's), McLaren is rightly recognised as the man who made this concept concrete – more than just an experiment. But with *Dots and Loops* one is forced to confront another aspect of McLaren's work – his rejection of the concern for the integrity of process and material that one associates with 'modernism' in art, McLaren's position remaining equivocal or whimsical at best. Most previous attempts by avant-garde filmmakers to make sounds visible or sights heard assumed a 1:1 relationship between sight and sound; the sound image (for the optical track) was synonymous with the picture image; both roles being taken into account in its composition, with no preconceptions about required musical form. McLaren's sound, composed two feet at a time in parallel with the picture, betrays an adherence to the shape of classical music but, more importantly, hides its synthetic origins, the dots and loops of the picture track (or more accurately the mutating heart-shapes, butterflies, asterisks, bows, figures-of-eight and all

the paraphernalia that one becomes so familiar with in McLaren) remain resolutely the primary focus of the film. McLaren offers a correspondence between image and sound, but does not reveal its exact relationship; he is still committed to seeing sound as a subsidiary reinforcement much as it is in Disney.

McLaren's films during the 1940s continued to explore the nature of image/sound 'equivalents' but increasingly moved into the more traditional area of animating to existing musical recordings, as with both *Stars and Stripes* (1939) and *Boogie Doodle* (1940). The precedents in this area were all well known to McLaren: Fischinger's *Studies* series (including his own favourite *No. 7*), Lye's *Colour Box* and *Trade Tattoo*, and of course in the commercial field, the cartoons of Disney and Fleischer, which were often tightly constructed round the rhythms and melodic lines of popular recordings. Fischinger was by far the most literal of these in his response to the interpretation of music – ordering his conventionally animated white lines into crescents, scroll-shapes, star-bursts and so on in superbly controlled and inventive movements, in a successful attempt at synaesthesia. Lye, on the other hand, was so intoxicated by his image-surface that music appears somewhat secondary to the image – but musical phrasing is frequently marked by colour changes or some similar notation, and even in his work some graphic motifs are drawn directly from the sound – a jagged line following the clarinet part and screened dots a drum roll in *Colour Box* for example. McLaren's position seems to be somewhere between these two, though increasingly his 'direct' films at the NFBC move in Fischinger's direction, culminating in his most complex stab at synaesthesia – *Begone Dull Care* (1949).

Boogie Doodle McLaren describes as a 'total improvisation', but as in *Colour Box* the film is organised round the notation used to mark each musical phrase, in this case a line wiping across the screen. Commenting on the similar construction of *Fiddle-de-dee* (1947) he says 'for each section of music I feel I ought to make some change. When the following musical phrase begins, something in the line or colour should be different'. McLaren sees *Fiddle-de-dee* as his most Lye-like film since it represents a break with his usual frame by frame method of drawing and an adoption of Lye's practice of making marks along the length of the film strip, ignoring the (invisible) frame lines. But, if anything, the technical similarities once again tend to emphasise the differ-

ence in approach between the two artists. In both one is aware that the images are hand-made, but Lye emphatically draws one's attention to the origins of his marks in the interaction of paint, stencil and film celluloid. He admits no other meaning. For McLaren it is the correspondence of drawn line with the linear fiddle tune which matters – not the nature of the brush that made it.

Both *Boogie Doodle* and *Fiddle-de-dee* were 'straight-ahead' animated in parallel with the music – McLaren starting at the beginning with the first bar and drawing in sequence until he reached the last – and this was the procedure on most of the 'direct' animated films of the 1940s. But with *Begone Dull Care* the scale of the work – its length, division into movements and even subdivisions within movements – required a greater degree of organisation, and McLaren ended up drawing five or six versions of each musical phrase before selecting the most appropriate for inclusion. As a consequence *Begone Dull Care* has a clearer shape and structure than most of the works preceding it, and a precision in its relationship with the music (a piece specially composed by Oscar Peterson) unusual in his work. His choice of motifs is similarly more consciously (if not consistently) synaesthetic – the film containing moments of quite Fischinger-like analogy between image and sound (the scratched lines in the slow movement, for example, mimicking the plucked bass chords they accompany).

During the second half of the 1940s, McLaren worked on a parallel series of closely interrelated films developing ideas incompatible with 'direct' animation. The first of these, *C'est l'aviron* (1944), creates the striking illusion of being in a small boat drifting mysteriously through a dark, apparently endless, seascape, dotted with small islands. It is, in other words, an exploration of the dynamics of movement into deep space, an experience entirely unlike anything encountered in the 'direct' works. But here again McLaren connects with the 'shared language' of animation – the dynamics of movement into (or out of) deep space being frequently exploited by (early) Disney and Fleischer, in shots which have no other purpose than to generate pleasure through a visual sensation. (The pleasure, for example, of seeing a street and its contents endlessly hurling towards the spectator while a hero-creature runs vainly in an attempt to penetrate the elusive central vanishing point). McLaren's interest in illusions of depth, demonstrated in *C'est l'aviron*, was extremely short-lived, in

SYNCHRONICITY Norman McLaren

fact his oeuvre as a whole shows remarkably little interest in spatial exploration. But the technique of overlapping dissolves invented for this film suggested another application which he developed in the series *Là-haut sur ces montagnes* (1945), *A Little Phantasy* (1946), *La poulette grise* (1947) and *A Phantasy* (1948–52). In these works his system of dissolves establishes a permanent state of unearthly transformation, the means of change remaining deliberately hidden from the spectator. As fantasmagoria, these works extend the 'surreal' principle of McLaren's own figurative 'direct' work (*Hen Hop* etc), but the focus on making visible the states between images suggests parallels with the work of one of McLaren's first heroes, Alexandre Alexeieff. Alexeieff, with his partner Claire Parker, developed in his pin-screen a device that uniquely forces the viewer to recognise the material continuum that lies behind all change – the pins of his screen are present as a constant element throughout the film – oblivious of or indifferent to the illusions that pass over their surface. In the first pin-screen work, *A Night on the Bare Mountain* (1934), this paradox is only occasionally exploited, Alexeieff's major concern being with fantasmagoria and the projection of figures and movements into space, but in the second work, the brief *En Passant*

(1943), the visualization of a prolonged moment of change supplants the realisation of movement as the *raison d'être* of the film.

To McLaren, the chosen medium of transformation is pastel crayon; to Alexeieff, light and shade falling on a field of a million or more pins – but both celebrate (and mystify) the invisible hand of the animator that magically effects these changes. Significantly Alexeieff made *En passant* for inclusion in the NFBC's *Chants populaires* series (to which McLaren contributed *C'est l'aviron* and *La poulette grise*) and one suspects that McLaren had a hand in persuading Grierson to invite Alexeieff and Parker to Canada. Certainly the meeting proved fertile for McLaren, but one can also speculate that the influence worked both ways, Alexeieff's third independent work on the pin-screen, *Le nez*, being structured round a rocking movement remarkably like that of the boat's prow in *C'est l'aviron*.

The careful attention paid to organisation and construction in *Begone Dull Care* marks the end of McLaren's faith in 'total improvisation' as a strategy in 'direct' filmmaking. His subsequent films in this area (*Blinkety Blank* (1954), *Serenal* (1959), *Lines Vertical* (1960) etc) each focus on one specific form of 'direct' technique and explore the potential within it. It is noticeable that increasingly during the 1950s and 1960s McLaren's films appear to regard technique as something to be defined precisely, and exploited just once – it seeming important that each film be regarded as a unique invention.

Blinkety Blank, McLaren rather jokingly suggests, was conceived in reaction to his extensive work on clear film – 'I wondered if I could do the opposite – engrave on black'. He similarly belittles the film's formal nexus – its exploitation of the single frame image ('blink') – attributing this simply to the impossibility of using his normal tracing method when working with opaque film. At McLaren's instigation, the soundtrack of the film (composed before the image) was itself the result of what he calls 'directed improvisation' – the composer Maurice Blackburn nominating interval and register but allowing the musicians to choose their own notes (McLaren adding some hand-drawn 'percussion' to the final film). Significantly no equivalent improvisation took place in the structuring of the image. McLaren adhered to his usual pattern of strict synchrony with the sound, and the film's visual originality is limited to its scratching technique and the 'blank' and silent 4–10 frame intervals that separated single images and explosive image clusters. Not unexpectedly the

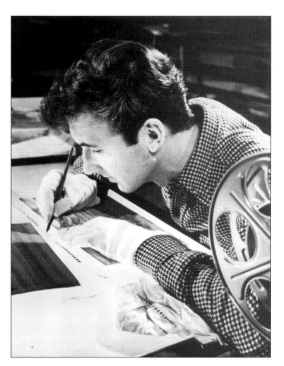

MCLAREN AT WORK

images contain the 'surreal' mutations McLaren is so fond of, with a rudimentary story of two birds in conflict. McLaren rather apologetically explains, 'I wanted at first to make an abstract film but having completed two-thirds, considered I wouldn't be able to hold the spectator's attention. So I returned to birds and other figurative elements.' This orthodoxy undermines McLaren's recognition of the legibility and iconographic strength of the single frame. His unwillingness to allow the 'blink' to free itself from narrative association denies it the reflexive relationship with the viewer associated with the avant-garde and modernism. It remains a pleasing technical novelty. In this instance the challenge of the single frame was quickly recognised by other filmmakers; Robert Breer's *Recreation* (1956) being the first in a whole series of films he made exploring the juxtaposition of opposed single frame images; Peter Kubelka's *Arnulf Rainer* (1958–60), some Fluxus films of the 1960s, Malcolm Le Grice's *Spot the Microdot* (1970) and the major part of Paul Sharits' oeuvre all elaborating upon this theme.

A similar criticism can be levelled at *Serenal* and its subsidiary *Short and Suite* (both 1959), the two works in which McLaren makes his final synthesis of ideas about 'direct' expressive engraving on (clear)

film. The technique is one McLaren had used inter-mittently, but never exclusively, since the late 1940s. But the idea of making it the sole focus of a film was prompted, one suspects, by his exposure to a modernist treatment of precisely the same concept. In this case the modernist artist was none other than his old colleague Len Lye, who returned to abstract filmmaking in 1957 with a film composed entirely of scratched gestures on (black) film – *Free Radicals*. McLaren in fact was instrumental in awarding Lye's film the 2nd Grand Prix at the Knokke-le-Zoute fes-tival of 1958, his co-jurors including the remarkable line up of Grierson, Alexeieff, Edgar Varese and Man Ray! Once again a pre-recorded soundtrack and the 'surreal' narrative elements in *Serenal* place severe restrictions on its expressive energy, a fact that McLaren may have appreciated since he relegates it (in the interview) to the position of 'minor work'.

And this is perhaps the point in the chronology to stop and ask how much the pressure to be end-lessly productive at the NFBC might have contrib-uted to the lack of formal rigour in McLaren's work? With the exception of *Neighbours* (1952) – which is unquestionably a sincere attempt at social interven-tion through allegory – the pixilated works, *Two Bagatelles* (1952), *A Chairy Tale* (1957) and *Opening Speech* (1960) seem precisely the kind of virtuoso, humorous but ultimately rather empty inventions that one might make in response to a feeling of obligation to work; the benign nature of the organi-sation to which one is obligated being somewhat immaterial.

In *Rythmetic* (1956) the invention involves pixil-lation of paper cut-outs rather than people, but interestingly with this film McLaren finally abandons 'interpretation of music' and establishes his film structure first, its mathematical form being derived from the didactic mathematical subject of the film. The numerical figures in *Rythmetic* are still treated anthropomorphically – they react to type-casting and their treatment in equations – and McLaren's subsequent development of this form of animation – *Le Merle* (1958) – takes a further backwards turn to 'surreal' metamorphosis. But the mathematical base of *Rythmetic* would appear to have inspired the most interesting group of films McLaren has made in recent years: the series *Lines Vertical* (1960), *Lines Horizontal* (1962) and *Mosaic* (1965), and the related works *Canon* (1964) and *Synchromy* (1971). Here at last McLaren allows his initial ideas about graphic form, process and materials to determine the struc-ture and appearance of the films – each one in the related series suggesting the form of its successor. Speaking of the genesis of *Lines Vertical* McLaren recalls 'Evelyn Lambart and I (she was his frequent collaborator) thought it should be possible to make a film with just one vertical line moving about alter-nately fast and slow', and later adds, 'one of the main advantages of abstract films is that one is able to stir up the spectator's emotions … the displacement of a single line can be marvellous'. He is clearly talking about a film equivalent of Abstract Expressionism, the breakthrough for McLaren being that he now recognises the line's ability to carry this expressive meaning on its own – it is no longer the dependent child of music.

The dynamics of *Lines Vertical* are entirely derived from this expressive line – through multiplica-tion, changes in direction and organisation in time – these elements, like the soundtrack, being math-ematically structured round the basic unit of a mea-sure of 19 inches – the length of Evelyn Lambart's ruler. By leaving this structure visible (despite the synaesthetic disguise of the post-synchronic sound that McLaren, being McLaren, felt obliged to add), McLaren comes perilously close to adopting an unapologetically modernist position.

His decision to make *Lines Horizontal* was prompt-ed by an equally modernist impulse: 'I was curious to see what the same procedure would give if the lines were placed horizontally', and goes on, 'I was per-suaded that the result was completely different since gravity no longer existed … one no longer knows what animates them'. The notion of gravity animat-ing anything sounds suspiciously anthropomorphic but the lines are suggesting procedures to McLaren, and he at last is prepared to adopt them without compromise.

Mosaic consists of a synthesis of both films, its structure being almost (McLaren's own qualifica-tion) identical with theirs, with only the intersections between the two fields of lines allowed to appear on screen. McLaren in this particular instance composed his own scratched synthetic sound for the film, and it is undoubtedly his most wholly abstract film to date, yet he subverts this stand by deliberately mystify-ing his procedure through a jokey introduction in which he (in person) laconically sets the first 'dot' in motion, endowing it with anthropomorphic life.

Canon, like *Rythmetic,* is a consciously didactic work – and sets out through three increasingly witty examples to explain the structural idea implicit in the title. As an exercise in technique it compares with *Neighbours* as a remarkable demonstration of

McLaren's virtuosity, but one would hesitate to claim that it embodies any challenging aesthetic ideas of its own; it is in no way concerned with the material of film. (One might contrast it for example with John Whitney's computer animation of similar mathematical concepts, which consciously attempt to locate their exploration within the medium of film itself.)

Synchromy on the other hand returns to the question of image/sound relationships – and the core of McLaren's aesthetic preoccupations. The film is in more than one sense a return, for McLaren not only revives one of the very first ideas he experimented with in the 1930s, but uses, as his source of sound and image, material he had drawn during the early 1950s. In this his most recent animated film, McLaren assumes the 1:1 relationship between image and sound that he has been skirting round for most of his working life. His original material consists of short strips of card with rectangles or lines drawn on them, their width and the intervals between them being calculated to produce notes of particular pitch when photographed onto the soundtrack area of film. In the 1950s his intention had been to use these cards to synthesise a theme by Paganini (as Fischinger had synthesised Bach in the 1930s), but in *Synchromy* he composes his own boogie-woogie like an abstract piece, and one gains the impression that image and sound considerations weighed equally in its composition. At any one time one may be listening to as many as three visual soundtracks in combination (producing a chord) and the corresponding three visual tracks are frequently mirrored and multiplied up to as many as eleven in total, to add the visual equivalent of volume, and one suspects, to deal with the awkward areas left vacant on the screen. McLaren strays further from a strict 1:1 relationship in his rather arbitrary colouration of the visual tracks – his work in general, it must be admitted, showing remarkably little interest in colour for its own sake. *Synchromy* is none the less a major work in McLaren's oeuvre and provides a satisfyingly clear exposition of one of his major preoccupations.

Tragically, McLaren's eyesight began to fail him in the late 1960s – no doubt adversely affected by so many years of close scrutiny of the tiny image area available on the 35mm film strip. In recent years he has produced a series of films which derive from filmed (live-action) dance movements – beginning in 1967 with *Pas de deux* and continuing with *Ballet Adagio* (1972), *Animated Motion* (1976–78)

and *Narcissus* (1981 – released 1984). A technique employed in this series is that of optical-printing – used to overlap successive film frames – to reveal the pattern of movement (much as Etienne-Jules Marey did in the infancy of cinema). By employing dancers and balletic movement McLaren is clearly reconnecting with first principles after the 'abstractions' of the 1960s; but these films would seem to contain a paradoxical reversal of the anthropomorphism of the early works. Where formerly his dots and loops were imbued with human responses, now his dancers – in their perfection – are stripped of individuality and presented as impersonal almost abstract shadows, involved in displays of mathematical precision.

McLaren's progress towards a modernist position suggests that in other circumstances he might have made a substantial contribution to the expansion of film language pursued by the avant-garde. His concept of what constitutes a 'natural' subject matter for animation – the substance of film itself – its surface and the marks that one can make on it, the kinetic and imagistic potential of the single frame and so on, is one frequently encountered in the avant-garde. Even the elements that might seem more obviously the domain of the commercial animator – his love of fantasmagoria and his flirtations with synaesthesia and anthropomorphism – have proved capable of modernist treatment by Breer, Fischinger and Smith. So these are not what disqualify his work from participation in the avant-garde debate. What does though, is the one element he shares exclusively with his commercial colleagues – his conscious adaptation and dilution of ideas to make them accessible to some notional average audience. 'I wanted at first to make an abstract film but … considered I wouldn't be able to hold the spectator's attention.' No modernist filmmaker could operate within such constraints: the risk of incomprehensibility is an essential ingredient of all avant-garde work. How much this restraint was the inevitable price of security within the NFBC and how much it reflects attitudes endemic in McLaren himself is a question only he is qualified to answer.

This article was first published in the Scottish Arts Council exhibition catalogue 'Norman McLaren' (1977) where it accompanied a lengthy interview with McLaren by Leo Bonnville and others (which originally appeared in French in *Sequences*, no. 82, October 1975). All quoted statements by McLaren are from that source. The article was slightly revised for *Undercut* and was reprinted with the kind permission of the Scottish Arts Council.

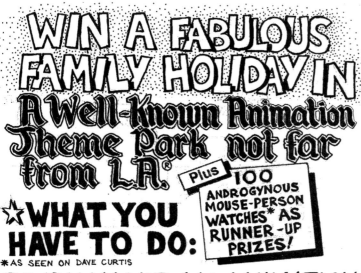

From the first window: You approach the familiar space. From the inside. You are confined by this space. You are not confined by time. You have all the time in the world. Only your movements are restricted. You make a move. Towards the window. Draw apart the curtains. And guess the time of day. It could be midday. It doesn't really matter what time of day it is. You stopped winding the clock a long time ago.

From the second window: They move towards their windows. They move for different reasons. Towards the light. And towards the noise. Towards the interactive movement of others. Others attract them. Their movements betray their dislocation.

From the third window: The onlooker. From the outside. He would sit there for hours, days. His face pressed against the window. He affects nothing. And nothing affects him. He remembers things as they were. The man in the window. Makes a movement. Almost as if inspired by this movement, behind other windows, curtains rustle. The spectators from their galleries betray themselves.

From the fourth window: The snoopers. There are the people from the DHSS. Observing the couple living below. They make strenuous attempts to conceal themselves. They skilfully avoid detection. But you can see them. If you look closely.

From the fifth window: The sniper. The curtains are drawn apart. The sniper makes his presence known. The waiting game has been endured. The target has been shadowed. Their response to the sniper is different in each instance of detection. It disturbs them and they become indignant. They then move out of the camera's view, usually to a recognised blind spot. Where the camera's presence – once felt is ignored.

From the sixth window: The commentators: the refugee problem had been solved, that all refugees had been assimilated into the economy; but mostly they had assimilated themselves into the city's roughest corners, alleyways, mud-slides, under parked cars.

From the seventh window: The bystander. The interruptions which distract us from familiar patterns and routines. Those of 'work, resistance and silence'. Those events which disturb them most. The 'things' they would rather not see. The 'things' they would rather not be affected by. They are the passersby.

From the eighth window: The historian: Where did this action take place?

beyond the camera barrier
tim cawkwell

All cinema is animation, breathing life into the lifeless, imparting motion to the fixed and static, giving structure and meaning to thousands, millions even, of discrete, frozen images. The 'science of motion' is something every filmmaker has to learn.

In practice the word 'animation' has a far more limited currency. It evokes a specialized aspect of the film industry in Hollywood, the Disney studio, Tex Avery at Warner Bros.; it evokes the tradition of fairytale, fantasy and surreal filmmaking in Eastern Europe; it evokes the primitive joy of the early animators, Winsor McKay and Emile Cohl.

So a limited definition would explain animation in terms of technique. Another dimension to its popular meaning is the element of caricature with which the art of animation is associated. It is a good vehicle for the comic and grotesque. People can be given rubber heads and bodies that bend into all shapes; objects can explode and reassemble. The drawing technique is inherently suitable for this, but its origins in the nineteenth century reinforce this role. Nineteenth-century childrens' toys such as the thaumatrope, phenakistoscope and the zoetrope were for people's amusement and it was congruent with the commercial impetus of the early film industry that when the apparatus for cinema proper had been invented in the 1890s filmmakers such as Cohl and McKay should begin to exploit it as a means of animating drawings for the amusement of audiences.

A feature of the toys of the last century is the crudity of the movements created by the series of drawings. This is not surprising when we consider that until the photographs of Muybridge and Marey and the invention of moving pictures, the means of studying the movement of humans and animals was very limited. (Noel Burch, in an essay in *Afterimage*, tells the story that when Muybridge animated his photographs of a galloping horse, the images seemed to arouse considerable mistrust that they were accurate.) For much of the history of animation, animators have striven to create a certain jerkiness of movement or an exaggerated elasticity of line on the grounds that these are virtues rather than defects.

The animated film therefore has roots in the nineteenth-century 'pre-historic' phase of the cinema. Subsequently certain characteristics of animation have developed on parallel, non-converging lines from the narrative or documentary cinema, and this has led to a rift between the two traditions in the minds of historians and critics. By contrast, it has been a merit of writers on the avant-garde film to avoid setting up this division. A significant chapter in the whole story of non-industrial/avant-garde/independent filmmaking is that concerning Eggeling, Fischinger and Ruttman as they experimented with animating abstract shapes. The continuation of that work on the West Coast of America by the Whitney Brothers and Harry Smith helped to keep alive the embryonic idea that animation, by its ability to manipulate shapes, patterns, movements or indeed any aspect of the perceptible world, could be a central means of illustrating the 'inner reality' of dreams, visions or the 'impossible', rather than a peripheral technique best suited to the caricature of the physical world. It was on these foundations that Stan Brakhage and Robert Breer were able to build in the 1950s and 1960s.

Breer had begun his career as a filmmaker by animating cut-outs to make purely abstract films. This led directly to collage films and the discovery in *Image by Images 1* that film itself is inherently a collage medium – by placing a series of completely different filmed images on a series of film frames, they can be fused in projection, because the spectator sees them as overlaid rather than single images. Breer has now produced a body of work in which non-figurative shapes and drawings of recognizable objects, usually of a domestic kind, such as hammers, milk cartons, children's tricycles, etc, are 'collaged' on film into a single entity by juxtapositions of the different images in alternating frames or pairs of frames, or by embedding an unexpected image in a sequence of related ones so as to surprise the spectator. This constitutes a major advance in how to use cinema motion, which Breer has recently extended by his introduction of rotoscoped elements.

From the very beginning, he strove to create short, rapid movement. This led him away from trying to achieve the smooth effect of cel animation which aims to reduce the amount of drawing required, and to the technique, developed in the

SFORZINDA Tim Cawkwell

SFORZINDA Tim Cawkwell

1950s, of drawing on plain 4" x 5" index cards. These 'flipbooks' enabled him to reshuffle his drawings in new orders, in effect to experiment with the editing of his images before fixing them on film, and gave him the necessary flexibility to devise optical and metrical effects. Breer must take credit for first applying a radical approach to montage in animation that links it indissolubly with the work of other avant-garde filmmakers, for example Kubelka, Sharits and the British Structuralists.

To posit Brakhage's significance in the development of animation, it is necessary to go back again to beginnings. Two streams have shaped the course of film since 1896, which have been called the 'Lumière aesthetic' and the 'Méliès aesthetic'. The basis of the former is that the apparatus of the cinema is a means of portraying physical reality. Its most articulate and eloquent theorist has been the French film critic, André Bazin, who used the films of Stroheim, Murnau, Renoir, Welles, Wyler etc to lay down the canons of realism in the cinema, notably invisible editing, continuity both in terms of space depicted and the duration of shots, and a self-effacement on the part of the filmmaker. His writing helped to put realism in the ascendent in the 1950s and 1960s as the critical basis for appreciating film history. At the same time, this tendency helped to relegate animation to the sidelines because although commercial animators use editing styles borrowed from the narrative cinema, even they do not aim to reproduce physical space exactly, but like all draughtsmen use line to interpret reality (by flattening space, altering perspective, etc) – and of course 'in a cartoon everything is possible'. Imposing this 'illogicality' on physical space renders the animated film suspect as 'true cinema'.

The ascendency of the Lumière aesthetic took place at the expense of Méliès aesthetic. While Méliès was a pioneer in using the camera, he was attracted to doing so by its ability to perform tricks.

Against the backdrop of his theatre sets, he used a battery of effects, most notably the technique of taking individual frames or shots in such a way that discontinuity was concealed, especially to the first cinema audiences who did not know how this new toy worked, to create effects of magic. Quite apart from the technical brilliance and fantastic quality of his work, Méliès is important as being the first to appreciate the manipulative quality of cinema. Besides the histories that describe filmmakers as striving after greater and greater verisimilitude, with editing techniques, with sound and with colour film, there is a history of the cinema that describes new and subtle ways of dislocating time and space with camera and film to create a reality that is different from the sensible world of time and space. It is in Eisenstein's silent films and writings that these ideas gained their widest currency.

With the increasing accessibility of equipment in the 1950s, an independent challenge could be begun to the commercial cinema and the way it made films. This challenge was well articulated by Stan Brakhage's *Metaphors on Vision*, published in 1963, in which he reasserted the idea of Méliès and the use of the basic elements of cinema – lens, splice, film frame – to shatter the mirror of outer reality and reassemble it to reflect inner reality.

Less well known than *Metaphors on Vision* is his 'A Motion Picture Giving and Taking Book', published in *Film Culture*, 41 (1966), yet it is perhaps in this essay that he most coherently reasserts the basis of the fusion of filmed reality with manipulated or animated reality. He begins with the simplest way to set about making a film – taking plain leader of any colour, identifying the frame, drawing on it and repeating the drawing. 'Draw, however sketchily, a single in-coming wave. Move down the strip of film one frame and redraw your wave as exactly like the one in the frame above as you are able, only make it a little, very little, more in-coming. … Move down to the third frame and repeat this process, draw-

DRAWING ON FILM Tim Cawkwell

ing-in your wave a little further. … You have now begun the creation of a potentially movable picture universe of your giving.' Brakhage then gives a clear exposition of how the shutter works, providing the black interval between the projection of each frame without which the motion of the film through the projector gate would produce a meaningless blur. 'The shutter is open when the frame is held perfectly still in the gate, so that the light passing through the shutter opening and the film frame projects only one picture, held absolutely still, at a time, and not the movement of the strip of film.' The shutter then closes, cutting off all light.

It was in reference to the fact that this invisible black presence makes the white transparent images coherent that Peter Kubelka claimed that it was 'between frames where cinema speaks' – i.e. no black interval, no illusion of movement. (Thus Kubelka's *Arnuff Rainer* is composed of the two essential ingredients for making cinema, light and the absence of light, the latter being as necessary as the former.)

To illustrate more convincingly the thesis that there is more to animation than the mere filming of drawings, and in the spirit of 'A Motion Picture Giving and Taking Book' it is worth listing some of the techniques for making films by hand. This process works directly on the film itself, dispensing with a camera to focus light on the emulsified surface of the film, and instead using the hand to create the image. The eye has to learn how to analyse and recreate movement – a lesson for all filmmakers even if they are never reduced to being without a camera to make films:

1. The simplest medium to use is clear leader, exposed and developed so that the emulsion has been removed altogether. While the clear polyester base, being non-absorbent, is a surface that is not suitable for all inks, indian inks used in rapidographs work well. These come with a range of point widths. Another good drawing tool is the fine-point fibre-tip pen such as Staedtler produce for use in drawing on transparencies for overhead projectors.

2. Drawing is also possible by incising on black or coloured leader. Unexposed and undeveloped film can be used, but film that has been developed without being exposed is both easier to scratch in (the emulsion can be softened with moisture if so desired) and produces a more interesting line with hints of the blue dye which is the bottom layer of the emulsion. Either way, the technique of incising requires a certain amount of practice in learning to control your scratching point.

3. Turning from line to colouring clear leader, there are a variety of media that can be used: felt-tip pens, inks and dyes. (Note also that these can be used to colour incised lines.) Because the making of films with a camera involves exposing film to light, I find that incising on black or coloured leader, by which one 'exposes' a line to light, is more satisfying than drawing on clear leader. For this reason, I feel that there is a need to develop a sort of 'artificial' emulsion that can be applied by hand. Spray paint is the simplest and most effective that I have discovered, but when I started to make films by hand, I hit on a process whereby black leader, unexposed and developed film, was immersed in a dilute solution of household bleach for just long enough to wash out the yellow and magenta dyes in the black emulsion, leaving a blue leader rich in colour and easy to draw on. Because of the labour involved in its manufacture I have used this process only occasionally.

4. Undiluted bleach can also be used for treating part of the surface rather than the whole, and even for drawing with. It also allows an etching process to be used: spread plastic glue, or cow gum, over the emulsion, and, before it dries completely, draw shapes or lines in it. The glue then sets, leaving the emulsion exposed where you have drawn. Place drops of undiluted bleach on these lines and the chemicals in the bleach react with the emulsion. Finally wash off the bleach and peel off the hardened blue, leaving the image in

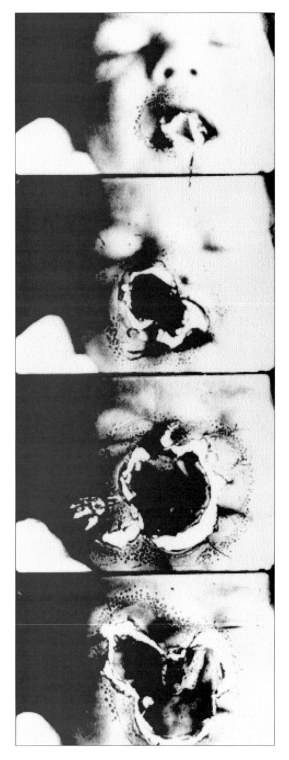

DOG STAR MAN Stan Brakhage

the emulsion. Harry Smith, in his *Early Abstractions Numbers 1*, *2* and *3*, developed a process on similar lines which he called 'batiking'. He fixed dots and squares on the film, sprayed it with colour, covered the strip with vaseline and removed the dots. A second spraying, followed by removal of the vaseline, gave two colours on the film, one inside and one outside the circle.

5. All these processes, especially incising and etching/batiking ones, can be used on images filmed in the camera.

6. Brakhage's approach to the hand-made film should be mentioned as well. In *Mothlight* he pasted moth wings, grasses etc. between strips of mylar tape which was then run through a printer, and in *Dog Star Man* he created patterns with assorted materials, e.g. mica, punched-out pieces of film, chemicals, glues etc stuck between clear leader and splicing tape and welded with an iron.

This catalogue of methods that dispense with the camera is probably not exhaustive. So as to avoid creating a separate, isolated category for the hand-made film, mention should be made of the scope it offers a) for being spliced in with camera-made film, whether found material or material specially filmed, b) for re-filming it with a camera shooting back-projections, or c) for reworking in an optical printer.

I have tried to develop in this essay the theme that the traditional view of animation as a technique in which drawings are filmed with a camera is too limiting. Understanding the technique of animation is crucial to understanding the illusion at the heart of filmmaking. This means that there is common ground to be found between animators in getting away from cel techniques and the rostrum, and filmmakers in using the camera and editing-bench to make films in frames rather than shots. The commonest ground of all is to bypass the camera altogether.

Indeed, when Brakhage made *Mothlight* by ignoring not only the camera but the top and bottom of the film frame as well, cinema entered one of its most radical moments. He showed that you could get away with not boxing images within the film frame, because the spectator was still able to register the shapes of his material and its supreme delicacy, and in fact their imprint was all the more vivid for being registered in 1/24th of a second. With this film we are at the frontiers not just of animation but of all filmmaking.

chapter 6 independent cinema

a dialogue
stuart hood, noel burch

Stuart Hood: One of the main problems which I come up against in discussing film in this country is that, even amongst people who would consider themselves enlightened about other art-forms, there is a conventional view of film which delimits it to the narrative film or the documentary in the straight conventional sense of the word. Anything else which lies outside these parameters is not film-making, as far as they are concerned – it doesn't exist, they don't see it, they know nothing about it. They find it, when they do see it, boring and incomprehensible and are not prepared to make the effort to understand what is going on, or indeed to show any understanding of attempts to introduce other modes of practice into the documentary or narrative film. I think one of the main difficulties is in fact an ideological one, that is of breaking down an ideological resistance on the part of such people, who include all the main critics and many other people of importance and influence who refuse to widen their views or even to look at the kind of work which for instance was shown at the Film-makers' Co-op Summer Show.

Noel Burch: I very much agree with that approach. But what I want to say about England, and the impressions I get from seeing the films at the Co-op, the NFT avant-garde festival and other places, is that one is dealing with a situation where, in spite of the resistance of the establishment which you characterised quite adequately, there have developed certain marginal sources of funds. If you take certain marginal state fundings like the Arts Council, Southern Arts, South West Arts, the possibility indeed of breaking down of these barriers of cinema which denounces precisely the ideological character of these categories, is very real.

SH: Yes, I think there are two tendencies in the situation in this country. The situation is such that there have been areas in which to develop new practices of filmmaking. And as you rightly say the kind of funds provided by various parts of the Arts Council have been very effective. However, if that tendency continues it is going to increasingly come up against strong ideological and political obstacles. I know of one film which was backed by the Arts Council but which it dislikes politically, and it is a film which deconstructs documentary. They say they were not happy with it on what they call a 'formal plane'.

NB: In this country, you say one should not exaggerate this aspect. Well, I would say I don't want to confine discussion to films shown at the Co-op though obviously within that space – and obviously we see that they are trying to extend it – the impact is healthy, although I would like to come back later to the way it is an organic outgrowth of the problems which people like Le Grice and Gidal had been posing over the years, in their somewhat naive way. But outside of that space the BFI has produced a number of films in the past years, political concerns are evident here in the work of people who are very familiar with, if not sympathetic to, the Modernist movement, films like Sally Potter's *Thriller*, which is I think one of the most important films made in England recently, or Penny Webb's *Young Girl in Blue* which although not specifically a political film is concerned with narrative or Tim Bruce's *Corrigan Having Recovered* which is a film straight out of the Co-op tradition, when one looks at these and quite a few other films, they seen to me to constitute a real movement.

Tim Norris: What now makes this new strategy evident for you apart from what you have already said?

NB: One has to go back to the 1960s to trace this change. First there was the impact of American cinema; it is clear that the impact of Snow and Warhol was very strong indeed. This impact translated itself into what we know as the very extreme structuralist movement. I think this was due in part to a certain theoretical proclivity on the part of the English art scene at that time. The intellectual scene was quite different in England to that of America in the 1960s; here you had publications like *Studio International* for instance. What happened therefore was a development through and around people at the Co-op,

people like Malcolm Le Grice and Peter Gidal, also Stephen Dwoskin played an important part in this. There developed a cinema which expressed ideological concerns, though I think poorly formulated in some cases, which was a conflation of the political and the artistic in a very naive way. The radical anti-humanist, anti-anthropomorphic gesture was regarded in itself a fundamental gesture. But it was a gesture which had taken account of the fact that our social experience of sounds and images is not that, and this was therefore a cinema which refused to even recognise the primacy of the general experience of sounds and images as communication and as language. This was their leftism if you like. However, having said that I still maintain that the writings of both Le Grice and Gidal (although I think Malcolm's writings are more important) did get people and especially filmmakers to think about issues of language and communication, as their films did. *Screen* too has played an enormous role, and people around it and the climate which it has created were also important.

TN: Many filmmakers actually see *Screen* as alien to their practices…

NB: But between *Screen* and say Malcolm Le Grice there is a world of difference. The debate however which this presumed alienness created was incredibly fruitful. The fact that people are now thinking of combating *Screen* with a new magazine is a further sign of a very vigorous theoretical activity. So in a way one can see that over the last four to five years this work has begun to bear fruit. Also one has in England with the failure of the Labour Party and the growing development of the Left, at least amongst the middle class and the rest of society (while in America your artist is in an ivory tower) I would add that the women's movement seems to have played a large role in this – since the fact is that many of these filmmakers are women.

TN: What are your feelings about this Stuart?

SH: I have a slight question at the back of my mind, but on the whole I go along with Noel's analysis of what has happened. I would like to back a little in what he has been saying. … I would locate one aspect of the leftism you talk about in the early avant-garde in the curious conflation of the word 'material-ism' – as implied in the materiality of film and the materialism as in dialectical materialism. It is a kind of sleight of hand which Peter Gidal is particularly prone to, and is one of the weaknesses of his theoretical writing. Another interesting point is that a lot of inde-pendent filmmakers come out of Art Schools and Art Colleges. This I think has been one of the main breed-

ing areas for the movement. The paradox of the situation is that, although some interesting work is going on there, a lot is also very conventional work because the atmosphere of the Art Schools in this country is away from any social reference. Anything with a social reference is looked down upon, despised. In spite of this one does see art coming up that has an edge and which is reflective. What I am trying to say is that the debate has filtered down, for a number of reasons … which I believe we could put our finger on. Thus there is a generation of filmmakers and film theorists, many of whom Noel has taught and some of whom are now teaching in Art Colleges. You see the work of their students and wonder where it comes from; you begin to see the feedback. The problem is that it takes several years for anything of this kind to show itself in the production of finished work which is publicly available.

TN: Earlier you mentioned that institutional and ideological resistances obstructed work, but at the same time you indicate that there are possibilities for artists to work within these constraints; how does this work?

SH: It is happening in cracks within institutions, in the area of film in some colleges, because film is something which is marginal to the rest of their activities. Film is something which the controlling bodies are less certain about, and therefore things can happen which they don't fully understand. And many colleges through their hierarchy do dismiss work. But on the whole I think I go along with what Noel has been saying. It has a lot to do with the debate, and whether one agrees with *Screen* or not, *Screen* is certainly an important factor in the discussion. The fact that there is a kind of counter-attack against *Screen* I think is totally healthy and absolutely necessary. *Screen* has got to be engaged with.

NB: And its collaborators must engage with themselves. I grant you that it is impossible to make a comparison with the US situation but it must be made because for 15 years America was the seat of avant-garde cinema. For all sorts of reasons, that is where it was happening, and the fact that there has been a shift of the centre of gravity away to England is a significant thing. British filmmakers and theore-ticians have to take this into account and to think about what it means, why it has happened and so on. I don't think this shift is my fantasy – it really is something that is happening. I think another aspect of the question may be money. For example I'm con-vinced that to develop the kind of filmmaking that we are talking about now, for filmmakers to engage

at a high level with the issues we are referring to here, you need more funding than is generally available to your independent filmmaker on his or her own. Now it is true that we've seen films at the Co-op made in very modest conditions. But they open up a space which, to be further explored, requires funding. Take the fact that Snow, for instance, has basically stopped making films, after reaching a point where to pursue his work he could not go further than *Rameau's Nephew* because he needs more money than it cost and cannot find it (and he's a pretty famous person) and he can't get it. In America there's no funding for expensive 'experimental' films. Don't you think there are different levels of budgeting and that having a large budget to work from involves greater control by the funding bodies?

NB: It is complex. My theory in this matter is that there is an intermediary area, in other words, a budgeting which involves between £25,000 and £100,000, which is more than most people can mobilise individually, and is certainly more than you can get for an independent film in America, unless it is a straight documentary, very few people manage it. Whereas in this country that kind of funding is available. It isn't available in masses but it is there and you have several sources for it. You also have Art Schools which provide some support. In this country the institutional infrastructure does serve to a certain extent, at least for artists to develop their needs. Whereas in America the infrastructure hardly serves filmmakers. In England there are Art Schools which are sufficiently equipped, they can do synchronised sound etc, of course beyond a certain amount, say £100,000, you are getting bound up with the contradictions of the system, as you pointed out. But the point is, I feel that there is a small space – not just in England I confess, but in Germany also and in Belgium – where filmmakers can develop beyond the traditional limits of the avant-garde. Chantal Ackerman's *Jeanne Dielman* is a case in point, and for me she is the most important filmmaker in the last ten years. That film was financed by the Belgian government to the sum of £80,000 I believe, and it's a film which is totally inconceivable as a produced film by a private producer. It's not earning money back and it's a film beyond the resources of your average filmmaker. It's that no-man's-land or no-women's, which exists between the traditional avant-garde film and the 'commercial' film where the most advanced work is now going to be done. How could *In the Forest* or *Phoelix* or Sally Potter's next film get made except by financing by the state?

SH: The funding question raises a number of important problems. First if we think about the Art Colleges, they are under extreme economic pressure at the moment. For example film students are going to be asked to pay more for materials. The cuts in some cases are immense, and film is one of the first targets for a variety of reasons. First because it's expensive, second because college authorities don't like what they see on the screen. If you come out of the School or College situation and move into the public domain I think that some of the same pressures will begin to make themselves felt. It is fortunately true that the Arts Council, for instance, has managed to increase its budget. Most of their documentaries have been exceedingly boring, but some of the other work sponsored by the Arts Council has been interesting. Then you have the BFI; the BFI presents certain problems which are that, as I see it, the main policy drift of the BFI is to come closer to the established centres of power and policy.

NB: Are you talking about the Production Board?

SH: The BFI as a whole and definitely the Production Board is leaning towards it. The dangerous situation might arise where they give larger sums of money to filmmakers, but to fewer filmmakers because they produce a kind of film which fits more readily into the categories that the Board has in mind.

TN: Perhaps we could consider both *Song of the Shirt* and *Radio On* which both fall into the large budget category, noting that *Radio On* was internationally financed and part financed by the BFI.

SH: *Song of the Shirt* has been widely shown to large audiences but to important audiences: filmmakers, people in the women's movement, political groups of various kinds. I think it is a seminal film in its attempt to tackle history in a different way from previous documentaries.

NB: I agree that *Song of the Shirt* is very much a part of the movement I am speaking of, but at the same time the film does have this particularity of being a militant film, it is a film which was designed to be shown, as I understand it, at history workshops. What that implies I'm not quite sure. The Art Houses and the Regional Film Theatres are potentially an important aspect of this development but do not often show films like *In the Forest*, *Phoelix* or some of the more convincing films of the type we saw at the Co-op. This I think should be the object of struggle, because there is an infrastructure and it's got to be opened up. I think for the specifically militant films, such as those of the Berwick Street Collective, or Cinema Action, it's going to be the militants who are to take these films in hand and use

them – that seems to be the only way to do this. I don't think films like these should be shown in cinema theatres, I think that's defeating their purpose.

TN: If we are to identify the new film practices, and if *Song of the Shirt* doesn't appear to succeed widely, what do you see as working?

NB: In my view, *Song of the Shirt* doesn't work because it falls between two stools. In other words, it provides a new version of the confusion between politics and aesthetics, if you like, which existed before in Gidal's and Malcolm's work.

SH: It is a very academic film.

TN: What does work?

NB: Well there is the exceptional film *Thriller* which is a political film and which is being used politically by women's groups, and I think effectively. I saw it first at the NFT last year in a version which was not retained by Sally Potter. She modified the film subsequently before the negative was cut (we saw a work print at the NFT and the film knocked me out, but was quite obscure). In showing the film to women's groups there were many complaints about the fact that the film was not explicit enough and it has since been made more explicit. I'm citing this because it seems to me to emphasize the contradictions as far as the specifically militant 'post-modernist' film goes.

TN: Is the filmmaker compromising by developing this type of practice?

NB: I don't think you can generalise that way because it is a different type of film practice, the militant film. I've made militant films in France during the period 1974 to 1978, and the question of your relation with your audience and the ways in which the film is to be used are very specific. I don't think one can confuse these practices. In America there are a few films which are also attempting to use the strategies of modernism within a specifically militant cinema. But for the moment, this seems a somewhat secondary issue. I think what we are really talking about is the relatively autonomous artistic practices which are being formed by political sensibility but which are addressing themselves necessarily to a middle-class audience and which will not be used in militant situations, but in theatrical or quasi-theatrical situations, because there are not that many other types of situations. I see only two types of situation for presenting films in contemporary capitalist societies. (This is not the case in Socialist countries. For example, they have factory film societies which use entertainment films' as bases for broad discussions in which people of all levels of consciousness participate.) Cinemas on the one hand and women's

groups or other militant settings, and that is about it. Even the Co-op is basically a theatrical situation even though it is freer in a certain respect. I think it remains theatrical precisely because of the ecumenistic nature of such screenings there. What works then? It seems to me that most of these films 'work' precisely because in a way the political discourse is aestheticised. I guess, too, that I am most interested in those films which are more explicitly concerned – whose political concern is with the strategies of the institutional film. One of the films which I found very interesting which we saw was *The Missing*. This may be the impact of Jon Jost's *Angel City* on it. We have seen *Corrigan Having Recovered*, and I understand there are several more, which engage with film noir, with the detective genre – Philip Marlowe and so on. I thought the film *The Missing* engaged in a witty way with the codes of cinema. I think this kind of self-reflexivity is one of the exciting dimensions of the English cinema. In a way perhaps that works best because that is where people are at! When people go into an auditorium and sit down, just as they do in the West End, and they see something which speaks to them, something about their experience as filmgoers, not just in terms of their life and its typical structure but with reference to their symbolic experience, their language experience of cinema, their deep experience of film, those are the films I find most gripping.

TN: Perhaps this would be a good moment to raise the question of Channel 4 which we were discussing before.

SH: I was raising the question whether Channel 4 offers any prospects to the filmmaker as a venue. The problem with Channel 4 is that certainly for its first few years it is going to be funded by the commercial companies who are going to pay the sum of £70 million each year. They will also control something like half the Board with their representatives. The rest of the committee is going to be made up of people representing the interests of independent filmmakers. But what does an independent filmmaker mean? This could range from a disappointed impresario – who's not been able to get on the present commercial television – to what we would recognise as independent filmmakers. The question we have to ask is: how can their voice be made to be heard on that committee, and how do they get access to the screen? I think one of the possible strategies might be to try and use the fact that Tony Smith, who is director of the BFI, is also on this managing committee.

NB: Will the institutions like the Independent Filmmakers Association be officially represented?

SH: Yes, the IFA will be represented. A lot however will depend on how that committee functions. Certainly the ground rules as conceived in the minds of the controlling authority in response to pressures laid down that it ought to encourage innovation in filmmaking – but what do these people think is innovation in filmmaking? It may not be what we think of as innovation. There is the possibility that what they consider to be innovation will be a kind of art film – or video art for that matter – which they might see as extremely adventurous. The kind of film we have been discussing would not enter their heads; this is the dilemma.

NB: It also seems to me to be the problem for the IFA itself. The great majority of members seem to be divided between what is basically a Cinema Action kind of approach, your politically overt film, and the traditional Co-op-type filmmaking. There doesn't seem to be much space in the IFA for types of argument which bridge this divide. There are people like Simon Hartog who are receptive to the arguments but they don't seem to have much to say at that level. They have an administrative, say, and a political role but it doesn't seem to have much impact on, for example, the way representatives of the IFA have behaved on the Production Board which has tended to favour these more ambivalent projects which are the most interesting ones. This thing is still not being thought out or theorised very much; most filmmakers are still thinking in terms of three basic categories: avant-garde film, documentary, and feature film. No one can conceive of anything else, and anything which comes inbetween is going to fall through the cracks. I believe the problem is an educational one. These things have worked on television in France because television is eminently suited to it. I am thinking of the experiments of the tendency called *l'écriture par l'image* in particular which involved production policy which allowed for films which refused the traditional categories.

SH: I think what happened in French television continues because of the intellectual momentum behind it, but at the same time it has been marginalised because of the political structures. The problem here is that there is not that intellectual momentum amongst those people who are going to take decisions about Channel 4. So the struggle becomes one of trying to capture intellectual positions within British society. The struggle as I see it is going to be an intellectual one and one of the problems, while

admitting the nature of the *Screen* discussion, one of the negative results of the terms and modes in which it was conducted has been that people have been able to dismiss it as being totally impenetrable and irrelevant to the development of any kind of normal debate.

NB: Yes, there has been an unholy alliance there between left and right.

SH: Yes I think so. I was astonished by the film *The Secret Life of Fish* by Steven Gough which I was amazed to see coming from the National Film School, because it is a film which attempts to deal with the other categories of filmmaking than those usually associated with Beaconsfield – because the National Film School is financed by industry and the Department of Education and Science. The thrust there is towards professionalism…

NB: And the perpetuation of the models…

SH: That is right, so attempts to question them are difficult. A very important question is the policy to be adopted by the new Professor of Film at the RCA. The answer to that will determine to some extent the way in which the kind of filmmaking we have been talking about will continue.

NB: Absolutely, because that is the main centre of opposition to the NFS.

SH: We come back to the dilemma we have already discussed. If one takes the RCA as institution and examines the members of the ruling bodies as representatives of the intelligentsia who concern themselves with artistic form, their ignorance of film is total.

NB: The financial problems now facing Britain will pose interesting problems. Since the area of the arts is useful in providing a kind of safety valve for certain turbulent sectors of the middle class. I refer to a curious conspiracy between social democrats and the ruling class around the need to preserve and develop artistic activities. Paris has developed a remarkable cultural activity in the past years which can be seen as a creation of the right. In this country, however, we are living on what is largely a social democratic heritage from the post-war period, for example the Arts Council is a post-war Labour creation. Consequently, the cuts in Arts Council budget are part of the overt class position of this government which is, as you know, 'fuck the working class'. I've never seen anything like it, it's totally up front…

SH: It's not concealed…

NB: Maybe it's a mistake on the part of the Right and maybe it will turn out indeed that the confrontation is going to be so severe that the Left can prof-

it by it. But besides that I frankly think that, while it is true there will be attempts to clamp down on your specifically political film, especially on television, for example on Channel 4, it's going to be very difficult to show socially relevant work. But at the same time I don't think the attack will be frontal in areas which are specifically cultural; it will be perceived that it is important to maintain the intelligentsia, at least certain sectors of it, in a state of relative neutrality.

SH: I would be more optimistic than I am if it weren't that my analysis of the British ruling class would be that if they don't have certain characteristics, for curious historical reasons, which the French ruling class has, and that is to say we did not have the Encyclopaedists, we did not have that intellectual history which was typical of France from the Revolution onwards. And in a sense the British ruling class outside of the aristocracy don't give a fuck for culture. Take the model of Channel 4 which was originally proposed by Tony Smith, now the director of the BFI, which was that it should be an open broadcasting authority, that is to say, that the authority would be a publisher not responsible for the content of anything which appeared on the channel except to the extent that it was libelous or otherwise against the law – just as any publisher is responsible. This was the stance which was adopted by Channel 4 and others; but it seems to me that it never had a chance because it was politically not in this country at this particular conjuncture. The idea that you could actually have a fourth television channel, which was not subject to the restrictions placed on other channels, which did not have the ground rules and boundaries which contributed the main method of control of the mass media in this country, seemed to me to be total political miscalculation. It was proposed under Labour, and basically it was supported by the Annan Committee – they more or less said yes, and the Labour Party said yes. Well of course the first thing that the Conservative Government did was to cut that away, so that you'll be back in the situation where the controls on Channel 4 are going to be quite strong. Interestingly enough, when Channel 4 was debated in Parliament it was made clear that the Conservatives saw the concern as provisional, and that if it wasn't successful financially, or otherwise, they were quite willing to revoke the idea; it's there on trial. That means to say that people who are in charge of it are going to be careful.

NB: What would be interesting Stuart would be if you could answer this question for me: What is the role, or what would be the role, of Channel 4 within Tory media strategy as a whole?

SH: Yes, Channel 4 arises from the contradiction within Tory policy – it always appears when it considers media. When commercial television was first mooted in this country there was strong opposition inside the Tory Party which came from what I would like to define as the feudal element, the landowner element, which says public services are very important and commerce is nasty. Therefore, they were against this nasty and to some extent Jewish-financed commercial venture. There is some evidence to show that when it became apparent to Thatcher that one of the results of the bringing in of Channel 4 was that the supplementary direct taxation, called the levy, which is taken off the present commercial television companies, was actually going to be milked to provide the £70 million to get Channel 4 started, she said 'no way'. Hereupon Whitelaw, who was the Home Secretary and therefore in charge of broadcasting, who comes from precisely that area of Tory policy, said now there was an undertaking that they would start this channel so it has got to go on. Having done this, what they did was to say to the present commercial contractors: you will however be able to have the advertising revenue from this channel. This was something which went against the interests of the advertising industry, which precisely wished to have the two channels, with Channel 4 separate from the two present commercial channels so there could be a price war.

NB: How were they different? How would the status of Channel 4 and the ITV be different?

SH: Well, the theory of it is that it will be different in taste, different in what it puts on the air; that it will give innovatory chances to different kinds of television. What is even more serious, statements have been made which say that the mix will be the same on both channels, but they will offset one another. From this point of view I am pessimistic. The Executive of Channel 4 will in fact be a programme purchasing institution with a lot of time to sell. It will not make any programmes. It's conceivable that it might be economically advantageous for them to buy fairly cheaply the kind of film which we have described, which would then be shown at 11.00 at night. Looking at it cynically that is one thing which might work. There was an extremely depressing programme on LWT a couple of weeks ago in which various independent producers appeared and said, 'Don't kid yourselves it will be the same kind of stuff you've always been seeing; we are the people who can do it.'

interview with sally potter
gillian swanson, lucy moy-thomas

Gillian Swanson: Can you tell us how you came to make *Thriller*?

Sally Potter: It started out as a rather rough idea and I applied to the Arts Council for a film bursary. On the basis of that I assembled the performers and did some work with them, and then just shot a lot of scenes, only a very small proportion of which were actually used in the final film. It was constructed as it went along, in the light of the material that arose. In other words, there wasn't a complete and detailed script to start with, it was constructed through the editing and through the mistakes.

GS: What was the budget, eventually?

SP: It's a bit difficult to calculate exactly because labour wasn't paid, but it was approximately £4,000.

GS: What was the initial reaction to *Thriller*?

SP: Well, the first version I showed, which I finished just before the screening at the NFT at a festival of independent films. In fact it was Penny Webb who spurred me into finishing the film at all, because I had had the original footage sitting around for a year and a half, and she phoned up and said she was booking it into the festival. I was on tour at the time, in Rome, and I heard this, so I thought OK, right, I'll get it done, and came back and launched into editing it. I finished it half an hour before the screening and dashed down with it in a taxi, and it was shown on a double-headed projector. The screening was about one in the morning, so I was pretty amazed that anybody actually stayed. Nobody had seen it before that, because it hadn't been finished. I had been working through the night for some weeks previously to get it together – after that I took it apart again and reconstructed it.

Lucy Moy-thomas: Because you thought you'd done it too fast?

SP: No, my feeling about it at the time was that it hadn't fully realised itself. It seemed to be weighed down by certain kinds of ambiguity that I felt were fetters from a past that I didn't actually need. I whittled away the whole concentration on formalist aspects, and chopped them out.

GS: Some people have said that the second version was far more didactic. Would you agree with that? Was it a deliberate strategy?

SP: I don't think it's wildly didactic now, actually, but I did want to make certain things really clear, otherwise I didn't think there was much point in making the film. It was attempting to demystify certain things, to present an analysis, and if it just whisked back off into the land of ambiguity, then I thought it was going to be rather counterproductive. It is extremely difficult to gauge the level of ambiguity that is useful, that draws one in on levels other than the obvious, and the point where it is necessary to lay certain things on the line. It's a political question really. Politically it is necessary to lay things on the line, while at the same time to be in a state of constant re-evaluation

GS: So did you have an audience in mind?

SP: I think that I did. I had a fantasy that it could be addressing mass cinema, and a mass audience. Within that there was a more realistic fantasy of wanting to serve the women's movement as a whole, which includes many women who wouldn't be interested in or concerned with self-referential things to do with the history of cinema. I wanted to make sure that it didn't have a circumscribed and limited audience.

LMT: Do you think that its being about an opera limited the number of people who would make up your audience?

SP: Probably, but it was a deliberate choice to use opera and look at how it functions. My views about this whole question of audience have shifted and changed in relation to going out with the film. It's so strange the way one juggles with so many different expectations and notions of audience when one is making something. I had this fantasy of showing it in Leicester Square Odeon and at the same time there was obviously a part of me which didn't expect more than twenty people to see it … so then I was very pleasantly surprised when it ended up somewhere in between the two. One uses the fantasy to bring it into reality at all. The dream pulls one on into a certain kind of possibility.

GS: What kind of things made the film accessible to more people?

SP: It is an uncompromisingly feminist film, but it nevertheless looks at various interlocking strands of the women's movement, and the various contradictory ways of looking at feminist politics, from very theoretical to very didactic, because it has references to psychoanalytic theory and all sorts of stuff about language. But it is also about women as victims and ageism and the more immediately graspable but just as complex issues that women of all kinds inside and outside the women's movement are looking at.

LMT: How do you feel about being the person who provides the reading and says what it's about, exercising your authority as 'author'?

SP: I really like going out with it and I like being in the position of both being the author and critic. It's not that I'm there to provide the correct reading, although I absolutely take responsibility for what I've done and I'm prepared to explain why I did it. Discussing the collective reaction, being put on the spot about it, has helped me also to dredge the reasons out of that murky semi-conscious area of the brain that they tend to reside in. It's forced me to be much more clear about it.

LMT: Did people ask you different questions about it when you took it to America? Did they react differently?

SP: In America, one difference is that all the issues around class are seen as more incomprehensible. Some people say, 'It may be that way over there but here in America we don't have a problem with class', so you have to argue that one through. There are certain questions that the film inevitably throws up, and there are certain questions that a particular culture or audience will be obsessed with. When it was shown at the festival in Berlin, people seemed to be particularly fascinated by this victim matrix. Presumably it has something to do with German history.

LMT: When I saw it at the Ritzy it was on with *Manhattan*. Most of the audience had gone to see Woody Allen; they were very restless and walked around and bought pieces of carrot cake and things instead of watching it.

SP: I was quite excited by that programme, because it was like a test, like the Leicester Square fantasy scaled down. I went to one or two screenings and observed the restlessness. I saw a lot of people there who had gone to see *Manhattan*, but were still giving *Thriller* a chance. In commercial cinemas there's a much higher rate of restlessness anyway, with people walking around during the screening. After I'd seen them do that with *Thriller*, I thought I'd better watch what they were like in *Manhattan*, and they were doing the same. It's a much more throw-away attitude. Being brought up in the independent cinema, you learn this history of absolute concentration on each frame. If it's a film which only has a frame every two minutes, you're going to miss it if you're not concentrating. So minimalism does sharpen the brain. I didn't give any breathing space for people to go and buy chocolate during it. It was tightly structured and condensed in a way that perhaps is asking too much of what people expect when they go to the movies.

LMT: So what about your next film, are you going to give more breathing space?

SP: Maybe a bit, not much! I'm drawn to the idea of something that is both committed to its audience and its political responsibilities, and is also structured unto itself with a certain perfection.

GS: Does this have something to do with your ideas about performance?

SP: The thing about working as a performer, touring, doing one-night stands in different cities, is that it makes you a realist about audiences. Different environments, ambiances and audiences create different things; and some gigs are good and some gigs aren't. … It's like simultaneously having your idealism destroyed and in a more profound way strengthened, sometimes in quite adverse conditions, and against all odds the most extraordinary things can happen. It makes you realise that there isn't a fixed audience and therefore you can't have a fixed product that is going to be universally appealing, you need different points of access. If I had just worked with film, I don't think I would have understood what audience response is about in the same way. The thing with performance is that it's the most perfectly adaptable form. But it's wonderful working in both areas and being also able to make something which is final and fixed, and endures after you've gone away. And then the other thing where you're absolutely on the spot, and have to meet the situation and it's gone when you've gone and can never be repeated.

GS: Do you have anything to do with planning the programme? Although *Thriller* raises questions that are really interesting and useful to a wider group, perhaps working-class audiences would never go to the kind of cinema, or programme, that might include it.

SP: I think one ought not to be too stereotyping about this. The women's movement has been characterised as a middle-class movement and people often name themselves middle class when maybe they've actually come from working-class backgrounds and been supposedly educated out of them. There are loads of working-class women inside the women's movement, and I'm sure many have been to see *Thriller*. There isn't one stereotyped kind of working class audience. The aim within the film anyway is to give the central voice to a working-class seamstress heroine who is amongst other things looking at what her job means class-wise in relation to the male artists. But inevitably independent film has a certain kind of circuit – universities and art-house cinemas – that is not a mass audience circuit, because of the monopoly on the big cinemas; it tends to have specialised audi-

ences, and a bias towards being what is commonly described as middle class.

GS: How do different audiences react?

SP: Some people are interested in why there are so many stills in the film, and others are very interested in the fact that it's in black and white and makes a use of shadow, and are very interested in drawing out where in the film are the references to film noir or Hitchcock, or certain kinds of lighting codes from 1920s cinema. And other people are pleased to discover that it was because I had one light, and was making the best possible use of it, in the circumstances. The form of the discussion seems be that it goes backwards and forwards between what is specific to the film, and more generally related issues. At a recent screening some men were worried about a contradiction between a politics based on class or politics based on gender. A discussion followed in which I was saying that there are many divisions that interlock; there's class, there's race, there's sex, there's people who have disabilities and those without disabilities … which isn't just to say that there's this great jamboree of interlocking oppressions, but simply that there are many different contradictions that have specific battles to be fought around them. The people that lead those battles are the people of the oppressed groups. We can't wait until after the revolution because any politics that doesn't include in it a vision of how things should be is bound to be absolutely useless. As long as there's any one group, be it Jews or whoever, that is left out of the programme, then it's no good. And being a woman, the things that I'm likely to produce are likely to be dealing with gender politics. Film can be a useful catalyst around which people can think about the issues without having to be too defensive. It's not like having a discussion where people are put on the spot and asked: 'What's your opinion about feminism?'

LMT: You said before this interview that the film was an exploration of an emotional experience and I asked you why you had chosen fear as the emotion you draw on. Presumably *Thriller* is a thriller, and it explores the fear that genre works with – that's the emotion that you are drawing on. Why did you choose that one emotion?

SP: When I was making the film, I found a lot of things about it really funny. The first time it was shown at the Edinburgh Festival, the audience there found it funny too. One of the ways of dealing with the heaviness and the fear, of the suspense genre, and death, etc is to laugh about it. People laugh at things to do with the opera, the romanticisation and so on.

THRILLER Sally Potter

Juxtaposing it with the suspense genre does create a certain kind of humour. I suppose that death, and in particular women's death as a cultural obsession is something we are being blasted with more and more. It's not something that is going away, by no means is it limited to *La Boheme*. Current campaigns, like 'Reclaim the Night', are organising against this fear. It is fear that keeps us in our place, fear of going out alone, and so on. We get used to making little strategies and diversions to make sure we don't go too close to the shadows … it just accompanies us, that kind of fear, and it is undoubtedly one of the ways that women are kept in line. I think that beginning to work with that from our point of view is essential. In all those fear/exploitation films we get the superior knowledge of the attacker, even if we are supposed to be identifying vicariously with the terror of the heroine. In *Thriller* Mimi is looking at it from the other side, and not accepting it … not accepting the victim role or the inevitability of death, not accepting the need for her to be sacrificed in order to make the point of the story. Also there's another level in the suspense genre which is not about fear, but is about literally suspense and about mystery and thrills. It's the thrills in this case of analysis, of peeling away the layers, which is actually a form of pleasure. The real thrill of thinking of getting it sussed. Because that's how I experience my life, feeling suspended for a while, and then breaking through. Suddenly you get a clue, and the mystery unfolds; why you are the way you are and other people are the way they are and how things are held together.

GS: One of the things that surprised me in the film was the way the two women's positions are explained at the end. Was that a deliberate strategy?

SP: When I was making it, I almost had to hold my breath, and think 'OK, I'm going to say it'. Having done

this investigation through making the film, this, to the best of my knowledge, is my conclusion about what is really going on. For years my position was that the most useful thing one could do would be to raise questions. I now think that's all very well, but it's about time that we made a few tentative conclusions and not just always leave things interestingly open. I also think it's very much more to do with making an analysis that lives, that's not just pure dissection. I like the idea of being able to work simultaneously on conscious and unconscious levels. The unconscious levels are partly worked with through the image, through the framing, through composition, through evocation, and through music. For example, in the synopsis of the opera at the beginning, you get little snatches of music which are the key, almost signature tunes, for each person. They then remain consistent throughout the film, so if you get the Mimi signature tune coming up over something else, some part of your brain will have registered it previously and a connection will be made.

GS: So how is the opera being used in that way? You talk about mocking it, yet you talked before about it being very emotional, and so how much do you think it's still leaving the enjoyment of that intact, or is it just absolutely debunking and undercutting it?

SP: I have a fairly contradictory attitude to the opera, because the debunking aspect is about the more overt levels of romanticisation that I think are primarily destructive. The prioritisation of the heterosexual romantic love relationship, in which the woman is the tragic consumptive victim, their love is bound up with her vulnerability and weakness. The disguising of class relations, in that she is working class and her labour is never represented, while the artists and the nature of their work are romanticised. All these things are really to do with narrative, and the representation of persons, classes, genders and epochs. However, there's an aspect about death and loss and love which doesn't transcend those but is not entirely collapsible into them. When I was working with the music, and had heard it ten mil lion times, I suddenly found myself crying during the death scene. I think crying is a very important human function. It's not that it has made me cry, it's that it's reminded me of something important for me that needed to come out. So I'm sure that when people go to the opera and cry in the last act, they desperately need to think about death or think about the great love they never had. There are a thousand different stories actually going on and everyone's pretending it's *La Boheme*.

GS: Can you tell us about the new film?

SP: It is going to be a feature-length film. I've been working on the script in collaboration with Rose English and Lindsay Cooper. Rose is going to do the design, Lindsay is going to write the score, and I'm going to direct it. Babette Mangolte is going to do the camera, and the two main parts are going to be played by Colette Laffont (who was in *Thriller*) and Julie Christie. The script is almost finished, and the great leap into practical pre-production will start in April and it will be shot in the summer. If *Thriller* is anything to go by, the whole idea will be transformed. Briefly, it's about women and money. The two heroines find out about the various levels on which one can think about money and/or gold, whilst also examining the history of heroines. The BFI have put forward £100,000, and they are looking for more money so that it can get made in 35mm.

LMT: And what do you think about having a star?

SP: This is a deliberate choice. That's for a lot of conscious reasons, not least of which is wanting to address mass cinema, and see how far we can push our relationship to it. This starts inside the text, because her part looks at the history of the cinema heroine. It also means a lot of people will get to see the film who otherwise wouldn't, so it's a part of a bridgemaking strategy. I think it will be interesting because other people in the film won't be stars, which throws up the function of the really familiar face. The function of repetition, the connections with the icon, and circulation of the female face; and their relation to value, the circulation of women as value and investment. Then of course there are the particular qualities of Julie Christie as an actress and it happens that it's a project that she wants to participate in for her own reasons.

GS: Does the fact that it's got quite a high budget mean it's going to be more glossy than *Thriller*?

SP: Yes, I think it will be considerably more glossy – no chunks of dust every ten feet! It's remotely possible it might be in colour, if the money comes from a television company and they will only want to bring it out if it's in colour, but basically the only colour I'm interested in is technicolour, and it seems to be impossible to get technicolour. I love technicolour, because it's like primary colours. I always find that all the other colours which are supposedly realistic leave out what is really exciting about colour. And black and white has in-built distanciation, but I find it actually draws me in, and I get irritated by the textural surface things about colour – the excess of naturalism about it.

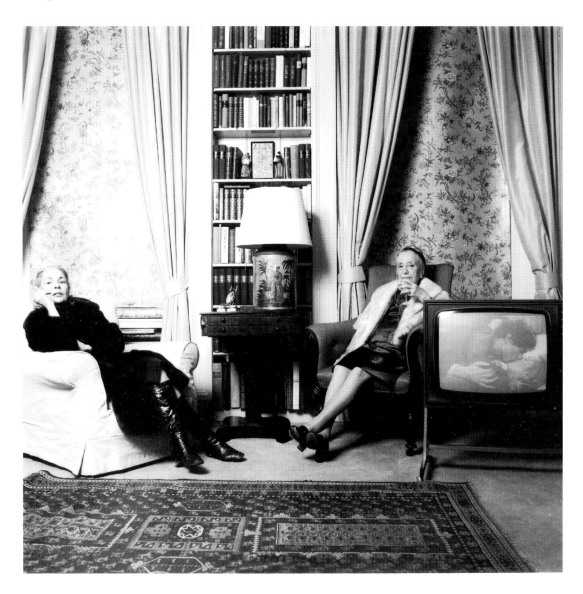

I live in the nineteenth century
the early nineteenth century
I am fascinated
by Napoleon and Metternich
two antagonists

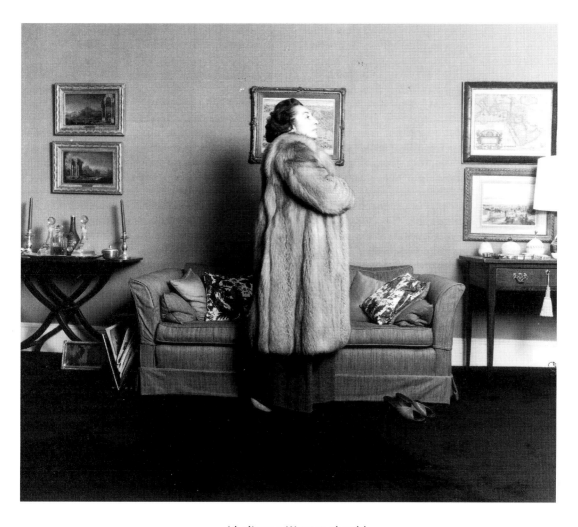

I believe a Woman should
keep her kitchen clean.
I walked into a friend's kitchen
and saw 2 Servants
squeezing oranges,
the sweat pouring
off their foreheads
into the juice.
I did not allow my Son
to drink it.

among godard's forms of thought
rod stoneman

introduction: the politics of polysemy

To talk of texts and associated modes of thought, the analysis of meaning production must start from an understanding of the interaction of text, context and reader as relative and dialectical ('the reading of a film is neither constrained absolutely, nor free absolutely, but historical', Stephen Heath). Alongside an investigation of the contexts and conditions of the reception of cinema we can also consider particular texts themselves as 'machines for thought'. A film is seen as the location of thought, the space where thought is at work rather than the transport system which conveys the finished product.[1]

Consideration of the political implications of different 'machines' inevitably raises a set of perennial questions which can perhaps be posed under the heading 'the politics of polysemy'[2] Some of these are articulated by Sally Potter in her interview in *Undercut* 1: 'It is extremely difficult to gauge the level of ambiguity that is useful, that draws one in on levels other than the obvious, and the point where it is necessary to say certain things. … It's a political question really – politically it's necessary to lay things on the line, while at the same time to be in a state of constant re-evaluation.'

Investigation into different modes of thought may allow us to be more precise about the ideologically enshrouded processes of 'artistic' thought and the specificity of Godard's textual production. His discursive figurations can be seen as quasi-theoretical in the sense that they are conceptual, analytical and critical but not as traditional forms of theory (this is not to identify theoretical discourse with that of art).

The often metaphoric thinking (in texts and interviews) throws up ideas in profusion – both new thought and also new non-linear modes of thought production. These are unrecognisable as sufficiently sophisticated models of understanding in purely academic terms. Producing new connections which transcend old categories its oblique lines of approach seem unrigorous as they move beyond constraining forms of logic. These are seen as *other* and are therefore not recognised by institutionalised forms of thought in equal terms.

The subject of these notes should be distinguished from those forms of the irrational espoused by surrealists and associated artists – another set of strategies explicitly in antagonism to the constraints of established thought. Surrealist programmes to mobilise the Unconscious for the more or less explicitly political tasks of cultural/social change seem to fall back into the still dominant ideologies of romanticism and individual creativity in time. Perhaps this is a result of the lack of clarity and precision of self-analysis applied to this strategy ('We are working at a task that is enigmatic even to us', Breton). Godard's mode of meaning production should be characterised separately in terms of its distinctive features and implications.

metaphoric thinking

The persistent textual figure of metaphor throughout Godard's work can be understood as an attempt to represent and think of this through that. Metaphor consists in giving a thing a name that belongs to something else, the presentation of meaning from one category in an idiom appropriate to another. 'Metaphor is a mistake or impropriety; a *faux pas*, a slip of the tongue, a little madness, *petit mal*, a little seizure or inspiration' (Norman O. Brown).[3]

In metaphor ideas and expressrons are formed at the intersection of the two paths of manifest elements and latent elements – a combination which produces specific 'interference effects'. The complexity of the intersection sets up a multi-dimensional interplay – friction is produced when meanings are articulated together.

The importance of the metaphoric vehicle itself, producing its own specific meanings, is shown in the use of prostitution in *Deux ou Trois Choses…* (and to some extent again in *Slow Motion*) and constipation in *Numero Deux*. These conditions stand for complex social positions and effects that go beyond any simple literal transposition. So too the metaphoric connection of Cowboy/Western and Western/Imperialism in *Vent d'Est* moves beyond reference to the literal historical identity of the components and into a field of resonance invoking wider aspects of contemporary cinema, popular culture and the complex relations of dominance between US/Third World/European cultures and economies.

The utilisation of some of the same working methods and modes of meaning in films that are chronologically a long way apart indicates the continuities that exist across the strategic rupture and interregnum of, say 1969–80; and the persistent legacy

of the unfocused poetic/lyrical critique of society found in the earlier films. Some of these continuities, and other aspects of Godard's recent personae that have often been discreetly ignored, might suggest a relapse into a morally-based critique, and connections between his libertarian politics of pessimism and a romantic humanism.[4]

In metaphor as in dream-work, representation is made easier when an abstract idea is worked through an equivalent which lends itself to visualisation – an emblem or concrete symbol. In representing ideas which are often complex and contradictory the complex figure becomes a nodal point for the formation of a disparate unity of meaning.

It is inevitable that the adoption of visual forms of thought, setting unstable metaphors and emblems for the complex interaction of over-determined meanings, will not be recognised by the predominantly verbal discourses of academic thought. The metaphor, in 'unleashing the power that certain fictions have to redescribe reality'[5] is confined, in the social hierarchisation of discourses, to the 'artistic'.

displacement, digression

The discursive strategies that Godard utilises in questioning the two small children in *France/Tour/Detour/Deux/Enfants*, and indeed in replying as interviews to the questions of others, are those of displacement, evasion and digression. Following his assertion that writing is only quantitatively and not qualitatively different from filmmaking, it may be appropriate to see articles written by Godard and interviews with him as a continuation of the 'creative' work – no more (or less) than the modes of meaning encountered in the films and tapes.[6]

In his discursive flow, ideas and referential systems are liable to detach and pass on to other ideas; one can make a guarded analogy to the 'free' displacement of energy which is seen in psychoanalysis as one of the characteristic modes of operation of unconscious mental processes. 'The psychoanalytical theory of displacement depends upon the hypothesis of an economic structure of cathectic energy able to detach itself from ideas and to run along associative pathways' (Laplanche and Pontalis).[7]

The enunciation of the speaking voice[8] slips aside, turning questions back upon themselves, channeling thought away from fixed paths and assumptions; it makes oblique advances and effects tangential, glancing blows at ideological positions. The subtle movement of thought, veering off logical progressions and fixed meanings, is exemplified in the long

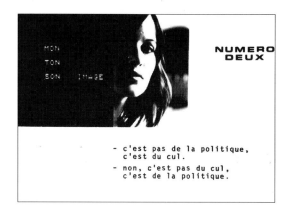

NUMERO DEUX Jean-Luc Godard

direct speech by Godard to camera at the beginning of *Numero Deux*; the successive shifts move between the personal, historical, analytical – 'This guy is complicated, right, but I'm talking about you…'

Digressions, taking unexpected and indirect paths of meaning, relate ideas only by tenuous and non-linear chains of association – precisely the detour involved in *France/Tour/Detour*. In deviating from strict and causal forms of connection they can be seen as transgressing the enforced economies of the dominant mode of representation, non-linear formulations offering new forms of textual productivity in their very unpredictability and excess.

The same oblique lines of enquiry and response which governs the interviews in *France/Tour/Detour/Deux/Enfants* as when the interviewer asks:

Do you enter your home or does your home enter you? It could be both…

and:

Do you think that great discoveries are made during the day or the night?

During the day.

Edward de Bono, in his work on the limitations of vertical/logical thinking, found that children, before they are educationally conditioned into rigid thinking patterns, often approach problems within changed perceptual and conceptual frameworks which leads to the possibility of changed solutions. In *The Child's Conception of the World* Jean Piaget extends and develops valuable research in this area, outlining the undifferentiated field of self and reality that young children think within; as not-entirely socialised, sexualised (stabilised) subjects they are the sites of 'other' forms of thought in which the dualism between internal and external, between thought and things and the economic paths of

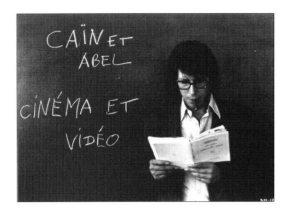

SLOW MOTION Jean-Luc Godard

mono-logic have not been constructed.

What is memory like?

It is a little square of skin, rather oval, and inside there are stories (les histoires). They are written on the flesh.

What is thought?

It's white inside the head.

What do you think with?

A little voice.

Where do dreams come from?

It's the night that makes dreams…

It is I that am in the dream, it isn't in my head.

(Extracts from conversations with children, 8, 12 and 5 years old, in *The Child's Conception of the World*, pp. 68, 66 and 121.)

The god of Delphi, who always spoke the truth, never gave a straight answer but always spoke in riddles, ambiguities; 'The real deceivers are the literalists' (Norman O. Brown)[9] and 'The truth: what is oblique' (Roland Barthes).[10]

puns and incongruity

Puns can be described as conjunctions of meanings (images and/or words) which are themselves fixed and stable, but which destabilise and lead to further polysemic change on combination. In puns 'two words get on top of each other and become sexual' (Norman O. Brown).[11]

In *Numero Deux* the verbal pun 'Mon, Ton, Son … Image' occurs when two dimensions in the word 'son'; arbitrarily motivated at the level of the signifier, and appropriate enough at the level of the signified (His image of…). Internal puns, the suggestions of words within words, are found in many of the earlier films:

E/SS/O in *La chinoise*, Cinema/o and Cinema/rx

in *One plus One*. The incongruity of the connection child/vagina/memory in *Numero Deux* whilst not exactly a pun has an analagous effect – provocative, disturbing, evocative…

Visual conjunctions, whether intentional or contingent, such as the Marlboro and tanks near the railway in *Slow Motion* or the Bechstein piano and musical action in the farmyard in *Weekend* destabilise meaning of certain scenes and the naturalistic space in which they take place through their incongruity.

The spectating subject is caught in the play of 'its' own readings of shifting meanings, almost bringing the structures of reception into play.

reversal, paradox

Whether condemned as a mere mannerism, a Parisian intellectual pirouette or celebrated as part of Godard's authorial eclecticism, verbal play hinging on repetition and reversal has been a repeated figure of his work:

'Am I happy because I'm free or free because I'm happy?' (*Le Petit Soldat*)

'Happiness is simple, unhappiness is complicated.' (*Numero Deux*)

'The beginning of a story or the story of a beginning.' (*France/Tour/Detour*)

Appearing more or less brilliant or captivating on first encounter, it is difficult to hold their meaning in focus in further examination: 'It's logical that the logical should contradict the logical,' (quoting Corneille in *Le Mepris*).

Offering the pleasure of paradox[12] or neat reversal they are thoughts which close in upon themselves elegantly and formally. Although they run the risk of becoming merely decorative or ornamental these figures of thought are loaded with the most spectacular signs of fabrication and break the surface of the text as though they were quotations from outside the film itself (remembering Brecht's injunction that 'lines should be spoken as though they were quotations').

intertextual thinking

Godard's mode of thinking through the fragmentation and recombination of previously existing material, almost to the point of assemblage, makes the intertextual space of his films explicit. The notion of intertextuality implies that no text is complete in itself but it is held in a set of complex relations with other texts – its place in culture and in history. Godard's work is exceptional in laying bare the networks of connection behind it.

Pierrot Le Fou makes intricate forms of reference

and connection, to both his own previous work and an unusually wide field of cultural production beyond it. There are precedents in literary modes – Joyce's work and Norman O. Brown's early *Love's Body* (1966) and more recently Barthes' brilliant *Fragments of a Lover's Discourse* which refers throughout to a disparate series of intertexts: Goethe's *Werther*, Plato's *Symposium*, Proust etc…

The play on parascientific meaning relations involved in Godard's arithmetic: 'Unemployment – Pleasure = Fascism' (*Numero Deux*) depends on a form of intertextual displacement, as do the metaphoric transpositions from myth such as: 'Cain & Abel: Cinema & Video (*Slow Motion*).

The intertextual aspects of the work of Godard, and its relation to other modernist practices, deserves description and analysis at much greater length than the scope of these preliminary categorisations; Peter Wollen has touched on some of these in his analysis of *Vent d'Est*.[13]

ending

Consideration of Godard's work in these terms leads again to to the politics of the specific signifying practices, forms of avant-garde[14] representation that he adopts. Any discussion of these politics should take into account the context of the reception of particular textual strategies, which is crucial if one is to avoid an exclusivist and sectarian response – espousing this or that form of film (be it agit prop documentary, radicalised art cinema or structural materialism) as the exemplary practice. Different signifying practices can be useful and justifiable (in defined political/cultural terms) in the different spaces of a culture at any one time.

The non-linear modes of thought adopted by Godard may be correctly assessed as respectively marginal, advanced, effective, confused in various different locations of reception. His work has to be placed in the history of meaning systems and their relation with the spectator.

The writing of the French philosopher Michel Foucault has indicated some of the ways in which discourses, as systems of speech and representation involve the transmission of power relations. He has described discourse as an ensemble of ordered procedures for the production, regulation, distribution and functioning of knowledge and power. In the end the modes and figures of Godard's discourse described in these notes can only be considered in the spaces and institutions in which they circulate. One would have to ask, among other things, how effective an intervention here were the programmes

made by Sonimage for French television (Jill Forbes has described the conflicts between the production and distribution arms of ORTF).[15] What impact did the earlier films such as *Pierrot Le Fou* and *Weekend* made in the reception space of Art Cinema, what are the possibilities of *Slow Motion* now? How can *Six Fois Deux* or *Numero Deux* for example, be used in education?

At best we might be able to talk of some of Godard's work mobilising a signifying practice for a defined usage, a certain type of discourse that engages and opposes (in) a certain field of knowledge. His work can be used in a context which disrupts and the continuities and exposes the contradictions of dominant discourses.

The avant-garde text moves into action, becoming an exploration of the spectator's relationship with language and with sexuality, and 'through these with ideology and the social system … it plunges deeper and deeper into the polysemic maze'[16] – hermetic and inaccessible to language users brought up on monologic.

1 Cf. Peter Wollen, *Signs and Meaning in the Cinema*, p. 164.
2 Polysemy – unstable and potentially multi-valent fields of meaning.
3 Norman O'Brown, *Love's Body*, p. 244.
4 A critique hinted at in some passages in Colin McCabe, *Godard: Images, Sounds, Politics*.
5 Paul Ricoeur, *The Rules of Metaphor*, p. 7.
6 To assert the continuity between Godard's discourses and textual elements of the films is not to deny the importance of other factors and collaborators (Gorin, Mieville, *et al.*).
7 J. Laplanche and J-B. Pontalis, *The Language of Psychoanalysis*, p. 121.
8 'Discourse' rather than 'History' to take up Metz's terms for the delineation of modes of address: 'Discourse and history are both forms of enunciation, the difference between them lying in the fact that in the discursive form the source of the enunciation is present, whereas in the historical it is suppressed. … Discourse always contains as its point of reference a "here" and a "now" and an "I" and a "you"'. Geoffrey Nowell-Smith, 'A Note on History/ Discourse', *Edinburgh 76* Magazine.
9 Norman O. Brown, *Love's Body*, p. 245.
10 Roland Barthes, *Fragments of a Lover's Discourse*, p. 231. As part of the attempt to develop a typology of meaning systems in history, perhaps we can also say, with Barthes, that 'the writer falls prey to ambiguity since his consciousness no longer accounts for the whole of his condition.' *Writing Degree Zero*, p. 60.
11 Norman O. Brown, *Love's Body*, p. 252.
12 Cf Patrick Hughes and Georges Brecht, *Vicious Circles and Infinity – A Panaoply of Paradoxes*.
13 Cf Section 5 of Peter Wollen, 'Counter Cinema and Vent d'Est', *Afterimage* 4
14 The Gap between Godard's work and the English avant-garde has been reduced in the period since the dominance of structural minimalism, cf recent films such as *Emily* (Legrice), *Vistasound* (Legget), *Thriller* (Potter).
15 Jill Forbes 'Jean-Luc Godard: 2 into 3', *Sight and Sound*, vol. 50, no. 1.
16 Cf Julia Kristeva, 'The Ruin of a Poetics', *20th Century*, 7/8, p. 115.

atmosphere, palimpsest and other interpretations of landscape
patrick keiller

I don't suppose I can have missed a single episode in the first year of *Z Cars*, but I can't remember any of them. In fact I don't think I can remember in detail anything that I ever saw on television apart from a few oft-repeated items, and I suspect that such lack of retention is general.

This is a pity, for apparently only two episodes of *Z Cars* survive from the first six months of the series. I mention this having seen them (again?) at the NFT last September, this time on the cinema screen, where they were revealed as examples of a hitherto unknown and rather timeless genre.[1]

'They fight crime on wheels in a new series beginning tonight', said the *Radio Times* on 28 December 1961. Fighting crime on wheels has got itself a bad name in the period since, but in those days the lads in the cars were cast as more or less sophisticated social workers, imbued albeit with the extra moral authority of the law, who cruised from domestic disturbance to truant shoplifter distributing a positive understanding over the public-sector suburban desolation of (Kirkby) Newtown. It is this desolation that hasn't dated: it's all still there, and it still appears on television, in the work of Alan Bleasdale *et al.*, though for my money a low-key *Z Cars* beats their didactic tear-jerking any day. The difference is that in 1961 things were considered to be capable of getting better, whereas now everyone thinks they're getting worse. Both the episodes shown took a 'social problem' as their theme rather than any crime. The first had Jock Weir and Fancy Smith ('Z Victor 1') trying to prevent the biggest of a shipload of hard-drinking just-got-paid Norwegian whalers from being fleeced by a girl desperate for money (the 'social problem'), posing as a waterfront prostitute. All the action takes place inside a pub, which is just as well as the surviving print is re-filmed from a video monitor and is not very sharp.

The other episode ('People's Property', 15 May 1962) was mostly the original, probably 35mm, film, but parts of this have evidently gone missing and been replaced by sections re-filmed from a video monitor, which are inserted quite uninhibitedly, the change often occurring in mid-scene. The original photography is very good, and when seen on the screen is reminiscent of later Ealing films. This is an observation one could never make seeing it on television, and which quite undermined my vague memories of the series. The episode makes 'much use of atmospheric locations', which probably also did not come across on television, the landscape locations suffering most of all. It is not, however, my intention to make a polemic on television versus cinema or video versus film, by suggesting that revelatory experience when seeing a 21-year-old television programme in the cinema is proof that, at least as regards the meaningful portrayal of landscape, television is a medium deeply inferior to the cinema. I probably do think all these things, but my purpose is rather to use the episode as a vehicle with which to get from the desolate landscape of Kirkby to another.

The story follows the exploits of two boys (the 'social problem'), one a clever misfit, one his stooge. The former looks a bit like John Lennon aged ten, but we weren't to know that then. First discovered misbehaving on the roof of a factory at night (the first atmospheric location), they go on to shoplifting and handbag theft. They are caught, but let out again because all the places they could be sent are full up. Skipping school they go on a spree of petty theft until they are caught again but let out for the same reason as before. In a last gesture they run away to Wales to climb a mountain, departing on the bus to Wrexham via the Mersey Tunnel. Jock and Fancy (ZV1 again) find out about this shortly after the bus has emerged from the tunnel, but being some miles behind, don't catch up with it until the boys have been thrown off as a result of their unruly behaviour, and hitched a lift with a farmer in a Ford Zephyr. He lets them off at his gate and they continue on foot up the desired mountain. By the time Jock and Fancy arrive they have left the road and are half way up. J & F leg it up the hill and after a display of puffing and rugby skills they apprehend the pair. All this time they have been facing in one direction, in single-minded pursuit of their respective goals, but after the capture, seemingly accepted by the boys, they all turn round, having got their breath back only to have it taken away again by a view for twenty miles across the Dee Valley. 'By 'eck', gasps Fancy, touched by the sublime, 'look at THAT'. The camera obliges with a slow pan over the view, during which not a word is spoken. An awesome spectacle of landscape, it seems, transcends even the most difficult predicament.

This is even more true in films than in life, and in both realms of experience such sentiments are prone to cliché. What is more surprising is that they seem to

INVASION OF THE BODY SNATCHERS Philip Kaufman

LE GRANDE ILLUSION Jean Renoir

be universally felt, and to a great extent in the same way, by persons of widely differing political and other persuasions, whereas other manifestations of beauty are not. There is nothing improbable in the idea of a policeman, even a real policeman lacking the insight of Fancy Smith, being struck dumb by a good view.

The view itself is worthy of some scrutiny: a patchwork of fields and hedges, the occasional tree or copse, the ground undulating in a small way, all this viewed from high ground to the west and lit from behind the viewer by the afternoon sun. This is a dairy farming landscape like those featured in butter commercials. It belongs to that type of view that could properly be called 'green and pleasant land', and is the dominant image of English landscape. In fact it is found only in small parts of the country to the west of a line between London and, say, Lancaster. The eastern counties and the hilly districts are not a part of this arcadia, and tend to be seen either as local phenomena, or in terms of landscapes of other countries: the East Riding of Yorkshire is 'middle European', the Cotswolds 'Mediterranean'.

The Dee Valley view is analogous with the view across the Severn valley from Malvern, perhaps that from Hergest Ridge, and others in the west of England. I suspect, however, that the hegemony of this type of view in the national imagination has more to do with the former appearance of Sussex than anything else, and reflects the class status of the home counties: their arcadia an imagined former rural identity now undermined by middle-distance commuting and suburbanisation. The famous view through the gap in the trees which surround the Duke of Norfolk's cricket ground at Arundel Castle is surviving evidence for this supposition, and its connotations are in this

location pinpointed by the feudal sounds of leather on willow etc.

The society of the Dee Valley is very much that of the Cheshire 'county'. It is their creation, in as much as all landscape is the result of human interference. It is where the Cheshire hunt still hunts, now with the support of non-landed bourgeois money from nearby metropolitan areas. In short, the connotations of both its imagery and its inhabitants are more or less disgraceful, and yet its representation remains moving. The experience of landscape not only transcends individual suffering (the boys' capture), but even that very general tragedy of which the landscape itself is a result. This combination of the tragic and the euphoric is a dominant quality in innumerable depictions of landscape, especially when these are from above, and so supply implications of pattern, understanding or explanation and hence compassion not available to observers on the ground.

It is a view that probably dates only from the nineteenth century, and is in any case not universal. Notwithstanding the difference in motive, those paintings of various of Napoleon's battles, seen from a nearby hill, contrast with battle scenes from a similar viewpoint in *Birth of a Nation*. The paintings display a disciplined efficiency, while Griffith, with a comparable lack of technical sophistication in visual matters, manages to present his war in a far more complex picture of chaos, squalor and pain.

Daniel Defoe, writing in 1724, says of the Dee Valley: 'The soil is extraordinarily good, and the grass they say, has a peculiar richness in it, which disposes the creatures to give a great quantity of milk, and that very sweet and good.'[2] Already the butter commercial is imminent, but here beauty is synonymous, rather

than simultaneous, with productivity or prosperity. In any case, Defoe may be said to pre-date the sense of the picturesque. In the rare instances where he describes landscape itself, that of the Yorkshire Dales for instance, his purpose is to discuss the disposition of industry upon it.[3] For him the Lake District was a barren wasteland.

In Richard Wilson's painting *The River Dee: Holt Bridge* (c. 1762), the picturesque is already well established, not so much a result of easier travel or burgeoning industrialisation, but the concurrent desire for a Virgilian idyll in which to set the then present-day. In the painting, which echoes a Venetian sensibility as well as that of Claude, elements of the scenery are stressed for their classical comparability: the sandstone cliff; the (church) tower; the flat plain and distant hills; the 'peasants' and the bridge. All these elements are interpreted in terms of Wilson's repertoire of elements of classical *mise-en-scène* collected in his sketchbooks while in Italy. Most important, because invisible, is the historical significance of the bridge itself as the link between England and Wales, and the aura of antiquity which this bestows.

This metaphorical transposition of landscape – seeing somewhere as somewhere else – and the consequent effect on the landscape are widely encountered in art, life and the relations between these. In the simplest sense, in *Radio On*,[4] the journey along the A4 is converted by the cinematography into one across some unspecified but definitely East European plain. Blea Tarn, which lies at the top of a pass between the two Langdale valleys in the Lake District, was the inspiration and subject of a passage in Wordsworth's *The Excursion*. A later sensibility, aroused perhaps by Wordsworth's poem, but informed more by Chinese and Japanese scenes, was inspired in the unknown landscape-gardening landowner who planted Rhododendrons around the tarn, which still thrive despite the altitude, and parallel the domestication of Wordsworth's vision. This is not so much 'seeing somewhere as somewhere else', but 'seeing somewhere in terms of a picture of somewhere else'.

By the time Thomas de Quincey passed through the Dee Valley, he too a runaway schoolboy in 1802, the sensibility of Wilson's generation had had its effect: 'The Vale of Gressford, for instance … offered a lovely little seclusion. … But this did not offer what I wanted. Everything was elegant, polished, quiet, throughout the lawns and groves of this verdant retreat: no rudeness was allowed here; even the little brooks were trained to 'behave themselves'; and the two villas of the reigning ladies … showed the perfec-

tion of good taste. For both ladies had cultivated a taste for painting.'[5]

The last sentence tells all. De Quincey moved on into the mountains in rehearsal for his sojourn as the Wordsworths' neighbour at Grasmere. Earlier in the same journey, he pinpoints the phenomenon: 'An elaborate and pompous sunset hanging over the mountains of North Wales. The clouds passed slowly through several arrangements, and in the last of these I read the very scene which six months before I had read in a most exquisite poem of Wordsworth's. … The scene in the poem (*Ruth*), that had been originally mimicked by the poet from the sky, was here re-mimicked and rehearsed to the life, as it seemed, by the sky from the poet.'[6]

Poe was familiar with this mechanism of romanticisation, but such ephemeral effects do not satisfy him: the landscape gardener is produced to cement the cyclical relationship between poetic experience and the material world, to conduct: '"Its adaption to the eyes which were to behold it on earth": in his explanation of this phraseology, Mr Ellison did much toward solving what has always seemed to me an enigma – I mean the fact (which none but the ignorant dispute) that no such combination of scenery exists in nature as the painter of genius may produce. No such paradises are to be found in reality as have glowed on the canvas of Claude. In the most enchanting of natural landscapes there will always be found a defect or an excess. … In all other matters we are justly instructed to regard nature as supreme. … In landscape alone is the principle of the critic true.'[7]

The supposition may be said to rest on misconceptions, but in the end it probably holds true. Landscapes that do not result from human intervention – rain forests, uninhabited islands – are no less susceptible to criticism than those that do, and still life and portraiture generally involve a far greater degree of verisimilitude, and consequently less idealisation, than depictions of landscape. The relation between the idea and the reality of landscape really is different. The reasons for this lie in the rather obvious distinction between, say, a sheep, as a thing, and a landscape, as perhaps also a thing, but more usefully a general disposition of things (one of which may be the sheep), and in the further distinction between the relationship of a viewer and the sheep, objects of more or less equal status, and that between this viewer and the landscape, in which the viewer and the sheep are constituents in the general disposition.

In the first distinction, the general disposition of

LA REGLE DU JEU Jean Renoir

NIGHT OF THE LIVING DEAD George A. Romero

things is much more susceptible to alteration (land-scape gardening) than any single thing (the sheep), and is corollary-wise much more likely to be at vari-ance with any imagination of it (a picture) than would be the case with the sheep. Thus the possibility of, and the desire for landscape gardening both stem in the very same way from the nature of landscape itself, and the cyclical relationship between the imagination of it and its reality is permitted: the real appearance of Tuscany gives rise to an imagination of landscape which gives rise to an alteration of the real appear-ance of England. This relationship is not confined to visual matters: every landscape has its myth and every myth has its history. The landscape of Milton Keynes is rooted in a myth about Los Angeles, and the land-scape of suburbia ('unplanned') is rooted in a myth about yeoman-villagers and their village, folk memory of the English petit-bourgeoisie.

In the second distinction, the viewer's gaze sur-rounds the sheep: it is apprehended all at once. Even if the sheep were as big as a house, the viewer would only have to move away from it to restore the rela-tionship.[8] In the landscape, however, the viewer is always surrounded, and so the business of picturing is infinitely more complex both technically and con-ceptually. Devices such as the 'frame within the frame' have evolved partly to deal with this, and it is this dis-tinction between modes of viewing that differentiates the parallel analogies between an object and an idea, and one's surroundings and a mood, atmosphere or state of mind.

Landscape functions in all these ways in the cin-ema, perhaps more so than anywhere else. The tragic-euphoric palimpsest; the reciprocity of imagination and reality; place seen in terms of other place and setting as a state of mind are all phenomena that

coincide in films.

The exact way in which this happens is generally determined by a more or less complex and more or less intense metaphorical relationship between land-scape and narrative, like that between the volcano and Ingrid Bergman's spiritual crisis in *Stromboli*. The volcano, as singular a presence as any, is employed in a variety of ways: its rumblings parallel her unease; it is the cause of her isolation and it hosts her despair and redemption when she tries to climb over it to the outside world.

Similar ambiguities between benevolence and malevolence are general and twofold. The landscape may or may not be sympathetic to the protagonists, and the film may or may not echo this judgement. In Herzog's South American ventures both forest and invaders are equally Godforsaken, but the forest is bound to win, and few tears are to be shed over this. On the other hand, the geography of *The Wages of Fear* is a lackey of the employers, and it really is sad when Yves Montand's truck goes over the edge.

In John Ford's films a more metaphorical idea of predicament is entertained. *The Lost Patrol* slowly and inexorably pursues the archetypal spiritual analogies of the desert, while the impotence of Boris Karloff's religious-fanatic behaviour increases as it becomes more extreme. Ford's desert is very like his opposite-but-similar ocean in *The Long Voyage Home*. In *The Quiet Man* the surface of Ireland is cast (as it often is) as a palimpsest of the type previously described, and the conflict that is the film's story is over rights of access to history and 'rootedness' through ownership of land and other property. The outsider, John Wayne, despite local origin of parents, is only able to secure these rights to their past by employing his skill as an ex-champion boxer, the very thing he was so anxious

to conceal in his own past. Subject matter and setting are even more closely identified in *The Grapes of Wrath*. Here the palimpsest is active, for the landscape itself, by physically blowing away, becomes the instrument by which the landowners' exploitation leads to suffering on a biblical scale.

With Renoir the relationship is similar, if more subtle. The passionate excesses of *La Bête Humaine* are orchestrated entirely by the railway, its own landscape and that through which it runs. The sexuality of the railway engine pervades the intricacy of timetabling, and the landscape, again as a palimpsest, models the ideas about heredity and misfortune that underlie Zola's novel. The country house and its surroundings in *La Règle du Jeu* offer some kind of social order, but it is riddled with pitfalls, like the location where the shooting party goes wrong, all marshes and thickets: a model for the confusion that is unleashed upon it. In *La Grande Illusion* the geography is again a predicament. The hostility of the warring nations and their frontiers are mocked by the continuity of landscape and its beauty, as in an atlas the physical map mocks its political partner. At the same time, for the escaping prisoner of war topography is all important: inaccessibility and concealment now offer safety rather than the peacetime risk of getting lost; and all the best frontiers are located by geographical features.

Invasion of the Body Snatchers shows a landscape which may offer concealment, required despite the lack of war, but is more likely to trip up running feet shod with city shoes. It conspires with the invaders to isolate the town without the need for frontiers, and lends its fertility to their marketing gardening operation. In a paranoid time nature is at best inconvenient and at worst actively hostile. Civil engineering projects were the human revenge for this. In *Hell Drivers* a pleasant enough countryside is subjugated to the needs of construction. The landscape is again physically involved in the story: the protagonists dig great holes in it, pick it up and carry it about. Their pitfalls are provided by the remains of previous human exploitations: the narrow twisting roads on which they drive so competitively, and the abandoned quarry pit, on the edge of which they fight.

Night of the Living Dead is probably the most visually sensitive of those later films (*Zombies, Shivers, Rabid* etc) in which unpleasant beings that are just scientifically plausible confront living humans, and in which landscape generally plays a neutral role. The opening scenes show a country graveyard in a Pennsylvania landscape. This scene is well aware of

its history: it looks European, and the name of Penn underlines this connection. Elegantly photographed in sylvan black and white – not at all noir – it presents a poetic if melancholy scene. Only its occupants are spiritually uneasy as they visit a grave, while the technological hubris of their society accidentally restores a kind of collective life to their recent dead, who rapidly infest the landscape devouring the living where they find them.

Several of the still-living find themselves sharing the refuge of an isolated house as night falls. This idea of the solitary house in the landscape is very clear, almost archetypal as in *The Fall of the House of Usher*. The landscape itself remains neutral: it provides concealment but isolates the victims from rescue; the living dead blunder across it, but it offers the possibility of escape. This does not occur, though, and the greater part of the rest of the film is set inside the benighted house, and offers more elegant photography in an essay of architectural phenomenology worthy of Gaston Bachelard: inside and outside; upstairs, downstairs and basement; windows, doors, cupboards and furniture are all clearly differentiated by the acuteness of the unusual circumstances. In the morning the one survivor, a black man, emerges from the basement to be shot by a sheriff's posse, who assume he is just another living dead-man, or by now simply don't care.

This brutalised attitude is duplicated in the portrayal of the landscape. Nothing about it has physically changed, but now the camera ceases to flatter: the sky is bleached, the composition is blunt. There is an expediency like that of television news footage. The only feeling left is the uneasy camaraderie between the slobs who comprise the posse, and it is their view that we see in these last scenes. As always, the meaning in the landscape resides only in the imagination of whoever looks upon it.

1 On the other hand, there were elements of nostalgia: the cars, for instance – there were always an awful lot of Fords. Perhaps the BBC had done a deal.
2 Daniel Defoe, *A Tour through the Whole Island of Great Britain*, Volume 2, Letter 7.
3 *Ibid.*, Volume 3, Letter 8
4 *Radio On* (102 mins, B&W, UK/West Germany, 1979), Chris Petit's road movie, photographed by Martin Schäffer.
5 Thomas De Quincey, *The Confessions of an English Opium Eater*, the revised version of 1856.
6 *Ibid.*
7 Edgar Allan Poe, *The Domain of Arnheim.*
8 If it were a house, the position would be slightly different, as the outside could not really be apprehended, and when it could the viewer would be inside it, and only partly aware of the outside. This is the unique dual status of architecture.

the picture of health?: signs of the body
jo spence, maggie murray

The pictures included here are part of an overall health project in which I am trying to make visually available what is usually unknown and unseen by most people. The entire project (funded by the Greater London Arts Association) will be shot in different styles and genres of photography in order to foreground how meanings are produced and how they differ within different discourses. I want to describe and problematize a particular form of struggle – physical and psychic – for health, particularly against breast cancer.

I am the subject and the director of these photographs which show acupuncture, moxibustion and herbal medicine for the treatment of my overall health condition within the system of Traditional Chinese Medicine. The pictures were taken by Maggie Murray of Format in collaboration with myself and constitute only a small part of the total number done for this section of the exhibition. This particular part of the overall project is to examine the benefits of low technology medicine at low cost, as against high technology at high cost (which is usually at high cost to the body too).

Apart from being involved in an actual struggle for health, I see this work as a symbolic struggle in which I am trying to understand what is happening to me. Although I don't believe that you can understand things merely by looking at them, women's bodies (and in particular their breasts) have for some time been a subject of debate within a study of visual representation. I am interested to help provide material to widen this discussion between those interested in aesthetics and those interested in political struggles around health.

This work when finished will ultimately be available to women's groups, health centres, schools, colleges and libraries.

– Jo Spence

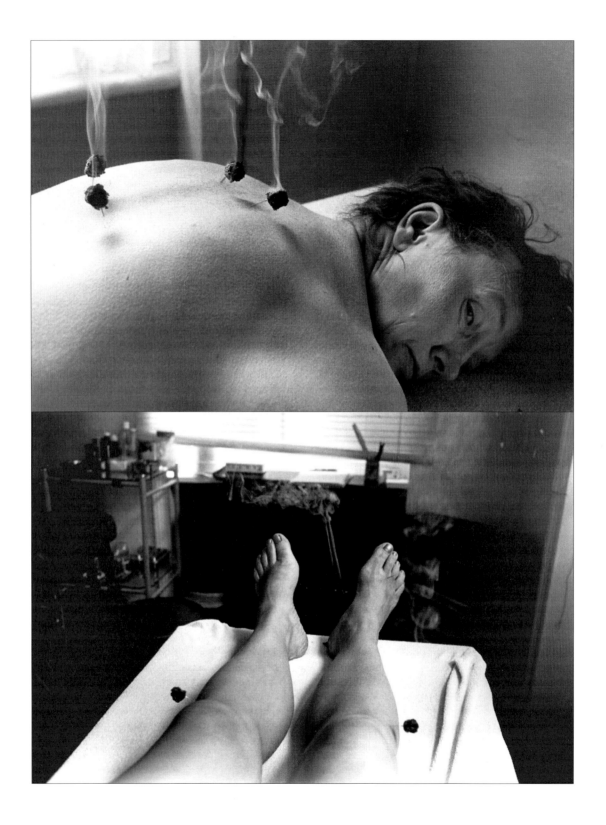

evidence of struggle – problems with 'india song'
trista selous

Whenever I leave a showing of a film by Marguerite Duras I have a sense of profound discomfort. A feeling that I have been taken – albeit willingly, I even paid for my ticket – for a ride to somewhere that, had I thought more carefully, I would probably have refused to go.

Before I ever saw *India Song* I had heard of it, and of Duras. I had heard of it as a film which explodes the strictures and conventions built into other films, closing their meanings and binding their viewers in certain positions of subjectivity. Duras refreshes the parts other filmmakers do not even know are there. By the second time I had seen it I had read the book of the film and other things by Duras. By the third time I had seen it, I had read a substantial amount both by and about Duras. I am recounting this because I do not think a film is an isolated text whose meanings are produced outside the context of what is written about them and the people who make them – which is, incidentally, one of the main reasons why I want to write about *India Song*.

Duras' work seems to generate two distinct categories of writing; one investigates it using a psychoanalytical framework – it produces sentences like this, from *Camera Obscura*, 6: 'If *India Song* proposes to us a reading of psychoanalytic theory, it is insofar as the film, like the fantasy, is the *mise-en-scène* of desire', or like this, from Lacan: '*Le Ravissement de Lol V. Stein*, in which Marguerite Duras shows she knows what I teach without need of me'[1] – in other words, Duras' work is seen as an exposition of psychoanalytic theory. Alternatively, there are those articles and texts, such as that by Bruno de Florence in *Undercut* no. 2, which are written more as personal statements.[2] The style is fragmented, verging on the poetic; the overall effect is that of a writer straining to express the inexpressible resonance within her/him of Duras' work.

These two approaches have one feature in common: they are never critical in the sense of censorious. De Florence says his text 'was a way for me to thank Duras and share my fascination and admiration for her with an English audience'. Lacan, not known for his charitable references to others, calls his piece on Duras a 'Homage to Marguerite Duras for *Le Ravissement de Lol V. Stein*'. Sentiments of gratitude/fascination/admiration permeate the writings of all those who want to write about Duras. They form part of the context in which *India Song* is seen. Marguerite Duras has acquired the mystique of someone who is more in touch with the fundamentals of human existence than other mortals. More specifically, as I read in the work of women such as Michèle Montrelay or Marcelle Marini, she is in touch with the fundamentals of women's existence. Her texts strike archaic and hidden chords in the breasts of these women, I read: Duras expresses 'femininity' in her construction of silence – a place from which that unspeakable can resound.

The tone of these writings accords with that of the places in which I have seen films by Duras. *India Song* I saw first at the RCA, then at the ICA, then at Goldsmiths' College. Films shown at such venues attract certain kinds of audience, there because the film has been given a meaning as 'interesting'.

Watching any audiovisual artefact requires a certain suspension of awareness of the context in which I am watching it, but a cinema is more conducive to that suspension than my livingroom, for example, when I am watching television. In a cinema people who rattle crisp packets or mutter in loud whispers may receive a torrent of abuse if they break the spell of the film. When the lights go down my relations and identifications with the people around me, my job, my friends, all are pushed to one side in favour of those I have with that source of light and sound, the film. In cinemas where I have seen films by Duras the audience is particularly quiet, thus allowing my relationship with the film to develop with the minimum distraction.

So we sit in silence with the image in all its plenitude before us, inviting identification with the figures on the screen and with the watcher of those figures, playing with desire. *India Song* both feeds and frustrates that desire, that process of identification, by at once presenting the image and imposing a distance from it, through constant aural and visual reminders that what appears to be happening here and now on screen is at the same time, past, long ago and far away. Anne-Marie Stretter is dead, the house is at once full of the richness and elegance of the highest echelons of colonial society and a decayed and empty shell. The soundtrack adds to this ambivalent status of the image, con-

INDIA SONG Marguerite Duras

sisting entirely of conversations spoken from some-where off-screen by disembodied voices whose identities are at the very least uncertain, although at points attributable to Anne-Marie Stretter, the Vice Consul or the *jeune attaché*. These conversations are often interrogations of the image, its meaning, its possible consequence, attempts to reconstruct a story which never quite succeed, always reminding the watcher that the image may not be what it seems, that it is simultaneously present and absent. Hence, it has been suggested in Lacanian terms, that the fascination which the film generates, is a constant representation of loss; the object which is there and not (it is the work of the fantasy to try to 'cover the moment of separa-tion between before and after ... between the two stages represented by real experience and its hal-lucinatory revival, between the object that satisfies and the sign (the breast) which describes both the object and its absence. ... The fantasy originates in the continually renewed and repeated moment of separation').[3]

But it is not any and every old object which gets invested in this way, there is a selection process. In different cultures different objects slip more easily into this position than others; whole sections of soci-ety may invest the same objects. This is something psychoanalytic theory has not adequately dealt with; possibly it is not able to do so without step-ping beyond its own terms. My discomfort tells me it is not entirely fortuitous that *India Song* presents me with the objects that it does; somewhere one or more of my possibles resists the investiture of Anne-Marie Stretter, the Vice Consul or Michael Richardson in the position of *objet a*, and one of the reasons is that I am not offered the option of taking my chanc-es and going for the beggar-woman instead.

So what is it about my fascination that bothers me? What are these objects anyway?

First is the 'author' of the film. I have referred to the weight of words I had read on, and by, Duras in the time it took me to see *India Song* three times. Duras, whatever that might mean, had evidently got mixed-up in my desire, her adulated and unknowable persona had taken on a role in my fantasy of myself. The more I know her, the more

we merge; as the degree to which she exceeds my understanding of her becomes less, the more I can identify with her, object of desire of the luminaries and the nameless alike. *India Song* becomes the signifier of the presence and absence of Duras, where Duras = source of meaning.

Second are the meanings which accrue to the images presented by the film itself. To begin with, the action takes place in the 'past'. Looking beyond the specificity of the events which may (not) be represented in *India Song* itself, and the effects of their uncertain status, the film has its place as one of a constellation of representations of a completed past. The music, the costumes, the servants, all evoke this past which is whole and finished, a possible object of desire in its lost plenitude. A 'period' is evoked, which can be 'looked back' to and fashioned after any desirable image.

India Song presents an image of the past as desirable by means of images which are themselves almost over-determined as objects of desire. Most obvious, perhaps, is that of Anne-Marie Stretter/ Delphine Seyrig. Delphine Seyrig is a conventionally 'beautiful' woman; she has the sort of body which is the stuff of a contemporary *objet a*. Her breast is the right sort of breast, even when it is dripping with sweat. Furthermore, as the voices off repeatedly remind us, as Anne-Marie Stretter she is the object of the desire of all the 'almost interchangeable' men in the film. Her image, already the locus of all the meanings with which that type of woman's body is charged through and by representations of women's bodies, from advertising to films to television to fashion magazines, is given another boost by the ceaseless spoken reminders of the desire of the Vice Consul, of Michael Richardson. It might almost be threatening in its potency were it not for the equally ceaseless reminders that the woman we see is dead. Lost. We can all identify as Anne-Marie Stretter and desire her in her difference without threat; she is an absent friend.

Another important aspect to the images of Anne-Marie Stretter and her friends is that they are all indisputably very rich. They are attended by faceless Indian servants, they live in a world of tennis courts and red bicycles, they are clean and their clothes look good even when it is very hot. *India Song* provides an opportunity to identify with the sort of people who have been giving readers and viewers vicarious pleasure for a very long time. There is nothing like watching the rich and powerful act out their misery and joy for your eyes only

to make you feel that you and they are just human beings and that maybe you should not worry about their power over you and your ilk. Particularly when, as is the case for the white European watcher of *India Song*, you can regard the people they have power over as different from yourself in ways that the rich, white colonials are not. Perhaps. The Vice Consul has apparently shot a few lepers back in Lahore, but for those, like me, who have not been to Pakistan – perhaps even for those who have – Lahore is an exotic 'Indian' name, lepers are a threatening unknown, the Vice Consul does not have the air of one who might conveniently be ejected into the category 'psychopath' and the fascinating Anne-Marie Stretter seems to think he is OK – and she should know.

Sitting isolated in the dark cinema (and not just the local Classic either), primed with my knowledge of Duras, I am offered images of beauty and riches, set in an exotic land far away in time and place, listening to a soundtrack of voices speaking their fascination with those images. I am offered identification in a story of suffering and desire (love and death) which echoes through the watching 'I', in the struggles of the voices to reconstruct 'what really happened'. The film offers me a place from which to watch it, how can I resist? I dutifully take a pew.

But I am not comfortable before this altar.

When I leave the isolation of the cinema, having had my money's worth, and talk to other people, I can allow myself to know why. What makes me uncomfortable about *India Song* is that it denies me a choice of reading in a way that other films do not – films with plots, films with 'messages'. If a film is trying to tell you something, a story or an idea, you can always look at the way it tells you, rather than just swallow what it tells you, you can pose questions from a place other than that which the film offers you. *India Song* is not trying to tell me anything, it is trying to fascinate me. Its interest lies not so much in what happens as in the gap between knowing and not knowing. The problem is that, in order to capture my fascination, it has to give me reasons why I might want to know, so that I can become aware of my uncertainty.

If I take up the place proposed to me by the film I have a colossal sense of freedom. The spoken words produce images which are not on screen. 'The black Lancia of the French Embassy has taken the Delta road.' But to allow these images their power I have to submit to the ideological weight of black Lancias. There are no answers to

the questions that *India Song* suggests I ask, I can make them up myself. But I might want to ask other questions, such as, how did the lepers feel about the Vice Consul shooting at them? – Don't worry, I quickly reply from the text of the film, lepers do not suffer. Anne-Marie Stretter is a leper of the heart, she carries with her the metaphorical corollary of that nasty disease. She does not suffer either, look at her smile. I might ask to see the beggar-woman, but again I reply with the text (or Marcelle Marini) that Anne-Marie Stretter and the beggar-woman are one and the same; one is rich, the other poor, one chooses to die, the other is insane, both have that lucidity that comes from an understanding of the hopeless cruelty of life. But, I might protest, one is visible and intelligible, the other is only incomprehensibly (exotically) audible. Ah but, I reply quickly, from the film and from my reading, both are silent, they are the same. Even so, I suggest, Anne-Marie Stretter's image is offered for my desire in no uncertain terms, the beggar-woman is irredeemably other; tentatively I might mutter about the indirect glorification of colonialism resulting from the almost total absence of the possibility of identification with its victims. Fool! I reply with a battery of respectably published critics. This is a film by Marguerite Duras! Have you not read her biography? Do you not know about her long years of poverty under the corrupt colonial regime in Indo-China? Her mad, dam-building mother? I look down and think for a moment. Aha! I challenge, why is Anne-Marie Stretter set up as an object of desire but allowed no desire of her own? She goes with whoever wants her, doesn't she even fancy any of them? Quick as a flash I reply with De Florence that such considerations belong to 'the clogging details of the bourgeois novel' and that I am watching a *mise-en-scène* of desire, a floating movement. But still, I persist, isn't she just a mutilated *objet a*? 'But remember', I reply with De Florence and many others, 'without her, no desire. She is the one who regulates the desire of these men and not the contrary.' Well, there is only one of her, I splutter, and they all want her, so if she is going to do the rounds she has got to say 'no' sometimes. The thing is, she has always already has said yes, so she can never make a positive choice – sounds like a representation of the sort of ideological position that gets women raped. But De Florence politely reminds me that 'she dies on her own initiative, her own wish' so she does make decisions. 'Rare

fact in contemporary cinema.'

These answers I must accept if I am to watch *India Song*. If I do so and become fascinated, I can join the ranks of Duras' admirers – I have to – because, if I start thinking 'yes, but…' too strongly, the fascination is gone and I have no option but to join those – not a small proportion of the audience in places where the tickets were cheap – who leave, usually fairly soon after the beginning. If *India Song* does not succeed in fascinating, it must be horribly boring. For me it works, I find it fascinating. But I cannot accept it without struggle. I cannot accept that Anne-Marie Stretter, the beggar-woman, the Vice Consul and the lepers of Lahore are all equally victims of the cruelty of this mortal coil, that Anne-Marie Stretter's constant acquiescence to the desire of men is not also, whatever else it may be, yet another representation of the silent desireless woman, acquiescent victim. I cannot accept that being the phallus does not involve an inferior power position in relation to those who have it, particularly when, in order to be seen to be it you must also be seen to be dead. I cannot accept that 'the film, like the fantasy, is a *mise-en-scène* of desire, not its object' (for how can you unravel desire from its object? I cannot accept that Duras is the sole source of the meanings of the film and that her biographical credentials are enough to ensure that it cannot be taken as a celebration of a certain colonial elegance; I cannot accept that I must silence all my questions, my possible and everyday identifications, the positions from which I ask those questions, as the only way to watch *India Song*. Not without a struggle.

But maybe I should just sit back and enjoy it. After all, *India Song* is not very widely seen. Except that it does seem to carry a lot of prestige; it has a place within certain institutions whose presence can be felt in journals where film theory or feminism (or both) draw heavily on psychoanalysis. To raise questions about the limitations of *India Song* is also to raise questions about the limitations of those theories and the institutions which are built around and through them, in which *India Song* has found such a cosy niche.

1 'Le Ravissement de Lol V. Stein, où Marguerite Duras s'avère savoir sans moi ce que j'enseigne'.
2 'About *India Song* and Marguerite Duras', Bruno de Florence, *Undercut*, no. 2.
3 From *Camera Obscura*, 6 – an article by Elisabeth Lyon called 'The cinema of Lol V. Stein'.

A plain buff folder, slightly dog-eared, stitched. 'Photographic Exhibits. Taken on Monday 30th January 1922.' Eight photographs, their age confirmed by creeping sepia, copperplate captions. A possible scenario begins to emerge.

The mystery, the puzzle remains. Each frame misses the action, the moment. The characters are figures, only, in a landscape. A local newspaper tells a story: January 20 1922 SENSATIONAL RIVER LEA TRAGEDY SERVANT BRUISED AND DROWNED ALLEGED LOVER CHARGED WITH MURDER. February 17 1922 RIVER LEA TRAGEDY HOME OFFICE EXPERTS EVIDENCE VERDICT OF 'MURDER' AGAINST LOVER. March 10 1922 RIVER LEA TRAGEDY PRISONER FOUND GUILTY SENTENCED TO DEATH. Figures in a landscape can be seen even now. The trees have grown, the towpath built up, Craven Walk now only a gap in a fence still the landscape remains a silent witness.

feminism and pornography: 'not a love story'
jill mcgreal

The issue with which pornography is indissolubly linked is that of censorship,[1] and feminists find themselves dubiously identified in their statements with such right-wing advocates of censorship as the National Viewers' and Listeners' Association (NVLA). It is important to note that the argumentation by which feminists arrive at their demand for greater censorship differ from that pursued by organisations like the NVLA. The former are more likely to argue that pornography is wrong because it degrades and humiliates women through their use as sex objects while the latter are more likely to argue that pornography is wrong because it 'has a tendency to deprave and corrupt' or is 'indecent or obscene'.[2] It should also be made clear at this point that not all feminists are themselves united over the issue of censorship, the division occurring at just that point where the contradictions and tensions mentioned above arise, namely between radical and socialist feminists, with the former, in the main, being protagonists of greater censorship.

Not a Love Story is a film about pornography released from the National Film Board of Canada (NFB). It is a film about pornography which is itself pornographic. There are several issues which the film raises at the level of its own internal structure. One is whether men should be permitted to see the film at all. One way of answering this point is to argue that the film's soundtrack and the way in which it is shot and edited give the film an in-built set of attitudes which effectively 'neutralise' its pornographic content thus rendering the film non-pornographic and therefore presenting no danger that any section of the audience will simply enjoy the film on account of its pornographic content. This argument, based on the separation of form from content, is not altogether persuasive: many people have enjoyed the films of Leni Reifensthal without succumbing to their Nazi propaganda. A commentary may contextualise a film but the film can still be viewed out of that context. But if there is persistent demand that the film should be viewed by women only, then there is clearly some notion that danger is attached to the idea of men viewing the film. At this point, the feminist criterion noted above collapses into the NVLA criterion: men's morals will be corrupted if

they view material of this kind, corrupted in such a way that they will henceforth be more likely to enjoy the spectacle of the humiliation and degradation of women or, alternatively, they may be initiated into this type of enjoyment. This style of argument suffers from three major defects: in the first place it advocates an authoritarian practice which itself prejudges the issue of censorship and prevents discussion arising. Secondly, it descends to the same level of simple cause and effect analysis as the NVLA position and thirdly, in relation to the last point, it neglects entirely the possibility that the film might have a similar effect on women.

It must be said that the film's inability to adopt any definite guidelines is less to do with bravery (in many ways it is a brave film) than with the lack of analysis of the subject matter of pornography within the film. The fact that the film regards all pornography as exploitative of women (in the sense described) and therefore condemns it as wrong makes the problem even more complicated, for now we must make another distinction between what is wrong but may be publicly consumed and what is wrong and must be censored. As always, a highly moralistic attitude towards an issue like pornography results in an insoluble set of contradictory impulses, in a situation where there can be no moral approbation without the accusation of a compromise of one's position.

The 1960s saw the reform of laws relating to divorce, abortion, homosexuality, suicide and censorship while the 1970s saw the introduction of the Equal Opportunity Act and the Sexual Discrimination Act and the reform of taxation laws, DHSS practices and other sexist state practices. Alongside this liberalisation of the legal system came changes in attitudes in schools, unions, political parties, the media and elsewhere. At the same time women set up Rape Crisis Centres, Refuges, journals and women's sections while all the time writing and studying together. Liberalisation came as a package out of which women have been able to achieve a closer, more honest, less repressed and alienated relationship to their bodies and their sexuality. The price that was paid was the explosion of the pornography

industry ('from a five million to a five billion dollar industry over the past twelve years') but the price is not so dear that the progressive reforms would be sacrificed in return for the legal clock on pornography being turned back. In relation to the relaxation of the censorship laws themselves, from which the pornography industry took off, there can be little doubt that the changes in the law have been progressive. The real need for education and knowledge of sexual matters could not have been fulfilled in their absence. The effect of these changes in the law on the pornography industry has been to transform the vast illegal industry into a vast legal one. The statistic in parenthesis above does not represent an absolute increase in the volume of pornography but an absolute increase in the volume of legal pornography. Pornography has always existed but at least it is now possible for women to confront the problem publicly whereas before it was difficult to confront it at all.

The tension caused in the women's movement is how to confront the issue of pornography while not, at the same time, attacking all that was progressive about the 'sexual revolution'. A further consideration is that a simple demand for the repeal of the laws that make pornography in its present form possible will, if it were to succeed, simply push pornography back beyond our reach into the underworld or will, if it fails, leave women in a defenceless and vulnerable position in the absence of any alternative strategy.

How then should feminists proceed in relation to an issue like pornography? There is perhaps the beginning of an answer to this question in one of the major critical responses to pornography itself. It is believed that the level and strength of pornography in a society has a 'filter through' effect on that society from the way in which women are represented in the conventional media down to the way in which a boss might treat his secretary or a husband his wife. Whether this analysis of sexist attitudes in society (i.e. as the result of the accessibility of pornography in that society) is correct or not, is not what is important here. What is important is that specific areas of public and private life other than that of pornography have been correctly perceived as areas in which the degradation and humiliation of women in various forms occurs. Here are areas around which women can campaign without fear that their campaigns might backfire

NOT A LOVE STORY Bonnie Sherr Klein

against them. In particular the standard and type of advertising in a society does seem inextricably linked to what is acceptable in pornography and in many ways could be seen as more dangerous ideologically than pornography itself. And advertising is also wide open to a feminist critique. Similarly, with regard to male attitudes to women at work. If feminists continue to work on these fronts with the kind of success achieved throughout the last decade then gradually, as sexist attitudes in society become less acceptable, the pornography industry will become more isolated and it is in isolation that institutions like pornography become vulnerable. Then a direct attack on the right grounds will be possible.

This sort of gradualist argument is not welcomed and, in many ways, understandably so, for the rage and pain experienced by women as a result of pornography is here and now. The only response that can be made to objections of this kind is that the women's movement is its own recent history, a history of struggle over the last fifteen years on a solid reformist basis with significant results. If the same progress can be made in the next decade as has already been achieved in the decade past then the future should not seem too gloomy.

In terms of the foregoing, the screening of *Not a Love Story* to an invited audience of feminists at Canada House encouraged optimism. What struck the audience, in the absence of any analysis, was the film's naivete. This absence within the film almost certainly persuaded some of the women in the audience that men should not be allowed to see the film for it was recognised that the simple expedient of having leading feminists talk about pornography was not strong enough to offset the interspersal between these

NOT A LOVE STORY Bonnie Sherr Klein

interviews of progressively more offensive pornographic material. Furthermore there was the major objection that the only solution proposed by the film is that progress can be attained through the personal within heterosexual relationships, thus ignoring the analysis made by lesbian feminists. With this level of sophistication of response from the audience there was clear indication that feminists can go forward and resist, for instance, Betty Friedan's proposals for a 'second stage' of feminism which advocates a return to the home and children. Women in Britain cannot yet afford this luxury.

It is a film directed in the classic NFB *cine-vérité* style and as such is open to a very particular type of criticism – that of being fettered by the past. In a recent review of the documentary film festival in Paris, *Cinema du Reel*, in *Framework*, Michael Chanan has made a similar criticism of some of the entries there.[3] In the case of the Paris festival, the dominating influence was the style of documenary filmmaking of Jean Rouch, a style which now produces very conventional imitators at the expense of younger filmmakers who are genuinely concerned with innovatory forms. He writes of Rouch's generation: 'But the possibilities they pounced upon – the flexibility to capture transient happenings, to enter a scene with the camera, to approach the task of documentary filmmaking with new-found spontaneity – established a set of ad hoc principles that have since been ossified and rationalised to become a doctrine that most of the younger generation of filmmakers present in Paris frankly find constraining.'

In the case of the NFB film, there is little indication that these constraints have been felt at all. Working at the NFB, the model is not the work of Jean Rouch but that of the Unit B filmmakers in the 1950s and early 1960s, in particular, Koenig, Kroitor, Low and Daly, who brought the techniques of *direct cinema* to Canada. The problem is not simply that the technique is now becoming old and overworked but that an added danger is posed of it becoming unsuitable as the form in which to direct certain films – with *Not a Love Story*'s subject: pornography, a case in point. As already noted, *Not a Love Story* takes the audience on a trip through the world of porn, cutting away from the pornographic images to give factual information and interviews, mainly with feminist writers and poets but also with the pornographers themselves and the performers. We first meet Linda Lee Tracey, a stripper from Montreal, at her work, a comic strip act about the adventures of Little Red Riding Hood. Throughout the film she then figures as the 'heroine' of a 'sub-plot' in which her increasing awareness of her position is documented as a dropping away of false consciousness, a process which is expedited through her coming to learn (by being told) that she is herself part of the world for which she comes to feel shame and disgust. 'I wonder what happened to Linda' is perhaps a common reaction to the film. The unsatisfactory nature of *Not a Love Story* is the lack of analysis of pornography – a lack which involves the spectator in the personal lives of the characters but renders them helpless in terms of the problem.

Two fundamental assumptions underlie Linda Lee Tracey's role in the film. Firstly, there is present the assumption that direct experience of pornography (i.e. Linda's being a stripper) places the subject in a special place in relation to knowledge of pornography – and that this knowledge is necessary for the transformation of false consciousness into its opposite. This assumption has two effects within the film. In the first place, the use of many pornographic sequences seems to indicate that the spectator, too, needs to know first-hand what goes on in the world of porn before it can adopt the right attitude towards it. In the second place, it is directly connected with a shameful sequence at the end which should never have been thought fit for filming let alone inclusion in the final edited version. It features Linda posing for Suze Randal, a photographer for the magazine *Hustler* whose special turn is to be able to make 'pussies' look like 'flowers'. Linda apparently wanted to pose for Suze just to experience the humiliation of being so treated, in order to confirm her disgust with the

proceedings, but does the audience have to experience the spectacle of Linda's humiliation in order to understand how pornography both humiliates and degrades women? More insidious still is the implicit assumption that because Linda is a stripper anyway shooting this sequence is somehow okay.

The second and more important assumption that is made by the film itself is that ideology is equated with false consciousness. Such an equation manifests itself at the level of documentary filmmaking in general as the idea that you only have to show how things really are in order to make people unders-tand how they really are. This particular idea can be traced back to the very beginnings of documentary filmmaking. Of Dziga Vertov, Masha Enzensberger writes the following: 'Vertov defines different camera technique – slow motion, filming with a moving camera, tracking shot, filming from unexpected angles, with a hidden camera, filming when the subject's attention is distracted, 'candid camera', running the sequence backwards … as "the possibility of seeing without boundaries or limits" as "the possibility to make the invisible visible, the vague clear, the hidden apparent, to unmask truth … the disguised … to turn lies into truth".[4]

This is a 'technicist misconception' of the same kind noted by Chanan in his review of *Cinéma du Reel* but it extends further than this, in the ideas of John Grierson as to the role of the documentary filmmaker *per se*. Grierson first became interested in filmmaking because of his ideas about education and democracy. The inevitable gap between the people and the State in a democracy threatened the very operation of that democracy and could only be filled by educating the people. Film, as a purveyor of knowledge, was thought to be the very best medium through which to fill that gap. Grierson never abandoned this idea of the function of film as straightforwardly educational. By the time Grierson left for Canada he brought with him a purified set of ideas about film and its educational functions which are now entrenched firmly within the history of the NFB and act as yet another fetter upon its present filmmakers. In the present context of *Not a Love Story* the assumption operates at two levels: on the one hand Linda's own false consciousness is supposed to be seen as falling away after exposure to the many aspects of the world of porn and on the other hand, the audi-

ence itself is supposed to undergo this same revelatory and transformational process as the pornographic sequences unfold before it. Even without the help of new and more complex theories of ideology, the audience is not taken in by this manoeuvring, as was shown by the audience response to the film at Canada House.

An analysis of the different forms of British and American feminism is outside the parameters of this piece but perhaps this is just one of the issues which the release of this film in Britain unwittingly raises. It is not being suggested that there is any shortage of discussion of the issues of pornography in Britain. What seems to be lacking is a unified strategy for feminists on this issue. There is a danger of theoreticism by which is meant that the theoretical analysis of pornography has no direct consequences for a feminist practice.[5] This danger seems to be linked to the idea of the 'imaginary unity'[6] of feminism as a whole, which, it is argued, should be preserved, despite the heterogeneity of feminist practices, in order to maintain a grasp on what feminism actually is. In the issue of pornography, this 'imaginary unity' functions as a mask or disguise of the different positions and practices within the women's movement which have a crucial bearing on how the movement should go forward. If *Not a Love Story* helps to promote discussion of these issues then there is a strongly overriding reason against the charge that the film should not have been made. If the only response to the film is that it should never have been made, then, given that it has been made, this response only serves as a way of not meeting the issues.

If I may end this piece on a personal note: at the time of writing this conclusion I am also preparing to screen *Not a Love Story* before a group of mainly male film students with whom there is to be a discussion afterwards. I am not looking forward to it.

1 Bev Brown's articles in *m/f*, 5 & 6 and *I & C*, no. 7 have been particularly useful. Since I wrote this piece I have read Rosalind Coward's article in *Feminist Review*, 11, which says practically everything that I would like to have said about the issues of pornography and feminism.
2 Obscene Publications Act, 1964.
3 *Framework*, no. 13, 1980.
4 *Screen*, vol. 13, no. 4.
5 As defined by Claire Johnston, *Screen*, vol. 21, no. 2.
6 Johnston op. cit. and Felicity Oppe, *The New Social Function of Cinema*: Catalogue: British Film Institute Productions 1979/80.

chapter 7 surveys

life in the trenches
michael o'pray

This essay was written quickly, in shoot-from-the-hip style with the deadline pressing, some twenty years ago. It was intended as a snapshot of the avant-garde film scene from one critic's point-of-view. As I remember, the essay was my way of smuggling into Undercut a discussion of the New Romantic filmmakers. Perhaps against my better judgment I have left the text warts and all unscathed, and have only corrected typos and glaring errors.

My title and this piece was provoked by Jonathan Rosenbaum's excellent book *Film: The Front Line* (1983)[1] which bravely and effectively begins a yearly series that will attempt to provide an overview of avant-garde film work internationally today, a necessary task now that the movement is too big for any one person (Jonas Mekas once did it) or magazine to have a full view of it. What follows will be a brief tour of the avant-garde in film in this country as at the time of writing. The aim is not to give a comprehensive account (although it will be as catholic and as unbiased as is possible) or a measured aesthetic judgement of contemporary experimental film, but rather to give a topography of theme, formal tendencies and modes of work, referring to as many filmmakers as possible in the process. With very few exceptions, any ommissions will be definitely unintentional. It is hoped that if any purpose is served, besides one of communicating information, it will be to provoke others to take up some of the filmmakers or themes and give them the individual treatment they deserve.

The collapse of the structural movement in the late 1970s, the result perhaps of fatigue, women's filmmaking, Le Grice's work in 'experimental narrative' with *Blackbird Descending (Tense Alignment)* and the emergence of a new generation of filmmakers, did not mean that such work ceased altogether. Gidal has stubbornly carried on that project that was so much his anyway, with his recent *Close Up* (1983), proof of his capacity to sustain imaginatively what for many is already a historical moment.

Dave Parsons, in his last piece lodged at the Co-op, *Picture Planes 2* (1979), signalled his continued committment to materialist exploration, with his influence being felt in his teaching work at NELP (North East London Polytechnic), which over the years has produced many exciting young filmmakers. As some historical perspective is gained over the years, Chris Welsby's unique production in the landscape genre seems to represent one of the most sustained bodies of structural work in this country, although in recent years there has been more emphasis on gallery installation work. His recent piece has only been shown once, at Slow Dancer Gallery in Liverpool, which reveals the difficulties for such work at the present time. At the landscape season in May 1983, at the London Filmmakers' Co-op and B2 Gallery, the bulk of Welsby's work was shown (a rare event) and testified to his importance. A younger generation of filmmakers (ex-students of Gidal's at the RCA) carry on the formal explorations of the structural school, although with more expressive dimensions. Michael Mazière's *Colour Work* (1981) and *Silent Film* (1982) (he is at present editing a new piece) balance rigorous camera movement with fine colour quality and expressive control and, surprisingly, as reminiscent of the style of early Brakhage as of Gidal, promising a renewed vitality in the structural vein. More varied in form than Mazière but equally severe in approach, Lucy Panteli's four films in as many years (*Sense of Movement* (1979); *Motion Picture* (1980); *Drawing Distinctions* (1981) and *Across the Field of Vision* (1982)) have had some impact with their strong visual sense and in the case of *Across the Field of Vision* (800 shots of seagulls), an assured, direct, imaginative grasp of form and content that makes it one of the most beautiful films to have come out of the avant-garde for years. Joanna Millett, associated with Mazière and Panteli in their materialist aesthetic, has produced in *Views from Itford Hill* (1982–83) a film of great fluidity and calm that integrates formal questions with aesthetic res-

onances. The fourth member of this loose grouping is Rob Gawthrop (now teaching film at Hull) who has been making films since the mid-1970s and whose recent *Coastal Calls* (1982) uses sound and image with ingenuity and to eerie effect. Andrew Dunlop's work fits also in this general post-structural category, and also shows with Mazière *et al.* Dunlop's *Waterloo Sunset* (1982) uses formal means to capture the forced evacuation of the famous Waterloo Gallery in Grieg's warehouse. Martin Sercombe's landscape work (*Track* (1980), *In Motion* (1981) and *East Coast* (1982)) is visually exciting, with *Track,* using widescreen and pans, being the most striking of the work I have seen. Alan Renton, particularly in his recent *Separate Incidents* (1981) is also engaged in formal work, using, as many English filmmakers do, the landscape as an aesthetic foreground to these experiments. More associated perhaps with Chris Welsby's work, Renny Croft made some excellent landscape films in the 1970s (*Cave Aperture* (1974), *Structured Walks* (1975), *Attermire* (1976), *Three Short Landscape Films* (1979)) and represents this sturdy tradition in British avant-garde film. John Woodman, who has had much success recently with his photographic work which uses landscape and temporality to great effect, has sustained a commitment in his film work to landscape and the notion of duration and phenomenology of the spectator.

A further loose grouping that has, in some cases, strong links with the structural movement but which has developed in different directions is that of Nicky Hamlyn and Will Milne (who would reject the idea of a structural influence). Both filmmakers have created a film sensibility that is intrinsically quietist, cool and subtley evocative of moods related to domestic interiors and human relationships, often in an implicit sexual context. Milne's *Same,* with its barely suggested narrative, consists almost of a series of 'moments' where movement occurs characteristically within the frame, and adding up in its twelve minutes to one of the best films to have come out of the avant-garde in the past few years. Milne's new film, *Meat of Other Times* (1983), takes the Elgin marbles and the nude male as its subject matter and further develops Milne's concern with fragmentation and the frisson of editing, where the cut is the dynamics of his filmic language. Without doubt, and justifiably rated, one of the best filmmakers in this country at present. Hamlyn's work is much more directly concerned with structural concerns and political matters as

FINNEGAN'S CHIN Malcolm Le Grice

they can be represented in the personal. His *Inside Out* (1978) is the film that most obviously breaks with his early intensely formal work, dealing as it does with the politics of sexual representation in a film that establishes also his interest in the notion of interiors as an alternative context for sexual and political action. His use of colour and ambiguity, through filmic devices such as the close-up and focus makes *Not to See Again* (1980) and *Guesswork* (1981) exemplary pieces that combine the formal and representational in ways that are forever testing the facile and the simplistic in filmmaking. Hamlyn's latest film, *Ghost Stories,* is having its first screening in December 1983.

Among many younger women filmmakers the concerns have often been of a personal and subjective nature. Joanna Davis' *Often During the Day* deals with a female experience of the subjective relationship to the domestic without excluding a broader analysis of how male control operates there. A less political approach is adopted by Nina Danino in her first film, *First Memory* (1981), which in elliptical sequences scrutinizes an interior

THE REFLECTED PORTRAIT – THE PETRIFICATION OF TRANSIENCE
Holly Warburton

accompanied by a voiceover iterating a memory of an elderly female relation. Its cool evocation of space and memory places it close, at times, to Hamlyn's and Milne's work. At present, she is finishing another film, *Detours*, set partly in Berlin. Jayne Parker's work, which I have not seen, from all accounts embraces a more symbolist film vocabulary. The excellent *What Just for Me?* by Deborah Lowenberg focuses on a relationship with a man and the geography of that relationship in terms of interiors and set-pieces. An excellent film that contributes to the new interest among this group in sexuality and the domestic. Lis Rhodes' new film, *Pictures on Pink Paper* (1982), rarely shown in this country since its completion and which I have not seen, was awaited eagerly given the strength of her work and success, particularly of *Light Reading*, a seminal work in this country. Susan Stein, who like Lis Rhodes distributes through Circles, has worked in the areas of personal politics, but again I am not familiar with her work. Anna Thew, active in the Co-op for years, has been involved in performance

work recently, but her last film *Berlin, meine Augen* (1982) was a wayward anti-narrative projected to her own arbitrary instructions.

It was the films of John Maybury and Cerith Wyn Evans that brought the title of 'New Romantics' to the attention of the avant-garde and a wider audience in the early 1980s. If, at that time, they seemed like rather self-indulgent and pop-world tainted brats to be ignored, then in the past few years they have brought with them other filmmakers and what amounts to perhaps the first cohesive and genuine movement in British avant-garde since the structural one. In reaction to the puritanical 'seriousness' of their teachers and the work of the 1970s, they have frog-leaped over the American structural movement of Snow, Gehr, Baillie, Frampton and instead are more influenced by and reminiscent of the American cinema of the 1950s, that of Ron Rice, Jack Smith, Stan Brakhage and particularly Kenneth Anger. Equally, and more interestingly, they have culled from the art cinema in Europe – Werner Schroeter and Syberberg are obvious examples. In this country they have strong connections with Derek Jarman who, beside his more mainstream work like *Sebastiane*, *The Tempest* and the punk nightmare *Jubilee*, has continued to produce Super 8 material, such as the *Home Movies* series, lodged at the Co-op, and his film of Throbbing Gristle's music *T. G. Psychic Rally in Heaven* (1981) which has gained some notoriety. Jarman's *In the Shadow of the Sun* (1972–80) is a collation of originally silent Super 8 films designed to be projected at 3–6 frames per second, and which he projected for his own pleasure to the accompaniment of tapes, a mode of projection which many of the younger Romantics or Decadents have adopted themselves. Jarman's influence among these filmmakers seems ubiquitous. Wyn Evans, for example, projects work and manually plays a tape from the projection booth, a mode of work that brings a certain rough-edged quality to the films, and hints at a transient and pliable aspect of the work but also at the technical problems faced by many young Super 8 filmmakers. Wyn Evans' Super 8 work is highly theatrical in content, using young men often in erotic *mise-en-scènes* of highly wrought staging that draws on the surreal, as in *Still-Life with Phrenology Head* (1980) and the sado-masochistic, as in *Dream Sequence* (1983) in which a young, shaven-head man is dangled by straps from the ceiling whilst on the other screen a half-naked young man poses among

PARDUS FUROR Steve Chivers

MALEDICTA ELECTONIA John Maybury

the chiaroscuro lighting, drapes, feathers – looking into the camera. In his *Untitled* (1983) two naked youths intertwine themselves in what seem to be wide bandages, reminding one of mummification, all the time gazing at the camera and person behind it. Slowed down and shot in black and white, printed on colour stock (I believe), the whole effect is one of great gentleness and affection that cuts through what seems simply fey and artificial. Artifice, in fact, is used for its own sake and quite blatantly reminding one of some of the recent trends in painting and sculpture (Wyn Evans with Maybury were included in the film section of the Tate Gallery's recent *New Art* exhibition) where quotation and bricolage is used ironically and knowingly in a post-modernist fashion. Maybury's work, which I am not so familiar with, takes a similar subject matter submitting more than Wyn Evans to formal devices as in *Tortures that Laugh* (1983) where there seems to be a more critical notion of film being used in order to subvert conventional modes of sexual representation. Sophie Muller's excellent film *In Excelsis Deo*, made at the RCA, takes the themes of Madonnas and Syberberg-like set-pieces with dry ice, expressionist camera angles, lurid colour and some wit.

The most complex, exciting and confident work comes from Holly Warburton, who has shown two large installation pieces comprising Super 8 back projection on as many as three screens with other screens showing constantly shifting slides, plus various objects – marble busts and drapes sharing the space. In her *The Reflected Portrait: The Petrification*

of Transience (1983) opera music accompanies the installation – a pure female voice singing Bellini is one piece, and others I didn't recognise. Here the sexuality is delirious and decaying, culling a decadence that was prevalent in European art late in the nineteenth century in the work of such as Delville, Rochegrosse, Keller and Stuck, to mention a few. Warburton, like Muller, has appropriated female icons and images and worked them positively in a way that could be usefully contrasted with feminist filmmaking in this country which has been inward looking, depressing and pessimistic perhaps. Here such moods are eschewed and an imagery of desire and ritual is reconstructed. The feeling among some critics that this work is reactionary seems to be based on the lack of political intention among these filmmakers and what seems to be a frivolous escapist subject-matter. Of course, the same criticism could be made (and was) of the original surrealists, abstract expressionists etc. Until a more measured criticism appears such an effect in the meantime seems to justify the view that the Decadents are fulfilling the criterion governing the avant-garde and that is the capacity to shock and estrange conventional criticism and aesthetics. Muller, like Warburton, overlays her images with opera arias, something now quite rampant among other filmmakers who have chosen more expressive forms. Bruno de Florence has used music this way in his interesting two-screen film *Skins* (1983). Cordelia Swann's work in video, film and slide-tape, whilst associated with the Decadents particularly in her *Rosemarie*, is more intent on arresting the

iconic moments of cultural objects, like film. Largely though, her films are Super 8 re-filming of brief moments in popular television: soap operas or Hollywood films, slowed down and repeated on multi-screen. In this context, although his work is not decadent but shares a symbolist and excessive style, John Apps' *Ora* (1980), for example, should be mentioned. Steve Farrer's recent film *Muscle Lens* (1983), which ends a period of relative silence since *10 Drawings* (1976), has achieved high status. Farrer's early work was mainly structural in format (much of it I haven't seen) and with *Muscle Lens*, using a more representational mode, again with music, there is an attempt to break away from the purely formal to the more expressive. Steve Chivers, with a reputation as a technical wizard, works at the Slade, and his involvement in many other films by such as William Raban, Sophie Muller and Renny Bartlett reveals great energy that can deflect from his own work. *Pardus Fûror* (1983), a Super 8 film, is a swirling necrophiliac poem of morbid female onanism. It uses subtle colour, tinting and arresting camera movement in a way that separates it off from other Decadent work, and is reminiscent of Kenneth Anger's work – using camera and printing processes to great effect. Chivers' longer work *Urich and Dèstine* is still uncompleted and awaits its first public showing. Patrick Keiller, in his films, slide-tapes and writing in this magazine, has traced a Romantic Realism that embraces film noir, British television realism, Baudelaire, the flâneur, and the surrealism of such as Romero and Ruttman. His latest film, *Norwood* (1983), a sequel of sorts to his first film *Stonebridge Park* (1981), portrays the bleak marginal demi-monde of derelict urban Britain today. Its first-person narrative of the sordid and very funny adventures of its anti-hero – petty criminal, fantasist and incorrigible intriguer – is set ironically against images that pay uneasy homage to architecture, space and the redemption of style. An individual talent – his work knocks spots off the so-called political films of the 'independent sector'.

David Finch has worked in the main in what might unsatisfactorily be called anti-narrative. His *Fall of the House of Usher* (1981) owed more to deconstructed narrative, in its highly stylized and distracted reworking of the Poe tale. His recent film *1983* (1983) was shown at this year's London Film Festival and, I gather, is more political in its direction. Peter Samson's *The Pharaoh's Parachute*

(1983) was also shown at the Festival and displayed a more traditional approach to narrative in its well-constructed and finely judged atmosphere.

Even more diverse projects are to be found among the older generation's work. Le Grice's *Finnegan's Chin – temporal economy* (1982) shown on Channel 4's *Eleventh Hour* series on avant-garde filmmakers, extended his work to the brink of narrative as it is generally understood; its conventional use of music adding to this effect. Nevertheless, in this way Le Grice, as usual, drives ahead of others and poses the problems for the avant-garde's recent foray into narrative, producing one of the best films to come from any sector for many years. Its elliptical imagery and visual puns create a strange nether world of modern existence. *Finnegan's Chin* stood head and shoulders above the hyped independent 'political' films seen over the past year on Channel 4. Guy Sherwin's *Short Film Series* must be one of the major avant-garde works, both in this country and abroad, even if critically neglected, with some exceptions. In the past seven years and more, Sherwin's 100-feet-reels now number about thirty and include films of beauty, technical dexterity and imagination. His latest film, just completed, *Messages* (1983), in Sherwin's own words, is about 'the visual appearance of the world, ambiguities of language, the way we relate to each other'. The film is a response to the early childhood of his daughter. William Rabin's *Black and Silver* (1981), made with Marilyn Rabin, ventured ambitiously into experimental narrative with an adaptation of an Oscar Wilde tale based on Velasquez's *Las Manias*. Shot on, what is nowadays, a small BFI budget, it produced some memorable sequences of icy beauty and formal delight, particularly in the interior scenes, and takes a Romanticist path that promises to be well-trodden by the end of the decade in this country. Rabin has just embarked on a new film. John Smith, a film teacher at NELP with Dave Parsons, has just completed a new film, *Shepherd's Delight*, which promises to enhance further his reputation as the avant-garde's humorist, who at the same time can dismantle that very trait before the spectator's eyes.

Of course, Margaret Tait and Jeff Keen, both eccentrics although of very different sensibilities, remain as active as ever, and lately Tait, at least, is more visible than in the past when she was unjustly ignored. Tamara Krikorian, in the 'Landscape' issue of *Undercut,* reviewed aspects of

her work.[1] Tait's hawk-like eye and subtle editing create film 'poems' that are always of-the-world, yet ethereal in their disquieting characteristic of setting images against images to create an aesthetic shock. Keen still manages to produce an art that is inveterately surrealist, located as it is in the strip-cartoon world of bizarrely dressed 'heroes', archetypal villains and kinky female side-kicks. Sci-fi action jostles with erotic sex in films of great energy where superimposition and colour are used with inventiveness, reflecting as much of the chaos of the world, as it does of Keen's own unstoppable anarchic imagination.

In *Grandfather's Footsteps* (1983) Anne Rees-Mogg reminds us of how difficult it is to categorise many films, a fact that can mean that some work is either underrated or even ignored, as in the case of Tait, for example. Rees-Mogg's film is a delightful and complex (both formally and emotionally)

evocation of the past, the family (her's), memory and the photographic image as trace. More importantly, however, is the sadness and sense of a life that suffuses the film.

Nick Collins' latest film *Passages* is also in the 'experimental narrative' domain, and extends his interest in both landscape and 'the re-working of historical moments' into essays on time, language and the past-made-present. His fluid camera work and imaginative editing make his work captivating and visually and intellectually complex and demanding.

This rough and rather superficial summary of recent film-work, I hope, gives some idea of what kind of work is being produced in this country at the present time.

1 'On The Mountain and Land Makar: Landscape and Townscape in Margaret Tait's Work', Tamara Krikorian, *Undercut*, no. 7/8.

recent english super 8 at b2 gallery
nicky hamlyn

The films that I saw recently at the B2 gallery in Wapping represent only a very small, though by no means unrepresentative, part of the phenomenon of Super 8. There are obvious economic reasons why the format is popular not only with practising artists but with art students too: the enormous cost of 16mm has forced many colleges to cut back or completely eliminate 16mm production and Super 8 is the obvious alternative for those not contemplating a career in the film or television industry.

While experimental departments in the Art Colleges were shedding their 16mm equipment, Super 8 was being used by 'punk' filmmakers to record events at clubs like the Roxy in 1976 and 1977 in a manner that recalls the New York 'Underground' genre of diary films and many of the current generation of arts students came through this cultural milieu where the DIY aesthetic in music, clothes and fanzines has an obvious corollary in Super 8.

Besides the financial considerations, there are various other factors that have a bearing on the current state of the medium. As Jo Comino points out in her notice for the B2 show: 'The fact that the cameras handle so easily is … counterbalanced by the difficulty of detailed editing once the film has been shot.'

In order to overcome this, Super 8 filmmakers have come to use a range of techniques: super-impostion, slowmotion, multi-screen, repetition plus shooting off video to control and enrich their visuals.[2]

Furthermore, the advent of domestic video formats on the one hand and the increasing 'professional' uses of Super 8 by television war correspondents (notably in West Germany) on the other has had the effect of displacing the medium from the home movie role it occupied as recently as five years ago. It has shed its amateur connotations and has acquired a new usage that is not born simply of financial convenience.

It is important too that this work has an enthusiastic audience and venues like B2 that take the medium seriously enough to invest time and money in properly organised screenings. Not that these screenings resemble standard cinema events, or even the relaxed but purposeful atmosphere of the Film Co-op. The mood is informal and intimate, and the audience consists mainly of other filmmakers and their friends.

Because the projectors are small and quiet, and are not capable of producing a bright, sharp image of any great size, the audiences tend to be small and sit close to the screen. The images lack the brilliance

of 16mm, but this in no way diminishes the quality of the experience. On the contrary, one has only to think of Stan Brakhage's Standard 8 *Songs* for precedents in this regard to appreciate the particular quality that low-resolution, dimly lit imagery can have. As in any other medium, the best work exploits these so-called weaknesses to produce a new aesthetic language that is not parasitic of existing forms.

The group of films shown at B2 were fairly representative of the kind of work currently being done in England. They ranged from a first-film by Jane Higgins through work of varying quality by Michael Kostiff, Brian Cleaver and Cerith Wyn Evans to the highly controlled films of Bruno de Florence, Jo Comino and Cordelia Swann. Although technical standards varied considerably, the similarities between the films, both in the devices employed and in subject matter, were striking.

Almost all the films were shot silent and had continuous music tracks taken from pre-existent sources (usually records transferred to cassette). Although these ranged from Vivaldi to Disco, they nearly all have the same kind of fortuitous relation to their picture track, suggesting that in most cases the role of the music is a traditional one of generalised 'mood enhancement'. All the films are dominated by human presence. A strong profilmic event determines the nature of much of the work, suggesting that film's traditional representational function is taken for granted, despite the use of slowmotion, superimposition etc. Only in the work of Jo Comino and Cordelia Swann did a self-conscious preoccupation with structure clearly emerge, but here too human presence was primary. The evident structuring is not disinterested or abstract, nor does it deal with abstract ideas about memory and perception but is directly concerned to work through the specific content of the film's imagery and its psychological effects. In this respect the apparent 'structuralism' of some of the work is fundamentally different from older generation Co-op filmmaking. Human presence is also primary in these films in the expressionistic way in which the filmmakers invest their own individuality in their work. Although this is facilitated by the one-person working methods of the medium, it is also a self-conscious aesthetic position stemming from the often narcissistic and autobiographical nature of the subject matter. In the films by Kostiff, de Florence and Wyn Evans the images are invariably of men or male bodies wrought in a melancholic style reminiscent of the camp/gay genre of 'per-

sonal' filmmaking represented by Kenneth Anger and Tom Chomont in the US and Derek Jarman in England (as I suggested earlier, these films remain part of a larger (sub)culture and as such are frequently screened at gay discos like Heaven as part of mixed-media events). Kostiff's *Mercury* is a ten-minute film of a male nude rendered in shades of red and filmed in slow-motion superimpositions. The particular device used in this film has been developed very effectively by Derek Jarman, particularly in his recent film *T. G. Psychic Rally in Heaven*, and consists in running two Super 8 projectors simultaneously in slow-motion onto the same screen. These double images are refilmed directly off-screen to create a new film. Because of the phasing effect produced by the interaction of the projector and camera shutters, the images appear to dissolve in and out of each other in a gently shifting rhythm that can transform crude source material which may contain dirt and conspicuous joins into a continuous kaleidoscopic flow whose length is limited only by that of the new roll of film in the camera.

Bruno de Florence's *In Memoriam* is a moody and sentimental film of a man wandering in a graveyard. The film uses numerous repetitions and refilming to effect changes in speed and colour balance. Although the composition of the film is carefully considered, the music track from Ravel's 'Le Tombeau de Couperin' is left more or less to itself to act as a symbolic and emotional companion to the picture. In *35 Portraits* a series of publicity stills of beautiful male film stars of the 1950s are interspersed with black spacing. As the film proceeds, the concatenation of looks from the men begins to suggest, in an amusing way, some kind of sexual complicity between them, but sadly, the subtlety of this effect is spoilt by the camp music track which, by overstating the latent (homo)sexuality in the men, detracts from the mental processes by which the viewer constructs such cause and effect relationships (of complicity, sexual or otherwise) where none actually exists. In the films of John Maybury and Cerith Wyn Evans there is a polemical disavowal of structure (Maybury rhetorically cites 'awful structural stuff' as an influence) apparently in favour of unmediated catharsis. In both Maybury's *Narcotic Narcissism* (1980) and Wyn Evans' *Untitled* (1983), however, this turns out to be little more than a self-consciously punkish admixture of Herman Nitsch-type actions in a Genetesque setting.

Narcotic Narcissism consists of a reverse action

sequence of a man peeling blue latex from his face, followed by various shots of milk being poured onto plastic sheeting on which is seated a woman in white muslin. The third section is a tableau vivant based closely on the only well-known photo of the Australian performance artist Rudolf Schwarzkogler, wrapped in bandages with a plastic tube issuing from his concealed mouth. The soundtrack is a recital of the Koran.

In *Untitled* the music of Throbbing Gristle accompanies a long camera movement around the arms and torso of a heavily tattooed skinhead. In the second section, the (same?) skinhead is seen hanging from the ceiling by a harness with a noose round his neck. The room is lit by coloured floodlights and the music is Messaien's 'The Ascension of Christ'.

Despite the iconic strength and sophistication of these films (*Untitled* in particular), they seem ultimately effete in failing to pursue the implications of the sadistic imagery they employ. In the absence of such questioning they can be little more than fetishistic vignettes offered narcissistically to the subculture from which they spring. If this seems like unduly harsh criticism, then one need only cite a film like Fassbinder's *Querelle,* which successfully assimilates its sources to produce a critique of narcissism through its reworking of homosexual mythology.

Although they have frequenty exhibited together and share a belief in the potential of Super 8, the work of Cordelia Swann and Jo Comino is essentially different from that of John Maybury and Cerith Wyn Evans. Where the latters' work is indulgent and introspective, Swann and Comino's films have a critical and outward-looking edge to them. Cordelia Swann extracts crucial moments from American soap operas and feature films and builds slide/tape pieces and whole films from single gestures or actions. In *Passion Triptych* (1983) the images come from the television series *Hill Street Blues* and form a three-screen Super 8 triptych. On the left, a small man leans ambiguously on a larger one. In the centre two men either embrace or fight while on the third screen a man and a woman seem to embrace and then fight. All three are sexually charged in thought-provoking and subtly different ways. The image quality is heavily degenerated through being edited onto Super 8 from second-generation VHS cassette, and the sound is a rising and falling sine wave based on the police car sirens of the TV programme.

In *Again* a man and a woman embrace and kiss in a three-second fragment taken from Douglas Sirk's

WINTER JOURNEY IN THE HARZ MOUNTAIN Cordelia Swann

All that Heaven Allows. The original action has been exhaustively reduced and reconstructed into a complex three-minute sequence of staggered, overlapping repetitions in which the monolithic icon 'The kiss' is rendered banal and mechanical. The ironic paradox of such special moments of supposed emotional veracity (which are deemed to 'really' exist, authenticated not by cinema but by life itself) is that they are simultaneously enshrined and devalued by cinema. In *Again* this point is humourously underscored by the accompanying song 'Again' sung by Frank Sinatra: 'Again, this could never happen again … mine to hold as I'm holding you now…'

In *Spleen* (1983) Jo Comino uses a mixture of TV and original footage of her highly structured work. In part one shots of animals in a zoo, a man walking and toy animals dissolve from one to another in a repetitive cycle. On the soundtrack a voice asks repeatedly in Dutch, 'where is the nearest bank, please?' In part two a woman newsreader is seen in slow-motion repetitions which 'reveal' successive different nuances of facial expression, each new expression contradicting the previous one. The soundtrack is from a cavalry western.

Although these films use repetition and slow motion as a means of formal analysis, they are not so much concerned with structure per se in a weak formalist sense, but with the way meanings, and in particular the illusion of psychological depth, is conveyed in film.

Clearly, there are considerable differences between the films I have so far mentioned, besides which there are numerous other uses to which Super 8 has been put which are outside the scope of this article. On the other hand, there are strong similarities arising more or less directly from the

peculiarities of the medium, consolidated by shared attitudes to what the medium can and should do. But is Super 8 merely a poor alternative to larger 'professional' formats or are the differences between Super 8 and 16 or 35mm as significant as those between, say, drawing and painting? The ideology of professionalism has to be combatted and yet it is hard to deny the fact that given the opportunity, most filmmakers would work in the largest guage available. After all, the original appeal of Super 8 was that it offered a frame area twice the size of Standard 8 at no extra cost, through the ingenious redesign of the sprocket hole's size and position. However, although free choice in the matter of guage remains an academic question for the majority of Super 8 users, many display a wilful primitivism in eschewing recent technological developments in the medium, such as crystal sync cameras and recorders, Steenbeck tables and comprehensive laboratory services. In their hands it is a slightly anachronistic anomaly, in which the techniques described by Jo Comino in her notice for the B2 show have been strengthened and developed into substantial and definitive devices. I believe these devices will help to ensure the future of the medium as an art form that owes less and less to video and cinema (both as form and as institution).

The idea of an aesthetic system that is developed out of the particular characteristics of the medium in question is not new, but it is one that continues to raise objections from various critics and writers on film, and, therefore, needs to be countered if the argument so far is to hold water. One essay in particular that is frequently referred to in order to substantiate the above mentioned objections is Althusser's essay 'On the materialist dialectic': 'Left to itself, a spontaneous (technical) practice produces only the "theory" it needs as a means to produce the ends assigned to it: this "theory" is never more than the reflection of this end … so called theories which have nothing to do with real theory but are mere by-products of technical activity.'[4]

For example, in the Bazinian system, in contrast to most avant-garde film, the ideal role of film is as a transparent medium through which the reality of life may pass unmediated. Quite apart from the flaws in the Bazinian model, though, the existence of distinct forms of naturalism in television, video and cinema suggest that the use of film (or television or video) for dealing with real-life issues and problems (the naturalist's simultaneous moral self-justification and

condemnation of the others) is just as much a product of a technology as are films about motion, duration or even sprocket holes – more so in fact.

In cinema, for example, the drive towards increased verisimilitude is only possible because of certain technical developments, and it is not merely a case of cinema having taken advantage of new products and techniques. As cinema has established its natural trajectory, new products have been developed in anticipation of this, and thus could be said to have a determining effect on new films. Recent examples might include the development of high-speed distagon lenses and colour negative to allow available-light filming (e.g. the candle-lit scenes in *Barry Lyndon*) and the increasingly sophisticated special effects products used in the new generation of sci-fi blockbusters.

As it happens, Super 8 appears to embrace both formalist and representational tendencies with its strong pro-filmic events which are then heavily inflected by television bar lines, colour shifts, VHS editing, slow motion etc. Some of the filmmakers take a historically conscious 'post-modernist' stance, while for others filmmaking is a more spontaneous reflection of a cultural milieu with its attendant imperatives and financial restrictions. But at the moment this is less important than the fact that they have helped to establish Super 8 filmmaking and exhibition as a vital and vivacious activity, perpetuating an important marginal area of experimentation in the face of an increasingly moribund, complacent and prestige-orientated 'independent' sector. Although their work is very different, this constituency of artists are continuing the tradition established by filmmakers at the London Co-op in the late 1960s.

1 In fact this article covers two related shows, the first in March 1983 at B2, which has since closed, and the second in June 1983 at the ICA.
2 Jo Comino in *City Limits*, March 1983.
3 Louis Althusser, *For Marx*, Penguin, 1969, p. 171.
4 This article has an interesting pedigree. As well as being quoted by Mike Dunford in his article 'Experimental/avantgarde/revolutionary film practice' (in *Afterimage*, no. 6, 1976, p. 10), the same quote appears polemically at the end of Peter Gidal's film *Condition of Illusion* in order to counter the charge that Structural/Materialist film is itself a product of 'technical theory'. A similar passage from the same page of Althusser's article appears in an essay by Stephen Heath entitled 'Technology as historical and cultural form' (in *The Cinematic Apparatus*, Stephen Heath and Teresa de Lauretis (eds), Macmillan, 1980, pp. 1–14) in which it takes place. The problem with Dunford's extrapolation from science to filmmaking is that the kind of 'knowledge' that may be produced by theories of artistic production would not qualify as knowledge at all in a proper scientific sense.

the current british avant-garde film: some problems in context
peter gidal

Romance without Finance is a Nuisance.
– Charlie Parker

They are saying to the new generation, 'It would have happened anyway'.
– Christine Delphy

The present British Avant Garde Film is at a crucial juncture. This is 1981, and since the mid-1960s, British Avant Garde and experimental film was most complexly imbricated in the *procedural* structures of filmmaking, thereby producing at the level of production, exhibition and distribution a materialist practice of cinema.

The films made thereby, between 1966 and 1976, were of a 'kind' which are readily recognizable as what British experimental films are. From the distinguishing marks of 'style' to the procedural contingencies that are never separable from film-in-time, film-as-projected (the durational) to the intense lack of that need for irony, a need so prevalent in the North American experimental film of the same period, etc: the list could continue quite a bit, we have come to know what the films I am referring to are (in this context that might be polemical). At least those who have an interest, in every, or in some sense, do. The crucial juncture I referred to is post-1976, a period whence there's been intense 'independent film' activity in Britain culminating in a series of practices none of them not influenced by the work that I previously referred to as emanating from the London Film-makers' Co-operative. This is one ten-year 'moment' in British experimental film but equally in British independent film as a whole which is in danger of (vehement) suppression. It is a crucial point of reference because the work that is so strong, so productive as cinema and as intellectual process of ideas in representation, through representation, is in danger of suppressing the antecedent, that ten-year period of Co-op work, yet a danger of revolution, ending the history, is precisely not what I'm worried about. What I am talking about, or reading, or whatever, is that the *suppression*, in the empirical 'real' of what it is that one is doing, has specific theoretical consequences.

These consequences in theory (understanding as we all do by now what theoretical practice is, no?) can be that current work and also the speech about current work may elide the production process's function(ing) in current work, and that can produce new work, future work, and current theorization around the meanings of current work and the necessities for future work, in such a way as to retrogress. Re(tro)gression: a state before the mechanism's foregrounding, before process and production as operative, before production of a *spectator outside of knowledge*.

If we, in other words, again start producing a spectator *in* knowledge, in the illusion of knowledge, in the illusion that what is there is real, or that perception equals knowledge, more profoundly: the willing contract thus to suspend disbelief (without necessarily being 'lost' or 'delirious' even), then we are regressing and retrogressing to a 'state', annihilating (in its practical, concrete, ideological, psychoanalytical determinants) that materialist practice which has been built up over those crucial ten to fifteen years. The fact that ideological dominance has always mitigated against materialist practice even in such 'unlikely' places as *Screen*, *Afterimage*, though not *Film Form*, in the power positions within the granting body British Film Institute and its educational, production, and cinema-exhibition departments, makes it all the more 'natural' for such a regress to seem not only opportune but correct politically. For the filmmakers working in the independent sector in Britain are nothing if not political.

There is a sector of Independent Cinema which does not have the above-mentioned problems, that is there is a group practice which sees, in its films, in its filmmaking practice, and in its verbal practice around film, the London Film Co-op as its experimental determinant, not so much as a constant admission, which is unnecessary, but in terms of the lack of need for constant ellision. The work for example of Liz Rhodes, of Jo Davies, of Mary Pat Leece, of Susan Stein, Rob Gawthrop, Nicky Hamlyn, Tim Bruce, Penny Webb, David Parsons, Halford & Raban (and of course LeGrice, and a dozen

others whose work I've heard of from those I respect but have not myself seen; I'm also refraining from mentioning those filmmakers who are 'students' at the RCA, Slade, St. Martins, etc.) does not occlude the concerns of 1966–76, perhaps partially because at various stages they produced those concerns. And I am speaking here not 'just' of filmmaking, but of distribution, of exhibition, and of for example the battle within our London Film Co-op against the patriarchal hold some of us were operating to the point where, productive as the Co-op in some ways for film not-withstanding was, other groups were formed by ex-Co-op people, productive in other ways, *more* productive.

Four Corner Films includes some, Felicity Sparrow's Circles distribution includes some, and so on. Interestingly enough, their rigorous critique of the Co-op on those grounds took what was of use and value for them as filmmakers, and though for example the Executive Committee for two years finally had women and men in equal numbers that was too little and too late. And it was the Co-op's loss, but in some ways it was Independent Cinema's gain, in that groups with specific political positions can articulate their demands from their base and with their own power over the means of production (*Circles* is its own distribution network, *Four Corners* is its own production and exhibition network, and the work is precisely the most advanced being done in Britain). I won't go on about specifics, as their history could not, and would not, be told by me, mainly as I do not, could not, know it. But what I do know is that the strongest filmmaking practice seems to be least in need of denying its history, its histories, though at the same time most powerfully refusing to leave the power relations as they were and are (though there are powerful changes within the London Film-makers' Co-operative, and that is why some of those listed above work exclusively there, and see their positioning there, thereby renewing the productive capacity of the LFMC). There are both antagonistic and non-antagonistic contradictions. Some productive for some, meaning loss of power for others, some not.

What the films I am not describing but alluding to have an interest in, which does *not* suppress their materialist practice and the necessities there of both in terms of the *material* vulgarly understood as the acetate (which was never cel-

luloid, for us) *and* the material of ideology and the material of the psychoanalytic, spoken of as the desire to remove the spectator from his or her solid not so imaginary though *Imaginary* position as consumer; that's how it started, progressing to the spectator as part of the process of arresting meaning and finding that 'truth' can not be found and known 'in' representation, all that can be is attempted representation and one's insertion into, and position from, that as contradiction and ideological conflict whether unconscious or not. What the films I am not describing but alluding to have an interest in, which does not suppress their materialist practice, is: a concern with how the seen is not to be believed, how the seen is 'read', how such light readings are readings which have to be not seen to be believed, which have to be seen to not be believed, how such succession of images in duration are not, is not, an unfolding, of anything prior, anterior, not even sexuality, but an unfolding precisely not an unfolding, rather: a concretion of meanings, obsessive processing of course never separated from the profilmic (it couldn't be), (nor is it essentialist, formalist (in-the-weak-sense-usage-of-the-term) abstraction).

So, an *issue* is how the viewer, also, is perhaps not necessarily or always a man, that phallocentric view of knowledge the hold of the cinematic the break of which is disruptive of everything including *Politics*. That break as political, which certain independent male film groups (let's call them that, 'pure' description) could not admit, as it is not their concept of *political*; it is against their narcissistic 'hand-to-hand combat', their mirror, their power. To not see it is to be in it and they are. Which is not to say to see it is to be out of it.

When I say disruptive of everything this mustn't be understood to mean some kind of total fissure, some kind of idealist pulverising, this anti-politics that has become the vogue in NY and Paris as a result of the unfortunate French Guattari and Lyotard and all the rest of it. Disruptive of everything, as attempt, that as felt by Patriarchy, was meant to describe the feeling of loss of the phallos, this 'new' phallic 'plenitude', which is but of course is precisely NOT everything. And the viewer as differently constituted, constructed, in viewing, by disrupting such interests, is a different viewer finally. Similarly the way sound is used to both subjec-

tivize the viewing situation and to not let the subjectivity hold forth the pleasure of an author or what is really the same, a text. Are my comments polemical, descriptive, critical, or theoretical? I do not know.

In case anyone hadn't noticed, by the way, empiricism's been back for a while, the result of which is in England we have little problems like BFI-SCREEN TYPES saying things like 'there is no film outside its context'. Now you'd think a sentence like that, having learnt from Wittgenstein, sounds right, and yet in the mouth of an Englishman it changes or transforms (this is counterrevolution) from: 'one is never outside the context', or 'ideological political sexual economic context for cinema, for work on representation, must not be suppressed or repressed' etc … transforms from that to: 'nothing exists for you, for the subject, outside the context i.e. the context is the meaning, there is no material reality, no material of ideology, no material of politics, no material of labour, no material of sexual difference or sameness, no economic material, no, nothing … the world does not, the material relations do not produce consciousness, but rather, consciousness makes the world, the world as visualization of the pure (or not so pure) idea. And all this to avoid (void) the real problematic. Consciousness is the product of social relations in its various practices *and* those practices are the material effects of other material practices known as ideas thoughts theories polemics ideologies. (Even the young Marx knew this though he tended to stress the base/superstructure model.) A separation can be operated which is not to deny vectors in both directions, semi-autonomous productions, as in: economic/sexual in the *last* (ideological and physical) instance and that *last* not always of such importance for theory or practice; at other times, of such extreme import as to produce by its denial theoretical and practical oppression in the extreme. Empiricism is back, contradiction seems to have been left out, dialectic never having been utilized except as euphemism for some kind of energy in the first place.

I think the Avant Garde or experimental film in relation to contemporary British filmmaking (in the independent sector, as the other sector as is all too well known is bad Hollywood and nothing but) is a relation of materialist vs. attempted anti-materialist practice. Or attempted materialist

versus attempted anti-materialist practice. The annihilation of the process of production and the deproblematization of the position of the maker and the viewer; the annihilation of subjectivity as a history inseparable from a film's history yet not covering it nor covered by it, the annihilation of the relations (in film, in frame over there, not after-the-fact), the annihilation of the questions of representation that could position themselves and you unconsciously or consciously and the ideological-political of all that, the annihilation of all but the profilmic represented via a style which is different enough from that which we see on television or in arthouse documentaries to mainly through its economic determinants be categorized as 'independent' but in no other way (proof if proof were needed is that the switch by such filmmakers and their practices from the independent sector into television and into scripts which could be in the main arthouse cinemas is a switch precisely of import because it is none.) Are names needed for this annihilatory practice, this attempted antimaterialism? Berwick Street 'Collective', Phil Molloy, Chris Petit, Richard Wooley, Ed Bennett, Mulvey-Wollen. But more important than these lists and the strict dichotomization are those 'in-between'.

The current British Avant Garde's relation to contemporary British filmmaking isn't, therefore, here, now, in this essay, anymore the subject. The subject is this in-between status of so many films, an 'in-between' that can also only be defined in relation to a present and a past with an ideal thought of what future that could possibly be. (Past examples include Sally Potter's *Thriller* and her forthcoming film, with Lindsay Cooper and Rose English, Sue Clayton's and Jonathan Curling's *Song of the Shirt*, Nick Burton's and Anthea Kennedy's works, as well as the works of Penny Webb, Gabrielle Bown, Joi Leatherbarrow's and Ian Owles' *The Death of Heroes*, etc … the work of and at the Film Co op as their film history too, though not necessarily their future.) Althusser's future anterior, born into ideology before being born, not far from Beckett and Warhol and Gertrude Stein and Christine Delphy. Thus now an attempt to define a juncture, a possible crux wherein different influences not so much converge in some anti-Leninist synthesis but rather find a point or points of reference to produce a productivity for current and therefore future film practice not necessarily

defined by either of the two options materialist or anti-materialist, and whilst only through my ideology being defined as 'in-between', as in-between is nothing if not an oppressed definition of *the new which I don't know* though am speaking here about, thereby void in advance, or trying my hardest to avoid.

The ideology of the new is so much a (post)-structural(ist) threat that I can't find myself (!) speaking it. What this means finally what it calls for is that you look at British independent cinema post-1976 (not a call against the period 1966 onwards but a polemical call for the viewing necessity of what is now being produced and somehow dealing with that as North American cinema culture refused the decade prior). Refused? Annette Michelson's *New Forms in Film*, a huge travelling exhibition, for which read 'New Forms in American Film', P. Adams Sitney's *The Avant Garde Film, A Reader of Theory and Criticism*, for which read as 'to 1960 and after'. The *American* Avant Garde Film, A Reader of American 'Theory' and Criticism, Peter Kubelka's Beaubourg (Paris) Archive *Une Histoire du Cinema*, for which read 'Anthology Film Archives' *American* Collection', etc … further refusals don't have to be cited though they abound in the sycophantic NY press given local, parochial American Avant Garde, an old battle not renewable here. I bring all this up only because there is no way the British experimental film apparatus would claim to have elicited its own history outside of North American influence, when one of the London Co-op's policies was precisely and always to have non-British work shown as a matter of cinematic cultural-political practice (equally to have 50 per cent of British work shown as similar matter). It took ten years after that to even have an executive committee that actually ran the organization, let alone one that was 50 per cent female. None of the above seems to have been contemplated individually or institutionally in North America.

Having started this paragraph attack on my own notion of 'in-between', my vested interest as representative of one extreme of experimental filmmaking and writing, I ended it with a not so hidden self rationalization in the form of an attack. To get back after all this to the point: the work totally undescribed, which will form the main focus or movement or *filming* will be rather than in-between, a result, an affect, an effect, of the history which had as its main problematic at

once both an ascetic Avant Garde and a cinema of political overtness, Politics in terms of the profilmic (e.g. Cinema Action) thus a kind of work which attempted to speak certain problems in the realm of the referent which though imaginary was a moment of short term illusionism for specific concrete ends and damn the philosophical consequences. Of course that position is a necessity if we are not to end up with a long term practice that is pure but leaves the immediate propaganda to the 'others'. And the structural-materialist necessity.

The problematization of precisely all that is what will effect the work now being done, as there are issues for example in the attempted representation of struggle that still want addressing, not merely camouflaging in some kind of 'cinematic form' that makes respectable for same spectators who don't need that respectability cast upon them, nor need a 'political content' (another respectability) within a 'radical' form. Only good conscience can be bought that way when good conscience may not be what's sought but a posing of other material. So films which are about a subject like, for example, the domestic labour and at the same time deal with modes of representation, production and reproduction, and subjectivity and crisis in representation, and the political effectivity let alone 'truth' of that (whatever the position taken) will have as basic problematic how not to merely use form, simply, or content, simply, as the good conscience of the 'other half' of (the) film. And it seems that 'work on narrative' form will with its questioning (when it does) of the knowledge/perception dichotomy imbricate the 'answers' that filmpractice is finding. We can thereby posit a filmpractice contradictory, problematical, outside of an opportunism, the opportune, the answer which by being answer posits no question was asked if question means asking something to which no answer has yet been established; posing something other, oppositional, radical.

Perhaps therefore my relegation of the new, the 'other', as 'in-between' in the presumption of the omniscient view should not have been attempted, it is a structural lock and ought to be restated as the I don't know that I was attempting to state way at the beginning of all this and then proceeded to not. If this all has been issueless it at least doesn't pretend to not have been, and you can take up these questions at will.

from structuralism to imagism: peter gidal and his influence in the 1980s
nicky hamlyn

Peter Gidal has been an abiding presence in English filmmaking throughout the 1970s and 1980s. Although arguably his influence has declined in the last few years many of the filmmakers whom he has influenced either personally, through his teaching at the Royal College of Art film school, or through contact with his films and writings, continue to be an active, if marginal, presence in the 1990s.

Some have abandoned the tough asceticism characteristic of Gidal's own work in order to return, however tentatively, to the image, to representation. Hence the 'Imagism' of the title. Nevertheless the filmmakers under consideration retain a Gidalian spirit in their approach to questions of representation and narrative and so, generally speaking, their work falls outside the current TV-oriented scene.

Much has been made of the disparity between Gidal's theoretical writing and his films. The former is an astringent polemical attack on aestheticism, and on the representational and illusionistic foundations of Cinema. The films, however, have been viewed as aesthetic and subjectivist, readily assimilable to the perspective of the visual arts: 'Far from being the negative, defensive body of work that they seem to many in the independent sector, Gidal's films, looked at from a fine art position, have exactly the opposite qualities of positive, affirmative and attacking work hewn out of the cinema itself' (Michael O'Pray, *BFI Monthly Film Bulletin*, vol. 53, February 1986, p. 64).

In the past Gidal has tended to respond to variant interpretations of his work either by accommodating them within his own position, or by dismissing them as attempts to recuperate his work into the terms of the commercial cinema. (See for example: 'Theory and Definition of Structural/Materialist Film', in *Structural Film Anthology*, BFI, 1976, pp. 17–18.) But the dichotomy nonetheless exists in his work as an avowed refusal of cinematic pleasure and as fundamentally pleasurable. His insistence that the work is meant to produce 'unpleasure' or 'productive boredom' has never seemed entirely wholehearted in the face of the fact that audiences do sit through them and clearly derive not only intellectual or masochistic, but scopophilic pleasure from them.

Room Film 1973 is often cited as a paradigm of the above dichotomy. It consists of a series of five-second shots, each of which is repeated once. After five seconds the repeat continues unbroken to form the subject of the next repetition, inaugurating the system for the rest of fifty-minute film, bar a five-minute section of freeze frames in the middle. Within this regular structure the decisions about the quality of the hand-held camera work, the green cast, muted colour and, indeed, the length and number of shots seem in one sense purely subjective. Yet this is a universal kind of subjectivism underlying all artistic decision making, and should not be confused with that subjectivism in which camera movements are meant to simulate 'stumbling around a room' or a colour cast suggesting an altered state of perception.

The subjectivism of *Room Film 1973* is of the same order as that in Mondrian's mature painting, where a decision would be made to move a vertical line a quarter of an inch to the right for example. Whilst such decisions are fundamentally subjective (how could they be otherwise?) the desired effect is the effacement of idiosyncrasy in favour of the withholding of full or firm representation (or in Mondrian's case in favour of an abstract equilibrium). Even in the work of a constructivist like Malcolm Hughes, who uses number systems to determine the form of a work, choices still have to be made about which system to use, and whether or not to modify it and how, quite apart from questions about materials, scale, colour etc.

The suggestion that the decision regarding quality of camera movement is subjective invites the assumption that putting the camera on a tripod, for example, would make the shots more objective. Yet in *Action at a Distance* (1980) Gidal does more or less this. The film consists of three static, ten-minute, hand held shots of areas of a room. Here it is the sheer duration of the shots, combined with a repeated minute-long monologue, which serves to frustrate an unproblematic viewing and engender a self-reflexive state in the viewer.

In the light of the above it can be seen that the equation of jerky, hand-held camera with a subjective approach and, conversely, static camera with an objective approach, is misguided, since both are valid devices in the project of problematizing viewing. The cultivation of a pseudo-scientific language

Upside-Down Feature (1967-1972) a film by Peter Gidal

can in any case create just another, equally strong, subjective mood, as it does in Alain Robbe-Grillet's dispassionate prose.

Gidal himself attempts to show how hand-holding forms part of an interactive system that is neither subjective nor objective: 'The hand, the eye, the mind and the mechanical apparatus in relation to one another have a force, their own productive use, separate from any intentionality or consciousness' (quoted in O'Pray, op cit).

This remark is reminiscent of an observation made by Michael Compton about the similarities between Jackson Pollock's paintings and Robert Morris' sculptures: 'Morris' felts may share with Pollock's paintings a partially-controlled indeterminacy and a looping rhythm, in each case operated upon by gravity and conditioned by the specific viscosity/pliability of the medium and by the gestures used in the making' (Michael Compton, Catalogue to Morris' Tate Gallery retrospective, 1971, p. 105).

Both these accounts take a behavioural view of art-making by describing the work strictly in terms of observable processes and materials, hence avoiding questions about the artists' intentions. In Gidal's case this involves the aforementioned distinction between hand-heldness as part of a system empty of emotional significance and hand-heldness as an expressionistic device.

Taken as a whole, Gidal's 'negative project' could be seen as paradoxical. He is against representation/reproduction and yet the large body of films constitutes a vigorous, even enthusiastic way of exploring and developing the range of possible ways of not-representing, or, more accurately, withholding full or firm representations. On the negative view, one can see the myriad ways in which narration and illusionism can return and corrupt the project. They are always present, just 'outside', pushing on the door against which Gidal is leaning as it were; in the glimpsed objects in *Room Film 1973*, the feet and disembodied whistling in *Silent Partner* (1979), in the speech by the Nicaraguan Minister of Culture in *Close Up* (1984)

and the floodlit lake in *Guilt* (1987).

In a positive sense though, these films deal with distinct aspects of the cinematic experience. Crudely; *Room Film 1973* with representational and visual memory, *Action at a Distance* with duration, *Silent Partner* with human presence/absence and off-screen space, *Close Up* with politics, *Guilt* with location. What unites these concerns is Gidal's treatment of them: always refusing an illusory spatial coherence, and an insistance on non-linear, non-hierarchical ordering of elements. This attitude surely stems from Gidal's time spent in New York in the 1960s, where it was common currency among sculptors like Eva Hesse and Carl Andre, painters like Frank Stella and Agnes Martin and musicians like Steve Reich.

The question of subjectivity that overshadows so much of the discussion of Gidal's work appears immediately less urgent in the work of those successive filmmakers who have come under his influence. Yet the critical context created by the debate around subjectivity has had a strong influence on the way the work of these successors has been received and understood. It has allowed the films to be seen in such a way that discussion of them does not get bogged down in psychologistic debates about the way a camera moves, or the symbolic significance of framing objects in the corner, or the meaning of cracks in a bare wall or whatever.

Gidal's work has always been vulnerable to this kind of interpretative reading because it so often resembles that of filmmakers to whom he expresses himself ideologically opposed, notably Stan Brackhage, whose work is avowedly poetic and mythopoeic: the expression of a personal vision. Hence Gidal's theoretical endeavours to create a critical context within which film can be seen in much the same way as minimal sculpture has been seen; that is, as autonomous objects which do not depend for their meaning on some extra-sculptural reality. This critical context also serves to validate a painterly approach to filmmaking that might previously have been dismissed as empty formalism (of course in some circles it still is).

Michael Mazière was a student of Gidal's at the Royal College of Art, and some of his best work was produced in that time. *Untitled* (1980) explores two adjacent spaces; a room and the street outside as seen from the room. Through an exhaustive use of focus-pulls, dolly-zooms, pans and superimposed zooms, Mazière draws out, with great clarity, the numerous ways of seeing these two spaces and their various interpretations. Sometimes the room is an interior world illuminated with light from the single window. At other times the room is a blackened void and the window a screen. At other moments the window permits a view out and we see the outside as a view from a window. Then we 'are' outside and the camera teases out the infinity of ways in which the space may be experienced. The camera manipulations successively redefine the exterior space, reminding us that seeing is relative; since each sweep of the camera displaces its predecessor, the notion of a cardinal viewpoint is undermined. The relativism of the viewpoint here is not to be confused with something apparently similar, namely the subjective expression of an individual's vision. The film sets up a system of elements; room, window, view out, exterior, camera, light, and darkness and sets these in motion. *Untitled* is a positive film. It stresses that seeing is a creative process, an act by which we construct and define ourselves in relation to our surroundings. The distinction between self and surroundings, observer and observed are blurred.

In Mazière's most recent work, *Cézanne's Eye* (1988), the strong formal constraints imposed by the room/window/outside of *Untitled* have almost entirely disappeared. The film consists of optically printed material that is freely selected from Super 8 and 16mm source footage of the Mt. St Victoire and surrounding landscape that is itself disparate, loose and expansive, so much so, in fact, that the scenic unity of the earlier work is largely absent. The optical printing sometimes affects to simulate the movement of the eye as it crosses and recrosses the landscape, while at other moments it freezes on fortuitous stillnesses, blurs and reflections spontaneously generated in the original hand-held footage. But the lack of a unifying element or structuring system or reference point makes the work seem somewhat aimless.

Mazière's contemporary at the RCA, Lucy Panteli, has attempted an impossible feat, in Gidalian terms: the representation of women, in her last film *Photoplay* (1984). For Gidal, all representations of women (and men for that matter), however seemingly innocuous, are intrinsically reactionary even if, especially if, the women are shown in a sympathetic or positive light, since such representations obscure all the more the insidious mechanisms which perpetuate women as passive, as seen: the object of the ubiquitous male gaze.

In her earlier work Panteli has always striven to suppress the profilmic (or at least to transform it utterly) by heavily reworking her footage in an optical printer. In *Photoplay* she goes a step or two further by introducing women engaged in various traditionally female activities; knitting, playing catch with a ball, applying makeup. In each section of the film the profilmic event is drastically altered by the unique filming method, which consisted of taking single-frame time exposures of approximately half a second every second or so over extremely long periods of time – in some cases up to six hours at a stretch. Hence there is a temporal continuity of filming, rather as if the film were shot at 24fps, but a resulting film that is much shorter, six hours having been compressed into about five minutes.

The introduction of women engaged in female activities is clearly intended to bring the representation of women onto the agenda, yet one wants to ask how the significance of what is represented can adequately be analysed through the use of a strongly procedural method that is uniformly indifferent to the particular content of each section of the film. If the function of this indifference is merely to preempt the usual identificatory mechanisms, then the question of how women can be represented (how they can represent themselves) non-repressively does not get tackled.

Another filmmaker who has approached this issue but from the opposite direction is Jean Matthee in her film *Neon Queen* (1987), which employs elaborate optical printing procedures to deconstruct the icon of the female heroine, in this case Dorothy Malone in Douglas Sirk's film *Written on the Wind*. Matthee takes a short section in which Malone paces across the room and throws herself onto a bed. Her movements are endlessly, meticulously reworked backwards and forwards, speeded up, slowed down and stopped. In contrast to the austere beauty of *Photoplay*, *Neon Queen* is full of two- and three-colour separations that range in tone from richly sombre to pale and acrid. The herione's movements are reworked in such a way that they seem to take on an expanding range of meanings; frustration, despair, misery? Yet these meanings arguably arise from the way Matthee treats her material, rather than being intrinsic to the original footage so it could be said that *Neon Queen* is the opposite of a deconstruction.

The film is paradoxical in its apparent attempt to obliterate its own imagery, and hence its *raison d'être*, through sheer repetition, darkness and dura-tion – a few seconds expanded to forty minutes. Thus the function of the work mirrors the self-destructiveness of the female heroine. Yet Malone is the film's *sine qua non*, and her necessary omni-presence is precisely what prevents a dialectical engagement: as long as she is there, there can be no fundamental crisis of representation, no difficulty and hence no struggle for the viewer. However, the aforementioned process by which the deconstructive strategies relentlessly produce new meanings (rather than deconstructing old ones) is pulled into focus, indeed this is the film's real problematic. In this sense *Neon Queen* is an illuminating and instructive film, regardless of whether or not it succeeds on its own terms.

In both *Photoplay* and *Neon Queen* there is a divergent impulse at work. On the one hand the filmmakers seek to reintroduce representations of women into avant-garde film, whilst simultaneously expressing the anxiety that the cultural accretions in which such representations are embedded will overwhelm or corrupt their radical project. But just because these representations cannot simply shed their existing meanings, it does not follow that they can never be used subversively (or just differently) against extant meanings. (As Gidal himself is fond of saying, one is inescapably in a culture at the same time as one does battle with it.)

Two filmmakers who have tackled directly and unflinchingly issues of female nudity and sexuality are Jayne Parker in her video tape *Almost Out* (1984) and Claudia Schillinger in *Between* (1988). Both these works employ full-frontal nudity, yet neither could seriously be accused of readmitting pornography, since both subvert the usual mechanisms whereby pornography functions.

A third function of cinema which has received considerable theoretical attention in Gidal's writings is narrative: 'Identification is inseparable from the procedures of narrative, though not totally covered by it. The problematic centres on the question as to whether narrative is inherently authoritarian, manipulative and mystificatory or not. The fact that it requires identificatory procedures and a lack of distanciation to function, and the fact that its only possible functioning is at an illusionistic level, indicates that the problematic has a clear resolution' ('On Identification, Theory and Definition of Structural/Materialist Film', *Structural Film Anthology*, BFI, 1978, p. 4).

Recently there have been attempts to utilise critically aspects or fragments of narrative in a way

that does not simply lead back to a 'Cinema of Consumption'. Increasingly in his recent work, David Finch has drawn on memories of his own past and of fragments from fairytales and feature films. By placing these in a new context his films obliquely shed light on how the fragments operate as narratives, on how they accrue meaning. Their 'preconstructedness' – the fact they bring certain meanings with them – is taken up in a critical way, in contrast to the so-called deconstructed narratives of Straub/Huillet and their followers, where the preconstructedness of their imagery is taken for granted, 'thus denying the historicity of the film processes' (Peter Gidal 'History', *Materialist Film*, Routledge, 1989, p. 90). In his most recent work, *Man of Stones*, Finch takes a restricted set of elements and puts them into various combinations to create a film about childhood memory. The material for the film is inspired by the answers his mother supplies to childhood questions about the origins of the universe and the material composition of God: 'He's not made of anything … he's made of stones.'

This explanation is interpreted as panpsychic and so the film is full of juxtapositions of stones and men. The narrative elements are slow-motion clips from *Carve Her Name with Pride* and *Sink the Bismark*, with various shots of naval warfare and Kenneth More's Hitler waving from a cavalcade. These are intercut with diverse shots and sequences including a street in Edinburgh which moves from wide-shot to close-up of specific windows to a medium-shot pan away to a grassy knoll. Hence the film is characterised by the combination of public and private images which, as remembered images, as memories, carry an equal amount of significance, notwithstanding the preconstructedness of the found footage. In *Man of Stones* the public imagery functions very much as a private repertoire whose original meaning has been partially left behind within its former context. Conversely, it becomes possible to locate the private imagery within an accessible, public context created by the juxtaposition with the found images, which are themselves united by the film's theme.

It would be wrong to push this reading too far since, as a whole, *Man of Stones* is an explicitly poetic meditation on memory, and the meaning of masculinity. Yet it is precisely the poetic quality that prevents the use of narrative fragments from simply instigating either another, unproblematic narrative or some sort of academic meta narrative, as perpetrated by the followers of Godard and Straub/Huillet.

In his first and only video tape, *Rich Blue and Fertile* (1988), Jonathan Dronsfield mounts an attack on the adequacy of narrative and documentary codes. The tape is marked by an extreme brevity – one and a half minutes – and has the curious quality of being highly condensed yet laconic: stepping along a barely discernible pavement. The legs' rhythmic progress is partly natural and partly contrived from a repeating loop of a single step, with periodic variations in framing. This sequence is preceded by a flash of text about Christopher Columbus, details of a room seen in the left-hand strip of an otherwise blank screen, bleached-out views of tower-blocks and a blue tinted shot of a bowl of fruit being tipped onto the floor. These images are too cryptic to be emblems; rather, they are counter-synedoches, whose collective incoherence reflects the incoherence of the world: 'The tape stands as a rejection of the possibility of recreating a believable world except through the distorting lens of cinematic narrative. This rejection is affected without either perpetuating that world or retreating into solipsism' (Nicky Hamlyn, 'London Film Festival', *Independent Media*, February 1989, p. 13).

The work of Cerith Wyn Evans seems at first sight to be diametrically opposed to Gidal's. His tape/film hybrids are lush, colourful, exotic and full of icons and symbols of late twentieth-century life. Yet Wyn Evans is also a graduate of the RCA who has acknowledged the influence of Gidal's strategies of distanciation in his work. In the last section of *Epiphany* (1984) a young girl dressed as a Madonna sits, barely moving, as sequins drip from her lips. The image is both startling and seductive, with an exaggerated 'otherworldly' quality created by transferring the material from film to tape and back again several times. Yet this shimmering electronic icon gradually turns sour, partly through its extreme duration, and partly through the girl's occasional smirks. The use of irony and duration, androgenous performers and overblown music tracks (Wagner, Kathleen Ferrier), all combine in *Epiphany* to create scenes which are compelling at the same time as they distanciate their audience. Most of the footage consists of electronic collage. Thus Wyn Evans creates in-frame juxtapositions, such as the skinhead sitting astride Piccadilly Circus, and these form a critical conjunction on which the audience has plenty of time to reflect.

Stephen Heath has remarked that: 'There is for Gidal a radical impossibility: the history of cinema. The fundamental criticism made of everyone from

the Berwick Street Collective to Akerman, Oshima, to Le Grice (even Le Grice) is that their films are part of that history, return to its representation, that they are in that cinema, repeat its implications. Strategies of deconstruction are merely a further turn of involvement: deconstruction repeats – gives currency once more to and looks into – the terms, the images it seeks to displace, is a continuing and reactionary reproduction of cinema' (Afterword to Peter Gidal's essay 'The Anti Narrative', *Screen*, vol. 20, no. 2, 1979).

I hope (perhaps naively) that I have shown, in the works discussed above, that there are ways of confronting representations – of space, women, contemporary icons – and working with those representations which do not necessarily lead back into cinema, 'return the representation' of its history. For me this is already happening, especially in the work that I have mentioned only in passing; work by Jayne Parker, Claudia Schillinger, Cleo Uebellman. They are not discussed here because they fall outside Gidal's sphere of influence, and this in itself is an encouraging sign in view of the sometimes restrictive effect Gidal's presence has had.

content in context
michael mazière

What can be shown, cannot be said.
– Ludwig Wittgenstein[1]

The attempt at contextualisation of experimental avant-garde work is, at present, carried in two different (but not mutually exclusive) directions. On the one hand the work is presented as 'oppositional', in the primary sense of an anti-narrative and anti-illusionist project as defined by Peter Gidal,[2] and on the other it is integrated into a more general perspective of modernist aesthetics (as part of the broader debates of painting, sculpture, performance). Either position argued in isolation, fails to articulate the specificity of experimental film practice, because both are 'caught' in a number of discourses which are not fully appropriate to that practice. For instance, the anti-narrative position leads to a debate on the grounds of dominant film theory precisely because avant-garde film is only defined in opposition to it. Although of some use in relation to subject/viewer placement, it fails to accommodate other levels of filmic signification: 'The identifications, projections, introjections and splittings set up in phantasy in relation to the viewing (and production) of a structural/minimalist film are not those achieved in mainstream cinema.'[3] However in placing the debate around 'aesthetic creation' or purely 'formal' concerns the specificity of film is lost in terms of its engagement with problems of reproduction/representation and excludes the question of content.

Thus, caught in the opposition of film as art (formal and aesthetic considerations) and film as language (semiological and psychological considerations) theoretical work often turns into tautology and/or contradiction.

In a recent interview, the filmmaker Martin Sercombe refers to a possible contradiction between the two main concerns in his work: those of a 'dominant aesthetic' and those of 'structural materialism': 'I wish to both "seduce" the audience into sharing my enthusiasm for the forms, colours, textures and rhythms that inspire each piece, (creating a passive relationship, within the established terms of that definition) and prompt a dialectic through the formal experimentation with audio-visual language. I see no reason why these two functions of a work cannot be co-existant.'[4]

In his two films *In Motion* and *East Coast*, Sercombe reveals that attempt at fusing formal, aesthetic and structural operations into a movement on/through landscape. The films use a number of visual possibilities in direct relation to the subject matter: hand-held shots for the stream sequence and

COASTAL CALLS
Rob Gawthrop

IN MOTION Martin Sercombe

rapid forward zoom in the forest sequence for *In Motion*, and in *East Coast* the use of single frame in the railing/plank sequence. These moments all work towards an *equivalence* of treatment with 'content' which the use of sound reinforces: loop sound of water in the stream sequence, hammering sound in the single frame/railing sequence. It is disputable whether the films 'prompt a dialectic' for the manipulations and filmic articulations are often used as *effects*, and only seem justified by the pure elements of the landscape they reflect (often as metaphor).

To avoid the problem of 'content' is to avoid a problematic; attempts at defining what constitutes 'content' in experimental film have been tentative and obscure: 'In fact, the real content is the form, form become content. Form is meant as formal operation, not as composition.'[5] Content defined as formal operation thereby delimits its operation, but a large number of recent avant-garde works transgress that definition so that the two notions are worked on in relation to each other, and identified as separate. In Martin Sercombe's films it is those instances of transformation when pro-filmic content (moving water) is broken down into filmic formal operation (camera movement, super-imposition) that the films reveal levels of material production. All too often, however, the material processes become metaphors for the given, raw representations and are then read as reflective of the pro-filmic content: in this case, landscape.

Within this framework, a concern for space and 'content', a number of issues can be raised. The image is crossed, in film, by two different instances of movement, one pertaining to its temporality and the other to its spaciality. Although there is a constant interaction between these movements, certain strategies tend to place the 'action' in either one domain or the other. The critical edges in film, that of the frame and of the splice, determine the scale of inscriptions levelled at the image and these delimitations outline directions (fragmented and multiple) of the viewers' access to the work. Peter Milner, however, argues that these factors should not be used to divide formal analysis from the question of content: 'The two aspects of the work, "the form" and "the content" appear to exist in mutual indifference. This is not peculiar to this film alone but to many experimental and "formalist" works that have followed it and exists as something of a lacunae in the thinking that surrounds it. The attitude that the "content", by which is strictly meant the pro-filmic, can be arbitrarily determined, in the hope that form alone guarantees political and aesthetic sincerity, ignores the inescapable fact that an image is an image of something.'[6] However determining construction and process are, content cannot be read off as neutral; questions of identification/identifying, representation/reproduction, pro/post-filmic content are crucial and have to be linked in order to contextualise the work. Subject matter in avant-garde work is then at that juncture between recognition and construction, not seen to be a representation but *in* reproduction. The 'residual content', the 'something' which is the turning point in the process of light reading is not arbitrarily selected by the filmmaker but has been chosen in relation to formal and procedural strategies. Whether it is conscious or un-conscious does not deny its relevance; there is space for a study of imagery in the avant-garde in relation to sexuality and the unconscious.[7]

But when showing me this, sly mountains, you block the distant view which gladdens me, for it reveals the attainable at a glance.
— Franz Kafka[9]

Landscape films do not hold a specific and homogeneous area of concern, but around them materialises a set of problematics in a more varied way than has been previously defined. Deke Dusinberre, in his article 'St George in the Forest',[8] selected specifically systemic films as representative of that area although the use of landscape has since been broadened to include other structural and formal manipulations:

Rob Gawthrop's *Coastal Calls* is a film which deals with primary filmic elements and produces constantly shifting relationships between them. The film is made up of four 400-feet rolls/takes of slow pans of a beach and its surrounding landscape with focus

and exposure in constant change. The sound is that of the space (sea, wind) alternating with that of a wind instrument (bombard). Only at specific instances do focus and exposure match to give an image that is readable in illusionistic terms, so that any attempt to 'place' oneself is subverted by the constant perceptual shift applied to the image. The film is made up of a number of different strands oscillating along the temporal axis: the frame (slow panning), the density (light to dark exposure), the sharpness (clear to blurred focus) and the sound (atmos to music). These move in accordance and discordance to each other throughout the film. The instances of representation where the materials seem to be stabilized work more as points of de-structuring of the film rather than solidifying the image.

Views by Joanna Millet also uses layers in its imagery but at a different and more localized level: the film was shot with a telephoto lens from a hill overlooking a valley, and with constant movement scans the surrounding landscape. Multiple exposures were made in a pyramidical structure, and exposure was changed accordingly so that as the layers increase and decrease the overall density of the image remains the same. Through the process of viewing, the depth and possible solidity of the image is eroded and the superimpositions appear more as subtractive than additive: each new layer compresses the image and disperses the 'content'. The inscriptions are contained along the linearity of the film and are read as multiple and fragmented. In this context, perceptions are seen as products of a number of procedures based on variants structured in a specific way, not as given constituents of knowledge. The materials at work in *Coastal Calls* and *Views* are materials of reproduction (emulsion, surface, focus, exposure) set against the duration of the films but never at a point of representation, that is, never gathered into representation but only crossing points of unstabilized representation, as if by accident.

Editing in these films is along the horizontal axis (what is left out through focus, framing, exposure) but never set against a vertical cutting of the film. They privilege temporality in the same tradition articulated by Deke Dusinberre writing about certain experimental films of the seventies: 'Literal in the horizontality of their construct, they emphasize the linear nature of the material of film without claiming for that linearity any of its common characteristics – neither as time posited on the movement of action and space, nor an "eternal present"

yanked out of time. Literal linearity is manifested by literal duration. Thus the privileged nature of the temporal experience in the emerging English tradition.'[10]

Other concerns (although related to those analysed so far, in the viewing process they produce) centre around more 'edited' structures, as in *Across the Field of Vision* by Lucy Panteli, which is made up of 'four hundred shots (of seagulls) of varying length, speed, scale and tonality'.[11] The subject matter of seagulls – always set against the flat space of the sky works as the reading gauge throughout the film, as a unit within a specific system. The unit (image of seagull) carries the motion and reads off the space; the crucial point here is that the film never emphasizes pro-filmic space or off-screen space, as each shot is cast against the previous one.

The films described work through a number of filmic processes in different, multiple and problematic ways. Whether the emphasis is on temporality or spaciality, they attempt to involve the viewer in a specific interpretive activity: 'Access towards meaning/s involves discourse on the part of the subject/viewer; s/he is then at a point of interaction between positions which are not given but in production.'[12]

1 Ludwig Wittgenstein, *Tractacus Logico-Philosophicus*, 4.1212.
2 Peter Gidal, 'The Anti-Narrative', *Screen*, vol. 20, no. 2, *Structural Film Anthology* (BFI).
3 Michael O'Pray, 'Modernism, Phanatasy and Avant-Garde Film', *Undercut*, no. 3/4.
4 Martin Sercombe, interview for *Framework*, unpublished.
5 Peter Gidal, *Structural Film Anthology* (BFI).
6 Peter Milner (on Malcolm Le Grice's 'After Lumière').
7 In this context see: Michael O'Pray's 'Movies, Mania and Masculinity', *Screen*, vol. 23, no. 5.
8 Deke Dusinberre, 'St George in the Forest', *Afterimage*, no. 6.
9 Franz Kafka, 'An address to the landscape', *Desription of a Struggle*.
10 Deke Dusinberre, op. cit.
11 Lucy Panteli, Co-op Summer Show Catalogue, Summer 1982.
12 Michael Mazière, Joanna Millet, Lucy Panteli, in Royal College of Art Degree Show Catalogue, 1982.

ACROSS
THE FIELD
OF VISION
Lucy Panteli

from across the channel and 15 years
barbara meter

Asked to write something about British experimental film – since I have seen quite a lot of it in the past year due to the programming I do in Holland – I had mixed feelings towards such a request because I have only seen most of the films once.

One could characterise my involvement with experimental film as somewhat periodic. I was engaged in it in the early 1970s and living in Holland, where there is a void in terms of avant-garde film, plus drawing the conclusions of the debate I was tangled up in at the time as to whether experimental film was 'politically relevant' or not (to which my answer then was no). I enrolled into making political action films (relevant or not). About three years ago now, I have 'returned to my roots' as it feels, and so have looked at this area anew.

So, looking again at the British avant-garde after 15 years it is as if I have plunged into an orgy of romantic images, grainy colours, decadent and dark moods and personal evocations. What a reaction against the asceticism of the formal and structural film which reigned at the time I was around. A predictable reaction of course – and one which is highly indebted to just that formal movement. I think that all of British experimental film pays a tribute to the structural movement (even when being vehemently the opposite, like the work of Cerith Wyn Evans, Derek Jarman, Anna Thew etc). Whatever it did, this formal 'regime' certainly made an extremely clear point of film as an autonomous art, as an answer to film as a derived medium.

I have a very high opinion of British experimental film. Almost all the films I saw are made with a lot of thought and devotion. At the same time they are made with a kind of ease, which depicts a cultural climate in which thinking of film 'as-film' comes almost as second nature. This is something which – coming from Holland – I am extremely envious of, and must be due to the teaching at art colleges, starting with people like Peter Gidal, Malcolm Le Grice, William Raban, Mike Leggett and all the younger filmmakers that followed – plus the incessant enthusiasm and zest with which all these artists have kept the London Film-makers' Co-operative active and alive for more than twenty years.

What an achievement for something as fragile, controversial and exceptional – seen against mainstream and all other forms of cinema – as experimental film. The British should be proud to have such a 'moving' visual art, unique in Europe, with its own characteristics and history.

But I know the 'British' are not as proud as they should be and there is a constant struggle to obtain the necessary funds and opportunities. I do not at all have the opinion that artists should suffer in attics in order to produce great works – but it could also be possible that this constant struggle was a factor in preventing an easy incorporation within the status-quo … I don't know, for I certainly would like to see the Co-op and film-makers provided with more means.

I can seen why it would be necessary to have more paid staff at the London Film-makers' Co-op. Apart from the fact that all distribution and workshop staff are overloaded and work much longer hours than they are paid for – new equipment is urgently needed and new premises will be much more expensive – I think that a paid person to promote British avant-garde film would help to maintain and expand this precious film-as-film climate, which is always under threat of being crushed by bigger institutions and more publicly accepted film forms. In a sense, the Film and Video Umbrella does this, but I think it would be vital to have someone from within the Co-op concentrating on trying to get a foothold in museums, art galleries, colleges etc.

I can see how English filmmakers have to work really hard to earn a living – grants obviously do not provide salaries, and are too little anyway – which means that there is hardly any time left for making films except in the much needed holidays. This does not seem to get any better under the current economic situation.

Having mentioned English 'characteristics' I am of course obliged to clarify this. It is walking on slippery ground, as it is slippery to say anything is 'typical' of a nationality. On the other hand I do think English avant-garde film does have a specific history and development, which is reflected in the works. The films mentioned are a selection of what I saw.

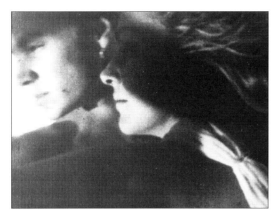

BEHIND CLOSED DOORS Anna Thew

CEZANNE'S EYE Michael Mazière

The outburst of voluptuous, rich, theatrical, dark and moody imagery as found in the work of Cerith Wyn Evans, Anna Thew, John Maybury, Michael Kostiff, Cordelia Swann and Derek Jarman seems, from the outside, typically English. First of all, this work has developed out of the punk movement, which had a strong impact in England, maybe even more so than on the Continent. The theatrical clothing of punk was both agressive and fetishistic. From that I see a development into the ritualistic and mythological symbolism of films like *Epiphany* (Wyn Evans) and *Behind Closed Doors* (Thew). The celebration of taboos, typical of decadence, like gayness, death, morbid sexuality (necrophilia in Kostiff's 8mm work), made me think of another historic mode in England at the time, the gothic novel – albeit on a higher level. These works also belong I guess to the expression of, as well the protest against, the immoral and decaying society which England seems to have become. As a reaction to the formal film-stream, it also pays its debt to it: none of these films is illusionistic, the medium is explored by ways of cutting and the layering of images which must be the outcome of the climate I mentioned before, film as-film, matter of factness.

Another 'genre' of film which I think of as typically English is the landscape film, which has obvious strong references to the formal movement, as each film (that I have seen) is highly structured and the medium is very much made visible. Landscape films to me are dialogues between the illusion of the representation and the questioning of it – between the pleasure and the sensuousness of a landscape and the exploitation and restriction of form – which amounts to a balance between

the 'emotional' and the 'rational'; which is English at its best.

One of the finest examples of landscape films I saw was *Across the Field of Vision* by Lucy Panteli. In it, shots of seagulls form patterns against the sky without any reference to time or space; they are composed in diverse combinations, speeds and movements without a rigid structure but at the same time carefully arranged. As in a piece of music the shots are placed in answer and development towards each other and in the end one has experienced the film as an object, a whole in itself. It made me curious to see other works by Panteli.

Through the use of reprinting, loops, superimpositions, time-lapses, pans, tilts, repetitions, accelerations and delays, Nick Collins builds up a personal interpretation and expression of landscape in *Sanday*. The result is a beautiful film which has a melancholic and somewhat yearning character without ever being sentimental or romantic.

Rob Gawthrop's *Coastal Calls* has a recognisable structure: the narrowing of the aperture after each movement across the seawaves, depicts the material aspects of film clearly in the change of texture, light, grain and so adding a footnote of representational comment.

I remember William Raban and Chris Welsby's films from long ago – being pioneers of the genre. This time I saw Welsby's last film *Skylight* and I perceived it as different from before – as if the restricting tendencies are now less prominent. This comes forward through the use of sound which is as if all the noise in the air is being absorbed, set against snow formations which are

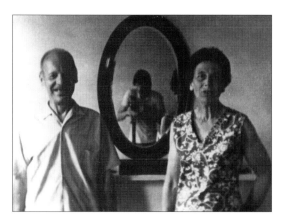

PORT WITH PARENTS Guy Sherwin

disorientating because often one cannot see the boundaries. I found it a somewhat disturbing but beautiful film, rather expressionistic – thus moving away from 'Englishness'.

Michael Mazière's *The Bathers Series* and *Cézanne's Eye* were among the first films I saw when I returned to England. I remember it was freezing cold and I sat in the Co-op with my coat on and a little stove at my feet trying to help. The films gave me the strong sensation of sun-lit Mediterranean afternoons. *Cézanne's Eye* is my favourite – in spite of objections to the didactic parts – because of the painterly qualities and the variations between movement and stillness; references to Cézanne's brushstrokes paralleled in the camera movements. Obviously I have not experienced them as English, although I could not help thinking that Michael Mazière plunged into pleasure as a rebellious reaction to the strictness of Peter Gidal, whose student he was.

An almost perfect balance between the representational and the restriction of form ('emotional' and 'rational'), I found in the films of Guy Sherwin, of which I saw *Messages*, some short films from the *Short Film Series* and some recent rushes. Through his films I got the sensation of seeing the world anew (which is, in a sense, the content of *Messages* I think). There is a subtle tentativeness in his use of light and space, in the shifts of focus from one image to the next within one frame – as if each time wondering about surroundings, objects, nature. The presence of the camera is always felt as it is used; as an extension of the eye, of thought and feeling.

Of Nicky Hamlyn's, I saw *Guesswork*, *Uncertainty* and *Ghost Story* which I experienced as diverse

chapters of the same film. In the films mostly daily surroundings are pictured: parts of walls, window views, rooms, domestic situations. Through the lighting, structuring and the timing, the fragmentation in the succession of images, and the sometimes almost haunting use of sound and silence, these daily surroundings stand for a higher order of life, although I find it difficult to put that in words (but did not Wittgenstein say…). Parts of the films remain enigmatic to me, which gives them an abstract quality which I regard as positive.

Moira Sweeney, especially in *Imaginary*, also pictures domestic surroundings and actions (lovemaking). Her images are impressionistic rather than formal – beautiful within a certain mode of aesthetics. When comparing her film to say, Nicky Hamlyn's the thought comes to mind as to whether her films are more 'female' and if there is something like a female 'imaginary'. Although I think that certain films like the historical *Fuses* of Carolee Schneemann, or indeed Moira Sweeney's, could not have been made by a man and it is 'psycho-logic' that conditioning should reflect itself in images, I find that distinction hard to make, especially in avant-garde film, where women have always played a prominent role, more so than in other forms of film (I think due to the lack of hierarchy in avant-garde film production, which makes it more accessible). 'Structuring', which is seen as belonging to maleness, is not restricted to male films in the avant-garde: Rose Lowder, Birgit Hem, Joyce Wieland or Lucy Panteli are making just as finely structured films as Malcolm Le Grice or Nick Collins, poetry is to be found in films of Anna Thew, Guy Sherwin, Stan Brakhage or Annabel Nicolson. Maybe it lies in the subject matter such as the search for identity as in the work of Sue Friedrich, Nina Danino, Lily Mankeiwitz. Interesting in this respect is *Man of Stones* by David Finch, in which the search for identity is mixed which clichéd male images, where the structure and poetry is mingled as well with the personal and the general and the film thus has an androgynous character.

I think that differences in 'ways of filming' in avant-garde film are made more by cultural conditioning such as film-history, than by gender – by which I mean that British avant-garde film has evolved out of the formal movement in the 1970s – which is to end how I began.

signs of the times – a review of the first ica biennial 1990
moira sweeney

The originality of genuinely experimental films and videos relies on more than a powerful evocation of the poetics of the respective medium. It is an intrinsically sensitive and provocative treatment of subject matter which creates that fine line of ambiguity, which is the hallmark of avant-garde practice. Whatever the aesthetic, political or psychoanalytical motivations and influences of a film or video, it is the vision and integrity at the heart of a work that makes for any significant intervention in contemporary artistic and social culture.

On entering the 1990s, no one reference could be cited to contextualise the vital undercurrents in contemporary British film and video. The first ICA Biennial of Independent Film and Video (selected by performer and actress Tilda Swinton) reveals the extent of the diversity of specifically experimental practice, ranging from blissful obscurity to mainstream accessibility. If the selection is characterised by anything, it is the cross-fertilisation and merger of previously polarised forces. Material differences in film and video are no longer issues, rather it is a question of which medium is most suited to conveying a particular message.

a decadent formalism

The formalist interrogations of European and American filmmakers and academics in the 1960s and 1970s are not just evident in Peter Gidal's *Guilt* (arguably an ultimate in pure cinema). They have also had a significant bearing on underlying attention to structure in other films in the selection. The cohesion of a work relies on a strong structure upon which to hang the threads of imagination and idea and Cerith Wyn Evans' *Degrees of Blindness* is a testament to this. It is a sardonic tribute to the wonders of form and colour. A stream of immaculately composed imagery commencing with the 'purity' of nature, crescendos in the controlled chaos of pulsing city lights, dancing figures, fireworks, and angel-clad Undergrounds. The tape culminates with the final explosion of a neon religious icon, and an expelled and sequinned Eve eases back into the cherry blossoms. Wyn Evans' twentieth-century digital video, delights in the harmony of nature and decadence of innocence lost as celebrated respectively in fifteenth-century Italian Renaissance and the later Baroque period respectively.

HOI POLLOI Andrew Kotting

leonardo's nails are dirty

As most of the film and video-makers in this selection have studied at art college, *Degrees of Blindness* is not the only work to display close links with the other visual arts. The vivid saturated colours of Michael Mazière's *Swimmer* are inspired by the paintings of Cézanne. The exquisite and mysterious animations of Paul Rodgers and the Quay Brothers have the tactile qualities of a sculpted interior world. Jayne Parker's minimalist and startling *K* is informed by body performance art which grew out of modernist assaults on traditional art in the 1960s.

Liberated from the weight of history by virtue of their relative youth, film and video have proven to be perfect media for experiment and critique of hierarchical values and codes within the art world. Clio Barnard has her own views on the hues and tones of the red apples in her still life,

as she lets her friend Vermeer on the mantlepiece know. In *The Limits of Vision*, the romantic artist's vision of the ephemeral beauty of the still life is brought down to deadpan domestic reality. The filmmaker shares her scientific discoveries with her friend Leonardo, whom she ponders could do with a bath. Deliberately anti-seductive and banal imagery, is interrupted by sarcastic renditions of slow motion beauty and brief flirtations with video duplicating techniques. The casual and understated manner in which beauty is created and discoveries are made effectively parodies the notion of grand master.

Judith Godard has fun with the medieval period in *Luminous Portrait*. A fifteenth-century painting of a burgermeister's wife is put through the motions of 500 years in the brief period of one minute. As the purity of the modest wife's expression transforms into a grinning twentieth-century woman, towerblocks soar and cars zoom through the medieval garden. Intricate video technology made such a feat possible in one minute. Andrew Kotting tries to make sense of the nonsense of a one minute piece (both were commissioned for television), in his mini-epic *Hoi Polloi*. He succeeds in producing a beautifully photographed trek through the great outdoors; 'Italy, Sicily, France and Spain, all round England and back again' (is it possible?).

Considering that the area of experimental film and video is so marginalised by independent film, television and the visual arts, it is a tribute to the imagination of these makers that they have managed to retain a sense of humour. Or perhaps a sense of humour is necessary to remain in the area.

the medium is a tedium

Deconstructions of dominant ideologies in this programme are marked by their disarming wit. This comes as a breath of fresh air after some of the more, rigorously academic and humourless exposes of representation in the last decade and a half. In *The Airwave Spectrum Has Some Defections*, Alnoor Dewshi mockingly delves into his dismantled television set in an attempt to see what factors determined the clichéd and limited range of ethnic minority imagery available. The lies and fallacies are revealed to be in the hands of action men disguised as pop stars and newsreaders. The celebrity Lawrence of Arabia leans against a petrol pump, presented as a man with 'a phobia that the peninsula is too insular'. In every telly drama the 'Asian woman's kharma is to be on the run from an

THE AIRWAVE SPECTRUM HAS SOME DEFECTIONS Alnoor Dewshi

PEDAGOGUE Stuart Marshall

SWIMMER Michael Mazière

arranged husband'. The brief foray into the inner mechanisms of television cultural representation, reveals the process to be a 'travesty of electricity'.

In *State of Division* Martha McClean deftly demystifies the traps of female stereotyping in Hollywood cinema. The androgynous child woman in the form of Judy Garland's Dorothy is contrasted with her counterpart, the psychologically complex adult women in the guise of Kim Novak (in Hitchcock's *Vertigo*). The latter's emotive voice repeats a dreamscene of virtual imprisonment couched in clichéd Freudian symbolism, stuck like a needle on a record. As the image of Dorothy, captured almost frozen in helplessness, duplicates and folds in on itself, the predicament for both females is highlighted. They have been 'framed' cinematically and psychologically, and are given no point of exit from the fairytale world of the Yellow Brick Road.

homophobic phantasies

Stuart Marshall has been a major exponent of video art in Britain throughout the 1970s and 1980s, in the field of sexual representation. In *Pedagogue* he ridicules recent legislation in the form of Section 28 which makes it illegal for local governments 'to promote homosexuality'. In a parody of the documentary 'talking head' format, Neil Bartlett, the busy and caring tutor, answers a series of 'personal' questions (posed by the filmmaker off-screen) with a spurious earnestness. The responses play on gay stereotyping and media fears, culminating in a wonderful sequence in which Bartlett gives a monologue on his dominant but caring role as a tutor. The camera meanwhile observes exposed flesh on his torso, the neat covering up of a tattoo and the metallic care badge of his leather zip. Since Bartlett avidly denied being 'a homosexual', Section 28 has been observed. Bartlett's students nonetheless proceed to 'come out' in a series of hilarious confessions, effectively paying tribute to their own integrity amidst ludicrous attempts to censor human rights.

at whose expense?

The films and videos discussed here thankfully avoid vacuous and divisively seductive technological wizardry. They purport to being informed by feminist thinking, as do others in the selection, which unfortunately on closer examination reveal persistent manipulations of women's representations in order to maintain the status quo. An exam-

LUMINOUS PORTRAIT Judith Goddard

ple here is David Larcher's fascinating *Granny's Is*. The filmmaker uses the digital possibilities of video in a therapeutic manner with which to draw out his relationship with his grandmother. Fragments of visual and audio recordings of time spent together prior to her death are connected by the finest of associations. As the dislocated images and sounds tumble around each other, disappearing and re-emerging, a multi-dimensional and magical world is created to converge with the filmmaker's reflections on the process of mourning. The disturbing evocation of tenderness however, takes place through emotional and voyeuristic sadism towards the grandmother (specifically). This works to affirm the omnipotence of the filmmaker, and by implication reaffirms patriarchy.

By contrast David Finch's *Man of Stones* presents a sensitive and mesmerising dialogue between innocent sexual questionings and overwhelming images of 'masculine' power. In attempting to place his fragile state within a series of supposed concrete realities, the filmmaker produces a tape that stands out amongst contemporary male work, and hopefully is a sign of things to come in the oft-abused area of sexuality and intimacy.

Whilst the Biennial does cover a range of issues, and a diversity of aesthetic approaches, the selection criteria have meant that experimental work exploring crucial contemporary issues of cultural dislocation and racism have been excluded. Also not in evidence are any films dealing with health, particularly AIDS. Conspicuous by its absence, this work takes on the marginalised position already allocated to it by mainstream culture. This is a sad state of affairs in an area which is hopefully working to counteract such ideology.

chapter 8 video art

video art: the dark ages
mike dunford

If nothing else, the current publicity being given to 'scratch' video, no doubt a short-lived phenomenon, draws a hard line between that video art which stems from the critical traditions of the avant-garde, and that which seeks an accommodation, even an acceptance, by the corporate media – the world-view of capital. It is not too hard to see which side 'scratch' falls on, as its techniques are urgently copied by adverts and pop-shows to enhance their 'street' credibility. The present period is sometimes characterised as post-structuralist, as the result of an impasse reached through the momentum of structuralist film-thought, and current work is seen as a rejection of the dry deserts of that thought for richer, more visually pleasurable pastures.

What this acknowledges is the immense leap, the conceptual break that occurred with the emergence of structuralist film. An unbridgeable gap between all that had gone before, and all that was made after. In particular English structuralist film brought to cinema and to a lesser extent to video, a rigorous politico/aesthetic analysis of the process of representation and the production of meaning that made it something that was not often understood at the time, even by structuralist filmmakers, and of course it was something that was almost totally ignored by the rest of the media industry and those who had a stake in conventional models of film and video representation. Since then, critical precepts that structuralist film offered have been abandoned in a wholehearted rush back to unreflective representation.

The response has been to ignore structuralist film-work, even to repress its existence and to regard it as a strange diversion from the paths of normality. In its place, in video art we have a turbid mass of pre-structuralist romantic imagism and political naiveté, and the more populist stance of scratch and scratch-type video, with its loving embrace of consumer values and the dubious model of pop music as a radical energy source. Maybe because structural-materialism was situated primarily in experimental film-work, much video art seems to characterise the worst excesses of reaction: perhaps because it is a refuge for those incurable anti-intellectuals, or maybe because of its early links with performance art – itself a refuge for intellectual reactionaries. At any rate new experimental film often still maintains some critical residue, whereas new video art rarely does.

I think it would be worth going back to try to recap briefly what it was that structuralist film tried to do, and why it was such a profound break with the past. Firstly it is important to realise that there never was a coherent theory called 'structuralist film theory' or 'structuralist-materialist film theory' that unified all the various strands of thought, and the structuralism of linguistics, though important, was only a component of a much wider gathering-together of ideas on political power, narrative representation, the imaging apparatus, and a kind of self-reflexivity and material awareness that derived easily from abstract art, music and the modernist aesthetic. It would be a mistake, however, to view the products of this movement as some kind of cinematic or video visual minimalism – which is what is often implied – since the work was never formalist in that sense, but derived from its own internal principles and logic. 'Structuralist film', as distinct from 'structuralism', was built on an approach to filmmaking that drew close links with the modernist aesthetic in other art-forms like painting, music, literature – that is to say, an intense self-reflexivity and concern with the medium of expression as its own source of content. This early empiricism led structuralist filmmakers to reject the uses to which the cinematic apparatus had historically been put in a search to rediscover what the apparatus materially was, and ideally what form a new cinema would take that was free from its shackles of illusionistic naturalism and narrativity. But this basis, set as

it was in the political ferment of the late 1960s, inevitably gained its political component. Thus this initial – somewhat empirical – position gained a political dimension in its rejection of conventional cinema, not just as the hegemonic use to which film had been put, but as the maintenance and reproduction of the particular world-view of a class, the modern bourgeoisie.

In appropriating the perspectival and ordered vision of the Renaissance artists, this bourgeoisie established, through its use and dissemination of this vision, with its effect of rationality and its magical illusion of the real world, a control over the means and form by which the world would be represented that enshrined their ideology, technologically reinforced in every photographic image of the world that was produced. The monocular, individual-centred and male view of the world which has permeated every corner of our culture under the guise of photographic reality was the cinematic inheritance against which structuralist filmmakers set themselves the task of attempting to create an alternative cinema, a new cinematic language. This political dimension went on to encompass all aspects of filmmaking, and gave much of the impetus to structuralist filmmakers to investigate the untapped possibilities of not just the cinematic apparatus – camera, film-stock, projector – but the entire cultural construct including cameraperson, actors, the projectionist, viewers. So structuralist film began the construction of a critique of current cinema, as a propagandist form laying claim to neutrality not just in the stories it told (and this aspect came to be examined through the use of semiology and linguistic models), but in the social relationships that it engendered, both during production, and between producer and viewer, down to the scientific, but ideologically conditioned construction of the movie camera and projector. Narrative, illusionistic cinema came to be viewed, as had figurative painting, and narrative literature, as constructs entirely dedicated to the maintenance and constant renewal of an ideology that primarily served the interests of the modern bourgeois class and its state.

It was the radical rejection of this basis for cinema that set structuralist film apart from all filmmaking before it, giving a view of cinema as the construct of a relationship between producer and viewer, as a product of work and thought on both sides, with no concession towards entertainment

and passive consumption. It was this position that provided structuralist film with its political energy, and its startling ability to create new forms out of an apparently closed technology. It is precisely this position that has proved an embarrassment to current video-makers, and which resulted in the apparent division between 'serious' structuralist film and 'entertaining' video. And, of course, as the political climate has changed, so the radicalism of structuralist film has been felt to be inconvenient in present more accommodatory times.

There are other problems too – in its extreme form structuralist film, rather than prohibiting the use of imagery, made the use of such imagery so transparently problematical that its use was severely curtailed and in some cases avoided altogether. The use of image, and therefore thematic, content – something that seems inevitably engendered by the technology of the machine – remained unresolved by structuralist film. A wide range of strategies were employed, all to some extent based on production of a self-consciousness, but the problem that this medium, the product of high technology and cultural preconditioning, was organised around a particular form of presentation (unlike paint, which does not have a predisposition towards figurative painting) was never successfully resolved. It probably could not be, but it was made visible and this is what I mean when I say that film and video could not be the same afterwards.

'Post-structuralism' established itself as a reaction to all this. As a reaction to a critique of bourgeois representation it obviously allied itself with certain aspects of bourgeois representation. The 'New Romantics' and 'scratch' artists plundered pre-structuralist art history in an attempt to avoid the questions structuralist film posed, and in tying themselves to outmoded notions of individual expression exposed the degree to which most English conventional avant-garde art is shockingly anti-intellectual and defiantly, populistically, naive and stupid.

The recent Channel 5 project of London Video Arts gave a large number of people the chance to see for the first time the heavily-hyped new 'video art'. The application of technology without critical thought led to the popular but intellectually derided film-work of the Californian 'West Coast School' of the 1970s. The same kind of slick, unintelligent use of visual effects and banal imagery over ten years later is now regarded as

DEATH VALLEY DAYS Gorilla

path-breaking video? 'Scratch' work slips very easily into pop-video iconography and technique, but its very ease of use and accommodation proves not the vitality and forward-reaching tendency of pop-video so much as the lack of critical or subversive substance in the video art. Clever, smart, meretricious pastiches seem to flow out of the graphics departments of London art schools like an unending stream of sweet vomit. Regurgitated and refurbished dominant symbology and imagery, spiced up with irony and cynicism. Slick, fashionable, like the pages of *iD* or *The Face*, this work appears to bear such a close relationship to the marketing functions of these style-mags that one expects to see it in clothing boutiques in Covent Garden. Thus the 1960s and CND become a collection of trite images of hairdos and funny faces, a recitation of verbal cliches ('you never had it so good', L-shaped room) delivered in a mocking, pedantic tone.

Death Valley Days, hailed as a breakthrough for political art, or as indicative of a new subversive element, bases itself on the formula of a political

lampoon. The use of network footage of Reagan rearranged and cut-up brings into sharp focus the power that such imagery contains, its inbuilt ideological bias and strength that no amount of rearranging or repeat-editing can alter or destroy. The image of Reagan is intensified, distilled, reinforced, as is all dominant imagery when used by scratch artists. Then we have sad attempts like Pimlico Project's *Workers not Shirkers*, a low thought-content approach to living on the dole and unemployment. My own tape about unemployment in the United States offered more genuine politics and from actual unemployed people in the street.

The picture is not entirely bleak. There seems to be a reaction against the reaction and film- and video-makers are recognising the need for a renewal of commitment to critical principles. Scratch has run its course, and shown its promise to be empty as has New Romanticism, noirism, and neo-narrative. There are many video-makers who are not caught up in the love affair with the media, who do think deeply about what it is

they are doing, and who do not, as a result, fall into any glibly defined category. Some appear to be working on extensions of the thinking that went into the structuralist film work of the 1970s and to be investigating notions of narrativity that structuralists found difficulty in approaching. Others, working from a feminist perspective, realise the absolute necessity of breaking new ground in a medium so organised around the male perspective, or else be condemned to abdicate their own humanity, and who show an awareness of the historically determined importance of their work in video and the responsibility it bears. Admittedly for a white (privileged) male video-maker it is harder. Harder to comprehend the totality of the medium's oppressive power and the ease with which its infrastructure expresses one particular world-view and represses all others. Harder to see beneath the surface of its appearance, its content value, and appreciate the radical restructuring that is needed to reshape its inbuilt vision. But this is why a genuinely radical practice in video is of necessity politically antagonistic to capital, and conversely why a critical, subversive, anti-patriarchal, anti-imperialist, approach of necessity must end by dismantling the hegemonic construct.

It seems that the misunderstanding of what it was that structuralist film was really about is what gave rise to the post-structuralist period characterised by the triumphant return to imagistic representation, or at least facilitated it. Its characterisation as a dry formalism provided the basis for the resurgent anti-intellectualism of so much new work. Anti-intellectualism in this country means anti-thought, though it disguises itself as anti-elitism and populism. This tendency has always strongly imbued performance art, and performance art's early use of video as a performance element, together with the acid-head, gee-wizz ideology of so many video-freaks (as they were called) seemed to solidify the strong mindless tendencies of video art as a whole: more, I think, than its close proximity to television.

Various invasions by filmmakers from the early days until now have been resisted by the collective tendency. Why is London Video Arts situated in the heart of Soho, amongst the media-biz of Wardour Street, and the London Film Co-op in a back street in Chalk Farm? What is represented in the difference between the two institutions? One dark, cluttered, staffed by committed underpaid workers, full of piles of cans, and messy works-in-progress, with an open distribution policy, the other clean, white, staffed by efficient middle-class people, looking like a PR agency, with a new and selective distribution policy? Is it the difference between messy old-fashioned film and new clean electronic video, or is it a difference of political attitude and therefore positioning? Or am I making too much of these things?

What is needed is a critical practice in video and a critique of its history, and for that which was learnt from experimental structuralist film in the 1970s to be applied to video and television now as it was applied to film and cinema then. Not a return to structuralist film of course, but the renewal of the kind of serious, responsible, interrogative approach that gave rise to structuralist film at the time, which was the dominant feature of that period, and which is essential to the growth of any work in media.

Why is it hard to think of work in video nowadays that is innovative and strong? Why does so much that one views from the English video scene seem like reworkings of early experimental film-work of the late 1960s and early 1970s? Why, for someone who sat through open screenings of those years, is so much present work so anti-climactic, derivative, or simply ignorant and dismissive of that history? Experimental film was never popular, was never heavily financed, never received consistent media acclaim, began as a marginalised activity and remains as one. Not because it is unimportant but because the work it does, and the position it assumes, inevitably sets it at odds with the art-establishment, and the media-establishment. The decisions of the BFI to finance large-budget narrative features and drop all commitment to experimental work was part of the rejection experimental film received after its brief flirtation with fame during the 1970s. But an experimental and critical practice will always be marginalised in this culture, in favour of an experimental practice that is either politically reactionary, or pretends towards some kind of impossible neutrality. The present flirtation of many video artists with some kind of notion of a commercially acceptable critical stance is no more a responsible critical position than the political posturing of many pop-groups, and becomes, similarly, a betrayal of ideals, and an accommodation of dissent and resistance.

love, light and time
breda beban, hrvoje horvatic

Recognize that which is before your very eyes, and that which is hidden will be revealed unto you.
— Gospel According to St Thomas

In our video works we explore love, light and time. These three things can belong to no one; we discover aspects of them through our self-deception. When we belong to them, then silence befalls us. At such times, the position of an 'artist who rules' is absolutely untenable. Only through observation, contemplation and humiliation can one achieve insights.

The treatment of the video image itself aims gently to shift the viewer away from his usual focus. He no longer is an open space and the monitor a 'window onto the world' at the center of which the lines of perspective converge. The spectator's eye must become this point of convergence and the electronic picture, a thin membrane, pulsating between the visible and the invisible. It thus pushes the limits of space out to infinity. The impression from watching arises there, where the image is. The image represents its object integrally.

We think in terms not of 'renaissance perspective' but of 'reverse perspective'. This is typical of a different cultural heritage and tradition.

We do not consider the image a mirror, but rather a dark glass through which one can peer.

landscape/video/art: some tentative rules and exceptions
mick hartney

The adoption of a brand-new medium by artists is frequently symptomatic of a periodic attempt to reject categories and practices currently embedded in the social and economic function of art itself. The early phase of video-in-art (say, 1965–70) coincided with a mood of quantum change which permeated the cultural avant-garde (at a time, perhaps the last time, that the term had real significance in an art context). One aspect of this sense of restlessness was a dissatisfaction with the paradigmatic role of the unique art-object as the instrument of a visual aesthetic. This reaction could be seen – simplistically – as a perverse response by artists to the potency, in commercial and social terms, of the projects of Abstract Impressionism, and of the dubiously defined stylistic developments which followed: Pop and Pop-Art, in particular. Other factors converged: an intensive proselytisation of Duchamp's work and thought, an effective cross-fertilisation, in the United States especially, but also in Europe, between the disciplines of music, theatre, literature and the visual arts. Increased prosperity and an expansion of tertiary education created a large, new, youthful audience for experimental activities. Arts Labs were established, of various kinds, on both sides of the Atlantic, helped by relatively cheap warehouse rentals and by an input of funds from a suddenly adventurous music business. The Vietnam War had two significant side-effects: an influx of young Americans into Britain and Europe, many of whom were artists, filmmakers, cultural and political animateurs; and the development of lightweight, portable video recorders: the now ubiquitous Portapaks.

I have prefaced this rumination on landscape and video with a potted cultural history, in order to signal my doubts as to the relevance of discussing video art in terms of a generic classification which is more appropriate to a specific period in the history of painting. Critical and curatorial treatment of video within the visual arts establishment all too often operate to perpetuate the impression that the values and potential of the medium are limited to those of traditional visual art practice. While the production and presentation of video art has benefited from this effect (the gallery, as a physically – if not politically – neutral space, is more hospitable to new or hybrid art-forms than other specialist venues) it would be

IN THE MIND'S EYE Tamara Krikorian

patently wrong to assume that the line of descent which is discernible from painting and sculpture through to video art represents an exclusive or even dominant source of inherited concerns. Before one can speak of 'landscape video' with any degree of confidence, a great deal of contextual clarification is necessary.

If I begin to discuss 'landscape painting' the reader will have to hand a set of references which are fairly well defined. The term describes a genre, like still life, or portrait, whose familiarity is guaranteed by the existence of a vast body of work, from which has evolved a clear set of academic rules and conventions. Discussion is precisely located within its parameters by the understanding that the term 'a painting' automatically means Art, regardless of the qualities of that painting. The medium embodies its own credentials as pertaining to an aesthetic practice, rather than any other kind. Video, as a medium designed *a priori* to depict, before the intervention of the specific user, is in itself, like photography, film and other means of mechanical or electrical reproduction, essentially neutral, in social and aesthetic terms. Many of the following remarks apply to all such media, and it should not be thought that I am indulging in special pleading.

It was the very neutrality of video which recommended itself to many of the artists who used it in the early phase. While painting and sculpture carried associations of wealth, class division and privilege, together with a set of critical precepts which, in the

late 1950s and early 1960s, had become increasingly esoteric and elusive: or alternatively, in the case of Pop Art, for example, had fallen prey to misrepresentation and crass exploitation by commercial interests,[1] video held out the promise of direct communication and familiarity. I use the word 'promise' advisedly, as the potential is clearly far from being fulfilled.[2] Television, in itself, was generally regarded as occupying the opposite pole on the cultural continuum from that of the individual, experimental artist. It was corporate, monolithic, inaccessible: the epitome of bourgeois taste. While most artists ignored it completely, a very few attempted to incorporate it into their work in some form. In Europe, Wolf Vostell and Ben Vautier used television sets in performances or installations. In the United States, the one universally acknowledged pioneer of video art, Nam June Paik, began to experiment with controlled distortion of the broadcast signal, and legend has it that he acquired the first available portable video recorder.[3]

For the growing area of performance or body art, video was an invaluable aid in recording otherwise ephemeral events. The tape was cheap compared with film, sound was automatically recorded in sync, while the equipment, though expensive, was almost silent in operation, and permitted simultaneous monitoring and immediate replay. Several independent filmmakers, particularly on the West Coast of America, had already been seduced by the 'psychedelic' quality of feedback effects and the specific texture of the video image. Scott Bartlett and Ed Emshwiller, among others, incorporated television material and telecine processes into their films, extending a particular tradition of synaesthetic imagery, usually associated with rock music and 'cosmic' or quasi-religious significance.[4] This tendency still has some adherents in independent video, although broadcast television, with its superior technical resources, has absorbed and refined most of this kind of experimentation into a mindless and over familiar ingredient of rock music programming.

It is from the use of video as documentation that the first serious engagement with the medium as a potentially autonomous art-form developed. In Germany, in the late 1960s, a young film student called Gerry Schum was producing documentaries about the visual arts milieux in Europe and New York. Two of his films: *6 Art Biennale, San Marino*, and *Konsumkunst – Kunstkonsum* were broadcast by the television station WDR III Cologne, in 1967 and 1968, respectively. Although Schum never took on him-

self the mantle of film or video artist, his activity as committed animateur was responsible for the most significant interaction to date between artists and the video/television medium, and the most intensive body of video work concerned with aspects of landscape. As a result of his close involvement with the artists, dealers, critics and galleries that constituted the avant-garde art world at that time, Schum had become acutely aware of the cumbersome and restrictive machinery through which information about new developments in art was disseminated to the world at large. He envisaged a 'Television Gallery' – the 'Fernseh-Galerie Berlin', which would consist not of a physical space housing objects for sale, but of a time-slot within the regular programming of broadcast television. Work by artists would not be observed, introduced and discussed on television, but conceived and broadcast as first-order artworks in the form of film or video tape, designed specifically for television broadcast.

Such a scheme clearly entailed close collaboration with artists who were already working in time-based media, or whose ideas could be translated into an appropriate form. In 1968, when Schum began shooting the first 'Exhibition', there were a number of artists 'exploring the possibilities of the relatively new media of film, television and photography. These artists are not concerned primarily with exploiting the possibilities of communication offered by the mass media. A more important consideration, I think, is that the greater part of our visual experience is induced by way of reproduction, with cinematic and photographic representation.'[5]

Many of the artists Schum approached at this time had been trained as sculptors, in the traditional sense of fabricating objects, but had moved out of the conventional studio/gallery/museum system, to work in a direct relationship with landscape, creating work which remained in situ, often in remote locations, until destroyed by time and weather. To support their activity, it was necessary for them to exhibit and sell documentation in the form of photographic or other records. Schum's first programme of work curated and directed in collaboration with artists was entitled *Land Art*. It was broadcast in April 1969, by Sender Freies Berlin, and included pieces by Jan Dibbets, Barry Flanagan, Richard Long, Walter de Maria, Dennis Oppenheim, Robert Smithson and Michael Heizer. Filming was executed in black and white 16mm cine, usually with a fixed camera, long duration shots and a minimum of editing. Concerned as he was with direct

communication of the artists' ideas, Schum made sure that the strategy of filming interfered as little as possible with the viewer's perception of the pro-filmic event. Nevertheless, the event addressed itself consciously to the camera, so that in each case the resultant work resided in the film, or more precisely, in its display on a television set. Here is a description of one piece from *Land Art*: the work is by Richard Long, who for about two years had been executing sculptures by traveling, on foot or by bicycle, as a development of earlier work made by altering or marking the land with vestigial traces of his presence. This particular work, entitled *Walking a straight 10 miles forward and back shooting every half mile*, was executed on Dartmoor in January 1969, and was also recorded in the form of photographs, for Martin and Mia Visser: 'The film begins with a survey of the landscape at the start of the walk, with the camera turning 360°.'[6] During this survey details about the place and time of the action slide across the screen. At the end of the rotation Richard Long enters the image; the camera is fixed in the direction in which he is looking: the direction of the straight line he is going to walk. Long takes a few steps and the camera takes that movement over, as it were, by zooming in. As the title indicates, the camera registers the view every half mile, both on the outward and the return journey.

'The turning point is marked by the water in a small river which first flows towards the camera, and then flows away from it (following the direction of looking). Every shot shows a landscape for a few seconds, then zooms in for about 6 seconds. The walk is given its own expression in the medium of film: a zoom lens can bring something that is far away up close, not by moving the camera, but simply by adjusting the lens. These repetitions of slightly differing images, which are brought close up each time in the same way, give rise to a strict visual rhythm.'[7]

The general character of *Land Art* can be sensed from this description. Although each artist included responded in a distinctive manner to the landscape and to the medium of television/film, the exhibition was given homogeneity by Schum's collation of these particular artists, by his sensitive deployment of the camera and sound recorder in each case, and by a constant awareness of the tensions between the space of the environment in which each work was executed, and the framing/flattening effect of the medium through which it was depicted. In some pieces this last factor was given special emphasis: Jan Dibbets' *12 Hours Tide Object* involved the demarcation of the screen edges by a tractor making marks in the sand, in a natural extension in film of the perspectival correction works Dibbets had previously produced as still photographs. Barry Flanagan's *Hole in the Sea*, for which a perspex cylinder interrupted the passage of the tide as it was filmed from overhead, created an extraordinarily ambiguous image which could be read as existing in the perspective plane of the water, or as contiguous with the surface of the television screen.

The public response to the broadcast of *Land Art* was surprisingly favourable, given that for most viewers this was a first encounter with new and unfamiliar notions of art, presented, uncompromisingly, without the usual patronising commentary, save for a spoken introduction by Schum himself. Typically, Schum felt that 'the almost irritatingly flattering reviews of the *Land Art* exhibitions are to some extent due to those impressive landscapes'[8] rather than to the work itself.

Nevertheless, the broadcasting station was not impressed, and discontinued the project. Schum arranged two further short transmissions by WDR III, Cologne: Dibbets' *TV as Fireplace* and Keith Arnatt's *TV Self-Burial*, before his second and last TV exhibition, 'Fernsehausstellung II – Identifications', produced and broadcast in 1970 with the collaboration of Hannover Kunstverein and Sudwestfunk Baden-Baden. 'Identifications' was less preoccupied with the landscape theme, consisting of short performances or situations by twenty artists from Europe and America, including Joseph Beuys, Gilbert & George, Richard Serra, Lawrence Weiner, Daniel Buren, Mario Merz and Klaus Rinke. It is worth noting that none of the artists involved have been primarily known for work in film or video, although some, like Serra, Beuys and Gilbert & George, have produced films or tapes subsequently. What characterised the assembled artists was their preoccupation with ideas and concerns which could be realised in almost any medium. The pieces in 'Identifications' functioned almost as commercial spots, introducing and epitomising each artist's preoccupations at that time. A few of the pieces were landscape works: Hamish Fulton contributed a piece in which he appeared on the far bank of a lake, slowly raising a powerful electric torch whose light eventually bleached out the screen image. Gilbert & George appeared posing tranquilly beside a stream in an idyllic woodland setting, typical of the pastoral painting/sculpture works they were producing at the time. The most awesome – and absurd – work was by Gino de

Dominicis. In *Tentativo di Volo* – Attempt to Fly – he did just that, repeatedly jumping from a foreground hillock, madly flapping his arms, while beyond him a breathtaking vista of water and hills calmly echoed the barking of a distant dog. 'It is possible,' he stated, somewhat unnecessarily, 'that I will never reach my goal. But if I can persuade my son to continue this exercise, and also the sons of my son, then perhaps one of my descendants will discover that he knows how to fly.'[9] The sexist note discernible here was unfortunately characteristic of the entire body of work that Schum brought into being: not one woman artist was included in any of his projects – a reflection, I feel, not of his own prejudices, but of those of the art world in general only a decade ago, which have only been marginally eroded since.

It was the art world, however, rather than the public or mass-media, which was most responsive to Schum's utopian ambitions for a gallery of television. After 'Identifications', his collaboration with broadcasting organisations ended abruptly. Schum was enraged by their attempts to dilute or distort the work with explanations and interpolations of extraneous visual material: they in their turn were afraid of confusing and alienating their audiences. The gulf between raw contemporary art and the public seemed insurmountable. In late 1970, Schum switched from film to video for origination, as portable production and editing facilities became obtainable. He worked firstly from a caravan/truck, and later set up a Videogalerie in Dusseldorf, from which he marketed videotapes in limited editions. His dreams of circumventing the gallery system through a more democratic means of distribution had met with disillusion, however, and in 1973 he took his own life, at the age of 34.

In the ten years since Schum's bold experiment ended, video art has moved some way towards achieving respect and autonomy as a distinct medium. From being a novelty, in which artists might dabble as an extension of their work in more orthodox media, video has become a powerful system of communication and a profitable industry, with implications which threaten the status of television as a dominant cultural influence. Most major art museums of the West have organised surveys of video art: many have begun to collect and preserve examples. It would be a relatively simple task to select programmes of tapes and installations around any one of a myriad themes and concerns with which video artists have been preoccupied: reflexive work, based on the properties and limits of the medium itself;

politics – party, interpersonal and sexual; the social and psychological implications of representation, of the self and others; the nature and implications of broadcast television; the quality of urban life. All these themes have their exponents and paradigmic works: yet landscape, as an enduring and pervasive theme, is all but missing, represented by only a few anomalous and problematic examples. Why?

Here are my deliberations, based on a necessarily incomplete knowledge of significant work to date, and in the light of some exceptions. First, consider the opposing prehistories of television and film. Early cinema was both produced and exhibited out of doors. Shooting was perforce executed in open sets, in locations at which good natural light was assured. The first films were shown in tents, at funfairs, and later in public halls. Television was predicated on instantaneous 'live' transmission from one private space, the studio, to another: the home. Equipment for television production was bulky, moveable only with great difficulty. The entire system was based on the frequency of the mains electricity system. Cameras and recorders which could operate from a battery power supply developed only very recently in the history of television. Outside broadcasts have typically covered urban events: State occasions, major sporting fixtures, political demonstrations, theatrical or musical events. Two of the significant cinematic genres, the western and the science fiction film, have utilised the large screen to depict the individual either conquering the terrain, or as vulnerable, exposed against it to hostile forces. By contrast, the two important narrative genres to have developed on the small screen, the soap opera and the detective series, rely for continuity from week to week on complex interrelationships between a large group of people, placed together by urban work or domestic settings. A typical resolution of the single feature film consists of the protagonist(s) leaving for another town, another adventure: the serial nature of typical television origination precludes the finality of the terminal long-shot.

Of course, generic distinctions cannot easily be extricated from technical considerations, and as these have become part of the orthodox content of experimental, as opposed to dominant commercial practice, in both film and video-as-art, we may now consider them in the light of their relevance to theme and content. Although the portable camera/recorder system has become increasingly available to independent video users, and in fact pre-dates its

general use in broadcast television, it places certain important constraints on the artist. Typically, it is used, like film cameras, in a shoot-and-edit mode, with editing taking place either on location (assemble editing) or at a fixed edit-suite. While this is acceptable for documentation or community/political applications, the self-conscious analytical use of the video medium often entails exploration of the intrinsic qualities of video as distinct from those of film. These could be partially catalogued as: in-stantaneous monitor display/replay, with the implicated potential of feedback from monitor to camera; multiple simultaneous views of a situation from two or more cameras, denoted either serially, through automatically on-action camera switching, or through superimposition, dissolve-transition or wiping, by use of a vision mixer; sync-sound, epitomised by lip-synch; keying of visual or textual material through luminence- or chroma-keying facilities. All of these characteristics of video production virtually necessitate the use of a studio, and have until now been almost totally inaccessible for exterior location work.

The basic unit of film is the still-frame, its imagery resulting from the disposition of a random distribution of grains within the film emulsion. The video process does not include discrete still images (although a still-frame can be simulated by continuous replay of a section of tape). The imagery is constituted by a constant scanning system modulated by continuous voltage changes, producing the familiar line-structure of the television or video monitor screen. The range between the brightest and darkest parts of the image (gamma) is considerably more limited in video than in film, while the resolution of detail and colour in 16mm film stock is considerably in advance of all but the most expensive video cameras. The film image is constituted from reflected light, as in nature, while that of video is produced by emergent light. The potential for screen size in film, until very recently, has been very much greater than the typical maximum of 26" diagonal afforded by video. The video camera does not respond well to bright sunlight, to extremes of heat and cold, to moisture, movement or shock. It works best, especially for colour recording, in the cosseted environment of the studio, where temperature, lighting, voltage levels and operational habits can all be carefully controlled.

If all this sounds like a sustained argument in favour of film as against video: it is not. But I do feel that the accumulation of all these technical factors constitutes some overwhelming reasons for the existence of a very small body of work in video art dealing with landscape, in comparison to the whole output of video artists in the last ten years. Those works which do exist, are significantly different in intent and emphasis from those in other media, often deriving their character and strength from the inadequacies of video to deal with landscape effectively.

There are two clear species of work in video which depict landscape at a remove, with a sense of withdrawal, the distance of loss, through memory or departure. The first is the work which embodies a journey, usually by car, but sometimes by train. Obviously, there are practical considerations involved in recording from a vehicle, rather than on foot, but such a stratagem also has a metaphoric role, duplicating the progressive reduction of the countryside from living environment to moving scenery, which has occurred from the eighteenth century until now, for almost all of us, except the very rich, who own the land, and the agricultural workers who labour on it. It also, by translating the features of the landscape from their individual detailed parts into an undifferentiated blur, which ultimately takes on the perceptual character of the medium itself, enables a meditation on the supplanting of nature, as a socialising force, by synthetic culture whose derivation from natural pressures and aspirations has become at second or third remove. Examples of this kind of work are numerous: Dieter Froese, a German artist now living in New York, made a three-monitor piece in 1976, entitled *Remember/Forget*. 'On three different dates a recording was made during a car ride in New Jersey. The first (standard) was the recording of the "historical event" and was intended to represent an objective or neutral impression of the trip. The second (I remember) was intended to capture only what I remembered of that trip. The third (I forgot) was intended to capture segments of the landscape which I realised, upon subsequent confrontation, I had forgotten either as to location or as physical size and shape.'[10] As presented on three adjacent monitors, the central, objective journey is accompanied at any given time by one or other of the two flanking images; as one fades in the other disappears. A more recent, single channel tape by Dominique Belloir, *Memory*, treats the same theme of fugitive experience embodied in travel through a landscape. Belloir's tape is more sophisticated technically: she employs soft, pastel colours, superimposition and inserted images, to evoke fragments of recollection,

from her childhood to the recent past, held together by a journey from an idyllic pastoral/beach setting, to the city. Kate Hayes evokes more disturbing memories in *Then he Kissed Me …* by juxtaposing highly formal panning and tracking shots of the lush autumn foliage of Sheffield Park, in Sussex, with a disjointed soundtrack in which a young girl recounts the progress of a romantic tryst which ends with an attempted rape.

The second kind of tape involves the reconstruction of an imaginary or mythical landscape from unconnected elements. The classic example of this, and for me the most beautiful and effective, is simply called *Landscapes*, made in 1976 by Nan Hoover, an American artist who lives in Amsterdam. For this piece, and in subsequent tapes, working alone, she used a series of close-up shots of fragments of her body to evoke a bleak, windswept terrain, the lighting making the most of the visual possibilities of the black and white camera, and with a soundtrack evoking vast spaces and dramatic natural forces. Other artists have used electronic colour effects to simulate interior, mental landscapes. Brian Hoey, in *Spered Hoilvedel* and *Tir Nan Og*, has collected and montaged images of water, natural forms and details of decorative artifacts, welded together through editing and colourising to form visual sequences which represent an exploration of his Celtic roots, 'a celebration of an ancient culture's survival and continuing relevance to the modern world'. He has worked in collaboration with Peter Donebauer, both making extensive use of the 'Videokalos', Donebauer's own invention and design: a device which renders monochrome images and internally generated patterns into vividly coloured abstractions. Donebauer's tapes, though not particularly to my taste, are undeniably ingenious, creating complex interactions of shape and sound which continue the film experimentation of West Coast American artists such as Jordan Belson and Storm de Hirsch. My objection to this area of work is that it tends towards escapist fantasy, already well catered for in commercial cinema and television, rather than positing a productive engagement with perception and knowledge, as conveyed by the medium.'[11]

During its formative years (which I feel are still in progress) video art has been much preoccupied, on the one hand, with the implications of real-time recording, which can consist of direct narration or performance to the camera by the artist, but can also include the forefronting of various elements in the camera, recording, replay chain; and on the other hand with the particular qualities of video reproduction and editing processes. One possibility not easily encompassed by video, but incorporated in film from the outset, is the compression and expansion of temporal perception, by manipulation of the recording process. As film images are discrete and immanent, that is they have visible existence in the form of frames on the film strip, each one exposed while momentarily stationary in the camera gate, it follows that filming can take place at any rate, and that the rate can vary from one moment to the next. Much use has been made, in independent film work, of time-lapse photography, with particular application to landscape, whose slow rhythms of change can be captured and compressed uniquely by film. Although video editing can achieve temporal ellipsis, through sudden changes, the continuity and organic change typical of landscapes eludes all but the most advanced video technology.

Kit Fitzgerald and John Sanborn, two New York video artists, do have access to sophisticated production facilities, and their work has a gloss and seamless smoothness which has inevitably been interpreted as superficial commercialism. Commercial or not, their use of A & B Roll editing has allowed them to produce tapes in which images gathered on location flow gently through each other in a manner evocative of changing seasons or weather conditions, while their use of high-quality colour cameras captures the subtlety of natural forms and tones, in natural lighting vastly different to the flat wash of light in the television studio. One of their early compilation tapes, *Exchange in Three Parts*, opens with a series of hand-held shots of a forest, slow lap-dissolves accentuating the mysterious atmosphere of the piece, which is partly created by using a soundtrack of a tropical jungle. The forest is gradually revealed to be full of television sets half-concealed in the foliage, displaying images of the same setting that they furnish. Other pieces in the tape spin variations on this theme, with monitors simultaneously interrupting and supplanting natural scenery by representing a detail of it through pre-recorded sequences, with which the artists interact, either on-screen or through manipulation of the camera. In their later work, Fitzgerald and Sanborn have evolved a rapid-fire editing technique, and chosen urban settings, for harsher, more melodramatic work which has sacrificed the elegiac quality of *Exchange* in favour of a punchy, immediate impact.

A distinctive area of video art, which differentiates itself clearly from either film or broadcast television, is the multi-channel installation, in which a series of monitors convey serial or interrelated imagery. Unlike expanded cinema, video installations can exploit the self-sufficiency of the monitor, which can be installed in any quantity and disposition to articulate the viewing space of an infinite variety of ways. Nam June Paik, the father-figure of video art mentioned at the start of this article, has executed a series of increasingly elaborate, large-scale – and some might say megalomaniac – installations, including most recently *Video Tricolor*, which filled the vast concourse of the Centre Pompidou with nearly 400 monitors, constituting a literal 'media landscape'.

On a more modest, but no less effective scale, two of the most thoughtful and committed of British video artists have created installations which quietly evoke natural settings, while at the same time reflecting on the nature of video as a metaphor of consciousness, using the medium in subtle antithesis to broadcast television. Stuart Marshall and Tamara Krikorian have both been working in video since the early 1970s, and both have displayed a serious, committed concern with the philosophical and phenomenological preoccupation with the medium, together with its relationship to the tradition of art and to the present context of mass communication. At this point it would be best to cease from generalised comments: not only do they work in a manner which is individual in each artist's case, but each work has slightly different implications, and alters one's perception of the preceding work. Their use of landscape elements has shown, however, the beneficial results of an exchange of concepts and attitudes, reflected by a long-standing dialogue in print between the two.

In 1975, Tamara Krikorian composed *Breeze*, a four-channel installation in black and white. It was shown in two versions; the first with two large and two small monitors; the second with four identical monitors and a projected video image. In each case, the image was of water moving across the screen, in close-up. 'The movement of the water related both to the surface of the screen and the scan lines of the monitor.'[12] But the artist's concern was not limited to a hermetic consideration of the immediate viewing situation. The images hovered on the edge of abstraction, while constantly reasserting their relationship with the passage of light which forms a series of links, through the camera/display apparatus, with the eye of the viewer. 'Realising that broadcast TV is a bombardment of sound and quick changing image, I thought that by reversing the identity of TV as an entertainment medium and turning the whole process of viewing into a minimal experience, one might provoke a more engaged response from the viewer.'[13] The following year Krikorian made another installation, this time for the Tate Gallery's 'The Video Show', which included six installations by six artists. *Disintegrating Forms* deployed eight monitors in a single plane, but at staggered heights in the darkened space, the highest mounted at 14 feet. Again the images were black and white, but from a single half-hour tape of clouds clearing from the sky, so that the very subtle image eventually seemed to vanish altogether, turning the screen into an imminent presence, rather than simply a transparent frame. Krikorian continued to be interested in using the elements of landscape in later work, but her attention became concentrated on aspects of still life painting, particularly the *Vanitas* works of Tournier and Bailly, whose genre provided the title for an evolving series of installations and tape work. This interest became enmeshed with the Portrait, as seen in paintings of the *Vanitas* period, and as epitomised in *Television* by the iconic newsreader. In 1981, the three subjects of portrait, landscape and still-life converged in a three-channel installation, *The Heart of the Illusion*. The three monitors of the piece, which was first shown at the Ikon Gallery, Birmingham, are separated widely, turned towards the walls, the images viewed via mirrors, maintaining the preoccupation with reflected views which is consistent in Krikorian's work. The piece, as an entirety, therefore required an effort of attention and intention on the part of the viewer, who had to explore the space of the gallery to assemble and interiorise the work, as one might investigate a landscape to construct a map.

For this installation, Krikorian was able to make use of the facilities of SPAFX TV, a commercial production company, and the broadcast colour camera they made available introduced the possibility of enormously increased subtlety in hues and image resolution. Each section of the work consists of a long slow unfolding of the features of the subject matter. In the landscape channel this is achieved by a vastly expansive panning shot, which emerging from a featureless green blank screen, gradually moves across details of grass and vegetation, slowly incorporating an accumulation of evidence of habitations: cottages, roads, electricity pylons.

The latter begin to impose a sinister rhythm to the movement, as the colour almost imperceptibly and ominously drains from the picture. Eventually, their destination and source is revealed as a nuclear power station, the terrifying symbol of the extent to which the landscape, itself a human invention, has been rendered vulnerable to annihilation by human enterprise.

To deliberately frame the landscape with this valedictory purpose is clearly a decision prompted in part by political concerns. Stuart Marshall, who wrote an introductory essay for the installation, speaks of Krikorian's work as being 'deeply political': but he is thinking not merely of symbolic presences in the content of the work. 'To deconstruct the fiction of the world that institutions such as television create for us,' he states, 'is to deconstruct our social identity for it is within this fictional world of misrepresentations that we constantly misrecognise ourselves and our social relations.'[14] Marshall's work has fairly consistently addressed the same primary task of deconstruction, though through means which have steadily diverged from those of Tamara Krikorian.

His recent tapes have dealt with conventions of narrative and social representation, as they are enshrined in television genres, with a dual attack of mimesis and investigatory deconstruction. Some of the installation work he has produced, however, bears significant points of correspondance with that of Krikorian. This is particularly noticeable in work made between 1975 and about 1979. In the Tate's Video Show of 1976, for example, in which Krikorian's *Disintegrating Forms* was shown, he presented a piece called *Orientation Studies*. This employed eight black and white monitors displaying a single channel of taped images. The monitors were laid in a line on their backs, turned 90° from the conventional viewing position, and were approached via a constructed stepped platform, something akin to the banks of a river, which the viewer mounted in order to see the screens. The tape displayed consisted of edited shots of flowing water (waterfalls, streams, rivers): 'The shots are organised through camera orientation, camera movement and editing to establish two autonomous and frequently contradictory structures.'[15] These concerned the relationships firstly between the images themselves – at times the water flowed 'across' the line of screens: at others, its movement could be read as reiterated but separate – and secondly, between the screens and the viewer, who watched constantly from above, at

images which were shot with the camera in a variety of positions relative to the subject matter. It might seem from this that Marshall utilised the images, with their obvious landscape connotations, as a convenient device for formal concerns; but this would be to ignore the deliberate echoes of a country stream in the overall configuration of the work – it is reported that some visitors picnicked on the banks! – and Marshall's subsequent work, which frequently incorporated both landscape images and the device of a viewing platform – a 'privileged viewpoint', as one often encounters at officially designated 'beauty spots'. This element is part of Marshall's concern with the spectacle, and the heavily partial or distorted view of social behaviour or environments promoted by television and dominant cinema in order to give the spectacular a prime position in the public's gaze.[16]

As a contribution to the 1977 Paris Biennale, Marshall made *Orientation Studies II* in which he extended and elaborated the structure of the earlier work. Imagery was derived from a series of long pans, zooms and other movements, providing an initial sequence of shots which were then displayed on a row of monitors, while the artist retaped from the screens, using camera movements which interrelated with the original sequence, arresting, continuing or contradicting the earlier movements. The final presentation was on a row of monitors which were overlapped, or staggered, 'which produced a suspicion of a temporal delay across the installation as the perspective regression of monitors produced a progressive masking of screens and hence a delay in the appearance of an object on screen.'[17] Later installations by Marshall applied some of the elements of image structuring and questioning, which dominate the *Orientation Studies*, to interiors, and to aspects of visual representation through text, and depictions in paintings, photographs and television. *The Streets of…*, a tape made in 1978/79, uses sequences of pictures and sounds gathered in San Francisco, sometimes used unaltered except through editing, and sometimes as background sets in sequences shot in a studio, promoting a view of the city as backdrop for a series of ritualised gestures and relationships. He returned to the landscape theme with an installation presented at The Kitchen in 1982, a meditation on the nature and implications of *Courtly Love*, in which the journey of a Mesapotamian Monk through an hallucinatory or mythical landscape is conveyed by tracking shots through undergrowth, interrupted by momentary shots of exotic fauna and ancient

ruins. On a central screen a ploughed field is seen, viewed at an oblique angle.

It is interesting to note that, unlike landscape works in painting, film and art making use of photographs, few of the pieces I have mentioned are specific about the origination of the images, the artists preferring to use details of landscape as metaphorical or allegorical elements in the work. Elsa Stansfield and Madelon Hooykaas, who together have made an impressive series of tapes and installations which incorporate particular exterior locations, have made pieces such as *Horizontal Flow*, a five-monitor installation, for which they have carefully selected a location – the South Gare breakwater at Teeside, but their primary concern is with the unbroken horizon line, which the place provided, rather than its intervening features. The horizon is experienced, on a curving row of monitors, as interacting with the line structure of the monitor image, as the camera slowly pans through a complete circle. In other works locations are depicted as embodying, in an enhanced or dramatic manner, generalised qualities appropriate to the fore-fronting of a feature of the medium of depiction. This is in keeping, in most work of importance which constitutes video art, as distinct from documentation, with a continual engagement with the illusory quality of video depiction, as a specific case of the undeclared illusionism inherent in broadcast television. The mass media present such an ubiquitous and threatening aspect of the artist's framing context, that an uncomplicated relationship with nature is neither sufficient nor possible as a

central concern – and the video artist is typically a concerned individual. It is appropriate that video should remain at present an agoraphobic medium.

1 And not just commercial interests: the misleading appropriation of the hetergeneous concerns of individual artists into categories such as 'Pop Art' provided careers for many a curator and art historian, while distorting the provenance of later areas of the visual arts to damaging effect.

2 This observation may appear paradoxical in the context of widespread commercial application of the video medium for entertainment and business use. I would contend that in almost all cases, the effect is actually that of obfuscation and mystification.

3 For more about this brilliantly erratic composer/artist, see *Nam June Paik*, Exhibition catalogue edited by John G. Hanhardt, Whitney Museum, New York, 1982.

4 For an approving survey of American work in this style, see Gene Youngblood, *Expanded Cinema*, New York: E. P. Dutton, 1970: especially part five, 'Synaesthetic Videotapes'.

5 Gerry Schum, 'Introduction to the Television-Exhibition Land Art', in *Gerry Schum*, Exhibition catalogue, Stedelijk Museum, Amsterdam, 1979, p. 73.

6 Lucy Lippard, *Six Years: The Demateria/ization of the Art Object*, London: Studio Vista, 1973, p. 74.

7 Schum, op. cit. p. 48.

8 Ibid., p. 74.

9 Ibid., p. 38.

10 Notes by the artist, London Video Arts catalogue, 1978.

11 In some work, the journey-tape and synthesised imagery coincide, notably in tapes by Woody and Steiner Vasulka.

12 Tamara Krikorian, notes by the artist.

13 Krikorian, op. cit.

14 Stuart Marshall: 'The Heart of the Illusion', poster/catalogue, Ikon Gallery, Birmingham 1981.

15 Stuart Marshall, notes by the artist.

16 A later installation included a viewing platform in conjunction with slides projected on the walls of a gallery, anamorphically distorted.

17 Stuart Marshall, notes by the artist.

notes from a video performance by mona hatoum
catherine elwes

A semi-circular arrangement of chairs faces into a central pool of light. I find a seat in the front row and take stock of my surroundings. A large video monitor sits high on a plinth with a deck, camera and an assortment of leads at its feet. There are many familiar faces around and an easy atmosphere combines with the usual sense of expectation to set the scene for the first live work I have watched at the LFMC Summer Show.

Mona appears, dressed in loose dungarees and soft shoes – her everyday clothes in fact. She moves into the light, picks up the camera and switches on all the equipment. She approaches

the audience. Her manner is relaxed and warm. She smiles easily but does not speak. The camera is fitted with a special lens which makes it possible for her to monitor her audience in extreme close-ups. She slowly scans her first subject. The image of a hand appears on the screen, a crumpled shirt-sleeve follows, the edge of a face is next then an eye flickers in recognition of its own image. We are drawn across a gesticulating brow, down a grinning cheek and on to the next subject. Mona's probe slowly reveals every ruck and wrinkle, every last fragmented detail of her audience's physical appearance.

UNTITLED (VIDEO-PERFORMANCE) Mona Hatoum

With a gathering sense of alarm, I realise that I am in the direct line of fire. My mind races around those deep-rooted, repressed fears that the situation is forcing into my conscious mind. Suddenly to become the focus of public attention in a situation that is controlled by another individual fills me with a kind of terror that I find hard to define. Memories of public school humiliation invade my mind. To be in control, to be actively showing, and attempting to direct the attention of the viewer to where I want meaning to emerge – all these possibilities are what draw me to live work.

The contrast between that ideal and my present situation suddenly clarifies my own investment in the activity. But I feel trapped. If I get up and move out of the camera's range, I draw attention to myself. If I stay where I am, I become exposed to this electronic voyeurism. The conflicts and contradictions of being a woman and a public spectacle, overwhelm any vestige of exhibitionism that may remain and I cover my face with my hands, mimicking rapt concentration. Mona's electronic eye surveys the woman sitting next to me. She is pleased by the results. Her t-shirt glitters and leaps on the screen as she laughs. A kind of intimacy is taking place. The camera has become an instrument of Mona's perceptions. It caresses her subject and delights in her responsiveness. My elbow comes into view. I can feel the heat of my embarrassment rising into my face. 'At least it's not in colour.' This observation does little to reassure

me and I concentrate on willing Mona with all my telepathic might not to show my face. Somehow the message gets through. Mona briefly scans my arms and moves on. I enjoy a considerable sense of relief and relax into absorbing the rest of the work.

Now that the front row of the audience has been systematically scanned, Mona puts down the camera and switches off the deck. She draws an arm's-length circle around herself with a piece of chalk and sits down facing the monitor. Isolated in this way, her territory defined, she effectively establishes herself as object of the camera's scrutiny. (Mona intended this 'magic circle' to represent a possible realm of fantasy and fiction. As a result, we are distanced into the role of observer and so occupy a space associated with concrete reality.) Mona raises the camera and points it at her head. (The suicidal overtones of this action reflect the dangers of self-scrutiny with a culturally 'loaded' medium.) Taking the risk, Mona becomes both active and passive, subject and object of the work.

Beginning at the top of her head and using the monitor as a guide, Mona presents an inch by inch close-up scan of her hair and scalp. Very slowly, she explores her face in its minutest detail. The effect is both beautiful and grotesque. I'm reminded of Nan Hoover's videotapes in which her body is depersonalised and transformed into a primordial and timeless landscape by the use of microscopic close-ups and barely perceptible scanning. Mona's face by comparison is seen at a sufficient distance for it to maintain its identity as a face, and indeed as specifically Mona's face. In this way a particular intimacy is being suggested with a recognisable individual and so the work retains a certain level of political relevance. As Mona pans down her own throat and across her shoulders, a discrepancy becomes apparent. The image on the screen is of Mona naked, and Mona live is clothed. The camera would appear to be an X-ray eye, as it were mentally undressing the artist. Once again, the mechanical eye becomes for me, a strong symbol of the patriarchal gaze. Its view constitutes the single 'human' perspective against which any individual modification is seen as deviant. (Mona saw this process of self-exposure as a way of sharing the tension felt by the audience who had themselves undergone a similar scrutiny. She now put them in the position of the viewer, a role she had previously played.) I can interpret this attitude as reflecting the cyclic aspect of the viewer/viewed relationship outlined

by John Berger.

The viewed (woman) looks at herself and others through the eyes of the viewer (man) and so reinforces the currency of his perspective. The implied question posed by Mona's work is: How do we break the cycle? When can we trust our own eyes and how do we express what we see?

I find myself pondering the difficulties of appropriating the means of looking which any medium offers. How do we avoid being distorted by the inbuilt sexism of these forms of art? Certainly not by suppressing them altogether nor by draining them of any female imagery or content which might suggest a parallel with biological determinism. This spring-cleaning process only adds a structuralist taboo to existing patriarchal censorship. It perpetuates the invisibility and inauthenticity of a woman's desires, emotions, intelligence and particular experience of her body and its changes. What needs to be attacked is the cultural value placed on those experiences and images. Obliterating them only sustains the aims of dominant ideology. I glance at the audience – men and women in fairly equal proportion. Their perceptions of the work must vary dramatically according to experience, class, race and sex. Does the 'male order' distort the work less for the women than for the men? Is our consciousness not more in tune with Mona's intentions? Can we, as women, not alter our own perceptions and create new meanings in art? Somewhat daunted by these questions, I turn my attention back to the screen.

Buttons, clips and studs are appearing at appropriate intervals on Mona's body. A bunch of keys in one invisible pocket and a crumpled shopping list in the other. (Mona tells me that as a child in Lebanon, she would delight in spying on people through binoculars from the safety of her balcony. So, in the work, she has allowed herself 'to deal with the private and the personal in a public situation. This is linked with … childhood fantasies of a scopophilic nature.' Mona goes on to tell us in her introduction: 'I imagined that my pair of binoculars were "magic" and enabled me to see through layers of clothes, skin, flesh etc. It is the curiosity of a child wanting to see behind the surface and finding, through fantasy, a way out of social restraints.') At one level, this penetrating action recreated in the work could be seen as a form of aggression mixed with genuine curiosity. At another, it is a way of communicating becoming intimate with another human being without facing the problems of overcoming those social restraints (represented by the clothes) that obstruct real human contact. By turning the camera on herself, Mona extends the idea and tries to come to terms with the socially constructed inhibitions which prevent her from ever truly 'seeing' herself as an autonomous human being. Woman is culturally alienated from her body and her feelings. Mona would, as she says, experience emotionally an acceptance of herself and her body which she had only, so far, been able to achieve intellectually. I believe that this is a problem many women share – certainly one that I share.

The personal bits and pieces that Mona has left attached to her body introduce a gentle humour in their reference to the missing clothes. They also stand as a reminder of the particular identity of the artist. Traditionally, the female nude in art has been stripped of any clues that might betray her real existence and subjective experience. Visual information might place her in a social class, but only to establish her status within the totality of a man's property. Stripped bare, she has served efficiently as a vessel for the projection of male fantasy, Mona's clues reverse that tradition. She is reminding us of her existence as an individual woman who lives, breathes, struggles and feels as an artist in our present social system. Much interested by this train of thought, I reluctantly notice that Mona has completed her body survey and is turning off the equipment. The work has ended and I leave with a headful of stimulating impressions that link up with many of the problems I attempt to deal with in my own work.

A postscript: One last thought which Mona's performance inspired – we are very dependent on our outward appearance, our clothes to define and communicate our social position, aspirations and political affiliations. (Dan Graham has 'described' his audiences in performances by pointing out the details of their clothes, gestures etc.) Women, in attempting to place themselves in a hostile society, have great difficulty in finding the appropriate social signifiers in their clothes. To dress severely, with masculine overtones, would deny our femininity and take on board all kinds of aggressive aspects we may not want to generate. To wear what fashion houses sell as 'feminine' is as restrictive as displaying the 'sexy' clothes that are assumed to reflect our sexuality. The only alternative is to buy shapeless, colourless clothes that make us as inconspicuous as possible. Once again we perpetuate our own invisibility.

still sharp screen surface layer area frame focus to
expose print bleach and compose expose position and
fix to exclude establish or project escape see the sea
the clear cloud sky blue pink dusk to dawn land mark
view point tree line light field dark dust grey grain
out line distinct neutral place lapse lack depth in time
transparent vanish softly blur and fade assume the
open or obscure prefer or refer repeat return and review

spin, tumble, freeze: technology and video art
steve hawley

The relationship between artists' video and the technology that spawned it has always been an uneasy one. In the twenty years since the first Sony Portapack went on sale in New York (and was bought by the seminal figure of video, Nam June Paik) progress in the quality and capabilities of video hardware has increased in an ever-steepening curve. At each point on this curve the influence of new technology can be literally seen, in tapes by artists whose attitude towards the tools of their trade seems to be ambiguous. On the one hand it was possible for the American William Wegman to produce his no-budget, unedited, black and white tapes in the early 1970s (often with his dog, Man Ray) with a seeming disdain for the technical demands of video. At the other extreme a few years later, the pioneer American video artist Woody Vasulka, when designing and building his 'Vasulka Image Articulator' with Jeffrey Schier, would at times sign, in solder, the circuit boards he was working on.

The situation has become more acute with the advent of digital technology, which can turn the video image into a plastic form to be manipulated at will. However, the cost of such digital equipment is so high as to make access for artists in Britain difficult if not impossible. It is certainly true that for the last 15 years the higher levels of public funding in the US coupled with a more adventurous broadcasting policy have always led to American artists having use of the newest, most sophisticated equipment. American culture automatically validates 'newness', regarded in Britain with a distrust matched by an official attitude of respect for traditional media. Whatever the reasons, this gap between the two countries was never so wide as it is now.

As a result, the peculiar opportunities and problems associated with this new technology are being faced now by American artists who, however, are arriving at widely diverging solutions. Two approaches to video technology can be seen in the work of John Sanborn and Bill Viola. Sanborn's short tape *Act III* is a technical tour-de-force. To the soaring systems music of Philip Glass, live camera-work is combined with symmetrical computer-generated forms which pirouette in video space. The tape also demonstrates some of the range of effects possible utilising digital technology, notably the ability to treat the video image as a two-dimensional plane that can be flipped, spun, zoomed into infinity, or even squeezed into a three-dimensional shape.

Bill Viola's work, whilst created often with the most sophisticated cameras and post-production, seems restrained by comparison. In his 12-minute tape *Anthem* he turns an unblinking gaze on the American landscape and culture as though looking from another planet. As oil pumps oscillate in the desert like giant birds, and shots of industrial plants alternate with life-support machines, the soundtrack underscores the measured pace of the edits (all straight cuts) with a low wail – the slowed down scream of a young Asian girl. She is shown again three times in the final sequence, in progressively slower motion, until the eerie rumble of the scream accompanies an almost motionless image.

Bill Viola manages to resolve very disparate material and maintain a narrative momentum in *Anthem* by his very precise editing. Because of the passivity of the camera, always still with no zooms or pans, the edits function like the ticking of a metronome. The final slow motion shots interfere with this rigorous sense of timing and yet preserve the content of the piece: time seems to run out, like sand from an egg timer.

Video effects can now be broadly divided into two categories, which are not however mutually exclusive: devices which serve as narrative punctuation or transition, and those which interfere with the illusionistic nature of the video image itself.

In the first category are straight edits and mixes, 'shove-ons', and also wipes, of which even the simpler vision mixers are capable in large variety, from the conventional horizontal or diagonal to complicated diamond patterns and others. In the second category are three kinds of effect. Firstly, those which treat the video image as a two-dimensional plane to be manipulated in an illusionary three-dimensional video space – in video terminology; spins, tumbles, squeezes and so on. This kind of effect is familiar from its use in television commercials and particularly trailers for broadcast television programmes.

Secondly, there are those which interfere with the time element of the illusionary image. This includes

ANTHEM Bill Viola

ACT III John Sanborn

slow motion (not produced in the camera as with film, but at the post-production stage), freeze and variable rates of grab. The latter, in which, say, each fifth frame is held for one fifth of a second, produces the jerky puppet-like movements widely used in pop promotional videos. Finally, there is a steadily increasing number of effects which interfere with the visual illusion. This includes chroma-key, poster-ization, colourization, pixillation (where the image is split up into a patchwork of square bricks of variable size), and many others.

One conclusion that could be drawn from this is that with an ever-growing variety of treatments of the video image, the video artist has at last the capability of fully controlling the instant medium. However, this capability brings with it some prob-lems. The spinning video image zooming into the blackness of space, the cracking of the image into myriads of coloured bricks which reform to the next shot, these have joined the mix and the edit as tech-niques of narrative punctuation. However their sig-nificance is different from the older techniques: they are meant to be seen, to be noticed and to impress as futuristic sleight-of-hand, a magical transition between shots. Some artists, like John Sanborn, have produced tapes in which transitions of this kind follow relentlessly one on another. In Robert Ashley's 7-part *Perfect Lives*, directed by Sanborn, the tumbling rush of shots is incessant, nowhere more so than in the 25-minute *The Lessons*, intended as a schoolroom demonstration of the available video techniques. However, where the piece is overloaded with devices for narrative punctuation, this effect is paradoxically lost, as in a written sentence which consists only of elaborate commas and full stops. It moves forward without anchor points among the

waterfall of images, which tend to run into each other in a solid mass.

The advertising industry has naturally seized on these new methods of product display for television commercials. However, this aligns accurately with the role of the advert as punctuation in the flow of television programming. The more conventional editing methods that digital effects are supplementing and occasionally supplanting, always relied in any case on much more rapid cutting than would normally be acceptable in film or television. In addition, the hope is that these transitions lend the commercial an assumed air of futurism and magic, which is one reason why they are used to promote the most banal of products – washing machines and game shows.

There is another difficulty following on from the use of devices which affect the illusionism of the image, in that so often these operate as a denial of meaning within a piece, an obliteration of content. There can be very few instances where posterization or pixillation can function adequately as overlays on an image in a metaphorical way or to further the narrative. If not, and if the viewer is not to be left merely passive, then failing to answer the question 'Why?', the only response left is 'How?'. This forced preoccupation with the means can be an opaque barrier shielding the viewer from the content of a piece rather than enhancing it.

As more and more effects are developed there is a period of time in which their impact is one of mystifying spectacle, but this however declines very quickly into mannerism.

It is interesting that the effects employed in Bill Viola's work are mostly manipulations of the time illusion of video. His tape *Hatsu-Jume (First Dream)*,

produced in 1981 in Japan with advanced cameras and technical assistance from Sony (where Viola was visiting artist), makes extensive use of slow motion, together with speeded-up motion. These effects do not function as punctuation, nor do they seem to interfere with the reading of the image, even if the question of why they are used is sometimes left unanswered. However, if the impact of a piece of art is the product of cultural and historical factors, then it may be that John Sanborn has found a form of expression that mirrors Western society in the early 1980s: its obsession with pace and technology matched by a jewel-like surface, which reflects much but remains opaque.

As the cost of new technology falls and it becomes more widely available, British artists working with video will eventually be able to gain access to new techniques. It remains to be seen whether these will take their place within the grammar of film and video or become, like some of the techniques of early silent film, disused aberrations in the medium's development.

joining the dub club: funkers, scratch and big noise
nik houghton

In this most experimental branch of video we succumb to the glow of the cathode-ray tube while our minds go dead. Until video is used as indifferently as the telephone it will remain a pretentious curiosity.
　　– Allan Kaprow, *The New Television*, MIT Press, 1977

Video is just so trashy. I mean everything about it is trashy. I suppose you have to accept that if you make video-work.
　　　　　　　　　　　　　　　　　– Fine Art Student

As video art shifts towards an era of post-modern popism where video effects, re-processing of image, multi-mix dubbing – indeed the whole arsenal of video technology – is increasingly employed in the production of tapes, it is informative to contrast the contents of London Video Arts 1979 catalogue and this organisation's most recent publication (The LVA 1984 catalogue).

The former profiles video/installation/performance-based art in a series of artists' statements that are littered with the jargon of the avant-garde, the buzzwords of the experimental/ conceptual/structuralist approach; 'spatial disruption', 'videotape as analogue of time', 'the condition of television' – these are some of the phrases which dot the catalogue's testament to a video art which, in the late 1970s, could be located within a formal/structuralist debate. FAST FORWARD to 1984. ZOOM TO CATALOGUE PAGE. FREEZE FRAME: 'Distinctions between Art and Popular Culture (have become) progressively eroded … (and) since the term "Post Modernism" became current in the late 1970s, there has been a marked shift away from the formal refinements that had contributed to contemporary art's severe insularity' (Jez Welsh, from 'Some Notes on Video Art and Populism', LVA Catalogue 1984).

The 'shift', well under way by 1982 as art students and their contemporaries broke with the 'tradition' of 1970s avant-garde art, was compounded by a number of factors, both technical and cultural.

By the early 1980s pop video had begun to establish itself as an integral part of a newly emergent pop culture where fashion, style, music and attitude blurred together to form an eclectic, cross-referential and fast-moving contemporary phenomenon in which art students were often centrally involved. Participants in what Edit de Ak has termed 'Clubism', art students now refused the distinction between the constrictions of fine art and the hi-speed buzz and crackle of pop art 1980s style. The additional nudge of the American wave of slick, racy, fast-edit art video (Dara Birnbaum, John Sanborn, Chicago Video, etc) coincided with an increasing expenditure by art-college media departments on sophisticated U-matic equipment most particularly in the area of post-production. The introduction of fine-tuned edit facilities, image-processors, colourisers etc into art schools, the American influence, pop video's appeal and a determinedly anti-formalist approach by art students and the young bloods of video all determined the direction of 1980s video art. This break with the restrictions of fine-art concerns and increasing bias towards technological gimmickry led to a situation in which, what I shall dub 'stylism', became a central aspect of video.[1] A fledgling art form, video, now shifted itself towards the condition of the pop video – slick, colourful – a pop-art thing constantly searching for a gimmick, big noise,

novelty and cheap visual thrills. These products of techno-trickery and their consequent espousal as prime examples of a 'new' video art precipitated a situation where, by 1985, it often seemed that it was not the strength of the idea and its expression through the video medium that was of consequence but how many image mixes there were, how much funky music, what degree of colour polarisation … Ideas? Who needs 'em, sucker, as long as it looks good.[2]

The effect of all this has been to marginalise tapes which are somewhat more difficult to ingest than the constant flow of treated images which currently infects video art. More importantly for tape makers, without easy access to the expensive gadgetry of a time-base-corrector, vision mixer or three-deck edit suite – the devices that facilitate the glib flashiness of 'stylism' – it must often seem that success in the video art field is dependent not on a currency of ideas but rather on the amount of over-priced technology one can get one's hands on. Economics and access are key issues here, and with community video, workshops and educational institutions under threat, a crucial one.

In this respect, the spurious but much touted claim that video is cheap, easily accessible to potential tape producers, readily disseminated and populist begins to take on the hollow sound of propaganda.

Of course it is true that video workshops do exist but, often under-funded and operating with limited resources, these practical attempts at democratising the medium can offer only restricted modes of practice, which normally exclude access to the hothouse of post-production facilities where the product can be constructed. Despite appearances, London actually operates very few venues where videotape can be viewed by the public – 'Expensive Hire Rates' and 'Limited Accessibility' outline the restrictive nature of video production. Video art, in particular, is tied to art schools and media departments. It is interesting to note here that many of the 'names' of video art either have connections with art colleges/media departments or else access to professional, commercial-production-house facilities.

Beyond these issues, however, lie questions of 'video aesthetics', the current diversity of art-video, its direction, shape and cultural value. In this context it is instructive to look at the relative qualities of video and film, to set production methodology in both media against each other in an attempt to

FILM VERSUS VIDEO DIAGRAM Nick Houghton

locate the ways in which production systems define the content and form of these separate media.

Video is:

- Synchronous – image and sound are automatically recorded in sync
- Instant – tape can be instantly replayed and requires no intervening system
- Electric – image is electrically generated, abstract in that it does not exist until mediated by technology
- Defined – by the box or screen through which it is played
- Edit-Easy in that 'flash-frame' edits, repeat edits and jumpcuts can be quite easily achieved
- Intertextual – with the correct equipment broadcast television, and mainstream films distributed on VHS, can be simply pirated
- Effects-based – image mixing, colourising, freeze-frames, distortion and 'picture framing' can, with the necessary technology, be quickly and easily obtained. As you can see, down here in the edit-suite of post-modernism, among the hardware, knobs and buttons, the humming gadgetry, we can mix, freeze, posterise, dub, dab, scratch and jive your video-tape around in no time. Scratchitup and mixitdown … Easy innit?

For the filmmaker working with limited resources, functioning in the ill-defined 'independent' sector, these devices of techno-trickery are almost impossible to achieve. Image mixing, for example, may require hours of careful pre-planning, minute attention to the printing process – for the tape-maker similar effects can be achieved at the press of a button. Paradoxically it is the very ease with which video effects can be produced relative to

the slower, more labour-intensive processes of film, which has channelled current art-tape into an ambiguous area of mixed styles, the kitsch and a colourfully vacuous modernity. Film, with its own inbuilt restrictions, its demands on the artist for concentration at every level of both production and post-production – sound, lighting, scripting, developing, printing, dubbing, editing and, finally, screening – obliges the maker to consider his/her intentions carefully and, most importantly, over an extended period of time when commitment to an original idea and consistency in working are primary factors in the realisation of the project. For the video artist the speed of it all – shooting and post-production editing, mixing etc – makes for a considerably less sweat-stained and arduous exercise in which decisions about tricking-up the product can become almost arbitrary. Dubbing and dabbling around in the edit-suite, with all its attendant eyeball-searing, image-tumbling possibilities, it is all too easy for the tape-maker to let the medium become the message in an indulgent celebration of style over content in which meaning and purpose is subsumed to the seductive appeal of the electronic tricks box.

The extent to which the production possibilities define the content and form of video-art is exemplified in the current 'state-of-the-art' hysteria which informs much UK practice. Here the arrival of some new device, the initiation of some novel item of video technology, is greeted with vacuous enthusiasm and instantly put to work on some spurious project that serves only to illustrate the 'newness' of video. 'Video', wrote John Baldessari, 'should be just one more tool in the artist's toolbox. … The case should not be: "I'm going to make a video piece", but, "What I want to do can best be done with video"' (*The New Television*, MIT Press, 1977, pp. 110–11). Updating this statement, it could be said that the current situation amongst contemporary tape-makers is not 'How can I best employ video-effects to strengthen my idea' but the reverse, 'How many video effects can I use at once'. Ideas, you see, are secondary, spectacle becomes everything. Self-justifying and 'successful' within its own, limited, terms of reference, art video becomes a fast-moving, style-conscious imitator of the snap-crackle-bop of mid-1980s television advertising. Within this reductionist space where politics becomes a matter of Pavlovian response and 'art' is redefined as style, the process base of much independent avant-garde film-making is regarded as hopelessly old-fash-

ioned, quaintly obscurist in its intentions. Video art, wearing the legend 'POPULIST' across the chest of its fashionably outsized t-shirt, sneering at the 'elitist' nature of much independent film, skidding from one idea to another, fails to take account of intellect, confuses complexity with sterile formalism. Instant, transient, restless, mainlining on gadgetry, video art becomes a form wholly defined by its mode of production – whilst film, often screened at a slower tempo, a medium denied the trickery of the effects box, remains a thing apart, strengthened by its own limitations. The rigours of filmmaking, the long-term nature of a project's realisation and the attention to every aspect of production/post-production, the possibilities of 'expanded' screening, all serve to generate an attitude of thinking where the damaging spectre of 'stylism' is denied primacy over innovation and intelligence. This is not to deny the value of much video art, nor an argument for a return to the formalist avant-gardism of too much early art video – rather it is a call for a moment of assessment and critical thinking. A point of disruption, perhaps, where art video questions its subservience to a production methodology which relies all too often on the razzle-dazzle repeat-edit devices of video technology.

The hip word-slingers of video-culture will no doubt view this notion as drearily outmoded, of no relevance to this upwardly-mobile art form; yet, if video is to expand and establish itself as something more than a cultural novelty, the medium must refuse the aesthetic of an ad-styled eclecticism and begin to question its own intentions. Technology should not be allowed to bully ideas and the questioning nature of fine art practice into silence and, before art video drives itself up a cultural cul-de-sac, it is my contention that tape-makers, critics and art schools should start to question the production values which now dominate the medium. Trash, after all, may be fun but let us not forget that really it is just another word for rubbish.

1 John Maybury's widely acclaimed tape *Circus Logic Film* mixes advertising and fashion imagery with supposedly poetic scenes of stylized posing. Critics dubbed this exercise in image-mixing 'poetic', 'rich' and 'multi-layered'. Beneath the style and surface gloss, however, no intention or meaning was apparent.

2 Confirmed scratchers, the Duvet Brothers came to the public's attention with a re-mix video of political figures set to New Order's 'Blue Monday'. Wild praise was afforded this example of hi-tech scratch, yet since then there seems little indication of direction or progress in this area. Recently even scratch guru Andy Lipman suggested it was time for a re-think when a new Duvet Brothers product was reviewed.

post-modernism and the populist tendency
jez welsh

In this essay on current issues informing much video art production in Britain, I shall first reflect on some general issues raised principally by the parallel situation in the US and elsewhere, and in the light of this I will then look at some of the more particular concerns and attributes of work being produced in Britain. The point of departure is in itself problematic; while in many ways it is now desirable to dispense with the term 'Video Art', it is nonetheless a fact that the impetus for this enquiry springs essentially from the historical process of twentieth-century art, and that the work under consideration is mainly produced by individuals who, in the absence of a better description, term themselves video artists. It has been argued, particularly by the American John Sanborn, that 'Media Artist' becomes a more apt title for the video user who begins to situate her/his activity within the context of mass culture; in describing the works of several artists including Tony Ousler and Gary Hill he writes: 'These quirky examples simply illustrate the growth of what I feel is a group of misleading media artists who do not make art as much as they make, well … media. The material is so strongly spelled PRODUCT that the process-oriented world cringes'. However, this is an artist talking about other artists, and I have no doubt that the media world itself would have no doubt but that such PRODUCT is art since it is clearly not MEDIA in its terms, as it originated somewhere 'outside'.

Undoubtedly, there are still those within traditionalist pockets of resistance in the art world who would argue the validity of video, or any popular cultural form, as art, but when considering the issue of the proposed new genre 'media artist' any such argument is irrelevant on two counts: firstly, it is historically untenable in its own terms, and secondly, whatever frame of reference is used to describe such individuals, as far as the media world itself is concerned, they are still basically UFOs, and 'video artist' is as good a bracket as any to put them in. The media world cares little about what artists call themselves, nor does it concern itself with whether or not one group of artists is considered to be art by another group of artists. The media can always find somebody to trot out a definition of art should the need arise. However, the point of this preamble is not to become embroiled in a fruitless area of discussion, but to establish the point that one is accepting as given the term 'video artist' for better or worse in order to avoid confusion.

is that all there is?

Populism in contemporary British art is not so much a consciously defined issue as a tendency which has evolved over the past few years. It first became apparent in the late 1970s, alongside the concept of Post Modernism, and while some early attempts were made to launch Post Modernism as a new canon notably in a 1978 Artscribe appraisal of a number of painters including Duggie Fields, the idea and the attendant concern with populism have largely taken root outside of the kind of rigorous debate that typified the preceding eras of minimalism, conceptualism and formalism. Whereas in the US populism is being heralded in a rather naive and inappropriate manner as the force that simultaneously puts the lid on the formalist avant-garde, and allows artists to penetrate the mainstream of media culture, here it is seen either as a stage in an ongoing process of development, perhaps a cause for cautious optimism, or simply as an opportunity, particularly when manifested through painting and sculpture, to pull bigger crowds into the galleries, thus validating their existence within a Thatcherite economy and enabling dealers to sell more art.

The uncritical acceptance in the US in the inevitability of significant 'crossover' into the mainstream looks suspiciously like a reiteration of the 'more = better' equation that lies at the heart of imperialism, monetary or cultural. There is an assumption that making art available to a mass audience is an act of democratisation in itself, regardless of content, regardless of the consumerist connotations, regardless of the political position into which the artist must of necessity have been forced by the communications industry. This is not to suggest that an oppositional stance is irrevocably debarred from a mass context, but the dynamics of that context inevitably dictate a rigid, unilinear flow between producer and consumer. There is no doubt that the crossover from minority interest to mass culture will increasingly take place; as the industry's hunger for new material grows, more artists will find their work reaching a mass audience, and they will gain expertise and not inconsiderable stimulation from their relationships with the entertainment industry. But it will not make their art either better or worse ultimately, and it will probably not make any real difference to the industry itself or to the behaviour

and attitudes of the recipients, other than extending the range of what they are prepared to accept as entertainment. The overriding effect of television – a kind of tautological democracy – is a process of evening out. Everything comes across, within a limited range, as more or less level, as a unitary measurement in the ongoing flow of television time. Although it is possible to intervene, to introduce new ideas or alternative viewpoints, the context somehow militates against the efficacy of content. The radical is generally assimilated instead of being defined or directed; the uniform quality of television is an affirmation of dominant values. The recent British election was won in the media because the Conservative political machine ruthlessly exploited the ability of the media to confirm suspicions, fears and prejudices by postulating them as inherently laudable national characteristics, which, if held firm, would deliver us ultimately to the gates of a consumer paradise. Political debate was reduced to the status of soap opera, which itself inadvertently took on the heroic characteristics of classical tragedy.

And so it is against this background of what mass media actually does or does not do that we must consider the issue of populism as a viable cause for the artist to embrace. Inserting 'alternatives' into the dominant stream does not subvert it and does not create access in any generalised sense. In fact, if one were to espouse a 'conspiracy theory' approach to the whole issue, it would be tempting to think that the real motive for allowing access to alternative viewpoints is simply to posit the inviability of such viewpoints in relation to the dominant norm. Utopianism is a tolerable deviation.

A recent issue of the American magazine *Art Com* devoted much space to the populist issue. Amidst a plethora of fashionable rhetoric, polemical platitudes and indigestible terminology, the apotheosis of the buzz-word mentality, there was little evidence that anyone had much idea what was going on, other than that a number of artists had broadened the scope of their work to embrace popular culture and would therefore address a wider audience, thus escaping from the cultural ghetto to which twentieth-century history had hitherto confined them. It seems the assumption had been made somewhere along the line that because these artists had been 'liberated' and cut loose in the mass market of popular culture, they would immediately start in on the heroic task of liberating everyone else, armed with their sharp sensibilities, their intuitive grasp of the new technology, their phrase books in media-speak and their pretence

to the status of businessmen. The real issue behind it all is whether the advocates of populism will win the battle for art-world supremacy, so that they can call the shots, define the context, refine the codes, dismantle the nexus of economic relations within the art world to institute a system more appropriate to their particular aspirations. (It is apparent that selling a lot of cars to a lot of people at the lowest possible price is a more effective strategy than selling a few cars to a few people at a high price, and subsidising this endeavour by trafficking in cocaine.)

Of the many views expressed in the *Art Com* survey, the most realistic in broad terms was that of Canadian artist, Tom Sherman, who is worth quoting at some length: 'Let's face it, artists choose to work within the mass media context for a couple of pretty good reasons. What better place is there for indulging in or criticising mass media than the mass media itself? What better place could anyone suggest for finding an audience interested in indulging in or criticising mass media?' Sherman's statement can be contrasted with the contention of editor Carl Loeffler that 'the "cross over" tendency creates an expanded arena or context for the expression of ideas by visual artists. The "new" arena for art involves radical changes toward the perception and definition of art'.

To determine 'new' perceptions and 'new' definitions for art, on behalf of the world at large, and to dump these into the context of popular culture, is not popularization through mass engagement, it is simply elitism on an extended scale. The issue of populism is not unique to American and British art, it crops up everywhere that an established avant-garde practice exists. It is probably more highly developed in America due to the sheer scale of the media industry there, and the comparative accessibility that artists enjoy. In Britain, it is a comparatively new issue, and one which is barely documented. There is the ongoing cable debate in Britain, but few now believe that there is any provision for truly democratic public access, and even if this were not the case, the question of art is not especially 'hot'. It would be pointless to make any claims on behalf of populist artists in Britain or to assume that the dawn of a new age of mass creativity or mass aesthetic involvement will be the inevitable result of a broadening of the art context.

populism as reaction

In beginning to look at the implications of populism within contemporary British art, and video in particular, we must first ask what it was that caused the idea to develop. It is apparent in the first

instance that it was, in art terms, a reaction to the formalism which preceded it. For many young artists in the late 1970s, there seemed nowhere to go. Many retreated into a romantic rerun of some era or other from art history, others reached the conclusion that the whole issue was arid territory and turned, as had happened in the 1960s, to popular culture. The violent energy of new-wave culture quickly penetrated every level of creative activity in Britain, throwing up a whole new generation of musicians, graphic artists, fashion designers, poets, performance artists and writers. By the 1980s, most of the early energy had dissipated, but by then certain ideas had firmly taken root in the art schools and in the minds of young artists trying to define a context for their own activities. And at the same time, cheap colour video was becoming a reality, video games were becoming a national obsession, home computers were becoming commonplace, and home recording technology to cater for the independent musician was invented. In the late 1970s, Post Modernism was declared as the point after the end point in the modernist process. Painting started to come back, artists' film abandoned structuralism in favour of a vocabulary that drew a direct line of descent from punk, but that also had all the right art-historical references. By the time punk had been declared officially dead, popular culture and high art alike had fractured into a million cults, trends, revivals and reruns. The era of New Romanticism introduced a note of self-conscious pomposity perfectly attuned to the emerging national philosophy of Thatcherism.

Within art schools, the great revival of painting, the noises coming from Berlin and New York, the reaction against all the avant-garde strategies of the 1970s, created an opportunity for video to come into its own. Video provided a refuge for those unwilling to take up the task of re-establishing painting and sculpture. It also provided a language that was rapidly becoming universally regarded as the authentic expression of the media-dense times, and it provided a direct point of access to the whole field of popular culture. A new generation of video artists emerged at the beginning of the 1980s. With scant regard for the process-oriented video of the 1970s, they set about their task of synthesizing; anything could be incorporated, television commercials, soap opera, pop music, literature, art history, fashion, performance, dance, computer graphics, video games.

Video in Britain is, all things considered, remarkably healthy now. Its roots lie in the development of video access facilities, such as that operated by London Video Arts, which came about in the 1970s in response to demands from avant-garde artists and community activists alike for the opportunity to explore and exploit the medium of video. We have now reached a position where such access facilities, in Britain at least, are becoming more widespread through the infusion of public money and more recently through the support of Channel 4. Alongside this move towards an open access to video facilities has been the massive explosion in sales and rentals of domestic video equipment. At a grass roots level, video production is mushrooming, not only in terms of the obvious examples of domestic pornography and home-movie making, but also in terms of a video subculture that is analogous to the opening up of musical production initiated by the new wave phenomenon in the late 1970s. This inherently anti-consumerist trend embodies the assumption that instead of paying to see a high-tech multi-media extravaganza, you can do it yourself, albeit crudely, with whatever tools are at your disposal. The audience will inevitably be smaller, but a context exists, an exchange of ideas is integral to it.

Against this background of developing guerilla activity, it is possible for the video artist to embrace populist concerns, to gradually reach out to a broader audience, without having to bow to the demands of the media industry. Through a network of alternative venues ranging from small galleries to clubs, cafes and discos, to community-based arts centres and video workshops and to private homes, a more critical media consciousness may develop, based not on the assumption that acceptance into the mainstream of media culture will automatically open up new horizons, but on the assumption that the media mainstream is not the only alternative. And the most vital element of this tendency is the fact that it operates on the principle of engagement and involvement rather than that of exclusion; it is still about communication, social interaction, all of the things that the immobilised television (or domestic video) viewer is denied. And populism in this sense does not simply mean the espousal of the style or imagery of dominant popular/cultural trends; it allows an engagement with issues of mass concern; sexual politics; the nuclear arms race; race relations; community politics.

Having illustrated the naiveté of assuming that intrusion into the processes of mass culture will ultimately be the saviour of art, or that such intrusion will have any quantifiable effect upon the

mass media itself, the mistake should be avoided of assuming that an emerging subculture based on video and other electronic processes will in itself make any noticeable impact upon dominant cultural forms. Certain elements will inevitably filter through and become assimilated; various individuals will make the transformation from 'alternative' to 'mainstream'; but a living oppositional culture will at least provide a spur to creative experiment and radical intervention which are difficult if not impossible within the dominant form.

image, music, text

The contemporary cultural project, and the video tape in particular, exists within a matrix of references – historical, cultural, linguistic and social – which has multiple points of access, drawing as it does upon an extensive pool of information that is generally available through the media of mass communication. Yet it is dense insofar as the extent of comprehension is determined by the ability of the viewer to decode and isolate particular strands, and to extrapolate constructs based on the interrelations and connections between these strands, a process that may in one case be based upon an established theoretical methodology, and in another, be entirely intuitive. This disjuncture between the analytical and the instinctual exists as much in the makers of the texts as in those who endeavour to interpret or simply comprehend them. While some artists, commencing from a position of acquired theoretical methodology, translated into informed practice, pursue a deliberate process of deconstruction/reconstruction, others operate instinctively in a field, drawing upon a wide net of inputs, and employing techniques of deconstruction/reconstruction as learned responses rather than developed techniques. The text is the direct reverse of the formalist work, whose reductive purity sought scrupulously to eradicate all reference to anything beyond the blunt reality of the object itself. The text is an admission of the relationship of itself to everything else, it desires to merge with the context surrounding it, accepts that it would be irrelevant in isolation: the individual video production as text is essentially a part of a wider text whose parameters are delineated only by the range of contributory cultural/linguistic threads.

Thus, for video, the context may shift from gallery to cafe to discotheque to specialist festival to television to community centre, and may ultimately mutate into a form that owes something to all of these, whilst being a response to a new set of imperatives. If the

video production is itself a text, or part of a text, then the situation in which it is experienced and commented upon is also part of that text on a broader scale. If video continues to attempt to engage a wider and less specialised fragmented) audience, then the dialogue between that audience and the art/artist will contribute to the growth of the form through the development of a shared cultural syntax. One area in which this process can already be seen is in the work of various artists who are currently concentrating on image/music relationships, and on the relationships between sounds/words/images. Such projects can clearly be seen to relate to and to be influenced by mainstream tendencies in pop video and commercial television, but they differ essentially in orientation. Whereas in the instance of the commercial pop video, the image, the narrative, is subordinated to the primary function of selling a separate product, artists, image/music tapes are aimed at creating a synthesis, a form in which neither part would be effective in the absence of the other. In this area there exists both great potential for the development of a truly populist cultural form, and the risk of rapid assimilation into the machinations of the consumer industries. A conscious decision by practitioners and enthusiasts of video art to encourage active participation in the production and dissemination of video through independently controlled channels, for the purpose of a broad and engaging dialogue, could create a strength that would allow for (potentially) mass exposure without massive dilution.

The most interesting aspect, perhaps, of the whole populist development in video, is that it is no one individual's sovereign province; it arises from a broader cultural concern. Although, like any other form, it produces both 'good' and 'bad' or 'successful' and 'unsuccessful' art, the individual work or the individual producer is not the main point; the fact that it is happening, and that a vital and energetic cultural endeavour may result, is the main point. For this reason, I have avoided the consideration of particular video tapes and individual artists. Another piece of writing setting up another new genre with its attendant personality cult of 'key' figures is not what we need at this point in time. What we do need is a sense of responsibility, a commitment to maintain an openness to new possibilities and a confirmed suspicion of anything that appears to be the easy option. The Post Modernist ideal of Populism will either result in a further de-specialisation of cultural production, or it will simply deliver up another load of willing compliants to the waiting arms of the media industry.

full index of back issues